THE BOOK OF
NATURE

The Natural Heritage according to UNESCO

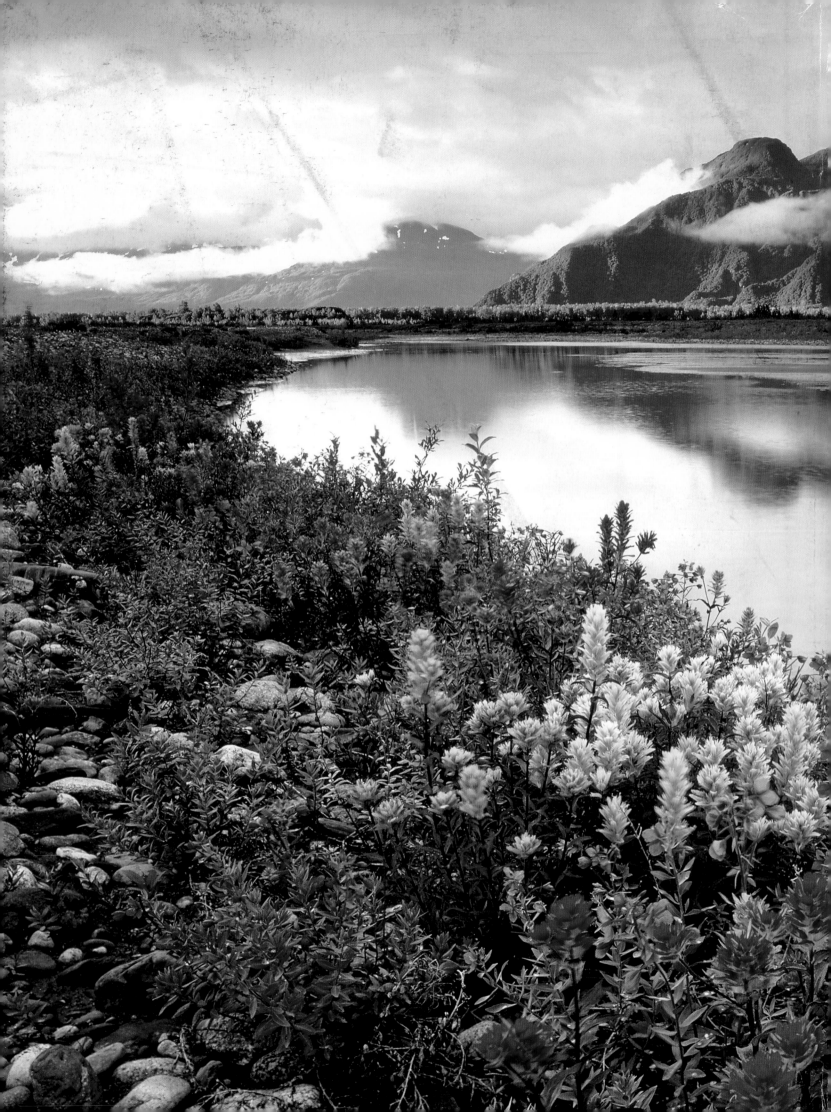

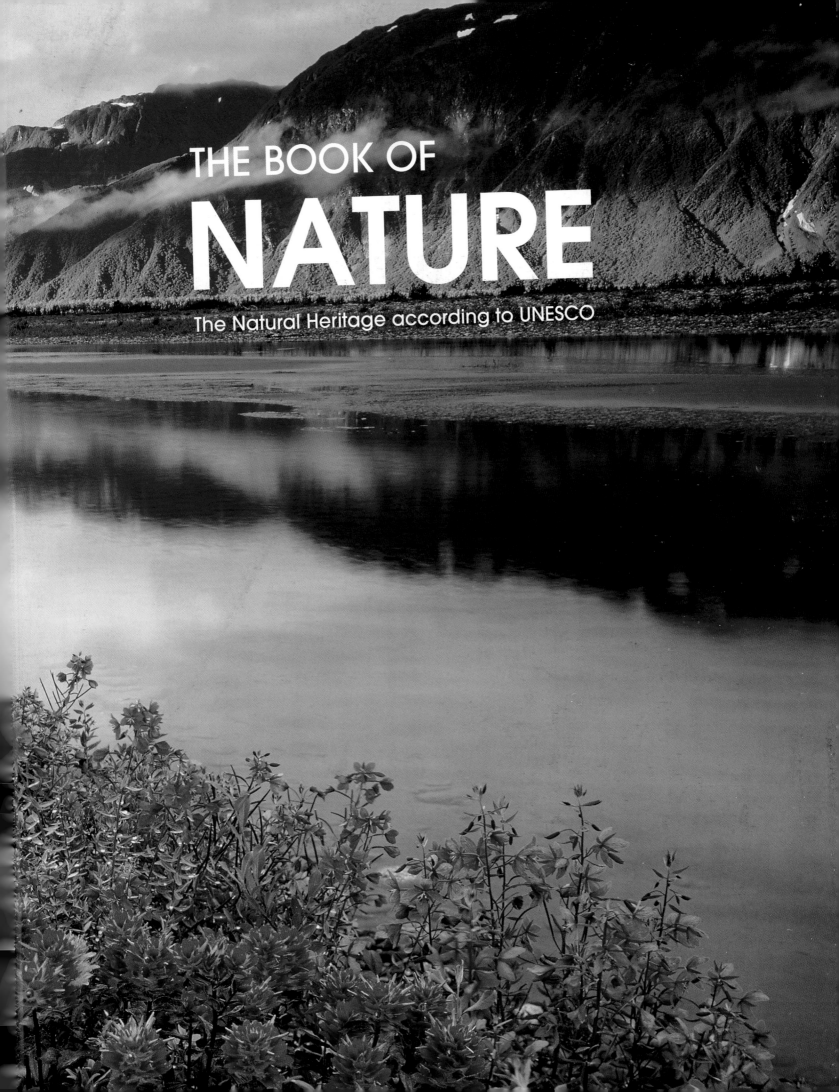

THE BOOK OF
NATURE

The Natural Heritage according to UNESCO

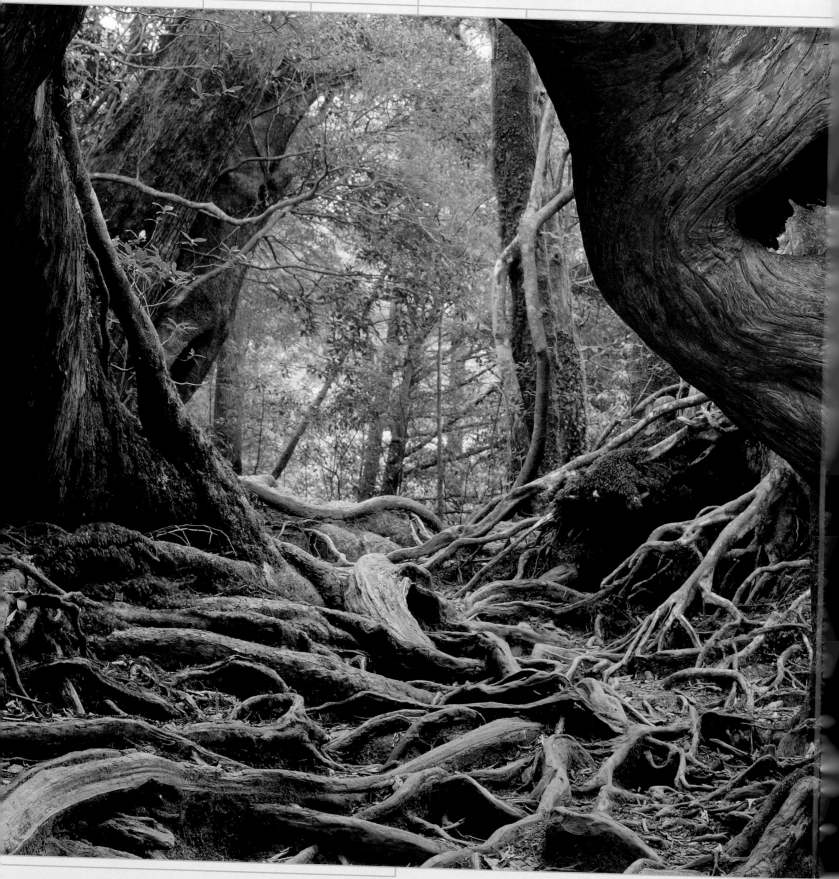

Previous page: A hundred years ago Glacier Bay was still completely covered in ice, but as the glaciers retreat beautiful wildflower meadows emerge along the banks of the meandering meltwater rivers.

Below: The imposing roots of the Japanese cedar spread out over the granite floor of the Japanese island of Yakushima.
Right, from the top: chimpanzee, fur seal, East African three-horned chameleon.

INTRODUCTION

The last remaining European primeval beech forests in the Carpathians, the impenetrable jungle of Sumatra, the Golden Mountains of Altai, the national parks of East Africa where big game flourish, the rocky moon-like landscape of the Tassili N'Ajjer in Algeria, gigantic glaciers in Patagonia, geysers and hot springs in Yellowstone National Park, the Great Barrier Reef off the east coast of Australia – such dreamlike, paradisiacal, untamed places can still be found, where nature has created amazing "artworks" of a unique grace and beauty which have largely escaped human interference.

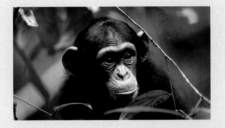

To preserve this situation in the face of continuing worldwide destruction of the natural environment, UNESCO (the United Nations Educational, Cultural, and Scientific Organization), together with the International Union for Conservation of Nature (IUCN), and the International Council on Monuments and Sites (ICONOS), has to date designated 201 natural monuments as World Heritage Sites – of which 25 are also designated World Cultural Heritage Sites.

To receive World Natural Heritage Site status, a site must be of "universal value," and particularly worth preserving, because of its aesthetic attraction, its scientific importance, or its status as a habitat for rare species of animals and plants. The integrity and authenticity of sites are also important, and a conservation plan must be in place. In many cases, the areas will already be protected by having National Park status, as for example the Serengeti in Tanzania or the Everglades in Florida.

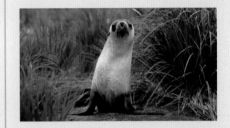

The UNESCO listing of World Natural Heritage Sites is designed to emphasize the fact that the preservation of our natural environment is not merely a national matter, but is a concern for all humanity – so that unique and vital ecosystems can survive, but also so that our descendants are able to enjoy these spectacular beauties of nature.

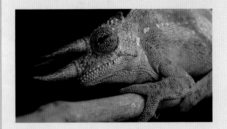

Since its last major expansion around 1860, the 23-km (14-mile) long Aletsch glacier has been receding. Thanks to global warming, it is currently shrinking at a rate of some 50 m (164 feet) per year.

Europe's last significant bison population is found in the Belovezhskaya Pushcha/ Białowieża Forest Park of Poland and Byelorussia.

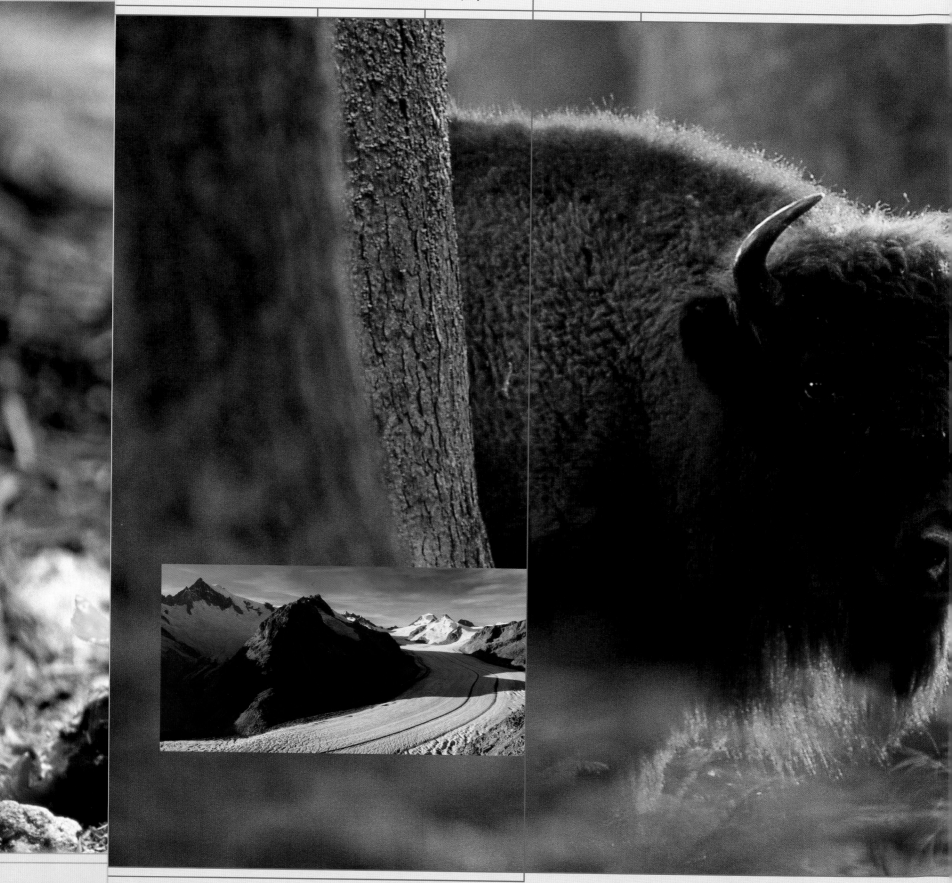

CONTENTS

CONTENTS

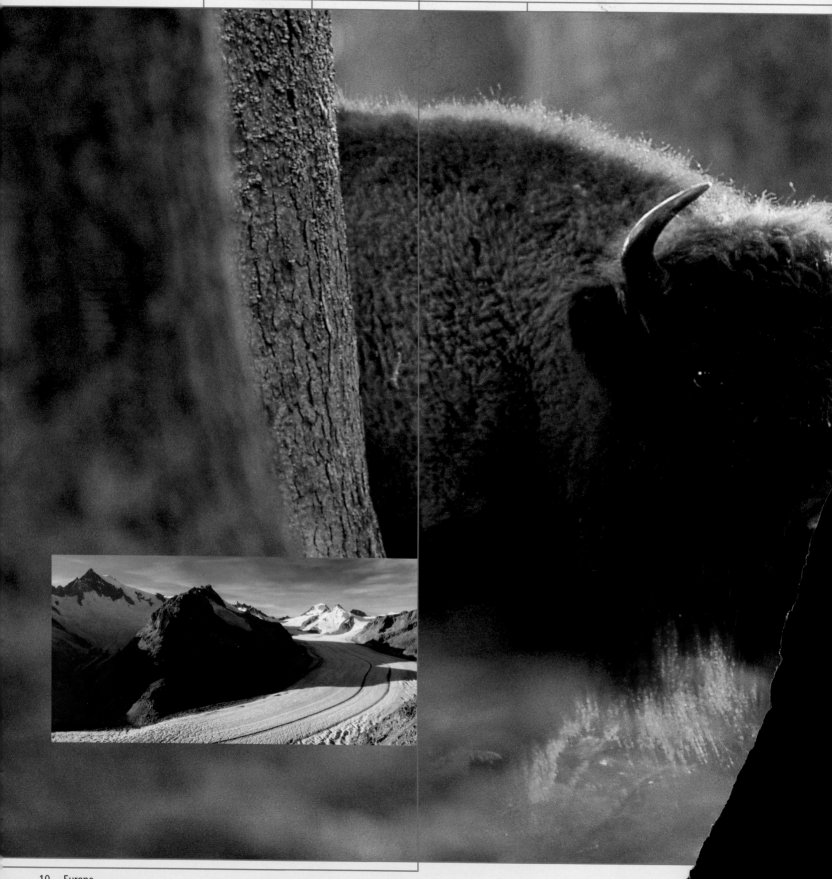

Since its last major expansion around 1860, the 23-km (14-mile) long Aletsch glacier has been receding. Thanks to global warming, it is currently shrinking at a rate of some 50 m (164 feet) per year.

Europe's last significant bison population is found in the Belovezhskaya Pushcha/ Białowieża Forest Park of Poland and Byelorussia.

EUROPE

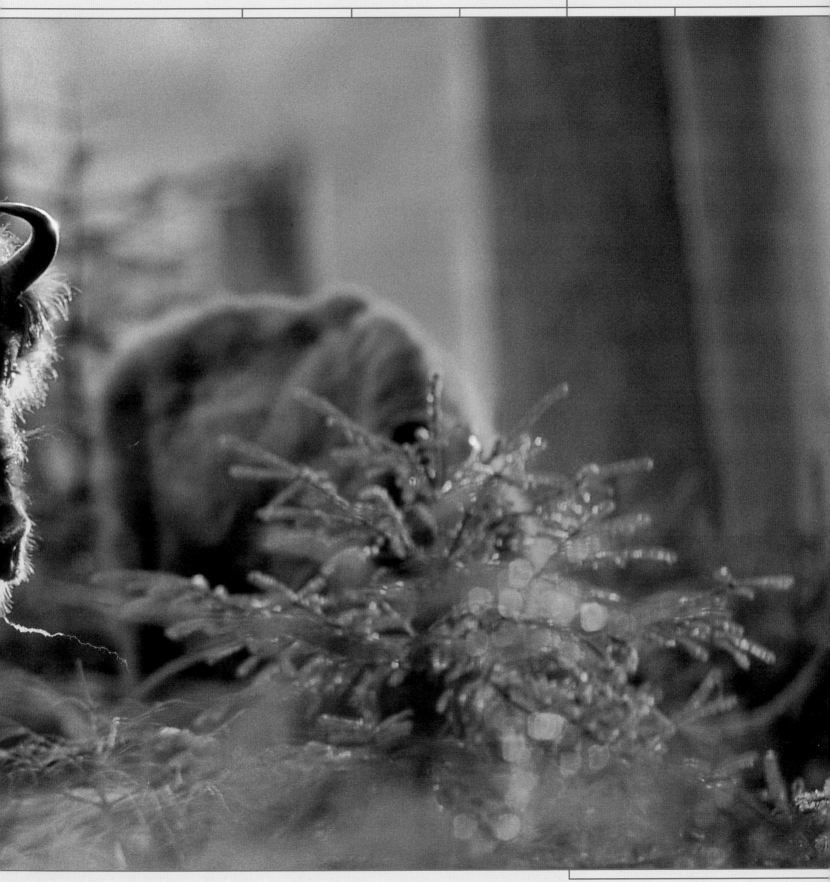

ST KILDA

Located around 175 km (110 miles) off the west coast of Scotland, Britain's most isolated and remote archipelago provides an ideal nesting place for the world's largest colony of northern gannets.

Date of inscription: 1986; Extended: 2004, 2005

Spared from glaciation during the last ice age, this volcanic archipelago has retained its characteristic landscape. The group of islands "at the end of the world" comprises Dun, Soay, Boreray, and Hirta. The residents of Hirta were resettled in 1930, and the island has been uninhabited ever since – given over entirely to nature. Its impressive, steep cliff faces provide optimal nesting conditions for rare birds, notably for the huge numbers of gannets who have taken refuge here. For the northern gannet, the archipelago is the world's most important breeding ground.

Despite the islands' harsh climate, they were first settled some two thousand years ago. The settlers' most notable buildings are the so-called cleits, of which there are 1,260 on

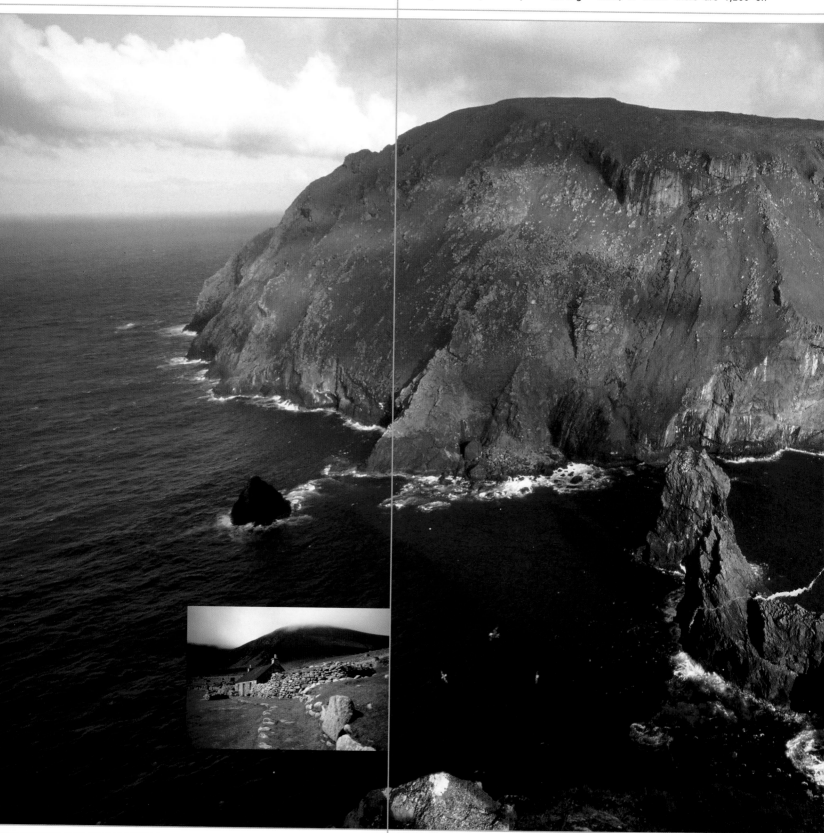

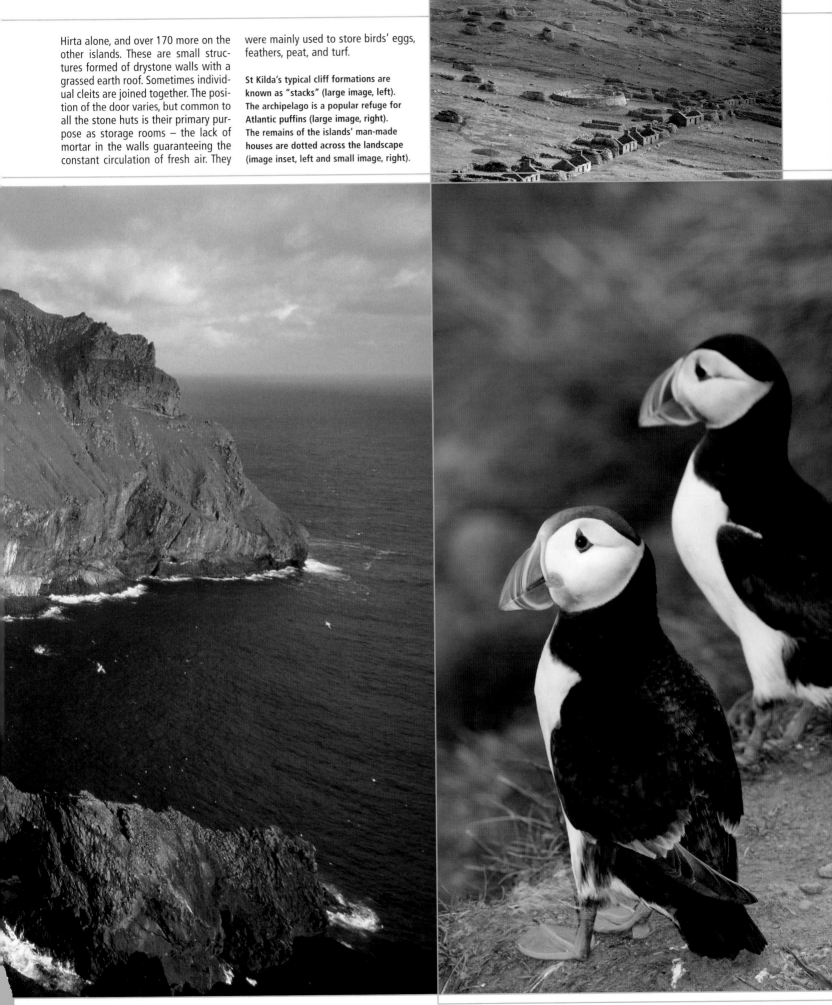

Hirta alone, and over 170 more on the other islands. These are small structures formed of drystone walls with a grassed earth roof. Sometimes individual cleits are joined together. The position of the door varies, but common to all the stone huts is their primary purpose as storage rooms – the lack of mortar in the walls guaranteeing the constant circulation of fresh air. They were mainly used to store birds' eggs, feathers, peat, and turf.

St Kilda's typical cliff formations are known as "stacks" (large image, left). The archipelago is a popular refuge for Atlantic puffins (large image, right). The remains of the islands' man-made houses are dotted across the landscape (image inset, left and small image, right).

THE DORSET AND EAST DEVON COAST

The cliff formations along England's "Jurassic coast" bear witness to 185 million years of geological history. Fossils from the Triassic, Jura, and Cretaceous periods have all been found here.

Date of inscription: 2001

The 150-km (90-mile) long coastline between Old Harry Rocks near Swanage in Dorset and Orcombe Point in Devon is known locally as the "Jurassic coast." The geology in this area spans the entire Mesozoic era. Rock formations from the Triassic, Jura, and Cretaceous periods are displayed like the layers of a sandwich, allowing visitors to clearly view these three sections of the Mesozoic era in an uninterrupted sequence.

Geomorphologists across the world first became aware of the importance of this piece of coastline in 1810, when an 11-year-old girl by the name of Mary Anning came across what she described as a "dragon" in the cliffs near the fishing village of Lyme Regis in Dorset. What she had discovered was in fact the first complete fossil of an ichthyosaur. It looked like a cross between a giant fish and a lizard, and gave rise to quite a sensation.

There has been a constant stream of new finds along the Dorset and east Devon coast ever since. The ongoing erosion of the cliffs means that the landscape here is changing at a breathtaking pace, and fossils can

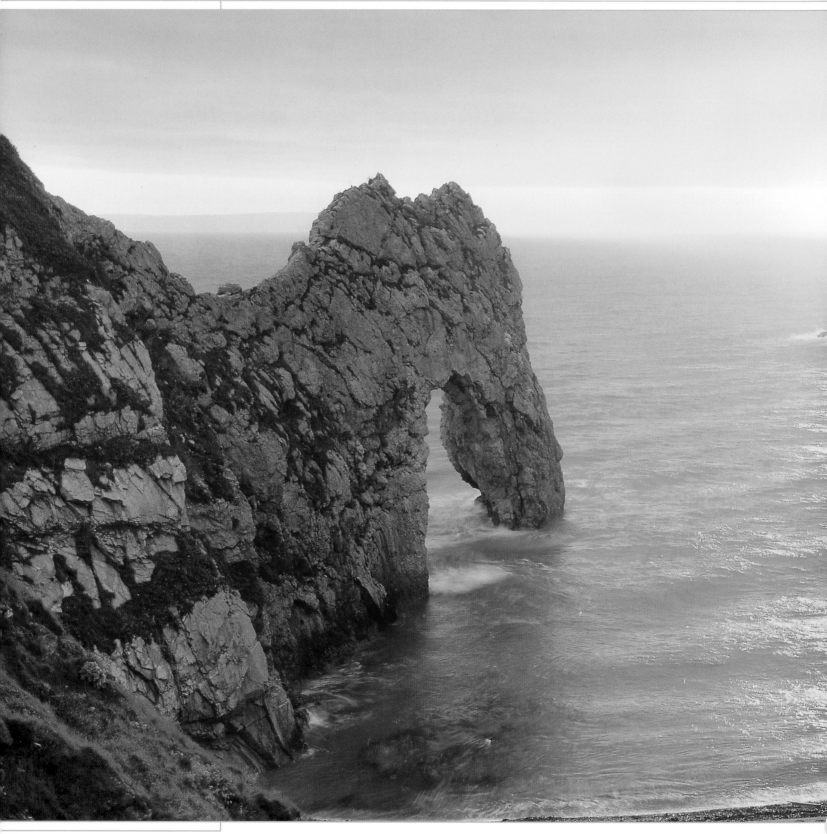

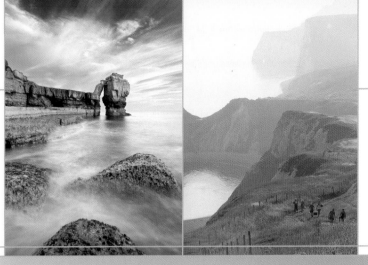

therefore be found without the need to excavate. After a storm, a stroll along the beach or the land behind it quickly becomes a journey of discovery through the different stages of our evolution and geological history.
In the interests of conservation, the National Trust has acquired around half of the world heritage coastline. It is a fascinating place to explore.

The south-west coast path affords fabulous views out to sea from the Dorset and east Devon coast (small image, left). Strange rock formations like Pulpit Rock at the southern tip of the Isle of Portland (small image, far left) and the rock arch of Durdle Door (large image) are two of the sights.

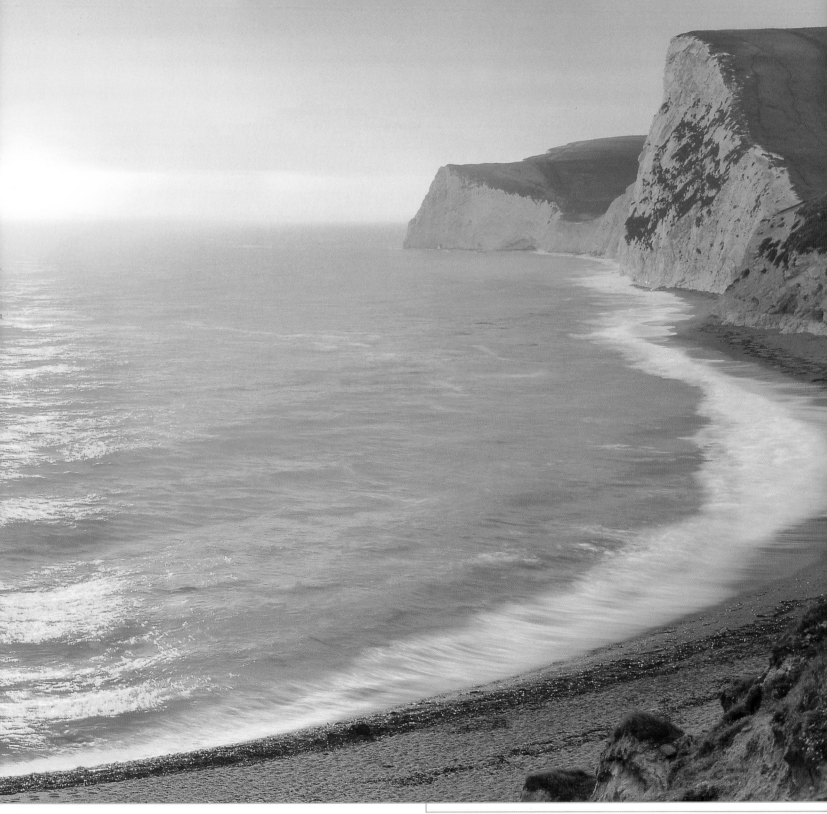

GIANT'S CAUSEWAY AND CAUSEWAY COAST

The basalt columns of the Giant's Causeway span 5 km (3 miles) of the Northern Irish coastline, and are the stuff of numerous legends.

Date of inscription: 1986

Not far from the fishing town of Ballycastle in Country Antrim, some 40,000 basalt columns rise out of the sea. Mostly hexagonal, the columns are believed to be approximately 60 million years old. Together, they create a 5-km (3-mile) path along the rocky coastline. They were formed by the crystallization of molten lava in the cold seawater.

The tallest columns are up to 6 m (20 feet) high. The name "Giant's Causeway" derives from one of the many legends to which this wonder of the natural world has given rise. According to the story, the Irish warrior Finn MacCool, challenged by his Scottish rival, the giant Benandonner, built the stone causeway to cross the Irish Sea to Scotland.

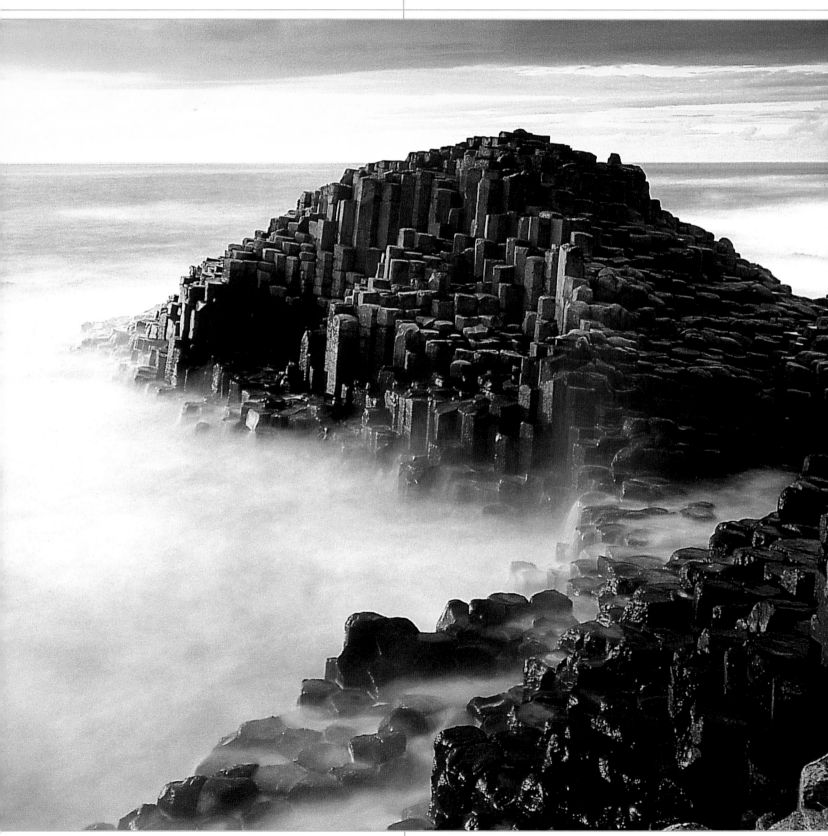

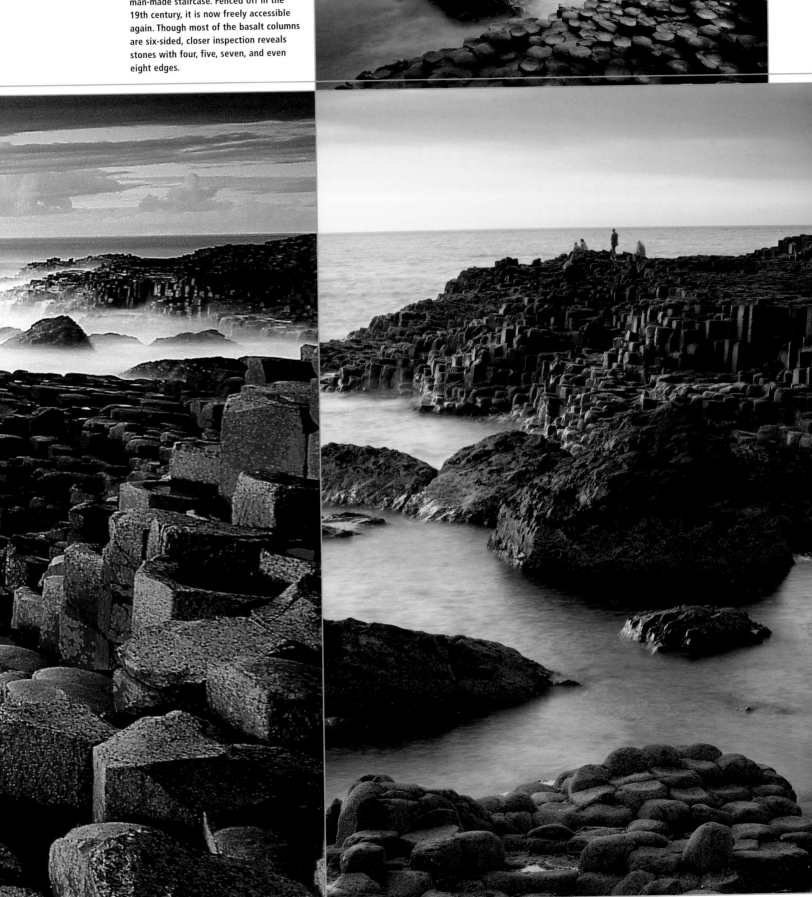

The Giant's Causeway looks like a huge, man-made staircase. Fenced off in the 19th century, it is now freely accessible again. Though most of the basalt columns are six-sided, closer inspection reveals stones with four, five, seven, and even eight edges.

THE VOLCANIC ISLAND OF SURTSEY

This island, 32 kilometers (20 miles) off the southern coast of Iceland, was the result of submarine volcanic activity between 1963 and 1967. Reserved for research by the Icelandic government, it is an open air laboratory for the observation of natural colonization behaviour in plants and animals.

Date of inscription: 2008

The island of Surtsey is off-limits to casual visitors. Surtsey has been reserved for scientific study since its creation, to ensure that the study of its flora and fauna is undisturbed by human intervention. The island, named after the Nordic fire giant, Surtr, was declared a wildlife reserve as early as 1965, while it was still being formed. Mosses and lichen were documented a year later, and these were followed by higher plants such as searocket, beach grass, and oyster plants, whose seeds had been blown across the sea from the bay some 20 km (12 miles) away. Birds and insects also reached the island in its first year of existence, and it is now home to 335 species of invertebrate and 89 kinds of bird.

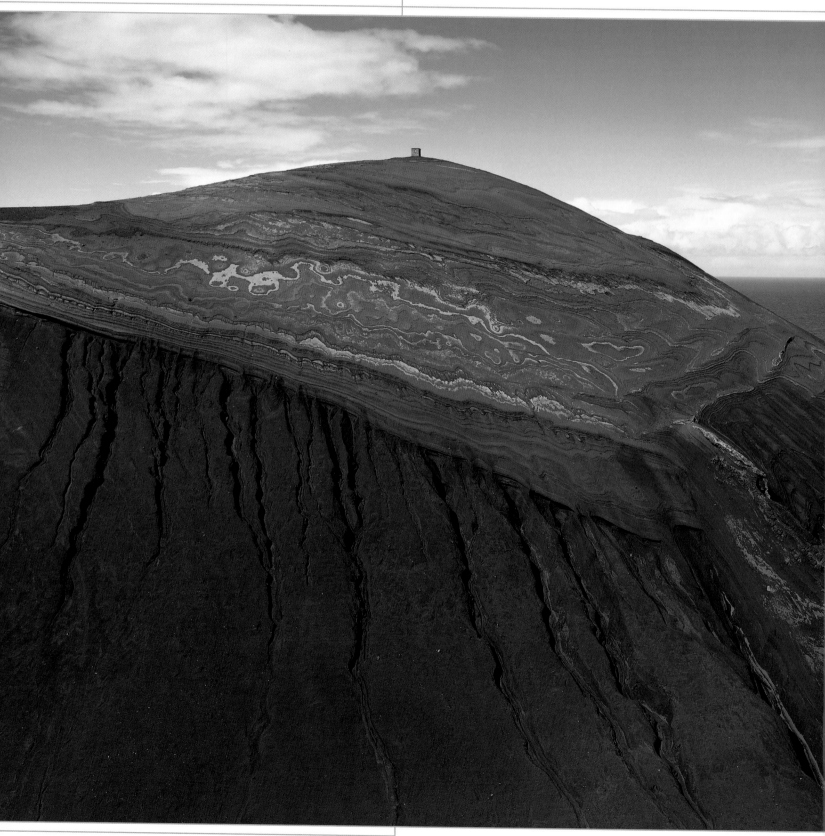

Surtsey, the southernmost of the Vestmannaeyjar Islands off the coast of Iceland, is a giant open air laboratory (below right). Violent eruptions under the Atlantic (right) led to its creation in 1963. The island consists of lava and pyroclastic material and has provided an opportunity for scientists to study the "undisturbed" development of animal and plant life (small image below).

However, time and tide have not waited for Surtsey. Rough seas, wind, and rain have eroded ever greater amounts of material and the compaction of the island's sediments and base material mean that its surface area is constantly shrinking. Once covering 2 sq. km (just over a square mile), Surtsey has now shrunk to 1.4 sq. km (three-quarters of a square mile) and the highest point has dropped from 173 m (567 feet) above seal level to 154 m (505 feet).

Scientists have estimated that the island will lose most of its land mass over the next century, but Surtsey will not disappear beneath the waves; the island's core will remain as a bare rock in the ocean.

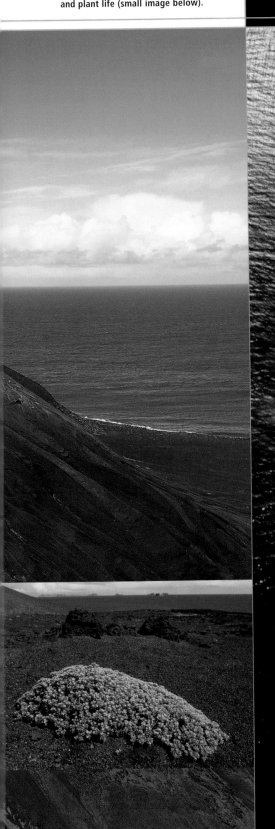

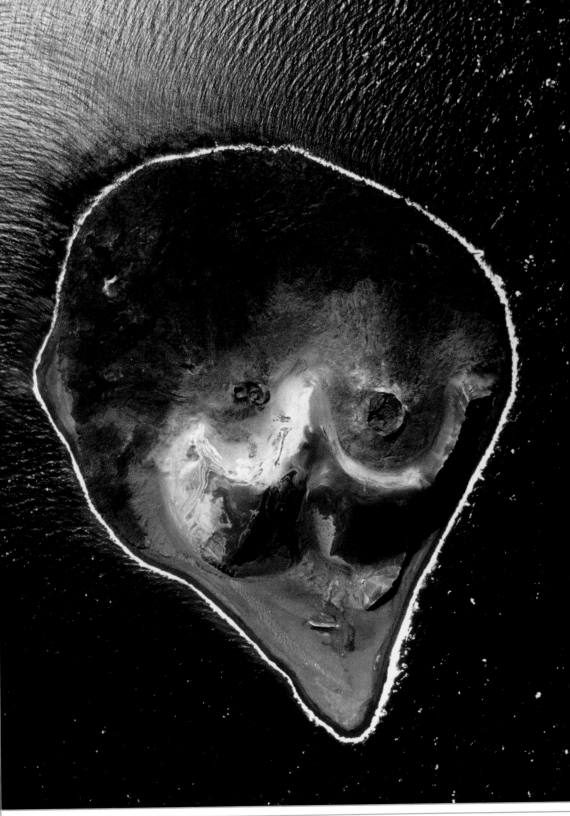

THE WEST NORWEGIAN FJORDS: GEIRANGERFJORD AND NÆRØYFJORD

Norway is a land of fjords. Two of the longest, deepest, and most beautiful examples are Geirangerfjord and Nærøyfjord, both located in the south-west of the country.

Date of inscription: 2005

"Fjord" is a Norwegian word describing a valley originally created by rivers, and subsequently shaped by huge glaciers during the ice age. These U-shaped valleys cut deep into the coastal rocks. At the end of the ice age, rising sea levels caused the fjords to flood and so penetrate deep inland. Fjords are typified by their steep, often vertical walls, which have been pol-ished by the movement of ice masses across their surfaces. Glacial detritus is found at the bottom of the fjords. Geirangerfjord and Nærøyfjord are about 120 km (75 miles) apart. The ice masses that created them penetrated some 1,900 m (6,230 feet) deep into the mountains, and the bottom of the fjord walls are as much as 500 m (1,640 feet) below sea level. The estu-aries are 1–2 km (0.5–1 mile) wide. Both fjords boast impressive mountain ranges that rise up behind the sheer coastal cliffs. Above Geirangerfjord, the Torvløysa mountain is 1,850 m (6,070 feet) high, and the Stiganosi mountain over Nærøyfjord reaches some 1,761 m (5,778 feet). While the Nærøyfjord mountains have rather flatter tops, the Geirangerfjord range is more alpine in

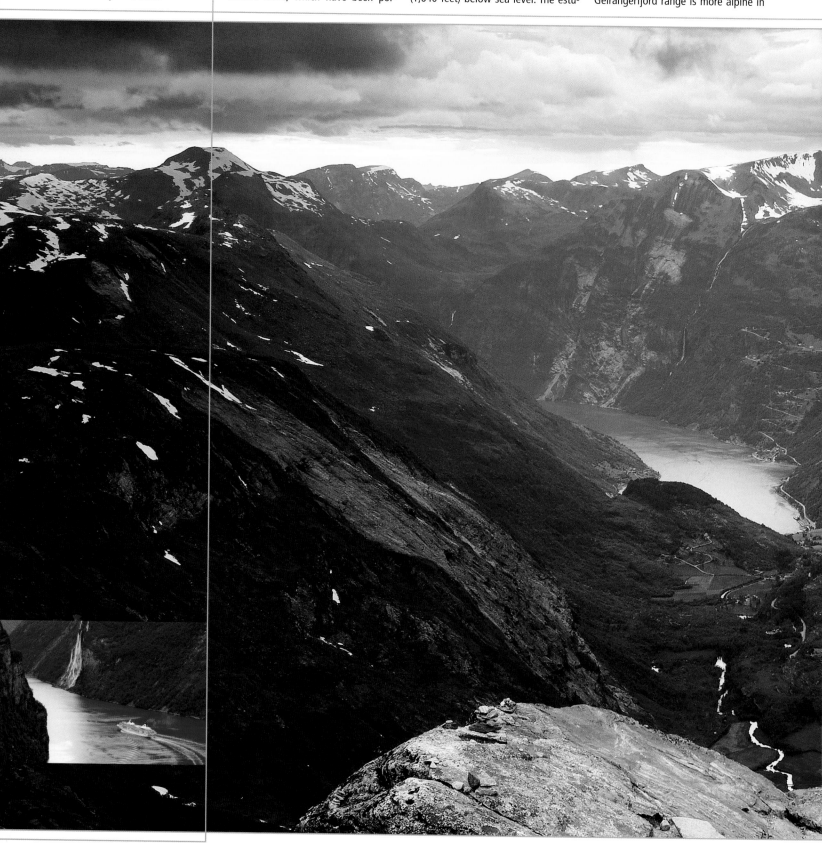

character. Streams from the nearby mountains flow into the fjord from hanging valleys, often falling down the cliffs as waterfalls. At Geirangerfjord and Nærøyfjord, these streams – unlike those at most other fjords – have not yet been used to generate power. Both Geirangerfjord and Nærøyfjord run parallel to the coastline, each opening out into a further fjord.

At a height of 1,476 m (4,843 feet), the Dalsnibba mountain offers panoramic views over Geirangerfjord (large image). Cruise ships pass the Seven Sisters waterfall (image inset, left), which drops some 300 m (984 feet). At certain points, Nærøyfjord, a branch of the Sognefjord, is only 250 m (820 feet) wide. It is surrounded by mountains that reach heights of 1,400 m (4,600 feet) (small image, right).

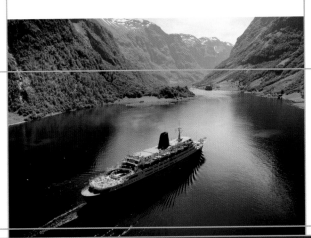

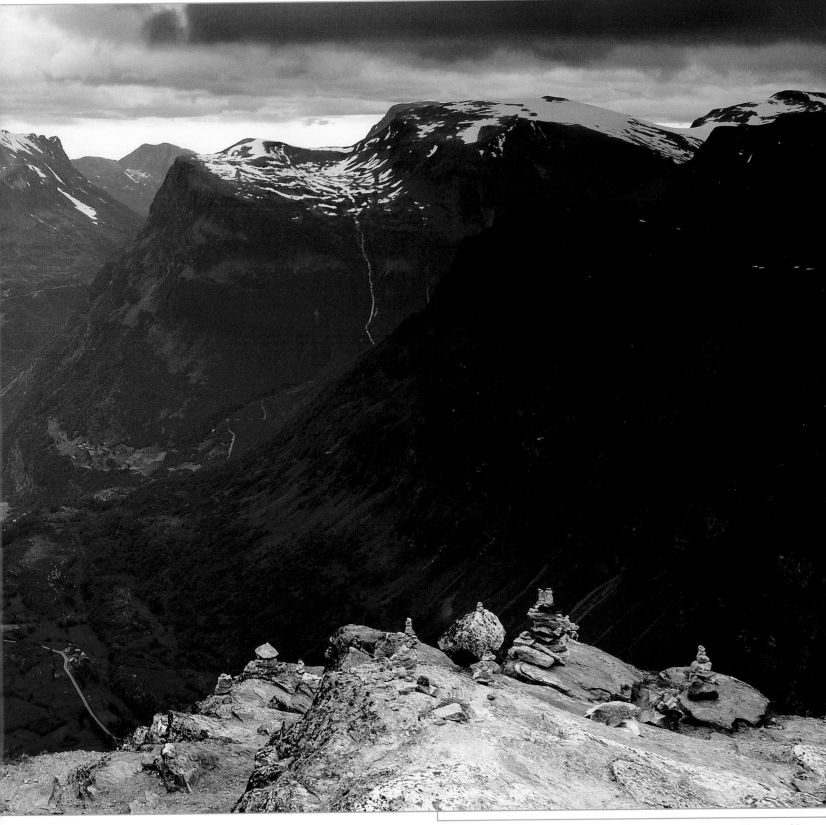

THE ARCTIC CULTURE OF LAPLAND

The vast plateaus of northern Sweden are home to the Lapp or Sámi people and their culture. The nomadic Sámi way of life makes the most of the landscape's sparse natural resources.

Date of inscription: 1996

The Sámi or – as the Lapps term themselves – Samek ("bog people") have inhabited the northern regions of Scandinavia for over two thousand years. Throughout their history, these people have roamed the barely populated landmass with their giant reindeer herds, covering vast distances every year.

Today, many Sámi remain true to their traditional way of life, even if they can no longer make their living from fishing and reindeer breeding alone. Tourism and conservation work have become important additional income sources. Sámi crafts, meanwhile, continue to flourish, notably in the form of lavish textiles, wood and bone carvings, and

animal furs. Traditional, bright Sámi clothing is also as popular as ever.
The areas of Lapland between the edge of the forests and the north sea coast are dominated by tundra vegetation, and are not used for agriculture. They are home to brown bears, as well as wolves, elk, and a wide variety of birds.

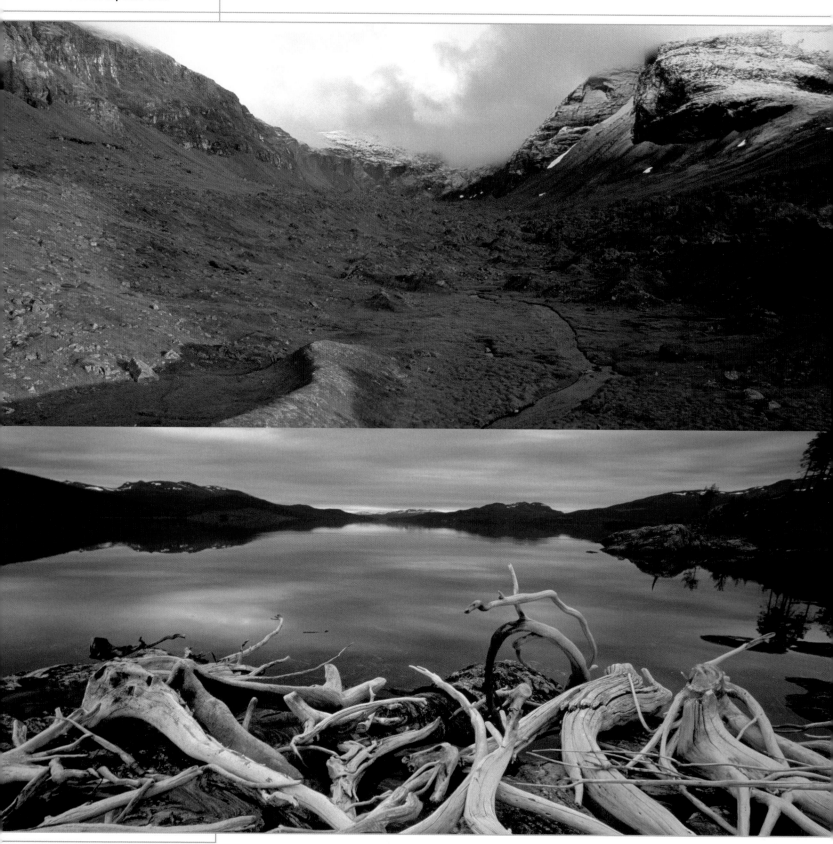

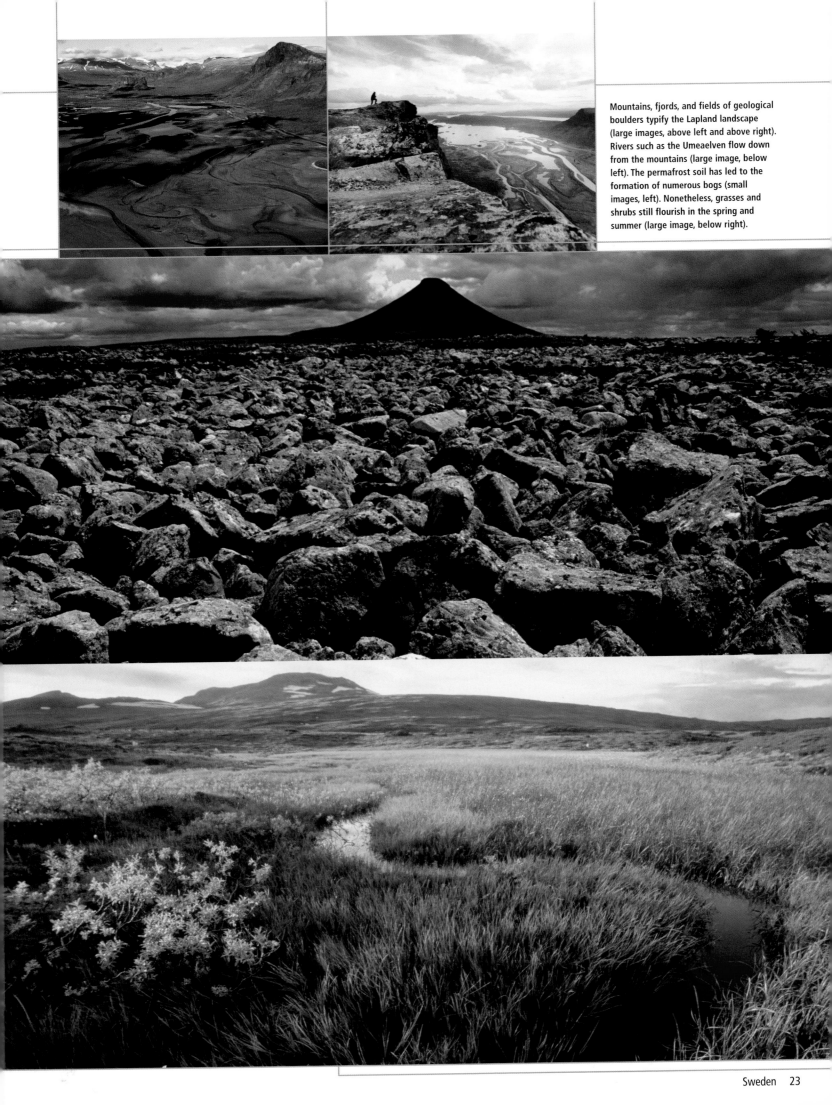

Mountains, fjords, and fields of geological boulders typify the Lapland landscape (large images, above left and above right). Rivers such as the Umeaelven flow down from the mountains (large image, below left). The permafrost soil has led to the formation of numerous bogs (small images, left). Nonetheless, grasses and shrubs still flourish in the spring and summer (large image, below right).

HIGH COAST / KVARKEN ARCHIPELAGO

Situated in the Gulf of Bothnia, the High Coast is a fascinating archipelago landscape shaped by the glaciers of the last ice age. The addition of the Finnish part of Kvarken Archipelago has turned this into one of the transnational natural heritage sites.

Date of inscription: 2000; Extended: 2006

These whaleback landforms in the Gulf of Bothnia were shaped by the last ice age, which began around 80,000 years ago and ended in Scandinavia about 9,600 years ago. When the giant ice sheets melted, sea levels rose by some 115 m (380 feet). As a result, large swathes of land were left below sea level. Freed from the weight of the glaciers bearing down upon it, the land gradually rose, and skerries (rocky islands) emerged from the sea. To date, the region has risen by 285 m (935 feet), and the process is still continuing. In fact, the subsoil is rising at a rate of around 93 cm (37 inches) every century.

The hills of the hinterland are up to 350 m (1,150 feet) high. It is a very attractive and largely untamed land-

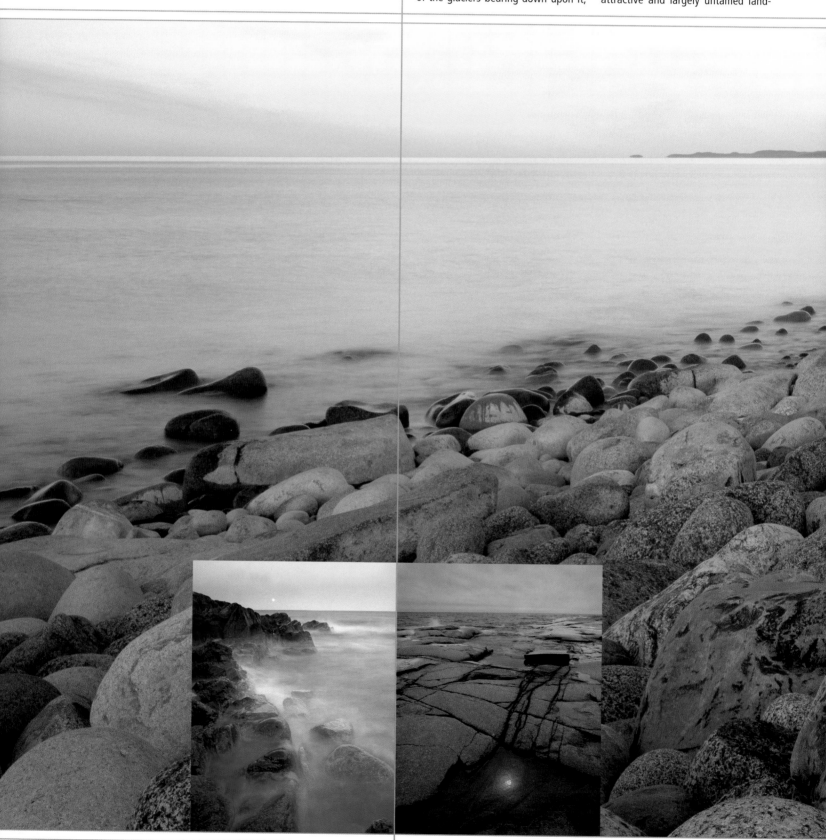

scape, boasting rich, chalky soil and numerous lakes – all left behind by the ice age. These freshwater lakes, together with the brackish water area of the flat estuaries and coastal islands, and the open waters of the Baltic, mean that the High Coast encompasses three geologically and biologically significant water systems in one small area.

The smooth surfaces of stones and rocks polished by the glaciers and water are typical of the skerries (large image). A 130-km (81-mile) coastal path runs through the Swedish part of the archipelago, offering plenty of fascinating views along the way (images inset). The play of nature's autumn hues is particularly charming (small image, right).

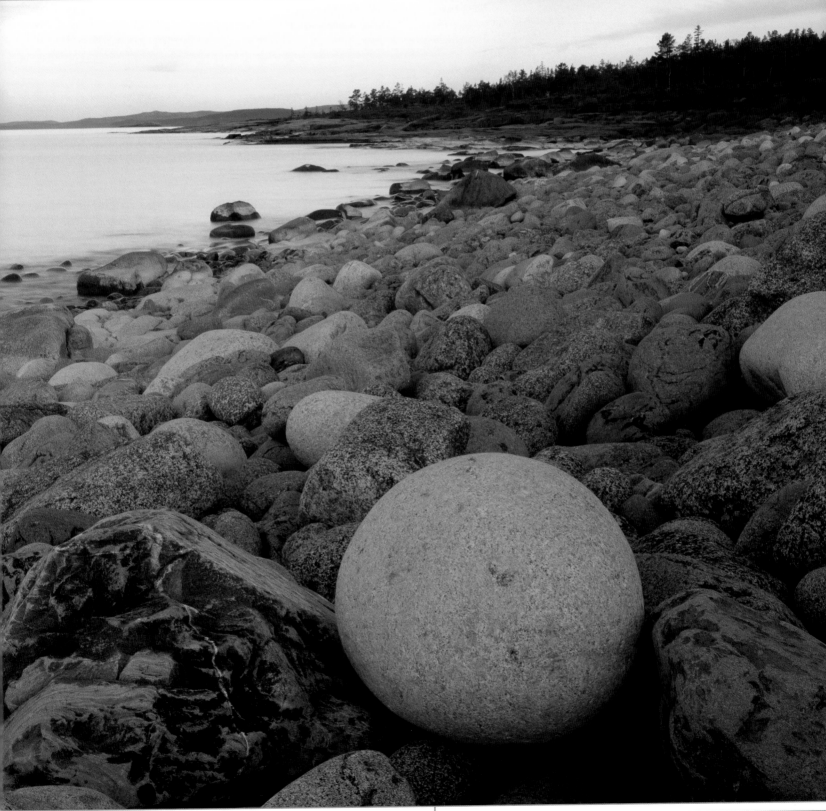

WADDEN SEA

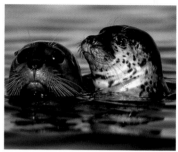

The mudflats on the North Sea coast are one of the last great eco-systems on earth to be controlled by the tides. The World Heritage Site includes an area straddling the German-Dutch border of about 9,700 square kilometers (3,780 square miles).

Date of inscription: 2009

Between Blåvandshuk in Denmark and Den Helder in Holland, there is a 450-km (280-mile) long stretch of North Sea tidal flats which can reach 40 km (25 miles) in breadth. Dominated by the ebb and flow of the tides, about two-thirds of the total area of this unique biotope for plants, animals, and humans has been declared a World Heritage Site, including the Wadden Sea National Parks of Schleswig-Holstein and Lower Saxony, and the West, East, and North Frisian Islands. This coastal landscape is characterized by sand dunes, salt marshes, mudflats, and mussel beds. The so-called "Priele" are watercourses which remain full even at low tide, providing a rich habitat for some 10,000 plant and animal species, ranging from the simple mudworm to the gray seal. Millions of migratory birds come to rest on the mudflats every year. The Wadden Sea is one of the few great natural landscapes in densely populated Europe where ecological processes have been allowed to continue undisturbed.

When the tide goes out on the mudflats (large image), only the "Priele" (channels) are left filled with water (top right). Seals (right) are the mudflats' best-known animal inhabitants.

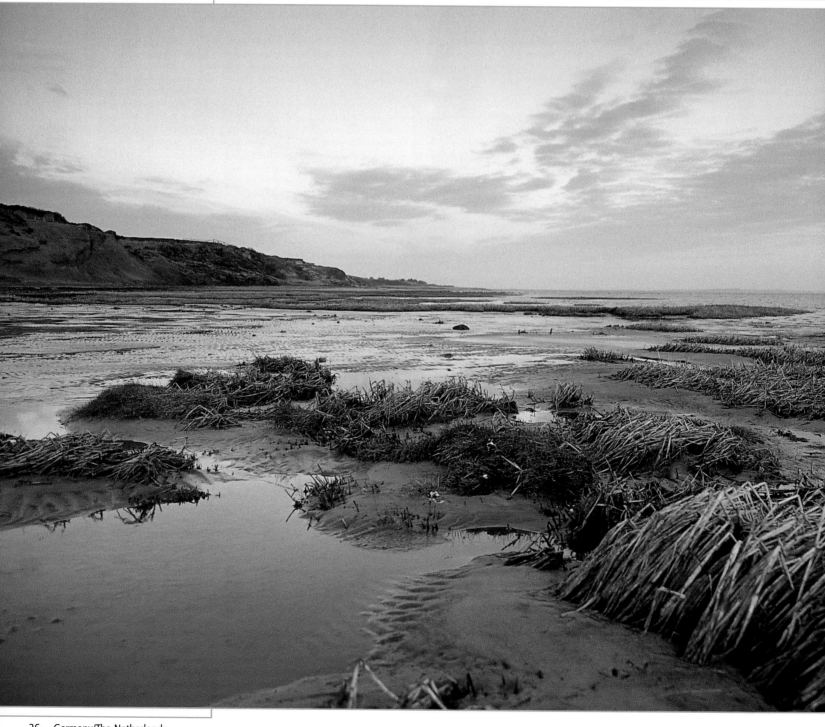

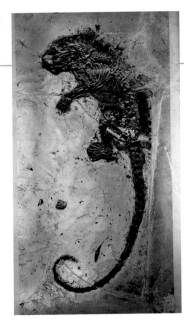

Messel Pit, the first UNESCO natural heritage site in Germany, is considered to be one of the world's most important fossil sites. The sedimentation and lack of oxygen in the water-filled volcanic crater have led to the preservation of fossils dating back some 50 million years.

Date of inscription: 1995

This 65-hectare (161-acre) pit near Darmstadt was, for several years, threatened with transformation into a landfill site. At the last minute, it was placed under special protection. The layers of oil shale at the site contain many well-preserved fossils, which together provide an almost complete picture of the climate, biology, and geology of this area during the Eocene epoch – a period of natural history between 60 and 36 million years ago, when, after the dinosaurs had become extinct, plants and animals gradually started to develop into the flora and fauna we know today. As such, the Messel pit provides a unique insight into the early evolution of mammals.

Among the most spectacular finds were the remains of over 70 early horses, including more than 30 complete skeletons. The skeletons of other vertebrates, meanwhile, were preserved with some soft body parts and the contents of the animals' stomachs intact. The finds also allowed scientists to draw conclusions about phenomena such as continental drift, land bridges, sedimentation, and the evolution of the biosphere.

Preserved in the oil shales, the Messel fossils include primeval insects, reptiles, birds, and mammals, some up to 50 million years old. They range from the orb-web spider (large image) to a rodent (right).

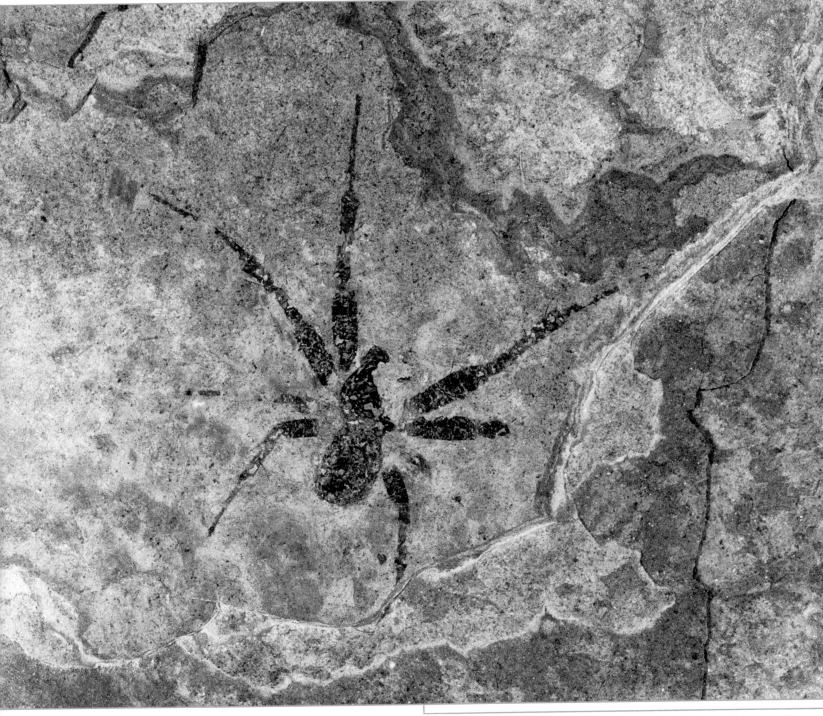

SWISS ALPS: JUNGFRAU-ALETSCH-BIETSCHHORN

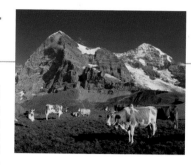

The Jungfrau-Aletsch-Bietschhorn region is the first part of the Alps to be added to the list of World Natural Heritage Sites.

Date of inscription: 2001
Extended: 2007

The Jungfrau, Mönch, and Eiger mountains form the heart of this dramatic mountain range. A rack railway takes visitors to the ridge of the Jungfrau mountain, terminating at an altitude of some 3,500 m (11,500 feet). The glass dome of the observatory is a well-known landmark. The only way up the north face of the Eiger, however, is by climbing. Located in the Bernese Alps, south-west of Grindelwald, the Eiger rises to a height of 3,970 m (13,025 feet). Its north face was first climbed in 1938, and – rising 1,800 m (5,900 feet) above the valley below – it has become the most famous climb in the Alps.
The region and its snowfields feed the magnificent Aletsch glacier, formed by the combination of the Aletsch névé, Jungfern névé, and Ewigschneefeld névé, which all come together at the so-called Konkordiaplatz – close to the Jungfraujoch. Spanning some 23 km (14 miles), this is still Europe's biggest glacier, although due to global warming it is slowly melting. A diverse range of flora and fauna can be found on the moraine surfaces around the ice flow. The Aletsch forest, for example, is a protected nature reserve that is home to the arve – a type of tree that can live for more than eight hundred years.
The Bietschhorn stands out for the dry, sunny valleys on its southern side, stretching out like fingers as far as the Rhône valley to the south and Lötschen valley to the north. The dry grassland of the rocky Walliser steppe is not farmed, and instead provides a home for rare plants and animals.

Europe's highest rack railway terminates on the Jungfraujoch. Known as the "top of Europe," it offers stunning views across the Aletsch glacier (large image). The Eiger, Mönch, and Jungfrau tower over the alpine pastures of the Bernese Oberland (above).

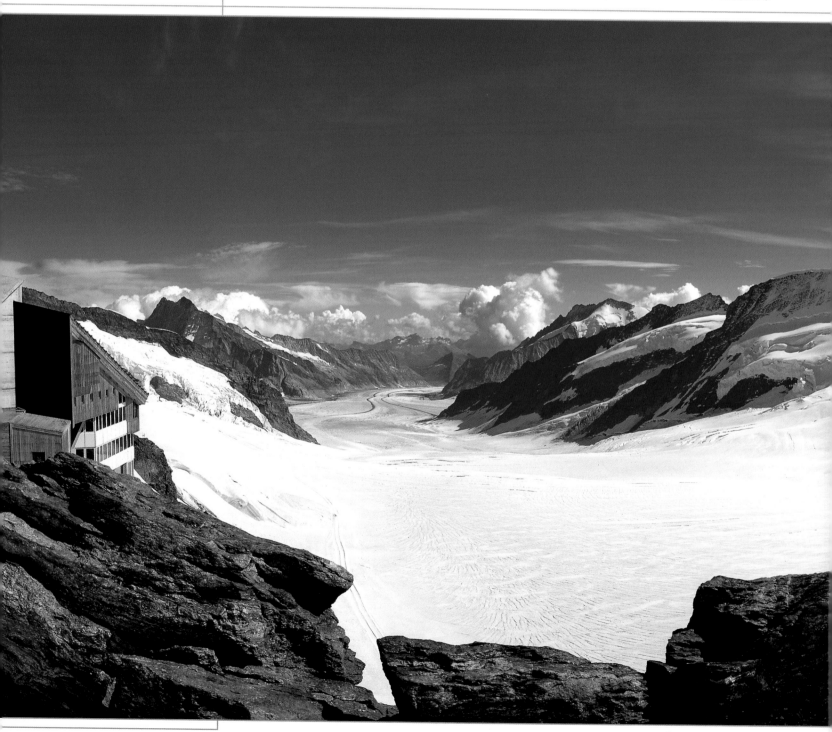

SWISS TECTONIC ARENA SARDONA

The Swiss Tectonic Arena Sardona is a mountainous region of 328 ha (810 acres) including seven peaks above 3,000 m (9,900 feet). The region is composed of biotopes and geotopes housing a variety of plant and animal life and is also the location of the Glarus Overthrust, a unique exposed feature which reveals its own geomorphological history.

Date of inscription: 2008

The mountainous region around the 3,056-m (10,026-foot) high Piz Sardona on the borders of the cantons of St Gallen, Glarus, and Graubünden is an example of orogeny resulting from the collision of continental plates and the release of tectonic forces. The area has been an important source of information concerning the origins and composition of the Alps since the 19th century. Visible for miles around, the Glarus Overthrust is the central feature of the protected area. Some 20 or 30 million years ago, a layer of rock up to 15 km (9 miles) thick was pushed up from the Anterior Rhine Valley over younger rock strata; along the thrust line, 250 to 300 million-year-old green and brown verrucano rock is lying on top of 35 to 50 million-year-old brownish-grey flysch. The overlap begins in the valley of the Anterior Rhine and finally culminates in the 3,000-m (9,900-feet) high Hausstock, Sardona and Ringelspitz chain of peaks before sinking away to the north. The Tectonic Arena Sardona also comprises several important biotopes, including high moorland and flood plains as well as the oldest colony of resettled ibexes in Switzerland. Amongst the geotopes here are the Martinsloch ("St Martin's Gap") between the twin peaks of the Tschingelhörnern, the copper mine on the Mürtschenalp, and the Segnesboden, an Alpine floodplain in the lower Murgtal which was formed by glaciers in the Ice Age.

The Piz Sardona (large image) is the highest point of the World Heritage Tectonic Arena. Sunlight falls through the natural phenomenon of the Martinsloch onto the church at Elm on only four days of the year (above).

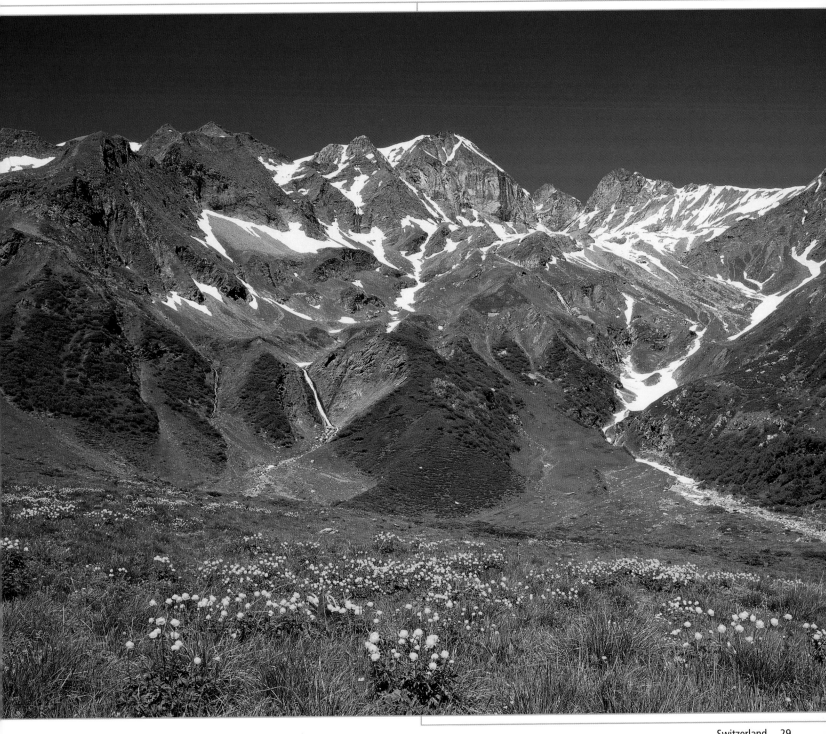

MONTE SAN GIORGIO

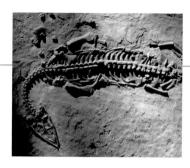

The pyramid-shaped Monte San Giorgio is considered to be the world's richest depository of fossils from the Triassic period, dating back 245–230 million years. The fossilized remains of numerous marine animals have been found here, among them saurians measuring up to 6 m (20 feet) long.

Date of inscription: 2003

Monte San Giorgio lies at the southern end of Lake Lugano, and is therefore still relatively cut-off. Very few parts of the landscape of southern Switzerland have remained so unspoilt. For many years now, the forest on the 1,096-m (3,596-foot) high mountain has been allowed to grow wild.

But the mountain's main claim to fame is as a significant fossil site. Nowhere else in Switzerland have such well-preserved fossils been found as in this region. The most spectacular finds are predominantly marine reptiles such as the Ticinosuchus and Ceresiosaurus ("Ceresio" being the local name for Lake Lugano).

The finds were made in five successive layers of earth, together documenting a complete chapter of the earth's natural history. This relatively short period in geological terms witnessed such great evolution of flora and fauna that the idea of an explosion of the species is not an exaggeration. To date, the remains of 80 species of fish, 40 reptiles, and several hundred vertebrates have been found. Because the lagoon in which these animals lived was separated from the open sea by a reef and also located near to the mainland, Monte San Giorgio has also yielded fossils of land-based plants and animals. Furthermore, the fossils are completely intact and exceptionally well preserved. Some of the most beautiful examples are on display in the small museum at Meride town hall.

Around 20 cm (8 inches) long, this Pachypleurosaurus (large image), a Triassic sea saurian, is just one of the specimens found at Monte San Giorgio. A further example of the same creature can be seen in the museum of the Paleontological Institute in Zurich (small image).

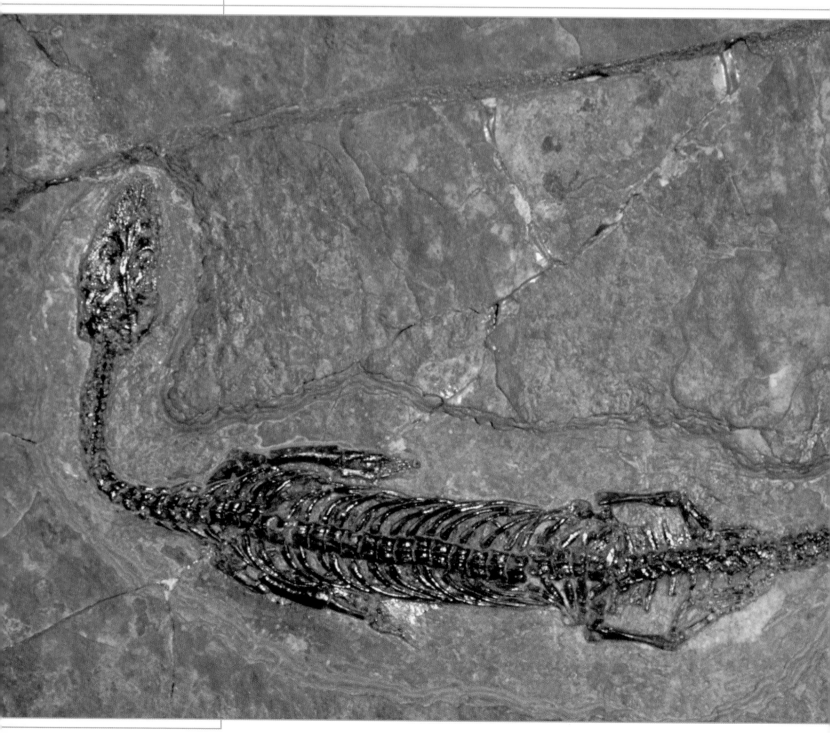

GULF OF PORTO

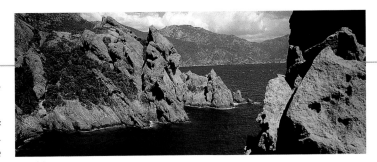

The **World Natural Heritage Site** along the middle of the west coast of Corsica includes the coastal region around the Gulf of Porto, local underwater habitats, and the islands of Elbo and Gargallo.

Date of inscription: 1983

In 2006, the official name of this site was changed to "Gulf of Porto: Calanche of Piana, Gulf of Girolata, Scandola Reserve." The inclusion of the names of the two bays and peninsulas reflected the full extent of the land covered by this protected area. It was listed not only for the beauty of its landscape, but also for its flora and fauna, and the traditional methods of agricultural and pasture management used by its inhabitants.

The nature reserve is part of a larger Corsican regional park. It provides an ideal nesting and breeding ground for many different seabirds, including seagulls, cormorants, and the now rare sea eagle. The rocky peninsula of

La Girolata is largely given over to wild forests, and there are large areas of typically Mediterranean maquis. Dense eucalyptus forests line the sandy, yellow beaches, and the waters around the bays and coves along the deeply fissured, rocky cliffs are alive with flora and fauna the likes of which are hard to find anywhere else. Rare algae are just one example of the underwater life that has survived here.

Both rough and smooth rock formations can be found on the Scandola peninsula. This remote region is only accessible on foot, crossing terrain overgrown with maquis (large image) before finally reaching the reddish cliffs of the steep coastline (small image).

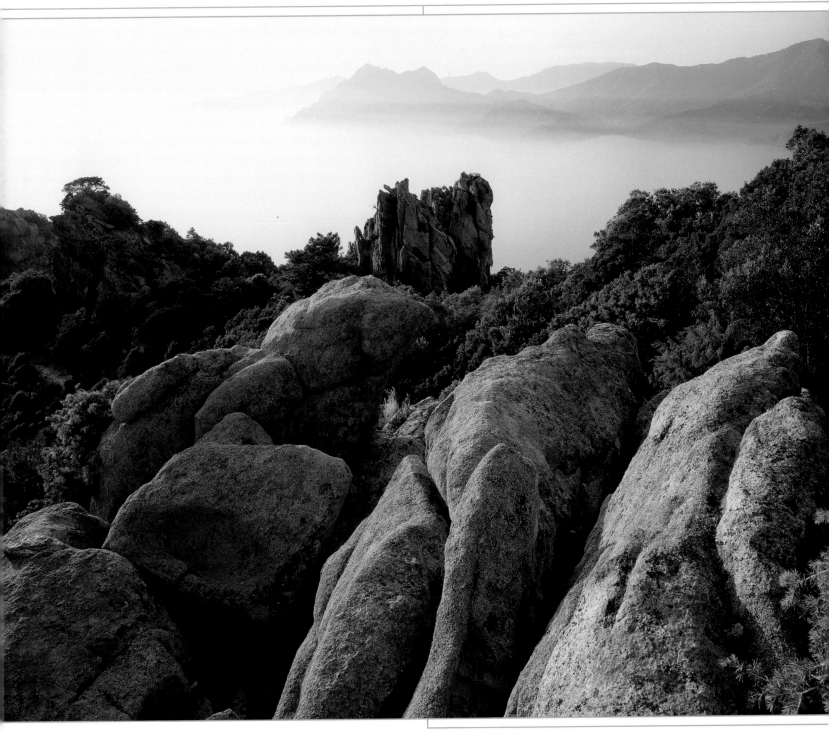

THE LAGOONS OF
NEW CALEDONIA

The lagoons of New Caledonia house a great variety of animal and plant life. Between clumps of marine grass there are reefs which are quite unique and not to be found nowhere else in the world, offering a habitat for endangered species of fish, turtles, and mammals. The World Heritage Site encompasses six ecosystems with a total surface area of almost 16,000 sq. km (6,200 sq. miles).

Date of inscription: 2008

New Caledonia covers an area of some 18,600 sq. km (7,240 sq. miles) and includes the eponymous main island and several smaller coral and volcanic islands. The island group came under French rule in 1853 and is now a French Overseas Territory.

The main island and the islands to its south are surrounded by a coral reef which, along with the Australian Great Barrier Reef, is one of the biggest reef systems in the world. The untouched mangrove forests are home to a variety of animal life and lush vegetation, and numerous species of fish, including parrotfish, leopard rays, reef sharks, and a species of lobster native to New Caledonia, the popinée, are to be found in the largely intact lagoon ecosystems. The shallow coastal waters are also home to the Indo-Pacific tarpon, an ancient bony fish, whose ancestors swam in the tropical seas of the Cretaceous period. Extensive meadows of sea grass provide sustenance for the world's third-largest population of sea cows. Since the extinction of their cousins in the Bering Sea in 1768, these animals, which can weigh up to 500 kilos (1,200 pounds), are amongst the last remaining dugongs. There are also ancient fossil remains of reefs in the lagoons, providing a rich source of information for researchers of the natural history of the Pacific.

The New Caledonian Barrier Reef (large image, with shipwreck) is home to numerous species of coral (above: table coral) and fish (image inset: blue grouper).

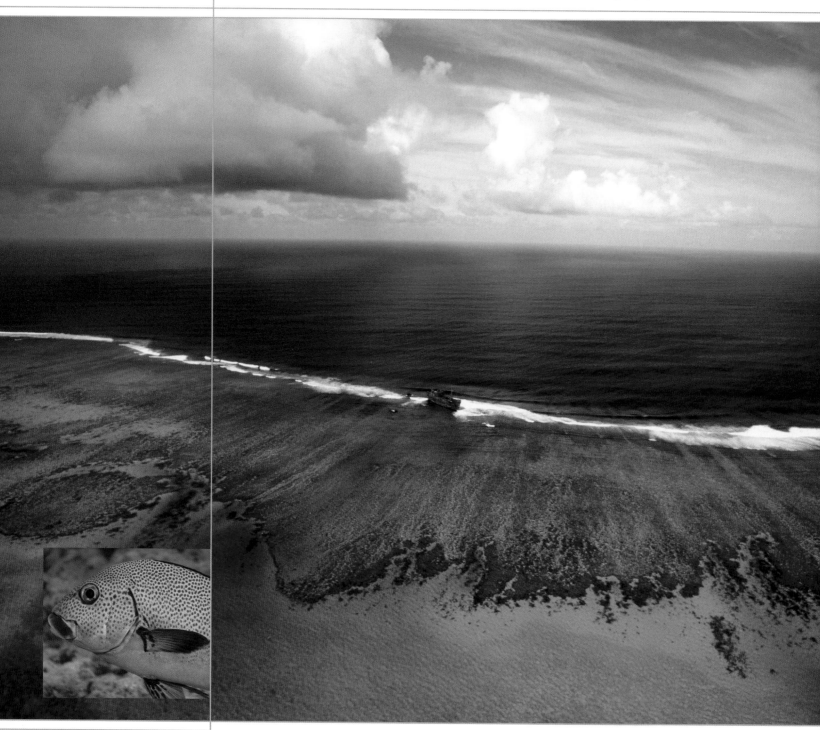

PYRÉNÉES: MONT PERDU/ MONTE PERDIDO

The extraordinary mountainous landscape around Monte Perdido – or, to give it its French name, Mont Perdu – stretches across both the French and Spanish sides of the Pyrénées, and features some impressive geological formations. Against this stunning backdrop, the lives of the local population are still heavily steeped in tradition.

Date of inscription: 1997
Extended: 1999

At a height of 3,352 m (10,997 feet), Monte Perdido lies on Spanish territory. The 30 sq. km (11.5 sq. mile) world heritage site around it, however, includes parts of the Spanish Parque Nacional de Ordesa y Monte Perdido and the French Parc National de Pyrénées. In 1999, the site was extended to include the French commune of Gèdre.

Caught in the interplay of the Atlantic and Mediterranean climates, the region's special geomorphology has produced some particularly striking rock formations. The Añisclo and Ordesa canyons – two of Europe's biggest – are the main attractions on the Spanish side of the border. The three valleys of Troumouse, Estaubé,

and Gavarnie, meanwhile, belong to the French administrative department of Hautes-Pyrénées. These U-shaped valleys were formed by the glaciers, and are among the most beautiful of their kind in Europe. The mountains here are also much steeper than those on the Spanish side of the border.

But the most striking feature of this imposing mountain landscape is its unspoilt peacefulness. Focused on pastoral farming, life here has remained almost unchanged for centuries, and the trappings of modern living have failed to leave any real mark on the villages, farms, and fields, which are still served by old mountain roads. The landscape bears testimony to a mountain way of life that has long since ceased to exist in other parts of Europe.

The rough, limestone summits that characterize the Monte Perdido region (large image) are an impressive sight. Waterfalls like this one near Cirque de Gavarnie (small image) or the Grande Cascade (image inset) – one of the highest waterfalls in Europe – are another typical feature of the mountain landscape.

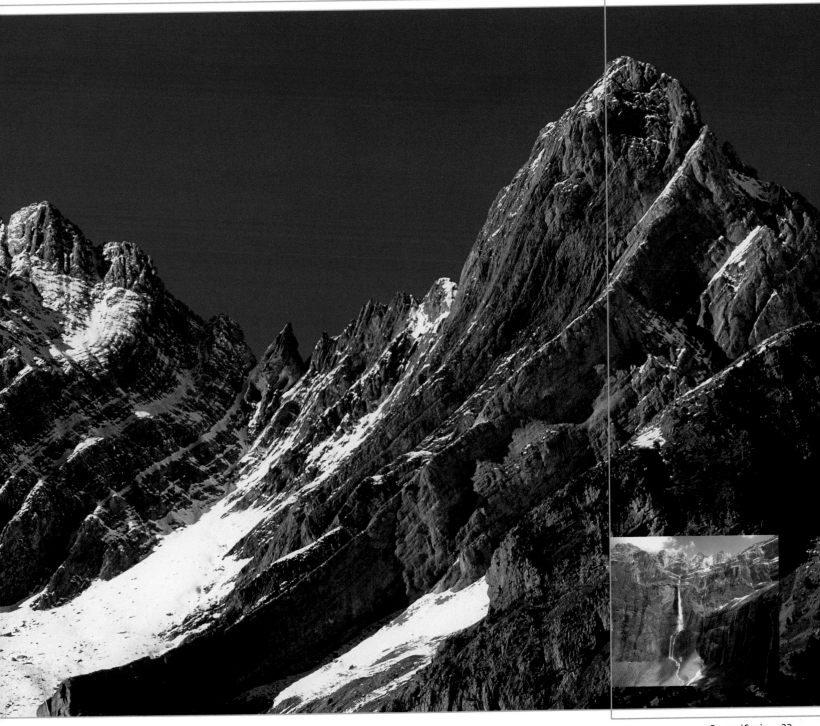

DOÑANA NATIONAL PARK, ANDALUCIA

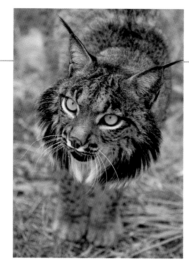

Doñana National Park in Andalucia is Spain's biggest national park. Once a royal hunting ground, these extensive wetlands at the delta of the Guadalquivir river are now a safe haven for numerous rare species. For many migratory birds, the park is also an important stop on the journey to Africa.

Date of inscription: 1994
Extended: 2005

Following its extension, the Doñana National Park – also known as Coto de Doñana – covers an area of some 540 sq. km (210 sq. miles). It is the diversity of its landscape that makes it so special. Alongside large expanses of marshland complete with lagoons and boggy areas, the park also features dry areas whose character is more akin to a heath or savannah. Here, 40-m (131-foot) sand dunes give way to bushy Mediterranean vegetation that includes rare plants like white thyme. There are also forests of cork oak, umbrella pine, and stone pine trees.

The wetlands, meanwhile, provide a nesting place for numerous species of bird. The area's large flamingo population is particularly noteworthy, but grey herons, storks, and cranes also come here to nest. The lagoons within the protected area attract wild boar and red deer. Other animals found in the national park include the Iberian lynx – which is now entirely absent from the rest of Spain – and the all-but-extinct imperial eagle. The Montpellier snake, white spoonbill, ichneumon (a type of mongoose), and monk vulture are equally rare.

Great sand dunes dominate the Atlantic coast of the Doñana National Park (large image), sheltering Doñana's umbrella pine forests. The park also provides refuge for migratory birds like storks (image inset: left) and rare animals such as the Iberian lynx (small image).

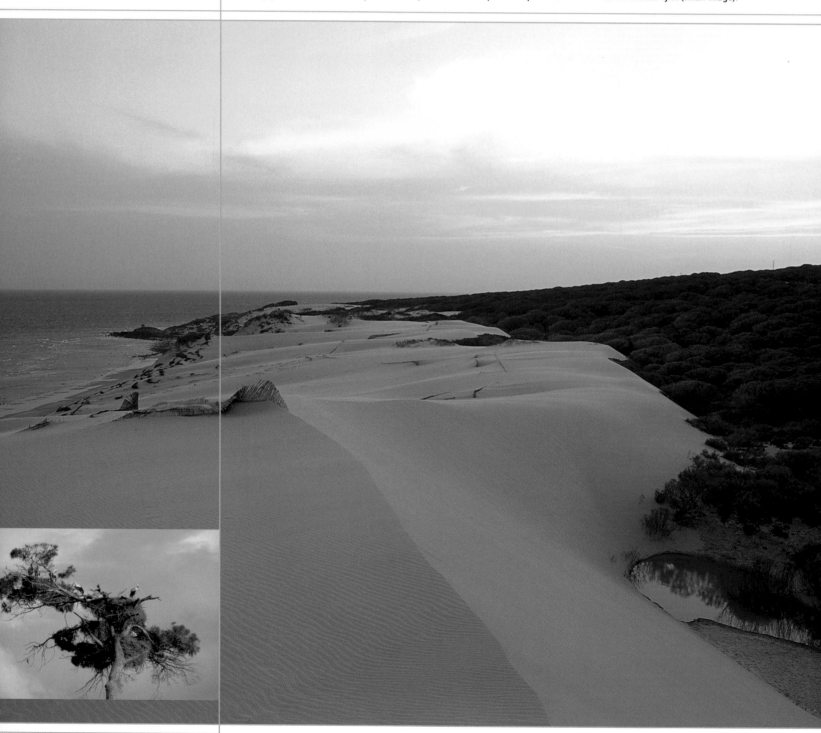

THE BIODIVERSITY
AND CULTURE OF IBIZA

This Balearic island is both a world natural heritage and world cultural heritage site. Its claim to world natural heritage status is founded upon posidonia, a grassy marine weed that plays an important role in the ecosystem and diversity of the sea around it. The island's significant architecture and archeological sites, meanwhile, confirm its cultural importance.

Date of inscription: 1999

Like nearby Formentera, Ibiza belongs to the Balearic archipelago. Together, the two islands are also known as the Pityuses (or Pine Islands) – a name whose roots go back to the Greeks. Ibiza's long history can be traced back to the 2nd millennium BC, and significant evidence of island life at this time has been preserved. Two archaeological excavations in particular – the Phoenician Sa Caleta settlement (700 BC) in the south-west of the island and the Punic necropolis Puig des Molins (5th century BC) – underline Ibiza's significance during the Phoenician-Carthaginian era. It was the Phoenicians who, some 2,600 years ago, founded the fortified upper town ("Dalt Vila") of Ibiza Old Town. Occupied without interruption ever since, it is one of the oldest towns in Europe. Its 16th-century town walls are an impressive example of Renaissance military architecture, and the same style would go on to exert a strong influence on the construction of Spanish fortifications in the New World. The town wall in Ibiza Old Town features seven bulwarks and one outwork. Within it, remnants of the previous medieval town wall are still visible.

Posidonia is a bit like a sea grass. It is only found in the Mediterranean, but even here is increasingly under threat. The posidonia off the coast of Ibiza provides shelter for a wide variety of marine life, in particular protecting the coastal waters and coral reefs from storms. In fact, 1 hectare (2.5 acres) of posidonia produces 21 metric tons of organic substances every year – almost as much as the same area of a tropical rainforest.

The World Heritage Site is part of the Salinas de Ibiza y Formentera protected nature reserve, which was established in 1995.

The sea floor around Ibiza is covered with extensive swathes of posidonia, a type of sea grass that is also known as Neptune grass. It is almost exclusively found in the Mediterranean.

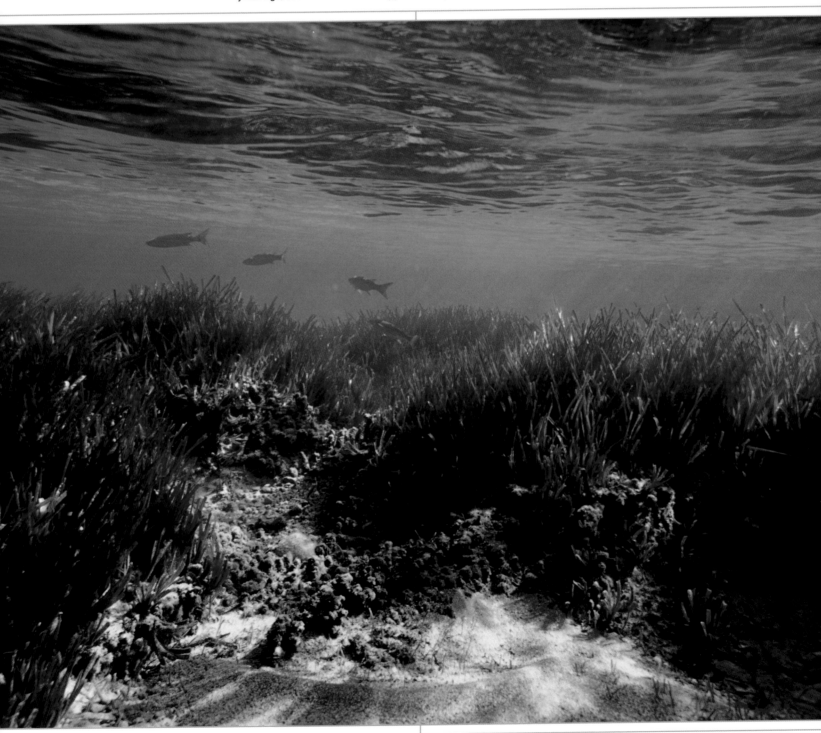

GARAJONAY NATIONAL PARK

The volcanic mountains of Gomera, Canary Islands, reach altitudes of up to 1,487 m (4,879 feet). The trees that cover them form Europe's last remaining subtropical primeval forest.

Date of inscription: 1986

Occupying an area of almost 40 sq. km (15 sq. miles), Garajonay National Park covers almost a tenth of the island of Gomera and crosses all six of its administrative regions. The park's unique ecosystem has earned it the status of a World Natural Heritage Site under UNESCO protection.

Thick forest covers the slopes of the Alto de Garajonay, the island's highest mountain. It is the last remaining subtropical primeval forest in southern Europe, including the world's only closed laurel forest dating back to the Tertiary period. Millions of years old, the forest's position in the middle of the ocean enabled it to survive the deteriorating climatic conditions that developed during the ice age.

Many of the park's plants and animals are only found here. Half a million people visit the national park every year. Some join guided tours, while others explore the designated walking trails independently.

In the Garajonay National Park on the island of Gomera, the mist almost always reaches the floor of the laurel forests (small image, right), creating what is often termed horizontal rain. This ancient ecosystem allows visitors to get a good idea of how forests might have looked some 65 million years ago (large image).

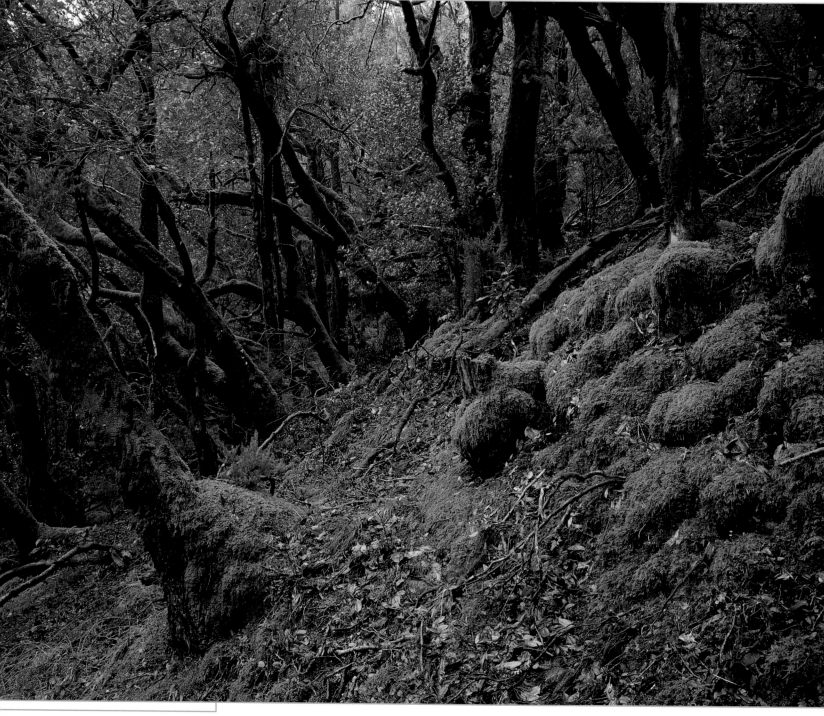

TEIDE NATIONAL PARK, TENERIFE

The natural heritage site takes in the fascinating volcanic landscape of the 3,718-m (12,198-foot) high Pico del Teide – Spain's highest mountain – along with the area's characteristic flora and fauna.

Date of inscription: 2007

Most of the national park is an inhospitable, volcanic landscape, dominated by the Pico and its caldera, whose diameter measures some 17 km (11 miles). The ever-changing climate and frequent mists lend the scenery a very special atmosphere. The Teide is too barren an environment to support a really diverse vertebrate life, but it is home to three endemic species. One of them, the blue-throated lizard (*Gallotia galloti*), has come to symbolize the park. The Teide blue chaffinch, at home in pine forests, is also found in the park. The Teide's rich insect life, meanwhile, encompasses 700 different species, most of them endemic to the

Canaries. The area's flowering plants have adapted to the climate by adopting a cushion-like form, reducing the surface area of their leaves, and growing waxy coatings and thick coverings of hair – all of which help to reduce water loss through transpiration. There are 168 different types of flowering plants in the park, 58 of which are endemic. Among the most striking plants is the viper's bugloss, which belongs to the boraginaceous family. The pyramid-shaped inflorescence of the red-flowered *Echium wildpretii* can grow as tall as 3 m (10 feet). The park's dominant plant, however, is the Teide broom (*Spartocytisus supranubius*), whose white or pink flowers produce a

very special honey. The bushes of Teide marguerite (*Argyranthemum teneriffae*), meanwhile, lend the park a unique character.

Towering above the clouds (large image), the 3,718-m (12,198-foot) high Pico del Teide rises up out of a caldera (above) that was probably created by a powerful landslide.

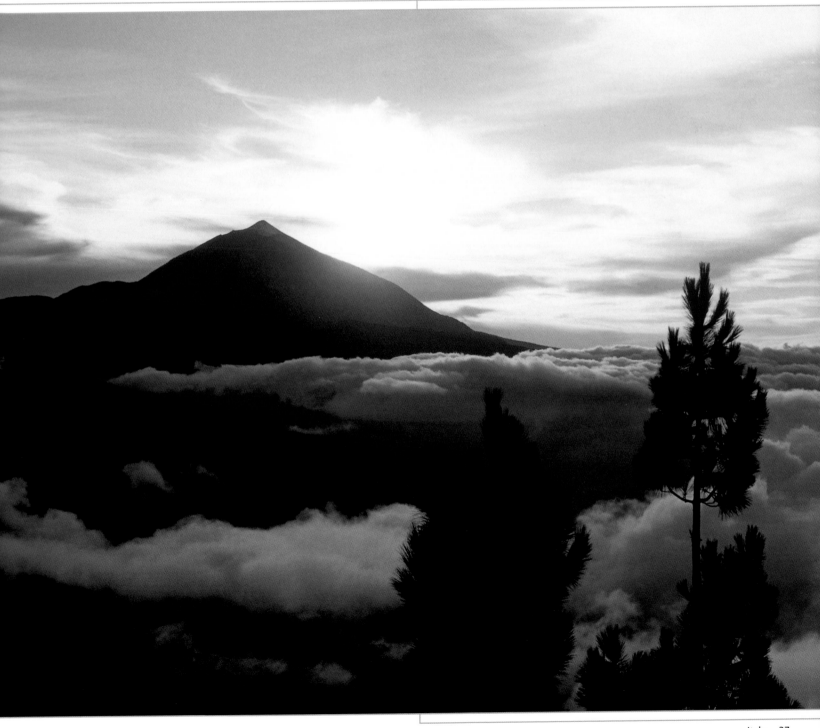

THE LAURISILVA LAUREL FOREST OF MADEIRA

Madeira was once covered in thick forests, but they have long since been decimated by clearing. Today's laurel forest is largely primary forest.

Date of inscription: 1999

The Madeiran laurel forests lie between 600 and 1,300 m (1,970 and 4,270 feet) above sea level. Along with the forests of the Garajonay National Park on Gomera, Canary Islands, they are all that is left of the extensive laurel forests once found throughout the Mediterranean.

The key historical forces behind the decimation of the laurel forests were what is known as slash-and-burn agriculture and deforestation, which became a widespread method of creating new arable land and collecting firewood from the 15th century onward. Along with overgrazing and forest fires, the introduction of new plants from distant regions has further contributed to the ever-increasing threats to the forest.

The result is that the forests on the steep north coast slopes of Madeira are almost all that remains of the original laurel forests. Here, the forest plays an important part in the provision of the island's water. The tree leaves "collect" water from the clouds, and this water is then retained in the understorey before finally being stored in the rocks. The laurel

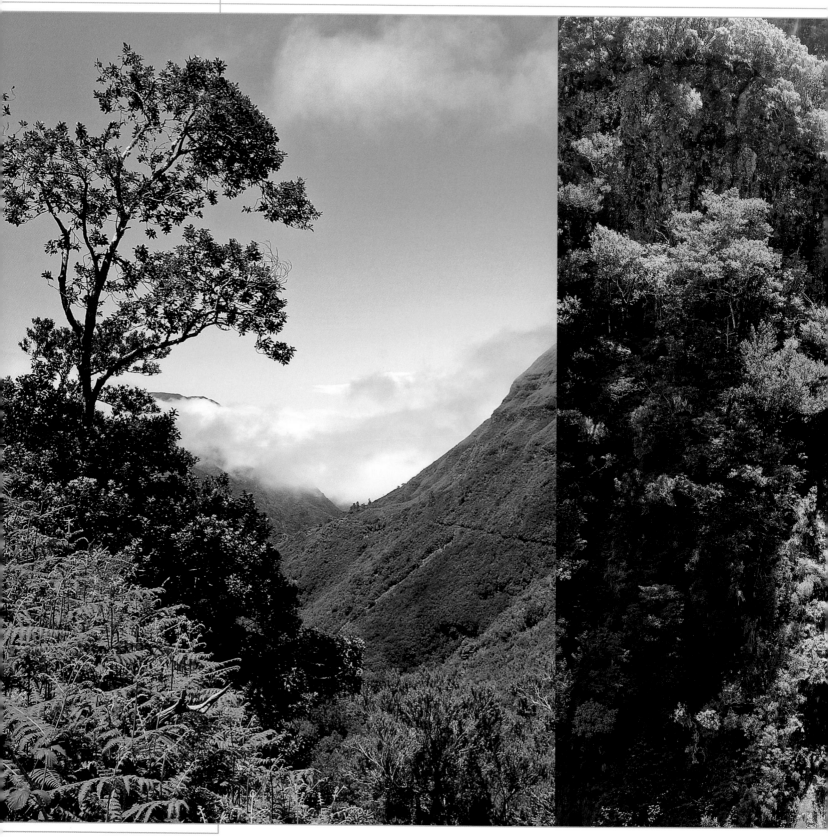

forests also help to significantly reduce soil erosion.

There are now numerous initiatives and schemes aimed both at protecting the remaining original forests, and restocking deforested areas. The survival of Madeira's laurel forests has already preserved the habitat of some unique plants and animals, birds and insects in particular.

The island of Madeira boasts a particularly large laurel forest (large images and small image, right). The forest covers an area of 22 hectares (54 acres), comprising species as diverse as the Madeira laurel, stinkwood laurel, and Canary Island laurel.

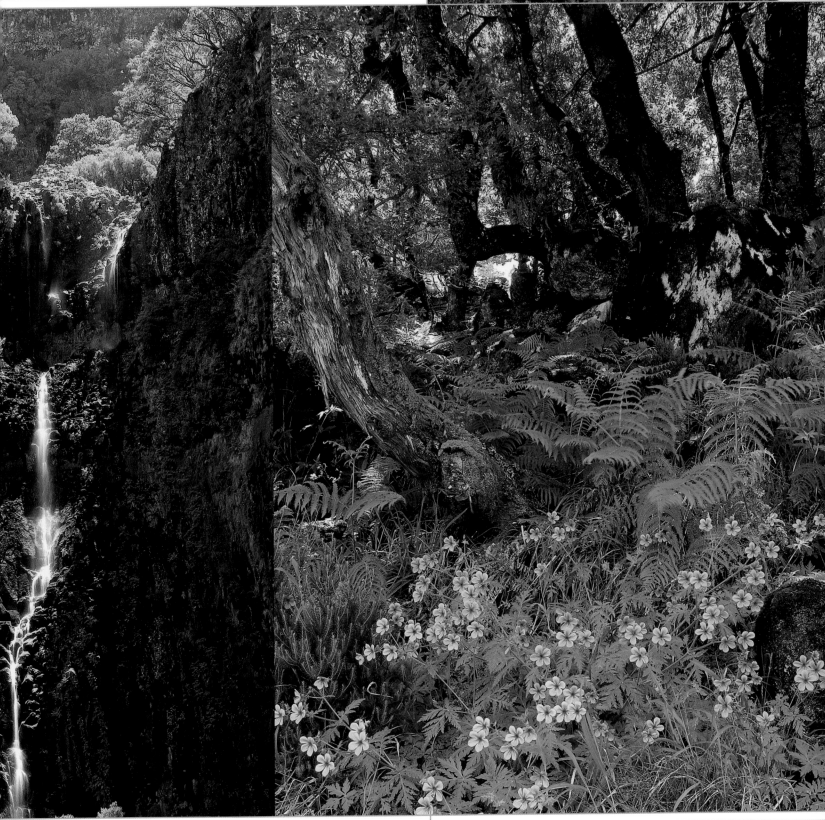

THE DOLOMITES

The Dolomites, situated in the north-eastern Italian Alps, have 18 peaks higher than 3,000 m (9,840 feet). The scenery is a captivating mixture of rocky slopes and narrow valleys.

Date of inscription: 2009

The Dolomites cover a total surface area of about 1,419 sq. km (548 sq. miles). The Marmolata is the highest peak at 3343 m (10,968 feet), but the precipitous charms of the Three Peaks of Lavaredo and the Rosengarten ("Rose Garden") are also well-known. Part of the Limestone Alps, this mountain group is a region of contrasts: lush Alpine meadows alternate with jagged peaks and hollows filled with moraine. This contrast is explained by differences in orogeny across the various areas, revealing recumbent folds of fossilized coral reef and rocks of volcanic origin. The Dolomites have glaciated areas as well as karst formations typical for limestone regions; combined with the fossil record, this makes the landscape an excellent example of a region whose tectonic history can be easily reconstructed. That is not the end of the story however – the floods, earth tremors, rock slides, and avalanches which continually reshape the earth's surface play their part here too.

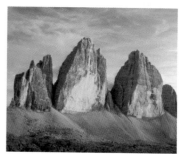

The spectacular rock faces and peaks of the Dolomites are enough to excite any climber; seen here are the Rosengarten group (large image, in early evening sunshine) and the Sexten Dolomites (right).

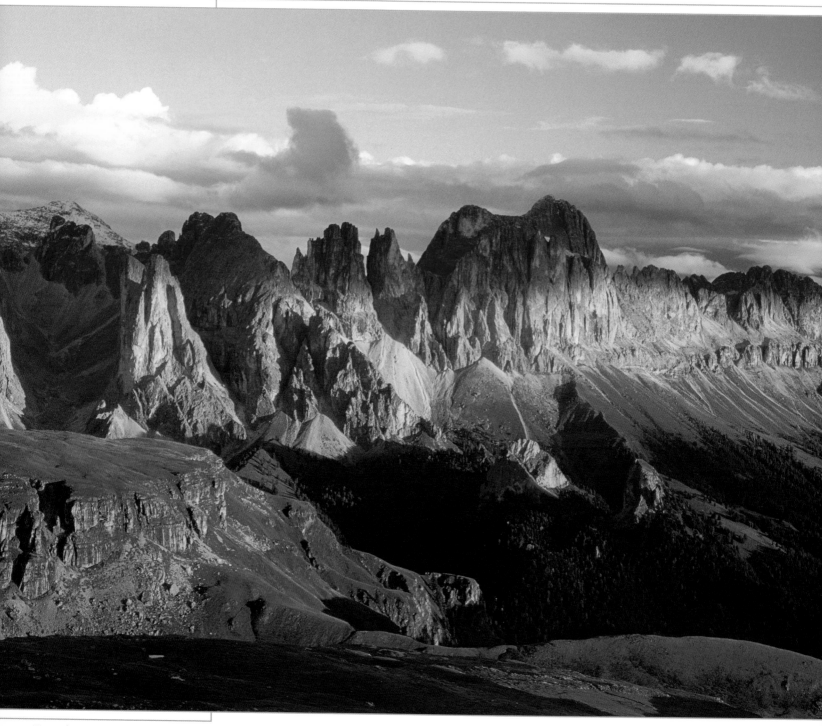

AEOLIAN ISLANDS

Situated around 40 km (25 miles) off the north coast of Sicily, the Aeolian Islands owe their inclusion on the world heritage list to their volcanic activity. The islands' geology and geophysics makes them of great scientific interest to volcanologists all over the world.

Date of inscription: 2000

The Aeolian Islands, sometimes known as the Lipari Islands, comprise Vulcano, Lipari, Alicudi, Filicudi, Salina, Panarea, and Stromboli. The tectonic basis of the archipelago's creation was the subsidence of the Tyrrhenian Sea during the Pliocene period. New studies have revealed that volcanic activity on the islands only began in the Pleistocene epoch, and the seven islands were subsequently created over three distinct periods of volcanic activity. Today, only Stromboli and the Grande Fossa volcano on Vulcano are still active, although there are also fumaroles and solfatara on Lipari. The most spectacular of the islands is Stromboli. It consists solely of the vol-

cano of the same name, which rises to an altitude of almost 1,000 m (3,300 feet) above sea level. There has been volcanic activity here for some forty thousand years, and pieces of lava and incandescent cinders are constantly being spat out around the openings in the crater – accompanied by quite significant explosions. In fact, Stromboli is one of the most active volcanoes in the world that can be observed at such close quarters.

The volcanoes on Filicudi (large image) and Alicudi (top right: here the island is shown shrouded in cloud) are inactive. Stromboli, however, is very much active (bottom right: lava eruptions at twilight).

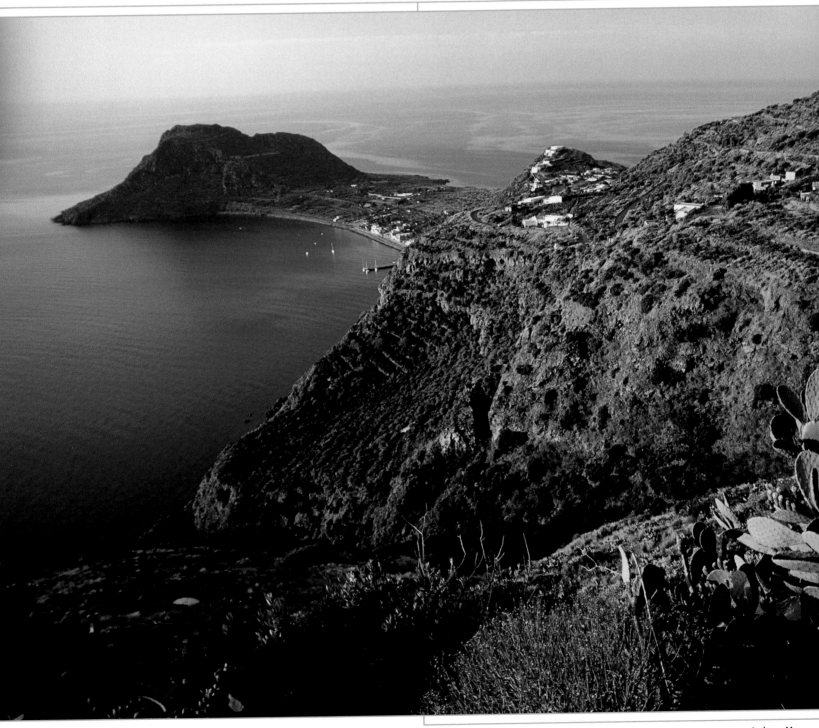

BIAŁOWIEŻA NATIONAL PARK/ BELOVEZHSKAYA PUSHCHA

One of Europe's last primeval forests runs along the Polish-Byelorussian border. It is home to some unique flora and fauna.

**Date of inscription: 1979
Extended: 1992**

Initially, only the Polish Białowieża National Park was designated a World Heritage Site, and the larger Byelorussian portion of the current heritage area – Belovezhskaya Pushcha – was only added in 1992. Together, they cover some 1,000 sq. km (386 sq. miles), making this the largest transnational UNESCO World Heritage Site. It was recognized primarily for its mixed virgin forest – the only woods of their kind in Europe. The heavily protected core of the park is home to spruce, pine, black alder, hornbeam, oak, birch, ash, lime, maple, and poplar, and some trees are natural monuments in their own right. There are also hundreds of species of fungi, lichen, and vascular plants.

The park is most famous, however, for its bison. The animals – cousins of the North American bison – came close to dying out, but were reintroduced to the wild in 1952 using zoo stock bred in the 1920s. Today, around 300 bison roam the vast forest once more. Bears, elk, wolves, lynx, and otters are further examples of the rare mammals found here, and there are also more than 220 species of bird, including the black stork.

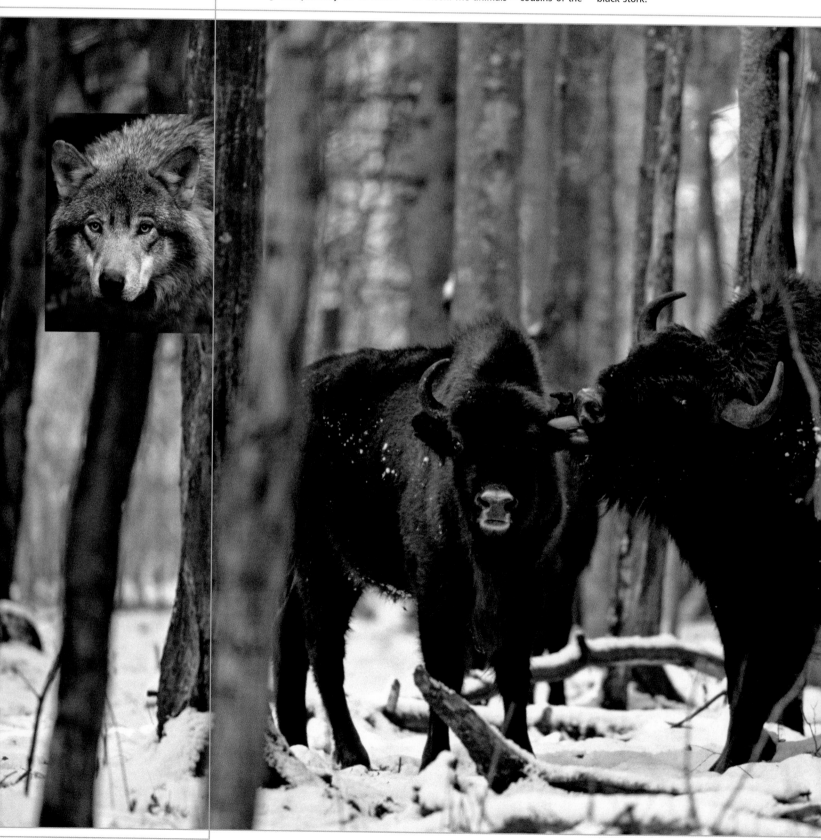

Europe's last significant wild bison population lives in the Białowieża/Belovezhskaya Pushcha Park, on the Polish-Byelorussian border (large images, below). The park's vast mixed forests (small image, left) are also home to wolves (image inset, left).

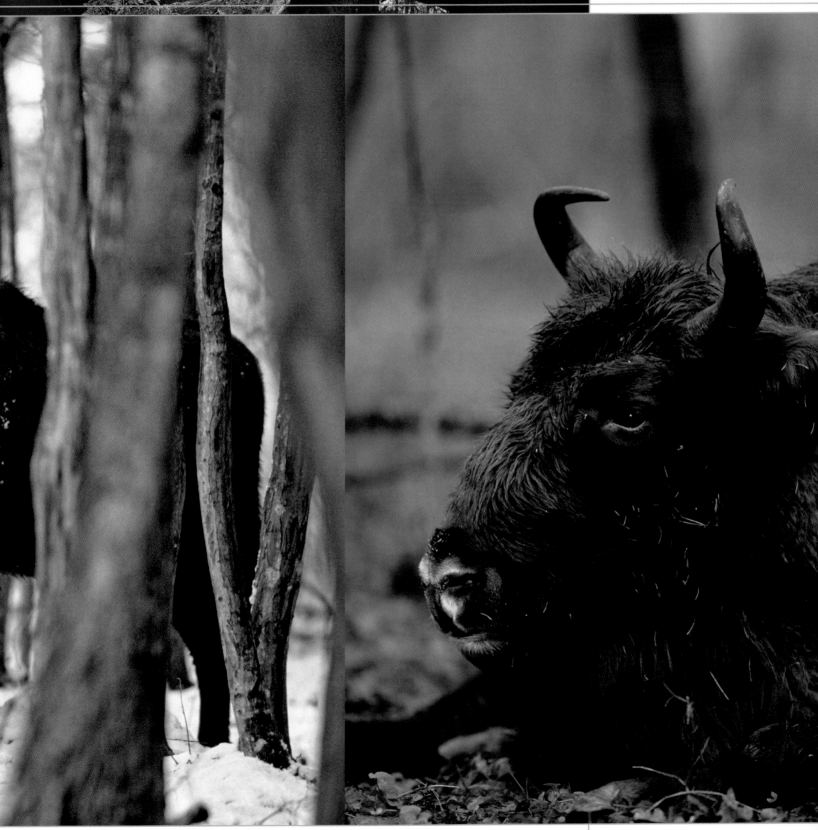

Europe's most beautiful and untouched beech forests are located around the border of Slovakia and Ukraine. The World Natural Heritage Site comprises ten separate protected areas along the southern slopes of the Carpathian forests.

Date of inscription: 2007

Deciduous woods and mixed deciduous forests once covered Central Europe, and beech trees were particularly important. Alongside its ability to adapt to a variety of different environments, the survival of the beech can be put down to its constant growth, spreading out to impede the development of other trees. Unlike other trees, the beech also resists the process of succession – in other words, it clings to its current position for generations and does not allow new plants to gradually supplant it. This is why untouched beech forests often look like monocultures – a canopy of towering beech with very few other trees.

Along with the Dinaric Alps, the Carpathians are one of the few

European regions whose beech trees survived the ice age. The area protected by world heritage status covers a total of 300 sq. km (116 sq. miles), and a buffer zone covers an additional 500 sq. km (193 sq. miles). Stretching along a 200-km (124-mile) long axis from the Rakhiv and Chornohirskyi mountains of Ukraine, along the Polonynian Ridge, and on to the East Beskids and Vihorlat mountains of Slovakia, the protected area is made up of ten separate areas: Havešová (location of the world's largest beech trees), Rožok, Stuica-Bukovské Vrchy, and Vihorlat in Slovakia; and Chornohora, Kuziy-Trybushany, Maramarosh, Stuzhystsia-Ushok, Svydovets, and Uholka-Shyrokyi Luh in Ukraine.

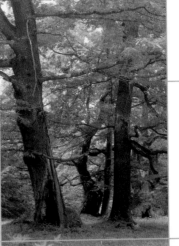

The red beech (*Fagus sylvatica*) grows in many parts of Europe, but pure beech forests and other beech-dominated woodlands are now only found in the Ukrainian and Slovakian Carpathians. Some of the trees here grow as tall as 55 m (180 feet).

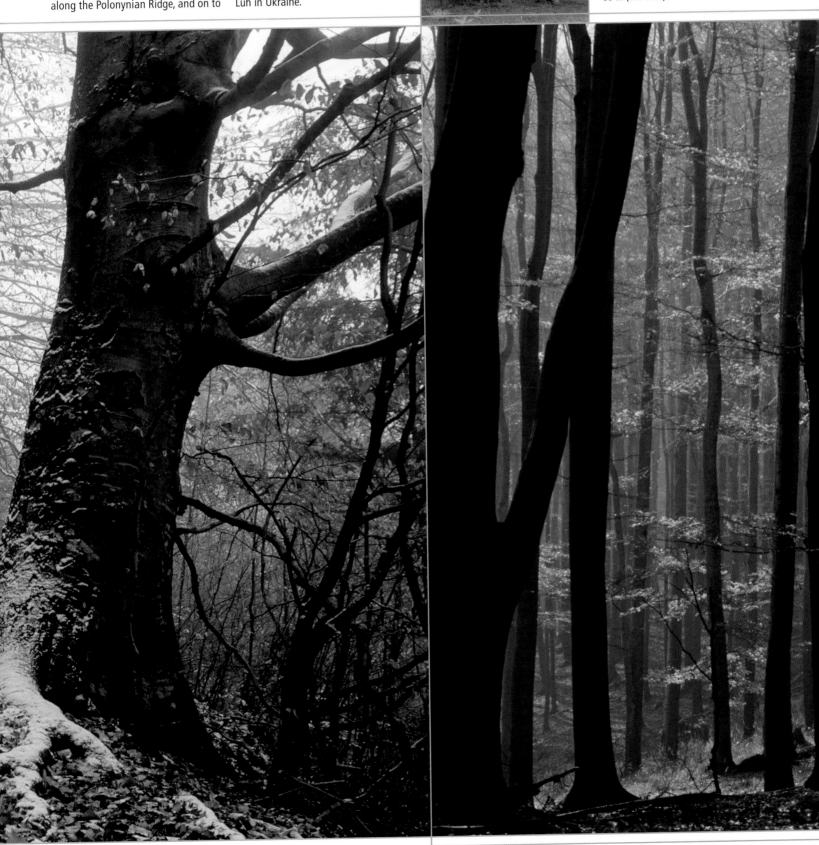

CAVES OF AGGTELEK KARST AND SLOVAK KARST

The Hungarian karst region lies in the foothills of the Slovakian Erz mountains. The area's many hundreds of caves, with their striking stalactites and stalagmites, are spread across both sides of the border.

Date of inscription: 1995
Extended: 2000

About 600 m (1,970 feet) above sea level, Aggtelek National Park is located in the karst region of the low mountain ranges of northern Hungary. The mountains reach into Slovakia, and the World Heritage Site takes in parts of both countries. Alongside the extensive cave network, it also boasts many rare plants and animals.

The many caves go down several hundred meters below ground, and can be accessed via several entrances. Joining a guided tour really makes the caves' geology tangible. The highlight of the tour is the huge Baradla Cave – an incredible landscape of stalactites and stalagmites. In some of the other chambers, meanwhile, fossils and evidence of the caves' Paleolithic inhabitants have been found. In 1965, the Béke Cave – the second biggest in the Aggtelek karst – was officially declared a "healing cave." Its atmosphere is particularly beneficial for asthma sufferers, and it is also used as a concert hall.

The network of dripstone caves in the Hungarian part of the Aggtelek karst region is 17 km (11 miles) long. Visitors are rewarded with the sight of a fascinating world of limestone columns, stalactites and stalagmites, streams, rock halls, and artificial lakes.

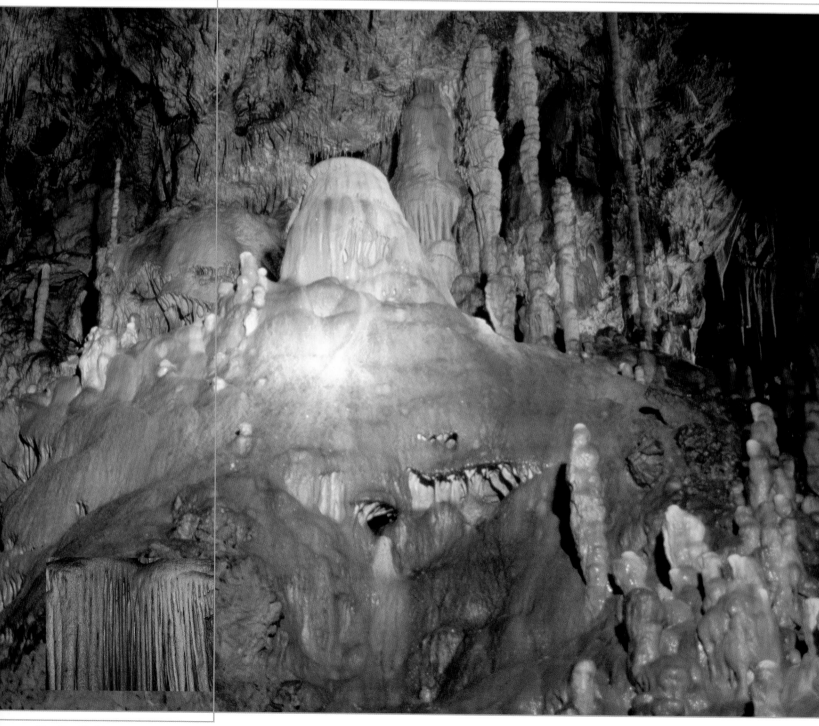

ŠKOCJAN CAVES

The Škocjan caves are located in the karst mountains of Slovenia, to the east of Trieste. Nearly 6 km (4 miles) long, this is one of the largest cave systems in Europe. The labyrinthine caves feature huge grottos, wonderful dripstone formations, and roaring waterfalls. They are home to numerous rare plants and animals.

Date of inscription: 1986

At Škocjan, the river Reka disappears underground. It flows for some 40 km (25 miles) before finally resurfacing near the Adriatic coast. In between, it creates a subterranean karst landscape that looks almost primeval – complete with all the typical signs of thousands of years of limestone erosion, namely crevices, gorges, shafts, sinkholes and basins, lakes, waterfalls, narrow passages, and chambers. The Martelova dvorana is the largest chamber, with a length of 308 m (1,010 feet), width of 123 m (404 feet), and height of up to 146 m (479 feet). When the snow melts, the water level in the 148-m (486-foot) deep Reka underground canyon can, within a short space of time, rise dramatically. Even in summer, the 25 roaring cascades in the "murmuring cave" are still a fantastic natural spectacle. The stalactites and stalagmites in the "silent cave," meanwhile, include both mighty and more delicate formations with names like the "giant" or the "organ."

One of the many entrances to the Škocjan cave system (large image). Inside, the river Reka flows 45 m (148 feet) beneath the Cerkvenik Bridge (small image, right), before finally emerging into the open near the Adriatic coast (image inset, right).

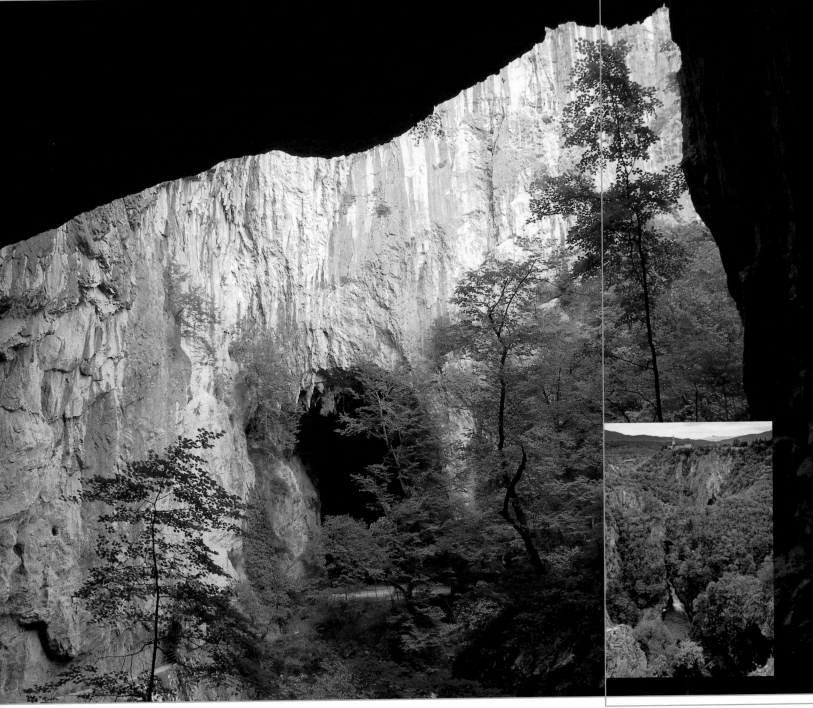

PLITVICE LAKES NATIONAL PARK

In the Croatian karst, not far from the border with Bosnia and Herzegovina, the 16 lakes of Plitvice Lakes National Park form an ever-changing, unspoiled natural panorama. They are connected by a number of cascades and waterfalls, forming a series of natural terraces.

Date of inscription: 1979
Extended: 2000

Spanning some 7 km (4 miles), this series of lakes is the result of a combination of limestone deposits and tectonic movements. The build-up of calc-sinter over millennia created the natural dams and barriers that capture the water. The lakes' bluish-green shimmer, meanwhile, is due to algae and mosses. The most impressive of the park's waterfalls are as high as 76 m (249 feet) and are found around the four lower lakes. The Plitvice river joins the water at the end of the chain of lakes, forming the source of the river Korana. Declared a national park in 1949, the region at the feet of the Mala Kapela mountains is home to a diverse range of flora and fauna. Deer, wolves, brown bears, and some 120 species of bird are all found in its dense forests.

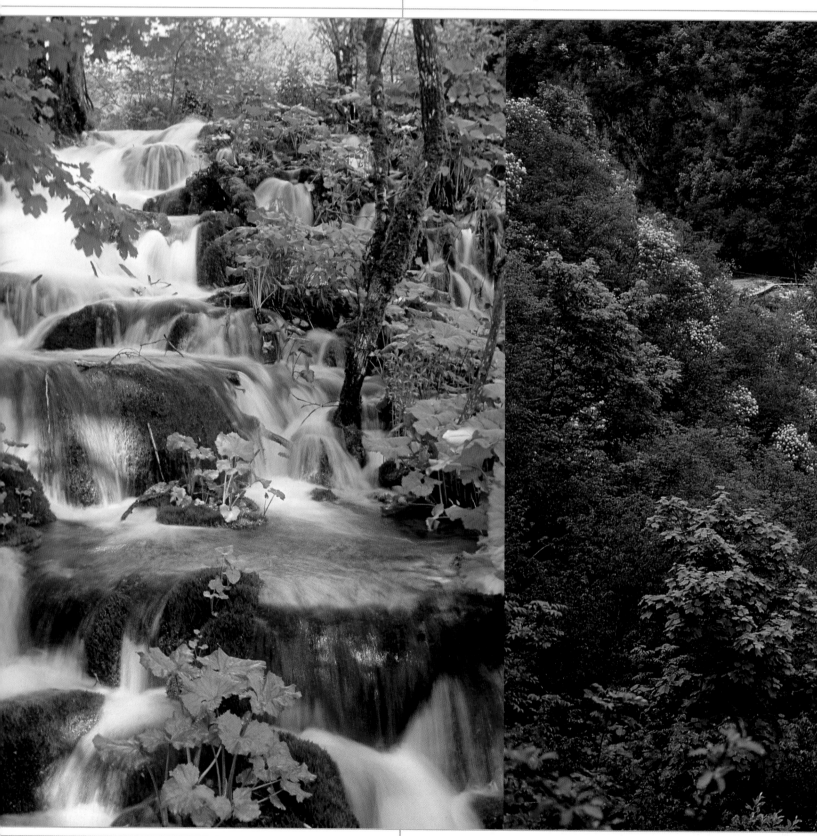

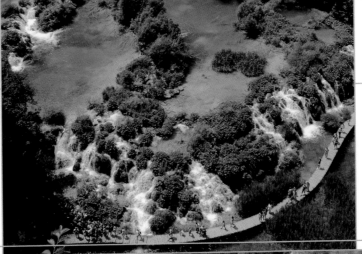

The contours of the terraces created by the flow of calcareous water through the lakes is constantly changing (large image, left). Paths and bridges allow visitors to discover the park on foot (small image, right), and it can also be explored by boat.

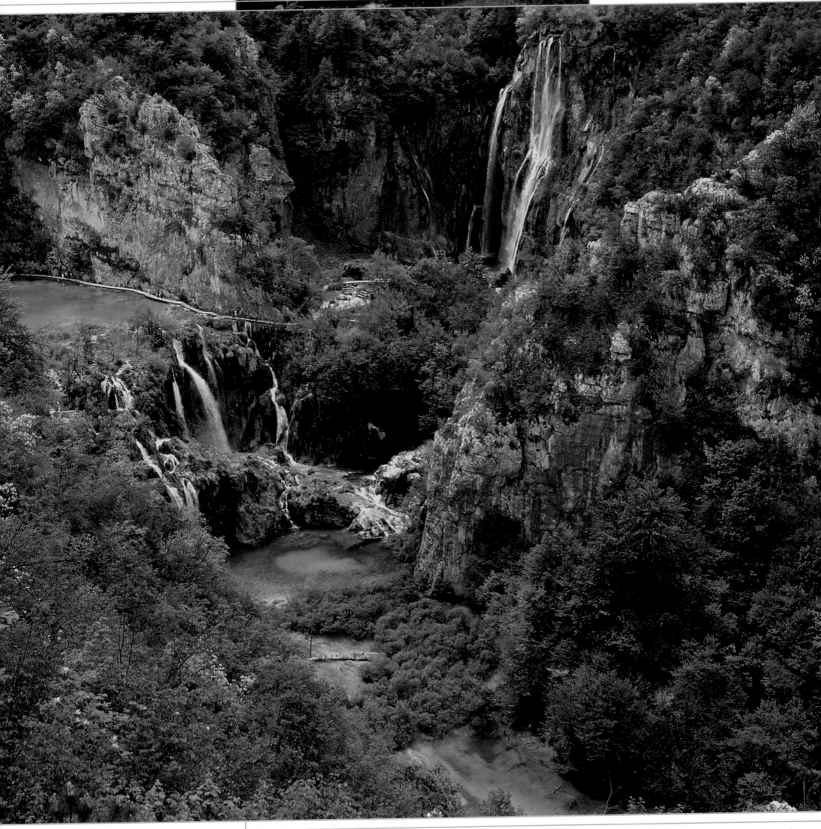

NATURAL AND CULTURAL HERITAGE OF THE OHRID REGION

In the 9th and 10th centuries, Ohrid, in south-west Macedonia, was an important spiritual and cultural hub of orthodox Christianity.

Date of inscription: 1979
Extended: 1980

Founded by the Illyrians as Lychnidos, Ohrid's advantageous location was not lost on the Romans. Positioned on the Via Egnatia – the main road between Byzantium and the Adriatic – the town became an important strategic base. Ohric became a diocesan town in the 4th century. In the 9th century, Clement and Naum, disciples of the Slav apostles Cyril and Methodius, founded several monasteries here. The town became the focal point of ortho-dox Christianity in the Balkans. At the end of the 10th century, the town was both a see of the Greek Orthodox Church and, for a while, the capital of Tsar Samuil's Bulgarian empire. Subsequently, the town fell under the rule of the Serbian potentate Dusan. It was conquered by the Ottomans in 1394, and remained under Ottoman control until 1913.

The 11th-century church of St Sophia was built under archbishop Leo, but converted to a mosque by the Turks – thus losing its impressive dome, bell tower, and internal galleries. The conversion also saw the whitewashing of the church's frescoes, which date from the 11th–14th centuries. They

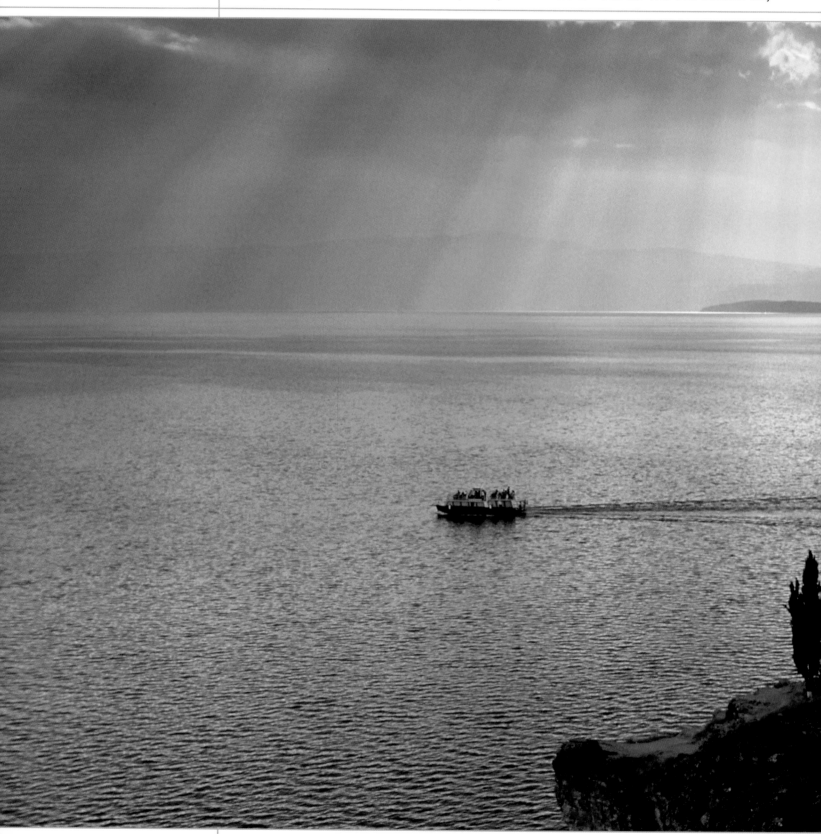

were finally uncovered in the course of restoration work in the 1950s. There are more Byzantine frescoes in the church of St Clement, which is also home to the best collection of icons anywhere in the former Yugoslavia. The old town of Ohrid is a conservation area, featuring many charming houses built in the typical Macedonian style.

Lake Ohrid is the largest lake in Macedonia. It is believed to be one of the oldest and deepest lakes in the world, and is home to several species of endemic fish. The church of St John at Kaneo stands high above the water. Its striking octagonal tower is a sign of the region's orthodox Christian heritage.

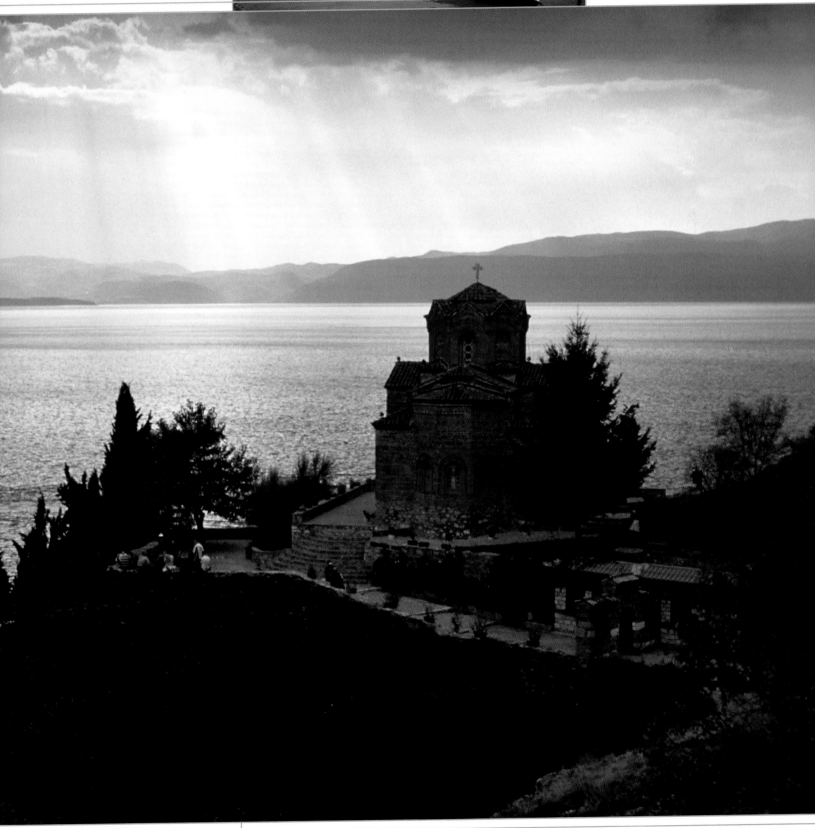

DURMITOR
NATIONAL PARK

Formed by the glaciers of the last ice age, the Durmitor mountains were declared a national park in 1952. The highest peak, Bobotov Kuk, reaches an altitude of 2,522 m (8,274 feet). There are 18 lakes within the region's mountains and forests, and the area also boasts Europe's deepest gorges. The park, which spans an area of more than 320 sq. km (124 sq. miles), is a refuge for numerous rare plants and animals.

Date of inscription: 1980; Extended: 2005

Raging through the dense coniferous forests, past the clear mountain lakes, the Tara is one of the last great, untamed whitewater rivers of the Balkan peninsula. In its wake, the gorges of the Dinaric karst are up to 1,300 m (4,265 feet) deep. With the exception of the skiers and mountain walkers around the Žabljak plateau, most of the Durmitor mountains have been spared human intervention. Alongside deer and chamois, the park is also home to a number of animals that have become very rare in Europe, namely brown bears, wolves, wildcats, eagles, black grouse, and capercaillies. About three-quarters of the mountain flora are endemic. The black pines – which constitute some of Europe's last primeval forests – are also noteworthy.

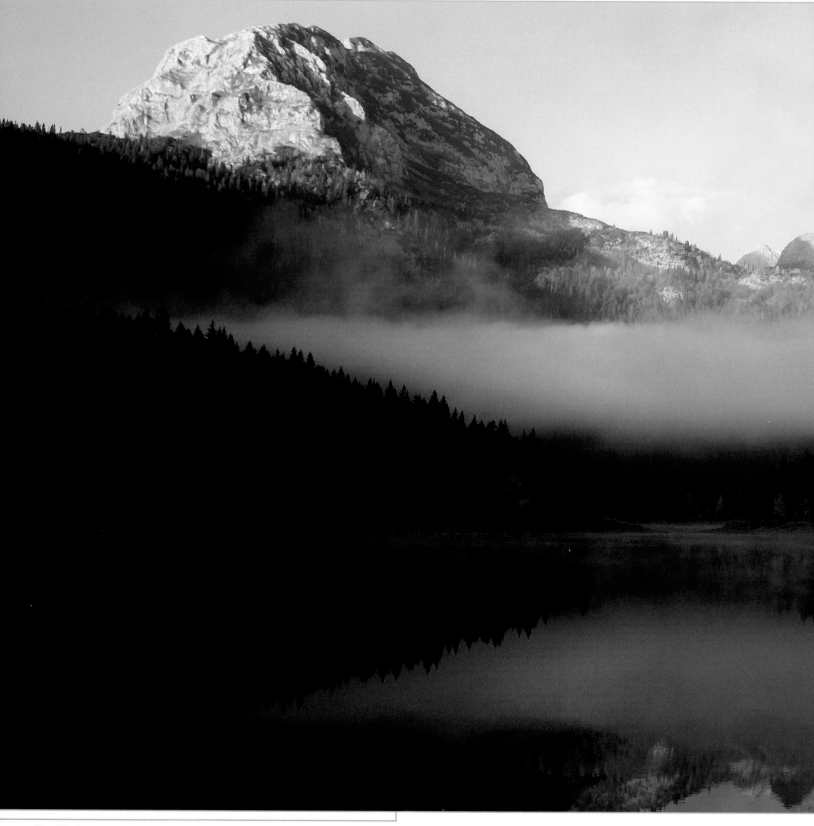

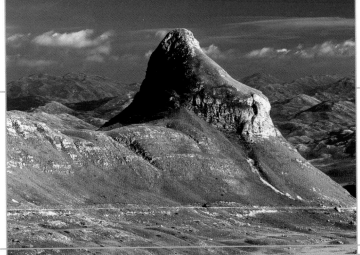

The Black Lake (Crno jezero) is located near Žabljak and is easily accessible on foot (large image). It is up to 49 m (161 feet) deep and lies at an altitude of 1,416 m (4,646 feet). There are no trees in the upper range of the mountains (small image, left), and the meadows here are the only part of the park where *Gentiana laevicalyx* grows (image inset).

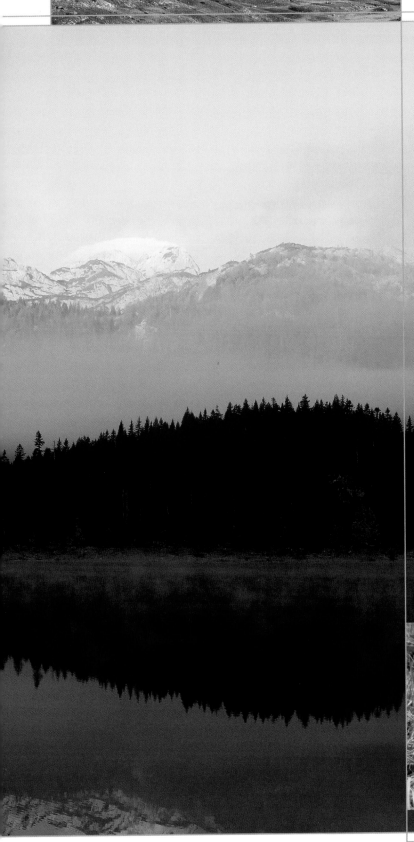

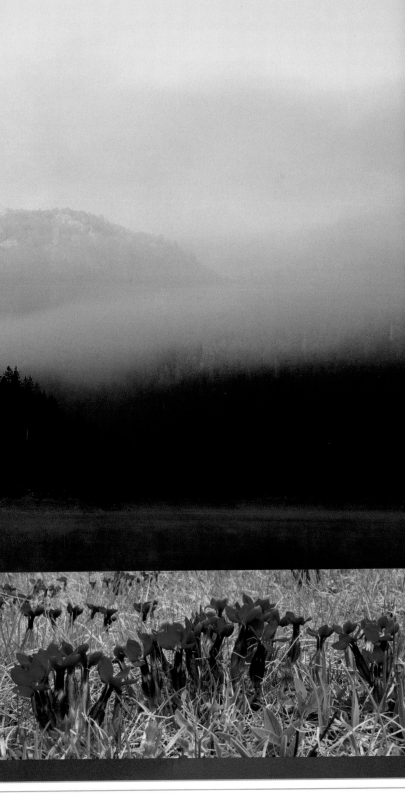

THE DANUBE DELTA BIOSPHERE RESERVE

The area where the Danube flows into the Black Sea is a tapestry of tributaries, channels, lakes, woodland, bogs, reed islands, marshes, and sand dunes that provides a habitat for some 300 species of bird, 45 types of fish, and 1,150 varieties of plant. Growing at a rate of 40 m (130 feet) every year, it is the second largest river delta in Europe. Most of the delta belongs to Romania, but a small part falls within the borders of Ukraine.

Date of inscription: 1991

Interrupted only by floating reed islands and the wooded dry land areas, the marshy delta landscape is one of the world's largest and most important biosphere reserves. Its wetland areas are home to rare plants and countless varieties of insects. Swans, geese, herons, pelicans, glossy ibis, and spoonbills are just some of the large birds found here.

Including the Razim-Sinoie lagoon system, the delta covers an area of some 5,600 sq. km (2,200 sq. miles), and is an important resting place for migratory birds. There are also large stocks of fish in the protected waters, including the now rare sturgeon. However, the biosphere reserve is threatened by both water pollution and the commercial exploitation of its reed beds.

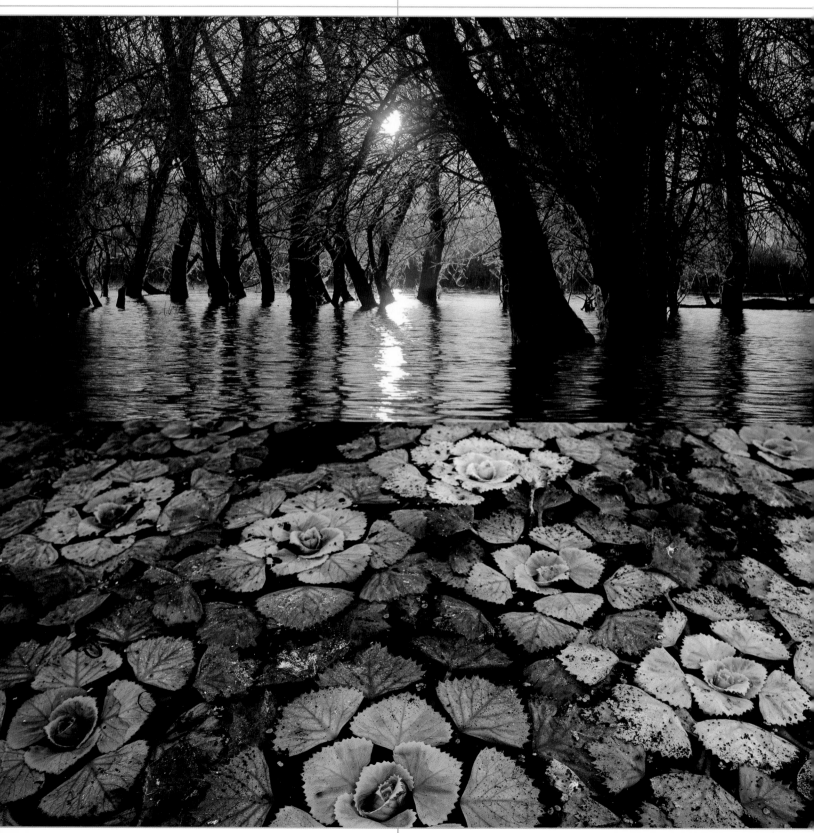

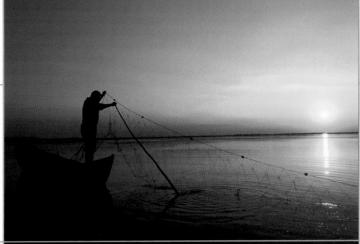

Covering 2,500 sq. km (965 sq. miles), the reed beds of the Danube delta are the largest of their kind in the world. In spring, the delta's riparian forests regularly flood, and large parts of its surface are covered with water caltrop (below). Fishing is an important source of income for the local population (small image, left).

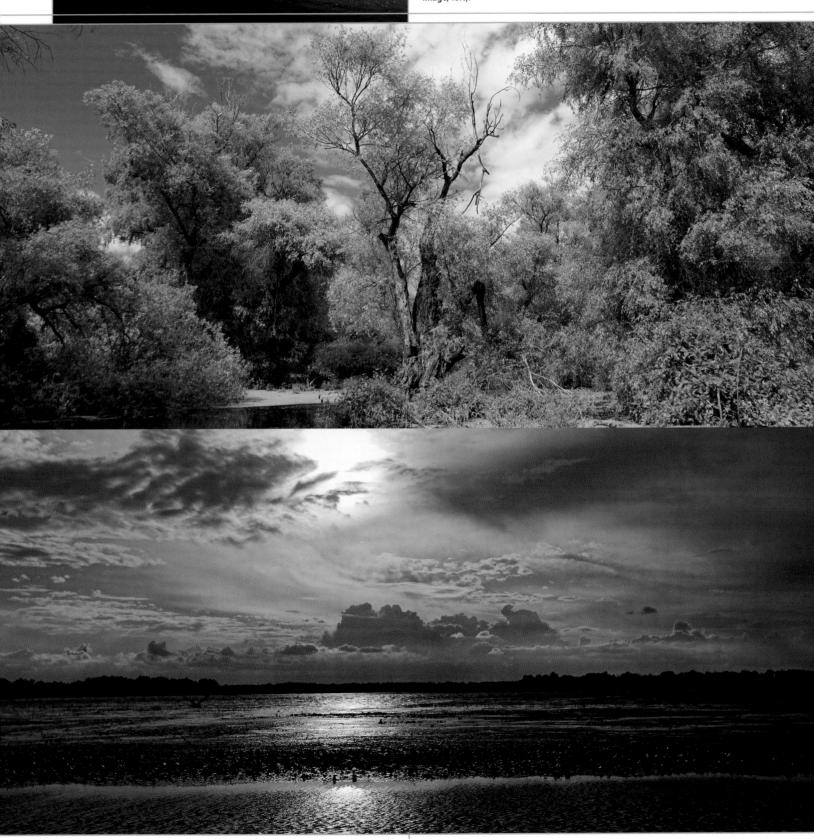

With its 18 specially protected reserves, the Danube delta is one of the world's main breeding grounds for the extremely sensitive white pelican (*Pelecanus onocrotalus*). The largest pelican colonies are located south of the St George tributary and, to the north, around Lake Rosca. Attracted by the lure of an easy meal, the birds sometimes get caught up in fishing nets, from which they then have to be freed.

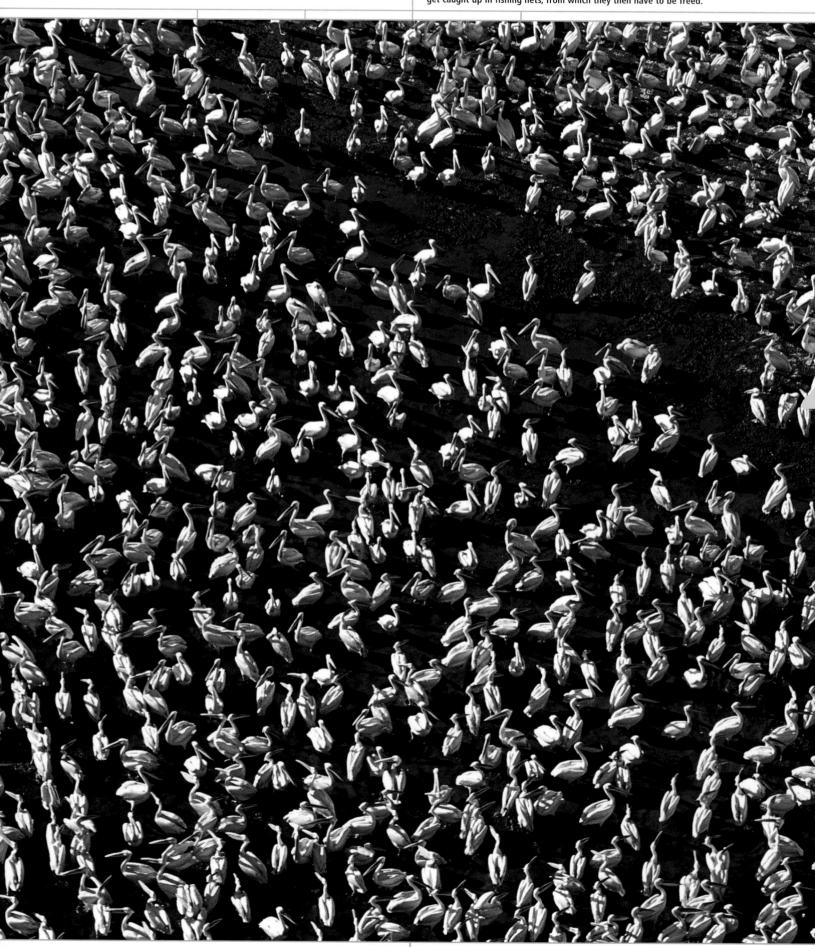

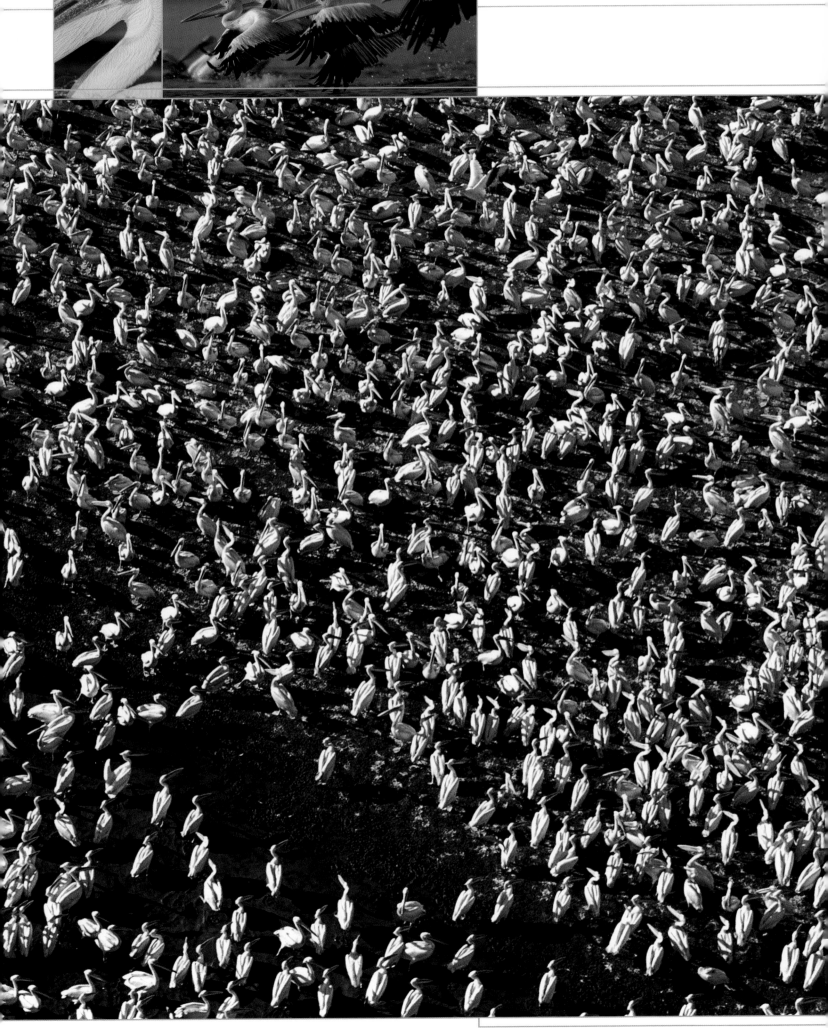

Herons are also part of the Danube delta birdlife (large images), among them the squacco heron (shown making its mating cry, third from left), gray heron, and night heron. At one time, egret feathers were popular for women's hats, and large numbers of these birds (small image, right) were sacrificed in the name of fashion. The delta's glossy ibis (small image, far right) are the only breeding ibis in the whole of Europe.

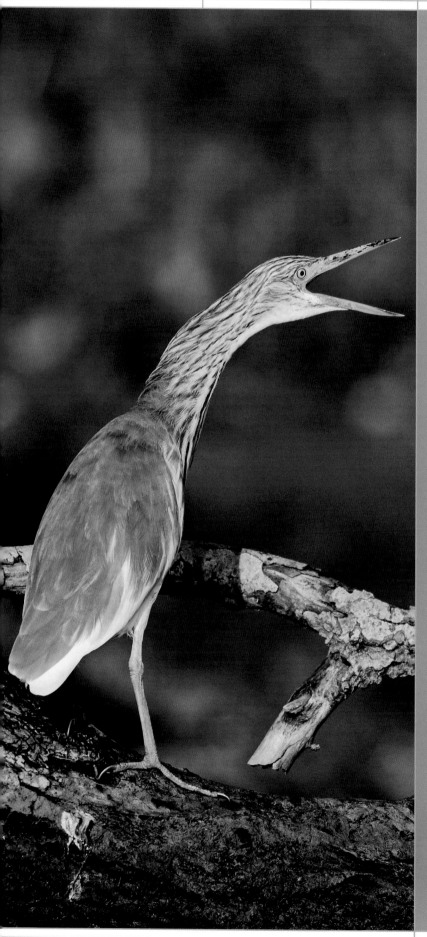

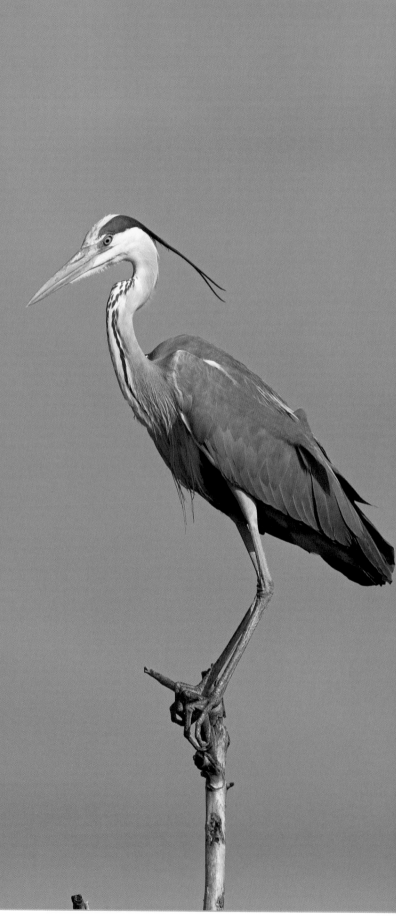

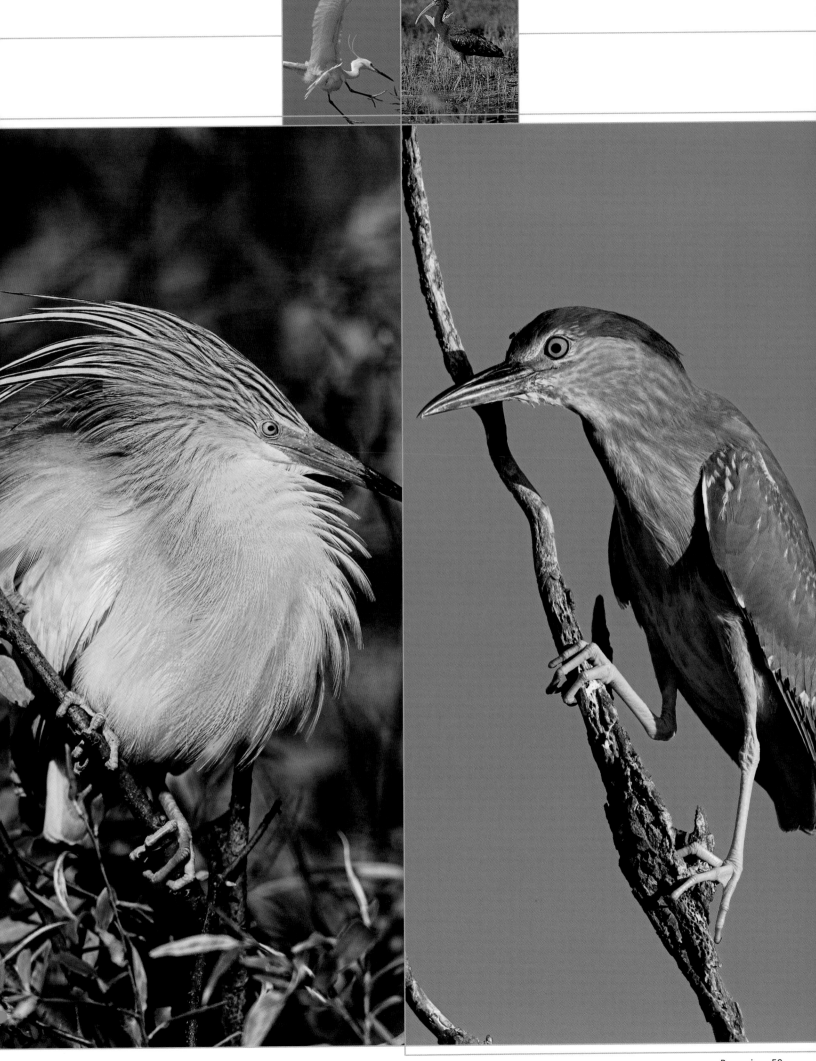

SREBARNA NATURE RESERVE

Covering an area of 9 sq. km (3 sq. miles), the Lake Srebarna nature reserve is home to a wide range of water birds – many of them endangered species. During the migration season, flocks of geese, cranes, and storks take to the skies above the reserve.

Date of inscription: 1983

This ornithological paradise is located west of Silistra, not far from the Danube. Around 80 different types of bird visit the reed-covered lake every year – some just passing through, others spending the winter, and others – like the great egret and the rare Dalmatian pelican – raising their young here. The total number of bird breeds found on the reserve and the three Danube islands within it stands at 233. Srebarna was designated a protected nature reserve in 1948, but between 1982 and 1994 a combination of flood prevention measures and droughts caused the region to literally dry out. The lake was connected to the river again in 1994, and, thanks to regular flooding, has now been almost completely regenerated.

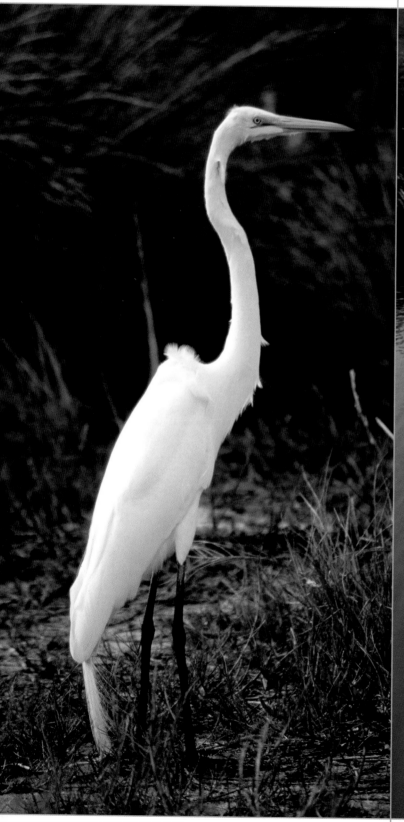

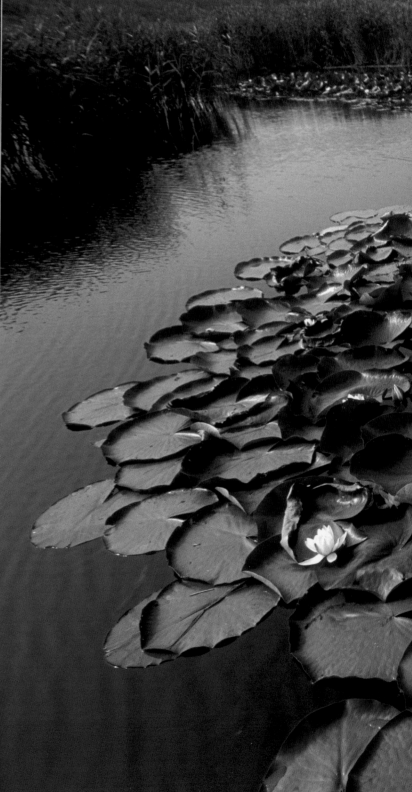

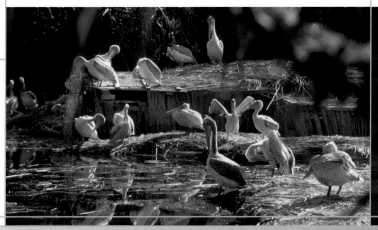

Lake Srebarna may only be an average of 2 m (7 feet) deep, yet it still boasts examples of around half the plant species found in all of Bulgaria's wetland areas (large image: water lilies). Some 400 hectares (990 acres) of the lake's surface are covered by reeds. The reserve is also home to Dalmatian pelicans (small images, right) and great egrets (large image, left).

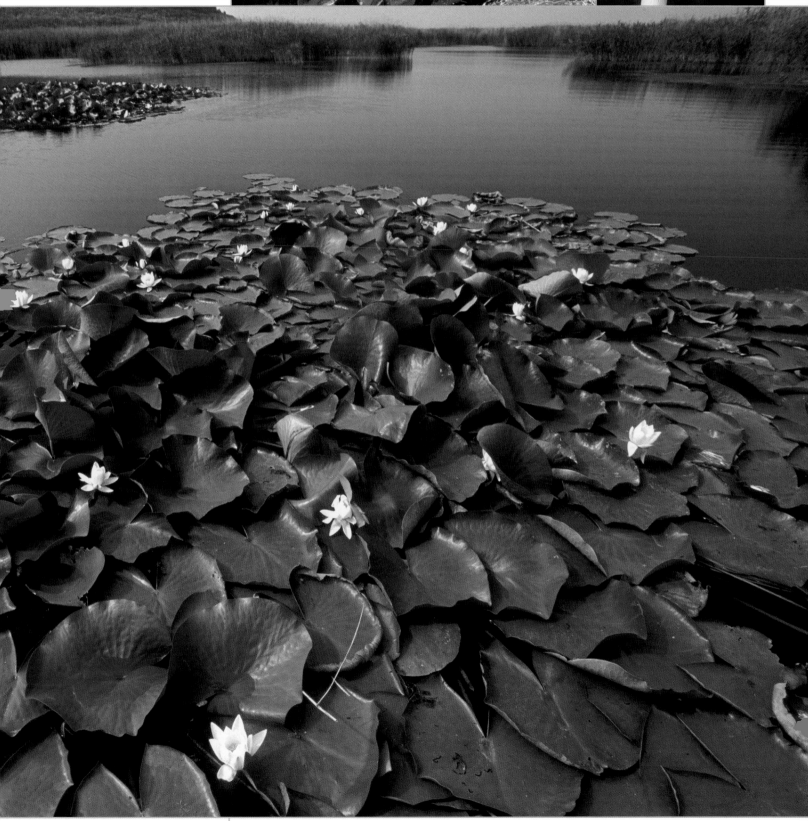

PIRIN NATIONAL PARK

Pirin National Park covers approximately 270 sq. km (104 sq. miles) of south-west Bulgaria. The coniferous forests that lie beneath its impressive mountain peaks contain some very rare plant species. Many, like the Macedonian pine, are only found in this area.

Date of inscription: 1983

The Pirin mountains lie at the north-western edge of the Rhodope mountains, about 100 km (62 miles) south of Sofia. They span about 40 km (25 miles) from north-west to south-east, flanked by the valleys of the Struma and Mesta rivers. Pirin National Park occupies the northern half of this heavily fissured mountain terrain, with 45 of its peaks reaching an altitude of over 2,600 m (8,500 feet). Towering above them all, the 2,914-m (9,560-foot) high Vihren is the third highest mountain in the entire Balkans. The Bayuvi Dupki reserve is the heart of the park. Some 70 glacial lakes are remnants of the last ice age, and – along with the park's waterfalls and caves – are typical of this limestone landscape. There are also numerous hot springs in the valleys.

The park is home to a wide variety of flora, including species typically associated with central Europe and the Balkans as well as alpine plants. The black pine and silver fir are two of the park's coniferous trees. Both are on the IUCN's Red List of Threatened Species, and some individual trees are over five hundred years old. This untouched landscape is also home to numerous rare birds and mammals, such as the wolf, European brown bear, golden jackal, and golden eagle. Otters, badgers, marten, ferrets, European wildcats, red deer, chamois, and wild boar are also Pirin residents.

With its numerous clear mountain lakes (large image), the vegetation at Pirin National Park ranges from beech woodlands to treeless alpine pastures – perfect for grazing sheep in the summer (image inset). The Pirin mountains are also a refuge for numerous rare animals, including several dozen brown bears (small image).

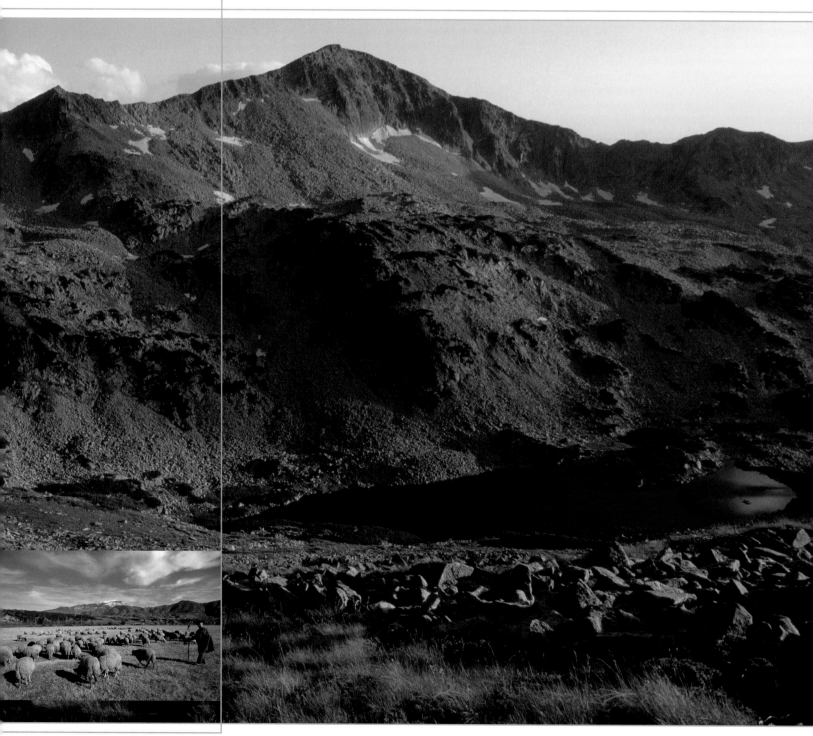

MOUNT ATHOS

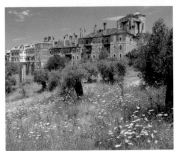

A total of 20 monasteries make up the autonomous monastic state on the Khalkidiki peninsula. It is one of the most important places in the Orthodox Christian world.

Date of inscription: 1988

The first monastery on Hagion Oros – the "Holy Mountain" – was built in 963. The monastic republic's autonomy dates back to the Byzantine period. Men under the age of 21 and women are not allowed to enter the monasteries, which are currently home to about 1,400 monks. Mount Athos has been a focus of Orthodox Christianity since 1054, and its influence is felt even in the secular world. In the 14th century some 3,000 peasants were employed by Athos to farm the republic's 20,000-hectare (49,500-acre) lands.

The style of icon painting practiced at Athos plays an important role in the history of Orthodox Christian art, while the influence of the monaster-

ies' characteristic architecture can be seen as far away as Russia. Of the 20 monasteries, 17 are Greek, one Russian, one Serbian, and one Bulgarian. Each monastery courtyard contains a domed church with three apses. The monastic cells and other buildings are positioned around the courtyard.

The Esfigménou monastery (large image) lies right on the north-east coast of the Athos peninsula. Poised on the edge of a wooded ravine, the perimeter buildings of the Dionysiou monastery cling to the ramparts like swallows' nests (small image, above right). Vatopediou is another of the monastic republic's monasteries (small image, bottom right).

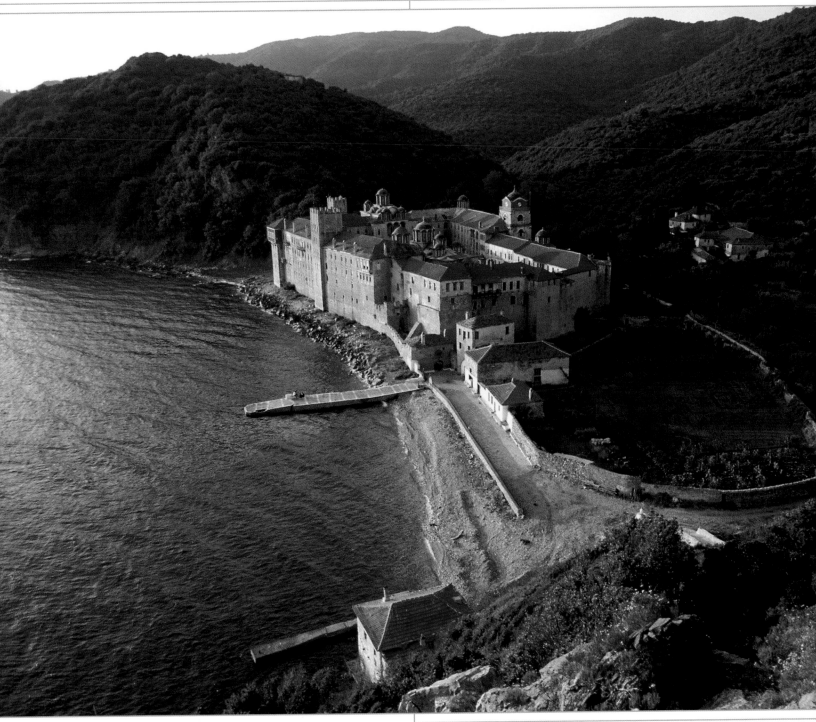

Meteora's 24 monasteries were built on steep, rocky peaks that raise them high above the world below. Most of the monasteries date as far back as the 14th century.

Date of inscription: 1988

The Meteora valley is located north of the town of Kalambaka. Its 24 monasteries – five of which are still occupied today – were built over time on a series of rocky peaks that tower over the valley. For visitors, it is a truly breathtaking sight.

The monastery situated at the highest altitude is Megalo-Meteoro. Founded around 1360 by the holy Athanasius, bishop of Alexandria, it was granted special privileges in 1362 and exempted from the local jurisdiction in the 15th century by Euthymius, patriarch of Constantinople. The other monasteries were placed under the authority of Megalo-Meteoro in 1490. The Monastery of St Nicholas Anapausas, meanwhile, sits on top of one of the other high mountain peaks. Founded around 1388, the monastery's late Byzantine frescoes by the influential Cretan painter Theophanes Bathas date from 1527. They were restored in 1960.

Varlaam monastery was founded in 1517 and was rebuilt between 1627 and 1637. It takes its name from the 14th-century hermit who first constructed a church here. The

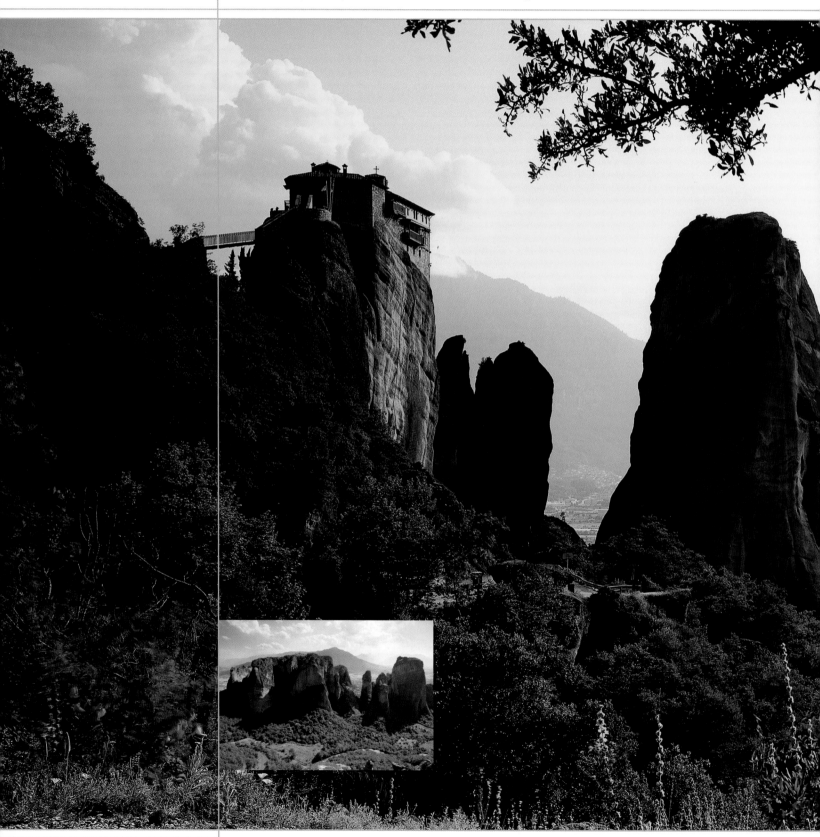

monastery's Katholikon, built in 1544, is considered to be an excellent example of the late Byzantine style. The Katholikon's fine frescoes were completed in 1548. Between 1961 and 1963, Varlaam was converted into a museum to house the most valuable treasures of the monasteries and is accessible via a bridge. By contrast, the Monastery of Roussanou has recently become occupied once again – this time by nuns. With its octagonal church, Roussanou resembles a smaller version of Varlaam and it is accessed via a bridge which was constructed in 1868. There are 130 steps to climb to reach the Holy Trinity Monastery. Its church was built in 1476, and the monastery also boasts an idyllic garden.

Meteora loosely translates as "floating in the air," and it offers correspondingly fine views across the Thessalian plain (large image). The rocks upon which Varlaam monastery (small image, left) was built are around 30 million years old. At that time, they would have been in the middle of the sea. They owe their curious shapes to erosion by the sea water and – as the sea level dropped – also to wind and rain.

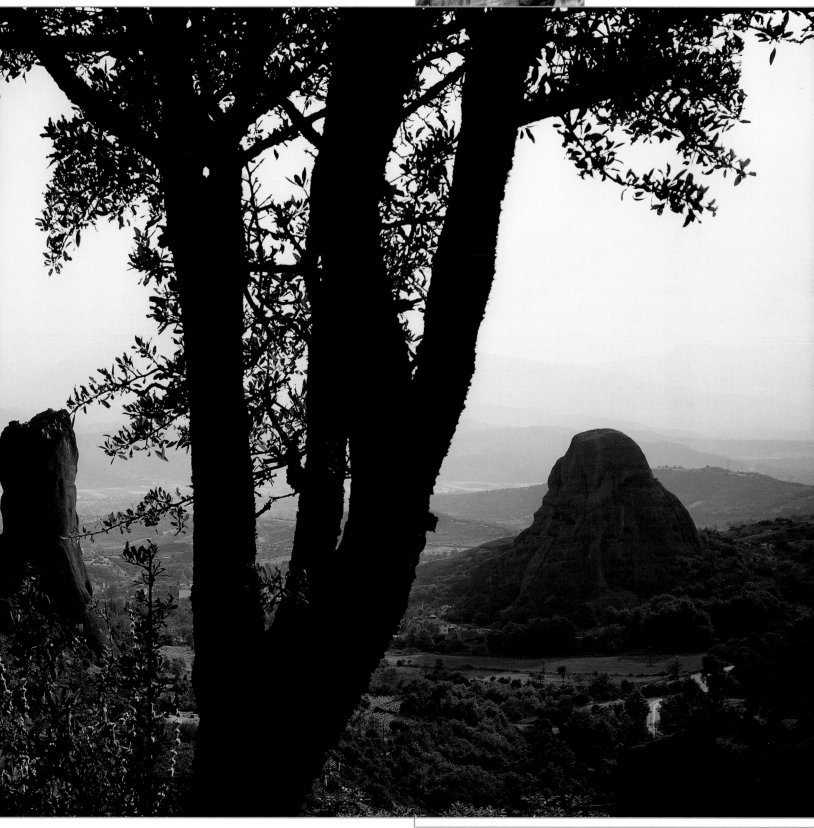

On the edge of north-east Europe, the Virgin Komi forests are one of the last remaining areas of boreal vegetation. These vast woodlands are dominated by conifers, aspen, and birch.

Date of inscription: 1995

The area protected by world natural heritage status covers 32,800 sq. km (12,660 sq. miles) of Russia's Komi Republic. Large parts of the forests have barely been touched by humans, and are therefore an extremely valuable resource for natural historians. The protected area stretches from the endless plains of the Taiga, before rising high into the Ural mountains. Its landscape takes in rivers, moors, and hundreds of lakes, alongside alpine and subalpine pastures, which melt into the tundra.

The forests are home to a wide variety of both European and Asian animal species, notably bears, wolves, polar foxes, deer, reindeer, elk, beavers, otters, and squirrels.

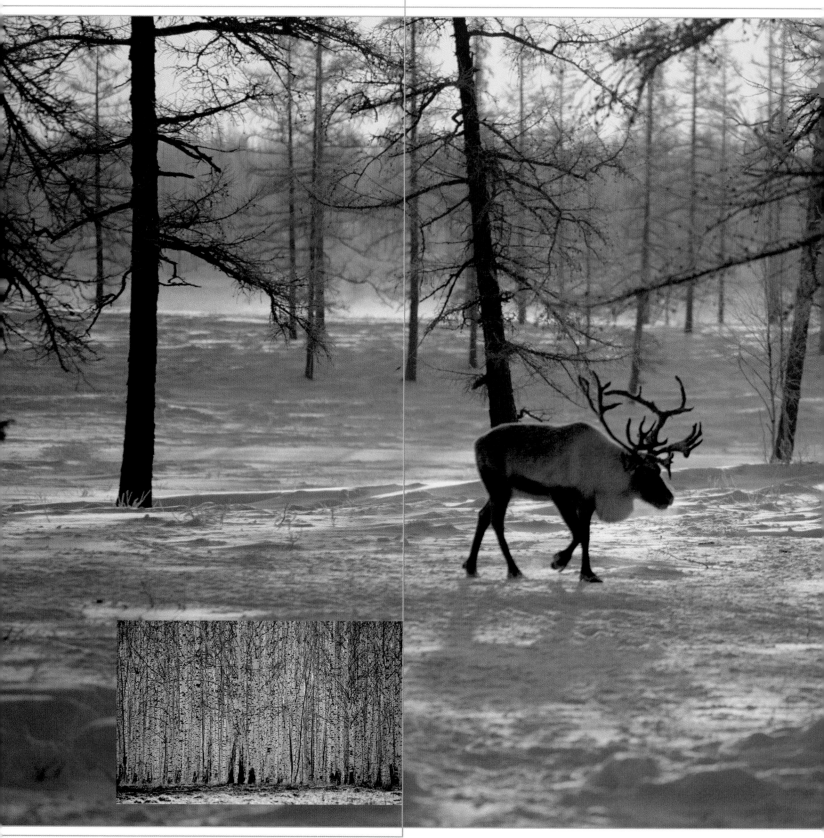

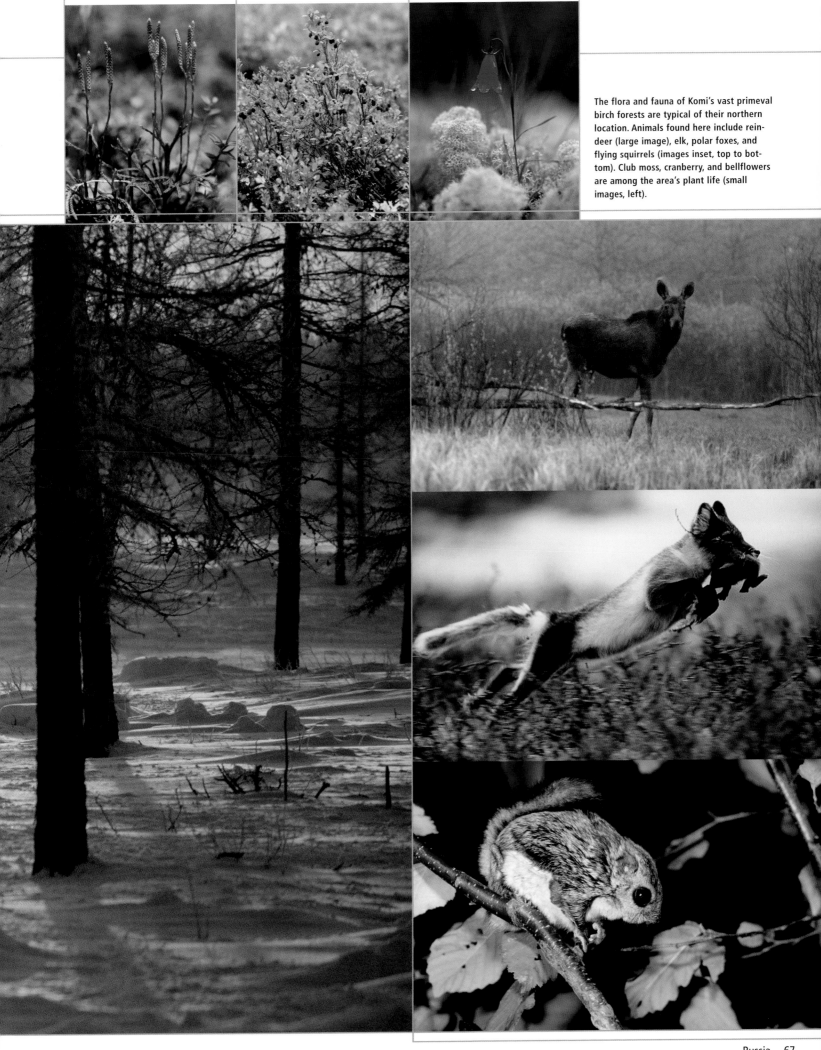

The flora and fauna of Komi's vast primeval birch forests are typical of their northern location. Animals found here include reindeer (large image), elk, polar foxes, and flying squirrels (images inset, top to bottom). Club moss, cranberry, and bellflowers are among the area's plant life (small images, left).

The Sundarbans mangrove forest, around the delta of the Ganges, Brahmaputra, and Meghna rivers on the border of India and Bangladesh, provides a safe haven for several hundred Bengal tigers.

Poking through the clouds, the rocky peaks of the Wuyi mountains, in China's Fuijan province, evoke an enchanted fairytale landscape.

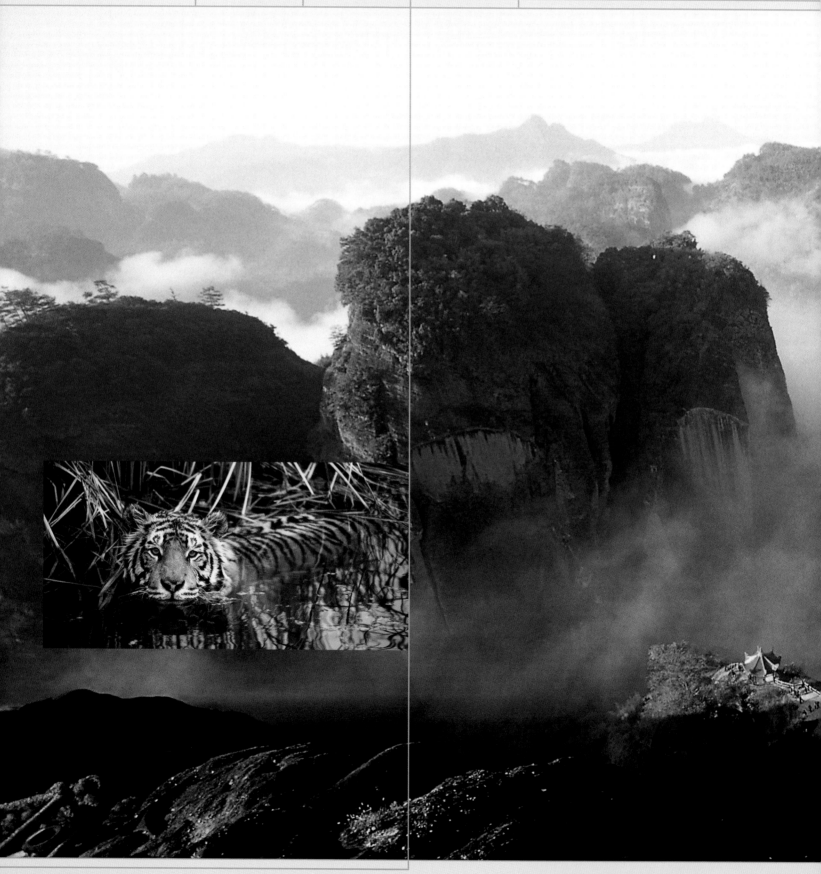

ASIA

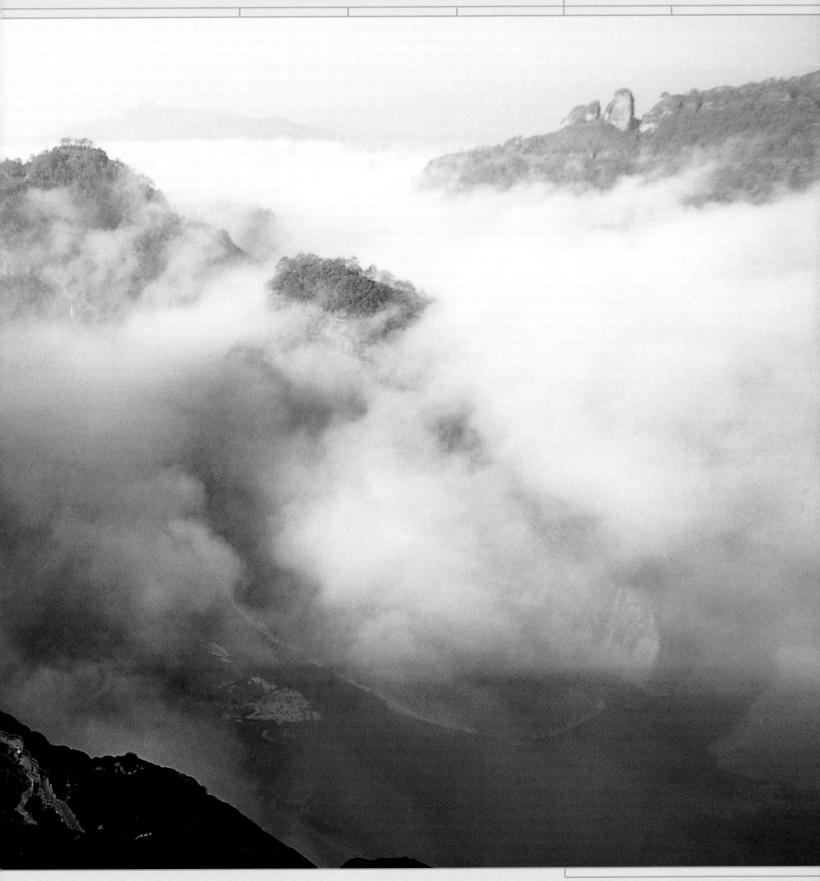

On the border of Europe and Asia, the western Caucasus encompasses a multitude of ecosystems that have so far been spared large-scale human intervention.

Date of inscription: 1999

The western Caucasus lies about 50 km (30 miles) from the Black Sea coast, and covers an area of nearly 3,000 sq. km (1,200 sq. miles). It stretches some 130 km (80 miles) from west to east, and some 50 km (30 miles) from north to south. The core of the natural heritage site is made up of large areas of the Caucasus biosphere reserve and its buffer zone, alongside the Sochi National Park and several smaller nature reserves. The landscape ranges from lowland areas to the pastures and forests of the site's subalpine zones, and on into its mountainous regions, whose highest peaks reach altitudes of over 3,000 m (9,800 feet). The site is home to numerous endemic and threatened plant and animal species.

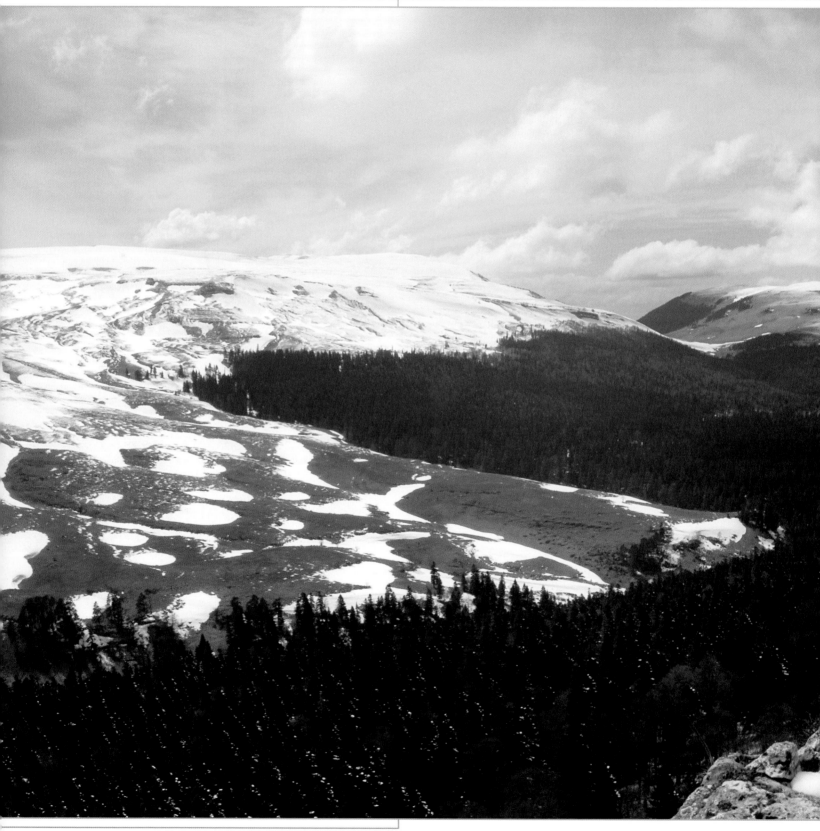

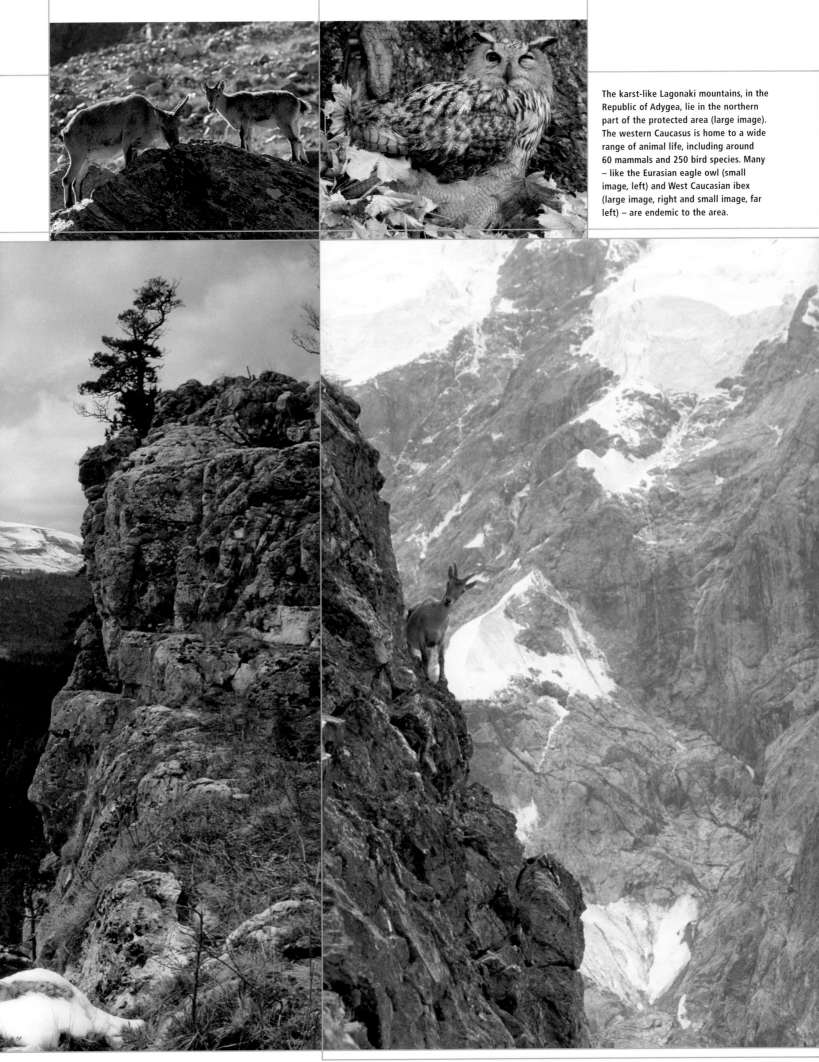

The karst-like Lagonaki mountains, in the Republic of Adygea, lie in the northern part of the protected area (large image). The western Caucasus is home to a wide range of animal life, including around 60 mammals and 250 bird species. Many – like the Eurasian eagle owl (small image, left) and West Caucasian ibex (large image, right and small image, far left) – are endemic to the area.

THE GOLDEN MOUNTAINS OF ALTAI

The Altai mountains of central Asia lie at the borders of Russia, Kazakhstan, China, and Mongolia. Covering over 16,000 sq. km (6,200 sq. miles), the Altai World Natural Heritage Site falls within Russian territory. It is home to numerous rare and endemic species of plant and animal life.

Date of inscription: 1998

Russia's Altai mountains, in southern Siberia, form part of an Asian mountain range that also includes the Mongolian and Gobi Altai mountains. The World Natural Heritage Site in the Russian Republic of Altai is comprised of three distinct regions, namely the Altai reserve and buffer zone around the 80-km (50-mile) long Lake Teletskoye, the Katunsky reserve and buffer zone around Mount Belukha, and the Ukok Quiet Zone.

From the steppe to its alpine areas, the Altai boasts the most complete sequence of vegetation zones in the whole of central Siberia. The variety of plant life is enormous. Over 2,000 genera have been identified, 212 of which are endemic. The area's animal population, meanwhile, is typical of its

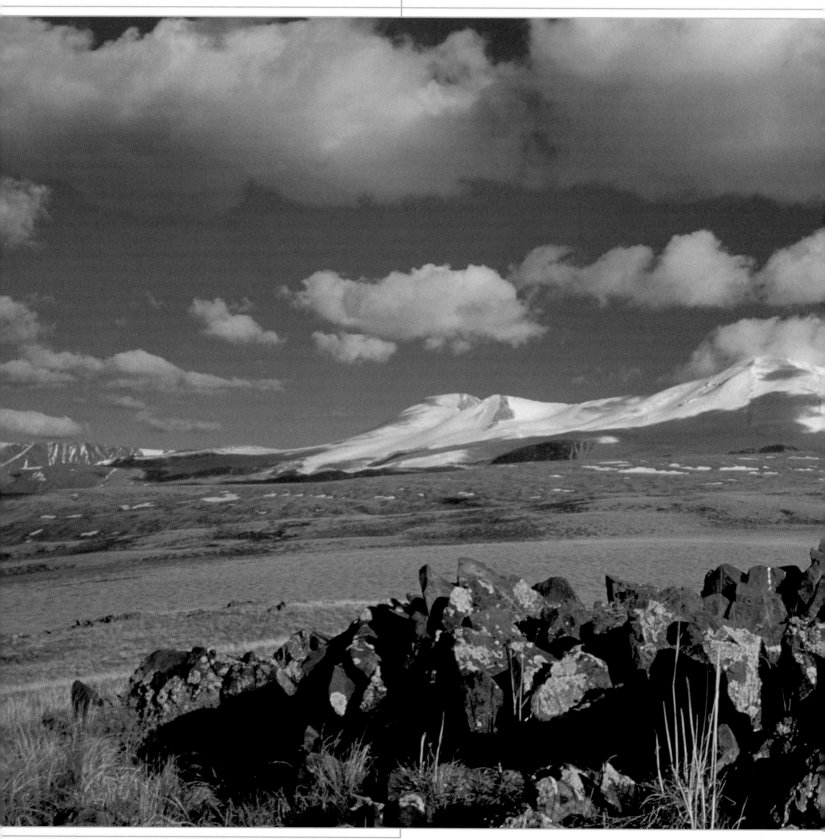

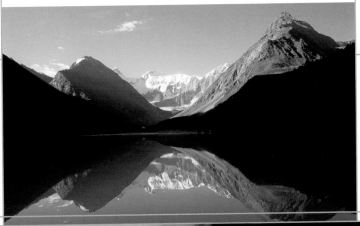

Siberian forest environment. There are over 70 different types of mammal, 300 types of bird, 11 types of reptile and amphibian, and more than 20 types of fish. Some of the mammals as well as many of the birds are included on the IUCN's Red List of Threatened Species, notably the golden eagle, the imperial eagle, and the snow leopard.

The 4,506-m (14,783-foot) high peak of Mount Belukha is the focal point of the impressive Altai mountain landscape on the border of Russia and Kazakhstan. The mountain summits are reflected in clear mountain lakes like Lake Ak-Kem (left). The Ukok plateau, on the border with China, is also part of the World Heritage Site (large image). Its stone graves are evidence of the Scythian Pazyryk people who once lived here (6th–2nd century BC).

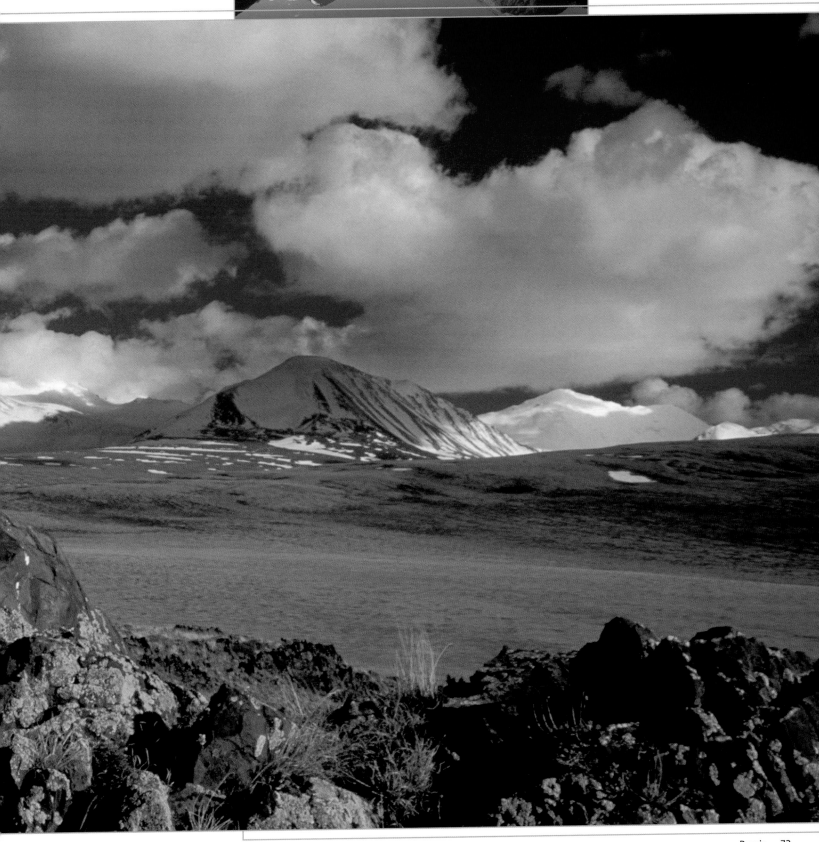

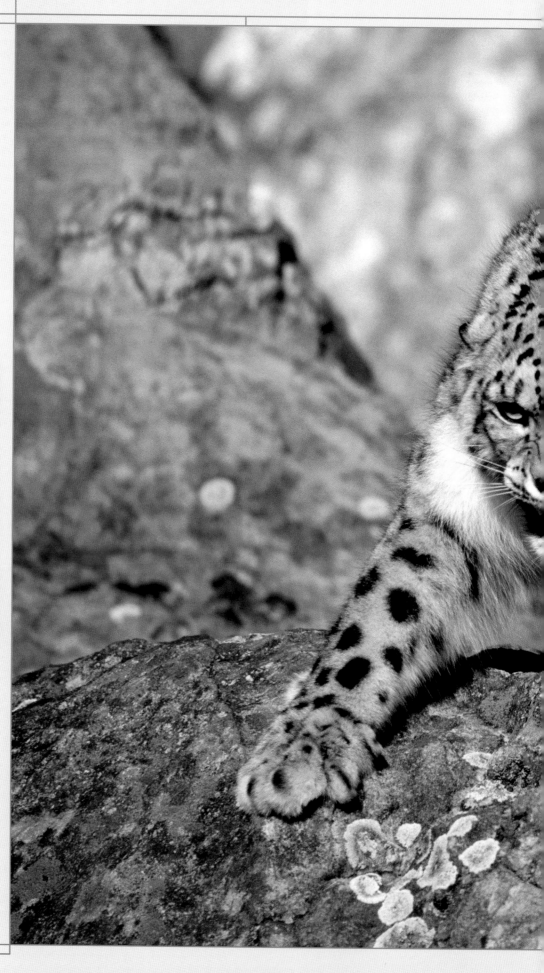

Threatened with extinction

From the Altai to the Himalayas, the mountains of central Asia are the preserve of the snow leopard. Their number has fallen sharply, and there are thought to be no more than 7,000 snow leopards left. Despite their inclusion on the IUCN's Red List of Threatened Species, they continue to fall prey to illegal hunting, their striking fur commanding high prices. Taxonomists are divided as to the correct classification of the snow leopard (or ounce, as it is sometimes known). Though originally placed in the genus *Panthera*, the animals have now been given a genus of their own (*Uncia uncia*). Technically, the snow leopard is not a true big cat, since its body is only 95–130 cm (37–51 inches) long. The snow leopard's tail

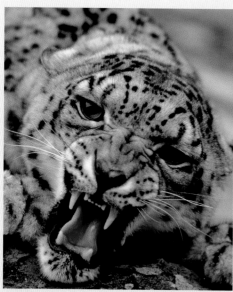

Stalking the mountains of central Asia: the snow leopard.

is just as long again, helping to stabilize it as it leaps; it can leap as far as 15 m (49 feet). It is this extraordinary ability that makes the snow leopard a hunter without equal. The tiger population of the Altai mountains, meanwhile, has long since died out.

The snow leopard is a shy, solitary creature, and observing it in the wild requires great patience. It is careful to raise its young away from prying eyes. Following a gestation period of around one hundred days, the mother hides her offspring in the rocky niches and caves, where they remain for some two months before finally following her out into the world. The best way to find an ounce is to follow the trail of its prey – moufflon, ibex, and yak, which also opt for its cold, high altitude habitat, some 1,800–6,000 m (5,906–19,685 feet) above sea level.

The snow leopard is also found in Russia's Altai nature reserve. There are, however, only 150–200 snow leopards left on Russian territory – far fewer than in the Mongolian Altai Gobi national park. High in the mountains, the animals' natural habitat only supports a low population density. But it is the snow leopard's fur and bones that could be the greatest threat to their existence – the latter being highly prized in traditional Chinese medicine.

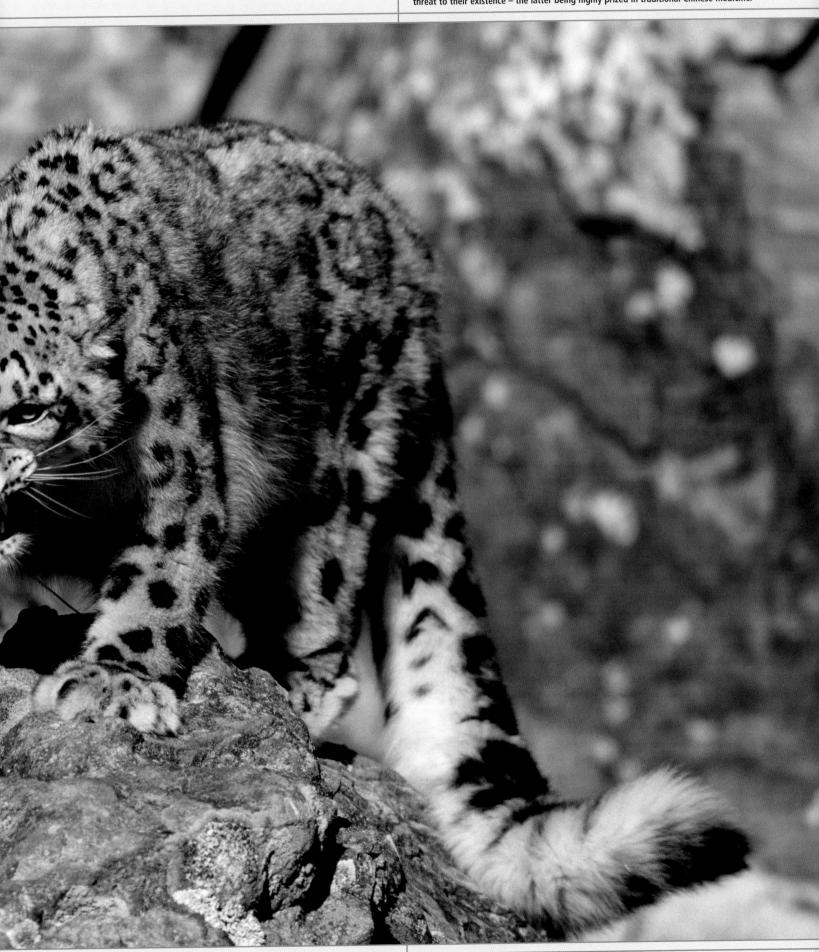

Lake Baikal is possibly the world's foremost lake. It is not only the deepest freshwater lake in the world with the greatest volume of water, but – dating back 25 million years – it is also the oldest.

Date of inscription: 1996

Lake Baikal is nearly 650 km (400 miles) long and, on average, just under 50 km (30 miles) wide. It is situated in southern Siberia, not far from the city of Irkutsk. Geologically, this is a highly active area, and the scene of frequent earthquakes. The mineral springs along the banks of the lake have led to the establishment of numerous spa resorts.

In the Buryat language, Lake Baikal means "rich lake," and the lake and its surroundings are indeed home to a great diversity of plant and animal life. Over 1,200 animal species have been identified in the water alone, and most of these – like the Baikal seal or the live-bearing golomyanka fish – are endemic. Some 600 plant species grow on the water's surface and banks.

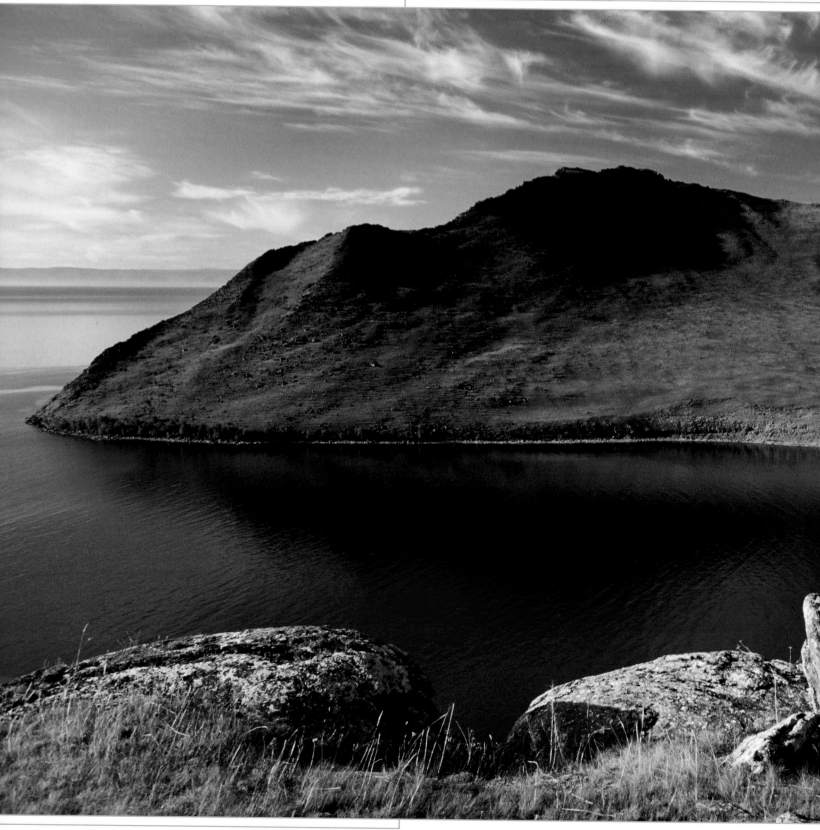

Lake Baikal is surrounded by high mountains (small image, left), including the Baikal mountains, Stanovoy mountains, and Sayan mountains. Places like Aya Bay (large image, left), Peschanaya Bay (image, inset), and Lena National Park (large image, right) are scenes of unspoilt peacefulness.

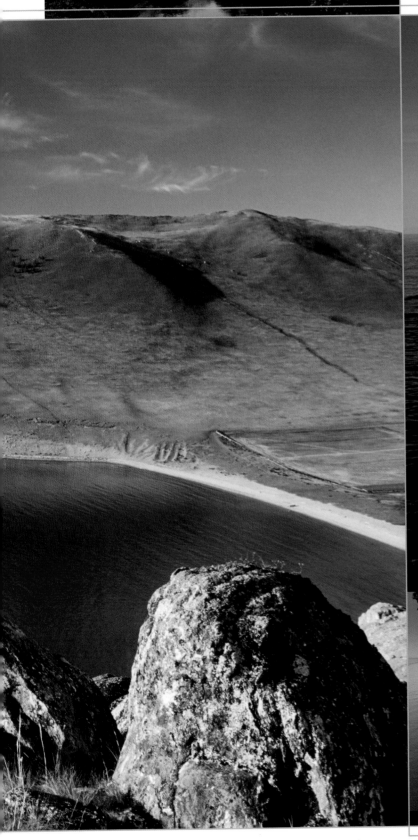

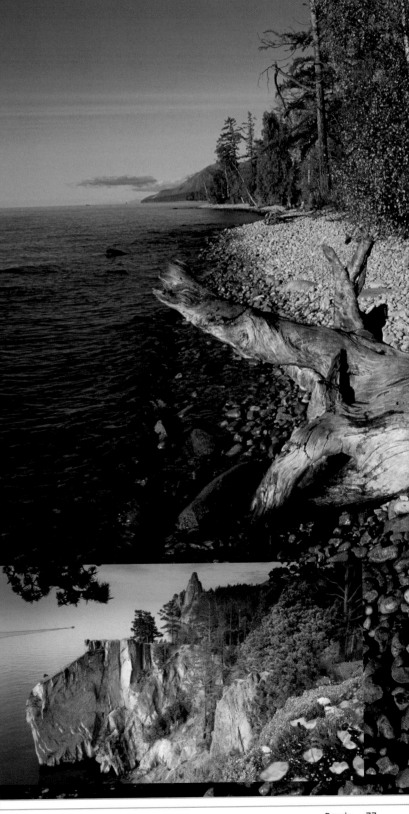

The Baikal seal (*Phoca sibirica*) is the only seal to live exclusively in fresh water. Its main prey is the Baikal sculpin (image inset, right) – a fish found only in Lake Baikal. The Baikal teal (right) is another example of the area's endemic species.

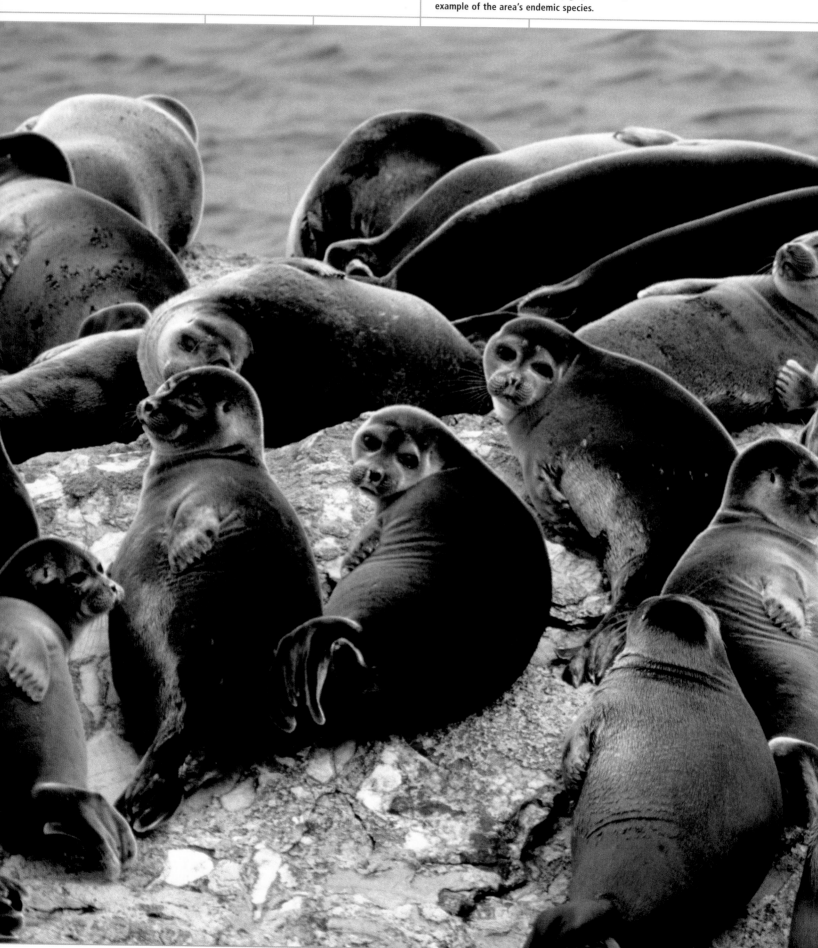

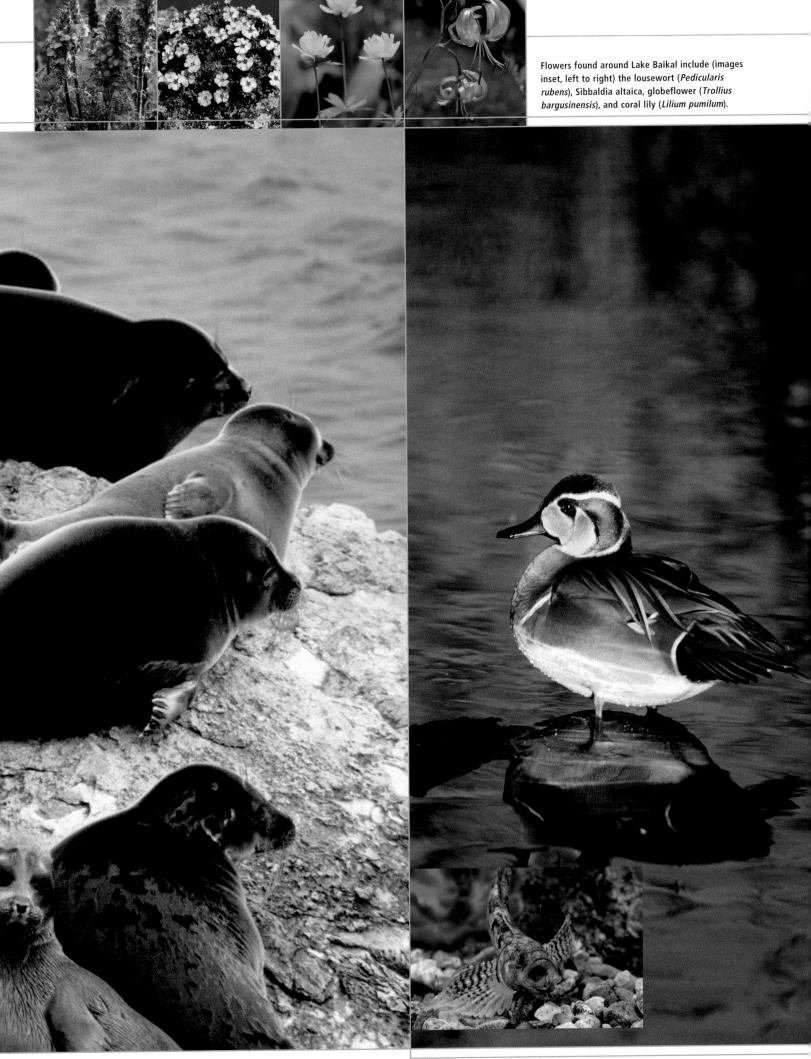

Flowers found around Lake Baikal include (images inset, left to right) the lousewort (*Pedicularis rubens*), Sibbaldia altaica, globeflower (*Trollius bargusinensis*), and coral lily (*Lilium pumilum*).

The Sikhote-Alin mountains protected area is the scene of a unique confluence of temperate and subtropical zones. Here, species of flora and fauna that usually belong to quite opposing ecosystems are found side by side.

Date of inscription: 2001

Covering approximately 15,000 sq. km (5,800 sq. miles), the central Sikhote-Alin heritage site comprises three nature and animal reserves in the mountainous regions of the Russian far east, as well as the mountain range along the coast of the Sea of Japan. It was first declared a biosphere reserve in 1979, and is notable for its mixed population of Siberian, Manchurian, and south-east Asian animal species. Here, brown bears live side by side with Asiatic black bears, endangered Amur (Siberian) tigers, and Amur leopards (whose population has now dwindled to very small numbers indeed). Over a hundred of the area's animal and plant species are included on the IUCN's Red List at either national or international level.

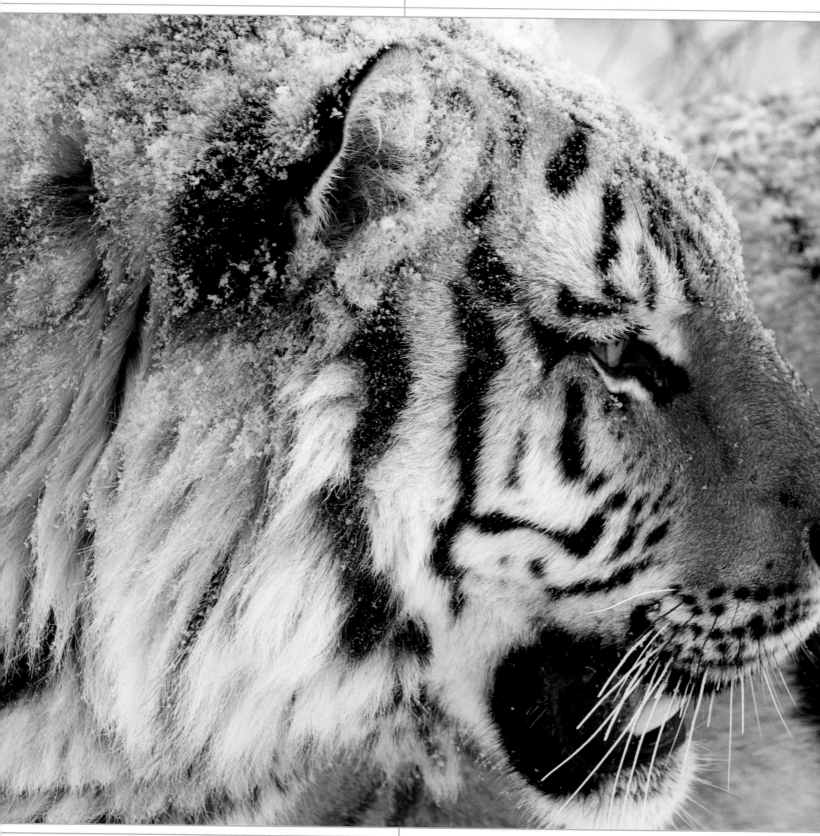

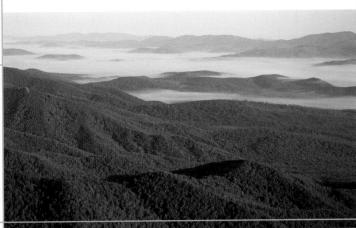

Dense forests are the predominant feature of the mountain landscape that stretches from Ussuri and Amur in the west to the Sea of Japan and the Strait of Tartary in the east (small image, left). Taiga and extensive wetlands dominate the more northerly regions, but they give way to subtropical deciduous forests in the south. Numerous endangered animals live here, not least of which is the Amur tiger. Nearly 4 m (13 feet) long and weighing up to 350 kg (770 lb), it is the biggest of the world's big cats (large image). Other native animals include the Siberian grouse, Siberian roe deer, and Asiatic black bear (small images, top to bottom).

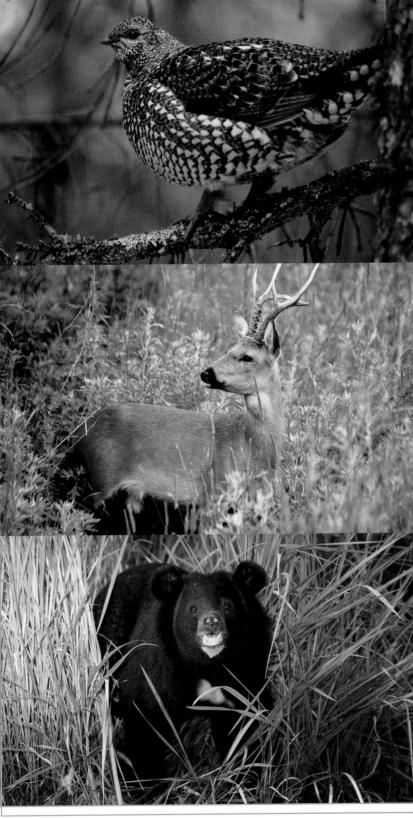

NATURAL SYSTEM OF WRANGEL ISLAND RESERVE

The mountains of Wrangel Island lie at the north-east extremity of Russia. Considering the island's northern latitude, the diversity of plant and animal life found here is quite extraordinary.

Date of inscription: 2004

Wrangel Island is located far north of the Arctic Circle, on the western side of the Chukchi Sea. Named after the Russian admiral and Siberian explorer Ferdinand von Wrangel, the island covers an area of around 7,500 sq. km (2,900 sq. miles). It is rich in geological features and boasts a great diversity of natural habitats, each of which has its own microclimate. Thanks to its mountainous terrain, Wrangel was never fully glaciated during the ice age, and it is this fact that explains the survival of plants and animals here that have died out elsewhere.

In fact, there are over 400 species and subspecies of vascular plants on Wrangel Island – double the number found in any other similarly sized tundra area. Of these, 23 are endemic –

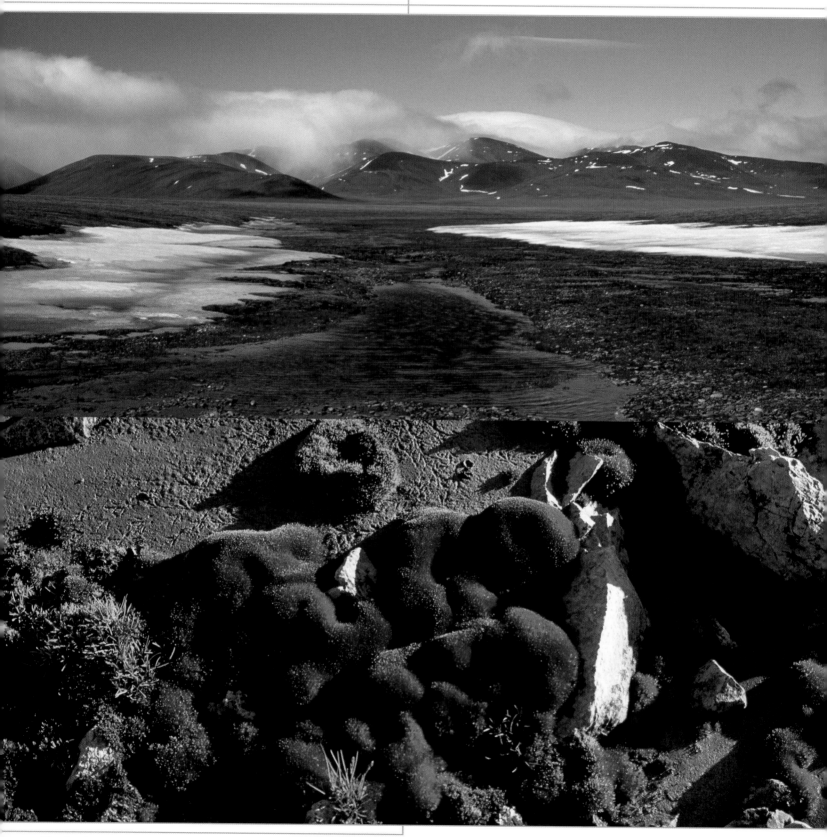

the product of recent hybridization. The island is home to the world's largest population of Pacific walrus – numbering up to 100,000 animals – and also boasts the world's densest concentration of polar bear dens. Two further notable animals are the musk oxen grazing on the tundra landscape, and the grey whales migrating from Mexico, for whom this is a plentiful feeding ground. Some 100 species of migratory bird breed on the island, among them the snow goose.

Wrangel Island's lemmings, meanwhile, are notable for behavior patterns that differ markedly from those of other Arctic lemming populations. Like the lemmings, the island's reindeer have also adapted to the local environment.

Characteristic of its northern latitude, the mountainous landscape of Wrangel Island is dotted with snowfields and waterways (large images, top left and bottom right). In this landscape, the sight of the island's diverse range of grasses and flowers comes as something of a surprise.

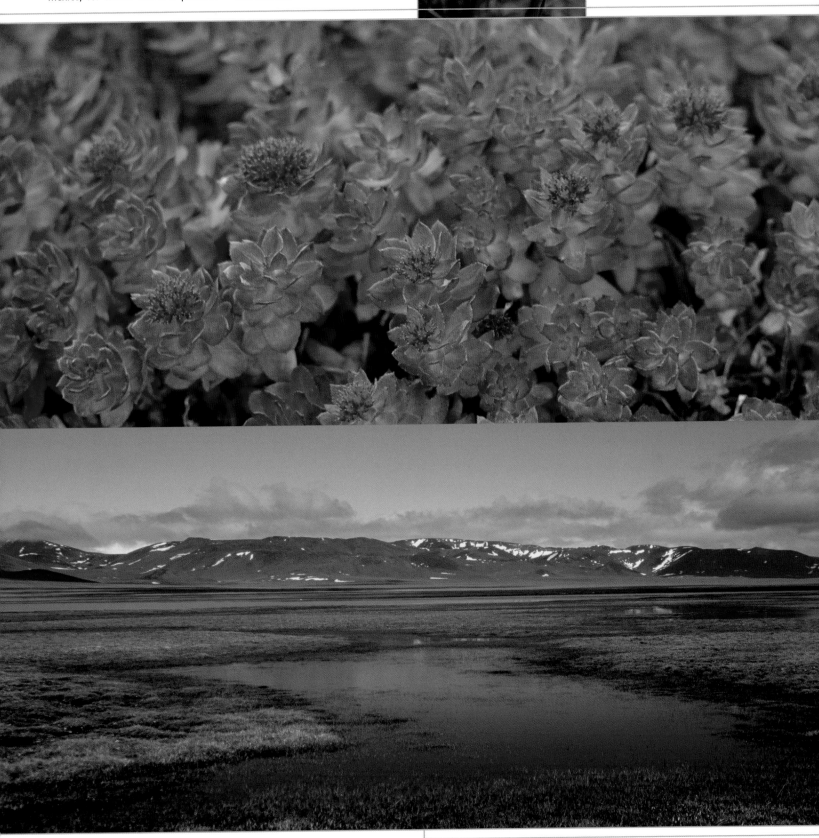

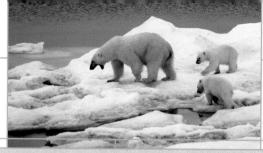

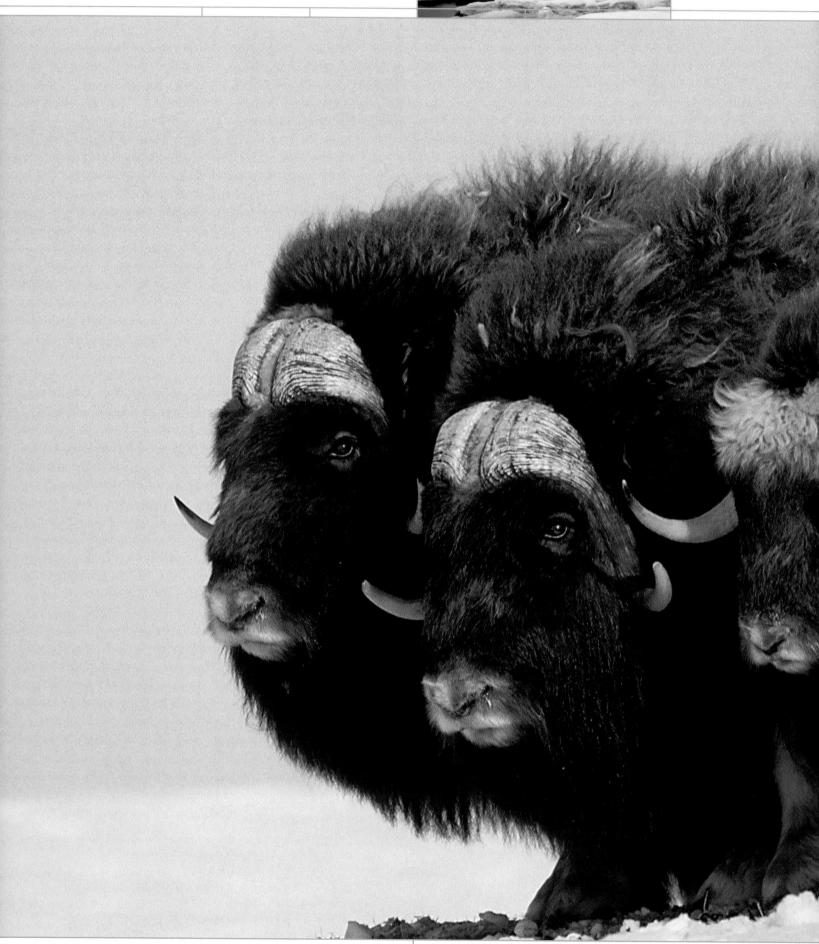

Musk oxen (large image) are not native to Wrangel Island, but are descended from animals released into the wild here. Up until 4,000 years ago, Wrangel Island would also have been home to woolly mammoths. Polar bears are one of the animals found here today. In winter, as many as 300 polar bears take refuge in the island's inland caves. This female and her two young are taking a ride on the drifting ice (small image, left).

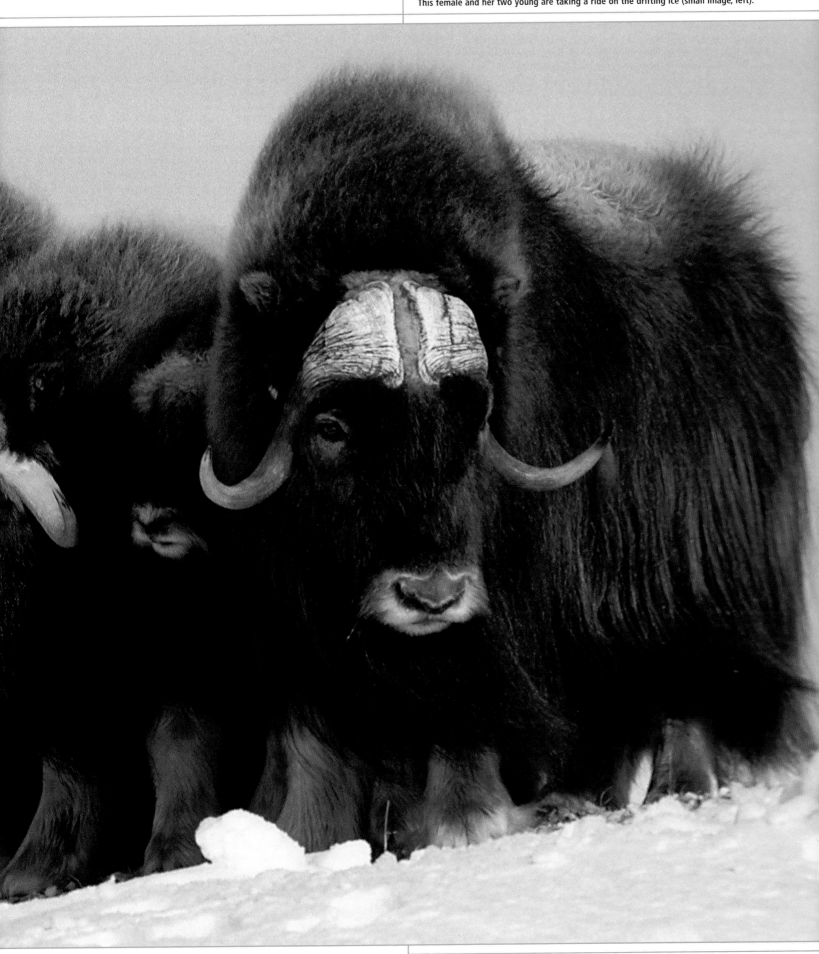

THE VOLCANOES OF KAMCHATKA

The Kamchatka peninsula spans 350,000 sq. km (135,000 sq. miles) of Russia's far east. There are 28 active volcanoes in the southern part of the peninsula, the highest – at 4,750 m (15,584 feet) – being Klyuchevskaya Sopka. Since its original inscription, the natural heritage site has been extended to include Kluchevskoy Nature Park.

Date of inscription: 1996; Extended: 2001

The peninsula is 1,200 km (746 miles) long and 480 km (298 miles) wide at its widest point. It lies between the Sea of Okhotsk to the west, and the Pacific and Bering Sea to the east. Two parallel chains of mountains run along the peninsula, with the Kamchatka river valley taking up most of the space in between. Reaching heights of 2,000 m (6,562 feet), the western or central chain is dominated by extinct volcanoes. The eastern chain merges with the volcanic plateaus with their active volcanoes. In contrast to the marshes of the west coast, the landscape of the east coast is characterized by steep cliffs and deciduous forests cover the lower regions. The world heritage site boasts many primeval, endemic plants, while Kluchevskoy Nature Park is home

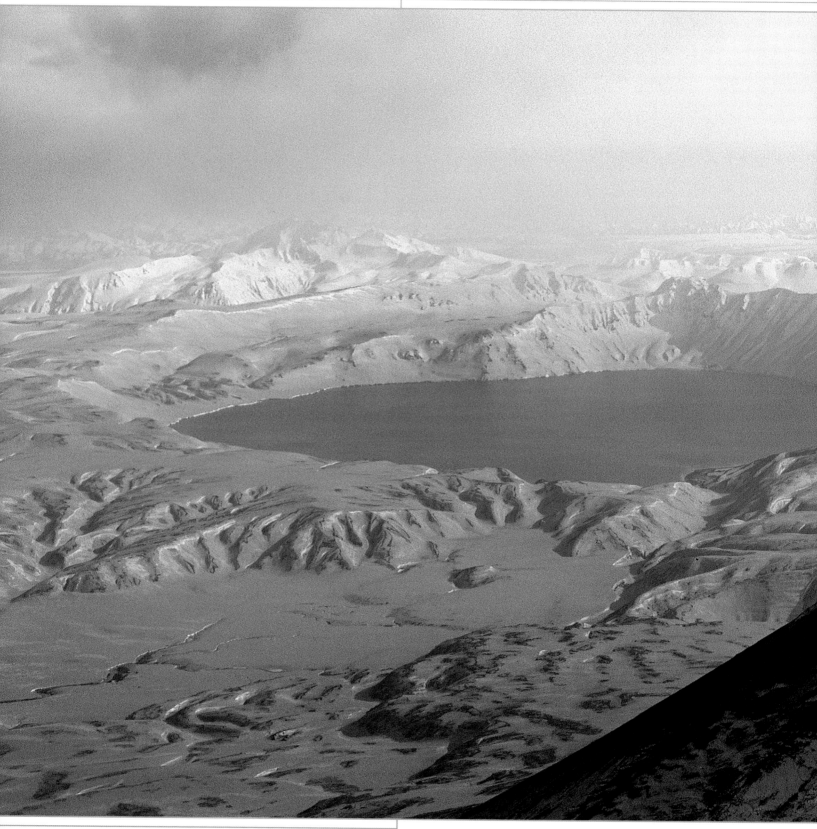

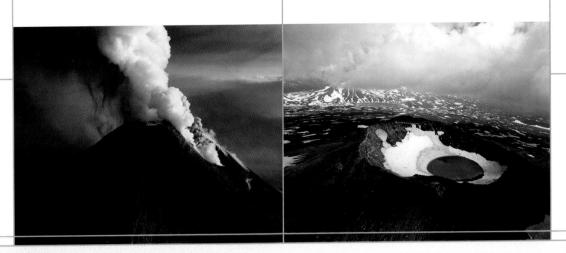

to large populations of sea lions, sea otters, and brown bears. The peninsula is also the location of the world's largest variety of salmonoid fish.

The view across the Kamchatka peninsula is a seemingly endless series of volcanoes. Many – like the Karymsky (large image and small image, right) or Kronotsky (small image, far right) – are still active.

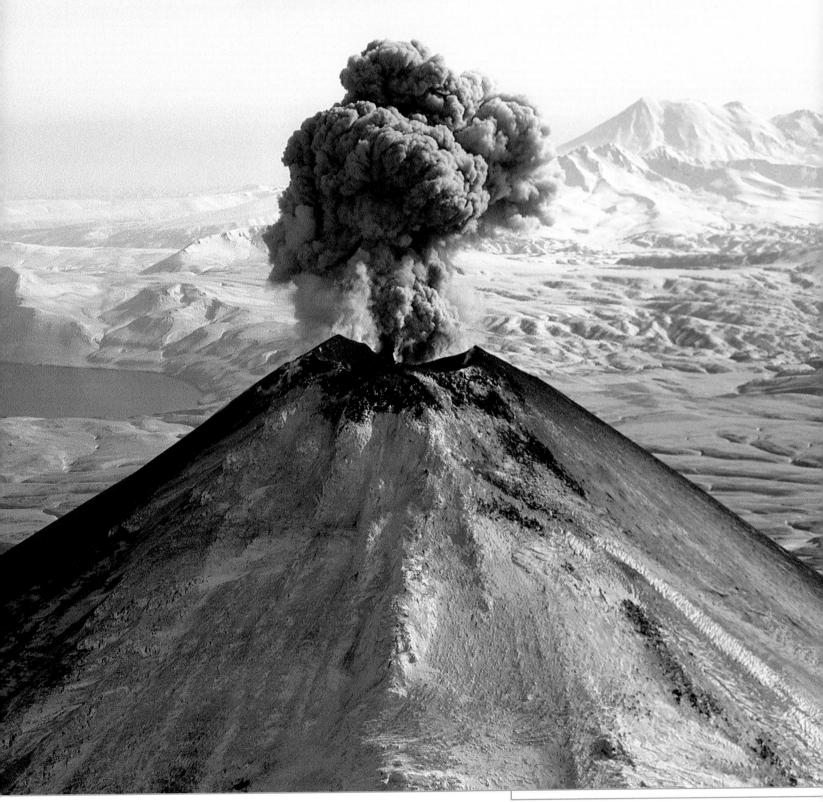

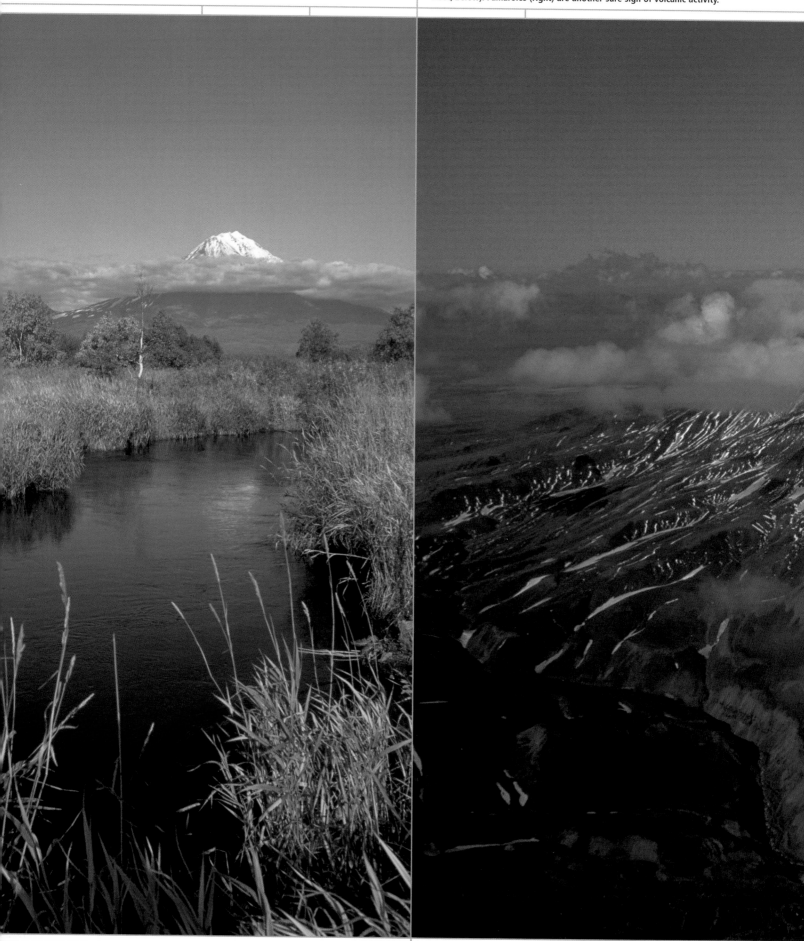

THE VOLCANOES
OF KAMCHATKA

Kamchatka lies within a geological subduction zone, where the Pacific plate slides below the Eurasian plate. As a result, numerous strato-volcanoes like Avanchinsky (below) have been created. They form part of the so-called Pacific Ring of Fire, and erupt regularly. Some of the volcano craters, meanwhile, have seen the formation of acidic lakes (image inset, below). Fumaroles (right) are another sure sign of volcanic activity.

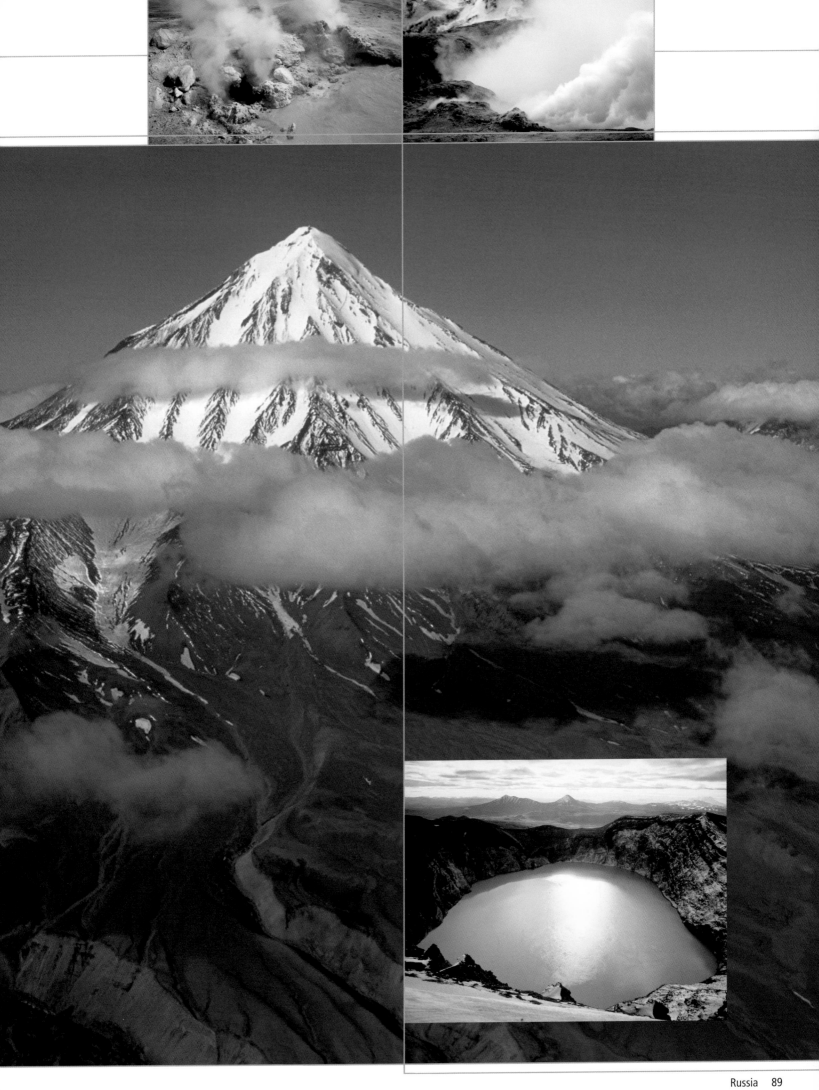

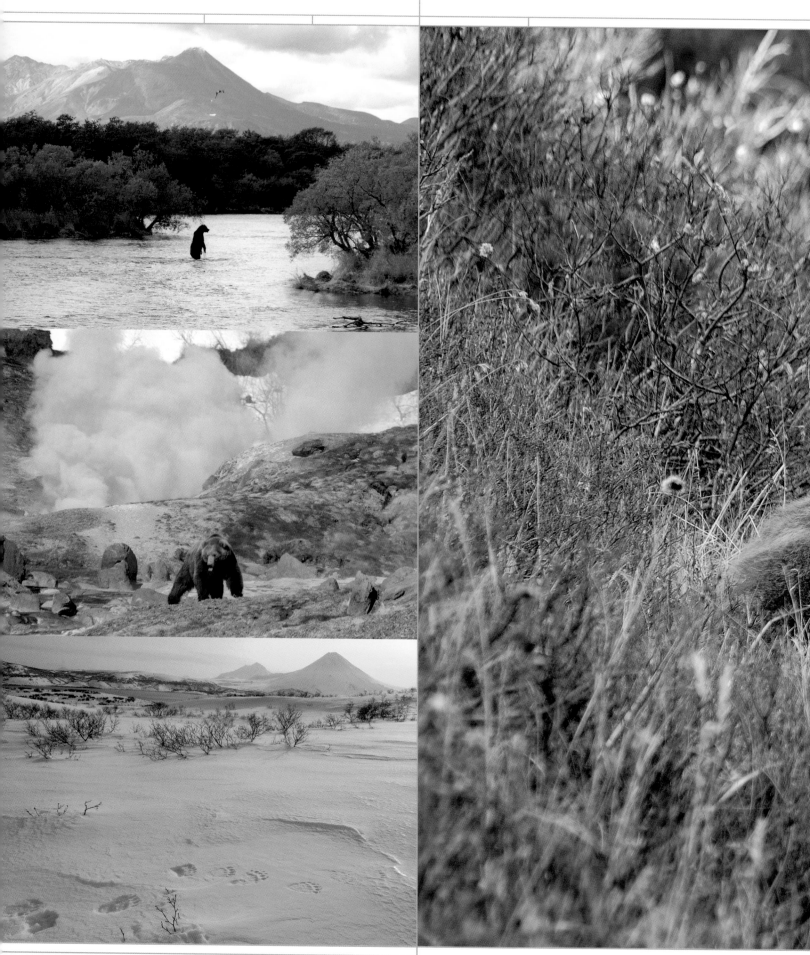

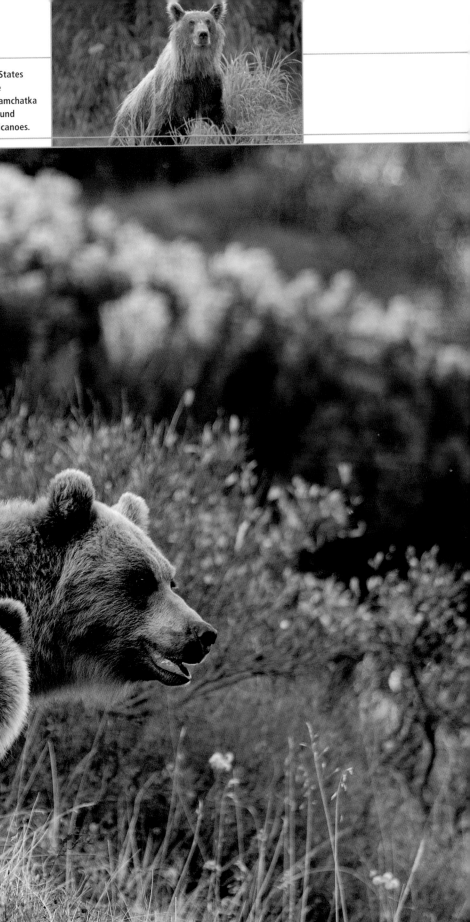

Until the end of the Cold War in 1990, Kamchatka's proximity to the United States made it a no-go area, and the peninsula's animals were therefore left to live relatively undisturbed. The most impressive of Kamchatka's animals is the Kamchatka bear (*Ursus arctos beringianus*), a subspecies of the brown bear. It can be found hunting for salmon and foraging for berries in the shadow of the nearby volcanoes.

GÖREME NATIONAL PARK AND THE ROCK SITES OF CAPPADOCIA

With its steep cliff faces and pyramid-like tuff formations, the Göreme valley, Cappadocia, is a truly fantastic landscape. Hundreds of chapels dating back to the Byzantine period are hewn into the rock. They are decorated with wall paintings from the period.

Date of inscription: 1985

The tuff formations of Nevşehir Province (Cappadocia) were created on top of the existing rocks as a result of volcanic activity, and shaped into their current forms by varying degrees of erosion. Some have become stone pillars, while others resemble mushrooms and pyramids. Together, the rocks form a quite incredible landscape. The Christian population of the Byzantine provinces of Asia Minor once sought refuge from Arab persecution here, building domestic accommodation, monks' cells, and chapels into the soft tuff. From the 6th century, complete cave villages and underground cities became established in the Göreme valley and surrounding area. They were at their most vibrant in the 7th century, when several hundred thousand

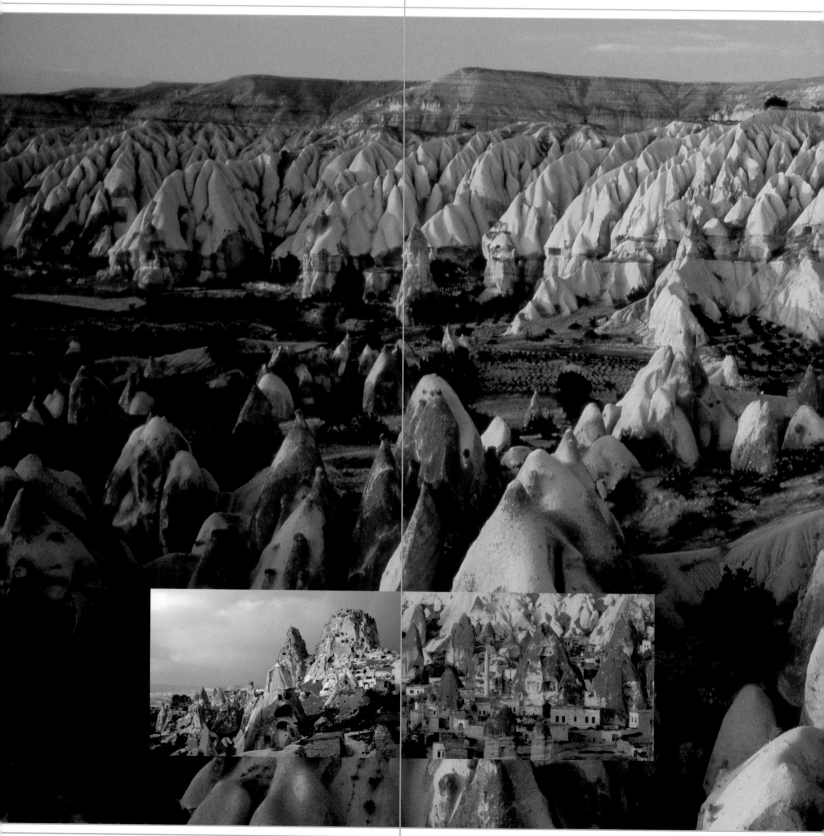

people are believed to have been living in this subterranean sanctuary.

The World Heritage Site encompasses both the historic rocks and the cave buildings. These include numerous monasteries and churches, whose construction draws upon several Byzantine styles of the period. The first figurative motifs in the church paintings date from the 9th century.

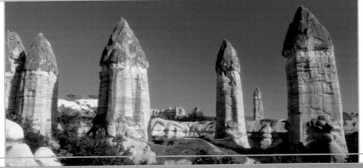

The Cappadocian landscape is characterized by its weird and wonderful tuff formations, into which numerous cave dwellings and churches were built. These rocky pillars (small image, left) are known as "fairy chimneys," and are sheltered by their "caps," which are made of harder stone.

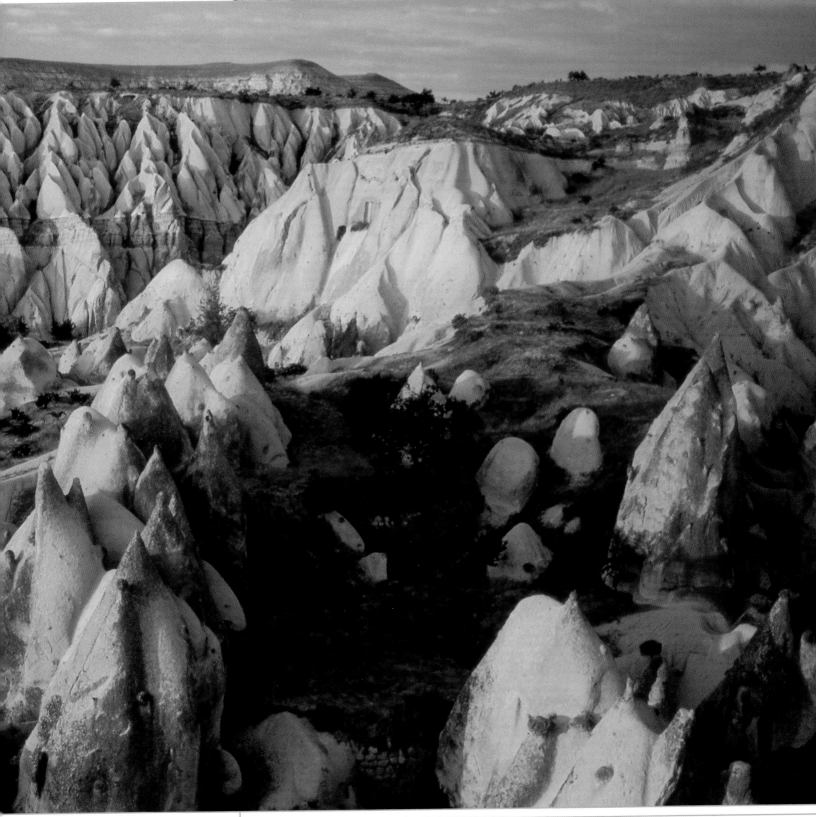

THE ANCIENT CITY OF HIERAPOLIS-PAMUKKALE

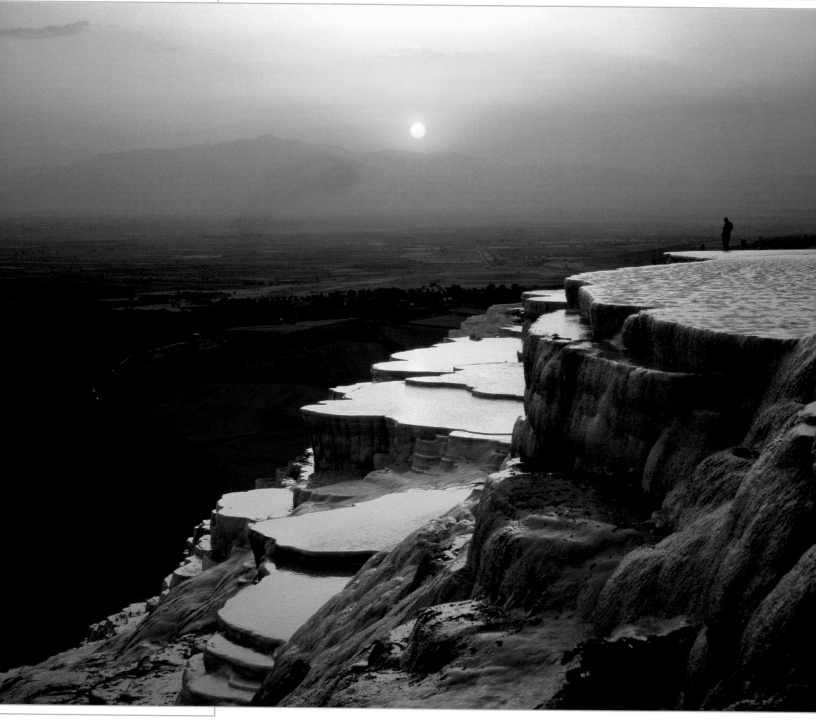

Alongside its famous calc-sinter terraces, the World Heritage Site of Pamukkale (the former Hierapolis) also boasts numerous baths, temples, and other monuments dating back to the Hellenistic and Roman periods.

Date of inscription: 1988

The area around the hot springs of Pamukkale was first settled in early times, becoming part of the Roman province of Asia in the 2nd century BC. The city of Hierapolis itself was built in 190 BC by order of King Eumenes II of Pergamon. Though essentially envisaged as a fortification, Hierapolis had its own baths right from the start. Residential buildings, temples, some early Christian churches, and other structures all sprang up around the baths, and the remains of these buildings can still be seen today.

The last of Pamukkale's ancient buildings date from the 4th century. Alongside the ruins, the area is also the scene of an extraordinary natural spectacle. About 100 m (330 feet) up Mount Çökelez, the hot springs emerge from a ledge protruding out of the rock face and flow down into the valley below. Over time, deposits of the mineral-rich water (sinter) formed petrified waterfalls, forests of limestone stalactites, and terraced basins. The overall effect is really quite otherworldly.

Pamukkale means "cotton castle" or "cotton wool castle," and the name is a good description of the fantastic natural landscape created by the deposits of limestone sinter from the area's hot springs. The warm water spills from one limestone basin into the next, creating weird and wonderful formations between the terraces. The ruins of some of Hierapolis's buildings lie right on the travertine plateau, close to the petrified waterfalls (small image, above).

THE SOCOTRA ARCHIPELAGO

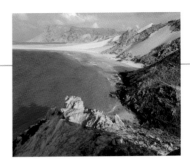

The 250-km (155-mile) long Socotra Archipelago, with its four main islands of Socotra, Abd al-Kuri, Samha, and Darsa, lies just off the Horn of Africa. The islands' importance resides in their great biological diversity and numerous endemic species of plants and animals.

Date of inscription: 2008

The abundance of incense ingredients, myrrh, and aloe, combined with its strategic position at the exit to the Gulf of Aden has made Socotra a destination for seafarers since the time of the Egyptian pharaohs. Nonetheless, the islands remained largely unknown to Europeans into the late 19th century, and scientific study on Socotra only began as Yemen opened up politically in the 1990s.

Socotra, the main island in the archipelago, has an area of 3,626 sq. km (1,400 sq. miles) and rises to 1,503 m (4,931 feet) above sea level. Geologically, it is a continuation of the Horn of Africa, but since there has been no land connection for some 15 million years, the isolation of its location has allowed unique plant and animal life to evolve; there are no mammals at all, and 90% of the island's reptiles are endemic. The world beneath the waves is also extremely varied – the island's reefs are home to 250 species of coral, 730 coastal fish, and 300 kinds of crab, lobster, and shrimp. Although Socotra is primarily an arid high plain, the vegetation is varied, and of more than 800 species of plant, over a third are endemic, amongst which is the dragon tree species *Dracaena cinnabari*, which can grow to a height of 8 m (27 feet). It is a stunning sight when fully grown. The desert rose is equally unusual.

Dracaena cinnabari (large image), the dragon tree, which is endemic to Socotra (above: Qalansiya Bay), exudes a natural resin once known as "dragon's blood." It was used as an ingredient in incense, natural remedies, embalming mixtures, and varnishes. The desert rose, *Adenium obesum socotranum*, is also endemic (inset images below left and right).

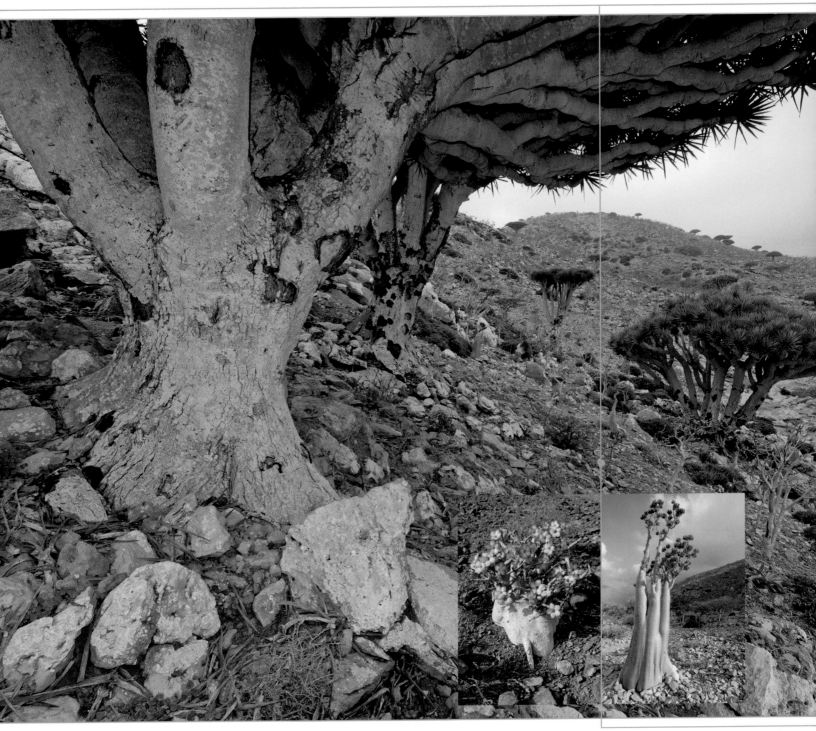

The World Heritage Site includes the State Nature Reserves of Naurzum and Korgalzhyn, with a combined total area of 4,500 sq. km (1,700 sq. miles), as well as a large area of central Asian steppe. The wetlands of the nature reserves are of great significance for many migratory birds, and the steppes are home to many rare species of bird and the endangered saiga antelope.

Date of inscription: 2008

The Kazakh Uplands (Saryarka) are located in the eastern and central areas of Kazakhstan, mostly at an elevation of 300 to 500 m (990 to 1,640 feet), although the land can rise to about 1,000 m (3,280 feet) in the east. The Aksoran is the highest peak in the region at 1,565 m (5,135 feet). The landscape to the north is characterized by grass steppe, and to the south by stony semi-arid desert. The wetlands of Naurzum and Korgalzhyn are important staging-posts for migratory birds travelling from Africa, Europe, and South Asia to their breeding grounds in Western and Eastern Siberia. Many of these birds are endangered species or are very rare,

such as the Siberian crane, the Dalmatian pelican, and Pallas' sea eagle. The area around Lake Tengiz and Korgalzhyn's other lakes sustains a total of some 16 million waterfowl, with around 350,000 birds nesting annually here, and a further 500,000 around Naurzum's lakes. The wetlands' seasonal hydrological, chemical, and biological processes, brought about as climatic conditions alternate between wet and dry, are of great interest to scientists. The steppe areas of the World Heritage Site are home to more than half the country's native species of steppe plants, and even the rare saiga antelope has found a refuge here.

In the spring, many flowers (large image) brighten the Saryarka steppe (inset left: an iris). The highly endangered saiga antelope, with its trunk-like nose (inset right) is to be found on the steppe. The region's wetlands (above) are a resting-place for the Siberian crane, also known as the Siberian white crane or the snow crane, which is threatened with extinction (inset middle).

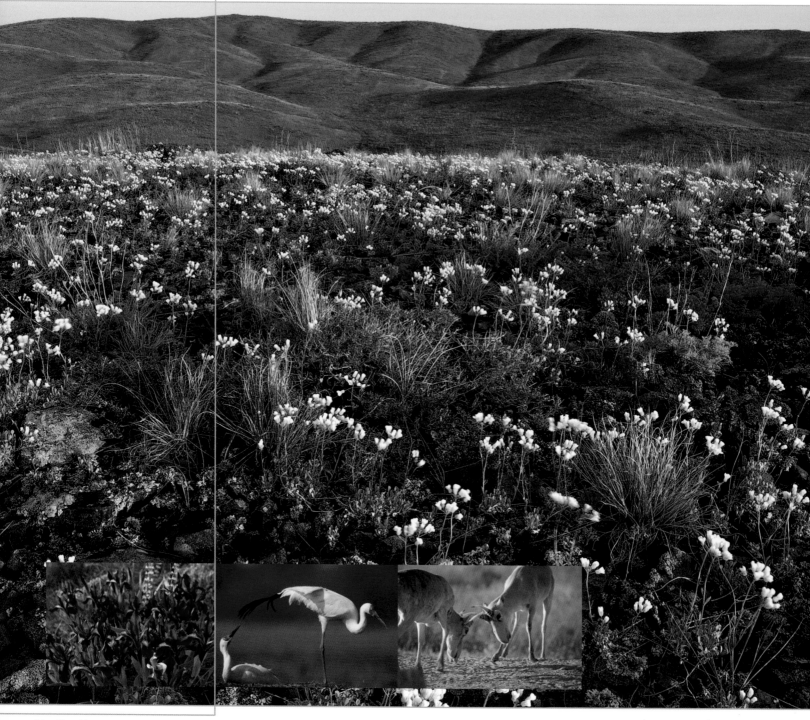

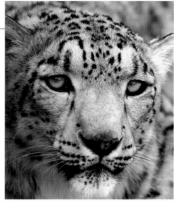

Reaching an altitude of 7,816 m (25,643 feet), the Nanda Devi mountain lies on the border of Nepal and China. The surrounding area is an important sanctuary for numerous endangered plants and animals.

Date of inscription: 1988
Extended: 2005

These days, no part of the world is beyond the reach of mass tourism, and – despite being almost inaccessible – the mountains around Nanda Devi are no exception. Even deep in the Himalayas, protected areas have played an important part in the preservation of the natural environment. Established in 1980, the national park around India's second highest mountain is home to snow leopards, musk deer, and large herds of blue sheep (bharal) and goat antelope (goral). The Valley of Flowers National Park lies alongside Nanda Devi. It is famed for its meadows and endemic species of wild flower, notably the Himalayan maple (*Acer caesium*), the blue poppy (*Meconopsis aculeate*), and a type of saussurea (*Saussurea atkinsoni*). The landscape of the valley is multifaceted. Though only a short distance from the inhospitable environment of the Upper Himalayas, the valley is home to several rare animals, such as the Asiatic black bear.

Both the valley and Mount Nanda Devi – whose name means "goddess of joy" – play significant roles in Hindu mythology.

At a height of 7,434 m (24,390 feet), the eastern summit of Nanda Devi is shrouded in cloud, but on the lower slopes many different species of flowers thrive, including varieties of poppy and geranium (inset below, left and right). The Nanda Devi National Park provides a safe home for blue sheep (large image), as well as their beautiful predator, the now rare snow leopard (above).

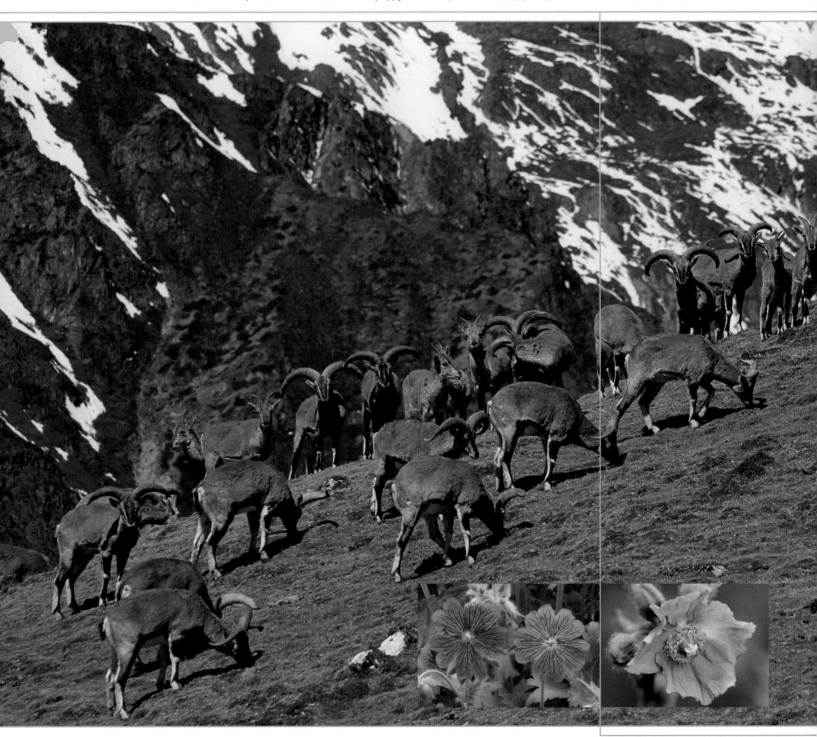

KEOLADEO NATIONAL PARK

Set in the marshes of Rajasthan, Keoladeo is an ornithological paradise. The bird population is at its highest after the monsoon, when the local waterfowl are joined by large numbers of migratory birds – some of them rare species.

Date of inscription: 1985

The national park's wetland landscape is man-made. It was formerly the hunting ground of the maharajas of Bharatpur, and the marshy natural depression provided plentiful bounty for duck hunters. In fact, a single day's hunting frequently yielded several thousand birds.

In the 19th century, the maharajas expanded the hunting waters through the construction of artificial canals and dams. In the middle of an otherwise extremely dry terrain, the maharajas had created what would later become a popular breeding ground for birds.

Today, the protected area is a permanent home to some 120 species of bird, including one of the world's largest heron colonies. In winter,

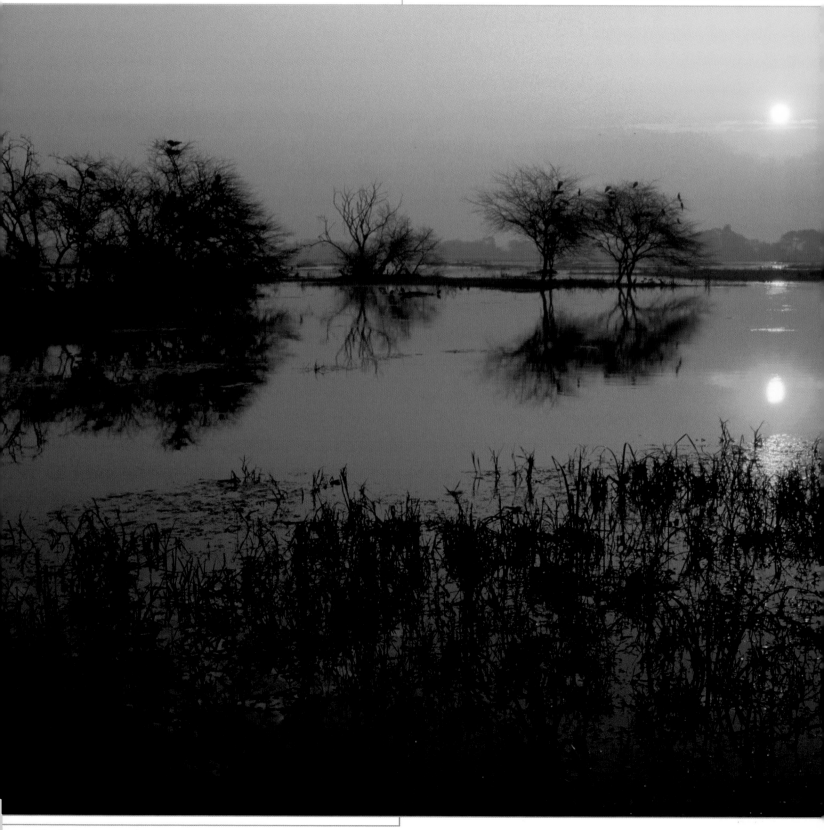

around 240 different species of migratory birds also settle here, among them the rare Siberian crane (or snow crane) and the falcated duck. The Siberian crane has always been one of the park's biggest attractions. Back in 1976, more than a hundred Siberian cranes spent the winter here, but the bird is now feared to have become extinct.

The artificial wetlands of Keoladeo National Park cover an area of less than 30 sq. km (12 sq. miles). Despite its small size, the park is a sanctuary for many endangered animals. These include the rhesus macaque (below right) and the Indian python. The latter can grow up to 7 m long (23 feet) and is an extremely good swimmer (small image, left).

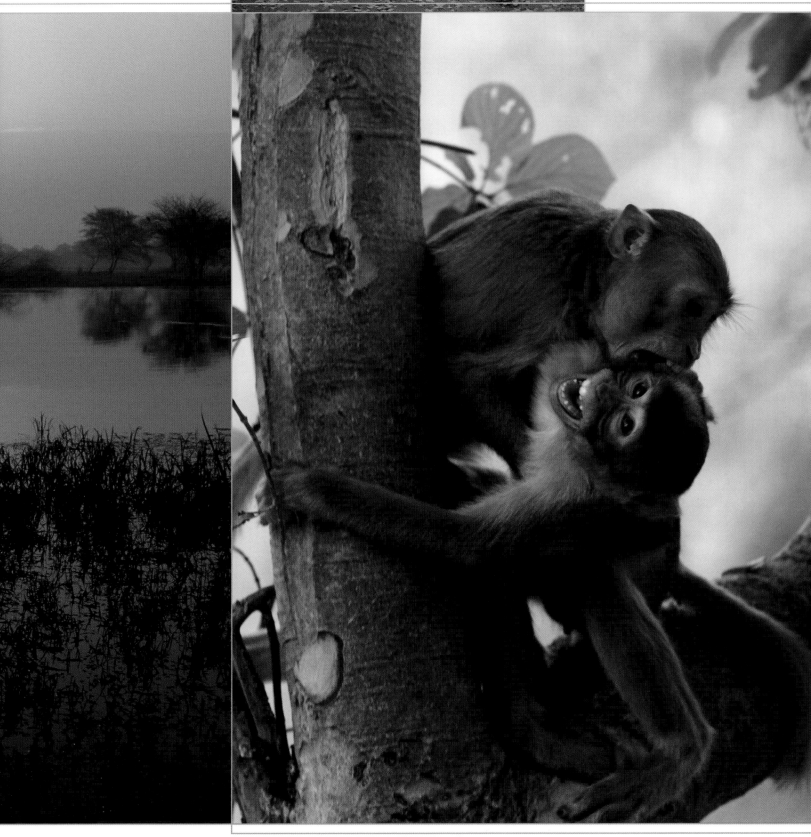

A diverse range of birds have made Keoladeo National Park their home. Pictured (below, clockwise from top left): the paradise crane (or demoiselle crane), rose-ringed parakeet (or Alexandrine parakeet), Indian roller, kingfisher, spotted owlet, purple heron, white-rumped vulture, and another kingfisher.

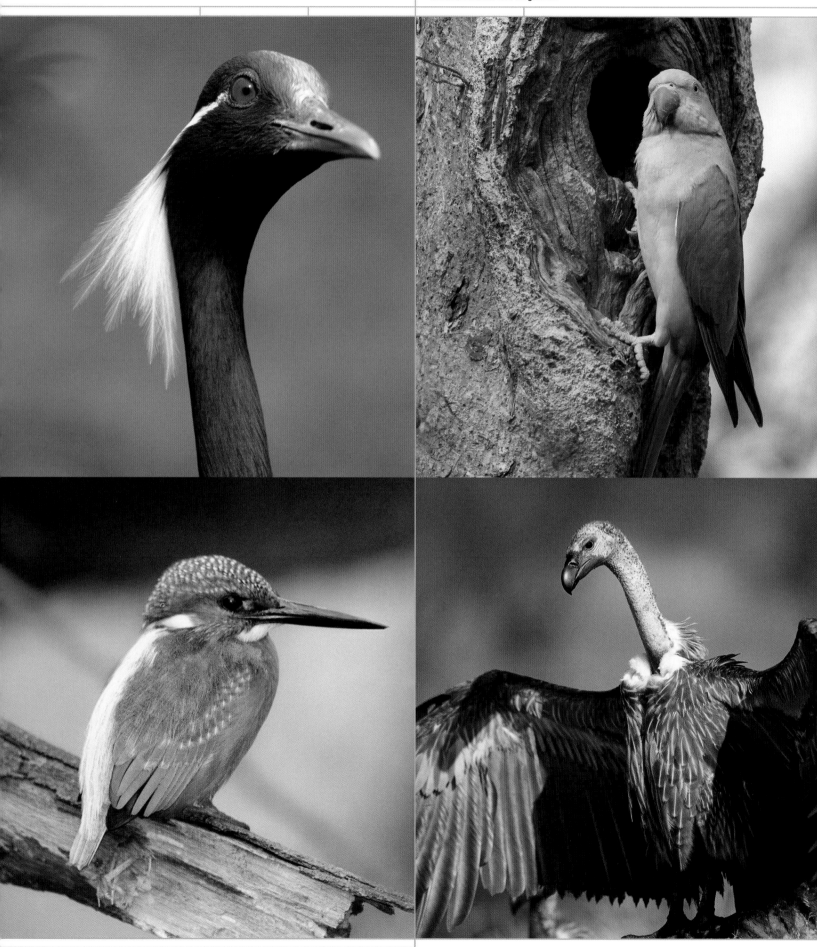

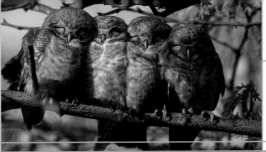

A group of spotted owlets (*Athene brama*) huddle together on a branch (small image, left). This particular type of owl is found from southern Iran to Indochina. Measuring just 20 cm (8 inches) or so, and weighing around 100 g (3.5 ounces), they are hunted by larger birds and other predators. The owl's own prey are primarily moths, beetles, and small rodents and birds.

Gentle, strong, and intelligent

For Hindus, elephants are sacred. The god Ganesha is depicted with an elephant head atop his human body, with its bulging stomach and four arms. Revered as a learned and educated protector, capable of overcoming all obstacles, Ganesha's character also exhibits traits typically associated with elephants. Measuring up to 3 m (9 feet) tall, and weighing as much as 5 metric tons (11,000 lb), the Asian elephant – of which the Indian elephant is a subspecies – is indeed a gentle, but nonetheless formidable pachyderm. Humans have been harnessing the elephant's strength, skilfulness, and intelligence for centuries – whether to transport goods, clear forests, provide a good vantage point for hunting tigers, or entertain the crowds at the circus.

The Hindu deity Ganesha, complete with elephant head.

Elephants use their trunks to breathe, smell, suck, spray, taste, pick things up, strike out, and trumpet. While the tip of an African elephant's trunk has two fingers, an Asian elephant's trunk has only one. Consequently, Asian elephants are far more adept at using their trunks than are their African cousins. With its double-domed forehead, smaller ears, and shorter tusks, *Elephas maxima* also seems less ferocious than *Loxodonta africana*. The elephant's famed memory, meanwhile, is common to both the African and Asian elephant. Whether the memories are good or bad, elephants never forget.

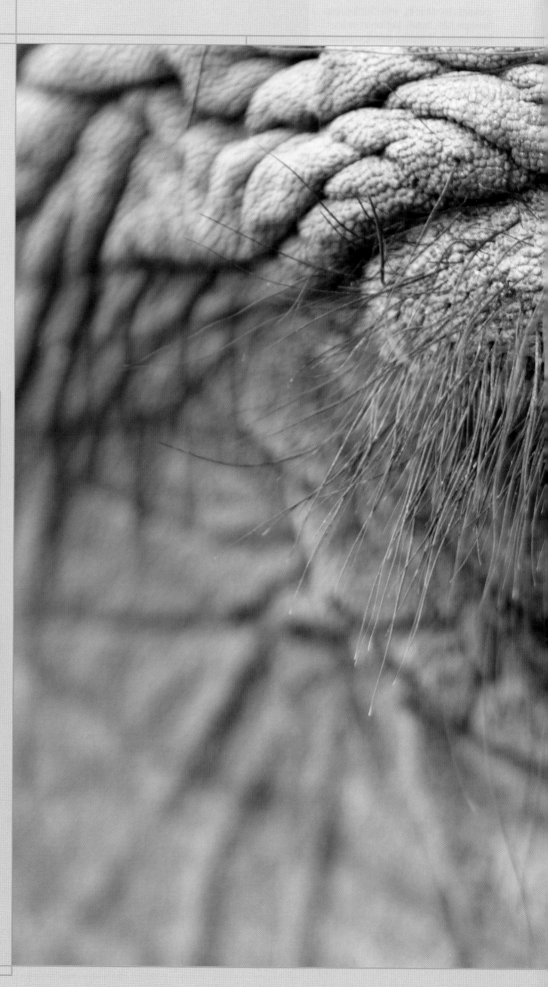

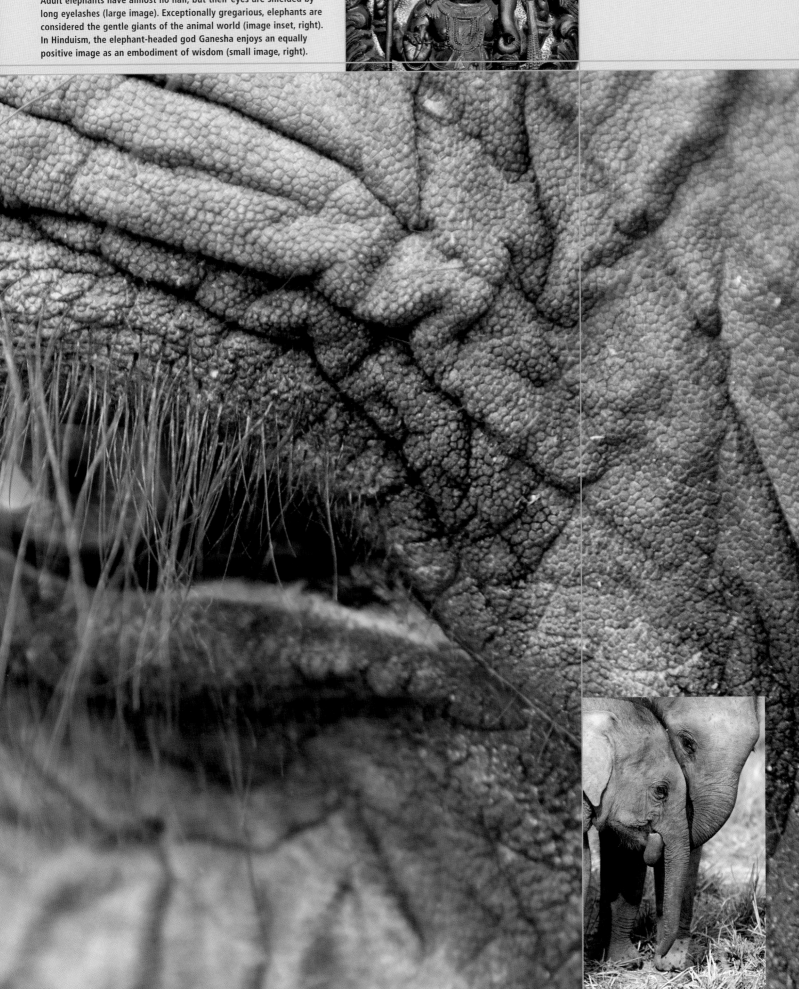

Adult elephants have almost no hair, but their eyes are shielded by long eyelashes (large image). Exceptionally gregarious, elephants are considered the gentle giants of the animal world (image inset, right). In Hinduism, the elephant-headed god Ganesha enjoys an equally positive image as an embodiment of wisdom (small image, right).

KAZIRANGA NATIONAL PARK

Set over 430 sq. km (166 sq. miles) in the heart of Assam, Kaziranga National Park is one of the region's last examples of an area untouched by human intervention. Rare animals found here include the world's largest population of the endangered one-horned rhinoceros.

Date of inscription: 1985

Conditions in Kaziranga National Park are closely linked to the heady fluctuations of the Brahmaputra river. During the monsoon season in July and August, two thirds of the park is regularly under water, forcing Kaziranga's animals to retreat to higher ground both within and outside the park.
Local conservationists have traditionally focused their attention on the fate of the one-horned rhino. At the beginning of the 20th century, the animal's population was already depleted enough to require prohibition of the issuing of hunting warrants. The region was declared a nature reserve in 1908, becoming a wildlife sanctuary in 1950, and a national park in 1974. Today, the number of one-horned rhino here is estimated to be around 1,500, and

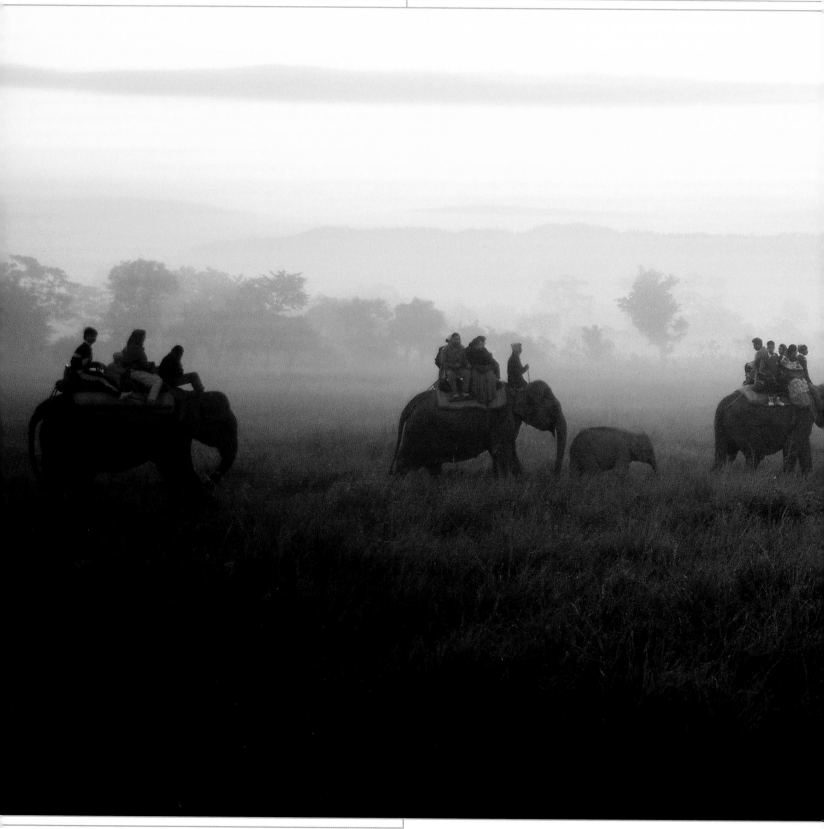

some of the park's animals were recently moved to the nearby Manas wildlife sanctuary in a bid to boost the rhino population there as well.

But rhinos are not the only animals in Kaziranga. The park boasts good numbers of elephants and buffalo, and several species of deer. There are also gibbons, tigers, wild boar, and rare birds like the bearded bustard and grey pelican, as well as Asian black bears and sloth bears.

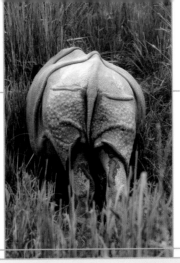

Kaziranga National Park, Assam, is truly a natural paradise. Traversing the grasslands, the park's one-horned rhinos (*Rhinoceros unicornis*) are its main attraction (small image, right), and an elephant ride is the best way to see them (large image).

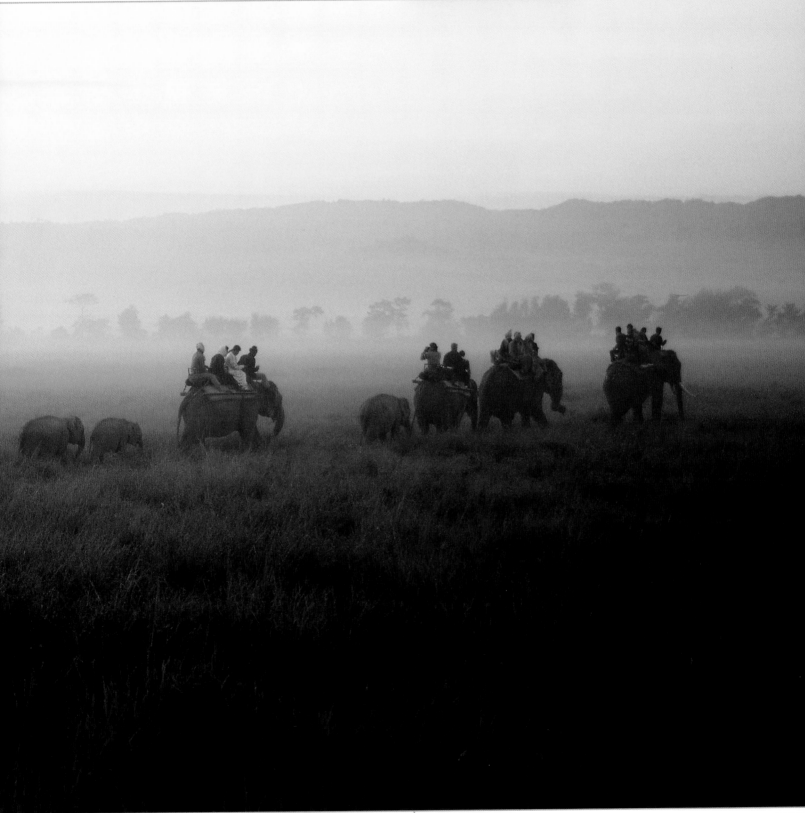

Rare and endangered

Stone age cave paintings prove that rhinoceroses were once common across the savannahs and grasslands of Eurasia. Those days are definitely over. Today, only five species of rhinoceros remain, three of them – including the Indian one-horned rhino – found in Asia. Even here, rhinoceros "populations" are barely large enough to merit the word, with only around 2,500 animals left on the entire Indian subcontinent. Some of the largest concentrations of rhinoceroses can be made up of less than a hundred animals, and examples of groups this big are limited to a small number of protected areas in India and Nepal.

The one-horned rhino measures up to 4 m (13 feet) long. Its body is covered with large folds of skin. Like the Javan rhinoceros, it has a single nasal horn, and this defining attribute is reflected in both its common and Latin names (*Rhinoceros unicornis*). It is the rhino's horn that explains the animal's inclu-

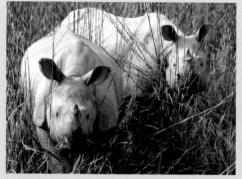

Young rhinos on the grasslands of the Indian savannah.

sion on the Red List of Threatened Species, since pulverized rhino horn has long been considered an aphrodisiac in traditional Chinese medicine. By the time that rhino hunting was brought to a halt at the beginning of the 20th century, the animal was already on the brink of extinction. Drainage of the one-horned rhino's preferred marshy habitat only added to its predicament.

The one-horned rhino is a solitary creature that needs to be given a lot of space. When rhino meets man, man can quickly find himself in danger – especially when a rhino mother is determined to protect her young. Ultimately, the combination of the rhino's size and weight with its agility, good hearing, and sense of smell ensure that it maintains the upper hand. The rhino's poor eyesight, meanwhile, means that anyone who fails to keep their distance can all too easily find themselves crushed beneath its heavy hooves.

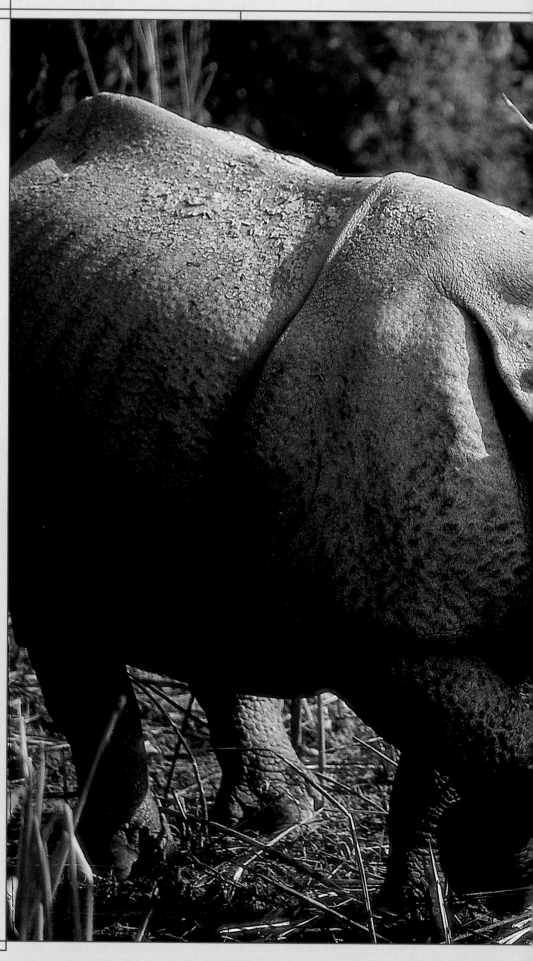

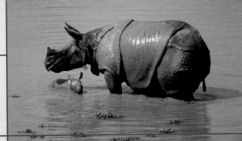

The Indian one-horned rhino (*Rhinoceros unicornis*) subspecies is some 10 million years old. It is most at home in grasslands and stagnant waters (small image, right) – a habitat whose size was dramatically reduced by drainage of the vast Indian wetlands in the 19th century.

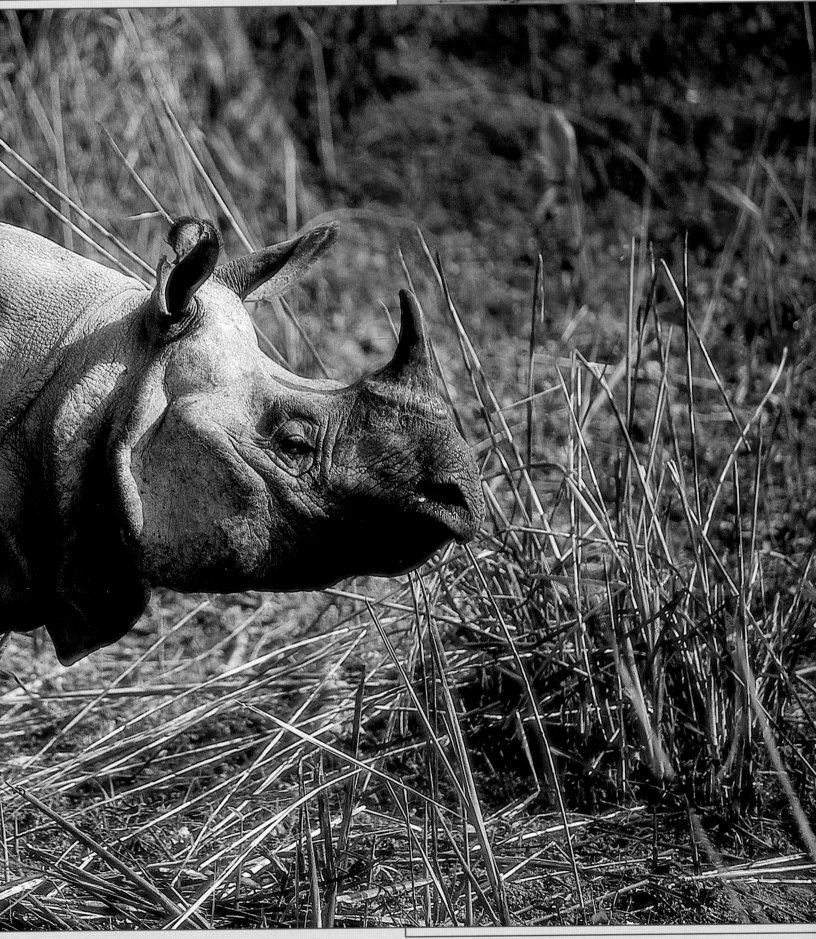

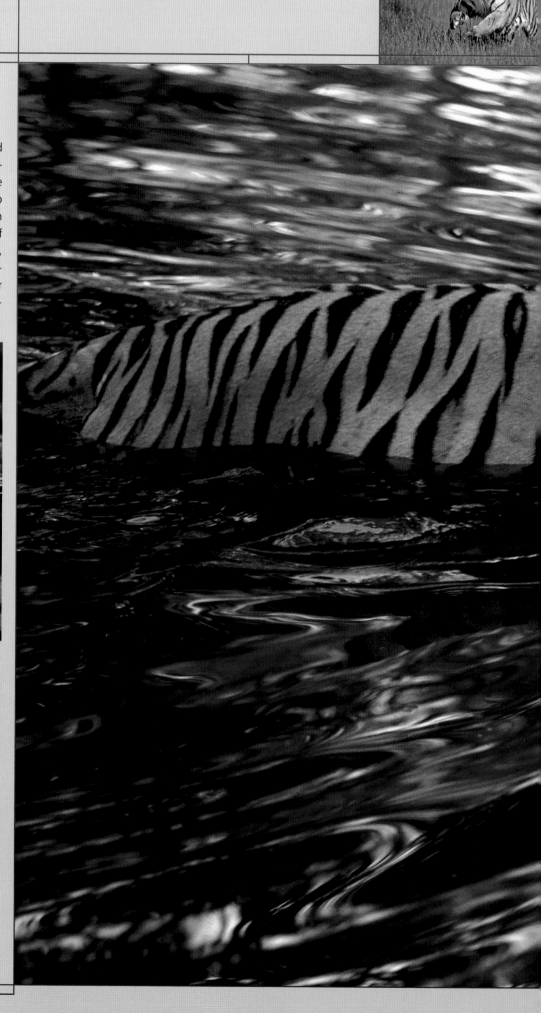

King of the jungle

The love of hunting shared by Indian maharajas and British officers, ordinary people's fear of the man-eating night-time predator, and above all the diminution of its natural habitat all conspired to bring the Bengal tiger to the brink of extinction in the 20th century. In 1972, just 1,800 examples of the *Panthera tigris tigris* remained. Since then, tough conservation measures – including the resettlement of entire villages – have seen the number of Bengal tigers in the wild rise again, with the population stabilizing at around 4,000–5,000 animals.

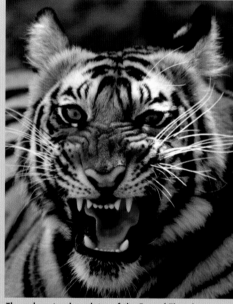

The only natural predator of the Bengal Tiger is man.

The Bengal tiger grows up to 2.8 m (9 feet) long (not including its tail), and weighs around 280 kg (617 lb). It consumes 8 kg (18 lb) of meat every day, and prowls an area of 65–200 sq. km (25–80 sq. miles) every night. As long as it has prey to hunt and space to roam, the Bengal tiger has learned to overcome otherwise difficult circumstances. The Bengal tiger's reddish-yellow fur with its greyish-brown and black stripes make it almost invisible in grass and undergrowth. It creeps up on its prey before pouncing. This powerful jump overcomes the tiger's victim in an instant, and the tiger then kills its prey with a bite to the throat or neck. Buffalo and wild boar are as likely to become the tiger's dinner as fish, frogs, and slow bipeds – it all depends on what the grasslands, marshes, and mountain, mangrove or tropical forests have to offer on any given day.

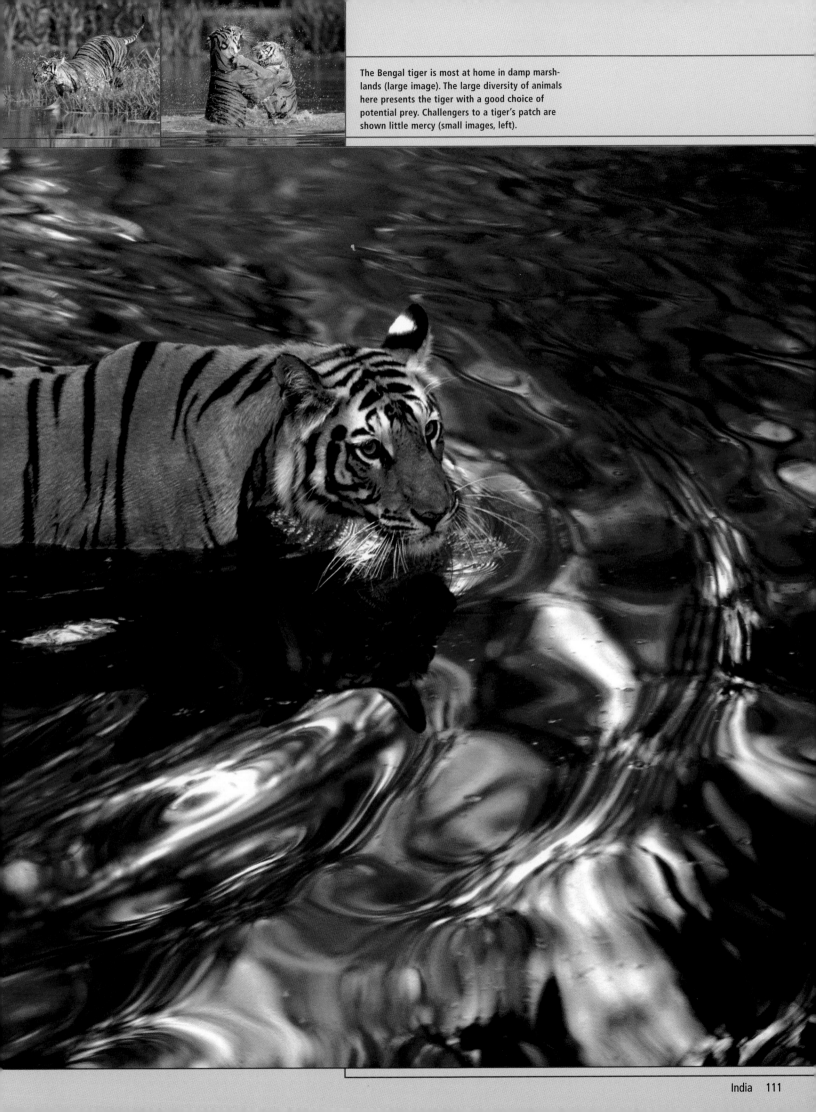

The Bengal tiger is most at home in damp marsh-lands (large image). The large diversity of animals here presents the tiger with a good choice of potential prey. Challengers to a tiger's patch are shown little mercy (small images, left).

The Sundarbans, the world's largest mangrove forests, lie in the delta of the Ganges, Brahmaputra, and Meghna rivers in the Bay of Bengal. These unique wetlands are shared between India and Bangladesh, and an area of each country has been declared a World Heritage Site.

Date of inscription: 1987

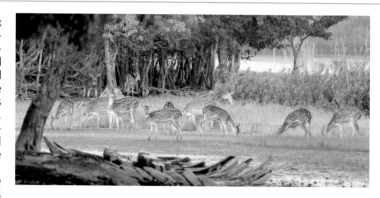

The Sundarbans are a highly complex system of rivers, channels, and marshlands. There is a 7.5 m (25 feet) difference between low and high tide, and the boundaries between land and water are constantly shifting. The Indian part of the Sundarbans covers more than half of the entire 10,000 sq. km (3,900 sq. mile) wetland area. Sundarbans National Park – the actual World Heritage Site – covers some 1,300 sq. km (500 sq. miles).

Fresh and saltwater zones come together here. The local ecosystem is characterized not only by its mangrove forests, but also by its rich fauna. Dolphins, otters, pythons, turtles, water monitors, crocodiles, storks, herons, cormorants, and curlews are all found here, not to mention chital and Barasingha deer, rhesus macaques, wild boar, and Bengal tigers.

Chital deer (small image) are related to the bigger fallow and red deer. In the Sundarbans mangrove forests, chital deer are found in large numbers (large image).

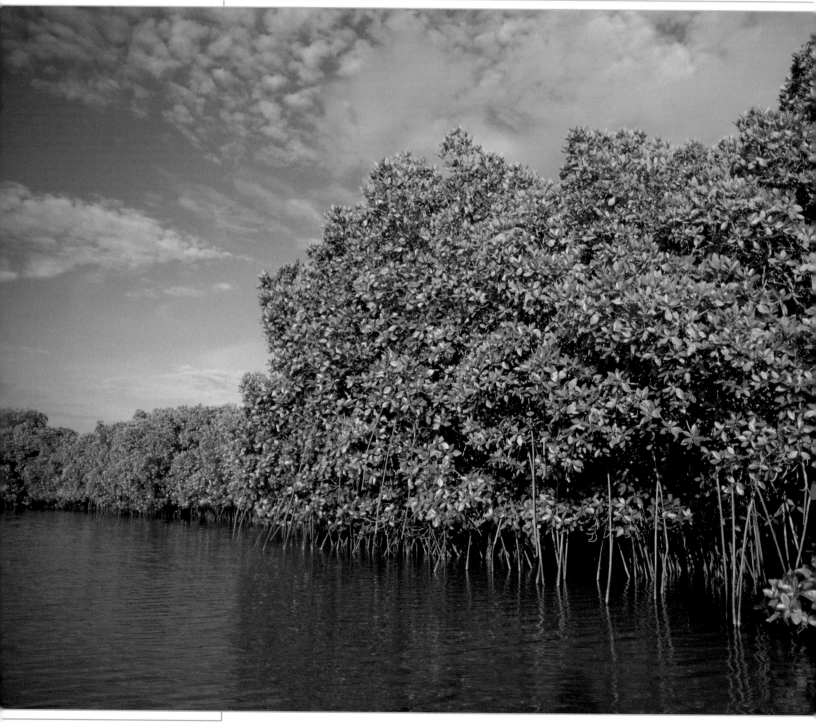

THE SUNDARBANS
MANGROVE FORESTS

Covering over 1,300 sq. km (500 sq. miles), the Sundarban Wildlife Sanctuaries comprise three separate protected areas that together form the World Heritage Site within the Bangladeshi part of the Sundarbans.

Date of inscription: 1997

Though the Sundarbans are divided between Indian and Bangladeshi territory, they are one complete ecosystem. The fact that the Sundarbans were inscribed as two adjacent but separate World Heritage Sites (as opposed to one transnational site) is simply a reflection of the political tension between the two countries.

Around a quarter of the Bangladeshi Sundarbans are protected. The Sundarbans West Wildlife Sanctuary adjoins the Indian World Heritage Site directly and lies east of the river Raimangal, which marks the border between the two countries. The South and East Sanctuaries complete the Bangladeshi World Heritage Site. As in the Indian

Sundarbans, heavy rainfall – up to 2,800 mm (110 inches) a year – and frequent flooding have created a transition zone of brackish and freshwater areas. Salt water dominates the western side of the site, meaning that the eastern part boasts the greater diversity of plant and animal life.

The site's flora and fauna also corresponds to that of the Indian Sundarbans. There are 27 types of mangrove, around 50 different mammals, 300 bird species, and 50 types of reptile. The Bengal tiger is the area's most spectacular animal, and over 350 of the animals live here – the world's largest single concentration of Bengal tigers.

But the Sundarbans are more than a

home for endangered plants and animals. They also form a kind of natural barrier that protects inland areas from tropical storms. However, the mangrove forests are themselves under threat. Climate change, the rising amount of salt in the freshwater areas, oil pollution, poaching, and illegal logging are all endangering this unique ecosystem.

The satellite image (below) shows the eastern part of the delta, including the Sundarbans. The dark green areas are the mangrove forests, while the light haze in the Bay of Bengal is caused by suspended sediment from the river tributaries.

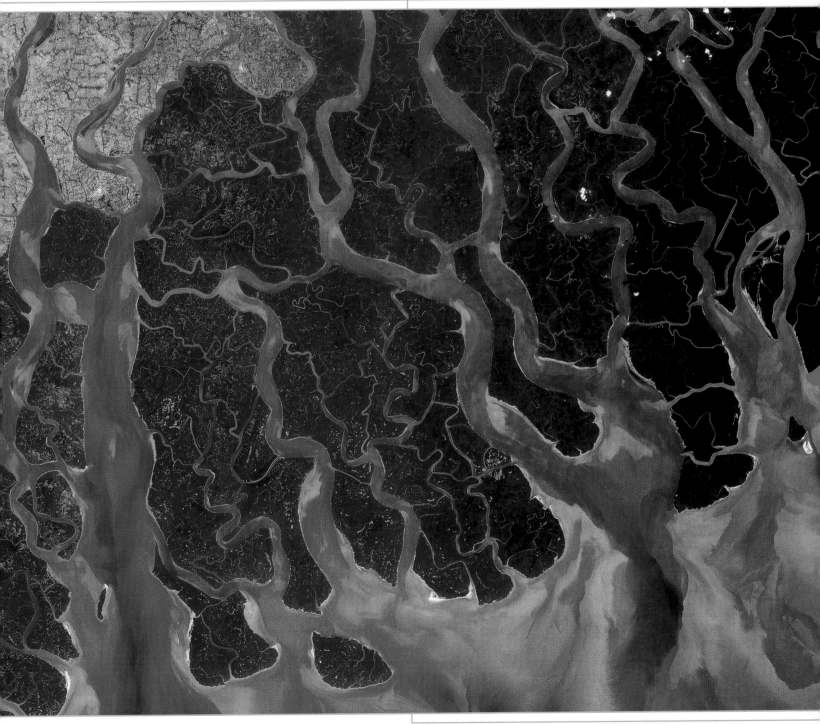

SINHARAJA FOREST RESERVE

At around 500–1,100 m (1,600–3,600 feet) above sea level, this hilly reserve is dominated by tropical rainforest. The protected area is rich in orchids and endemic species.

Date of inscription: 1988

Located in south-west Sri Lanka, the Sinharaja reserve is the island's last remaining area of primary rainforest. Sinharaja's name means "Lion King." The government declared the 85 sq. km (33 sq. mile) area between Ratnapura and Matara a biosphere reserve in a bid to protect it from excessive logging – an activity that had already damaged many of Sri Lanka's other forests. The very first nature reserve here in fact dates back to 1875, when the area was under British colonial rule.

There is a long history of human exploitation of the tropical rainforests for economic gain. The forests provided material for house building, and were a source of all manner of medicines and exotic spices. The rapid

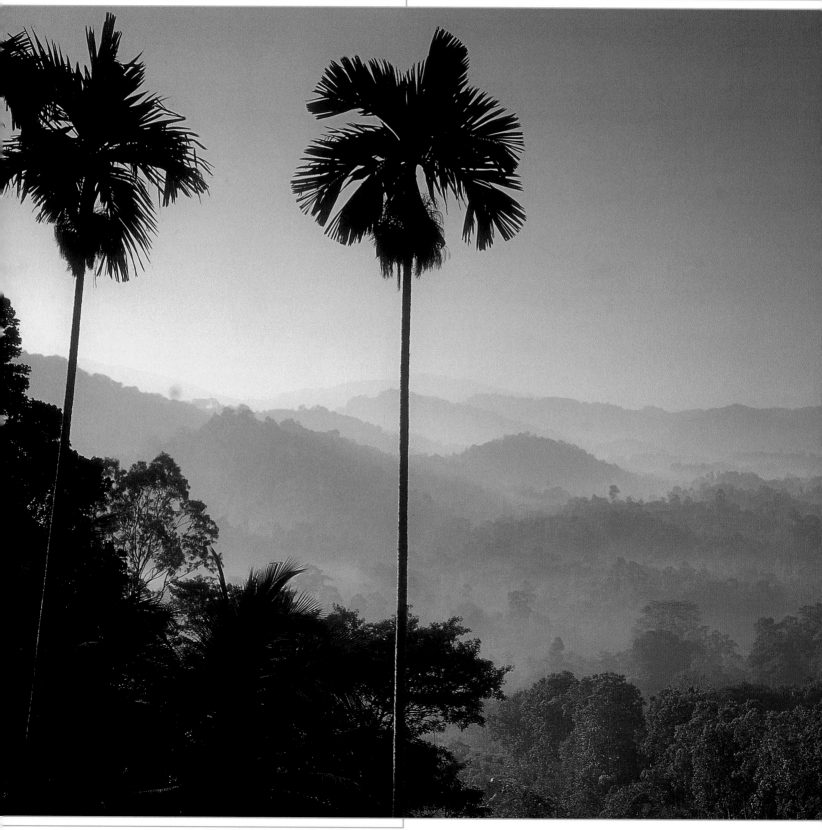

growth of the local population, however, means that this complicated ecosystem cannot survive any further large-scale human intervention unscathed. New laws have therefore been introduced to forbid all types of exploitation other than the collection of kittul fibers from the leaf sheath of the fishtail palm tree (*Caryota urens*). Nonetheless, illegal slash-and-burn activities and gem mining continue to cause serious damage.

Most of the forest's trees are rare, and around 60 percent are endemic — found only in Sri Lanka. The area's many orchid types further enhance its status as a natural treasure trove, and the primary rainforest is home to many rare animals, including various types of insects and amphibians.

The hills of Sinharaja are covered by a thick carpet of primary rainforest (large image). Water lilies (large image, right) and fishtail palms (small image, left) are two examples of the area's diverse flora.

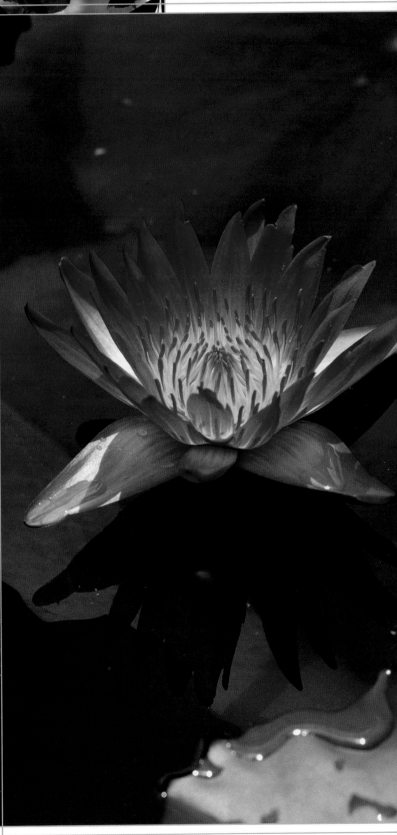

The mountains around Everest are not only a popular destination for trekkers, but also a showcase of the fascinating flora and fauna of the eastern Himalayas.

Date of inscription: 1979

The popularity of trekking created real environmental problems for the Himalayas, and it was to protect the ecological balance of Nepal – and above all the area around Mount Everest – that the site was declared a national park in 1976. The Nepalese call the world's highest mountain Sagarmatha, or "head of the sky," while the Tibetan name for Everest, Chomolungma, means "goddess mother of the world." Like Everest, Mounts Lhotse and Cho Oyu also rise above 8,000 m (26,250 feet), and with further peaks reaching altitudes as high as 7,000 m (23,000 feet), this is the highest mountainous region in the world. Mount Nuptse stands out less for its towering 7,879-m (25,850-foot) high summit than for its 3,000-m (9,850-foot) high south face, while at 20 km (12 miles) the Ngozumpa glacier is the longest glacier in Nepal.

For a short period in summer, the snow on the southern slopes of the giant mountains melts away, and varieties of carnations, gentians, and cruciferous plants bloom at heights of up to 6,000 m (19,700 feet) above sea level. Only extremely undemanding soil funghi can

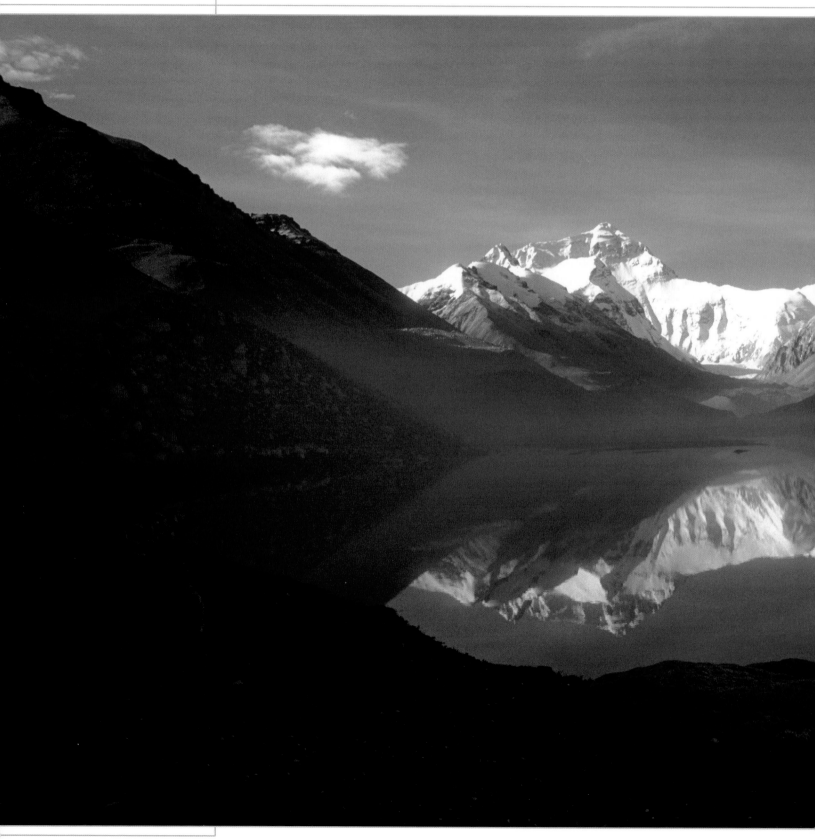

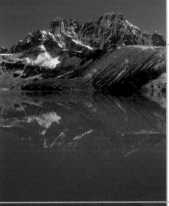

survive at higher altitudes, but in the lower regions mountain plants like edelweiss, Himalayan lilies, and other shrubs all flourish. The deciduous and coniferous forests are found at altitudes of up to 4,000 m (13,100 feet). Around 30 different mammal species live within the park. The Himalayan tahr, now no longer endangered, is most at home on the rocky terrain, as is the musk deer. The park is also home to the rare snow leopard, the Himalayan fox, Himalayan weasel, Himalayan black bear, wolf, and small panda, while majestic predatory birds like the golden eagle, bearded vulture, and griffon vulture are kings of the Himalayan skies. The yeti, however, is probably best consigned to the realm of fantasy.

This view of Gokyo lake (left) is typical of the breathtaking mountain vistas that greet visitors to Sagarmatha National Park. Most treks follow the southern route to the 8,850-m (29,000-foot) high summit of Mount Everest (below). The alternative northern route starts in China, reaching the summit via the Rongbuk valley.

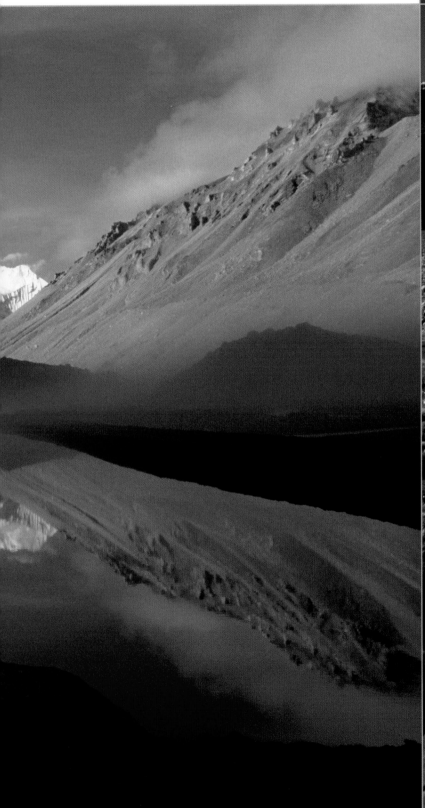

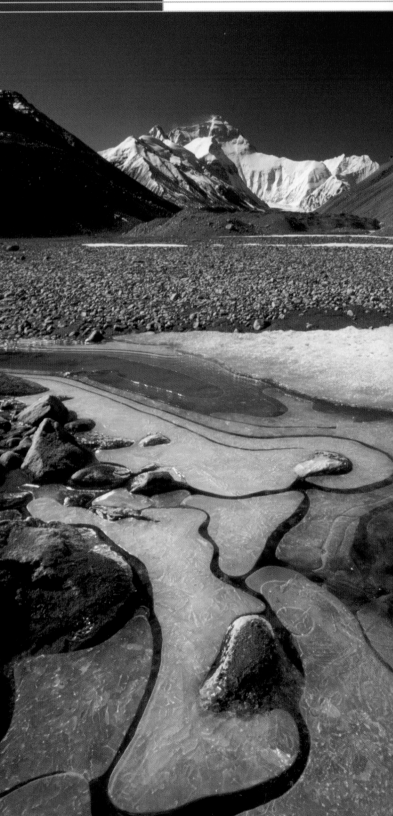

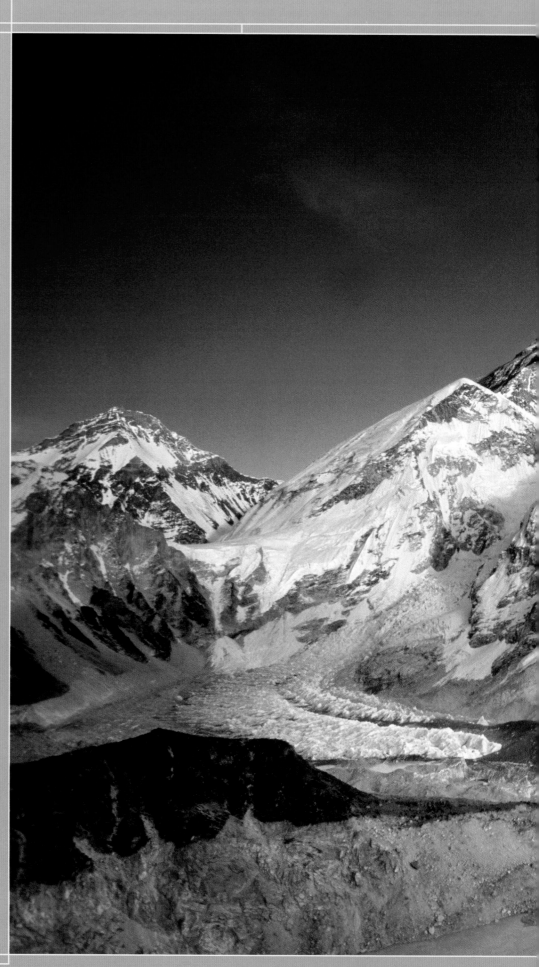

A landscape of sacred mountains

The high peaks of the Himalayas are simply awe-inspiring. To the native Sherpas of Khumbu Himal, both the mountains and the good and evil spirits that inhabit them have long been sacred. Fearful of disturbing the mountains, the Sherpas who act as guides for visitors still offer a sacrifice before they set out. The celestial tranquility that characterized the "roof of the world" for millions of years has not really existed since the 1950s, and it was the need to protect the area from the effects of mountain tourism that led to the creation of the Sagarmatha National Park in Khumbu Himal in 1976.

In the 19th century, British colonialists became the first Europeans to arrive here. In 1865, the world's highest mountain was duly named after the surveyor George Everest. Its 8,850-m (29,000-foot) high summit was first climbed by New Zealander Edmund Hillary and Sherpa Tenzing Norgay in 1953. Their achievement was a worldwide sensation, but today's adventurers need to have climbed all 14 of the

At the foot of Mount Everest, stupas containing written mantras and surrounded by prayer flags are a sign of respect to the mountain gods.

Himalaya's highest mountains – each over 8,000 m (26,250 feet) high – at least once in order to be newsworthy. At 8,201 m (26,906 feet), Cho Oyu is among the most climbed of the region's highest mountains. Its summit was first reached by a team of Austrian explorers in 1954. Cho Oyu is now popular for commercial climbing expeditions, largely because relatively few climbers have died in the attempt to reach the top. Mount Lhotse is another of the national park's highest mountains. Lying alongside the Everest massif, its 8,516-m (27,940-foot) high summit makes it the fourth highest mountain in the world. It was first climbed by a Swiss team in 1956.

Mount Everest (large image) was created by the collision of the Indian subcontinent and Eurasian plate some 50 million years ago. Tectonic movement continues to this day, causing the mountain to grow approximately 3 cm (1 inch) higher every year. The Rongpu monastery is located on Everest's north face (small image, left).

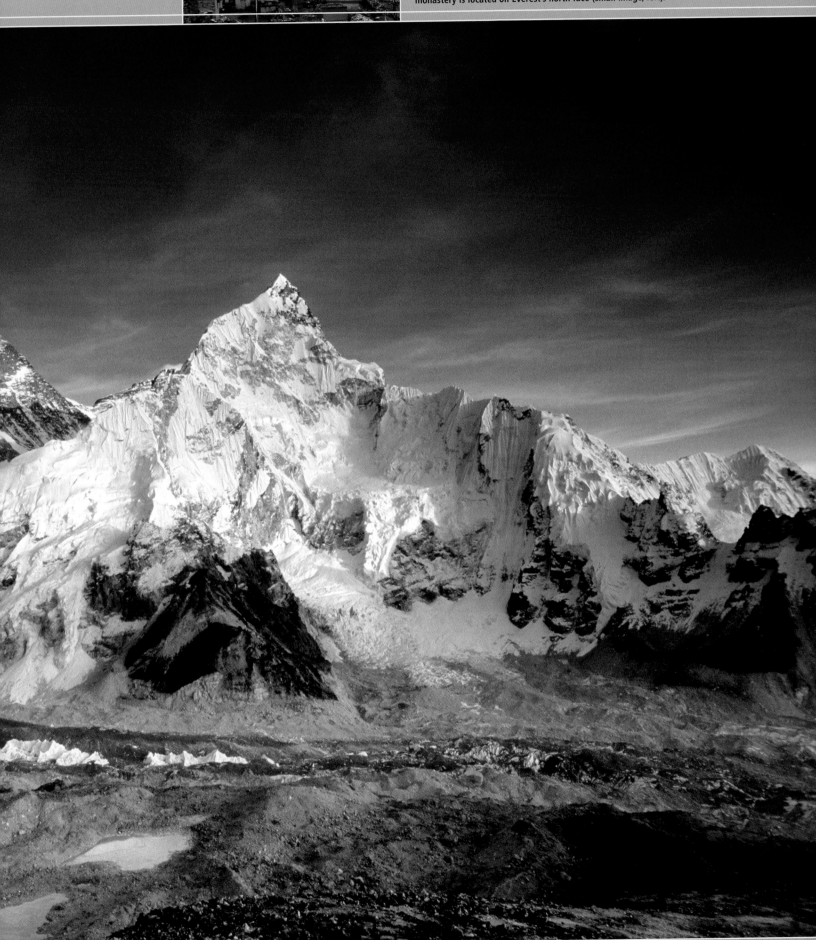

Nepal's oldest national park is dominated by sal forests and extensive areas of elephant grass. It is home to one-horned rhinoceroses and many other endangered animals.

Date of inscription: 1984

Chitwan National Park lies in southern-most Nepal. Visitors are sure to come across at least one of the roughly 400 resident one-horned rhinos; adults can eat 200 kg (441 pounds) of grass and drink 100 litres (26 gallons) of water a day. Around 200 leopards and 80 tigers also prowl the park's tall elephant grass, and although their protected status has failed to save them from the poachers, the once decimated population of these three species has none-theless quadrupled in recent times.

The origins of the park go back to the land that was designated as a pro-tected area by King Mahendra in 1962, in order to help save the one-horned rhino. This reserve was then made a national park in 1973. Some of its most common wildlife includes sambar and chital deer, four-horned antelopes, wild boar, sloth bear, wild bison (gaur), and rhesus macaques while langur monkeys swing through the treetops. At dusk, mongoose and honey badgers are out hunting, and at night the howl of the golden jackal resonates through the darkness.

Mugger crocodiles and gharials – famous for their striking, elongated

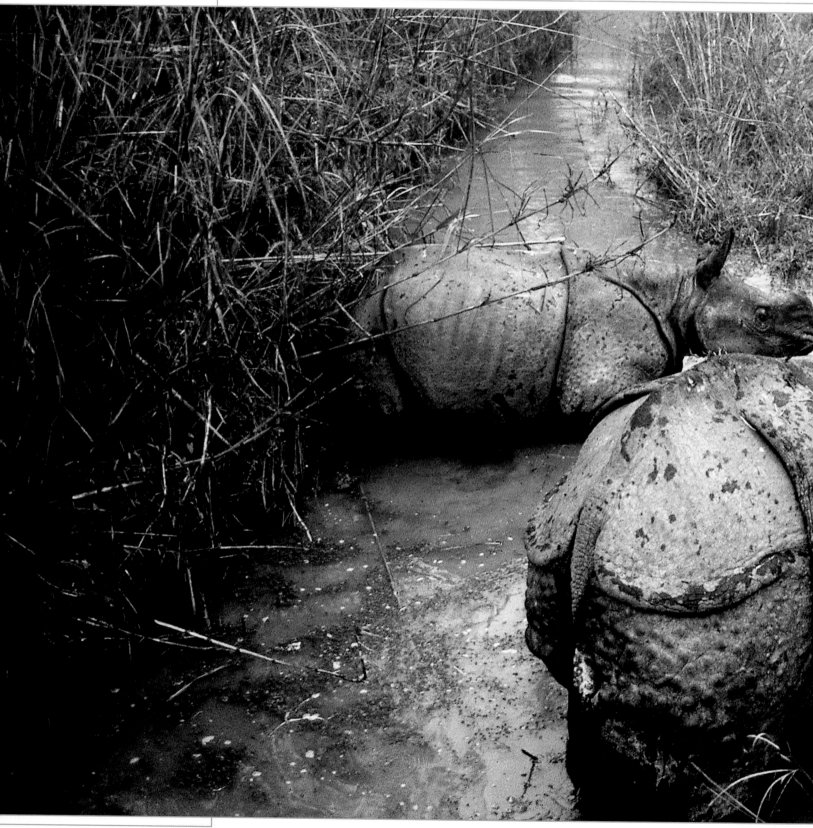

jaws – doze away the days in the park's rivers. They measure up to 7 m (23 feet), but do not present a threat to man. The Bengal monitor, another of the park's resident species, is found in the more open areas. Chitwan National Park is also an idyllic home for over 400 species of bird, among them the sarus crane, kingfisher, great hornbill, and the cormorant.

There are still several hundred one-horned rhinoceroses living within the boundaries of Chitwan National Park (large image). The park is best explored from the back of an elephant, accompanied by a local guide (small image, left).

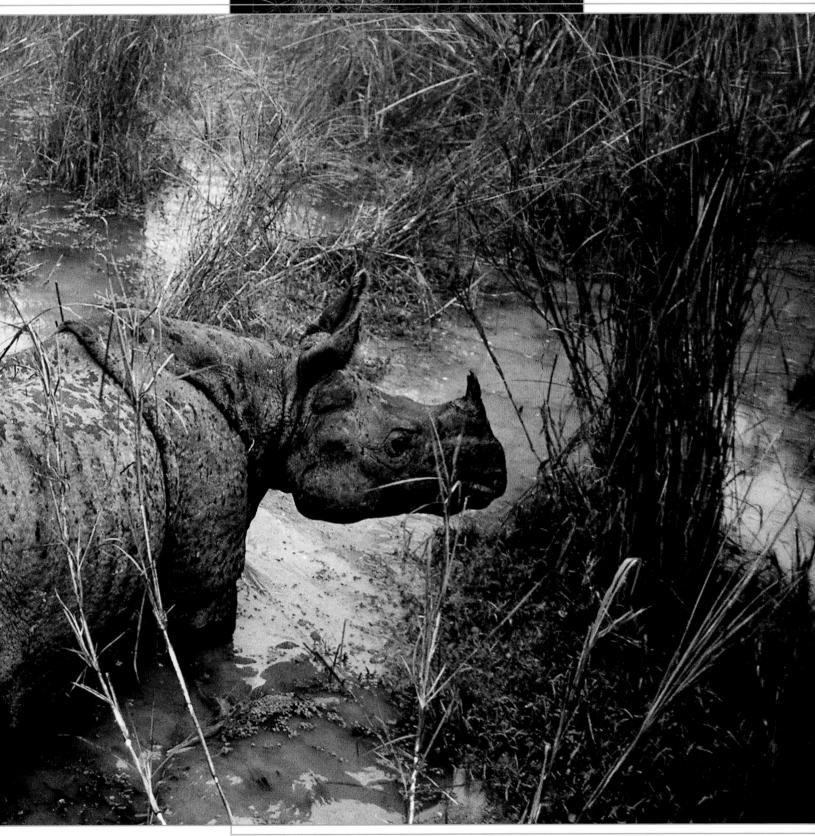

Few visitors to Chitwan National Park are lucky enough to get a glimpse of the Bengal tiger (large image). This rare, endangered, and extremely shy animal is most active at night. Elephants, water buffalo, and chital deer, on the other hand, are a common sight along the Nayarani river (small images, right). The deer like to hide in the reeds, making them hard to spot at first.

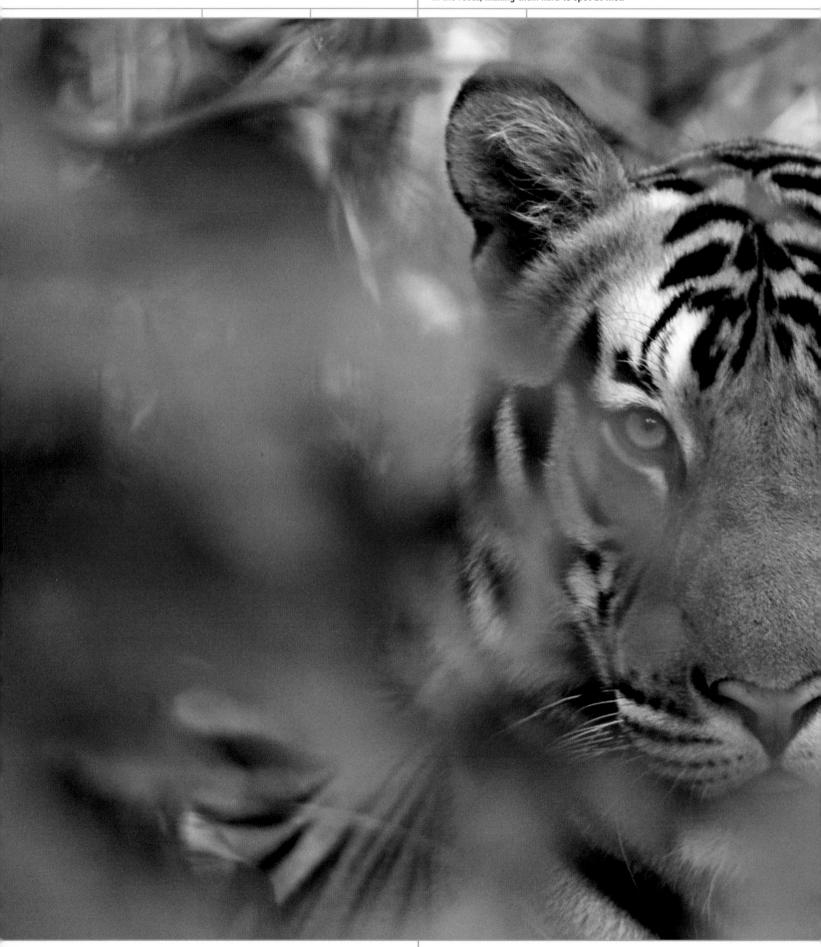

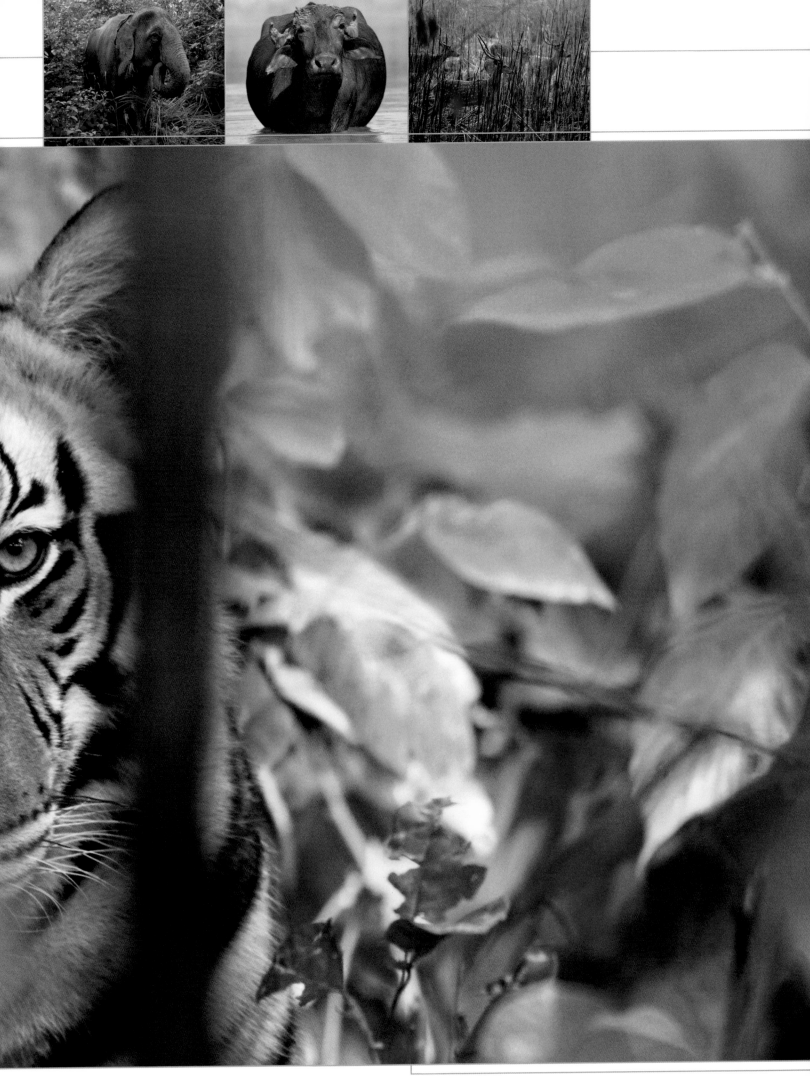

UVS NUUR BASIN

This transnational World Heritage Site encompasses 12 protected areas in north-west Mongolia and the Russian republic of Tuva.

Date of inscription: 2003

The Uvs Nuur basin is a 10,000 sq. km (3,900 sq. mile) endorheic basin. Surrounded by mountains, the basin takes its name from the saline lake at its bottom. The region is notable for its wide range of ecosystems, representing all of central Asia's landscape and vegetation zones, from marshlands, to deserts, steppes, different types of forest, rivers, freshwater lakes, alpine

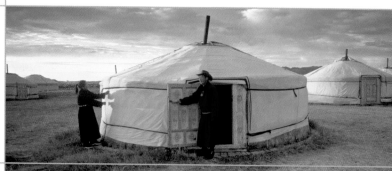

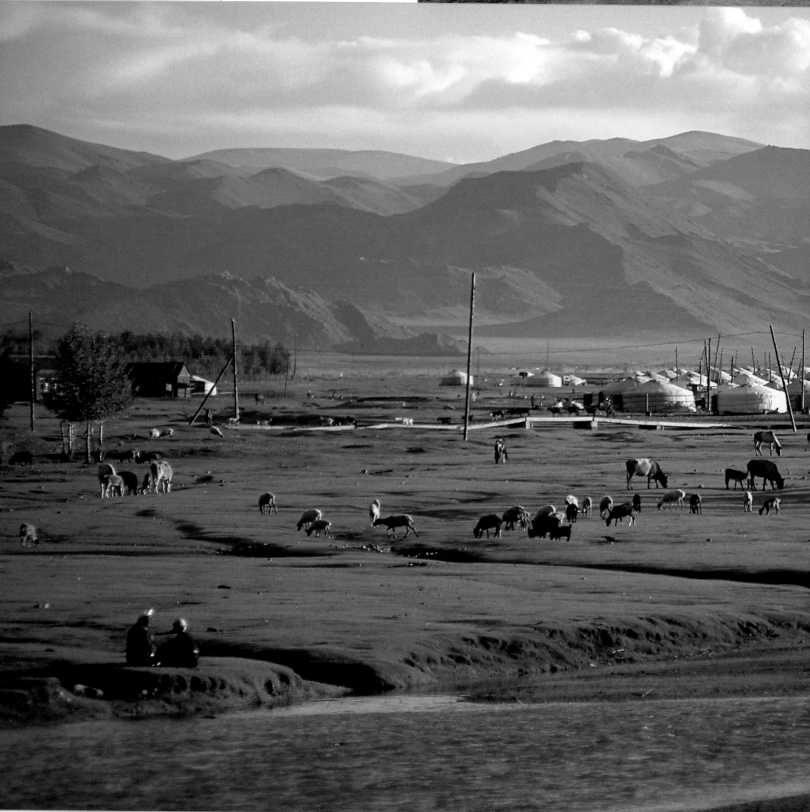

areas, and permanent snowfields. Mountains, cliffs, and granite rocks eroded into strange, often pillow-like shapes complete the landscape.

The area is considered to be one of the largest intact watersheds in Central Asia, within it are located 40,000 archaeological sites. For thousands of years, nomads have roamed the grasslands here, living in yurts. Today, the stability of the region's ecology makes the Uvs Nuur basin a good place to measure global warming. Its various ecosystems are home to a wide variety of endemic plants and invertebrates. Some of the most common vertebrates, meanwhile, are jerboas, squirrels, dwarf hamsters, and marmots.

The mountainous western regions of the site are particularly important as a refuge for endangered species such as the Siberian ibex, marbled polecat, argali, snow leopard, Mongolian gerbil, and polar cat. Both the saline Uvs Nuur lake and the freshwater Tere Khol lake are home to numbers of seabirds and seals, and in summer the two lakes provide a resting place for migratory birds. It provides a safe refuge for many endangered species.

Nomads and their animals roam the Uvs Nuur basin (large image, left). They live in yurts (small image, left). The argali – a type of wild sheep with huge horns – is one of the endangered animals for which the region is a safe home (large image, right).

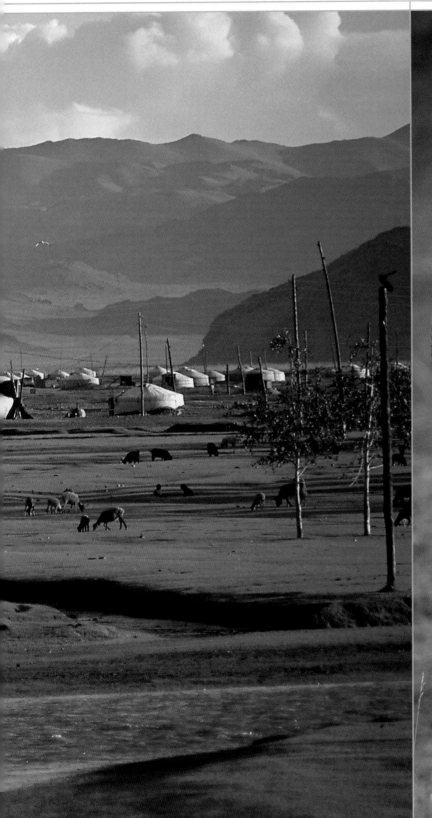

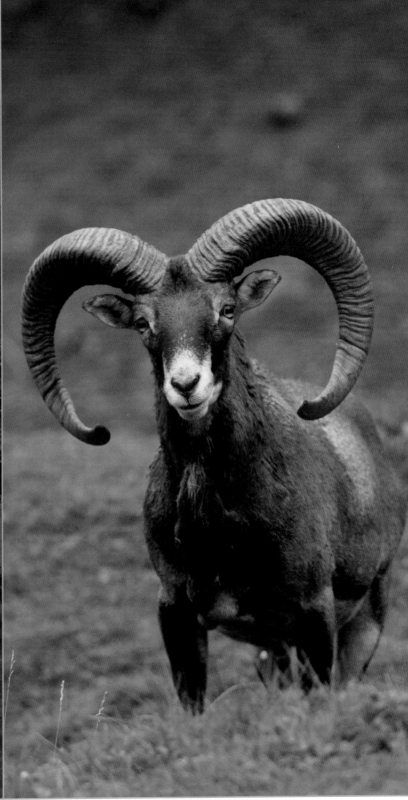

The western foothills of the World Heritage Site are the location of impressive plateaus, as here in the Chachira mountains of the Mongolian Altai (large image). The Kargy and Mogen-Buren valleys in Tuva (small images, right) are also noteworthy.

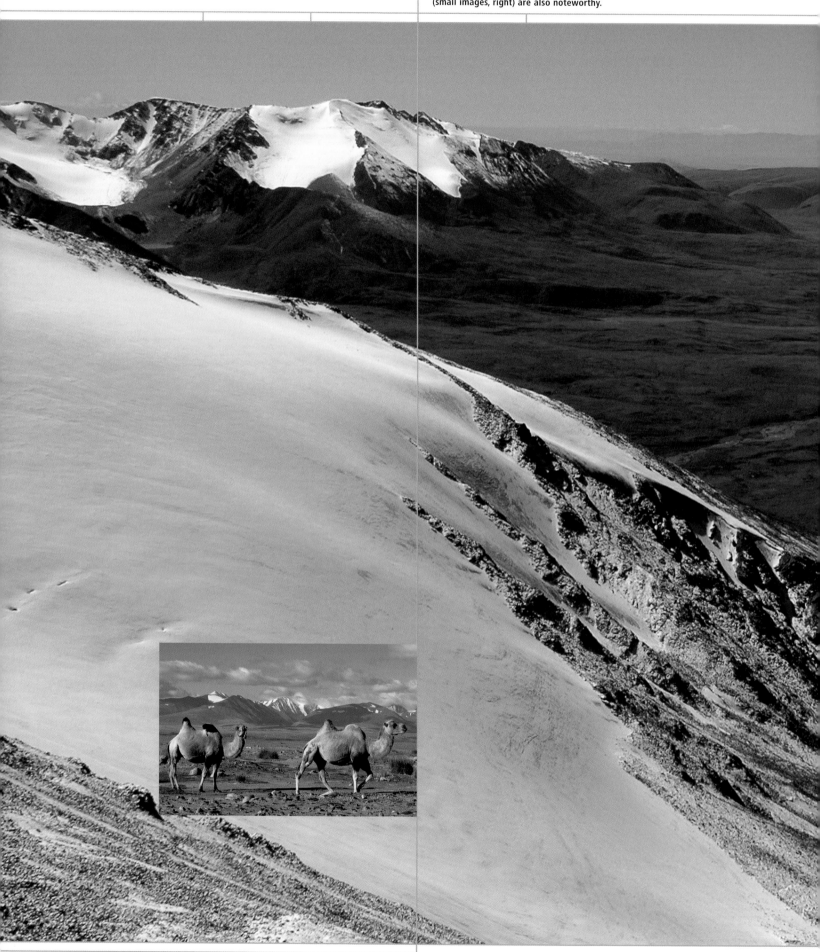

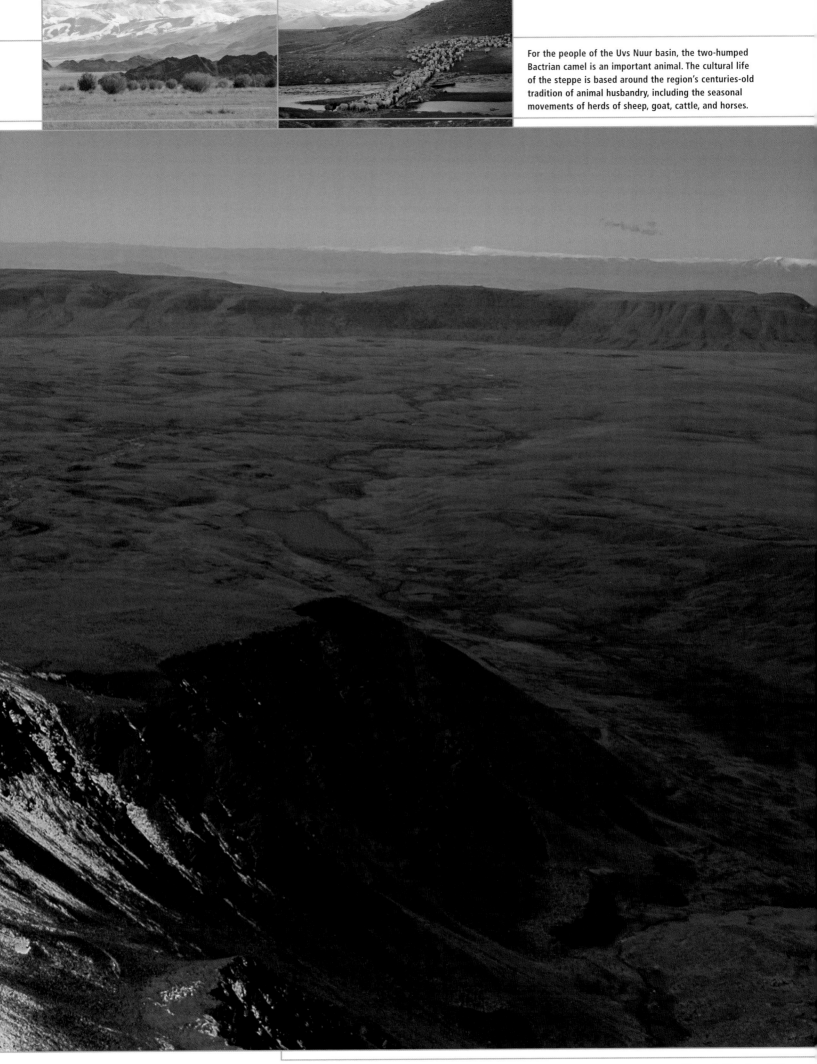

For the people of the Uvs Nuur basin, the two-humped Bactrian camel is an important animal. The cultural life of the steppe is based around the region's centuries-old tradition of animal husbandry, including the seasonal movements of herds of sheep, goat, cattle, and horses.

This sacred mountain lies north of the city of Tai'an in China's Shandong province, and is 1,545 m (5,069 feet) high. In Chinese mythology, the mountain is associated with heavenly powers, and the tradition of Chinese emperors making sacrifices to the mountain goes back to the 2nd century BC.

Date of inscription: 1987

The Taishan massif is the highest mountainous region for 1,000 km (620 miles), and its streams and sheer mountain faces are truly magnificent. As the rock massif faces the sunrise, it was believed to preside over life and death. The first Chinese emperor, Qin Shi Huangdi, ascended the mountain as part of his first tour of the newly unified empire. Before him, Confucius pronounced Taishan a place that allowed man to see how small the world really was. Many more famous figures followed Confucius up Taishan, leaving more than a thousand stone inscriptions. Nearly a hundred temples once lined the path to the mountain summit, and 22 survive today. Nature worship dates back through over 2,500 years of Chinese history, and it was here that

this tradition was most splendidly expressed. In fact, the ritual ceremony performed here is so elaborate and politically significant that it has only taken place four times since the beginning of the common era. The penultimate occasion was in 725, when Emperor Xuanzong visited the site. The event is commemorated by a 13-m (43-foot) high gilded inscription in the rock.

With its many rock inscriptions (left), Mount Tai is one of the five sacred mountains of Taoism. Here, the famous inscription left by the Tang emperor Li Longji provides a backdrop for a monk's tai chi exercises (large image, left). The mountain and the many pagodas that line the path to its 1,542-m (5,059-foot) high summit are frequently shrouded in cloud (large images, right).

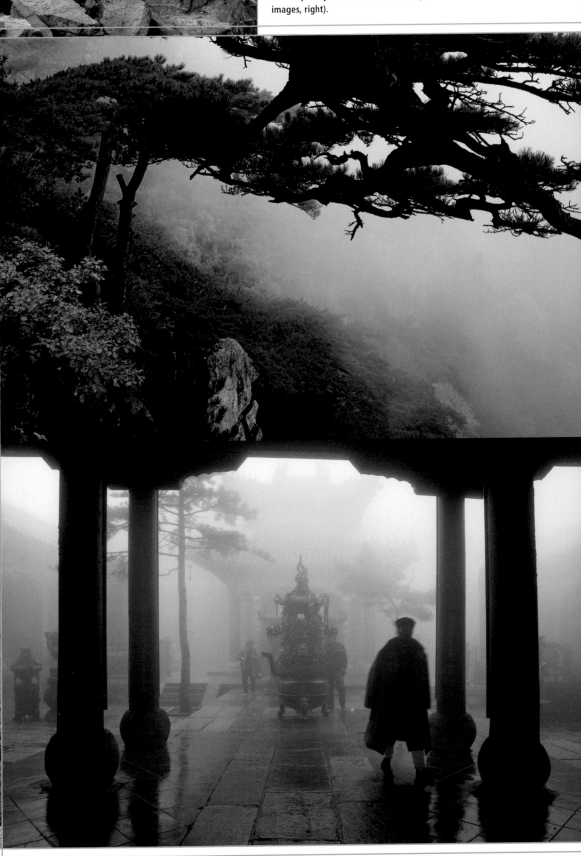

In the south of the People's Republic of China is the city of Huang-shan, whose administrative area includes the famous Huangshan mountains. Here, rocks appear to float in a sea of clouds, as if nature had conjured up a fantasy landscape.

Date of inscription: 1990

Although it covers only around 150 sq. km (90 miles) of Anhui province, there are no fewer than 77 peaks between 1,000 m (3,300 feet) and 1,850 m (6,000 feet) high tightly packed into the mountainous region of Huangshan (Yellow Mountain). On around 250 days of the year mist drifts through the deep valleys in such thick patches that, seen from above, the landscape looks like a sea on which the peaks are floating. Over the centuries numerous pavilions have been built from which people can gaze on the mountain scenery, which corresponds almost exactly to the Chinese ideal of a perfect landscape. The beauty of Huangshan, which strongly influenced China's classical academic culture, is perfected by the ancient pine trees that grow here.

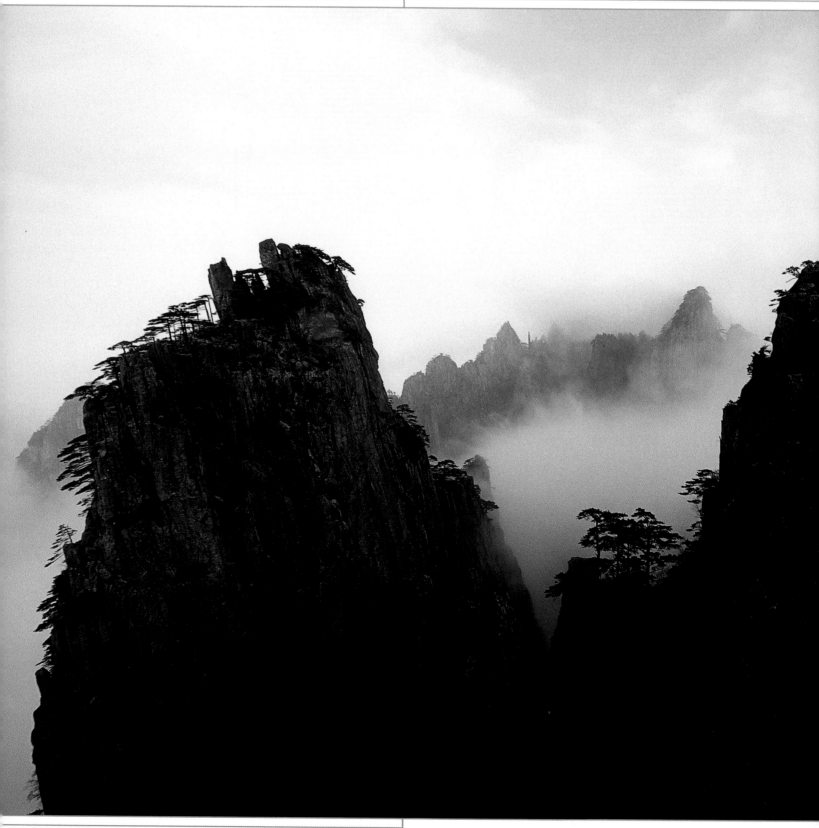

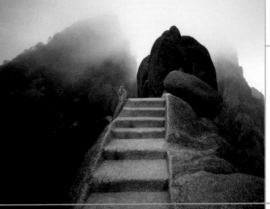

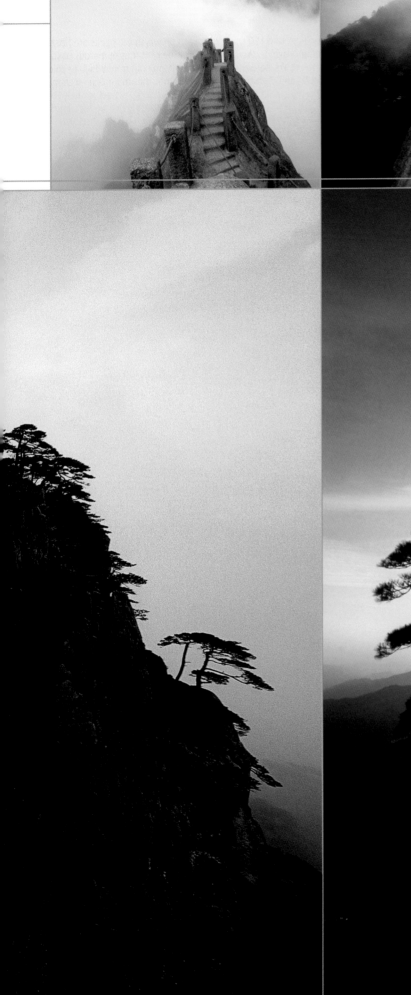

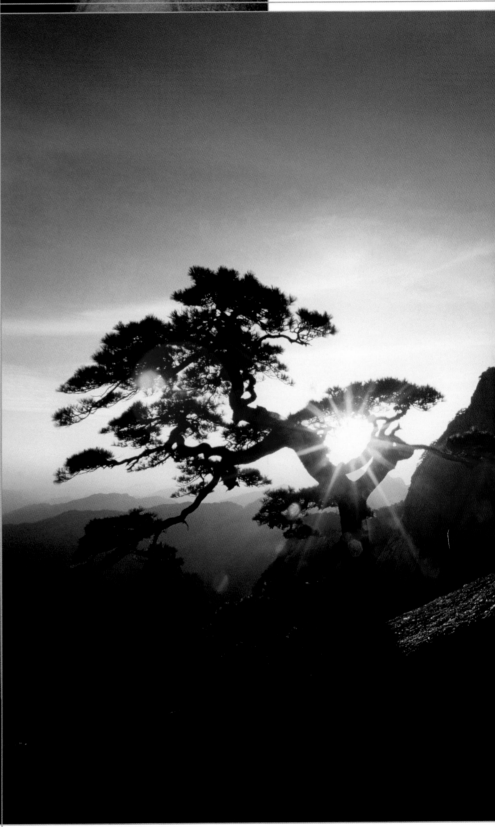

The Huangshan mountains is one of the most famous mountainous regions in China. With its strangely shaped rocks and gnarled pines (below) it corresponds to the Chinese landscape ideal. Its mountains include the Heavenly Capital Peak (left) and the Lotus Peak, with the One Hundred Step Cloud Stairs leading up to it (far left).

The ancient, subtropical forest, with its rich flora and fauna, is a paradise for rare animals and plants, but its steep rocks and crystal-clear rivers also give it a special beauty.

Date of inscription: 1999

A subtropical forest habitat has survived in China at the highest point of the Wuyi mountains in the far north-west of Fujian province. Almost 2,500 higher plant species and around 5,000 types of insects as well as 475 kinds of vertebrates have been found here. For all of these, the Wuyishan represents an important refuge in densely populated China.

Because the average altitude in the Wuyishan is only 350 m (1,100 feet) above sea level, temperatures are relatively mild here even in winter. The nature reserve is of biological importance, but the highly impressive landscape also has a charm of its own. This is due in particular to the 36 steep rocky peaks towering into the sky on both sides of the Jiuquxi, or

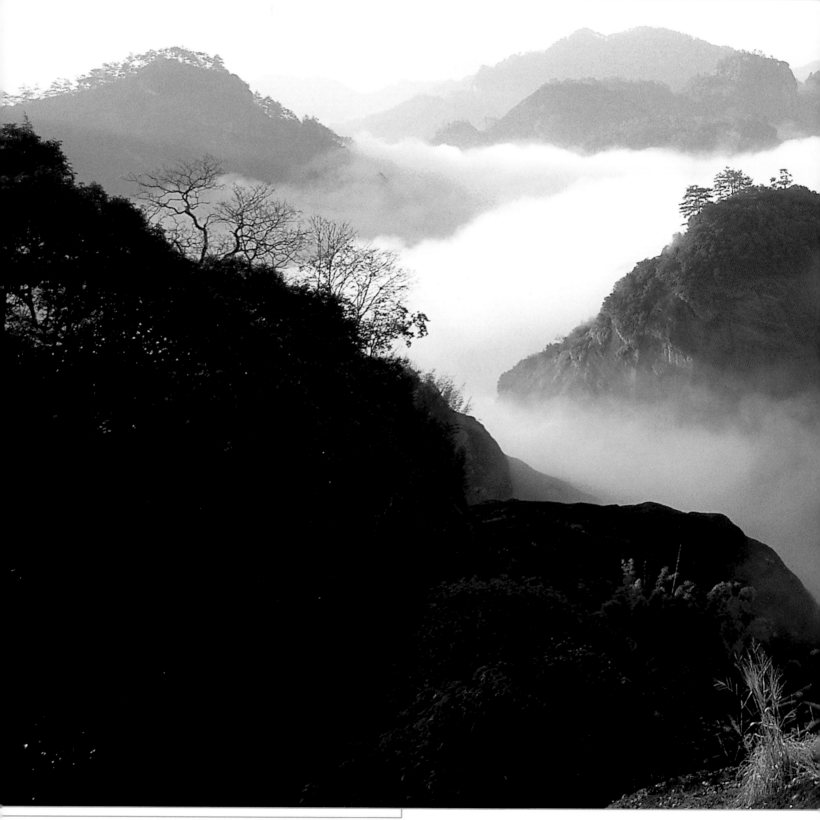

Nine Bend river, which rises in the west of the region. This stretch can be explored by boat, with curious landscape features to admire along the way. For example, there is a high, shell-shaped grotto, from the top of which spring water flows down. In another place there is a vertical crack in the rock at the end of a tunnel-shaped cave, only half a meter (1.5 feet) wide and around 100 m (330 feet) in length, which reveals a strip of gossamer sky.

Early Chinese scholars used the Wuyishan as a retreat. It is very close to the archeological excavation site of Chengcun, the administrative capital of the Minyue kingdom during the Western Han dynasty (206 BC–AD 25). It is a very tranquil spot.

Literary figures and scholars once used the remote mountain country of Wuyi (large image) as a retreat. Up to 95 percent of the landscape is covered by forest and is a paradise for birds and snakes. The river Jiuquxi meanders through the mountains for around 60 km (37 miles) (left).

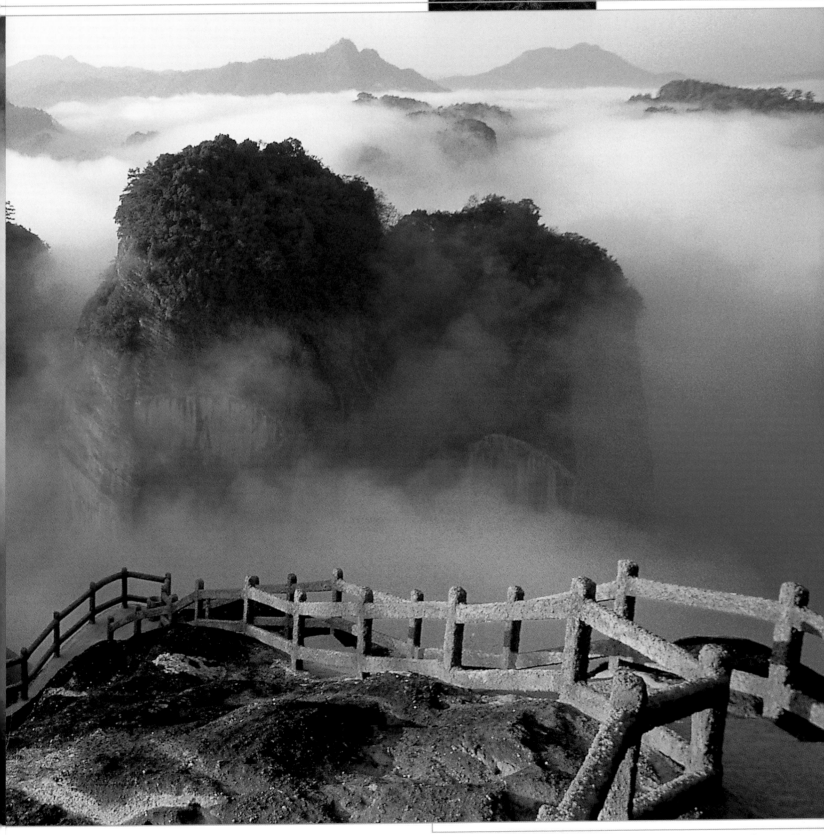

JIUZHAIGOU VALLEY SCENIC AREA

A unique abundance of natural wonders is found here in three high valleys in the north-west of the Sichuan province, with brightly hued pools, torrential cataracts, rare animals, and lush vegetation.

Date of inscription: 1992

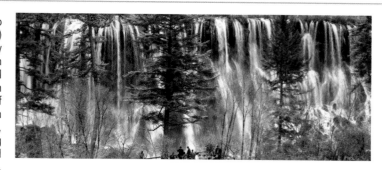

Three densely forested valleys rise up from a height of 2,000 m (6,500 feet) to form a Y-shape, towered over by snow-covered peaks up to 4,700 m (15,500 feet) high. The karstic subsoil enriches trickling water with calcium salt, which re-emerges in the form of large sinter terraces. Cataracts gush over tree-covered tufa embankments, with the largest waterfall plunging down almost 80 m (260 feet). Several lakes gleam in a variety of hues, from yellow and bright green through to blue.

With its secluded side valleys, Jiuzhaigou is also a refuge for some rare plant and animal species, for example giant pandas and golden hair monkeys, together with numerous species of birds.

The name Jiuzhaigou means Valley of the Nine Villages, a reference to the nine Tibetan villages situated in the 60 sq. km (23 sq. mile) area. There are around 120 lakes, which shimmer in different hues according to the time of year (below). Waterfalls flow out of the lakes (above) and plunge into more water basins, in turn forming new lakes.

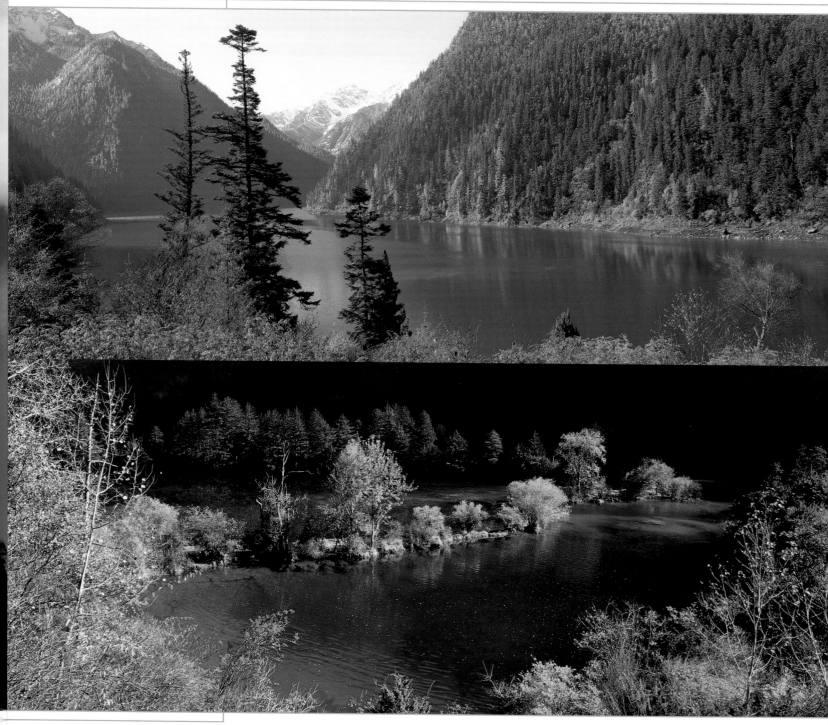

As well as an impressive mountainous and glaciated landscape, visitors to the Huanglong Scenic and Historic Interest Area will also see a succession of sinter terraces almost 4 km (2.5 miles) long, stretching through a high, forested valley.

Date of inscription: 1992

The former glaciated valley is in the autonomous region of Ngawa in Sichuan province, and rises from around 3,000 m (9,800 feet) above sea level to the high snow-capped mountain Xuebaoding, 5,588 m (18,300 feet) high. It is also known as the refuge of the giant panda.

Yellow sinter terraces have formed here at the bottom of a thickly forested side valley. The water in the basins shimmers in many and varied hues due to the algae and bacteria living in it. Adjoining basins are consequently of very different shades which, along with the reflections of the foliage, sky and clouds, results in a fascinating play of colors. There are

also small trees growing in some of the pools.

The main attraction of the nature reserve is a steeply sloping travertine area around 2.5 km (1.5 miles) long and 100 m (33 feet) wide, which is covered by a runnel only a few centimeters deep. This phenomenon is associated with a yellow dragon (Huanglong in Chinese) and is how the World Heritage Site gets its name.

The terrace-like pools in the Huanglong valley (large image) formed during the ice age when the whole region still lay under a glacier. Due to its high mineral content, the glacial water eroded the soft limestone rocks, creating basins and hollows in which water has gathered. This water pours from one basin to another creating numerous stunning waterfalls.

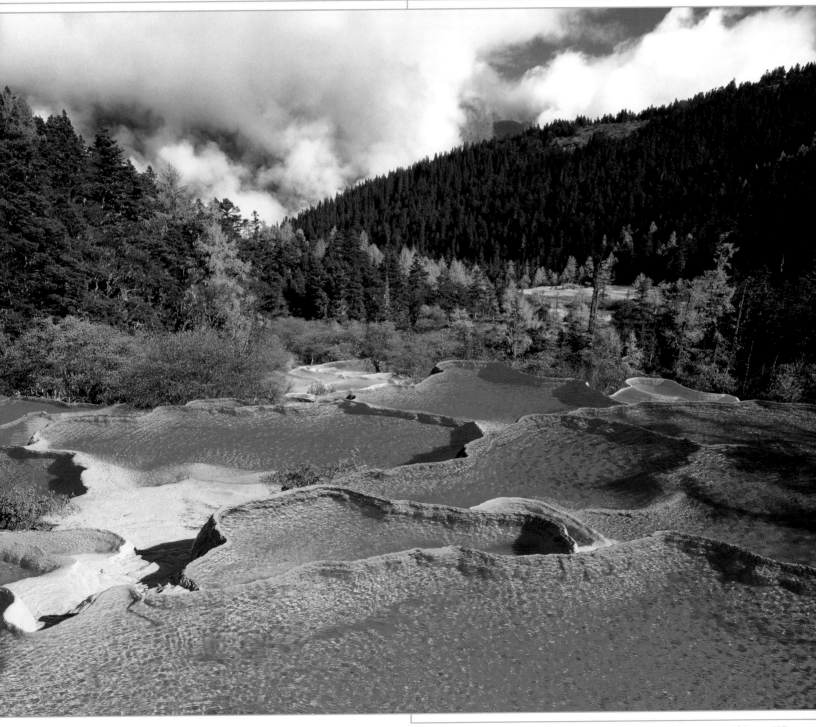

THE SICHUAN GIANT PANDA SANCTUARIES

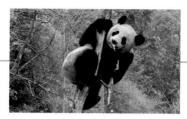

Around 900 animals live in the Sichuan panda reserves, including 30 percent of the world's remaining wild giant pandas. The area is also one of the richest in the world in terms of flora, outside the tropics.

Date of inscription: 2006

The Sichuan Giant Panda Sanctuary in south-central China is situated in the Qionglai and Jiajin mountains. As well as seven nature reserves, it comprises nine "scenic parks" that are also open to visitors. The nature reserve is home to almost a third of all wild giant pandas and so is the most important conservation and breeding area for this endangered species. five to six thousand types of flowering plants, belonging to more than 1,000 genera, also grow here, with around a fifth of the genera only found in China.

The area is also a veritable treasure trove for the medicinal plants used in traditional Chinese medicine. One reason for the abundance of plants is the enormous diversity in the land-scape – the difference in altitude between the lowest and highest point is around 5,700 m (18,700 feet).

So far 543 vertebrates have been seen in this region, including 109 mammals, which constitutes around a fifth of all Chinese species. Endan-gered species found here include the snow leopard, the red panda, and the clouded leopard.

Bamboo is one of the plants typical of southern China, and forms the basic diet of the giant panda (large image and top image above). When large areas of bamboo plants died off in 1975, around

140 bears died of starvation. Since then the number of pandas living wild in the reserve has risen again. The red panda (bottom image above) is crepuscular and nocturnal.

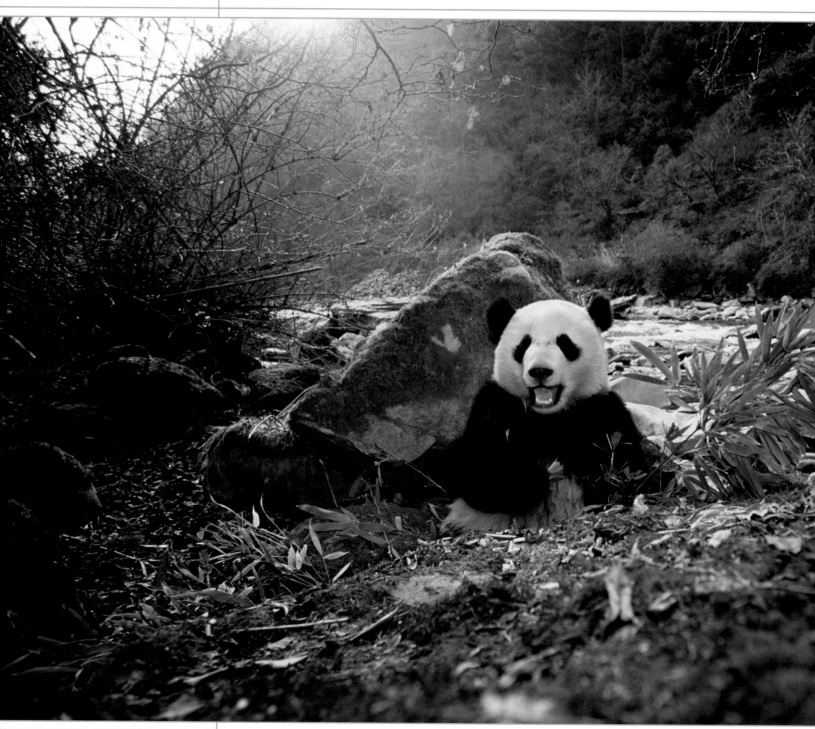

MOUNT SANQINGSHAN NATIONAL PARK

Characterized by lush forests, countless waterfalls, and fantastically shaped rock formations, Mount Sanqingshan National Park in south-east China is a fascinating landscape of extraordinary beauty.

Date of inscription: 2008

Mount Sanqingshan National Park in the Chinese province of Jiangxi is at the western end of the Huyaiyu mountain chain and was declared a national monument as early as 1988. The protected area of 230 sq. km (89 square miles) is at an elevation that varies between 1,000 and 1,800 m (3,300 to 5,940 feet) above sea level, although the highest peak is Huyaiyu, at 1817 m (5,961 feet). These differences in altitude mean that the national park includes areas of subtropical and maritime climates, with rainforest and evergreen regions covering an area of some 145 sq. km (56 sq. miles). These lush forests are home to more than 300 animal and 1,000 plant species.

Between the peaks and the canyons there are numerous lakes, springs, and waterfalls of heights up to 60 m (200 feet).

The unique granite formations of the Huyaiyu chain are one of the main attractions: many of the 48 peaks and 89 pillars are reminiscent of human figures or animals. Banks of cloud and mist only increase the effect, creating a constantly changing landscape with unusual and fascinating light effects, such as the so-called "white rainbow." The great age of the mountain chain, up to 1.6 billion years, has made research of the area of great interest to geologists. It is a stunning and unique area.

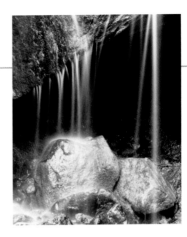

Mountains with trees which grow horizontally, clinging to jagged rocks (below), and the shimmering light effects from the waterfalls (above) make the panoramic landscape of Mount Sanqingshan National Park seem almost unreal.

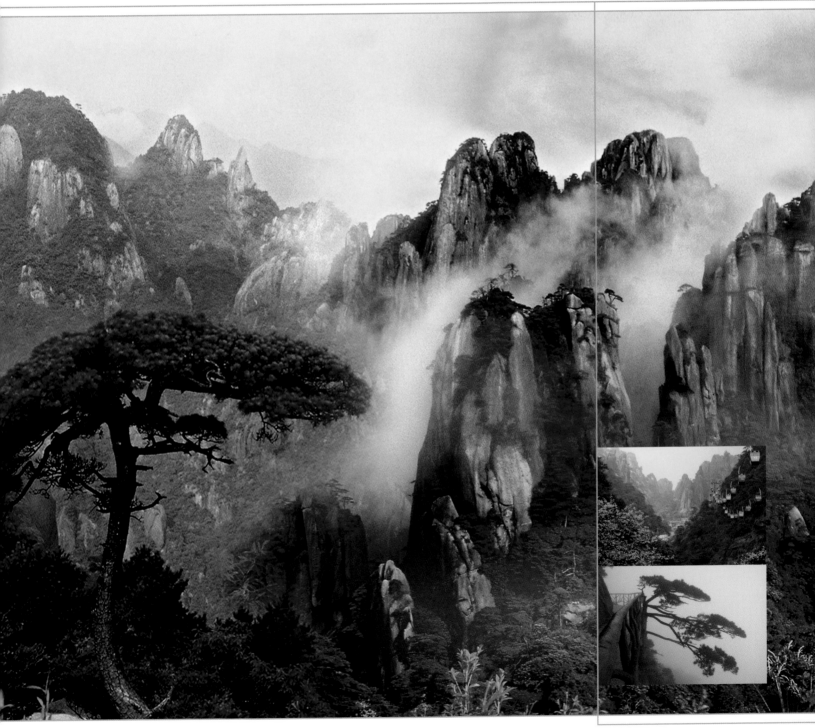

The largest of the four sacred mountains of Chinese Buddhism goes back to the 2nd century. The largest Buddha figure in the world is also on the World Heritage list.

Date of inscription: 1996

Precipitous rocks, deep crevices, mountain streams, waterfalls, steep, towering peaks, dense forests with trees sometimes over 1,000 years old: the sacred Mount Emei ("Delicate Eyebrow Mountain"), which is over 3,000 m (9,800 feet) high, has always been the perfect setting for anyone wishing to turn their back on the world. Mount Emei, on the south-western edge of the Red Basin in Sichuan, has been a sanctuary valued by hermits since the Eastern Han period (AD 25–220), and the first Buddhist temples and Chinese monasteries were built here soon after that. According to legend, Samantabhadra, bodhisattva of the Law and patron saint of the mountain, is said to have taught in this place. There is a statue over 8 m (26 feet) high in remembrance of him in a mountain temple. There are now more than 200 monasteries and hermitages here and the stream of pilgrims has continued to grow. Many of the sanctuaries fell victim to the Cultural Revolution, but among the 20 that survived, nestled against the rocks or built on peaks and ridges, are many that go back as far as

the Sui period (AD 581–618). The buildings that remain today are predominantly from the 17th century.

The attractions for pilgrims in the region include the 71-m (233-foot) sitting Buddha statue in Leshan, 35 km (22 miles) away at the confluence of the Minjiang, Dadu, and Qingyi rivers. It was sculpted from a single rock face in the 8th century by Buddhist monks.

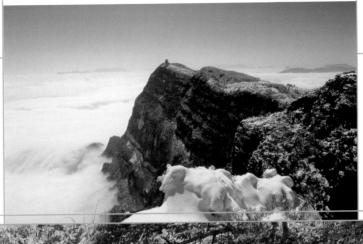

Qingyin-Ge, the Pavilion of Clear Sound (large image), stands at 710 m (2,330 feet) above sea level, on the path to the summit of Mount Emei. The name of the sacred Mount Emei (left) means "Delicate Eyebrow Mountain." On the Golden Summit, 3,077 m (10,000 feet) up, stands a temple inhabited by monks.

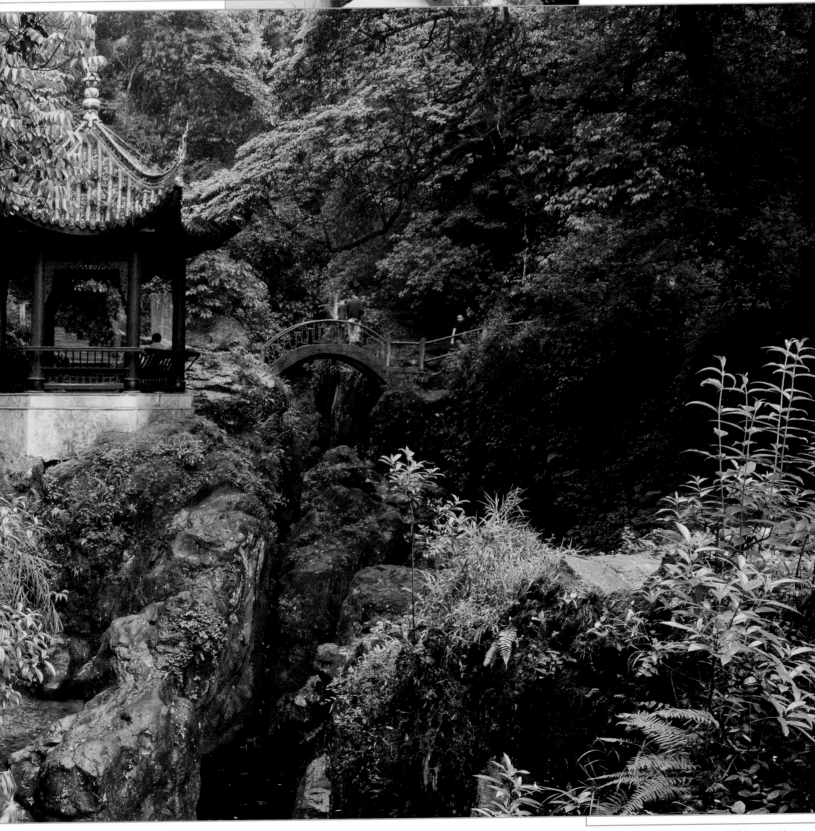

THREE PARALLEL RIVERS

In north-western Yunnan, three rivers, the Yangtze, Mekong, and Salween, run largely parallel to each other for a distance of around 170 km (105 miles). Almost all northern hemisphere types of landscape and ecosystems can be found in this area, as well as immense biodiversity.

Date of inscription: 2003

From a geological standpoint, the area known as Sanjiang Bingliu is exceptionally diverse with, for example, magnetic rocks, limestone with karst phenomena, weather-beaten granite, and sandstone. In places the three rivers form extremely steep gorges, up to 3,000 m (9,850 feet) deep. They are surrounded by 118 mountains over 5,000 m (16,400 feet) high, the highest being the Kawagebo at 6,740 m (2,211 feet), with the Mingyongqia glacier that stretches up to 2,700 m (8,850 feet). This sometimes extreme steepness is linked to recent geological history, as about 50 million years ago the Indian and Eurasian plates collided, pushing up the Himalayan mountains we know today.

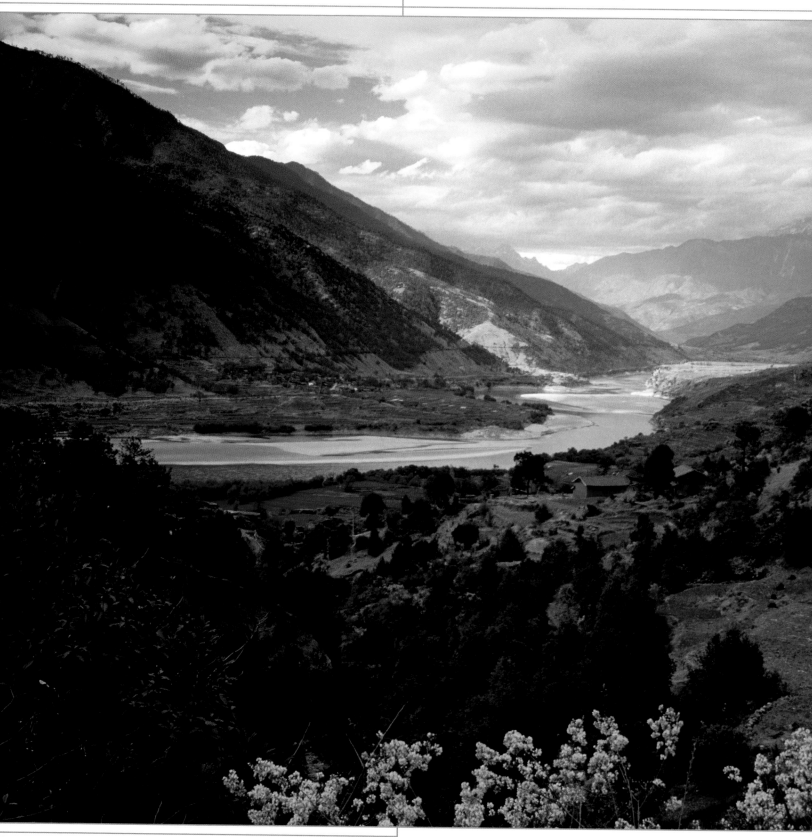

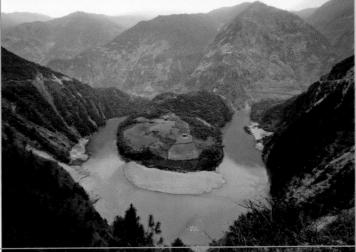

The Three Parallel Rivers National Park lies in the biogeographical convergence zone between the Palearctic and Oriental regions and therefore has features of both the temperate and tropical zones. During the ice age the area served as a corridor for many types of flora and fauna moving south before the imminent glaciation.

The Yangtze (below left) has carved a spectacular gorge 15 km (9 miles) long out of the stone of the Yunnan mountains. Known as the Tiger Leaping Gorge (below right), it is considered one of the deepest canyons in the world (left). A barrage project is on the verge of destroying the World Heritage Site.

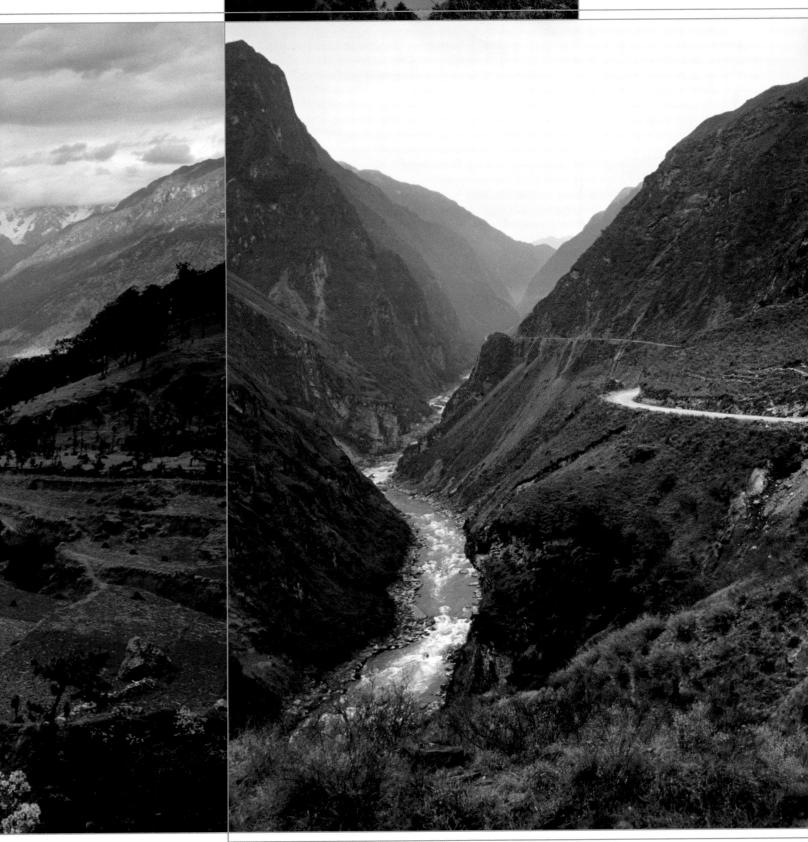

SOUTH CHINA KARST

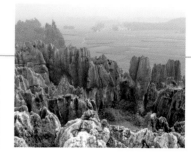

The karst formations of South China extend over an area of around 500,000 sq. km (310,000 sq. miles), of which some sections, representing the whole area, have been designated a World Heritage Site. With their weird and wonderful formations, these sections constitute some of the most spectacular examples of tropical and subtropical karst landscapes.

Date of inscription: 2007

In tropical South China, distinctive weathered forms, known as karsts, have developed through carbonic acid reactions. The intensive weathering results in strange and wonderful shapes, for example, cone karst, tower karst, and stone forests. The World Heritage Site comprises several formations over an area of around 100 sq. km (62 sq. miles) in Shilin near Kunming, Libo near Guiyang, and Wulong near Chongqing.

The Shilin karst in Yunnan is made up of stone forests with deep, sharp channels. The Libo karst in Guizhou beautifully illustrates the transition from cone to tower karst. Dolines (sinkholes) with deep gorges, caves, and bridge-like structures dominate the Wulong karst in Chongqing. caves, in particular, illustrate how the carbonic acid weathering can also run in the reverse direction, depositing dissolved limestone which forms stalactites and stalagmites and sinter terraces.

Two hundred and seventy million years ago, a karst mountain range, the Shilin karst ("stone forest") developed out of a shallow sea close to the present-day city of Kunming. The rock formations often resemble animals or people (large image; top right) and have names such as "Birds feeding their young" or "A phoenix grooming." The area can be viewed from an observation pagoda (right).

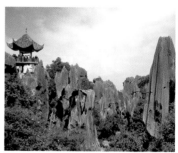

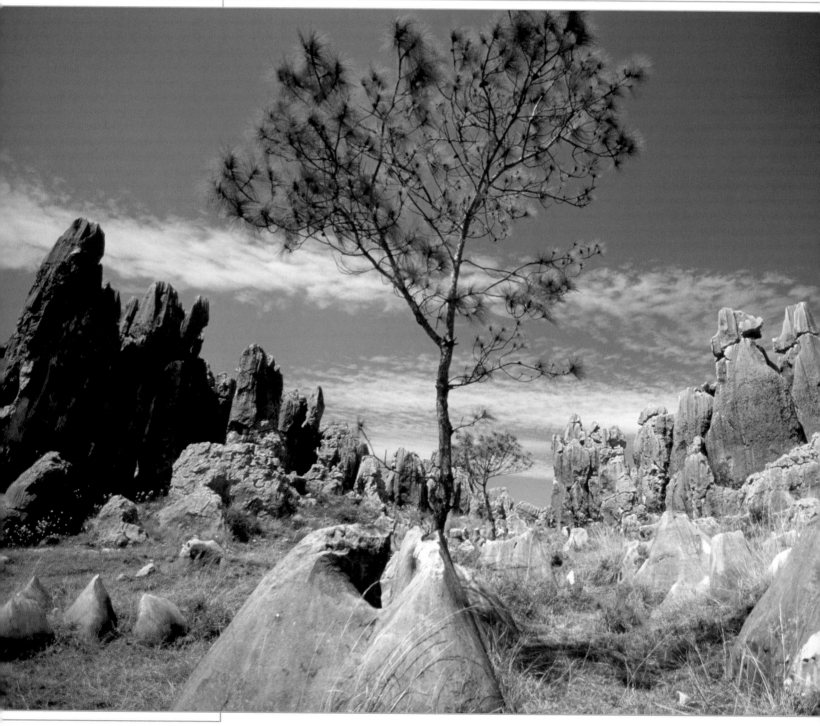

JEJU VOLCANIC ISLAND AND LAVA TUBES

Three sites and landscapes on the South Korean island of Jeju make up the Natural Heritage Site. Important phenomena concerning the geological development of the island are in evidence.

Date of inscription: 2007

The island of Jeju, off the south coast of Korea, is an undersea shield volcano on a continental plate. It was formed over a hot spot – a "weak point" in the earth's crust – that was dissolved from the interior of the earth outward by rising magma. The conservation area around Mount Hallasan, the highest mountain in South Korea at 1,950 m (6,400 feet), makes up the largest part of the Natural Heritage Site, which covers a total of 1,890 sq. km (730 sq. miles); the surrounding region ranges in height from 800 m (2,600 feet) to 1,300 m (4,200 feet) and includes a crater with a 1.6 hectare (4 acre) lake, a trachyte dome, waterfalls, and basalt columns. The vegetation, with many endogenous plants, ranges from temperate deciduous oak forests to subalpine evergreen conifer forests. The geomunoreum, part of the World Heritage Site, comprises five lava tunnels formed when the top layer of liquid lava cooled. This finally solidified to create a roof over an area in which hot lava continued to flow. When the lava stopped flowing, a hollow mould was left. The longest lava tunnel, Manjang, measures 7.4 km (4.6 miles), the shortest 110 m (360 feet). Typical of a geomunoreum, brightly hued carbonate deposits adorn the roof and there are numerous stalactites and stalagmites. The 182-m (597-foot) high tuff cone Songsan Ilchulbong, at the eastern end of Jeju, was formed by a volcanic eruption on the shallow seabed. Erosion by wind and water exposed the sediment layers.

Hallasan, the highest summit on Jeju, is an extinct volcano (large image). The Yongduam rocks (small image, below) seem very porous, relics of a volcanic eruption. The lava tubes (above) formed 100,000 to 300,000 years ago.

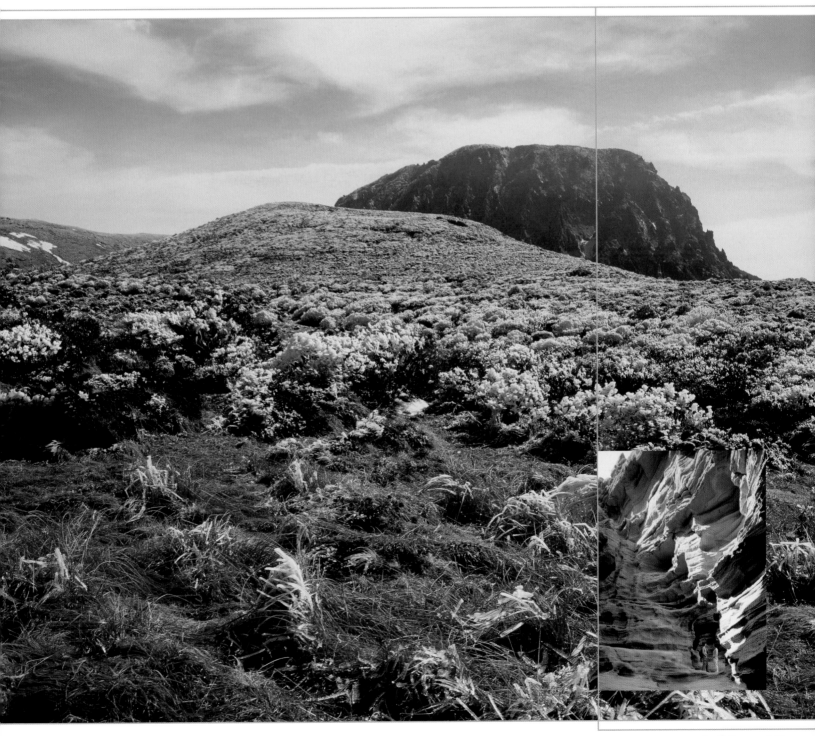

SHIRETOKO

Due to the distinctive climatic features, the ecosystems on the Shiretoko peninsula and in the surrounding sea are exceptionally rich in nutrients and contain a great many species.

Date of inscription: 2005

Cold winds blowing across from Siberia cause the sea to freeze just off the coast of Shiretoko in the northeast of Hokkaido, the lowest latitude in the northern hemisphere to experience seasonal ice. Beneath the layer of ice, large quantities of phytoplankton grow, the start of a long food chain. They are the staple diet of krill and other tiny aquatic animals, which nourish crustaceans and small fish. These in turn are consumed by larger fish, marine mammals such as seals and sealions, and sea eagles.

Large numbers of salmon and trout swim up the rivers to spawn inland. They provide food for the Hokkaido brown bears as well as for the endangered Blakiston's fish owl and Steller's sea eagle.

One of the reasons for the enormous productivity of the marine ecosystem is the different salt content in the layers of water, which scarcely ever mix because no large rivers flow into the Sea of Okhotsk. A total of 223 types of fish, including ten types of salmon, and 28 sea mammals have been recorded off the coast of Shiretoko. The yellow-brown Steller's

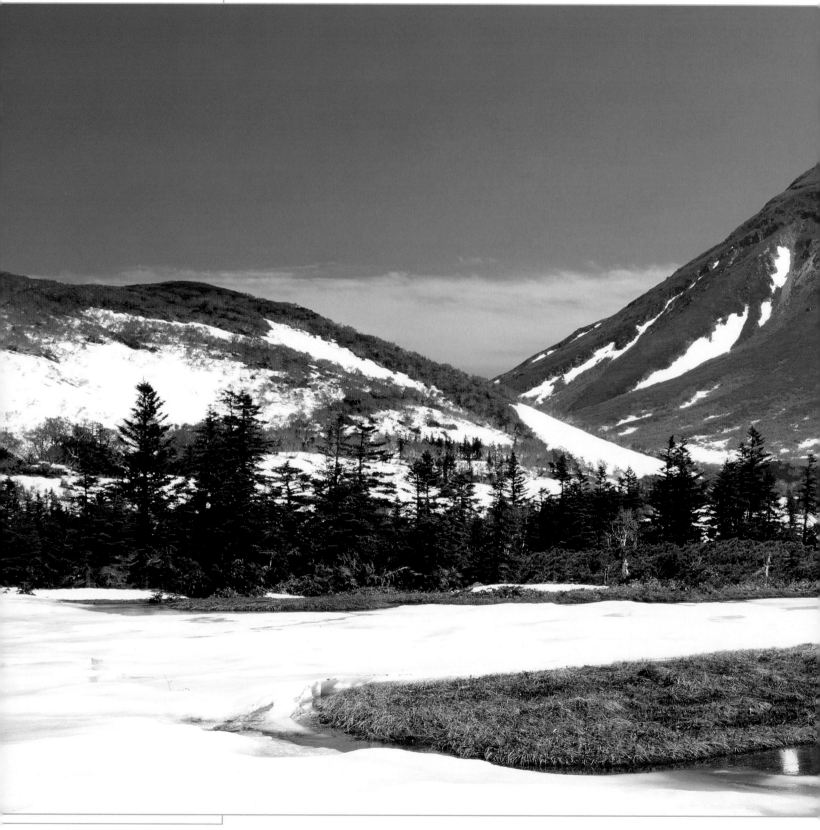

sealion, which is almost hairless apart from its opulent mane, needs special protection. Like all sealions the animals live in harems and stay close to the coast during the day. They are relatively philopatric and return to Shiretoko to their birthplace each year to reproduce.

As with all eared seals, there is a substantial difference between the weight of male and female Steller's sealions, with bulls weighing up to 1,100 kg (2,400 lb), while cows weigh less than 300 kg (660 lb). The animal population has decreased by two thirds since 1960, because there are fewer and fewer fishing grounds that can satisfy the large food requirements of these sealions.

Waterfalls gush over the steep cliffs of Shiretoko into the sea (left). In winter, the seas around the Mount Rausu volcano are covered in ice (large image). Japanese sika deer are also found in the snowy landscape (below right).

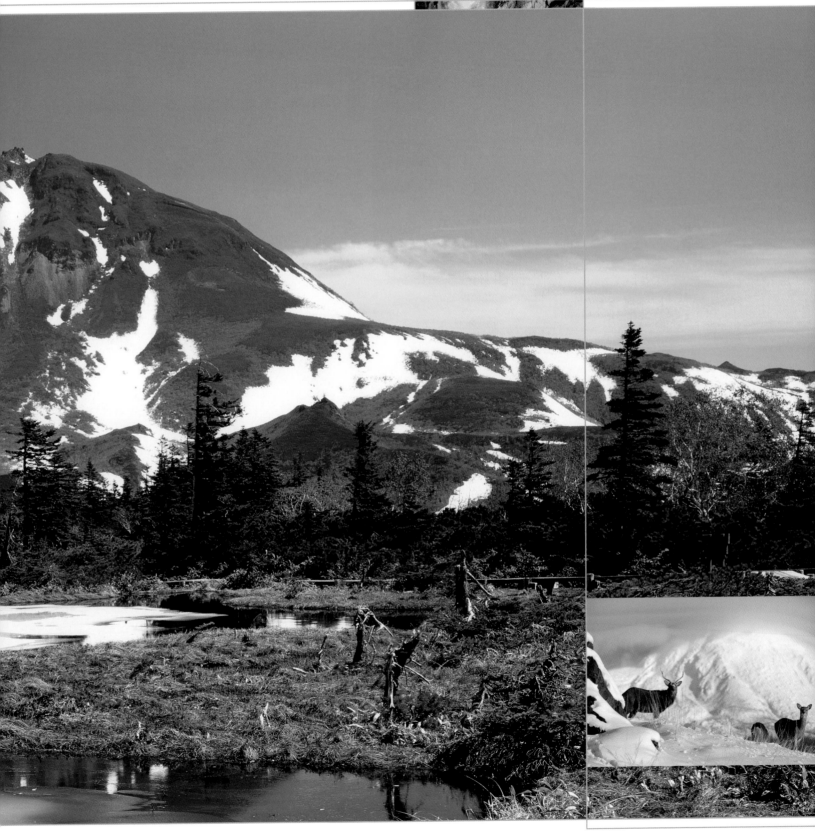

Steller's sea eagle (image inset, below left), Blakiston's fish owl, and the Hokkaido brown bear (image inset, right) eat salmon that breed upriver in the summer. Fish that are already weak from spawning are especially easy to grab.

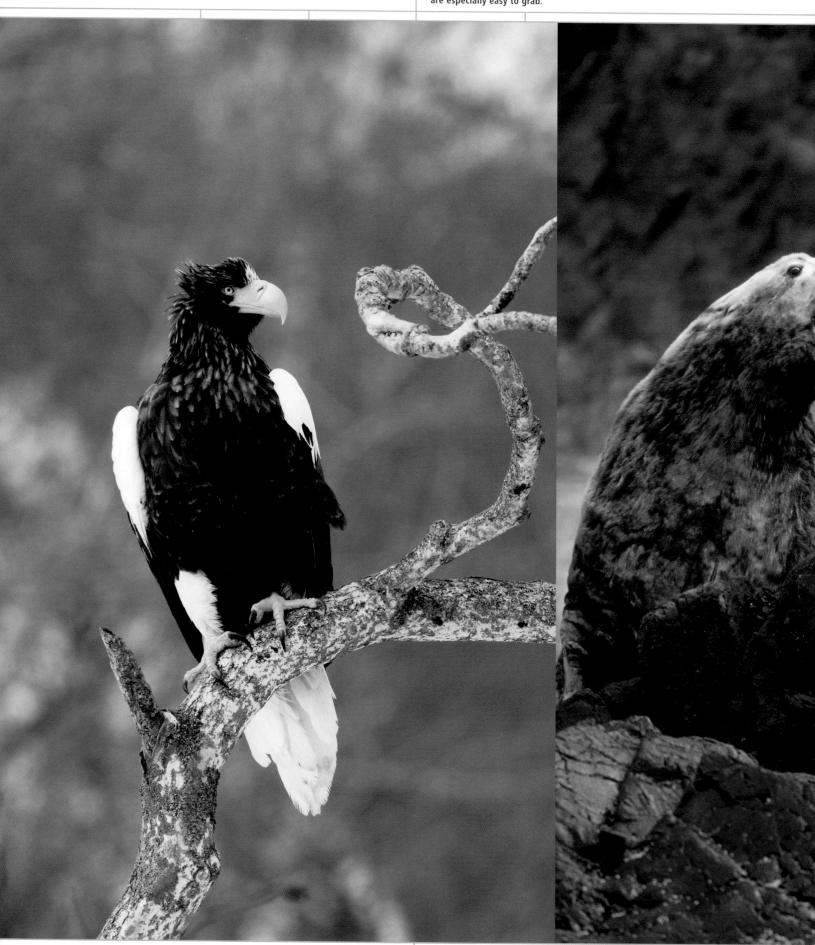

The waters on and around Shiretoko are a sanctuary for numerous types of bird whose numbers are endangered, such as the harlequin duck (left). Birds of passage also stop over on the peninsula. Steller's sealion (image inset, middle), considered aggressive, was named after the German naturalist Georg Wilhelm Steller (1709–1746), who explored the Siberian Kamchatka peninsula.

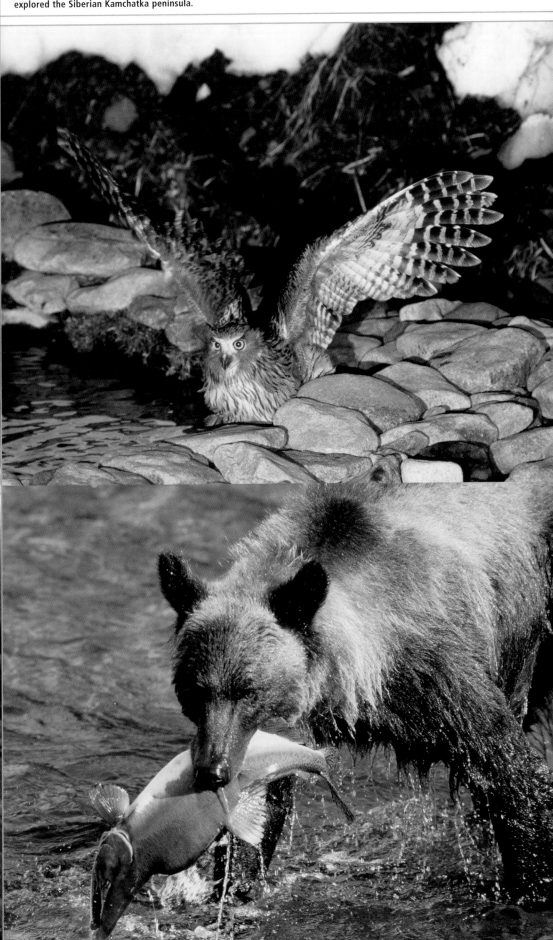

SHIRAKAMI-SANCHI BEECH FOREST

One of the last ancient Siebold's beech forests in East Asia is symbolic of the preservation of the natural habitat in densely populated Japan. The Shirakami-Sanchi World Heritage Site comprises around 170 sq. km (105 sq. miles).

Date of inscription: 1993

Ancient forests once covered almost all of Japan, with Siebold's beech the predominant type of tree. Most forests were severely decimated by felling, but after protracted discussions in the 1980s, the trees that had been spared in the north of the island of Honshu were protected by law, with the core zone of the Shirakami-Sanchi comprising around 100 sq. km (38 sq. miles).

The largest primeval beech forest in East Asia is an important sanctuary for the most northerly monkey population in the world, as well as Asiatic black bears, the Japanese serow, which belongs to the goat family, and 87 types of bird, including the black woodpecker, which is on the IUCN's Red List of Threatened Species. Over 500 types of flora also grow in the

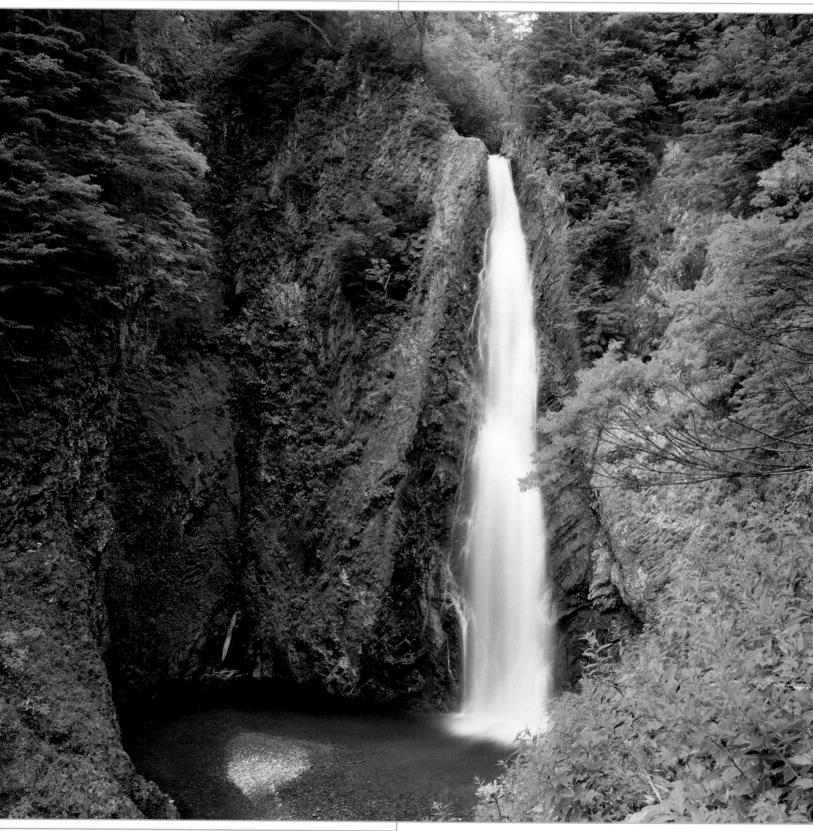

Shirakami-Sanchi forest, including rare orchids. The mountainous landscape, up to an altitude of 1,240 m (4,000 feet), in which 15 rivers have their source, has very few paths and herb gatherers have lost their way in this region on at least one occasion. By contrast the part of the ancient forest that is a World Heritage Site is almost untouched by man.

The water of the Anmongawa plunges over the Shadow Gate Falls into the Meya valley (below left). Some beech trees are more than 200 years old (below right). Also living in Shirakami-Sanchi are the Japanese serow, weighing up to 100 kg (220 lb) and the Japanese macaque, the most northerly living species of monkey (small images, left to right).

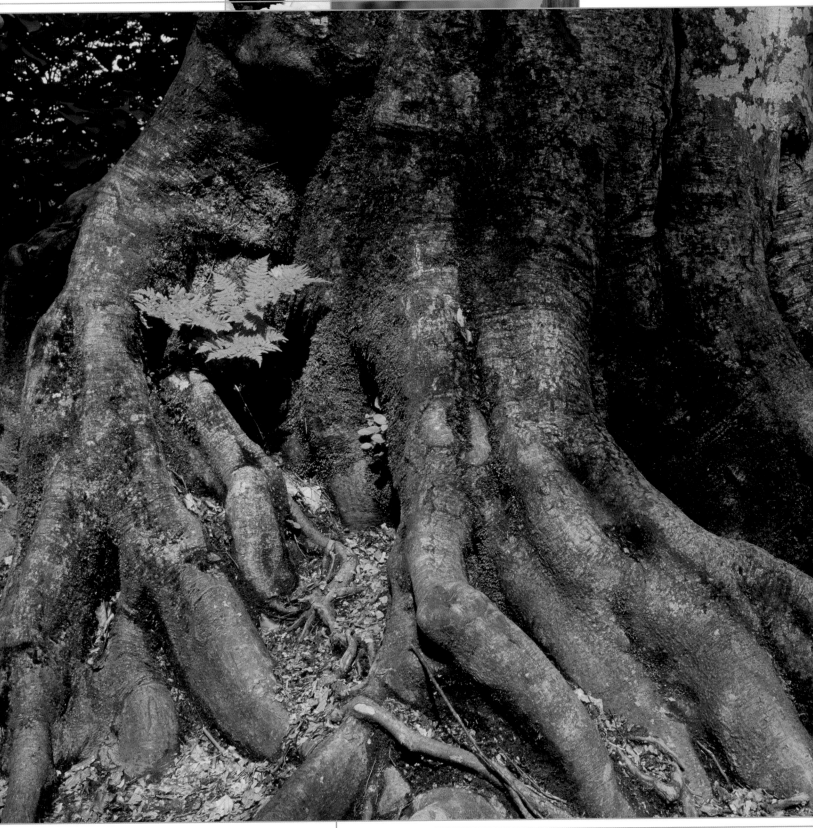

YAKUSHIMA CEDAR FOREST

Japanese cedars up to 3,000 years old are the most precious botanical specimens in the evergreen primeval forest on Yakushima Island. They are the reason that the interior of the island has been designated a World Heritage Site.

Date of inscription: 1993

This island of granite lies 60 km (37 miles) off the southern point of Kyushu Island and rises to 1,935 m (6,350 feet) above sea level. An annual rainfall of up to 10,000 mm (390 inches), together with a range of different climatic zones, ranging from the subtropical coastal region to the alpine mountain regions, have enabled about 1,900 plant species to flourish. The central, temperate zone is home to a unique primeval forest containing ancient Japanese cedars and sickle pines (*Cryptomeria japonica*). This pine tree, distantly related to the Cedar of Lebanon, is a member of the Cypress family; it grows to heights of 40 m (130 feet) and its timber was traditionally used in Japanese buildings. The timber trade played an important

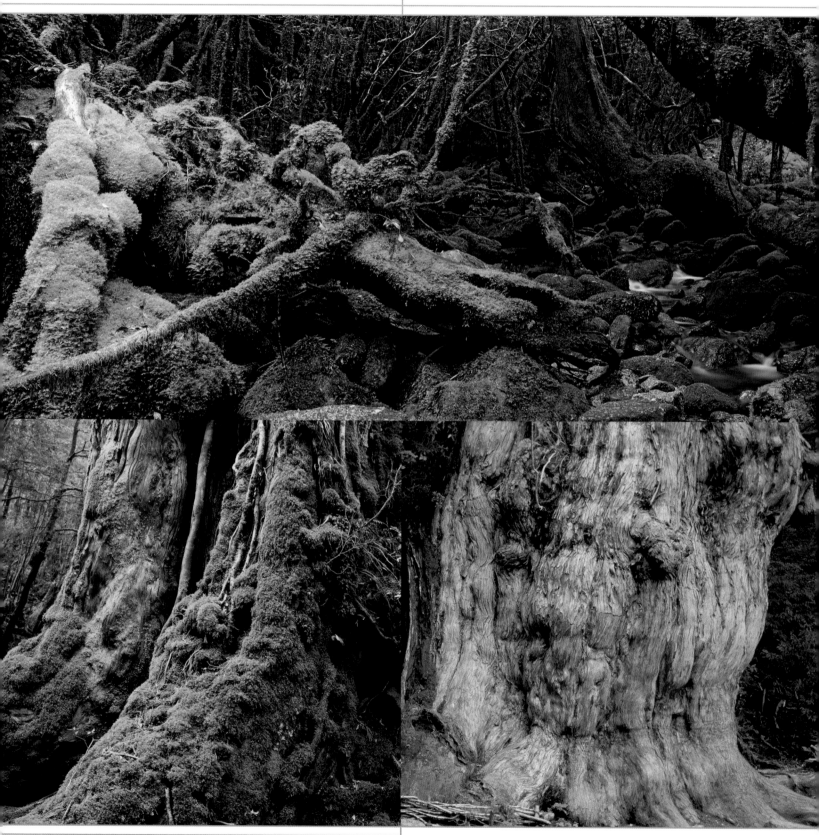

part in the Yakushima economy right up until the 1960s. At that point, one third of the island was declared a national park, mainly due to the large number of impressive giant trees, the most famous of which is the Jomon Cedar, first discovered in 1966. Its trunk has a diameter of 16 m (52 feet) at chest height, and it is reckoned to be about three thousand years old.

The national park's chief attraction is Jomonsugi, the almost untouched wetland forest, with its mosses and lichens, and its impressive Japanese cedars, which are venerated as sacred trees (*Yakusugi*). This is where the Jomon Cedar, thought to be three thousand years old, is to be found (image, below middle).

THUNG YAI AND HUAI KHA KHAENG WILDLIFE SANCTUARIES

Taken together, these forest sanctuaries, Thung Yai and Huai Kha Khaeng, in western Thailand, cover an area of 6,100 sq. km (2,350 sq. miles) and constitute one of south-east Asia's largest wildlife reserves.

Date of inscription: 1991

In the mountainous country along the Burmese border, where rivers and streams rush down slopes that vary in height from 250 m (820 feet) to 1,800 m (5,900 feet), savanna-type highlands (Thung Yai) alternate with dense forests that consist primarily of bamboo, though tropical trees such as teak also grow here. Indeed, there is scarcely any plant species native to the south-east Asian mainland that does not grow here. The region is also home to about 120 species of mammals, 400 bird species, more than 100 types of river fish, almost 50 amphibian species, and about 100 types of reptiles.

These protected areas were deliberately not registered as national parks, since this would have required opening them to the public, as is the case

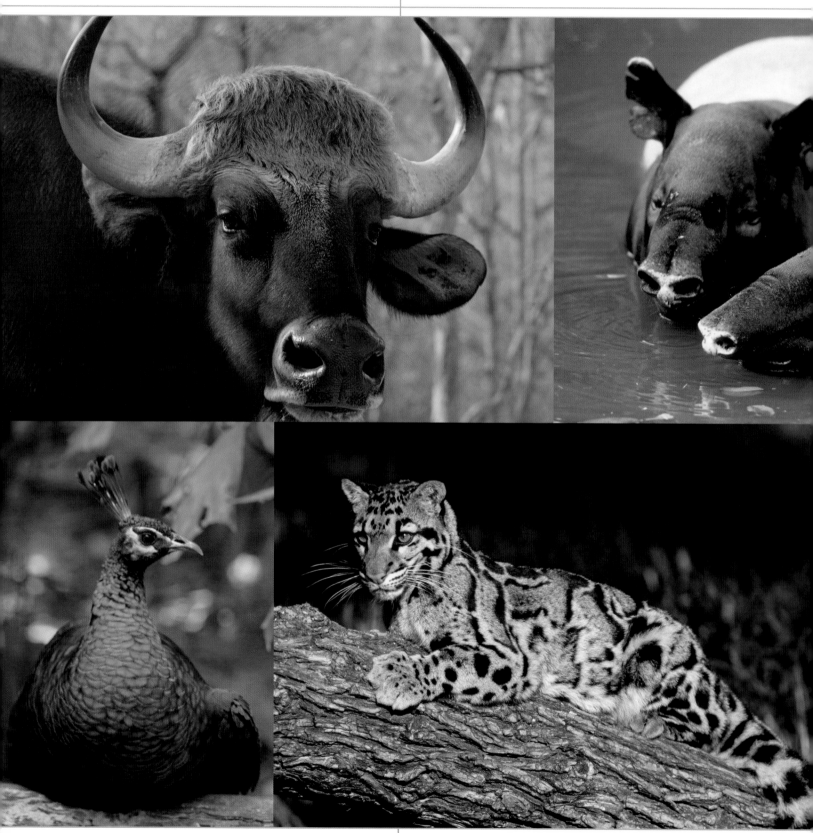

with the national parks to the south and east of the Sri Nakharin dam. Special permission is needed to visit Thung Yai and Huai Kha Khaeng. As a result, large mammals such as tigers, leopards, clouded leopards, elephants, bears, and tapirs are able to live almost completely undisturbed by humans, though under the watchful supervision of the keepers. It is, however, permitted to log tropical timber within a prescribed area.

In the grasslands and evergreen forests (left) a wide variety of animal species can be found, such as gaur (a wild ox), tapirs, Asian water buffalo (above, left to right), green peafowl, clouded leopards, hog deer, and the northern pig-tailed macaque (below, left to right)

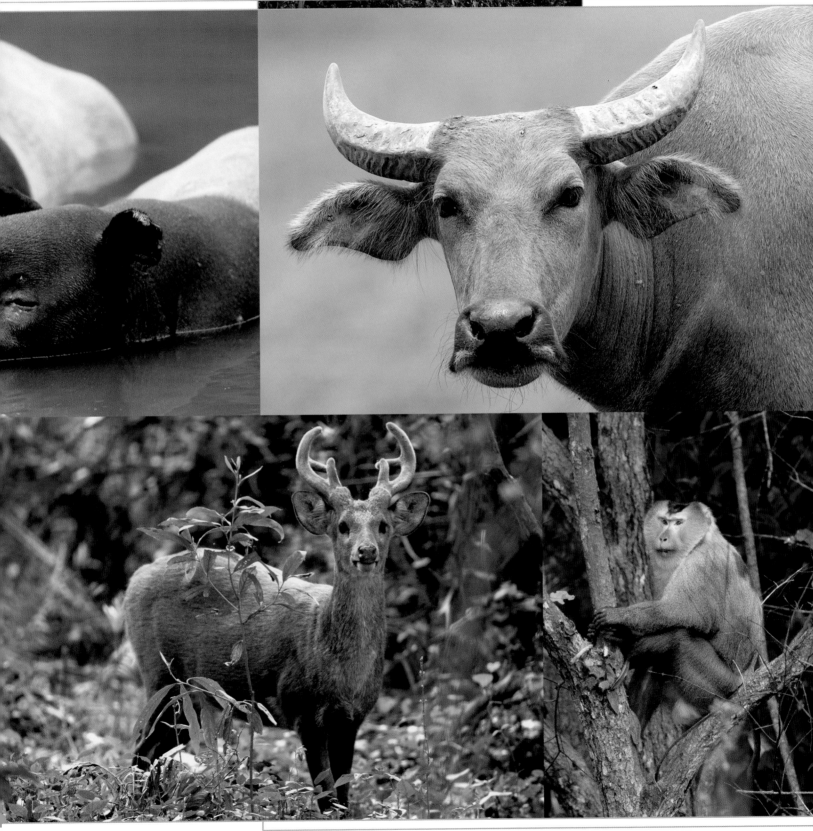

DONG PHAYAYEN– KHAO YAI FOREST AREA

The huge tropical forest of Dong Phayayen–Khao Yai covers more than 6,000 sq. km (2,300 sq. miles) and constitutes an ecologically valuable refuge for endangered mammals, birds, and reptiles.

Date of inscription: 2005

This forest area lies in the rough hill and mountain landscape that rises 100 to 1,350 m (330 to 4,430 feet) above sea level, and extends from the southern part of the Khorat plateau to the Cambodian border. It comprises the four national parks, Khao Yai, Thap Lan, Pang Sida, and Ta Phraya, and the Dong Yai Wildlife Reserve. There are several vegetation zones, ranging from rainforest to bush and grassland, in which 800 animal species flourish. The average annual rainfall varies between 3,000 mm (120 inches) in the west (the Khao Yai National Park) and 1,000 mm (40 inches) in the east (Ta Phraya National Park). Most of the rainfall comes during the monsoon season, which lasts from May to October. During the long dry season that starts in November, the evergreen forests remain sufficiently damp, but the mixed deciduous forest further to the east tends to dry out. There are extensive bamboo forests in Pang Sida.

In the Dong Phayayen–Khao Yai region there are almost 400 types of birds, including endangered species such as copper doves, maroon orioles, green peafowl, and the masked fin-

foot. Among the world's most endangered mammals are the Indian elephant – Khao Yai has the largest herd, with 200 elephants – and various wild cat species. These include Bengal cats, clouded leopards, tigers and their relations, marbled cats (which, although related to tigers, are no bigger than domestic cats), and Asiatic gold cats, the latter being practically extinct everywhere else due to the destruction of the rainforest. This forest area is also a refuge for bear macaques and capped gibbons, as well as Malaysian bears, Asian wild dogs, and large spotted civets. In addition, there are wild cattle species such as the banteng, serow, and gaur, and the hairy-nosed otter, as well as more than 2,000 reptile and amphibian species.

Although extensively depleted by humans, the Dong Phayaen–Khao Yai area still contains expanses of primeval forest (large image, left). Khao Yai is the most accessible of these four national parks (image inset, below: hanging bridges; below: primeval forest giant, with air roots).

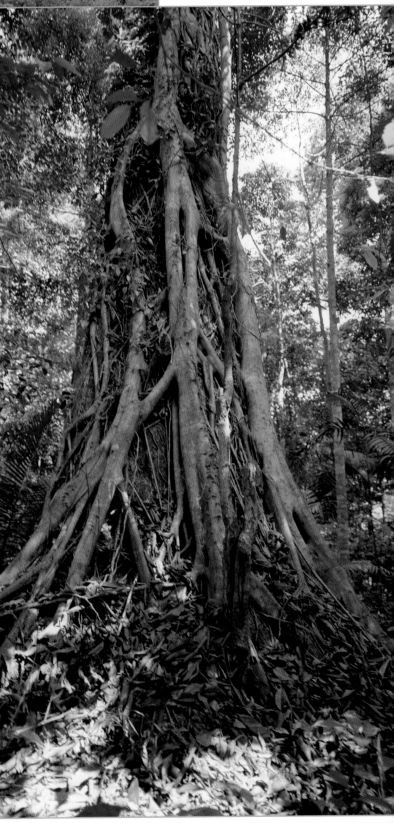

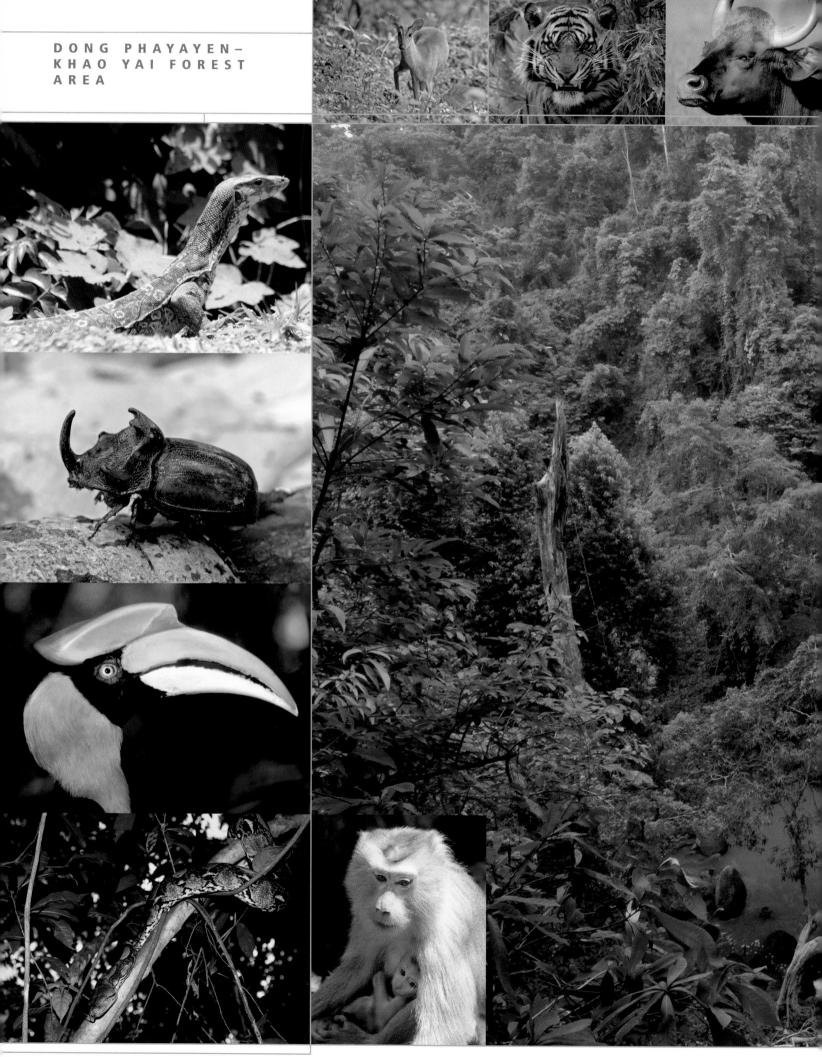

This rainforest (the image shows the Nam Tok Haeo Suwat waterfall in the Khao Yai National Park) is a wildlife refuge for about 8,000 animal species. In addition to mammals (small images above, left to right: muntjac, tiger, and gaur; below left: bear macaque) there are numerous bird, reptile, and insect species to be found (column from top to bottom: iguana, stag beetle, great hornbill, and Burmese python).

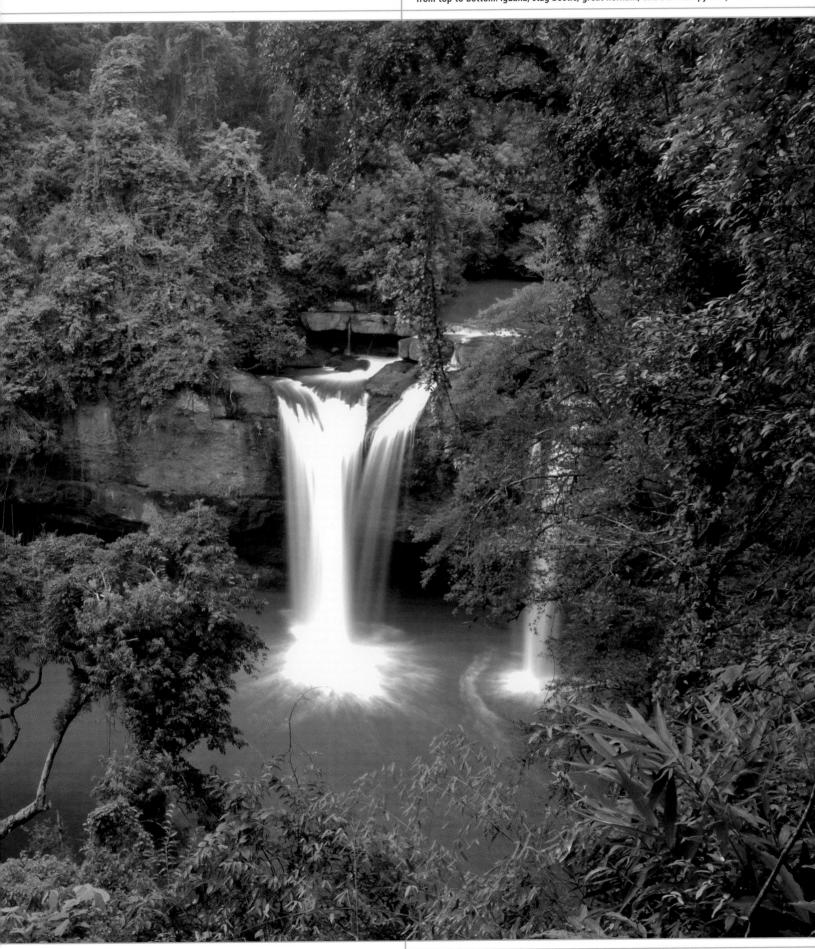

HALONG BAY

Situated in the Gulf of Tonkin in North Vietnam, this island landscape with its bizarre shapes contains about 2,000 limestone islets and cliffs. Wind, weather, and time have conspired to create this dramatic natural artwork.

Date of inscription: 1994; Extended: 2000

Halong bay contains dense clusters of limestone karsts that rise out of the water, achieving heights of up to 100 m (330 feet), and are reminiscent of Chinese landscape paintings. The cliffs and mountains present an extraordinary variety of shapes: the range extends from broad-based pyramids to high overarching "elephant backs" and slim needles.

The inhabitants regard this island landscape as the result of mythical events rather than as a natural phenomenon. A dragon (Ha Long, hence the name) is supposed to have fallen from the mountains, or out of the sky, and to have created this natural wonder when he destroyed an invading army with great blows from his mighty tail – or maybe he was simply

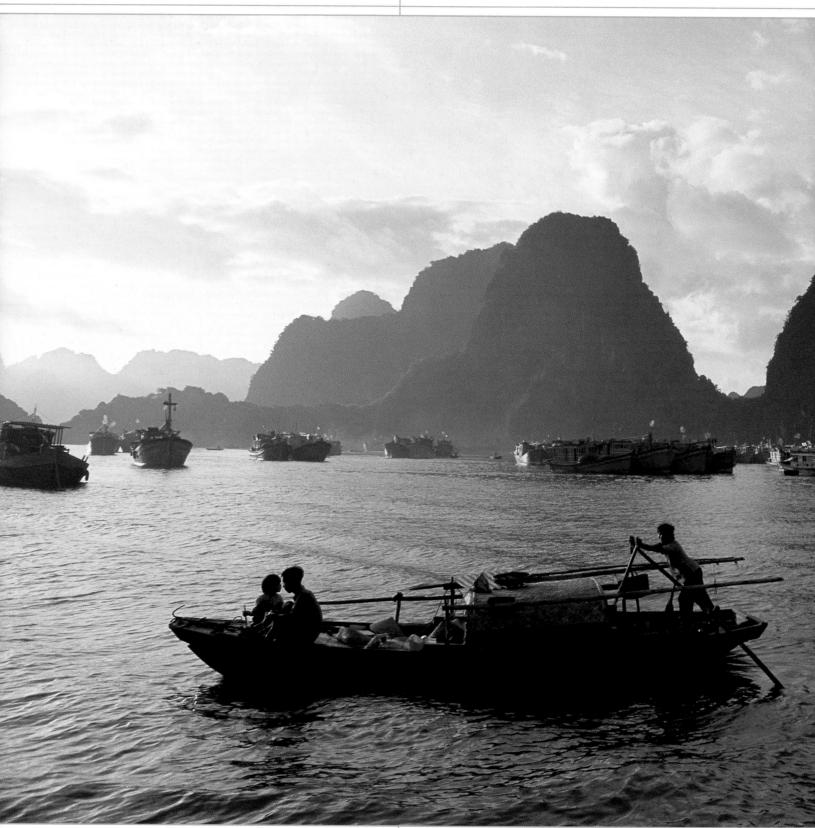

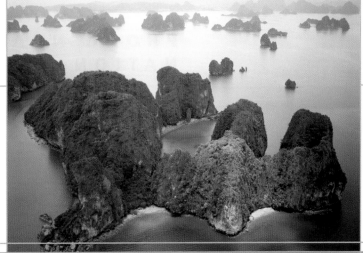

giving vent to his rage at being disturbed? The channels and gorges thus created were flooded with water when the dragon dived into the sea. The geological facts are rather less dramatic: after the last ice age, the thick limestone layer along this part of the coast sank and was covered with water. These bizarre forms are the result of erosion.

Halong Bay is home to a brisk boat traffic (large image). Almost every one of these innumerable islets has its own name (left). Many caves and stalactite caverns can only be reached at low tide (image inset, below).

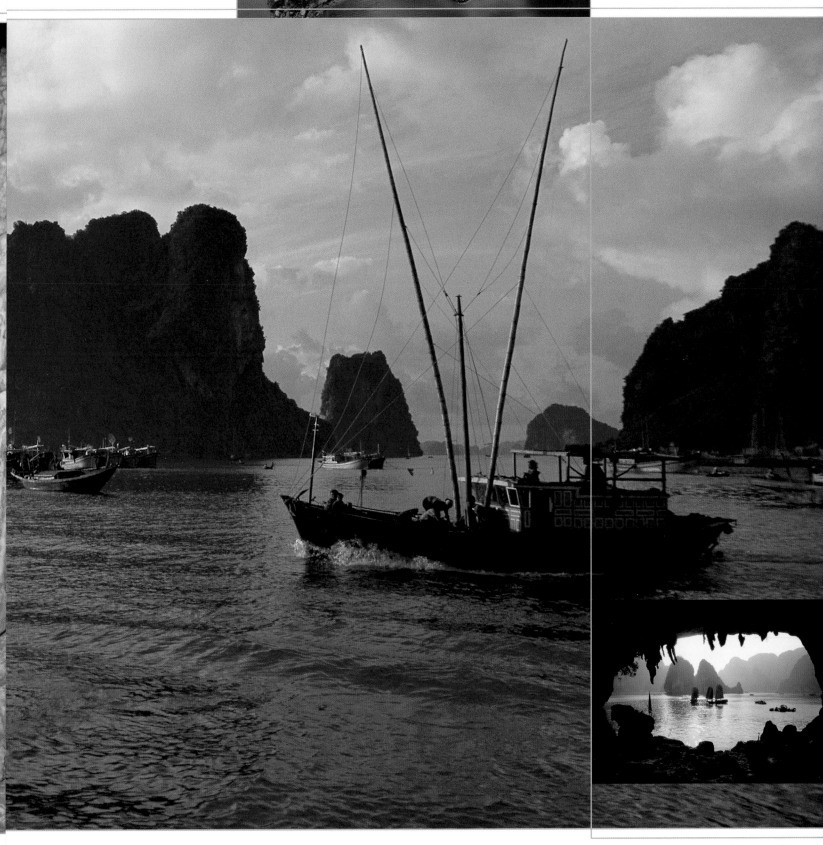

KINABALU NATIONAL PARK

Kinabalu National Park is in the Malaysian province of Sabah, at the northern end of the island of Borneo. It is particularly famous for its very ancient flora and its mountain, which is the highest in south-east Asia.

Date of inscription: 2000

Mount Kinabalu forms an impressive focal point for this park – it is 4,095 m (13,435 feet) high, and is the highest mountain between the Himalayas and New Guinea. This site features a great variety of flora, ranging over very different zones, starting with the topmost alpine region. In the lowest area, the tropical rainforest contains more than 1,200 wild orchid species and many rhododendrons. The flowers vary in hue from the deepest red to pale pinks and whites. Further up, in the highlands, the mountain forests feature 40 different types of oak, their branches draped in mosses and ferns, which then give way to pine woods. Closest to the summit lies an alpine region of meadows and shrubs, along with other forms of dwarf vegetation.

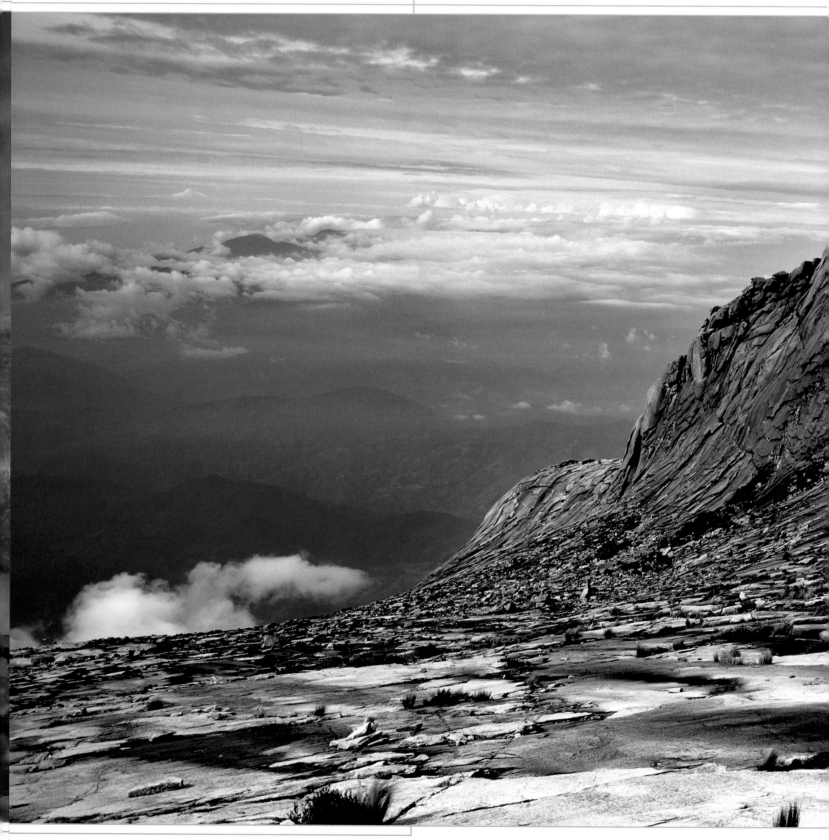

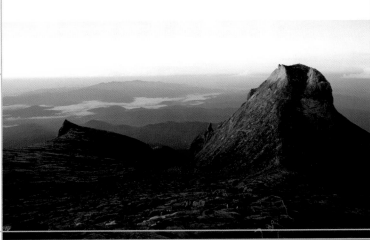

The jagged peak of Mount Kinabalu in Borneo looms over the Kinabalu National Park, and offers a fascinating panorama of the surrounding mountains and low-lying country, with their varied habitats.

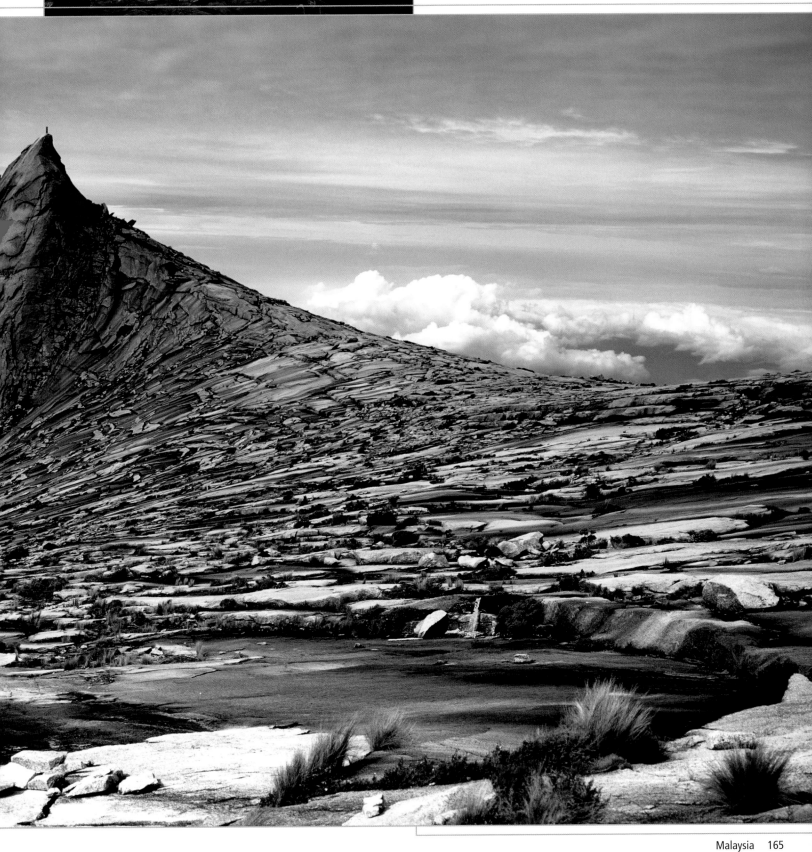

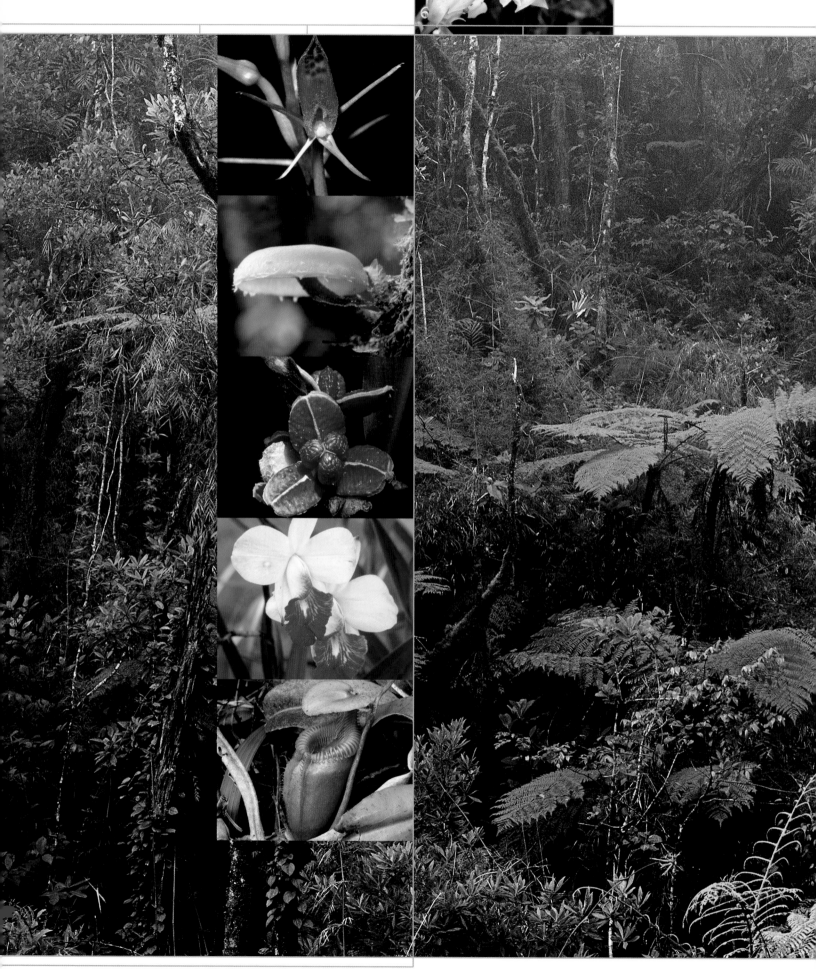

The rainforests of south-east Asia form a complex ecosystem that has developed over millions of years, and they are among the most species-rich habitats in the world (large image). Kinabalu National Park alone contains almost as great a variety of flora as can be found in Europe. Among these are orchids (small image left, and first and fourth image in column), fungi, ginger, and cannas (second, third, and fifth images in column).

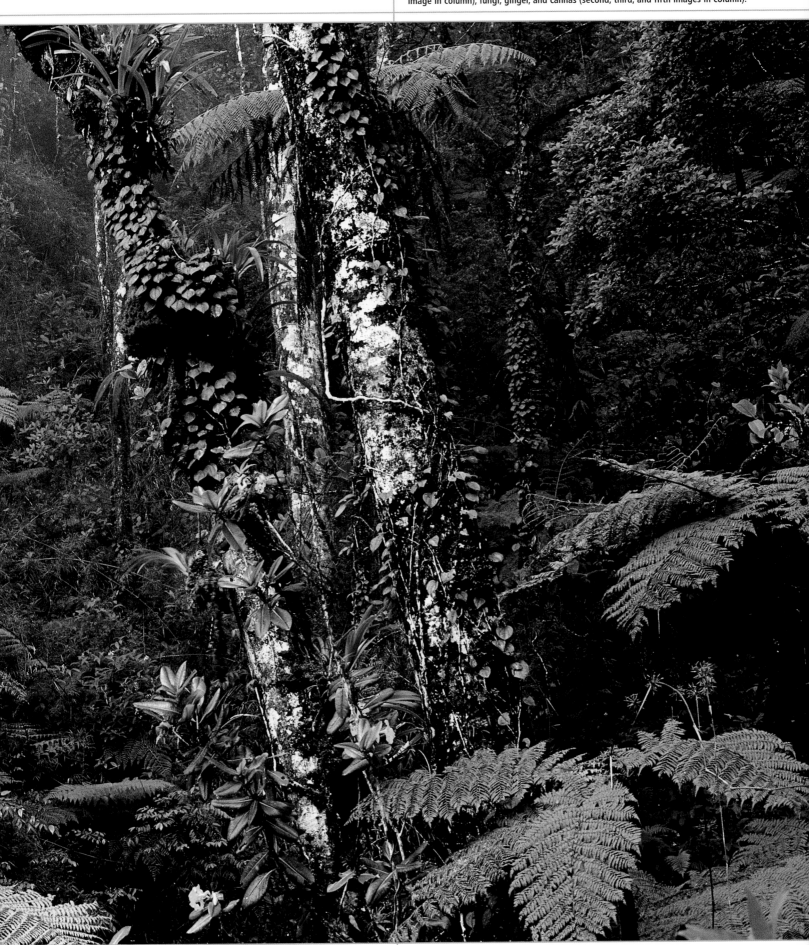

GUNUNG MULU
NATIONAL PARK

The world's largest complex of caves can be found in the spectacular mountains of the Gunung Mulu National Park in the Malaysian province of Sarawak in Borneo.

Date of inscription: 2000

This cavernous landscape first began to emerge some thirty million years ago. Back then, a layer of volcanic rock that had been ground into sand and sediment was covered by the sea. Over millions of years, corals and other marine creatures formed limestone deposits on top of it.

Changes in sea level forced the land to warp, so that mountains such as Gunung Api (1,750 m; 5,741 feet), consisting of extremely pure limestone, rose up next to the sandstone. The latter can be found on the highest peak, Gunung Mulu (2,377 m; 7,799 feet), after which the park is named. Over millions of years, rivers tore through this huge system of caves, which are inhabited by numerous bats and insect species, and hollowed them out.

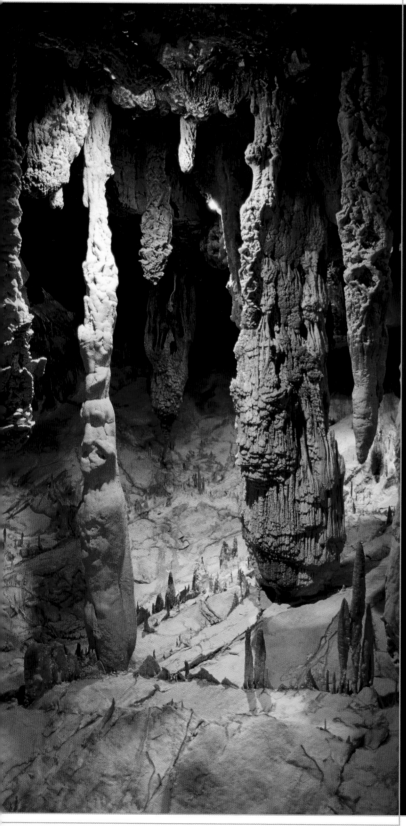

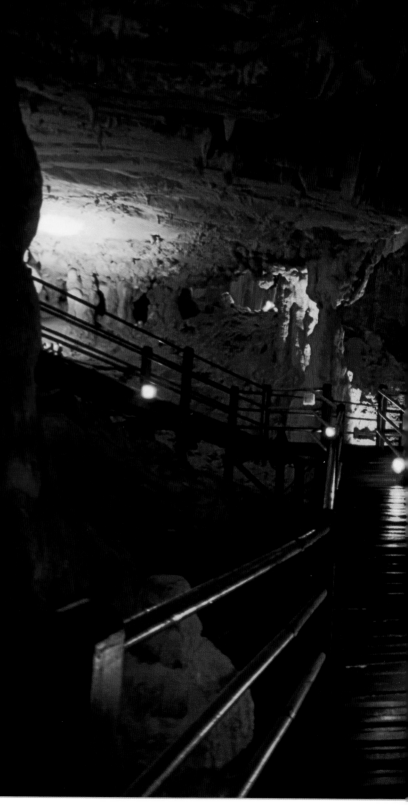

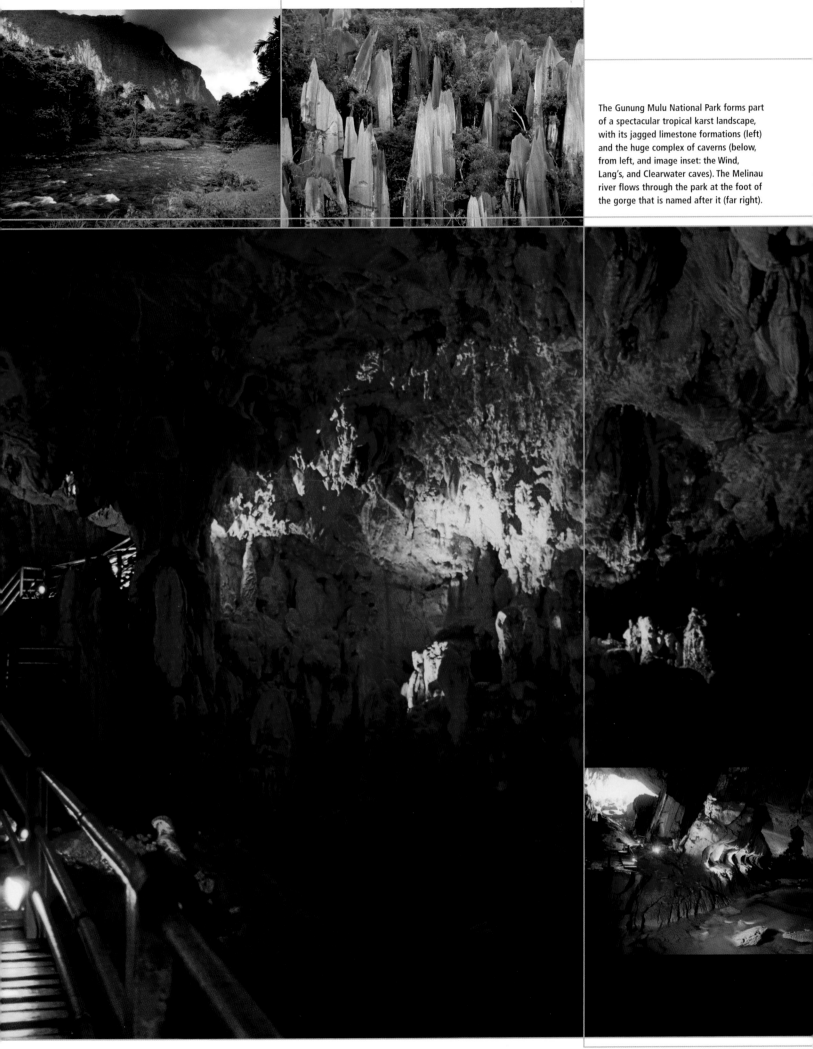

The Gunung Mulu National Park forms part of a spectacular tropical karst landscape, with its jagged limestone formations (left) and the huge complex of caverns (below, from left, and image inset: the Wind, Lang's, and Clearwater caves). The Melinau river flows through the park at the foot of the gorge that is named after it (far right).

PUERTO PRINCESA SUBTERRANEAN RIVER NATIONAL PARK

The main attraction of this national park with its tropical karst landscape is the navigable subterranean river, the longest in the world.

Date of inscription: 1999

This national park is situated about 80 km (50 miles) to the north-west of Puerto Princesa, the capital of the island of Palawan. Its most impressive features are the limestone formations in the St Paul mountain range. Mount St Paul rises to a height of 1,027 m (3,369 feet) and is the highest peak in a chain of rounded limestone mountains that runs from north to south.

The flora and fauna on Palawan are clearly differentiated from those on the other islands of the Philippines. This island has more in common with the natural landscape of Borneo. The different soils have given rise to three types of forest. The hardwood forest in the low-lying land contains the richest tree flora in the whole of Asia. The karst areas are less densely wooded,

and the coastal forests give way to stretches of seaweed, and, in Ulugan Bay, to huge mangrove swamps. The offshore coral reefs are home to turtles, and enormous numbers of bats live in the caves. The indigenous fauna includes various skunks, porcupines, and shrew species. The bird population is particularly varied in this region, and kingfishers, owls, and sea

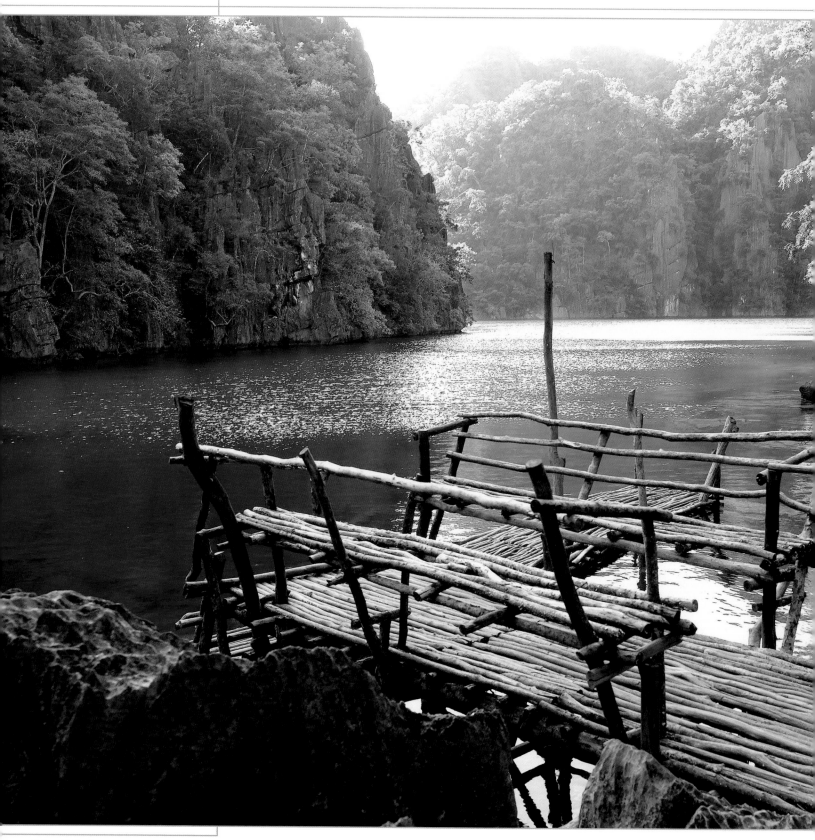

eagles are among the species present. The main geological attraction here is an underground river, which flows for a distance of about 8 km (5 miles) – more than 4 km (2.5 miles) are navigable – and in the process has hollowed out a sequence of enormous caves. These caverns can rise to heights of 60 m (200 feet) and they are filled with huge, strangely shaped stalagmites and stalactites, which also feature in the smaller caves. This cave-system terminates in a large grotto, where daylight can enter.

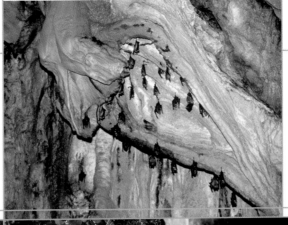

The landscape of the national park with its limestone and karst features (below) is traversed by an underground river, which rises about 2 km (1.2 miles) southwest of Mount St Paul, and then, having followed an almost entirely subterranean route, emerges into the light of day in St Paul's Bay. Many of the caves here provide an ideal habitat for tiny pipistrelle bats (*Pipistrellus pipistrellus*).

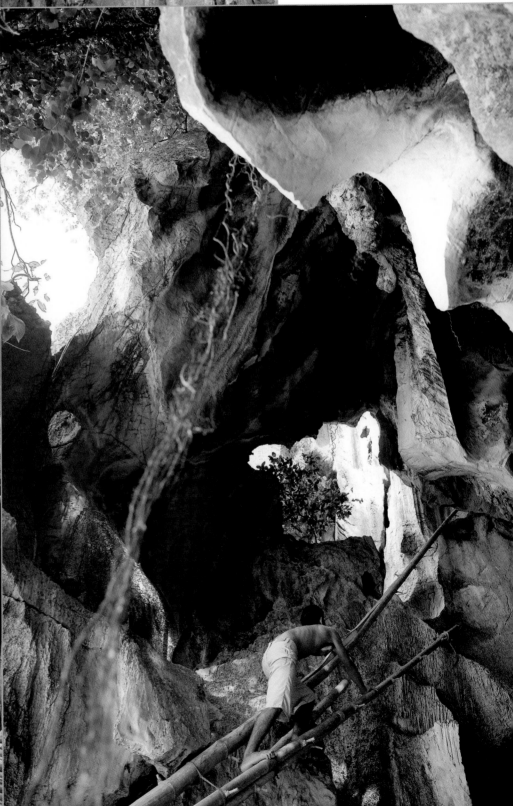

TUBBATAHA REEF MARINE PARK

This maritime national park in the middle of the Sulu Sea consists of two ring-shaped atolls, which are famous for their extensive coral reefs and fascinating underwater world.

Date of inscription: 1993

About 180 km (110 miles) from the south coast of Palawan Island lie two small atolls, which represent the central point of this marine park. These atolls are very hard to reach; they stand only 1 m (3 feet) above sea level, and thus offer an almost undisturbed habitat for a great number of different creatures. For instance, they are home to the now rare hawksbill and green turtles, as well as all kinds of swallows and boobies, and numerous corals – there are more than 40 kinds, including branching and cabbage corals.

The larger northern reef is also known as "Bird Island," and forms an oval approximately 16 km (10 miles) long and 4.5 km (2.8 miles) wide, surrounding a lagoon of coral sand, and

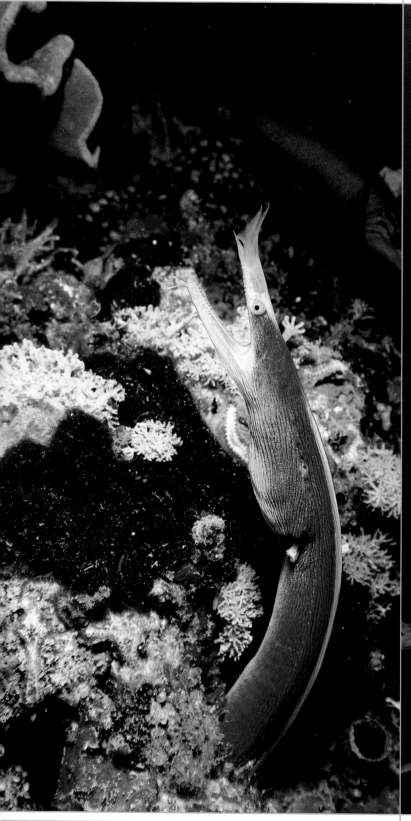

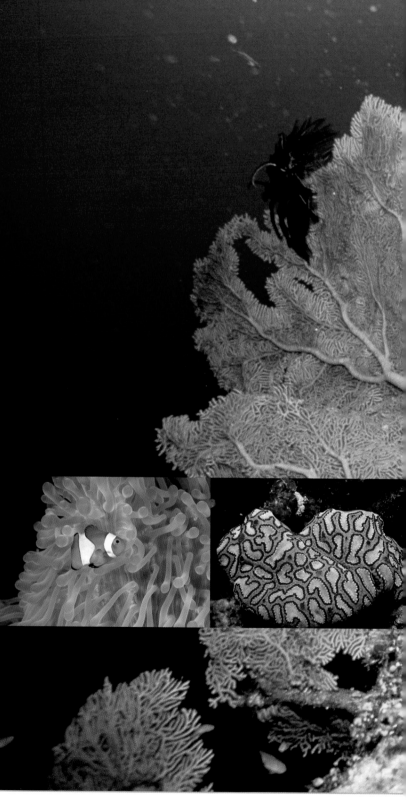

thus providing an ideally sheltered nesting site for birds.

The southern atoll is the smaller of the two, and they are separated by 8 km (5 miles) of sea. With about 380 species of fish belonging to at least 40 genera, this park contains an even more diverse underwater world. Along with reef sharks, eagle rays and manta rays can also be seen here.

The maritime park's underwater world includes ribbon eels (below left), giant squirrel fish (large image), clownfish, and sponges (images inset below, left). This view of clouds surrounding this World Heritage Site (left) was taken from the space shuttle *Endeavour*.

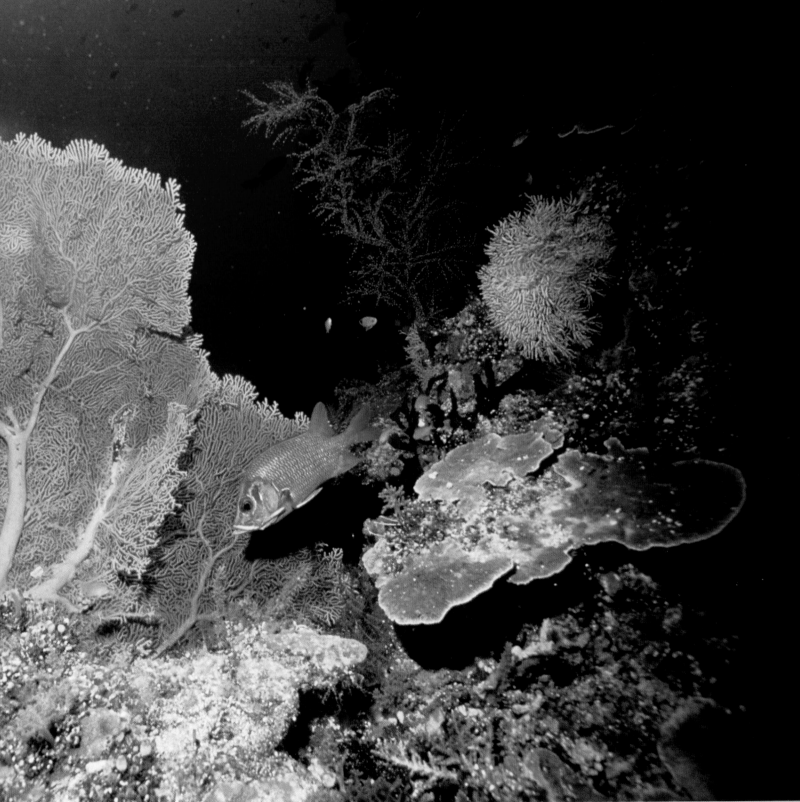

THE TROPICAL
RAINFOREST OF SUMATRA

Three national parks have been combined here to form one World Natural Heritage Site, and they protect one of the world's last large continuous rainforest sectors.

Date of inscription: 2004

This World Natural Heritage Site includes the Gunung Leuser National Park in the north and Kerinci Seblat in the central part, as well as Bukit Barisan Selatan, which lies further to the south of Sumatra. Around 10,000 plant species flourish in this area, including 17 endemic plant types. More than 50 percent of the plant types present in Sumatra can be found beneath the flowering canopy. Among the most famous are the largest flowers in the world *(Rafflesia arnoldii)* and the flowers with the tallest blooms, the Titan arum *(Amorphophallus titanum)*. The variety of fauna is just as great, and only part of it has been classified scientifically. To date, 580 bird species have been identified, of which 21 are endemic. The most spectacular animals

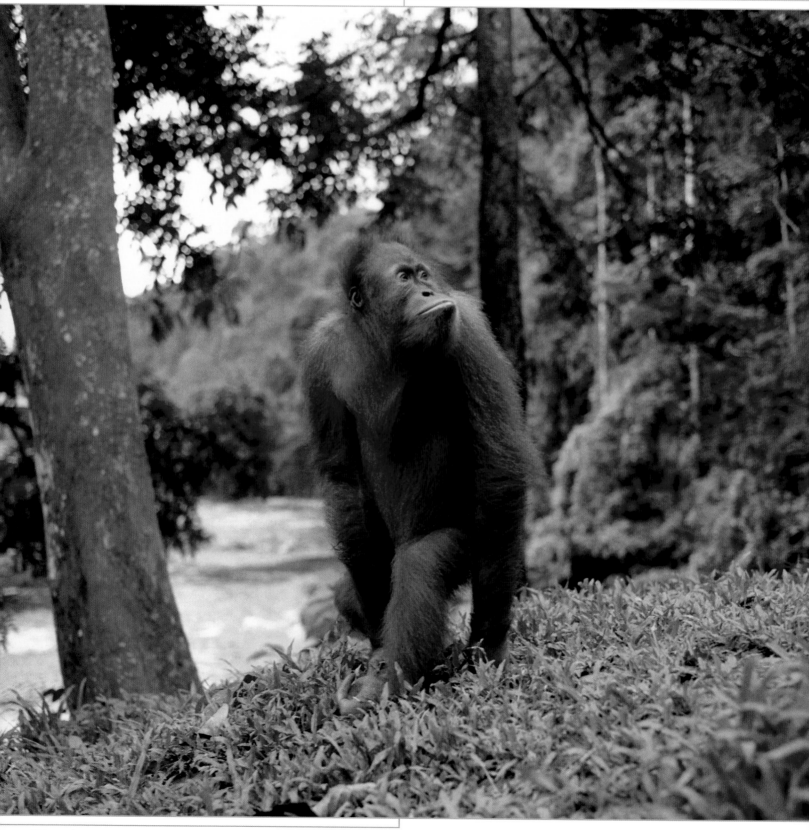

to be found here are the orang utan, tiger, rhinoceros, elephant, serow, tapir, and cloud leopard.

This high level of biodiversity corresponds to a wide range of geological formations and habitats. In addition to the tropical rainforest, there are high and beautiful mountains, with forests, lakes, volcanoes, fumaroles, waterfalls, caves, and wetlands.

The Gunung Leuser National Park rainforest (below, middle) is a refuge for threatened animal species, including orang utans (below, left and right). In the communities of these "people of the forest" (the literal meaning of orang utan), the young are raised by females. Captive animals are taught how to survive in the wild in the Orang Utan Rehabilitation Center.

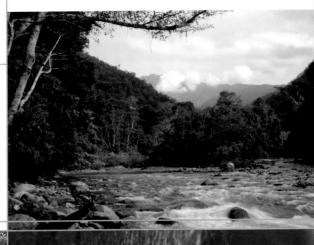

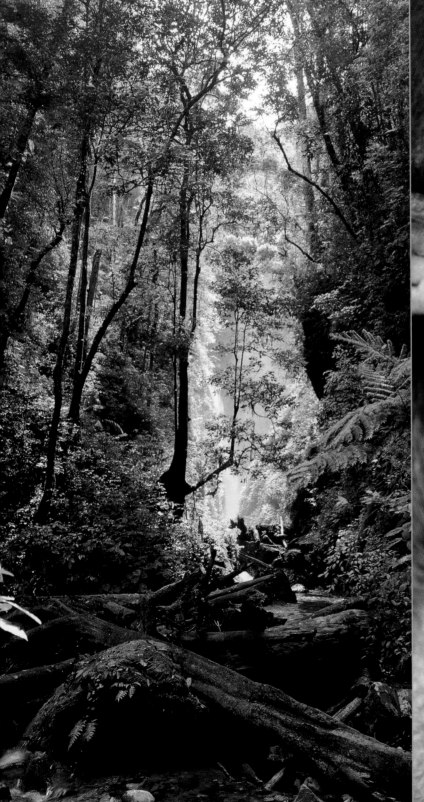

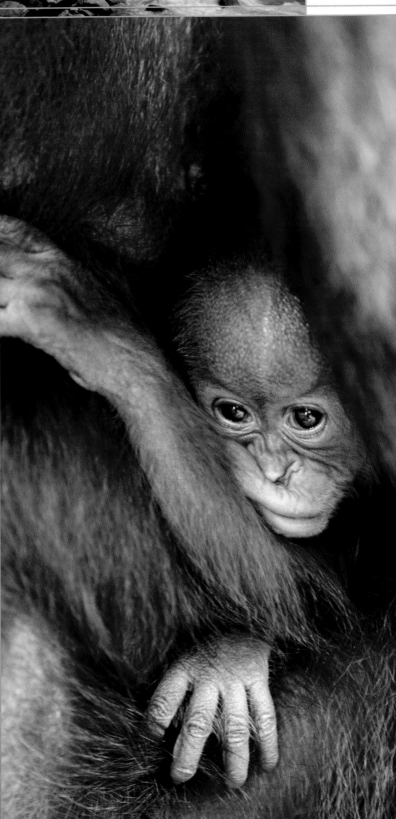

THE TROPICAL RAINFOREST OF SUMATRA

A characteristic feature of the tropical rainforest in Sumatra (below: Kerinci Seblat National Park) is its "three-storeyed" nature. The crowns of the giant trees, which can reach heights of 70 m (230 feet), poke out from the canopy like islands. The storey beneath is made up of trees that grow from 15 to 50 m (50 to 164 feet). This is where about two-thirds of all the plant and animal species live, since scarcely any light can penetrate at the lowest level.

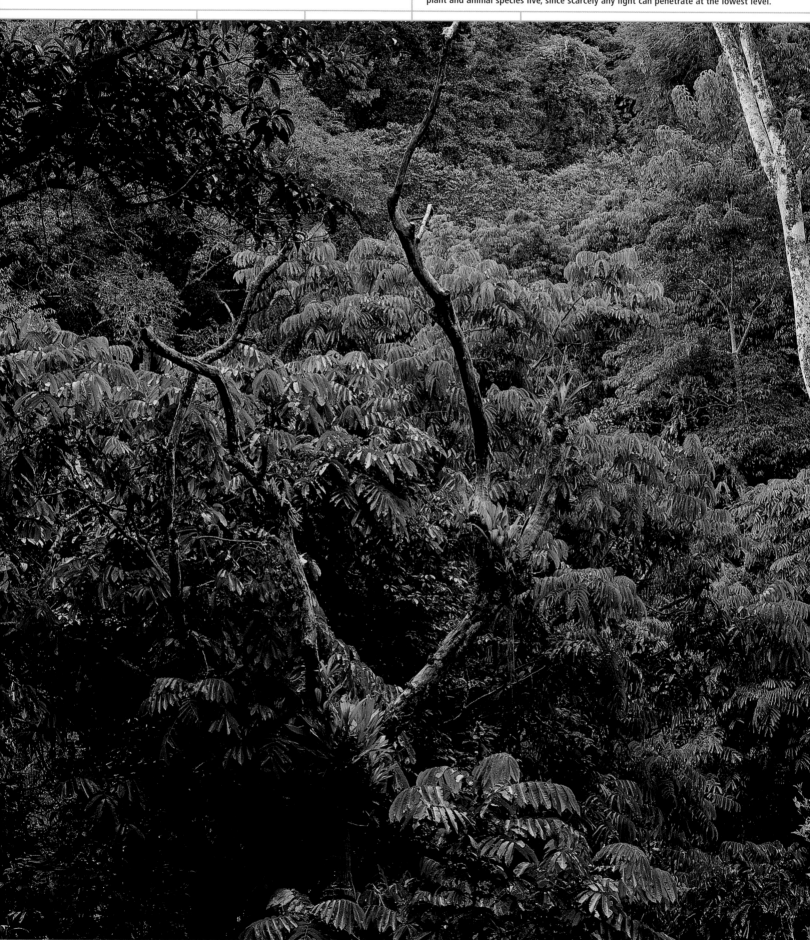

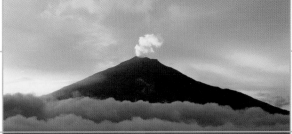

The 3,805-m (9,200-foot) high Gunung Kerinci (left) in the national park of the same name is an active volcano, and Sumatra's highest peak. Its steep, pointed shape is typical of this type of volcano, which is made up of alternating layers of hardened lava and ash.

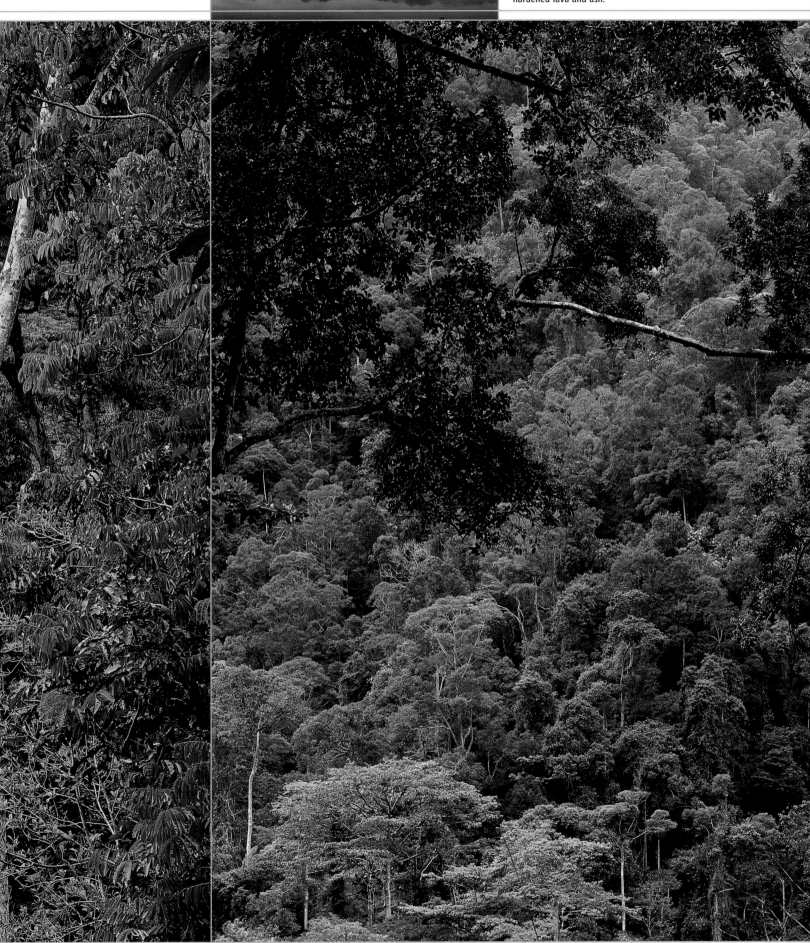

Threatened Giants

It is thanks to the diverse habitats and climatic conditions of the Indian subcontinent and South-East Asia that a very varied vegetation has been able to develop. This wealth of different types of plant life dates back to 15 million years ago, when India as we know it today was joined to the southern coast of Asia, and Africa lay close to Europe, forming an African–Eurasian–Indian land bridge with corridors to the north-west and north-east. Hence mammals such as elephants, lions, gazelles, and jackals were able to migrate along the corridor and move from Africa to the Indian subcontinent. This was undoubtedly also the origin of the enormous and partly endemic plant life that exists in this part of the world, where the predominantly warm and moist climate has given rise to a huge number of

The foul smelling *Rafflesia arnoldii* is the largest flower in the world.

plant shapes, sizes, and hues. Alongside palms and bamboos, and hardwood trees such as teak, smaller ferns, orchids, and rare carnivorous plants, such as cannas, flourish.

As a result, a whole host of superlatives have to be used to describe the plants of South-East Asia, which include the world's largest and the tallest flowers. Nevertheless, there is a real risk that many endemic plants such as the slender Joey palm (*Johannesteijsmannia lanceolata*) will shortly become extinct. Attempts at halting the ongoing large-scale appropriation of land for logging have resulted in the creation of special zones of protection such as this tropical rainforest World Heritage Site in Sumatra.

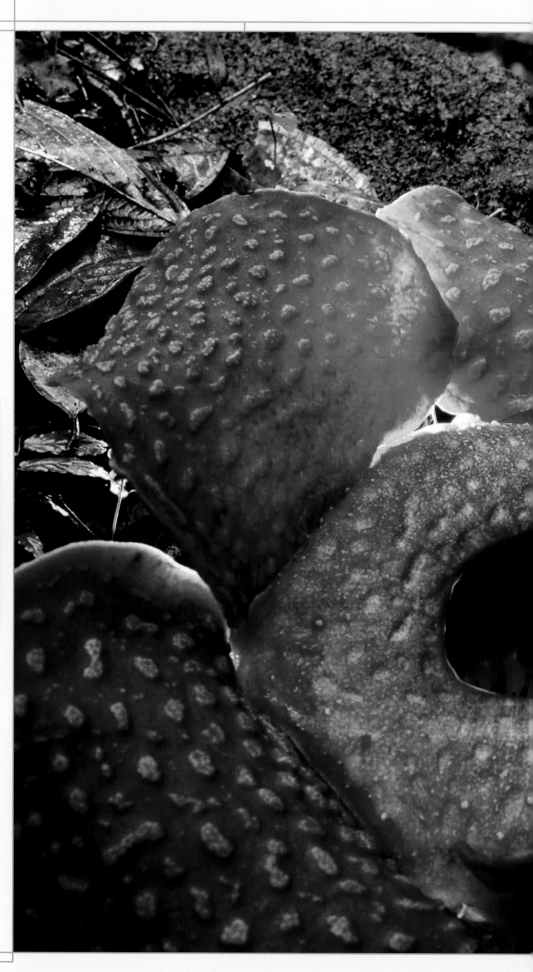

The giant rafflesia (*Rafflesia arnoldii*), with its five red petals, can grow as much as a meter in width, but it only blooms once every three or four years. Once touched, it soon dies. The titan arum (*Amorphophallus titanum* – photo strip, left) also blooms at irregular intervals and produces the world's tallest inflorescence (3 m/10 feet).

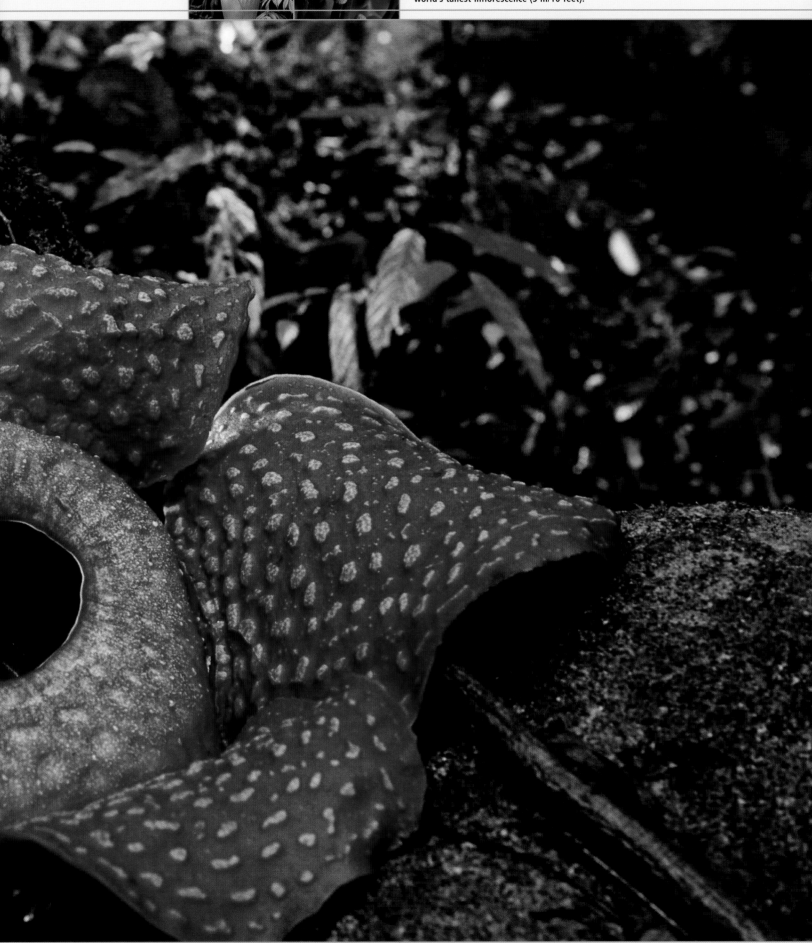

UJUNG-KULON
NATIONAL PARK

Ujung-Kulon was Indonesia's first national park. Its importance resides above all in these last remnants of lowland rainforest and the small population of very rare Javan rhinoceroses.

Date of inscription: 1991

Java is the smallest, but most important, of the Greater Sunda islands in the Malay archipelago. The national park comprises the Ujung-Kulon peninsula in south-west Java and the islands of Krakatau, Pa-naitan, and Peucang in the Sunda Strait. It encloses Javan lowland rainforest, coastal coral reefs, and the flora and fauna on the volcanic island of Anak Krakatau. The most endangered species in the rainforest is the Javan rhinoceros. At one point, poaching had reduced the population to 25, but this now seems to have risen back to 60 animals. The timid Javan banteng is represented more numerously in the national park, along with deer, apes, leopards, saltwater crocodiles, and hornbills.

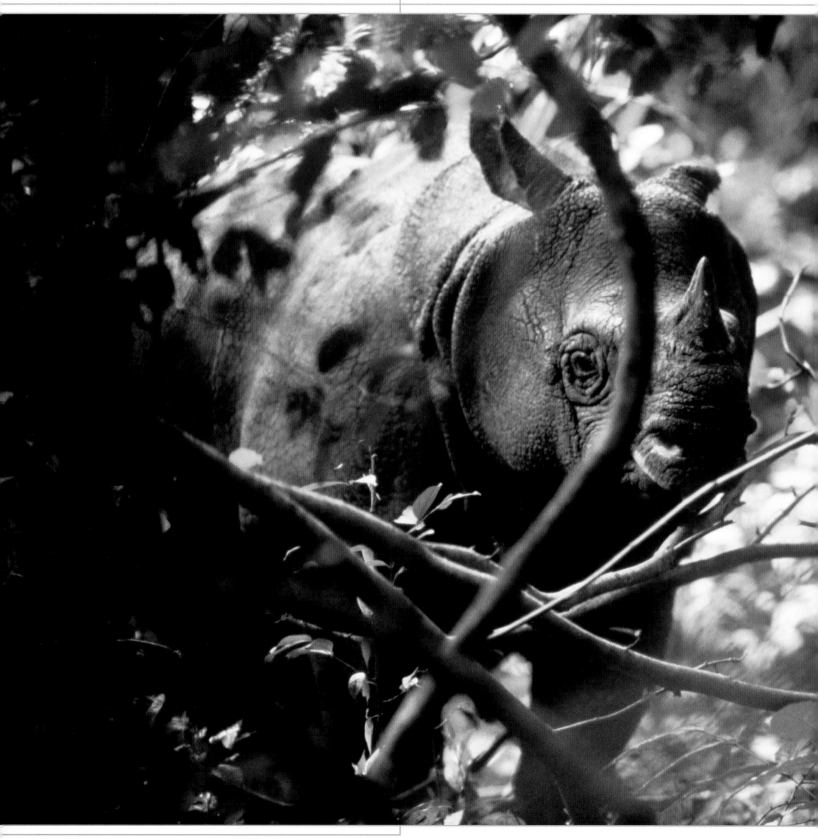

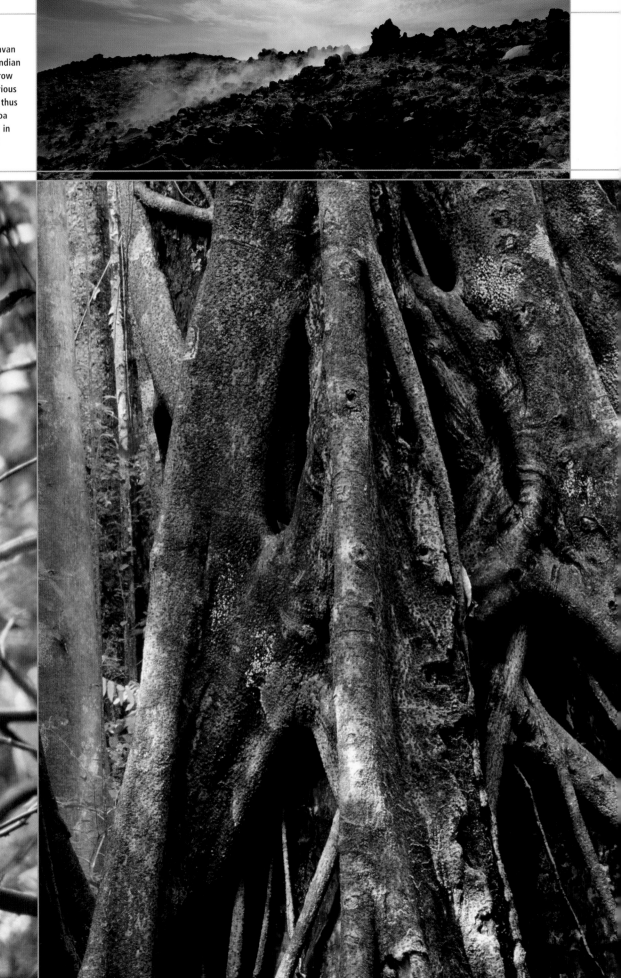

Three of the world's five species of rhinoceros are native to Asia – the Javan (below left), the Sumatran, and the Indian rhinoceros. Banyan figs, which can grow to a height of 30 m (100 feet) on various host trees, send out aerial roots and thus choke the host (below right). Krakatoa was destroyed in a volcanic eruption in 1883, after which the island of Anak Krakatau arose (right).

KOMODO NATIONAL PARK

The Komodo dragon is found in the wild only here, and enjoys ideal conditions for hunting wild pigs and deer in the rainforest and savannah of its protected area in the national park.

Date of inscription: 1991

The national park is not limited to the island of Komodo, which measures only 35 km by 25 km (22 miles by 15 miles) and is part of the Lesser Sunda island chain. It also encompasses the smaller neighboring islands of Padar, Rinca, and Gili Montang, and the west coast of Flores. The abundant vegetation is divided between tropical monsoon rainforest, grassland, and savannah, and in many places there are mangrove forests. The main attraction is the Komodo dragon (*Varanus komodoensis*), the world's largest species of lizard. This diurnal ground-dweller lives on mammals such as wild pigs, deer, larger birds, vipers, and tortoises.

The park authorities estimate the total population of these approxi-

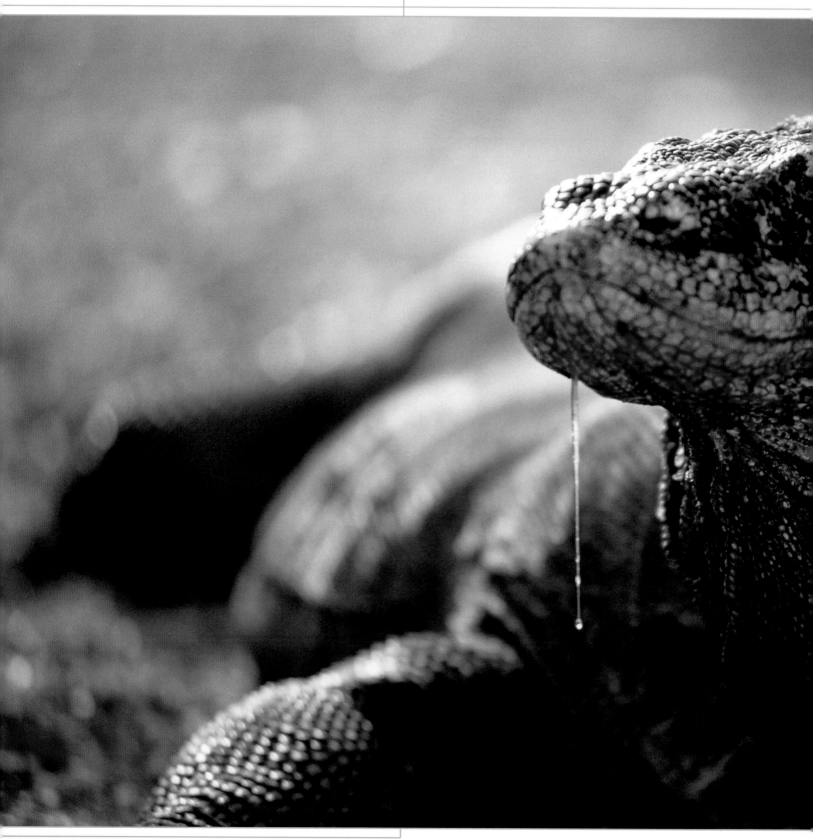

mately 3-m (9-foot) long "dragons" at around 6,000; on the island itself there seem to be at most 3,000 specimens, or perhaps considerably fewer. These can be viewed by tourists accompanied by park wardens. Artificial feeding has reduced many of the giant lizards to lethargy; however, their dangerousness should not be underestimated.

The Komodo dragon uses its long, deeply forked tongue to waft the faintest of scents onto an olfactory organ seated in its palate. It can detect carrion at a distance of 5 km (3 miles). The young have to retreat to the trees to avoid being eaten by their elders. The waters around the island of Komodo are also protected (right).

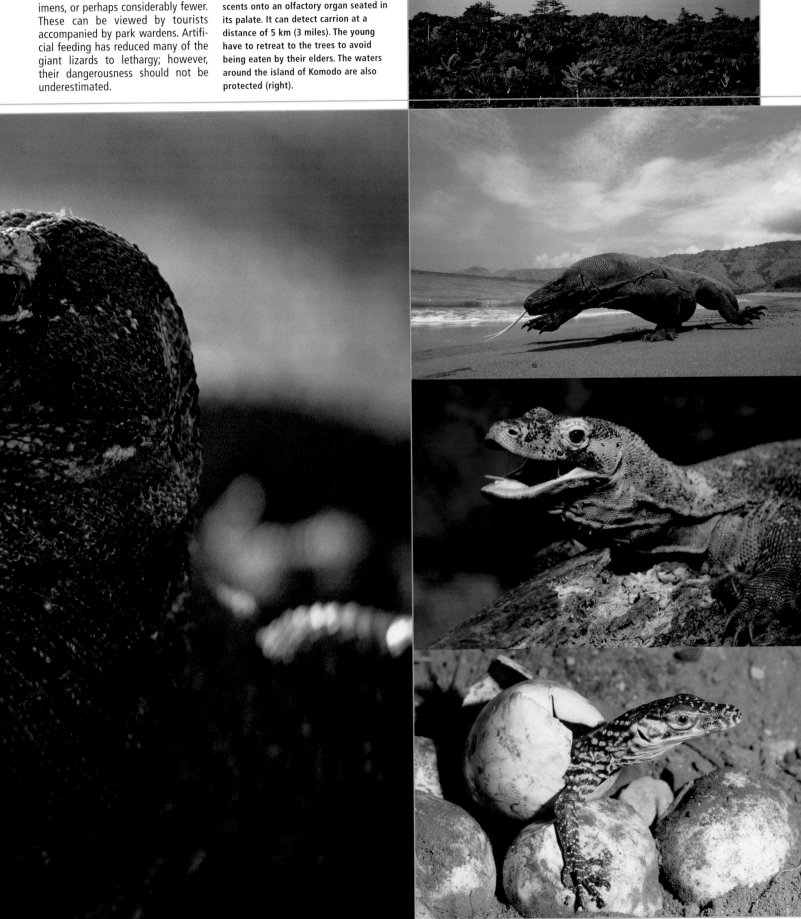

Nowadays, the nature reserve also includes the coral reefs lying along the coast. Within this fascinatingly varied world can be found sea slugs (*Nembrotha kubaryana*, large image) as well as (from top left), emperor angelfish (*Pomacanthus imperator*), Commerson's frogfish (*Antennarius commersonii*), and red lionfish (*Pterois volitans*).

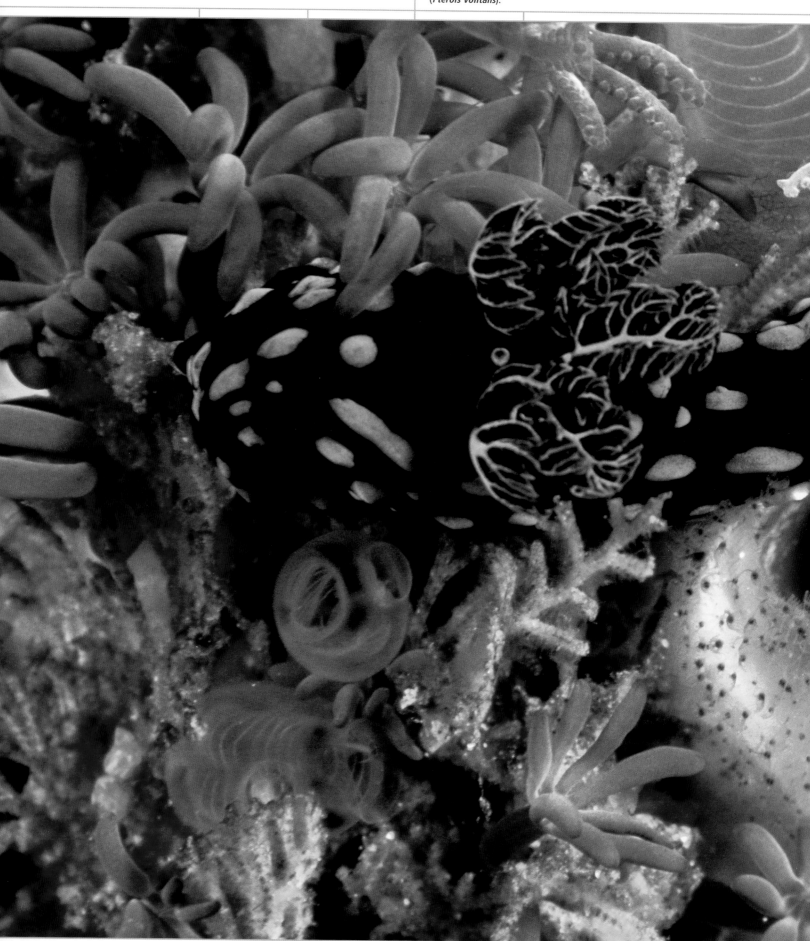

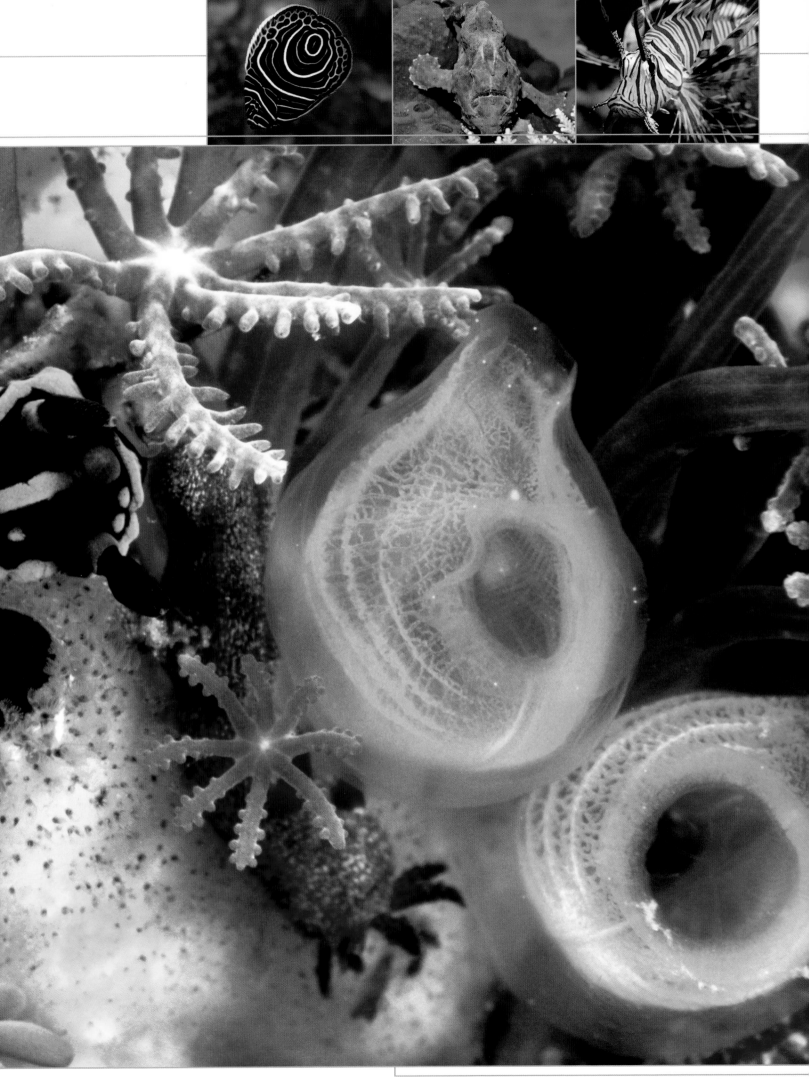

LORENTZ NATIONAL PARK

South-East Asia's largest nature reserve in Irian Jaya, the Indonesian part of New Guinea, combines the most diverse scenery with a variety of flora and fauna.

Date of inscription: 1999

This unique national park boasts a complex geological structure and a variety of species second to none. The area can be roughly divided into swampy lowlands and a higher region of mountains. The central mountainous region arose through the movements of two converging continental plates, a process still not complete today. The glaciated summits of the mountain range reach a height of about 5,000 m (16,400 feet). The lowlands are a swampy plain with largely undisturbed forests, through which stream countless watercourses.

The lowland vegetation consists of simple plant cultures on the beach, and rather more complex ecosystems in the evergreen mixed forest inland. The most varied flora in New Guinea

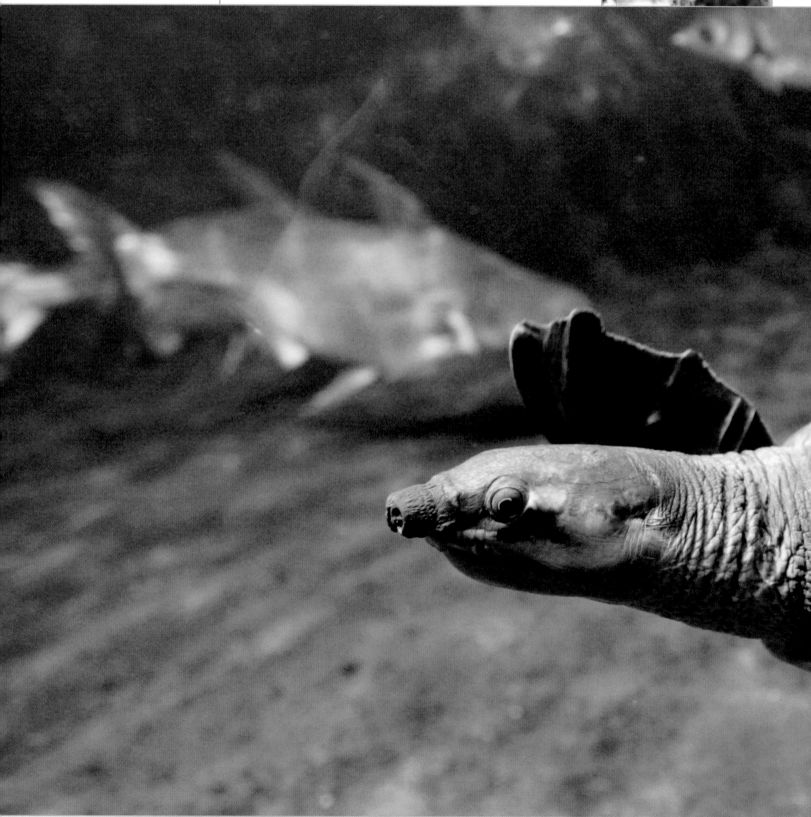

Such a variety of creatures – with such a wealth of endemic species – is to be found hardly anywhere else in Indonesia. The Papuan soft-shelled turtle (large image) lives in rivers and feeds on small fish and crustaceans. The Matschie tree kangaroo (left) is named after a German biologist.

is to be found still further inland, at an altitude of 600–1,500 m (2,000–4,300 feet) – some 1,200 species of tree grow here. Unbroken forest ranges up to an altitude of 4,100 m (13,500 feet), although this has decidedly fewer plant species. Above the tree line only low bushes, grasses, mosses, and lichens can survive.

Many of the bird species found here are endemic, including the various brilliantly hued birds of paradise, whose numbers have been considerably reduced through overhunting for their plumage. Several species of marsupials, tree kangaroos, and monotremes like the echidna are only otherwise found in continental Australia. Around 150 varieties of amphib-

ians and reptiles remain largely unresearched, among them endangered river turtles, rare lizards, and pythons, as well as two species of crocodile. The local waters teem with some 100 species of freshwater fish.
The area of this gigantic national park amounts in total to approximately 25,000 sq. km (9,700 sq. miles).

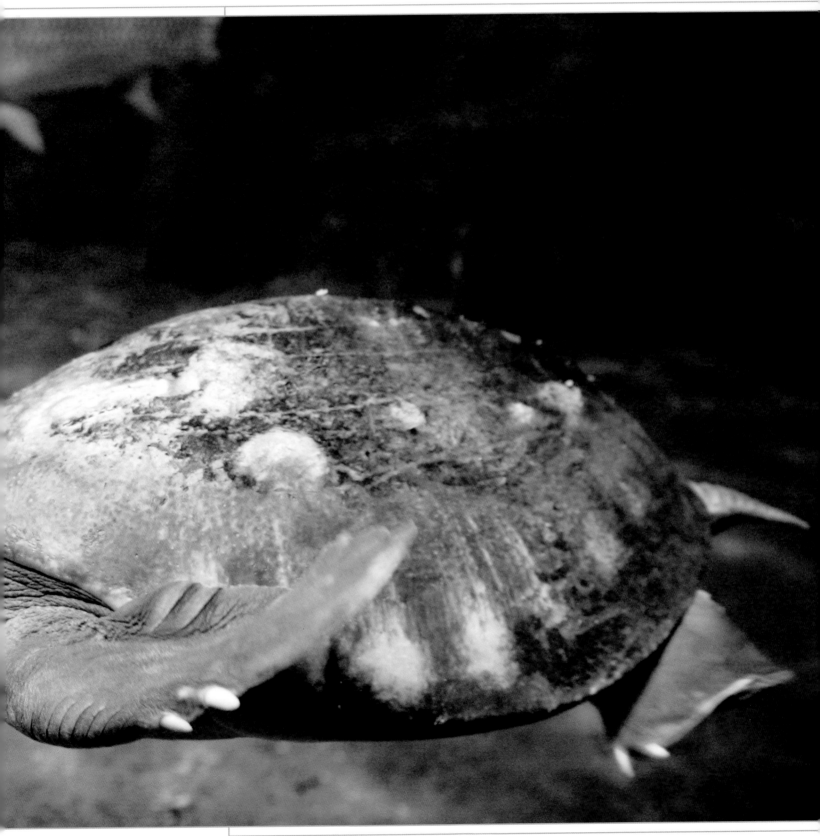

Macquarie Island, lying halfway between Tasmania and the Antarctic, has been described as the "Noah's Ark of the Southern Hemisphere." Southern elephant seals live contentedly here.

The "Walls of China" is a lunette dune in Australia's Mungo National Park, part of the Willandra Lakes World Heritage Site. This rock formation was created by erosion, allowing sand dunes to deposit behind it.

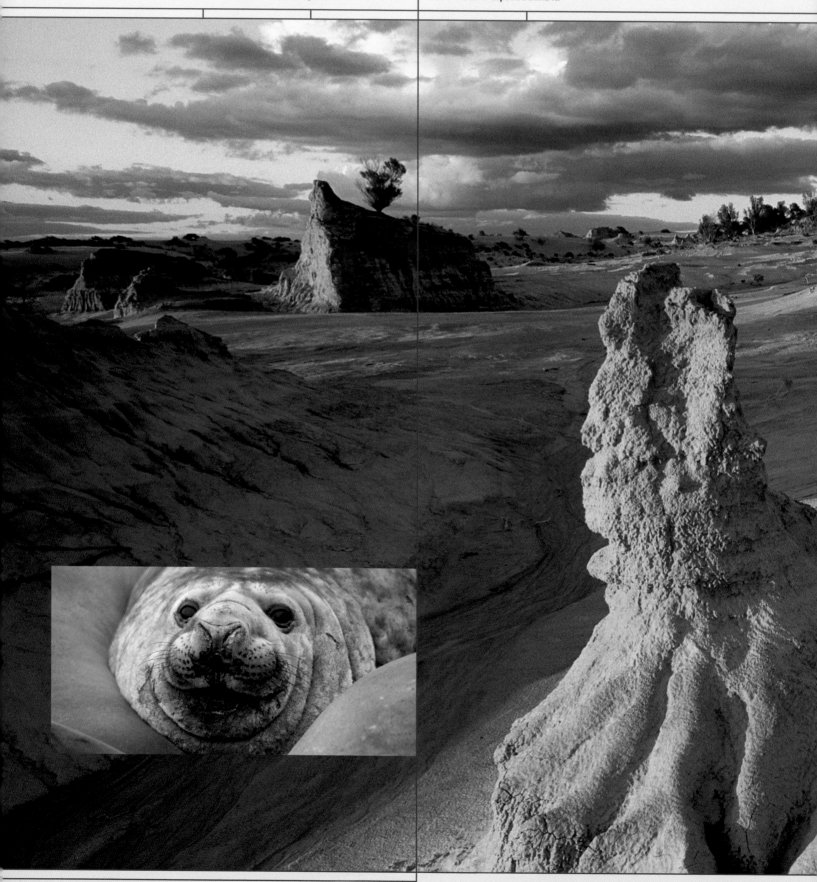

AUSTRALASIA

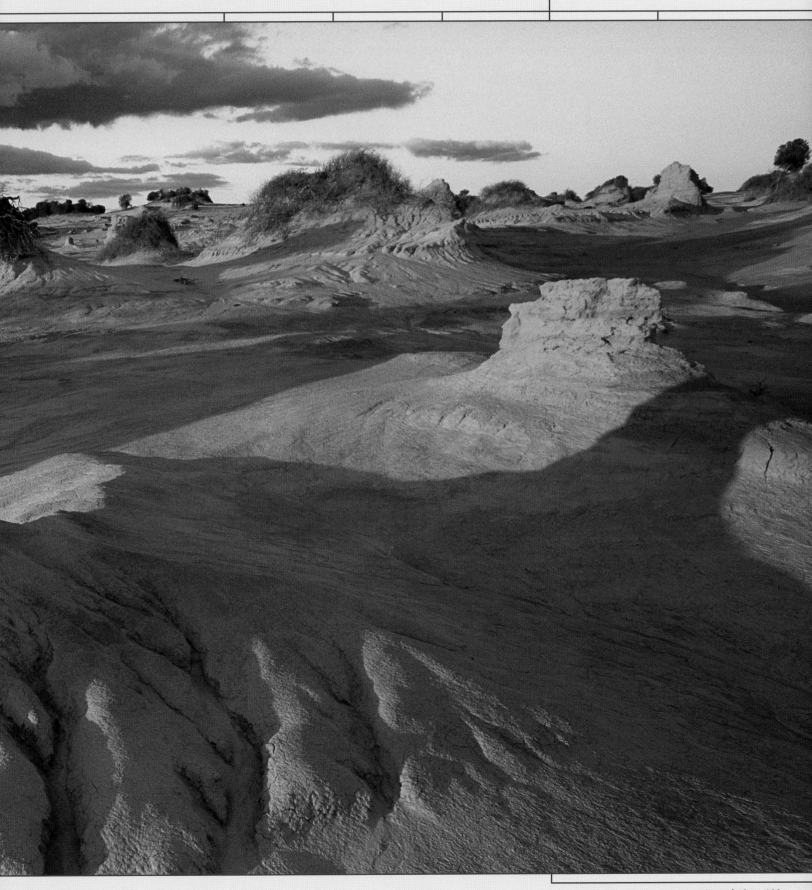

KAKADU NATIONAL PARK

Kakadu National Park boasts not only diverse scenery but also impressive Aboriginal rock paintings.

**Date of inscription: 1981
Extended: 1987, 1992**

Kakadu National Park, now expanded to its current area of 20,000 sq. km (7,700 sq. miles), lies 250 km (155 miles) east of Darwin and encloses five distinct kinds of landscape. In the tidal river estuaries, mangroves have established root systems in the silt, protecting the hinterland from the destructive effects of wave action. In the rainy season, the coastal areas transform themselves into a bright carpet of lotus flowers, water lilies, and floating ferns. Rare waterfowl, such as the brolga, the Jesus bird, the white-faced heron, the great Indian stork, and the snake bird are native to here, as is the saltwater crocodile, the largest living reptile.

The adjoining hills, with their wide variety of open tropical forest, savannah, and grassy plains vegetation, form the greater part of the park and offer a refuge for endangered species, such as dingoes and wallabies. Several of the rarer kangaroo species live on the sandstone plateaus of Arnhem Land and on the Arnhem escarpment, a 500-km (310-mile) long cliff crossing the park from the south-west to the north-east.

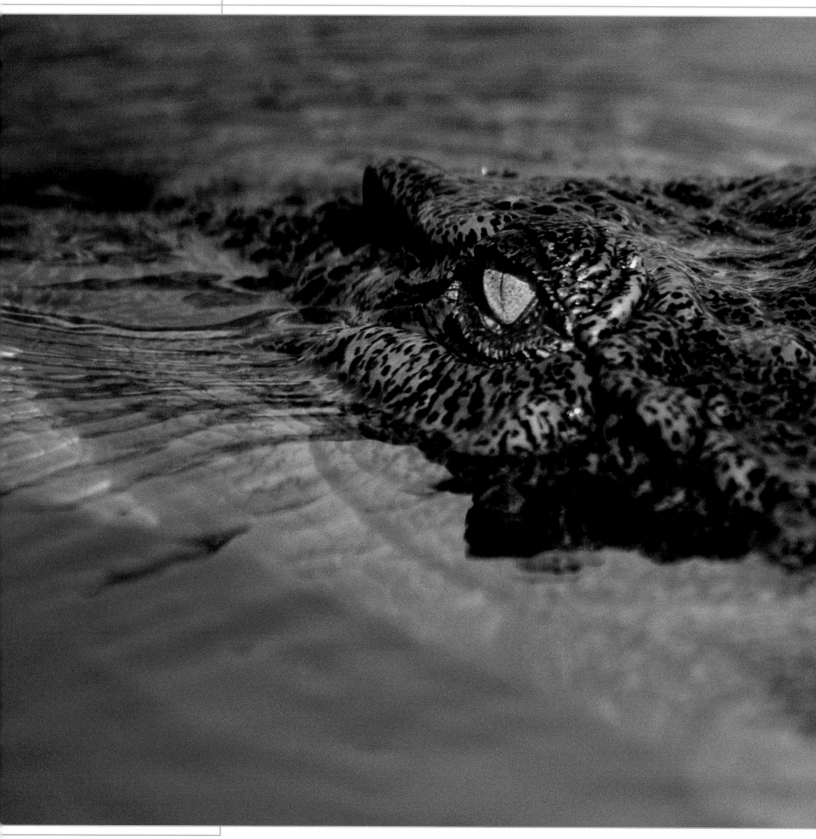

The park, which is jointly managed by its traditional Aboriginal owners and the Australian Government, became internationally famous in the middle of the 20th century, when excavations uncovered Stone Age tools that were at least 3,000 years old. Numerous rock paintings reveal details of the hunting habits, myths, and customs of the Aboriginal tribes who lived here.

The South Alligator river, with its filigree of tributaries (left), flows through the Kakadu National Park. The saltwater crocodile, at up to 6 m (20 feet) in length, is one of the most aggressive of the *Crocodylidae* (large image). During the rainy season, animals living in the mangrove swamps penetrate far inland.

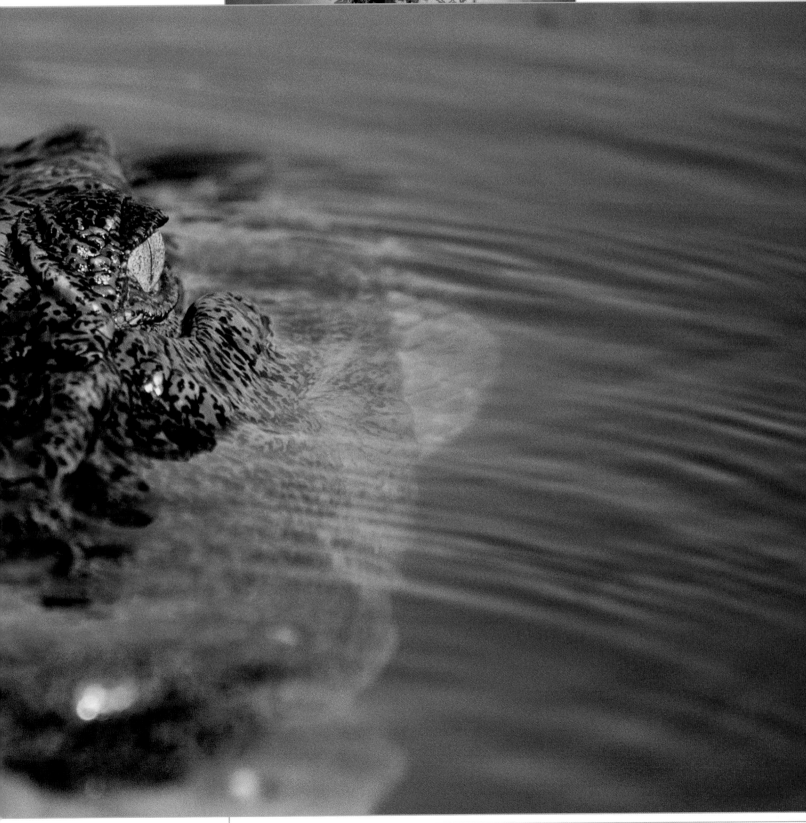

PURNULULU NATIONAL PARK

Purnululu National Park near Hall's creek in the northern part of Western Australia is distinguished by extraordinary, dome-shaped rock formations, caused by the weathering of sandstone. "Purnululu" means sandstone in the language of the indigenous Kija Aborigines.

Date of inscription: 2003

In the heart of the Purnululu National Park is the Bungle Bungle mountain range, rising to 578 m (1,896 feet) above sea level. The mountains are composed of Devonian quartz sandstone and are approximately 370 million years old. In the last 20 million years, horizontally striped, beehive-shaped rock formations have arisen through the effects of water erosion.

The stripes are characteristic of softer, porous rock, on which cyanobacteria are able to grow, darkening the surface. The harder, interposed strata are orange, betraying the presence of iron and manganese. These tones change in the course of the seasons and are especially stiking after rain. Between the domed rocks lie gullies, with streams and pools fringed with large

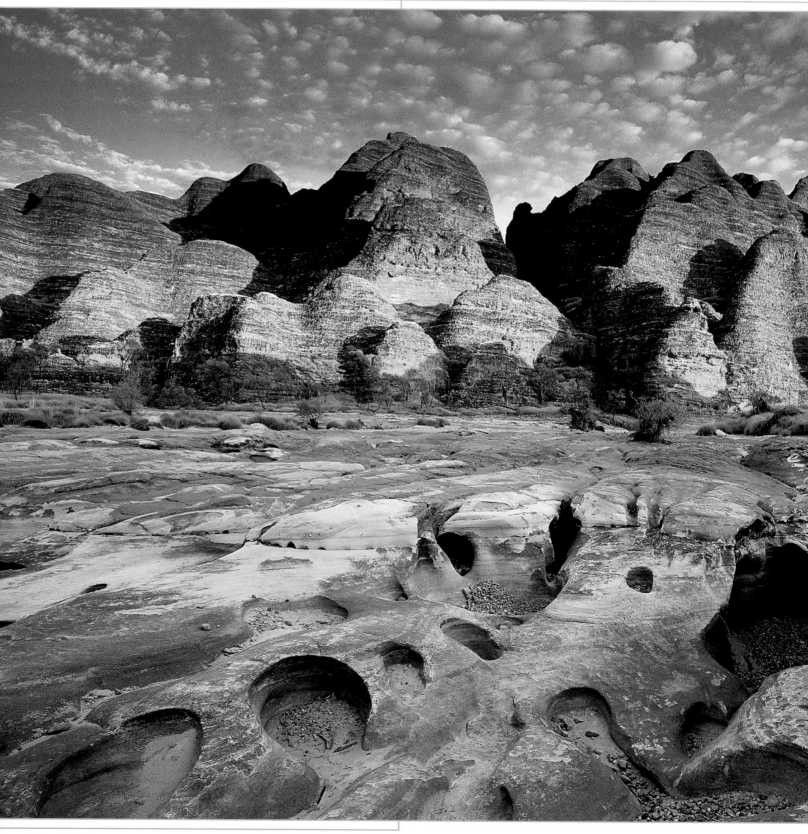

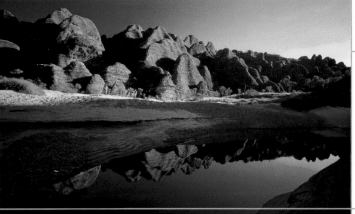

Australian fan palms (*Livistona australis*). Aborigines have inhabited the Purnululu area for millennia, leaving behind numerous rock paintings and burial sites.

There are approximately 130 bird species, including the European bee-eater and bright budgerigars, the most striking creatures in the park.

The unconventional scenery of the Purnululu National Park is composed of hundreds of sandstone domes, cupolas, and pyramids, towering like beehives up to 300 m (990 feet) above the surrounding grassland. They were "discovered" by a film team only in 1982, and became so popular that a national park was established to protect them.

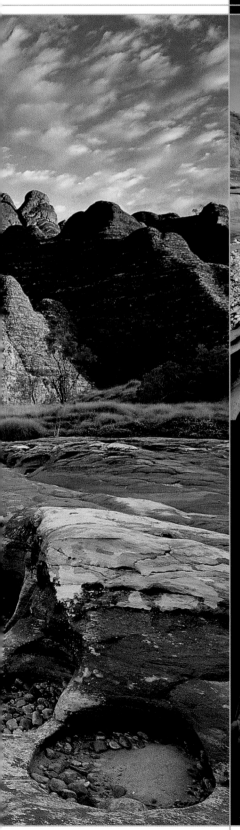

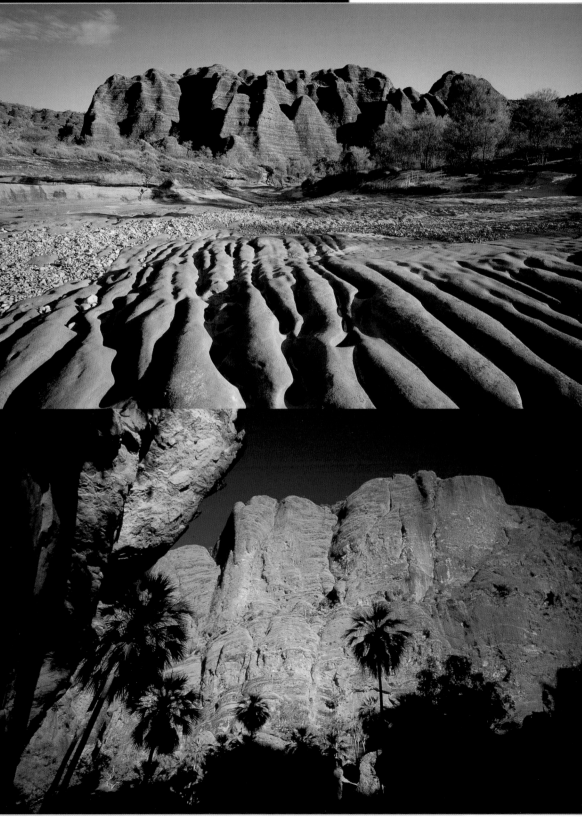

SHARK BAY

The distinguishing features of this protected area are the varied species of the seagrass meadows, the stromatolite colonies, and the world's largest dugong population.

Date of inscription: 1991

The Shark Bay Marine Park, a coastal area of abrupt cliffs, lagoons, and sand dunes located about 800 km (500 miles) from Perth, is the habitat of many endangered aquatic and land-dwelling animals. The nearly 5,000 sq. km (1,900 sq. miles) of seagrass meadow, among the richest in species variety in the world, are particularly impressive. These meadows serve above all as a refuge for small fish, crustaceans, and larger crabs. They also foster the formation of stromatolites (layered algal accretionary structures). In the shallow, brackish waters of the lagoons these tiny organisms, in existence for 3.5 million years, form cabbage-shaped, chalky clumps, sometimes breaking the water's surface at low tide.

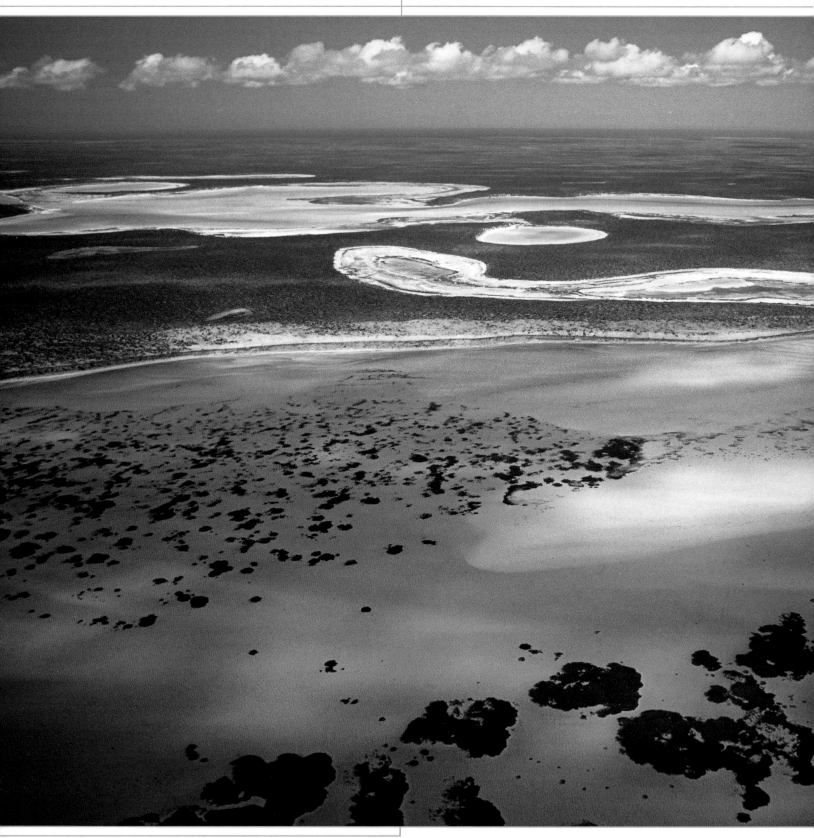

In summer in Shark Bay, you can see humpback whales mating, marine turtles laying eggs, and dugongs raising their young. These sea mammals, once thought extinct, exist here in a population of about 10,000, one of the world's largest.

The islands and cliffs are the preserve of several rare seabirds. Australasian gannets, fish and sea eagles, and pied cormorants hunt for fish in the abundant waters. The coastal islands and the area around Cape Peron are the habitat of the Shark Bay mouse, which was once found throughout the greater part of Australia.

The most popular ambassadors of the nature park are the bottlenose dolphins in Monkey Mia Bay, which are fed by rangers.

Viewed from the air, the varied seagrass meadows (below left, in the shallow waters of Denham Sound) look like dark patches. The François Peron National Park (below middle) is also part of Shark Bay. The characteristic stromatolite colonies (below right) and fish such as the algae-encrusted, poisonous stonefish are all to be encountered in the conservation area.

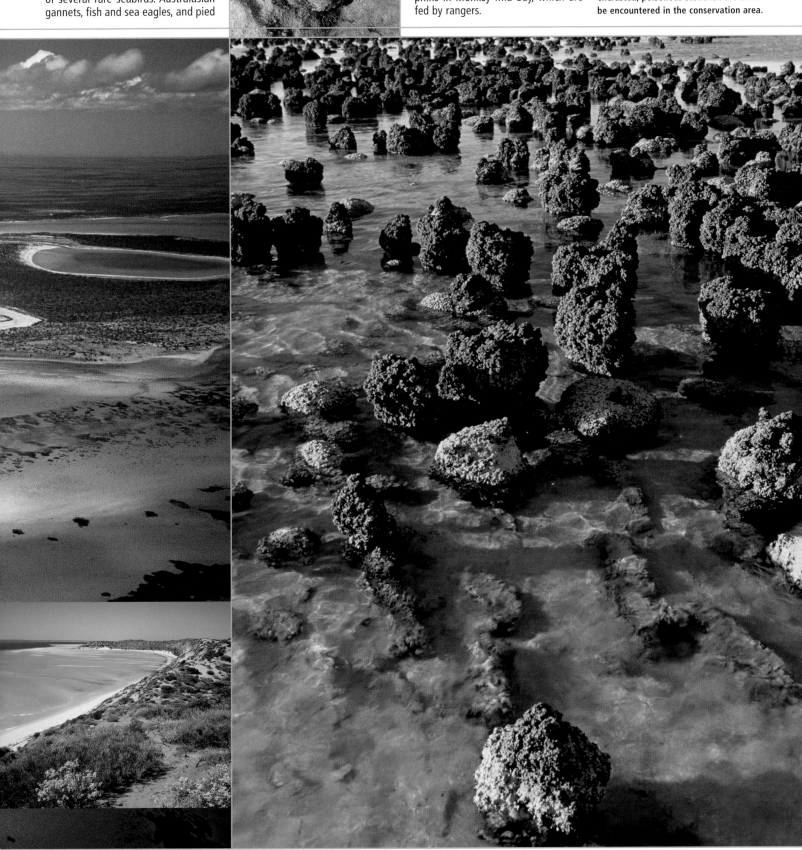

ULURU–KATA TJUTA NATIONAL PARK

The spectacular geological formations of Uluru and Kata Tjuta jut out like mountainous islands in the middle of the fifth continent. They reflect varying shades of red, depending on the time of day.

Date of inscription: 1987; Extended: 1994

In the middle of an expanse of barren, dry savannah south-east of Alice Springs lies the "red heart of Australia," the Uluru–Kata Tjuta National Park. The immense rocky monolith, Uluru ("shady place," once called Ayers Rock), and the 36 summits of Kata Tjuta ("many heads," once called The Olgas), are the best-known natural wonders of Australia.

The history of their formation, beginning 570 million years ago, is closely linked with that of the formation of continental Australia. In contrast to the surrounding rock formations, the monoliths' resistant stone weathered only slowly, and thus today they tower over the plain as mighty, petrified testaments to earth's prehistory. Uluru is a mythical place for Aborig-

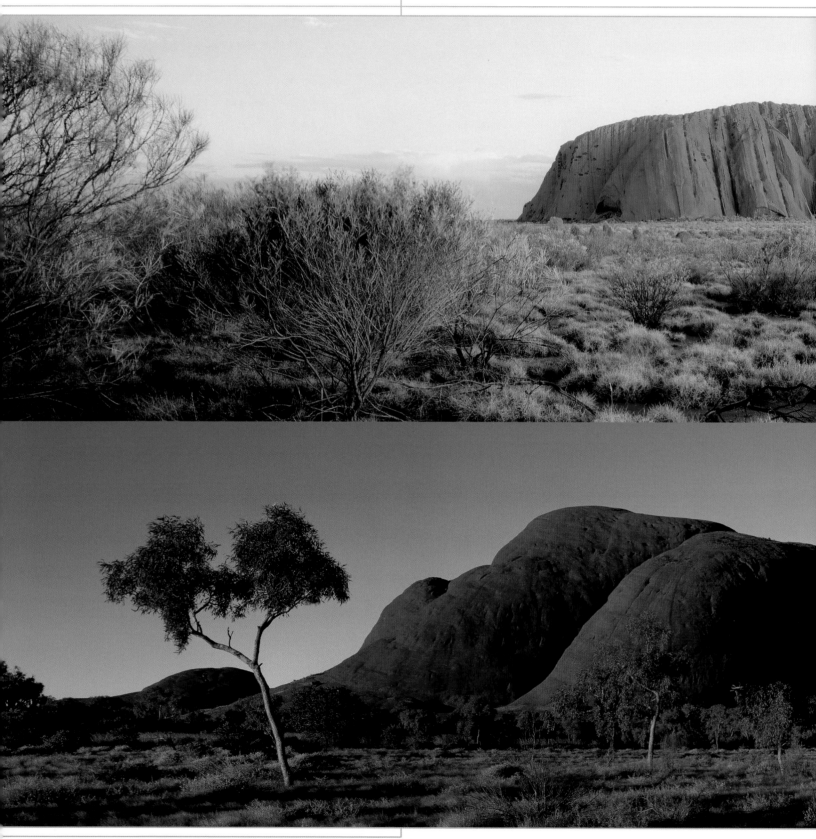

ines, with rock paintings and sacred sites. It was a meeting place for their ancestors when they created the land and every living thing, during their wandering in the Dreamtime. There are also rock paintings at Kata Tjuta. Despite the dry, inhospitable climate, the Anangu Aborigines have lived here for millennia.

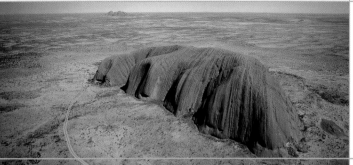

While Uluru (left and below) rises like an isolated island with a circumference of about 10 km (6 miles), Kata Tjuta is formed of 36 smaller rounded peaks (bottom). This area's inscription as a World Heritage Site is also explicitly related to the mythological importance of the rock formations for the Aborigines.

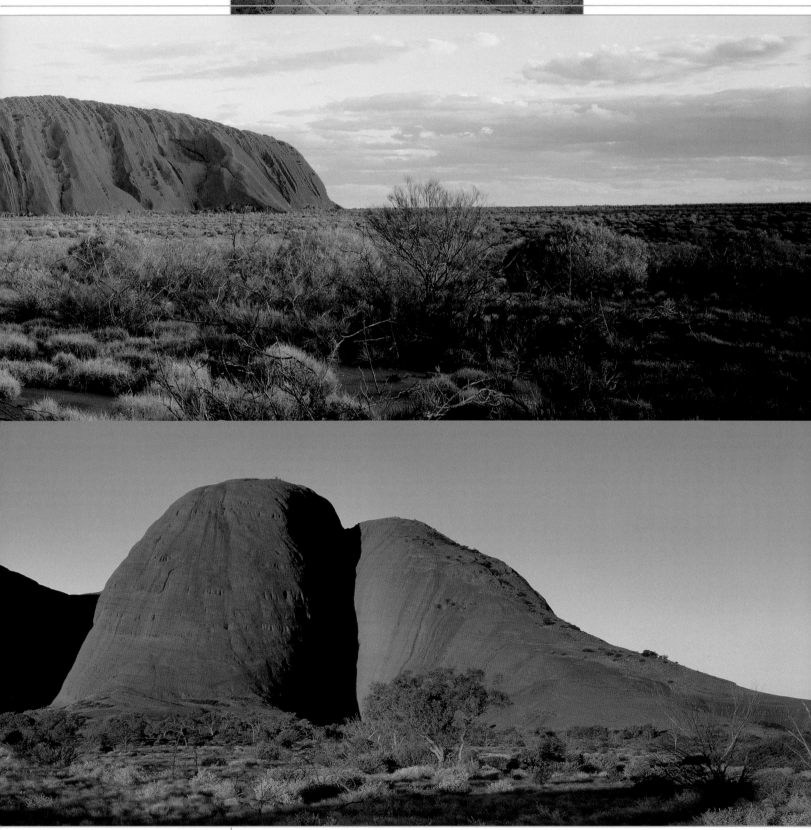

Born blind, deaf, and hairless

The evolutionary history of Australian marsupials stretches back some 150 million years, to when Australia was isolated during the fragmentation of the Gondwana supercontinent. Marsupials could thus develop here undisturbed by competition from the placental mammals found in Asia and South America. The best-known are probably the koala and the giant kangaroo. A further 250 species developed in total, occupying the most diverse ecological niches and taking every imaginable form: carnivore and herbivore, arboreal and ground-dwelling, burrowing and gliding, pachydermous and thin-skinned. The variations in size, too, are considerable, from a few centimetres of body length in marsupial mice up to a height of nearly 2 m (6 feet) for giant gray and red kangaroos. Common to all of these is their mode of reproduction.

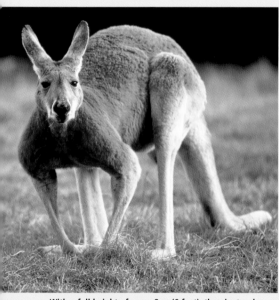

With a full height of some 2 m (6 feet), the giant red kangaroo is the largest living marsupial.

In contrast to placental mammals, where the embryo is nourished in the womb and comes into the world fully developed, marsupials are almost always born as a completely helpless embryo, growing in the mother's pouch until able to survive in the outside world. Tree-climbing kangaroos, wallabies, wallaroos, pademelons, and the quokka all belong to this numerous sub-class.

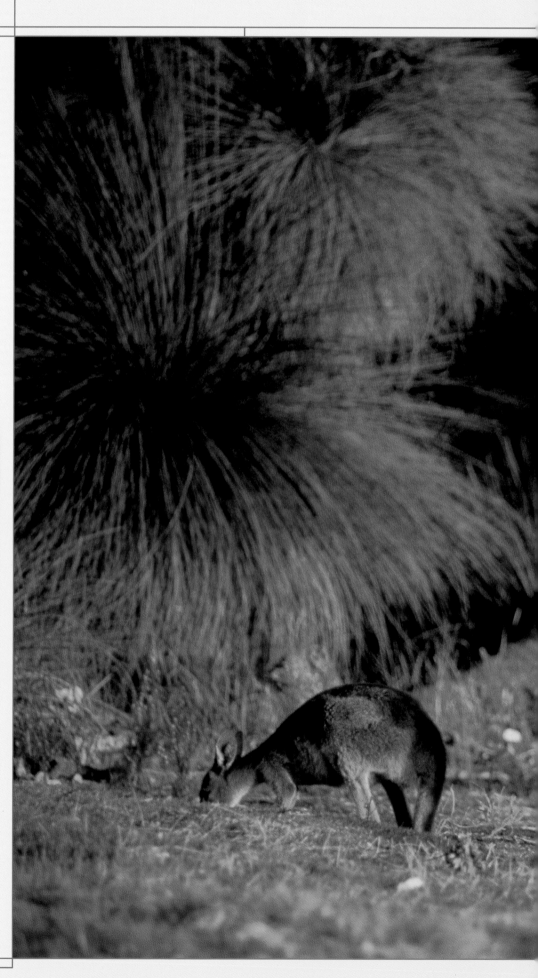

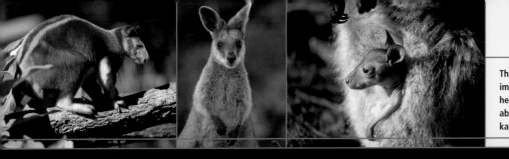

Thanks to their unusually strong back legs, giant kangaroos (inset image: young in pouch) can make leaps of 10 m (33 feet) and up to a height of 3 m (10 feet). Tree kangaroos (image, far left) are considerably smaller. Wallabies, too (image, middle), are among the smaller kangaroo species.

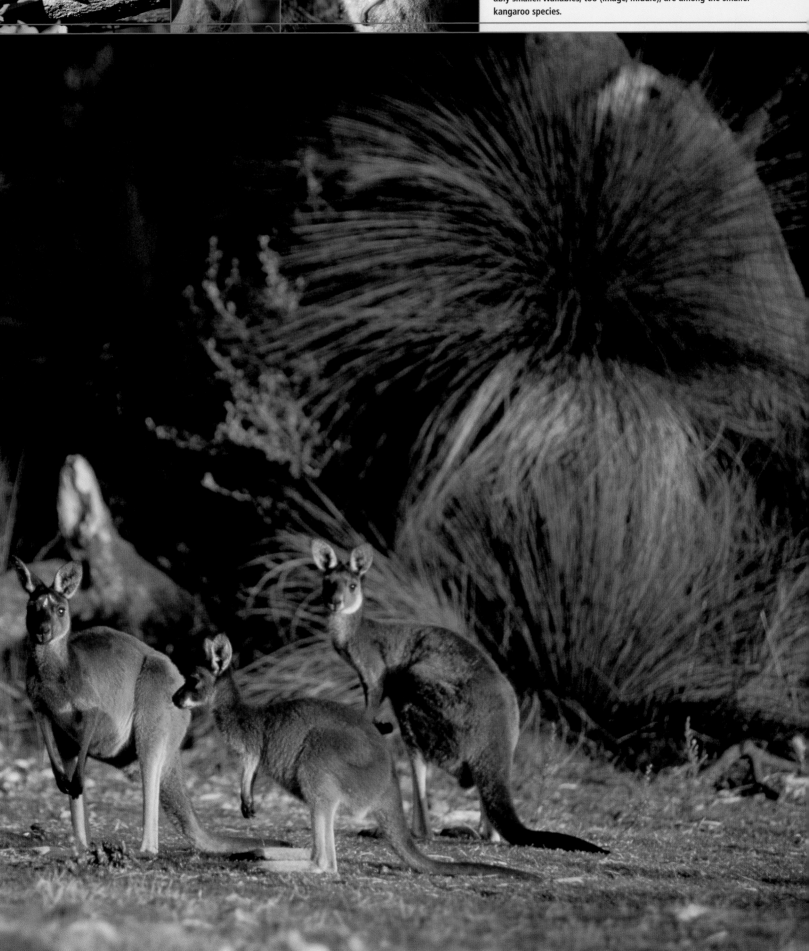

QUEENSLAND'S WET TROPICS

The approximately 450-km (280-mile) long littoral between Townsville and Cooktown in Queensland is one of the most extensive and varied rainforest areas in the state. This World Heritage Site of some 9,000 sq. km (3,400 sq. miles) encloses about 20 national parks and other protected areas.

Date of inscription: 1988

Until deforestation began in the late 1700s, tropical rainforest completely covered the Australian continent. Today, it covers only parts of the Great Dividing Range mountains, the dip slope of the Great Escarpment, and a section of the Queensland coast, where, in contrast to other areas of Australia, the tropical climate has remained stable over millions of years. A varied animal and plant biotope was thus able to develop undisturbed. More than 800 species of tree form a forest in various "layers." Beneath the almost impenetrable canopy of the giant trees, up to 50 m (164 feet) in height, grow more than 350 species of the various higher plants, especially ferns, orchids, moss, and lichen.

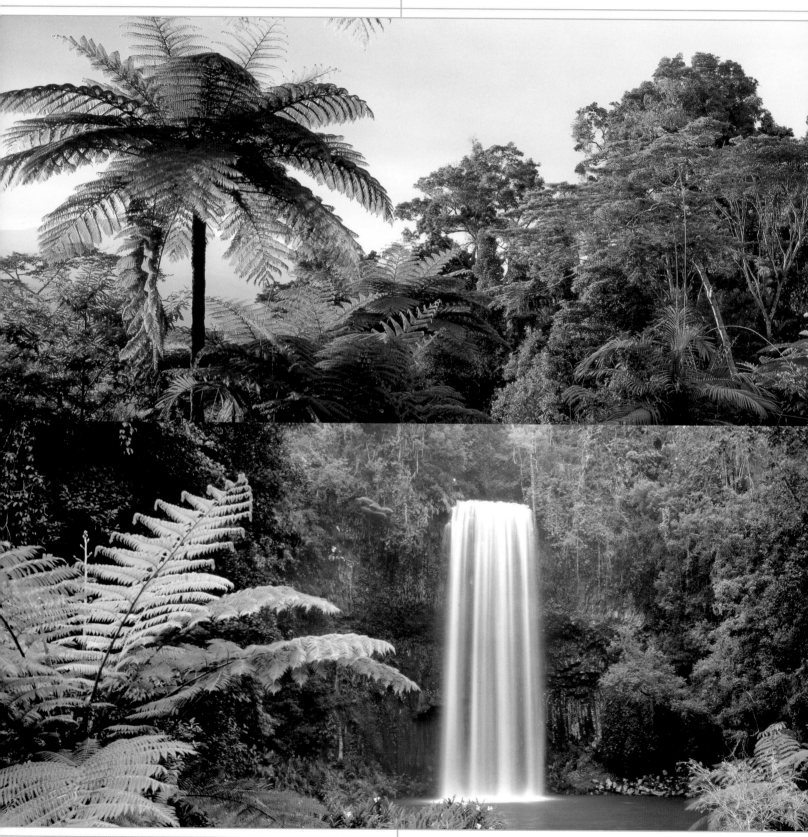

The animal kingdom is also richly abundant. The Wet Tropics National Park boasts the greatest variety of fauna on the continent. Approximately a third of all Australian marsupials and reptiles and two-thirds of all bat and butterfly species are indigenous to this relatively small area, which occupies only a tiny fraction of the whole continent.

Typical inhabitants include the sugar glider, the saltwater crocodile, the Ulysses moth, and the stockwhip bird. Among the rarer species are the green tree python, Boyd's forest dragon, the Lumholtz tree-kangaroo, the musky rat-kangaroo, the spotted-tailed quoll, the tooth-billed bowerbird, and the southern cassowary.

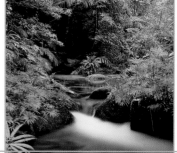

Impressive tree ferns (large image, top), up to 20 m (66 feet) in height, live in the rainforest of the Wet Tropics National Park, along with climbing palms, and a species of rattan (below right). The area, crossed by several rivers, is a biotope for the most diverse species (left). The protected area also includes the Milla Milla Falls in the Atherton Tableland, part of the national park (large image, bottom).

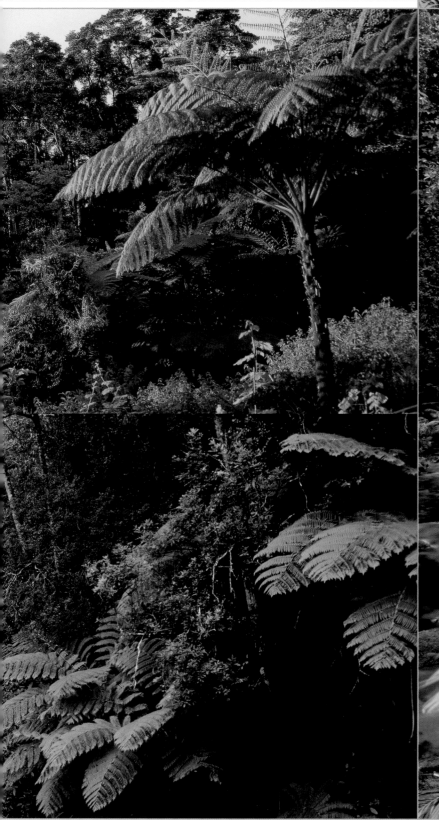

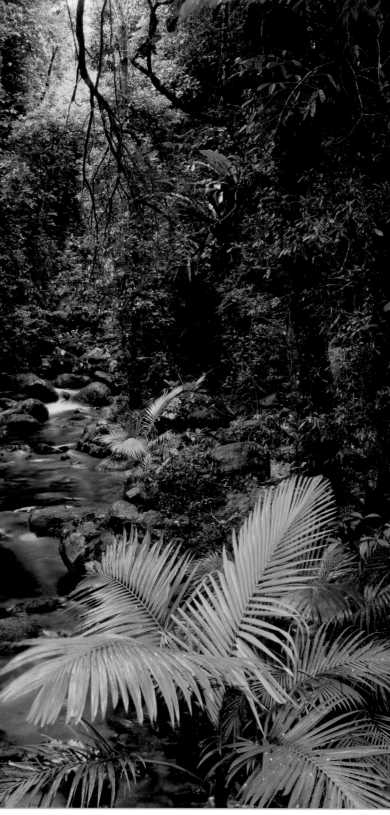

The World Heritage Site once known as "Rainforests of the East Coast" was renamed "Gondwana Rainforest of Australia" in 2007 and encloses 15 national parks and conservation areas in Queensland and New South Wales.

Date of inscription: 1986; Extended: 1994

All the following UNESCO-protected regions are in the transitional zone between a damp, tropical climate and a warm, temperate zone, with the result that a huge variety of vegetation has been able to evolve within a relatively small area. Southern beeches grow alongside temperate forest in the south, while on the high plateaus, expanses of rain moor are host to red toons and species of eucalyptus. Subtropical rainforest, with banyan fig trees, orchids, and ferns, predominates further north, on the volcanic plateaus. Subalpine forest with eucalyptus trees is encountered at altitudes of up to 1,500 m (4,900 feet). The national parks of Border Ranges, Mount Warning, Night Cap, Washpool, Gibraltar Range, New Eng-

land, Dorrigo, Werrikimbe and Barrington Tops were inscribed as World Heritage Sites in 1986. Springbrook, Lamington, Mount Chinghee, Main Range, and parts of Mounts Mistake and Barney National Parks were added in 1994. Barrington Tops and the Border Ranges are famed for their enormous wealth of bird life. Satin bowerbirds, rainbow lorikeets, king parrots, and kookaburras are seen here relatively frequently, although the rare Albert's lyrebird is less common. The Heritage Site's new name harks back to the supercontinent of the southern hemisphere, Gondwana, which in the middle geological period (Mesozoic) fragmented into the continents we know today.

The Barrington Tops National Park (below left and below) is characterized by temperate rainforest on the valley floor. In Dandahra Gorge in the Gibraltar Range National Park, a waterfall rushes over a rocky terrace (bottom). Among the inhabitants of the rainforest are vivid parrots like these rainbow lorikeets (*Trichoglossus haematodus*, left).

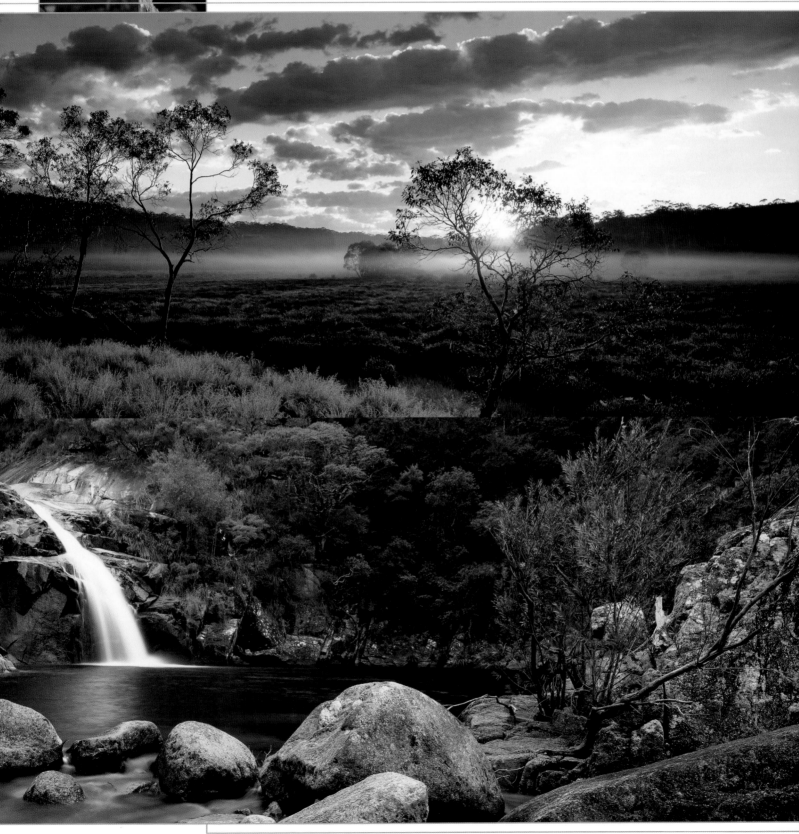

GREATER BLUE MOUNTAINS

At the gates of Sydney there is an expanse of primeval landscape which even today has been only partly explored. The Blue Mountains arose about a million years ago in the Pliocene era and belong to the Great Dividing Range chain.

Date of inscription: 2000

The charming landscape of the Blue Mountains is a living laboratory of jagged sandstone formations, caves, and complex ecosystems. Although they are not very high, between 600 and 1,000 m (1,970 and 3,280 feet), the mountains are steep, with many valleys and canyons still untouched by humans. There is an unprecedented wealth of eucalyptus species and rare and endangered plants. Around 150 indigenous plants and trees flourish in the thick forest, including the Wollemi pine, discovered only in 1994. This is regarded as a living fossil, with roots reaching back at least 90 million years. Cave paintings and rock drawings attest to early Aboriginal settlement.

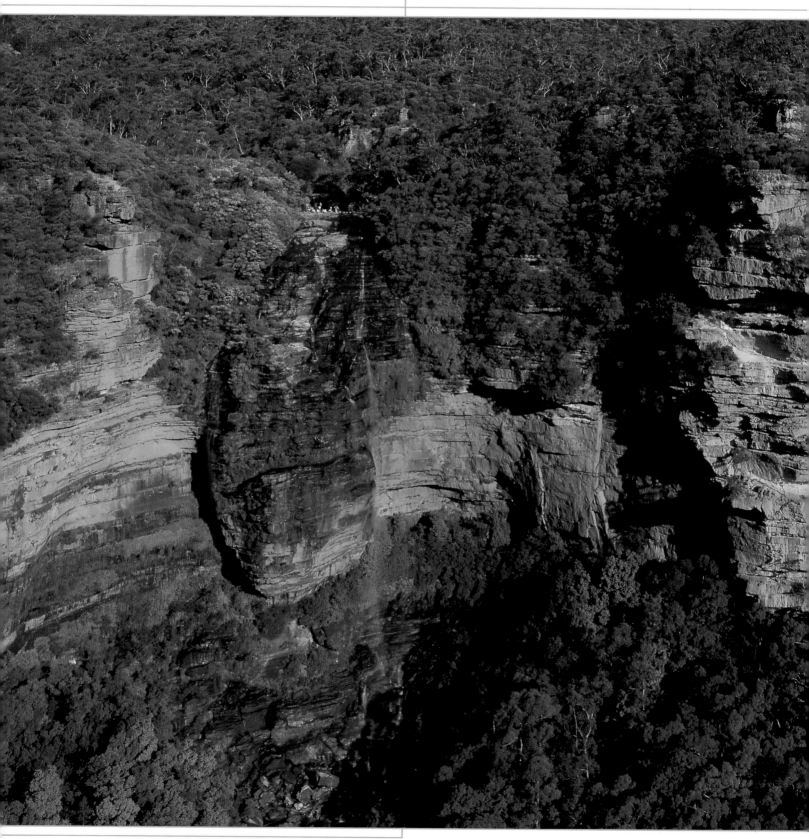

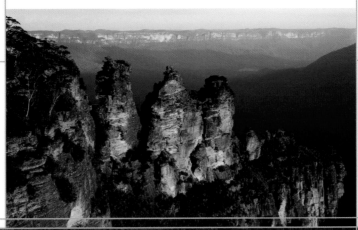

The Blue Mountains are a globally unique example of dynamic interaction between extreme climatic conditions, adapted eucalyptus species, poorly nutritious soils, and fire. Their name is derived from an optical illusion – the eucalyptus forests appear blue in the vapour haze of the oils exuded by the trees.

The Greater Blue Mountains are fascinating, with impressive gullies and waterfalls (large image: Wentworth Falls; small image, below: Katoomba Falls). The most famous rock formation in the Blue Mountains is the "Three Sisters," which rises some 300 m (990 feet) above the Jamieson valley (left).

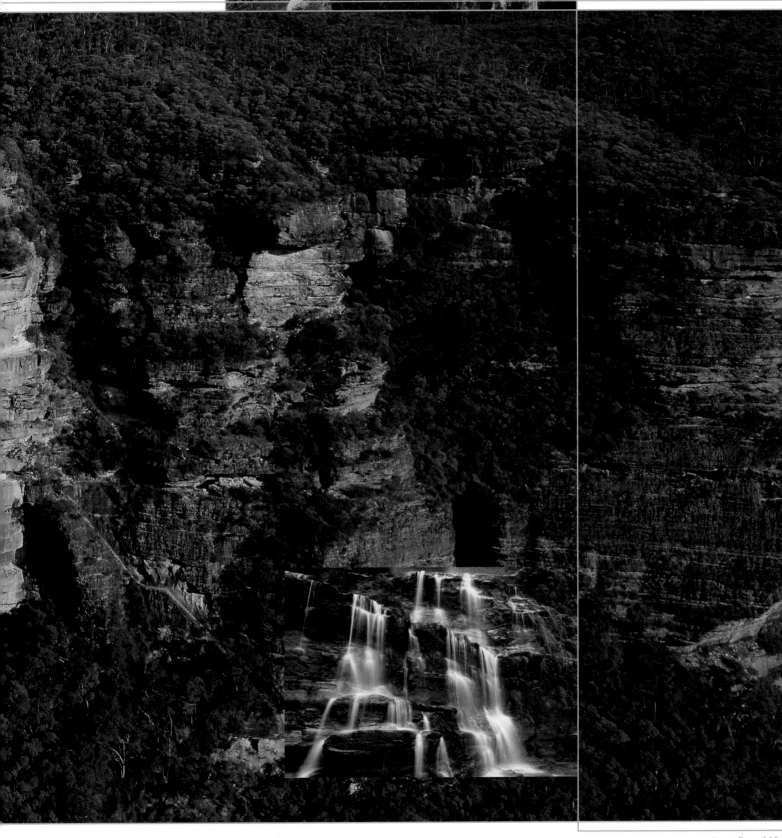

The Australian national animal

Koalas (*Phascolarctos cinereus*), which grow to a size of about 80 cm (30 inches), have a silver-gray, woolly coat and prehensile paws with needle-sharp claws. They look as cute as teddy bears, are docile and can often be affectionate; exaggerated displays of affection are best avoided, however, because of the koala's sharp claws. Koalas are herbivorous and feed exclusively on particular species of eucalyptus. For this reason, the animals are difficult to keep outside Australia. An adult koala needs between 600 and 1,250 g (1–2 lb) of leaves per day. These contain a lot of water (up to 67 percent), which is why koalas are considered never to drink, but they are not very good to eat; the leaves are difficult to digest, but the koala has the longest caecum of all mammals, at 2.5 m (8 feet), and tiny, symbiotic organisms process the cellulose there. The young leaves in particular also

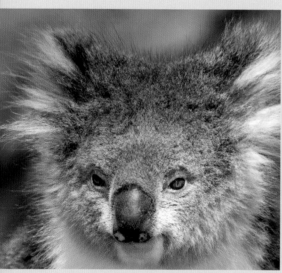

The koala is a marsupial and lives exclusively on the leaves of certain species of eucalyptus.

contain extremely poisonous compounds of cyanide, and koalas eat certain soils that neutralize these poisons.

The soft and durable hide of the koala was once greatly sought after, with the result that the population was much reduced by hunting. Now the animal is strictly protected and there are once again about 80,000 koalas in the wild.

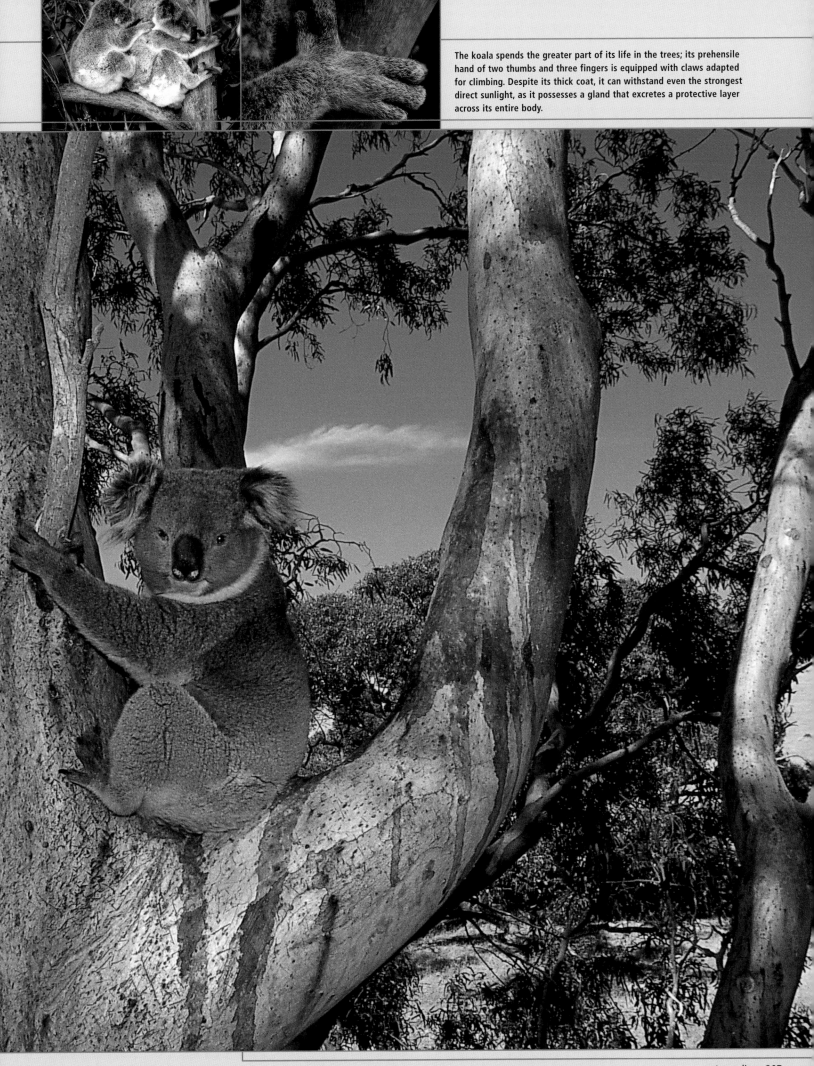

The koala spends the greater part of its life in the trees; its prehensile hand of two thumbs and three fingers is equipped with claws adapted for climbing. Despite its thick coat, it can withstand even the strongest direct sunlight, as it possesses a gland that excretes a protective layer across its entire body.

FRASER ISLAND

The world's largest sand island, still partially covered with primeval lowland rainforest, provides a habitat for rare birds and frogs.

Date of inscription: 1992

The surface of this 120-km (75-mile) long island, located at the southern end of the Great Barrier Reef, has been on the move for 140,000 years. The crescent dunes, which reach a height of up to 250 m (820 feet), migrate up to 3 m (10 feet) to the north-east every year, driven by the constant south-westerly winds. No sooner had the island been discove-red in 1836 than the settlers began the exploitation of the tropical rainfo-rest and its variety of species. The Queensland kauri, the bunya-bunya tree, the tallow and blackbutt eucalyptus, and the 70-m (230-foot) high satinay tree were regularly felled. Today, only small areas of the island's interior are covered in rainforest. The remaining landscape is diverse and offers a refuge for over 240 species of bird. The mangrove honey-eater lives in the mangroves on the coast, while the ground parrot is found on coastal heaths. The red-green king parrot hunts for nectar in tropical forests, and the stubble quail is indigenous exclusively to damp areas of moor. Many migratory birds stop here.

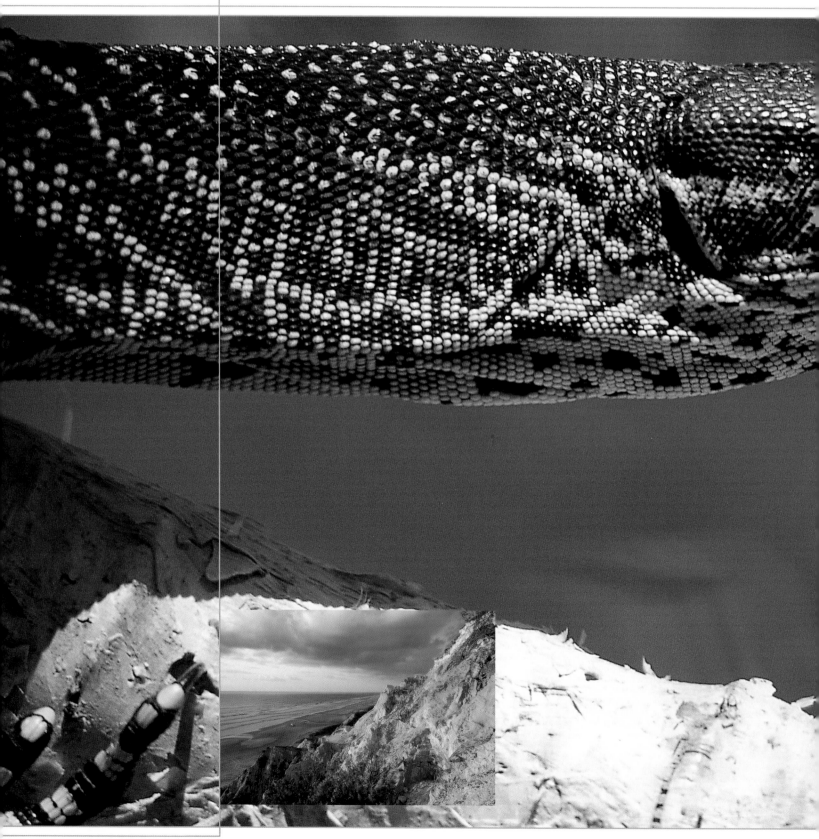

With the exception of a few volcanic rock formations, Fraser Island is composed almost entirely of sand, as are the so-called "cathedrals," sand cliffs on the east coast (small image, below). From a bird's-eye view, the dimensions of the crescent dunes, which can reach 250 m (820 feet) in height, can only be guessed at (right). A sand monitor, one of the 20 species of monitor lizards on the fifth continent, seen here resting on a paperbark tree, feels at home in this terrain (large image).

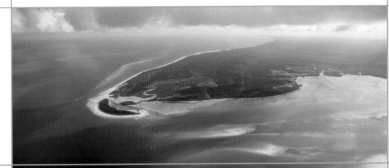

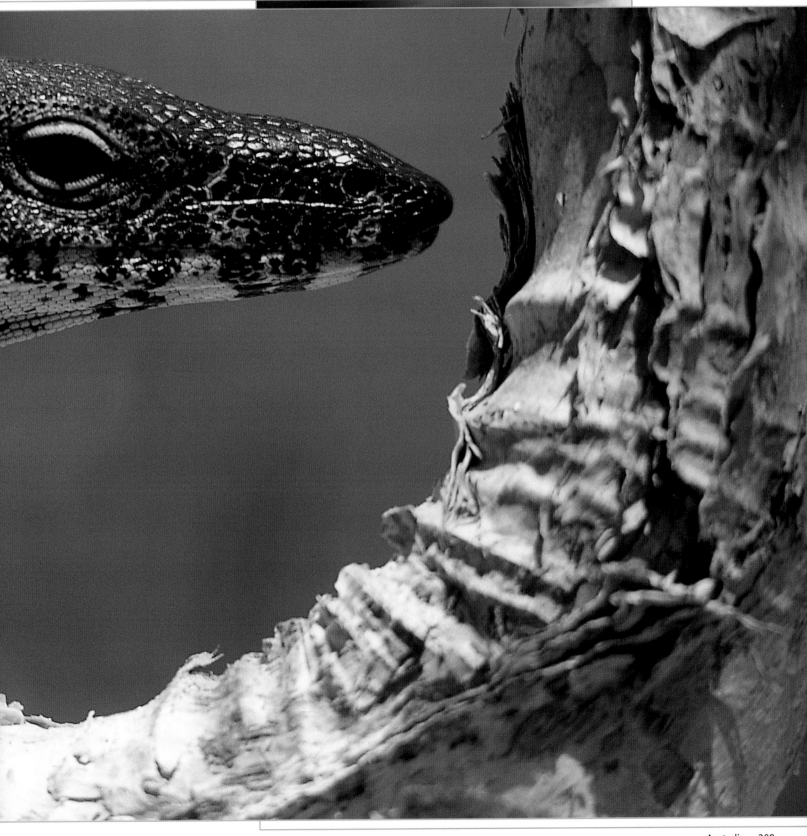

THE GREAT BARRIER REEF

The Great Barrier Reef follows the north-eastern coast of Australia from the 10th to the 24th parallel south. Coral polyps, in their singular underwater world, have been building this largest of natural "edifices" for 8,000 years.

Date of inscription: 1981

The reef, which is composed of about 2,500 individual reefs and 500 coral islands, follows 2,000 km (1,250 miles) of the coastline of continental Australia at a distance of 15 to 200 km (9 to 124 miles). It was "constructed" by coral polyps, working symbiotically with cyanobacteria. Able to swim from birth, the polyp larvae hatch in the spring and settle on the reef, near the water's surface. They develop a skeletal structure and form a colony with others of their kind. After a while they die off and their coral skeletons are ground to a fine sand. The algae then "bake" the sand into an additional layer of the reef, upon which new polyp larvae can settle, and thus the reefs and islands have grown over millennia.

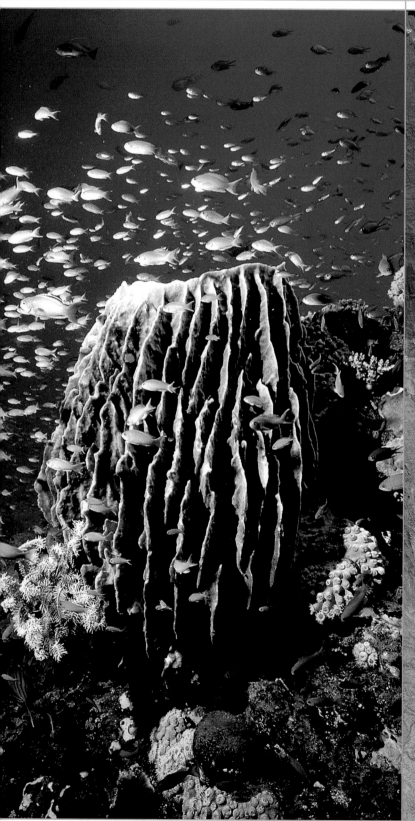

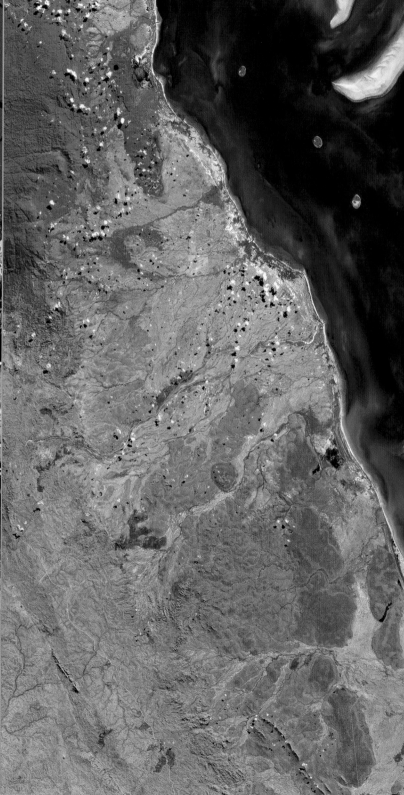

Among the 1,500 species of fish that live in the waters surrounding the reefs are the brilliant and exotic coral trout, the golden damselfish, the parrotfish, and the stingray. Hundreds and thousands of varieties of birds, corals, and molluscs live here. Bird species include pelicans, frigate birds, noddies, and a number of terns including sooty, roseate, and crested.

The structures of the Great Barrier Reef can be seen in outline on the satellite image of Princess Charlotte Bay and Cape Melville (large image). The longest living coral reef in the world reaches from the Tropic of Capricorn to the estuary of the Fly river (New Guinea). The reef is the habitat of multi-hued flora and fauna (below left), among which lurk sharks (right).

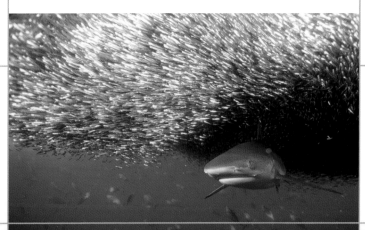

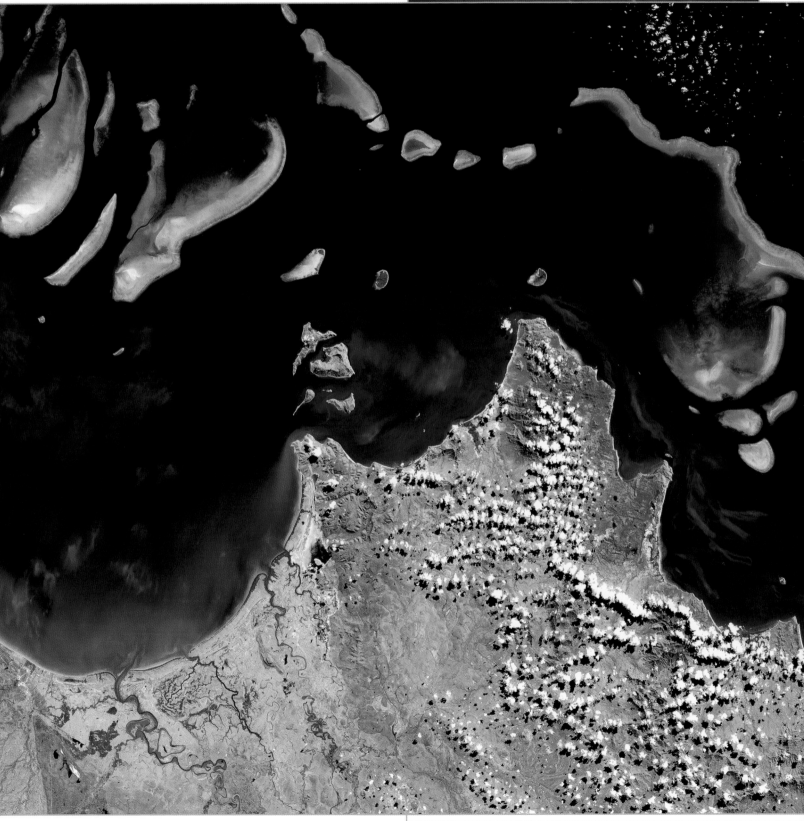

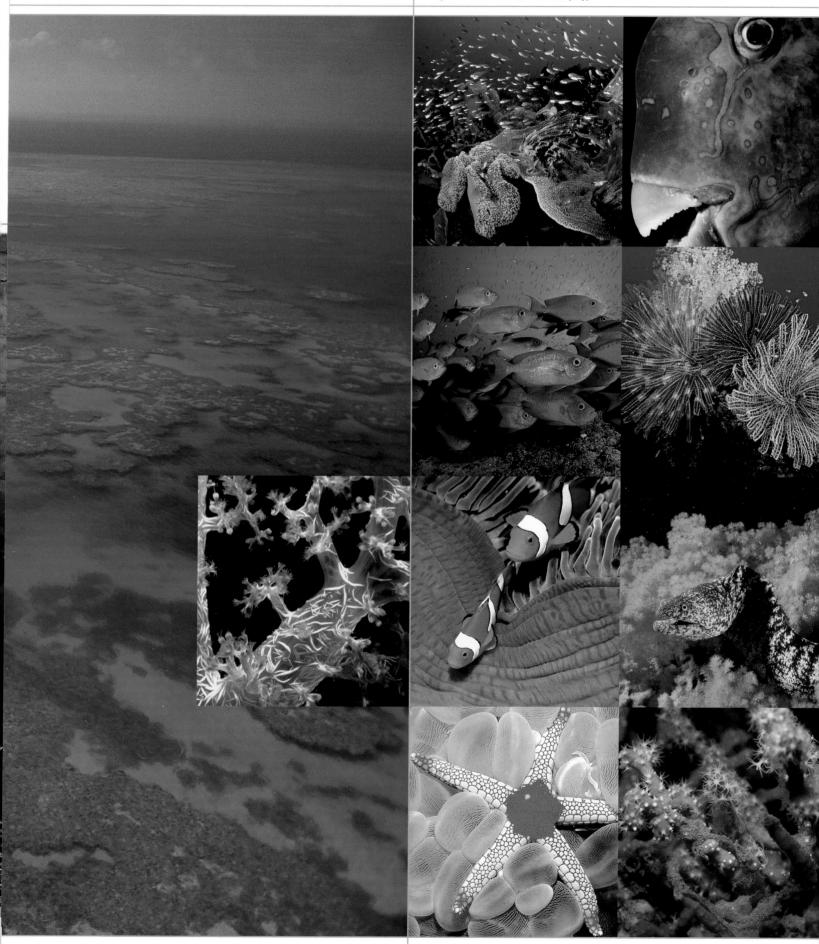

One of the most beautiful sections of the Great Barrier Reef is near the Whitsunday islands. The greatest variety of ocean-dwelling species, with every manner and shade of fish, coral, and starfish, fill the crystal-clear waters, delighting divers and tourists in glass-bottomed boats. The creator of this singular world is the humble coral polyp.

THE TASMANIAN WILDERNESS

The national parks of Western Tasmania, with their temperate rainforests and singular fauna, are considered one of the world's last untouched ecosystems.

Date of inscription: 1982; Extended: 1989

This World Heritage Site, which is located between Cradle Mountain and Tasmania's south-western cape, is composed of five national parks – Lake St Clair, Franklin–Lower Gordon Wild rivers, South-West, Walls of Jerusalem, and Hartz mountains – and several other conservation areas. Deep gullies, steep summits, eroded plains, raging waterfalls, and trough-like lakes are typical of this glaciated landscape. At greater altitudes, there are expanses of moor and heath, and, nearer sea-level, stretches of bogland. Although the temperate rainforest has been much reduced by intensive logging, there are still traces of these great mixed forests, composed of numerous subantarctic and Australian tree species.

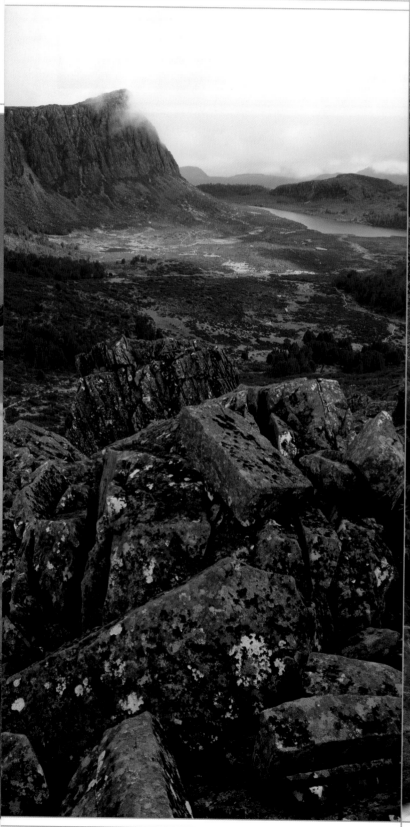

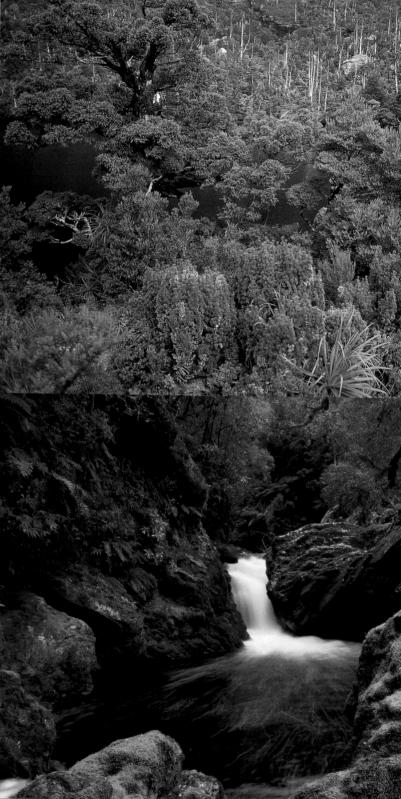

A singular animal world, including numerous unique species, is at large in this diverse landscape. The nature reserves are home to 27 mammal, 150 bird, 11 reptile, six amphibian, and 15 freshwater fish species. The endangered orange-bellied parrot, the Tasmanian wedge-tailed eagle, the Tasmanian devil, and the Pedra Branca lizard occur only in Tasmania.

The Bennett wallaby, the tiger quoll, the duck-billed platypus, and the short-beaked echidna are also to be found here.

Archaeological finds such as rock paintings, stone tools, and the remnants of canoes attest to the first human settlement of the island over 30,000 years ago.

Steep cliffs and alpine vegetation characterize the Walls of Jerusalem National Park (below left). Rainforest dominates the Franklin–Lower Gordon Wild rivers National Park (below middle: on the Bird river). The indigenous *Richea pandanifolia*, reminiscent of the palm tree, also grows here (above middle). Mount Anne in the South-West National Park is 1,424 m (4,670 feet) high (below). The Tasmanian devil is found only in Tasmania (left).

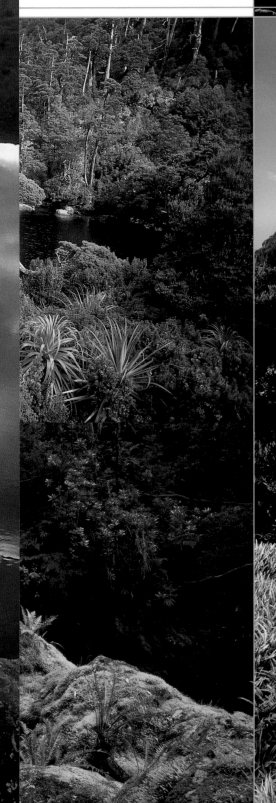

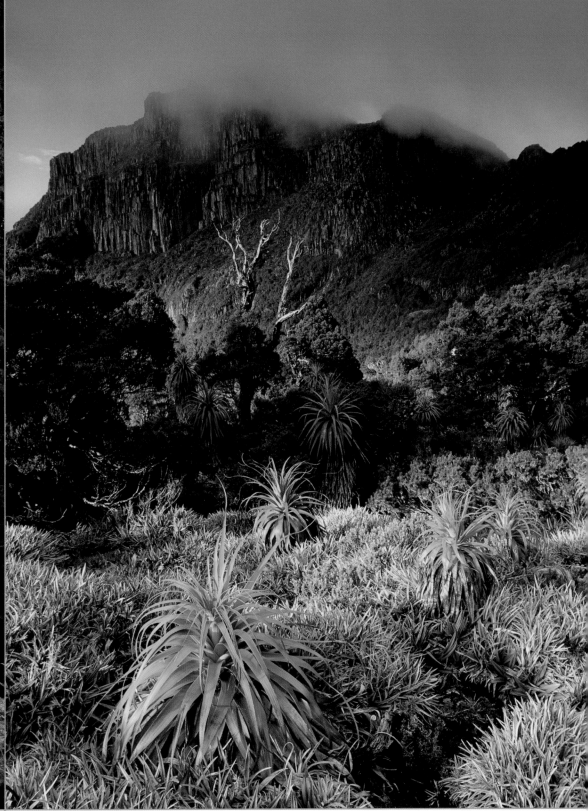

LORD HOWE ISLAND GROUP

Lying 600 km (370 miles) from Port Macquarie, the island group owes its World Heritage status to its spectacular topography and its flora and fauna, much of which is unique.

Date of inscription: 1982

About seven million years ago a giant, 2,000-m (6,600-foot) high shield volcano erupted in the Tasmanian Sea off the east coast of continental Australia. As a result of the erosive power of rain, wind, and wave action, the only remnants of this colossus today are the 28 islands that form the Lord Howe island group. Because of its isolated geographical location, a quite distinct biotope has developed here. Sheltering some 220 species of plants, of which roughly a third are unique to the area, dense cloud forest has become the habitat of many endangered bird species, including the wedge-tailed shearwater, the Kermadec petrel (which nests on the steep cliffs), the oddly hued, white-bellied storm petrel, and the flightless Lord Howe woodhen. Off the south-west coast of the Lord Howe islands, stone coral and calcified red algae form a fantastic reef. In the waters between the spurs of reef live numerous exotic fish, such as the coral trout, the parrotfish, and the sablefish.

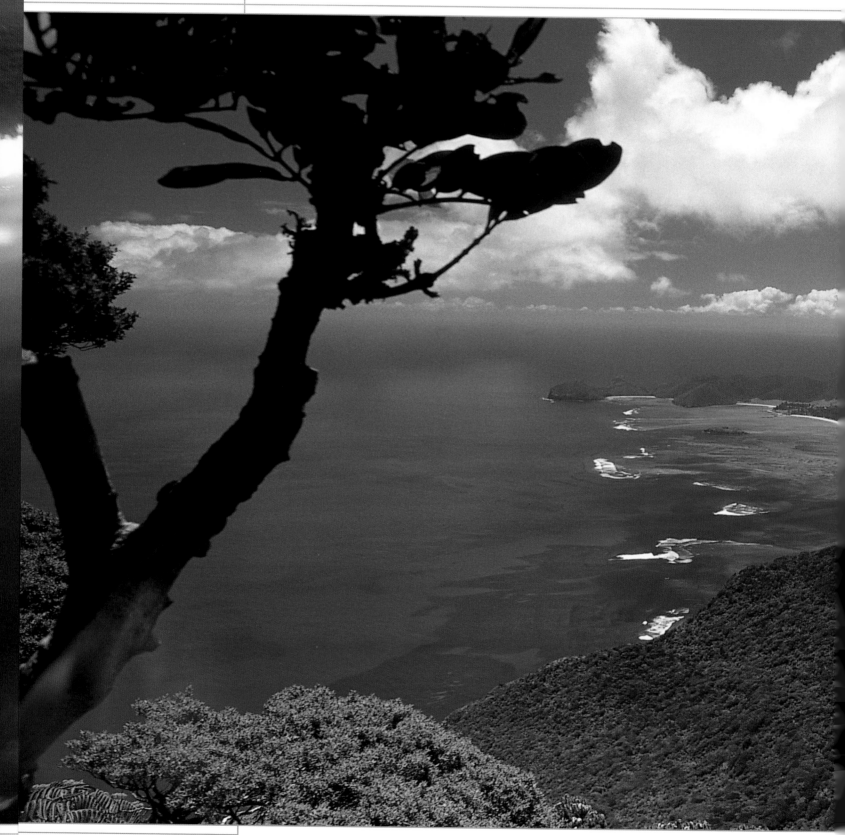

Lord Howe Island (large image: view of Mount Lidgebird) is the largest island of the group. The world's southernmost coral reef is growing just off its south-western coast (below right). There is a great variety of flora, such as the mountain rose (right, middle), and of fauna, especially bird species, including the white-capped noddy and the Lord Howe woodhen (right and far right).

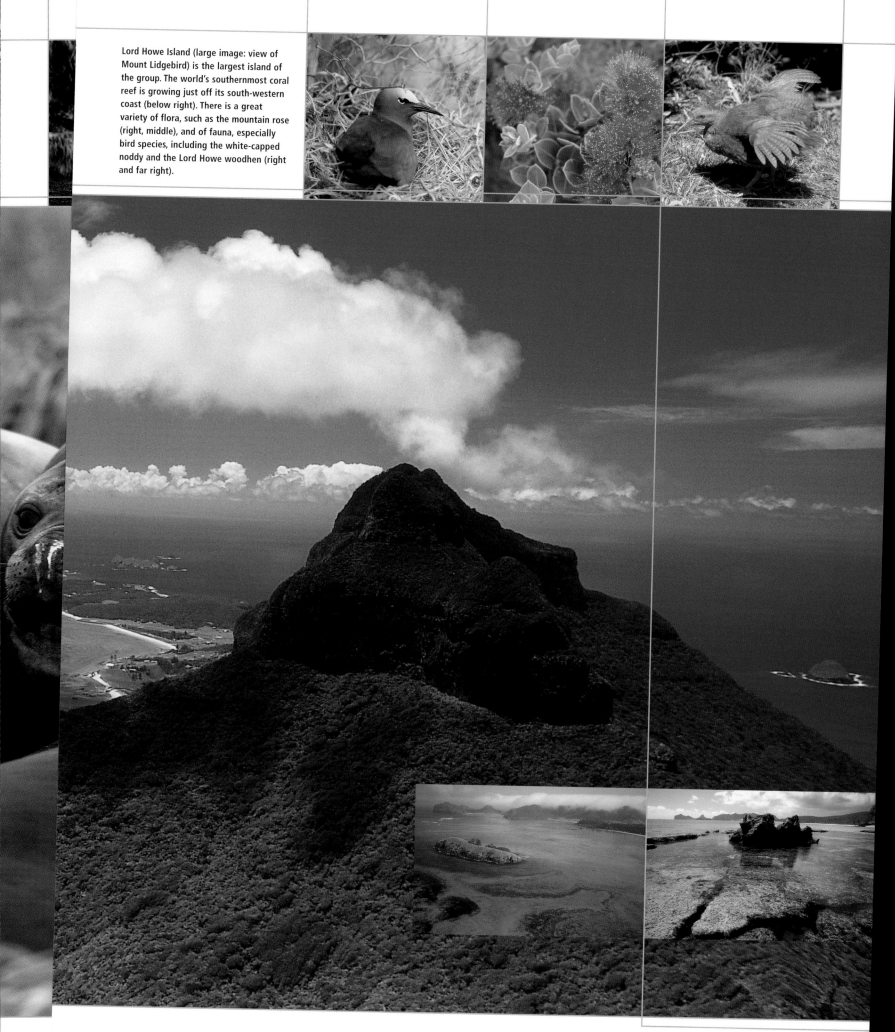

HEARD AND MCDONALD ISLANDS

These, the only subantarctic islands displaying volcanic activity, provide great insight into the dynamic processes of the earth's interior. Their ecosystems remain largely unaffected by outside influences.

Date of inscription: 1997

The islands lie some 4,000 km (2,500 miles) south-east of Perth and about 1,500 km (930 miles) north of the Antarctic continent. Mawson Peak ("Big Ben"), 2,745 m (9,000 feet) high and Australia's highest mountain, is an active volcano on Heard Island. Since 1992, McDonald has also suffered volcanic eruptions. Glaciers and ice sheets cover about 80 percent of the islands' surface and the inhospitable climate permits only sparse vegetation, grasses, and algae. To date, 42 varieties of moss have been recorded but the taxonomy of many of the lower plants, algae, and mosses has yet to be determined. The islands have been spared unwelcome "immigrants" such as cats, rats, and hares, so the penguins, sea mammals, and seabirds are undisturbed.

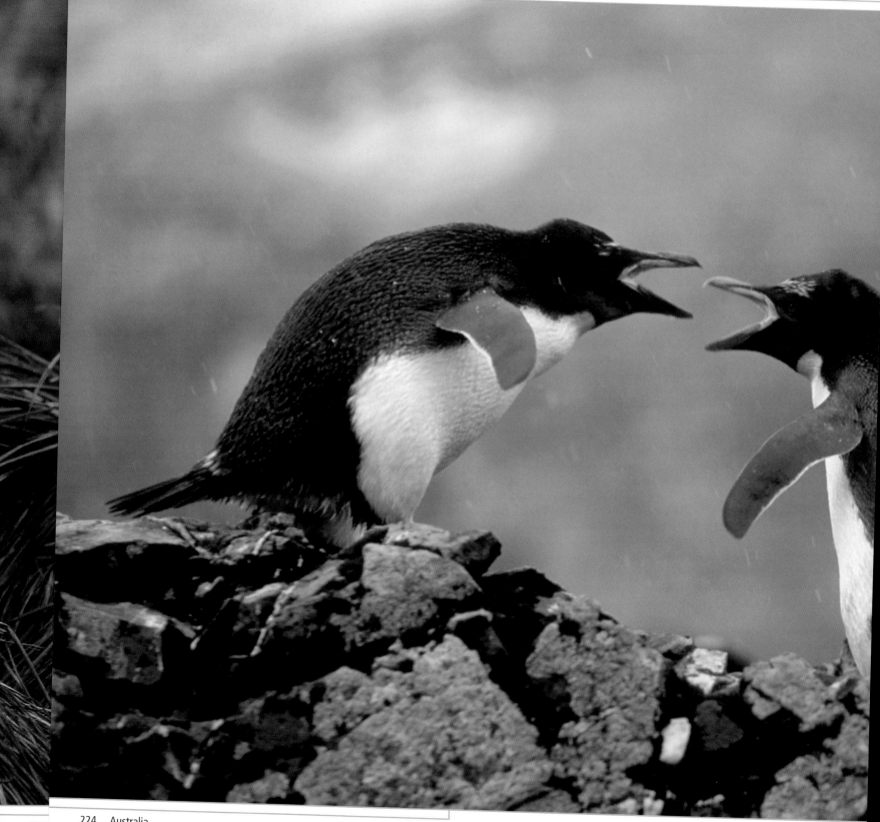

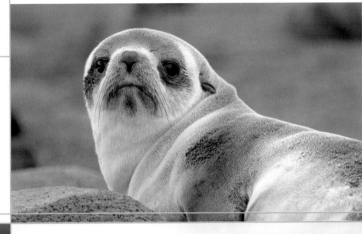

the 11 spe[...]
unique to t[...]
species nes[...]
four ende[...]
endemic s[...]
two variet[...]
one, *Latica*[...]
in fresh w[...]
peri). The [...]
sea snake,[...]

The islands are geologically and ecologically important as a window on geohistory and for the undisturbed evolution of their flora and fauna. Macaroni penguins (large image), the Antarctic fur seal (right), the elephant seal and the king penguin (bottom) all live here. Old shelters in Atlas Cove on Heard Island are indicators of earlier research activity (below right).

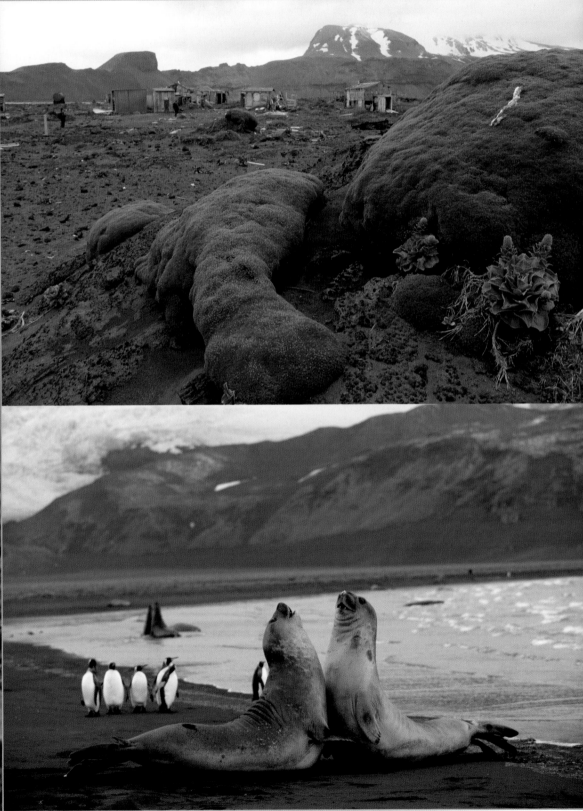

Rennell is
dry coral
ernmost
including
World He

Date of i

New Zealand's oldest national park (established in 1887), in the middle of North Island, can be traced back to a gift from the Maori to the New Zealand government. Its 750 sq. km (300 sq. miles) enclose three active volcano systems.

Date of inscription: 1990; Extended: 1993

The history of this volcanic landscape began about two million years ago, when the Indo-Australian and Pacific continental plates converged. Because of the plates' resistance, a large amount of frictional energy was released which melted the surrounding rocks. Hot magma resulted, and strong volcanic activity began above the plates' friction points. The erup-tions of the three active volcanoes, Tongariro, Ngauruhoe, and Ruapehu, are evidence of this continuing geological process, leading to the creation of the mightiest lava plateau in the world.

The vegetation is extremely diverse. Rimu, matai, and miro trees grow in the lowland rainforest, adjacent to which is the Inaka bushland with its

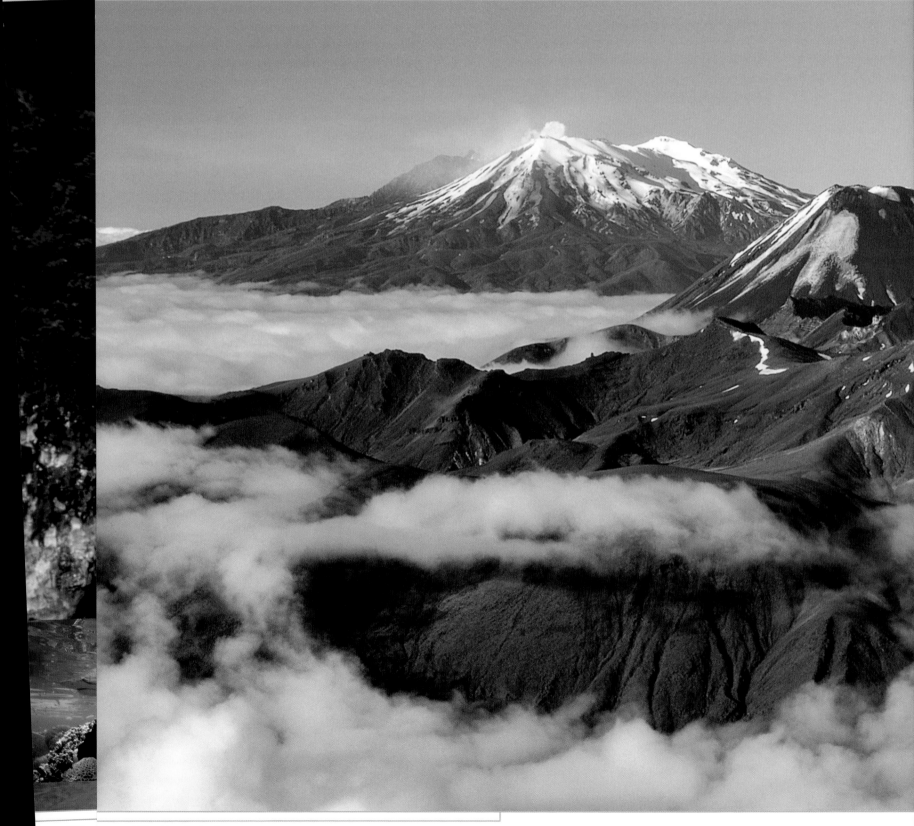

tussock grass. At higher altitudes, mushrooms, lichen, and mosses flourish on the desolate ash and lava plain. The high plateau is free of vegetation. Particularly notable among the animal life are the birds: there are more than 50 species, including rare indigenous birds such as the North Island brown kiwi, the blue duck, the kaka, the double-banded plover, and the Maori falcon; makomako, tui, Southern boobook, white-capped noddy, kakariki, fantail, and New Zealand robin are more common. The only two species of mammal unique to New Zealand also live in the national park, the short- and long-tailed New Zealand bats.

The national park was initially established in 1990 in response to the geological importance of its landscape; in its 1993 expansion, Tongariro was the first World Heritage Site to be inscribed as both a natural and cultural landscape. This distinction of the mountain, which lies at the heart of the national park, was prompted by UNESCO's recognition of its cultural and spiritual importance to the indigenous Maori.

Tongariro National Park's main attraction is the perfectly formed volcanic peaks (large image: summit of Ngauruhoe, with Tongariro in the background). Other areas of natural beauty in the park include waterfalls, such as the Taranaki Falls or the Mahuia Rapids cascades (inset images, left and middle). The park's landscape was formed over millions of years through lava flow.

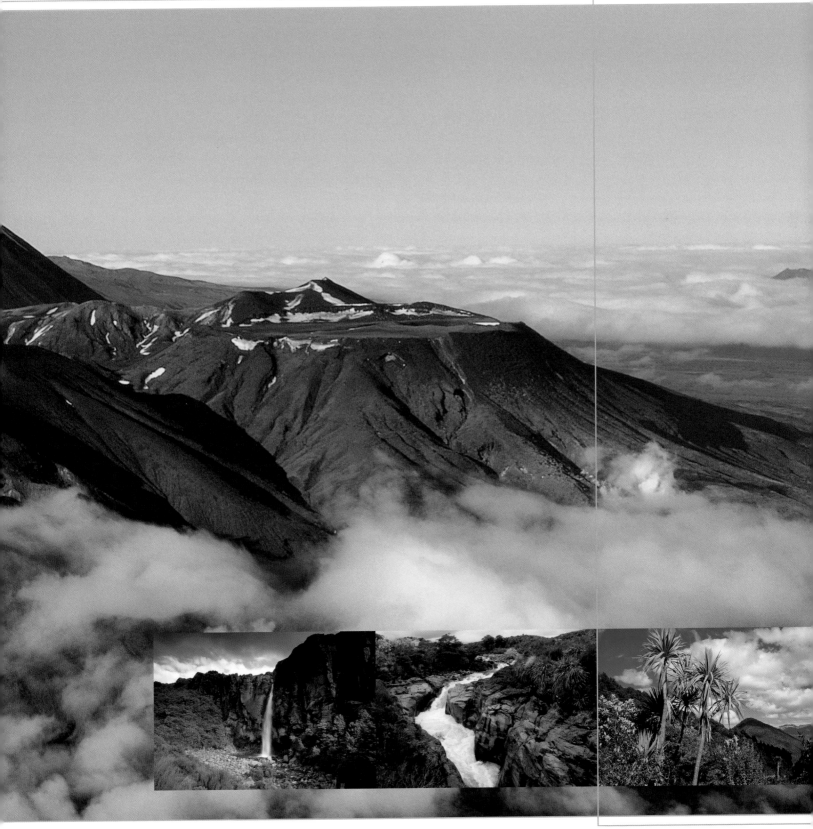

For the Maori, the New Zealand volcanoes (below: Ngauruhoe; right: Ruapehu) are sacred places, the resting places of their ancestors or the locations of mythical events. They are also the stage for displays of elemental power, as instanced in the mighty 2007 eruption of 2,797-m (9,200-foot) high Ruapehu, or when a crater lake broaches and an avalanche of mud pours down into a valley.

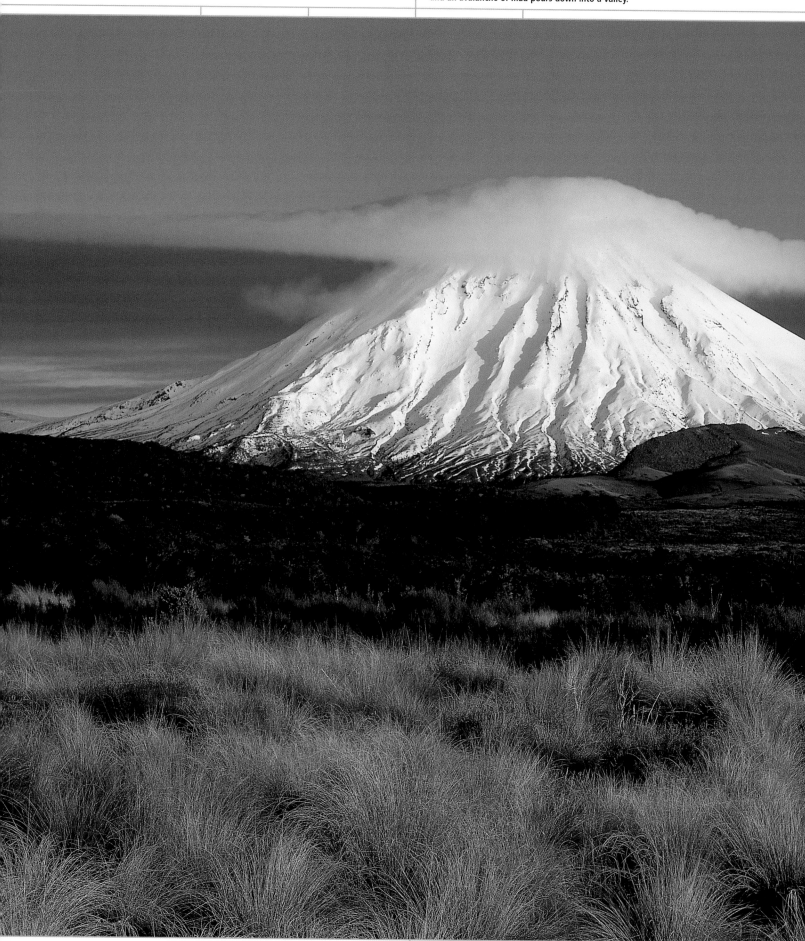

TONGARIRO
NATIONAL PARK

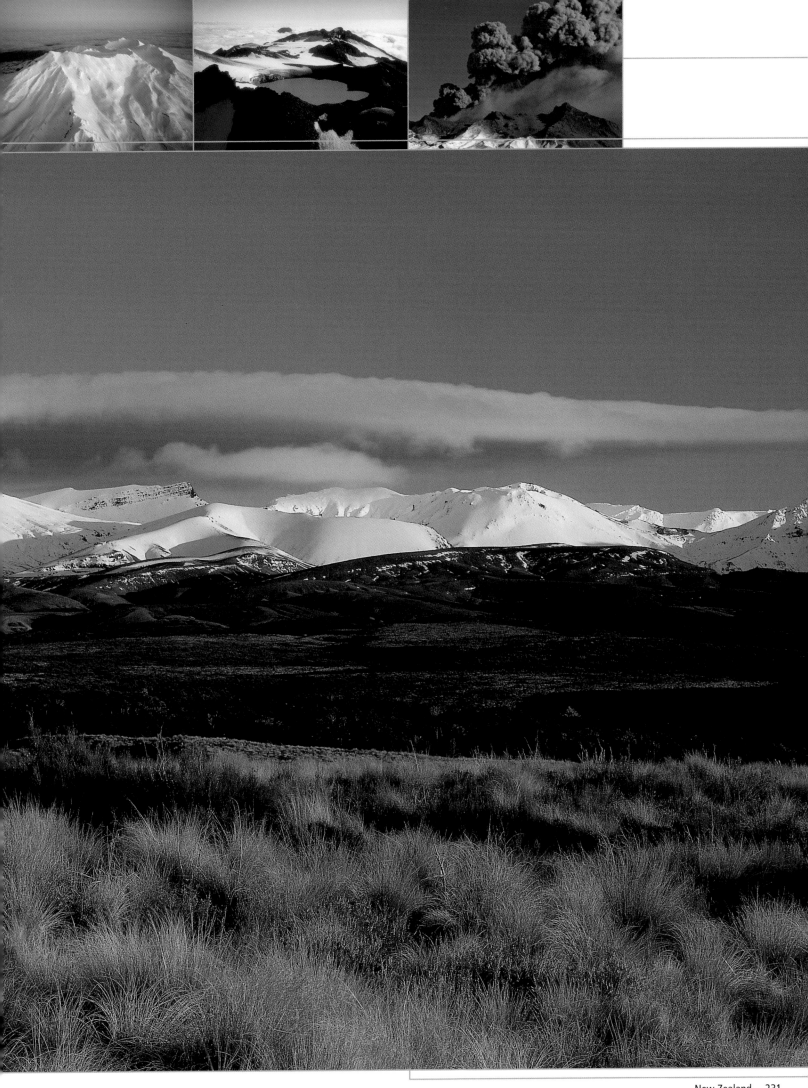

New Zealand's bird life

New Zealand came about some 100 million years ago on a tectonic fold thrown up at the unstable border of two continental plates. This geological history was responsible for establishing a great selection of indigenous species. The majority of the insects and a quarter of all the bird species are found nowhere else on earth. As New Zealand was separated from other land masses so early, for a long time there were no land mammals. With no natural predators, many species of bird lost the power of flight. Colonists brought rats, dogs, martens, and foxes with them, transforming the natural bush and woodland habitat of many flightless birds and endangering them.

The kiwi is a nocturnal flightless bird of the *Apterygidae* family, and its population is estimated at about 5,000. The Takahe (*Porphyrio mantelli*) of the rail family (*Rallidae*) is much more rare, and was considered extinct until rediscovered in 1945 by a walker in the Fjordland National Park. The salient example of acute endangerment – and of intensive

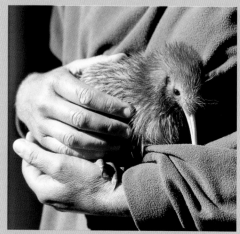

In the Kiwi House and the Otorohanga Native Bird Park, New Zealand's national bird is protected and conserved.

conservation attempts – is the kakapo (*Strigops habroptilus*), or owl parrot; this timid creature was considered extinct until 1974, when a few examples were discovered on Stewart Island. By 2005 their number had risen to 86. The moa (*Dinornis maximus*), a giant flightless bird, is long extinct, hunted to death by the Maori.

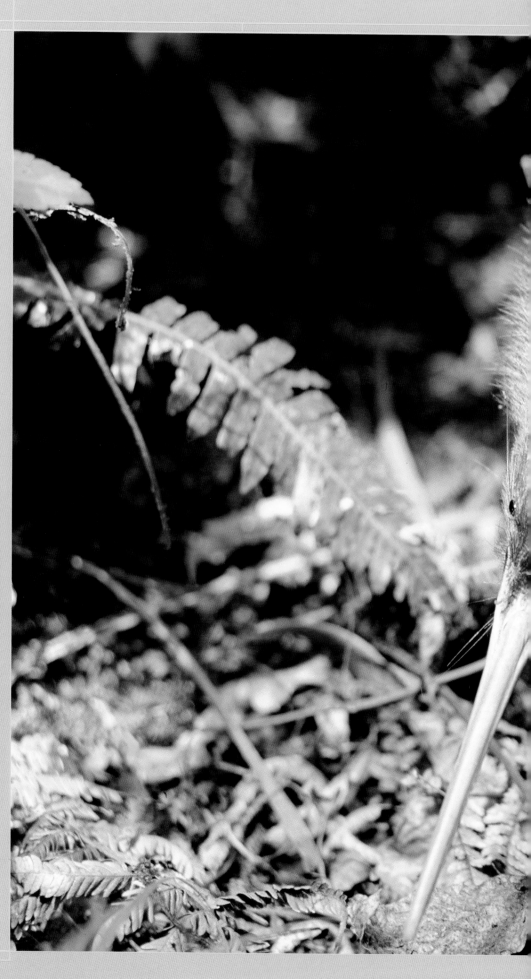

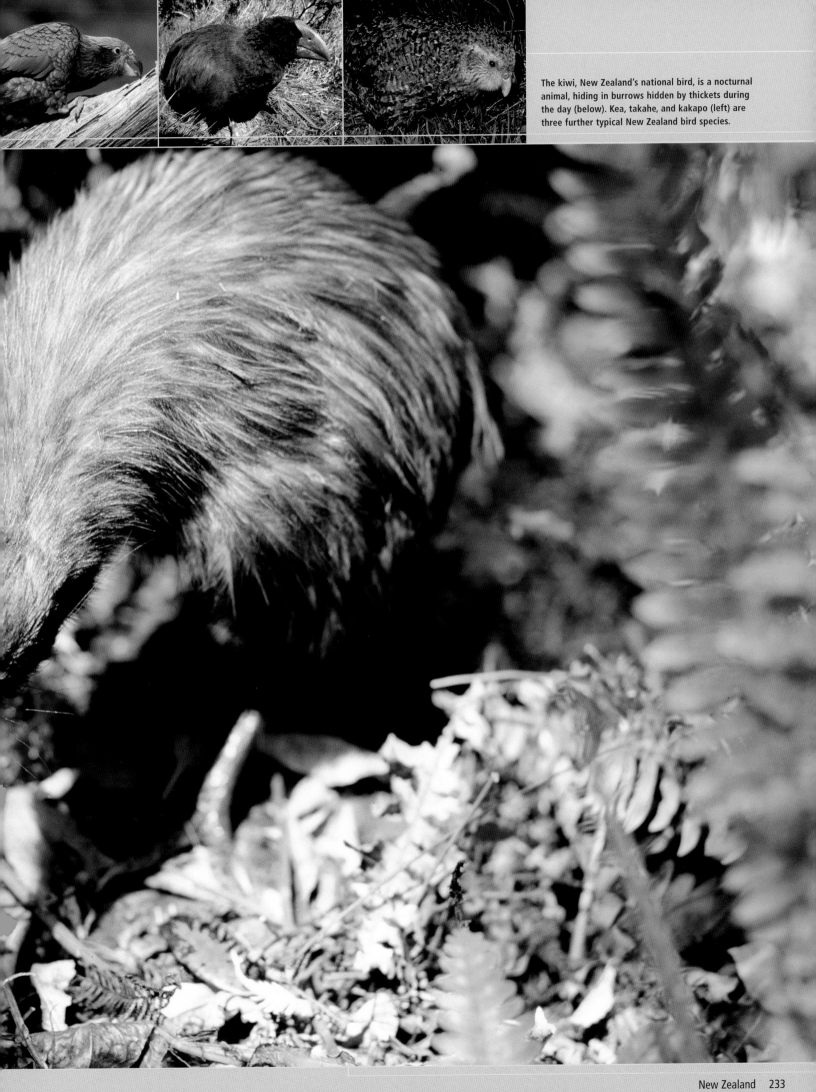

The kiwi, New Zealand's national bird, is a nocturnal animal, hiding in burrows hidden by thickets during the day (below). Kea, takahe, and kakapo (left) are three further typical New Zealand bird species.

TE WAHIPOUNAMU – SOUTH-WEST NEW ZEALAND

On the south-western coast of New Zealand's South Island, four national parks boast impressive mountainscapes and numerous ancient species of animal and plants.

Date of inscription: 1990

At about 26,000 sq. km (4,100 sq. miles), Te Wahipounamu (Maori: "place of jade") is one of the largest conservation areas in the world, and includes Westland, Mount Aspiring, Mount Cook, and Fjordland National Parks. Spread over large parts of the south-western coast of New Zealand, Fjordland is the largest of the four conservation areas and owes its name to its coastal fjords, underwater valleys up to 400 m (1,320 feet) deep. Annually, up to 10,000 mm (394 inches) of precipitation fall on this glaciated landscape, ideal conditions for subtropical rainforest to flourish. There are many species of plants and animals still in existence here which, millions of years ago, were indigenous to Gondwana, the southern hemisphere's former supercontinent. Trees here are often overgrown with carpets of lichen and creepers. Innumerable varieties of fern flourish in the undergrowth. Unique bird life lives in the seemingly impenetrable foliage. Dolphins and eared seals swim alongside the indigenous Fjordland penguin in the crystal-clear waters of the fjords.

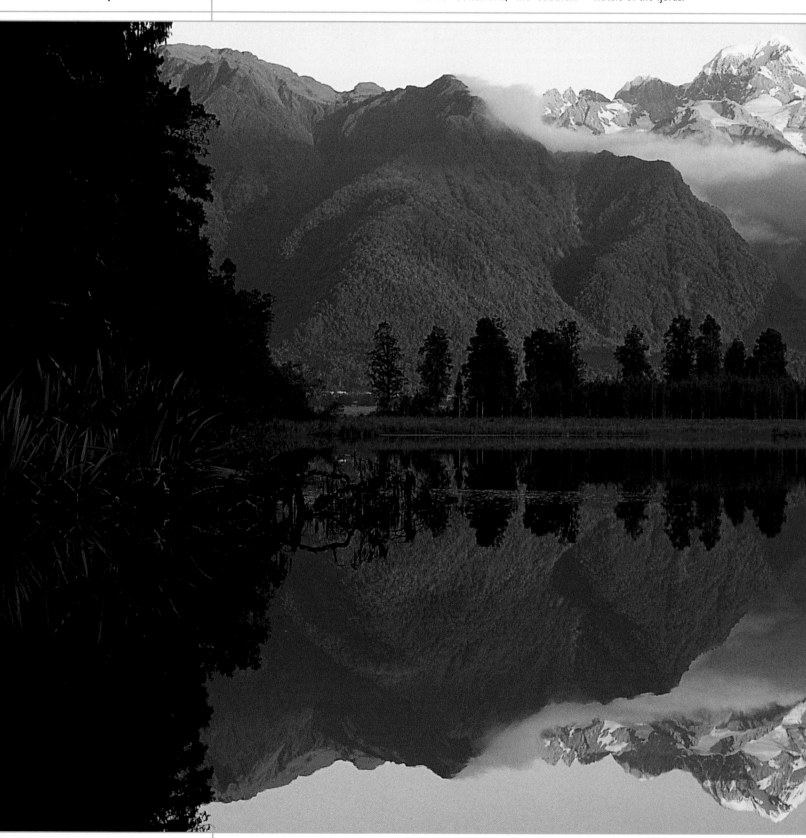

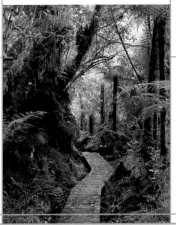

The dying rays of a long summer's day illuminate the peaks of Mount Cook and Mount Tasman (large image), reflecting their glaciated summits in Lake Matheson (near Fox in Westland National Park). It is easy to find solitude on many of the paths in this park (right: the path to Lake Wombat).

Mount Cook, at 3,754 m (12,310 feet) the highest mountain in New Zealand, rises amid the Southern Alps. The highest points of the mountain-scape, especially Mount Tasman at 3,498 m (11,470 feet), are dominated by glaciers. The two picturesque lakes lying at the foot of Mount Cook, Tekapo and Pukaki, teem with fish. In early spring, the shores of the lake bloom with unexpected beauty. The Westland and Mount Aspiring National Parks are equally fantastical, glaciated landscapes; the long protrusions of the Fox and Franz-Josef glaciers in Westland National Park stretch down through troughlike valleys almost to the coast.

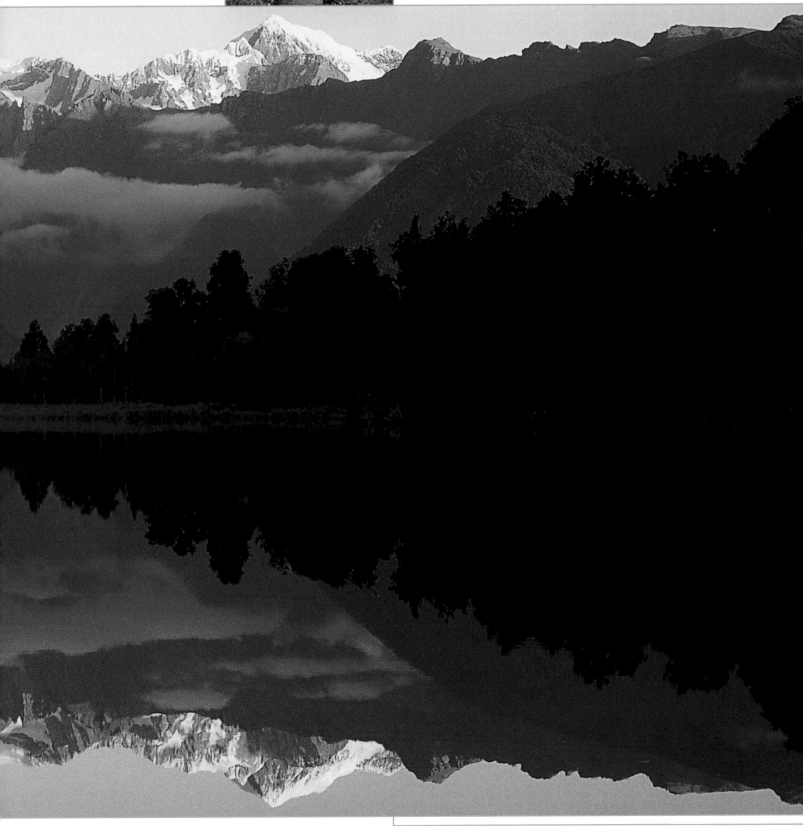

Mount Aspiring National Park's northern border is the mighty Haast river, which flows past the town of the same name into the Tasman Sea. To the south, it reaches as far as the Fjordland National Park. Here, hikers encounter challenging routes such as the Roaring Billy Falls walk (right) or the resplendent Routeburn track (middle and far right).

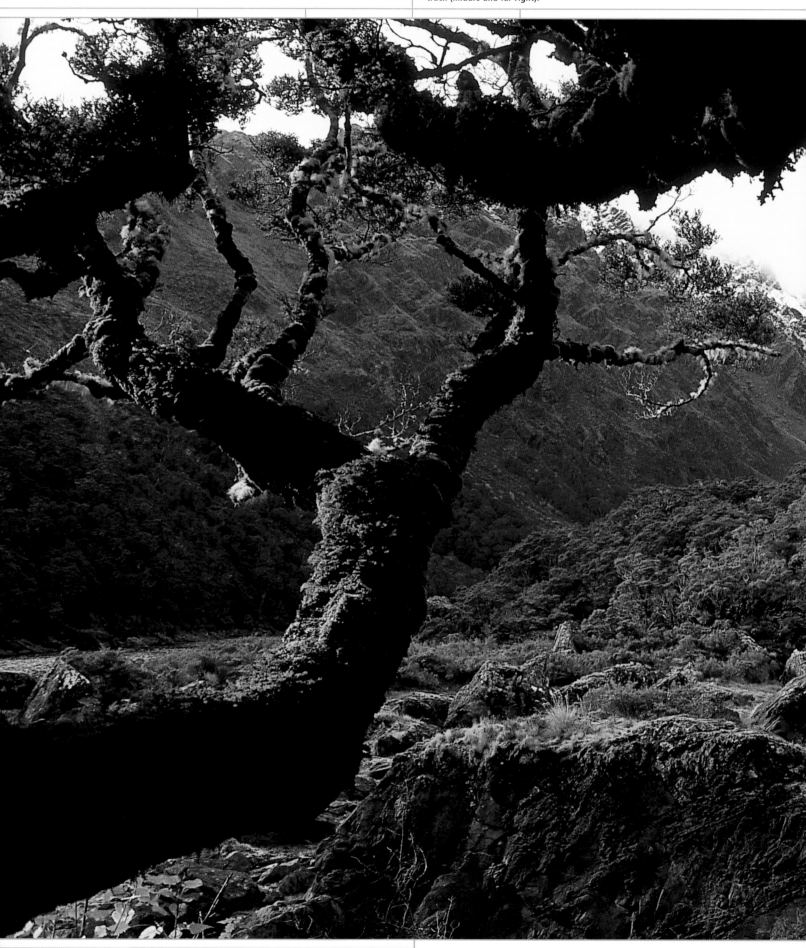

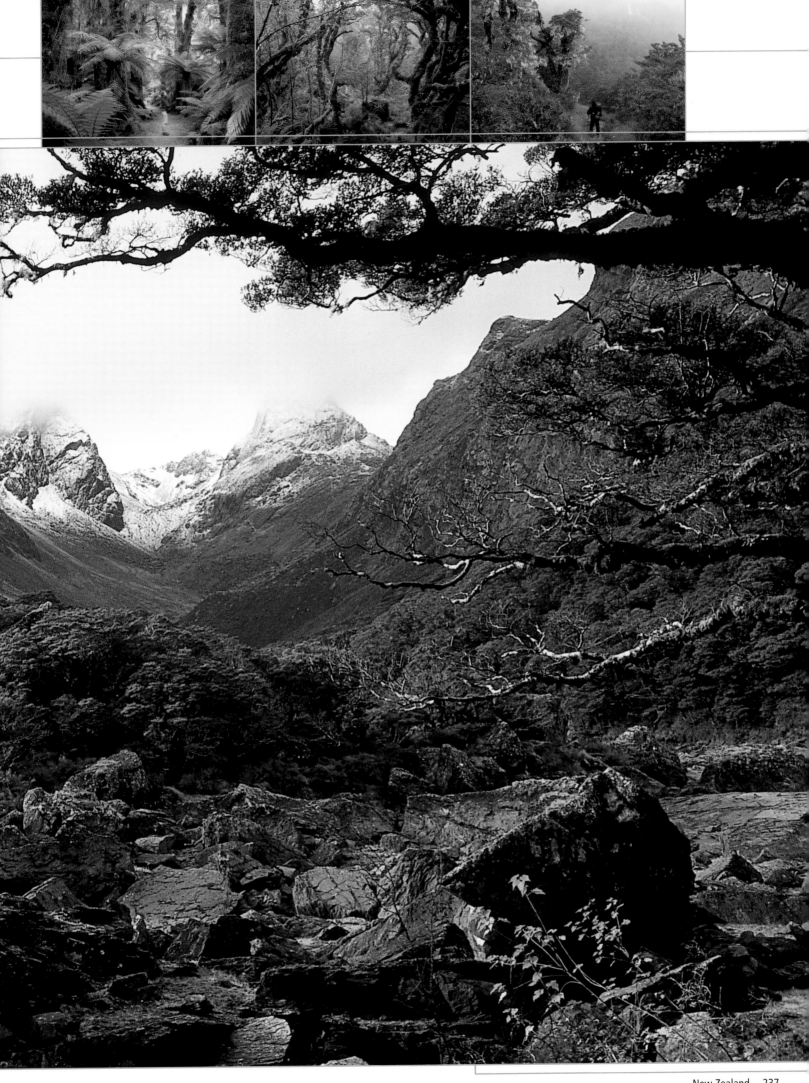

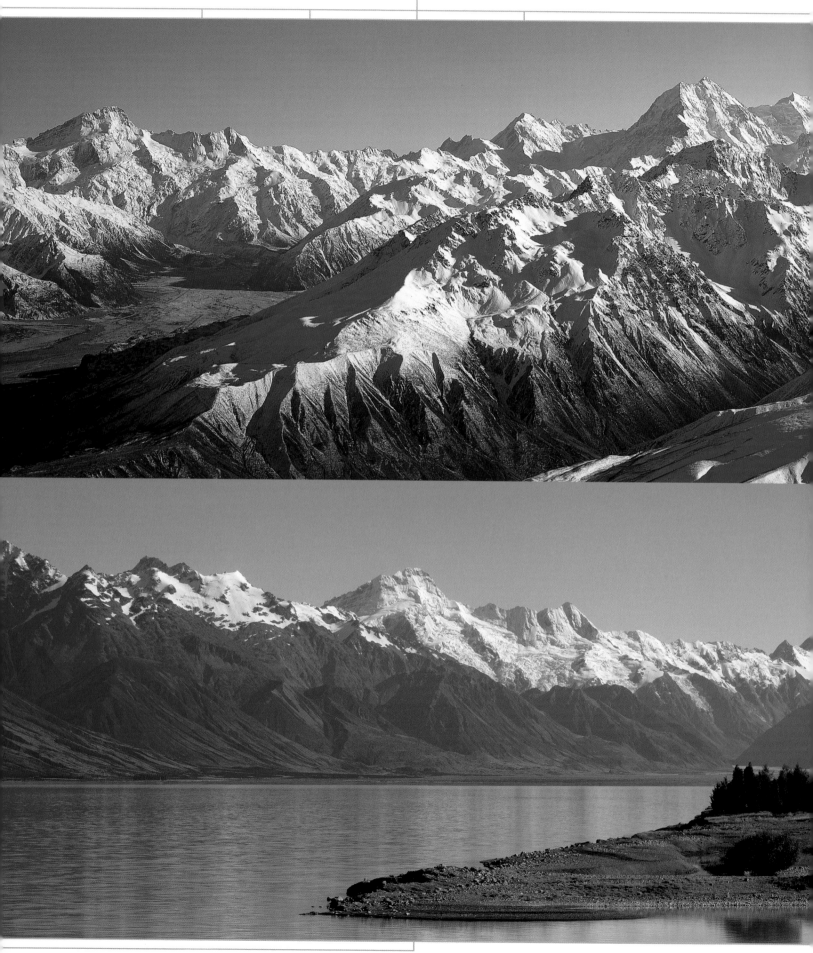

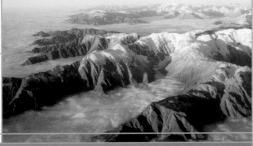

There are more than 19 peaks higher than 3,000 m (9,900 feet) in the Mount Cook National Park, forming a mountainous panorama impressive at any time of the day or year. Mount Cook itself, the highest peak in the Southern Alps at 3,754 m (12,310 feet), is called "Aoraki" ("cloud-piercer") by the Maori. It is accessible from the east via a 60-km (37-mile) long dead-end path running along Lake Pukaki (below left).

TE WAHIPOUNAMU – SOUTH-WEST NEW ZEALAND FJORDLAND NATIONAL PARK

At 12,500 sq. km (4,900 sq. miles), Fjordland is New Zealand's largest national park and is considered its most beautiful, with crystal-clear rivers and peaceful lakes (below left: Lake Te Anau), majestic fjords, such as Milford Sound, which flows into the Tasman Sea (below right), and many objects of natural beauty by the roadside (right: daisies, fern growth, moss, fern leaves).

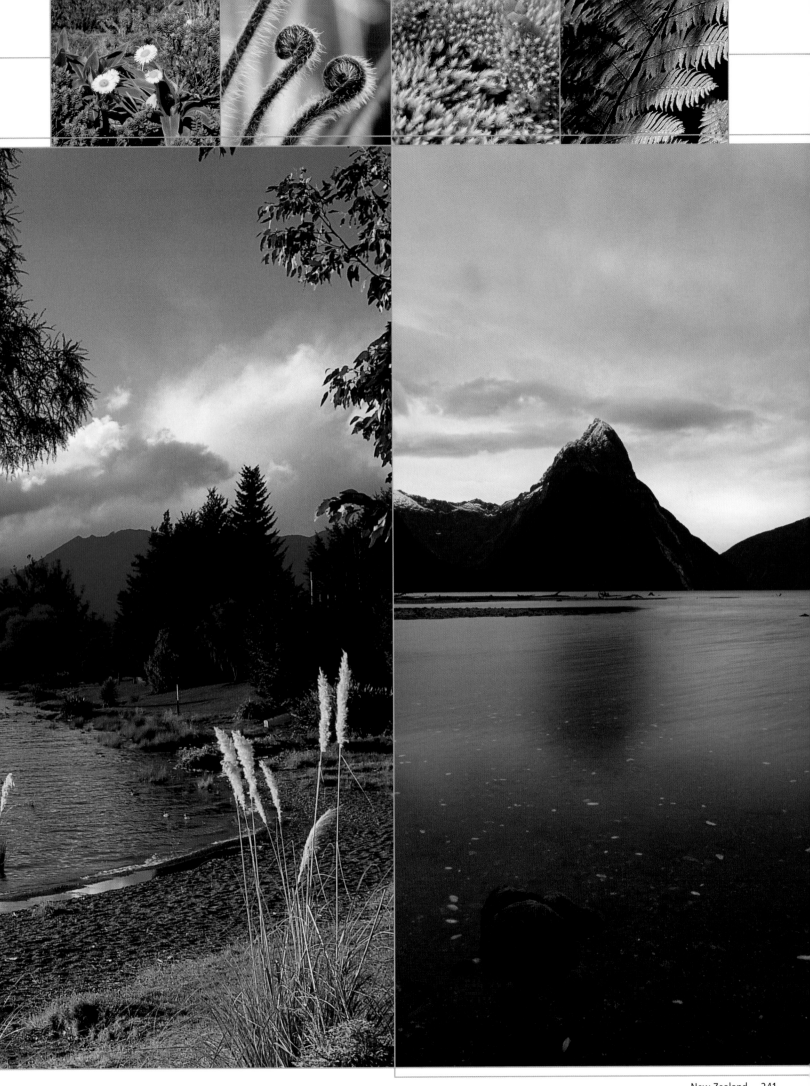

NEW ZEALAND'S
SUBANTARCTIC ISLANDS

These five island chains in the South Pacific represent a singular ecosystem. A diverse – and often unique – biotope has developed at the confluence of the Antarctic and subtropical ocean currents.

Date of inscription: 1998

The uninhabited Auckland, Campbell, Antipodes, Snares, and Bounty island groups lie south and east of the New Zealand coast. With the exception of the low cliffs of the Bounty Islands, they are carpeted with moorland. The deep fjords of the Campbell and Auckland Islands show signs of a prolonged period of glaciation. With the exception of the Bounty Islands, these island groups have the richest wealth of flora of all the subantarctic islands. Of more than 250 species, 35 are endemic and 30 considered very rare. The world's southernmost forests are to be found on the Auckland Islands, with great numbers of tree ferns. Among 120 recorded varieties of bird are 40 different seabirds, of which five nest only here. Of 24 species of

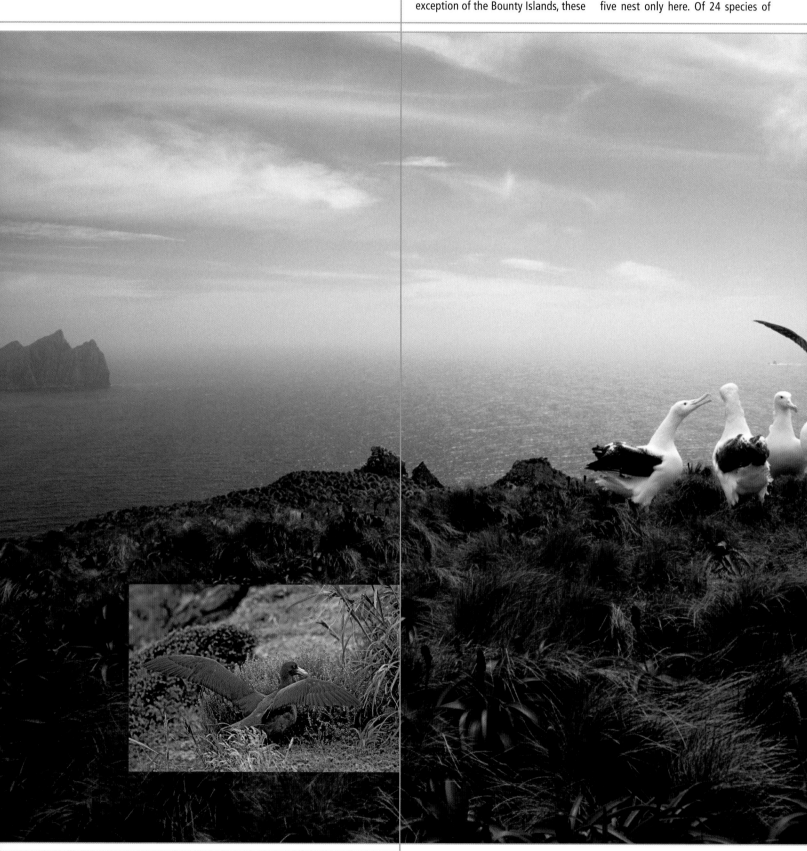

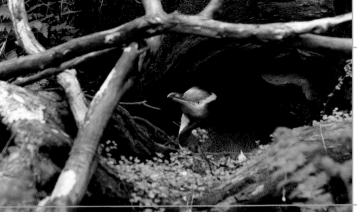

albatross, 10 are unique to the islands, including the southern royal albatross. Also unique are two of the four species of penguin.

In addition, the islands afford a refuge to the rare New Zealand sealion and large colonies of New Zealand fur seals. Several species of insects, snails, and spiders are also found only here.

Royal albatrosses (large image: on the Campbell Islands) only visit the island coasts to nest. They usually remain on the water or in the air, in contrast to the southern giant petrel (inset below: on the Auckland Islands), which feels quite at home on land. Yellow-eyed (left) and Snare's Island penguins (below) live on the subantarctic islands.

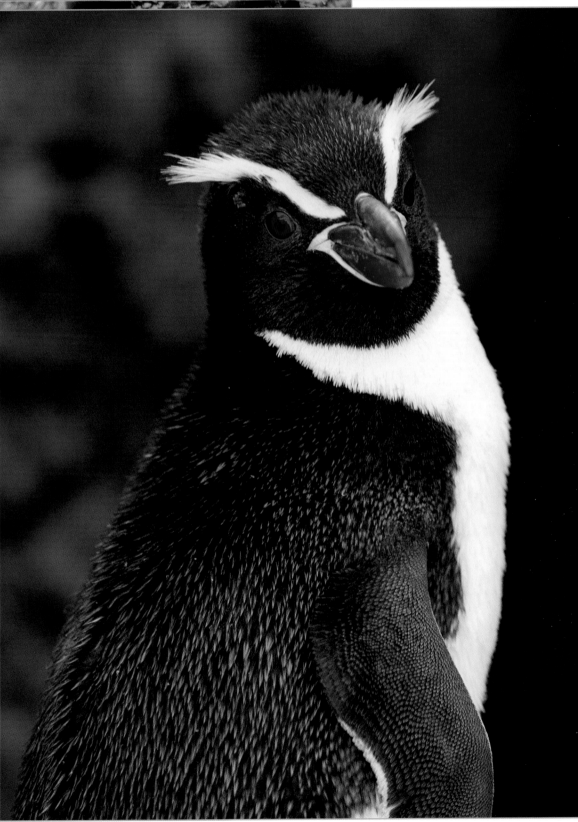

At 10 km (6 miles) in length and 5 km (3 miles) in width, the island is the largest in the British Overseas Territory of the Pitcairn Islands and has remained largely undisturbed.

Date of inscription: 1988

Until the 18th century, this remote island was largely spared from human influence. The animal and plant life on this towering atoll with its steep cliffs was thus undisturbed; its dense bush forest has revealed 11 plant species unique to Henderson Island. More than 20 land and seabirds, and many insect and snail species, are also found only here.

Resembling Table Mountain, Henderson Island rises some 30 m (100 feet) out of the sea. It is a paradise for plants and a habitat for rare birds, including the English fairy tern (large image) and the noddy tern (inset image).

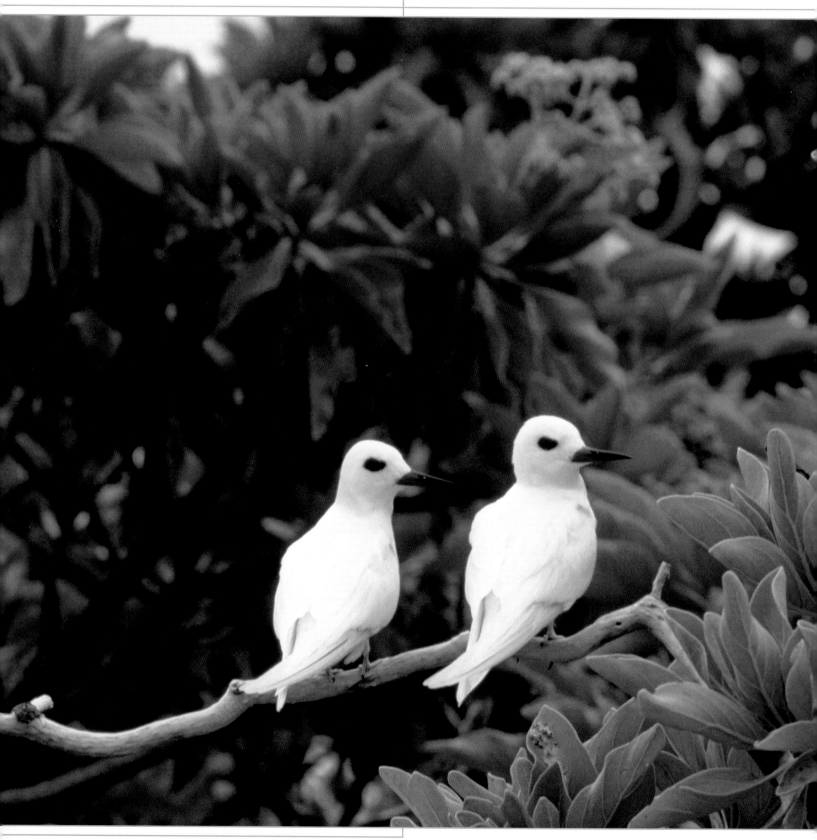

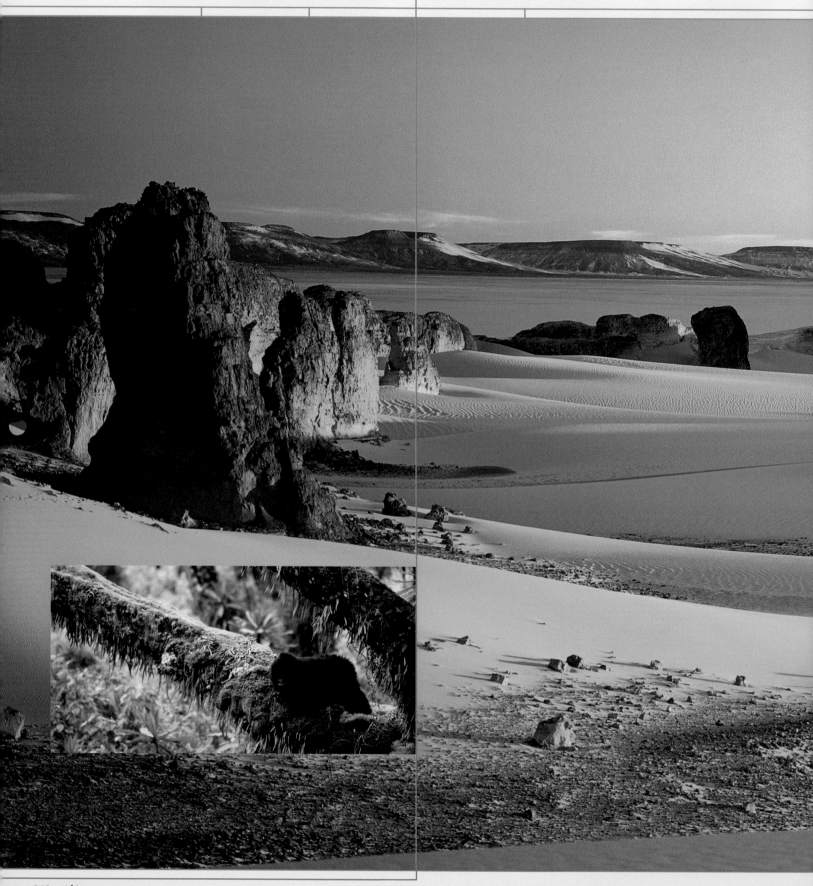

Worldwide, there are only a few hundred mountain gorillas left. About half of these live in the Virunga National Park, in the north-east of the Democratic Republic of the Congo.

The red glow of evening penetrates the Tassili N'Ajjer mountain plain in Algeria. The effects of erosion have created a unique landscape of sand dunes and fantastic rock formations.

AFRICA

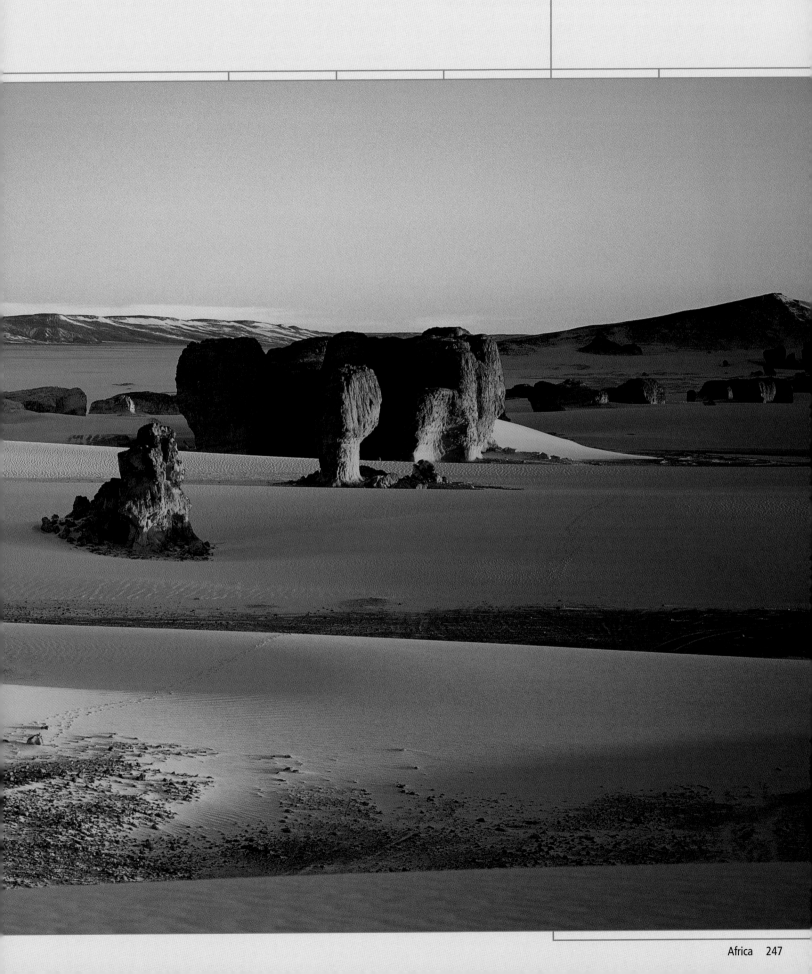

Many prehistoric rock paintings have been preserved in the jagged terrain of the Hoggar mountains – invaluable documents of the earliest period of human development. This desert region, characterized by numerous ravines and bizarre rock formations, is home to rare animals and plants.

Date of inscription: 1982

The Tassili N'Ajjer mountain plateau ("plateau of the rivers") covers an area roughly the size of England in one of the least hospitable areas of the Sahara, near the Libyan and Niger borders. In 1933, numerous cave paintings were discovered in this magnificent rocky landscape.

More than 15,000 cave drawings and engravings have been documented so far. The designs date back to various periods, the earliest to 6000 BC. They document decisive stages in human cultural development from a time when today's desert still enjoyed a damp, tropical climate. The rock paintings, protected from the ravages of the elements in ravines and caves, depict hunters and herds of elephants, giraffes, and buffaloes. Domestication

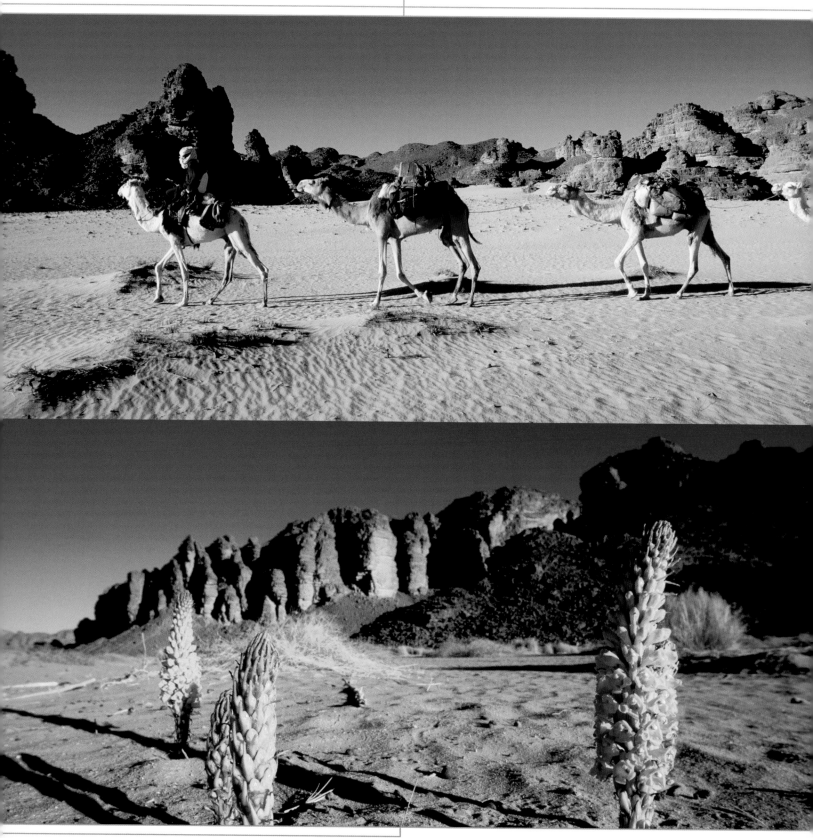

also seems to have been practiced, as herdsmen are shown grazing their animals on the savannah. Camels appear in the later paintings. The indigenous Saharan cypress and the Saharan myrtle are typical of the vegetation, and among the indigenous animals are the endangered Barbary sheep, the dorcas gazelle, the caracal lynx, and the sand cat.

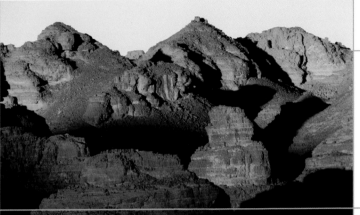

The mountain chain resembles a moonscape (below right); its appearance is due to erosion. Rocks jut out of the sand like giant stalagmites (bottom, left and right), but plant life can nonetheless flourish, thanks to the water-retentive properties of sandstone (bottom left). This bizarre scenery can be explored by camel (below left).

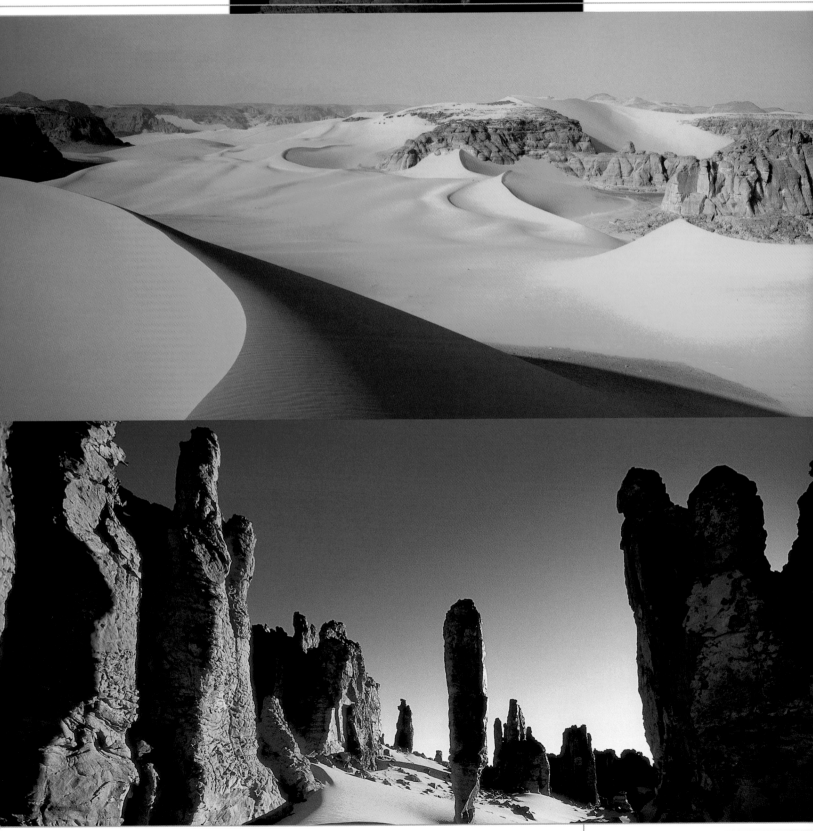

Certain styles and phases can be determined in the hunting and ritual scenes depicted. The earliest motifs are abstract and very schematic (below middle). In later periods, vitality, movement, and elegance predominate (above right and below). People are often shown with clothing and body decoration (large image; inset images, right).

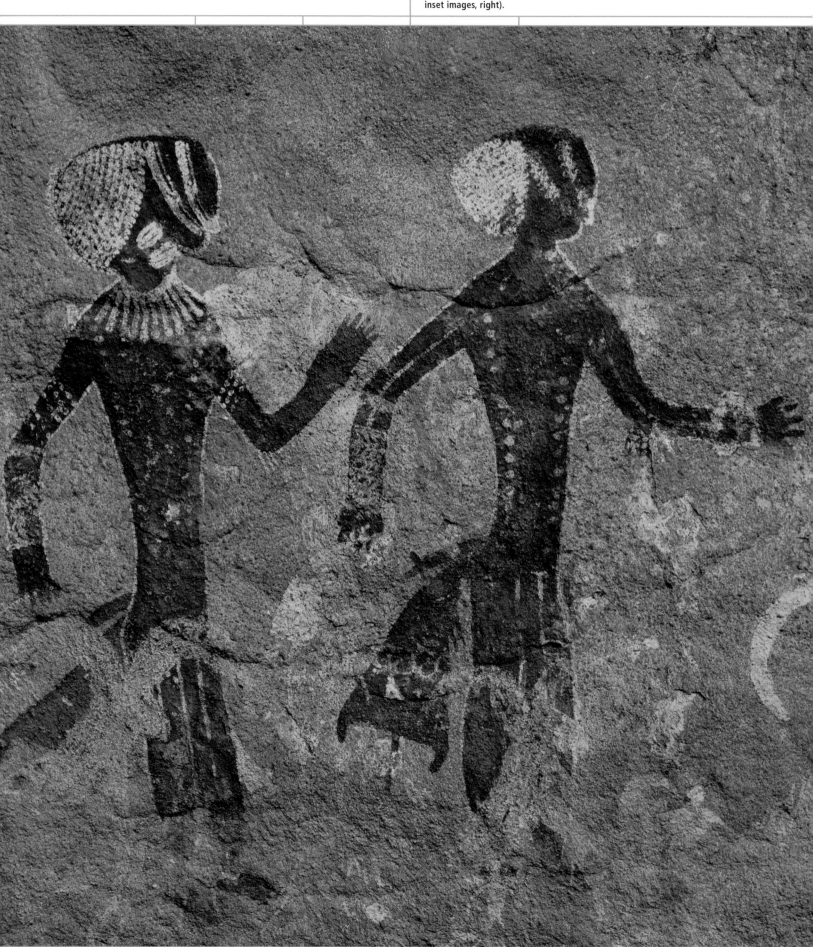

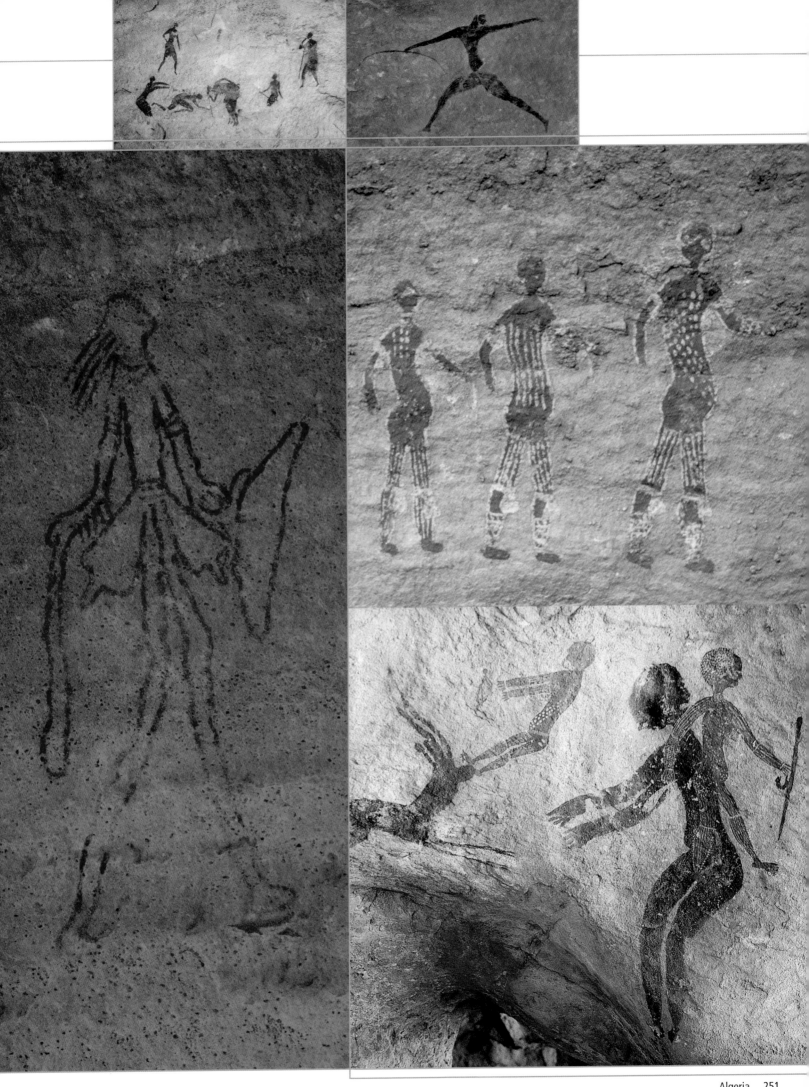

ICHKEUL NATIONAL PARK

At 100 sq. km (39 sq. miles), the national park encloses both Lake Ichkeul and its tributaries and the 511-m (1,680-foot) high Djebel Ichkeul massif. It is one of north Africa's most important wetlands and a habitat for numerous bird species, water buffaloes, and bog plants.

Date of inscription: 1980

At a distance of 25 km (16 miles) south-west of Bizerta, and connected to the Bizerta Lagoon by the Oued Tinja, the region immediately surrounding the 100 sq. km (39 sq. miles) of Ichkeul Lake, with its teeming fish life, is fed by streams from the Mogod mountains. The lake has both fresh and salt water, the salt content increasing in the dry summer months and decreasing with heavy rainfall. Various species of rushes, irises, swamp lilies, reeds, and water lilies grow in the fertile oases. The conservation area is also a refuge for Tunisia's largest mammal, the water buffalo, weighing up to 1,200 kg (2,900 lb), as well as almost 200 species of bird, of which the majority are waterfowl, such as ducks and coots. In the winter, it is home to hundreds and thousands of migratory birds from Europe. Nowhere else in north Africa are there so many gray geese. Fossil deposits of hominids, primates, and extinct giant mammals are also found in the area.

The dense vegetation on the shores of Lake Ichkeul teems with life. Among the inhabitants are the widgeon (large image), the ferruginous duck (inset below) and the white-headed duck (above right); as well as the garden warbler (right) and the coot (inset above).

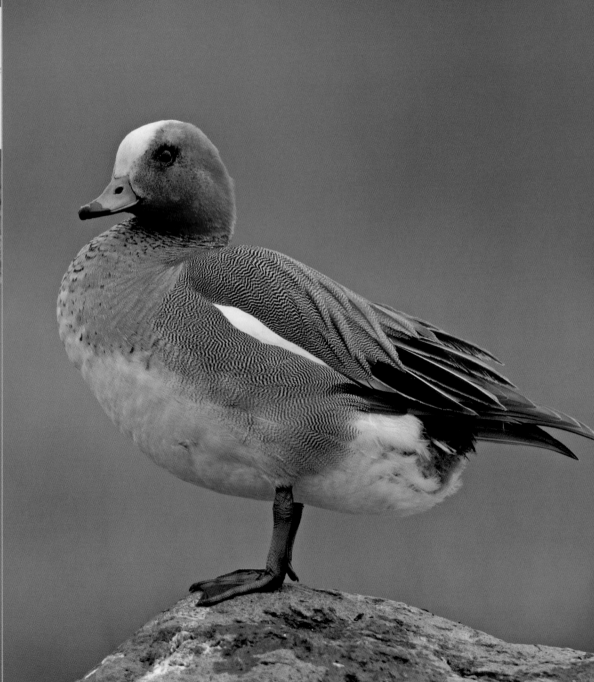

WADI AL-HITAN

Fossilized precursors of modern whales, the Archaeoceti, have been found in Wadi Al-Hitan ("valley of the whales").

Date of inscription: 2005

Wadi Al-Hitan lies around 250 km (155 miles) west of Cairo, in an extraordinary landscape of sand dunes and cushion-shaped rock formations caused by wind erosion. However, the main attractions in this dry valley are 380 well-preserved whale fossils. Sixty million years ago, the earliest ancestors of the whale were land-dwellers, although they lived close to the lake shore. The Mesonychids are most closely related to modern ungulates, but were carnivorous and resembled the common otter. From these developed the life-forms whose remains were found in the valley. *Zeuglodon isis* lived from 45 to 38 million years ago, was more than 20 m

(66 feet) long, hunted in the water and probably only returned to land to reproduce. By this stage its back legs had already atrophied and, instead of forelimbs, it had five-fingered fins. The fossilized remains of the whales are preserved in sandstone, slate, marl, and limestone. The rock strata were laid down at the bottom of the prehistoric Tethys Ocean, which once stretched south beyond the modern Mediterranean coast. The oldest strata in the whales' valley are about 40 million years old and contain numerous whale and manatee skeletons, shark's teeth, turtles, and crocodiles. Fossilized whales are also to be found in younger strata.

The Qasr El-Sagha rock formations from the Eocene contain many other sea creatures as well as whales, including sharks, bony fish, and sea snakes, along with plant life like seagrasses and mangrove trees. These reveal the composition of the ecosystem in which the whales moved. In some whales, even the stomach contents have been preserved.

Wadi Al-Hitan (below right) is an important fossil site. Numerous whale fossils lie embedded in the desert sand (large image).

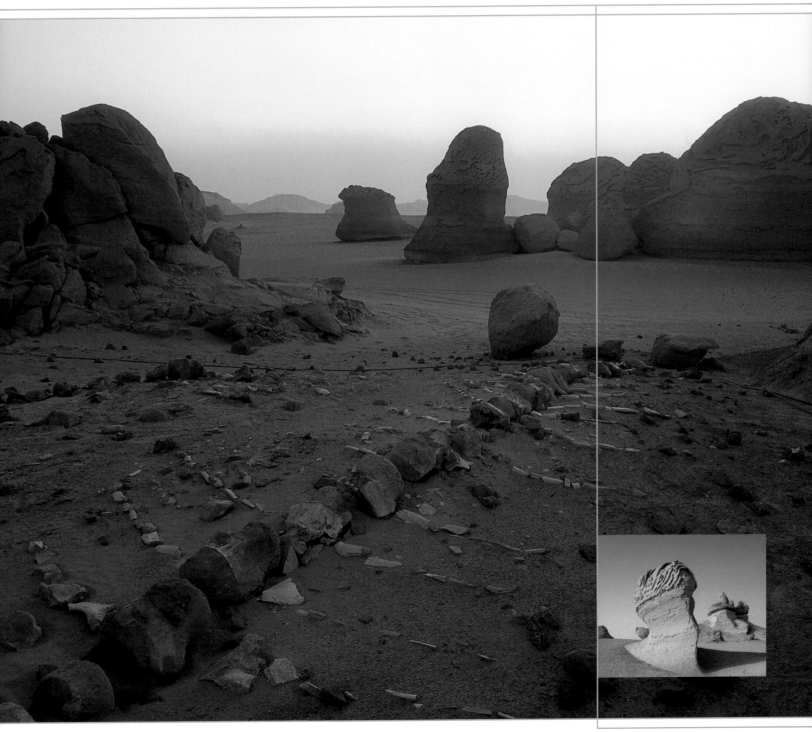

Qasr El-Sagha rock formations

BANC D'ARGUIN
NATIONAL PARK

With a total area of around 12,000 sq. km (4,700 sq. miles), of which half is marine, this bird sanctuary on Mauritania's Atlantic coast is one of the largest breeding grounds in west Africa. Many migratory birds from Europe and Asia spend the winter here.

Date of inscription: 1989

Located halfway between Nouakchott and Nouadhibou in the transition zone between the Atlantic and the Sahara, this national park consists of stretches of coastline frequented mainly by seabirds. They populate mangrove swamps, coastal sand dunes, open water, and the small, sandy islands grouped off the coast around the main island of Tidra.

Around 100 species regularly nest and winter here. The number of breeding pairs fluctuates between 25,000 and 40,000.
Among the other residents of the shores and coastal waters, which teem with fish, are flamingos, pelicans, herons, spoonbills, and cormorants, as well as assorted species of sea turtle and dolphin.

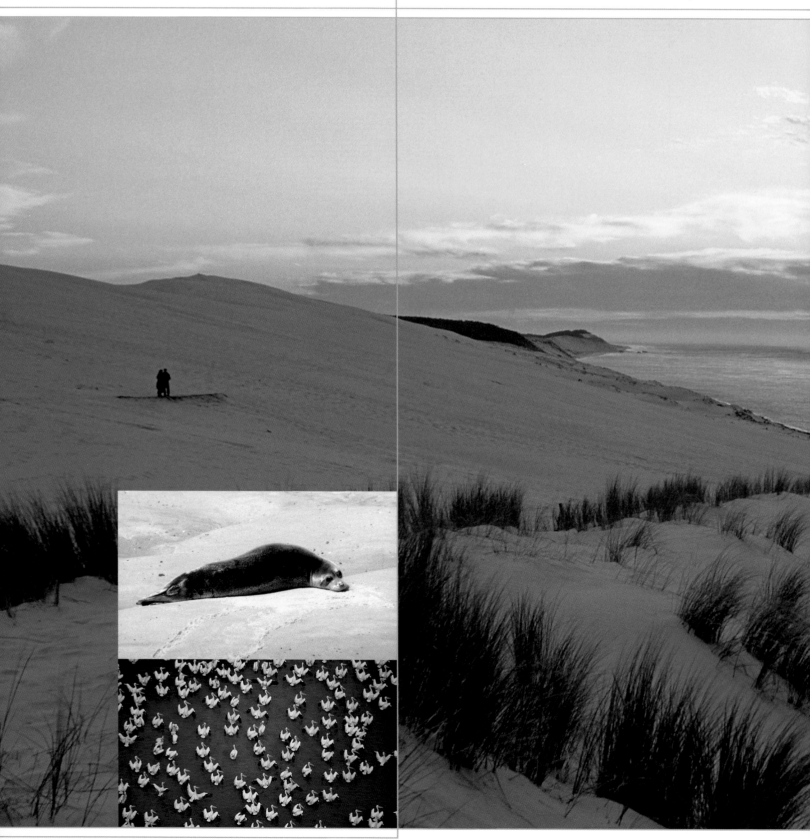

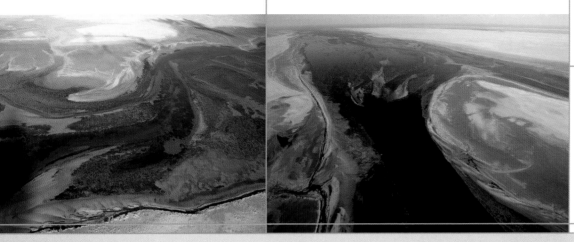

Located where the Sahara and the Atlantic converge, Banc d'Arguin National Park represents a unique transition zone from sand dunes and sandbanks to silt and mudflats, reefs, peninsulas, and islands (large image; small images, left) – an ideal habitat for seals and pelicans (inset below left).

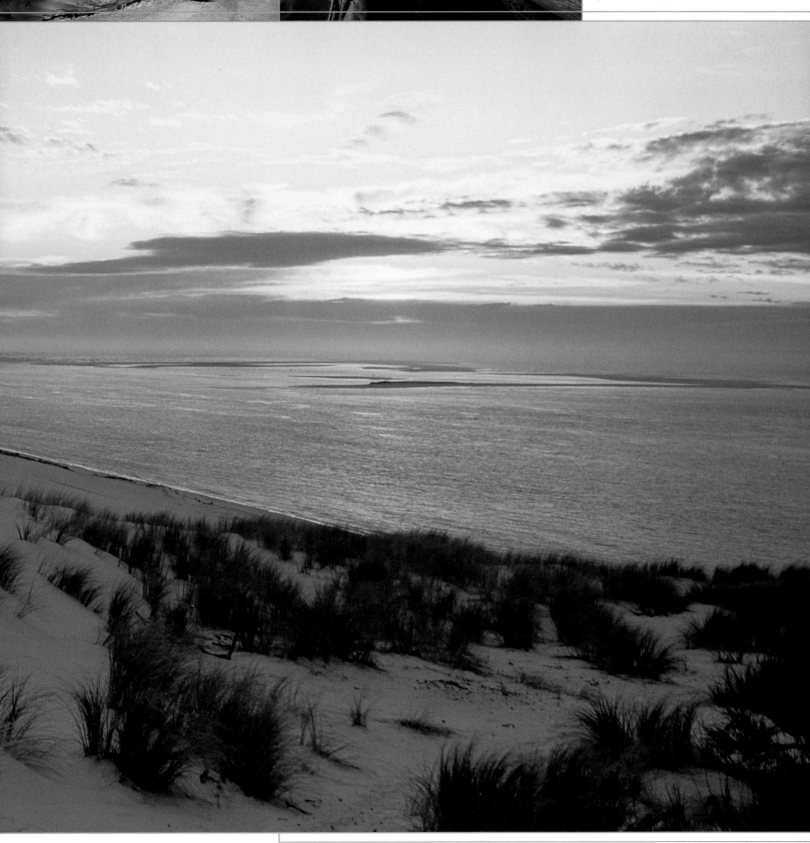

A 150-km (93-mile) long escarpment lies east of Mopti. It is the home territory of the Dogon, famed for their mud huts and masks.

Date of inscription: 1989

This World Heritage Site includes both the dip and scarp slopes of the Bandiagara escarpment and the plain below it, as well as 250 Dogon villages and the surrounding Songo community. In the worldview of the Dogon, all elements of the universe are closely interlinked in a dense concatenation of symbolic relationships. The architecture of their dwellings, temples, and communal buildings is thus determined by religious and mythological considerations. A house façade, a village, a garden, a field, or a shroud can all display similar patterns. The village is laid out in an anthropomorphic form received from their mythical ancestors, and the architecture of the mud huts reflects the duality of man and woman. The most spectacular Dogon villages are situated on steep cliffs, with squared-off mud huts and conical-roofed clay granaries piled up in several layers. Men and women each have separate granaries, in which millet, their main subsistence crop, is stored, along with their jewelry. Among these are located the temple-like round towers of the Binu shrines, and the Toguna

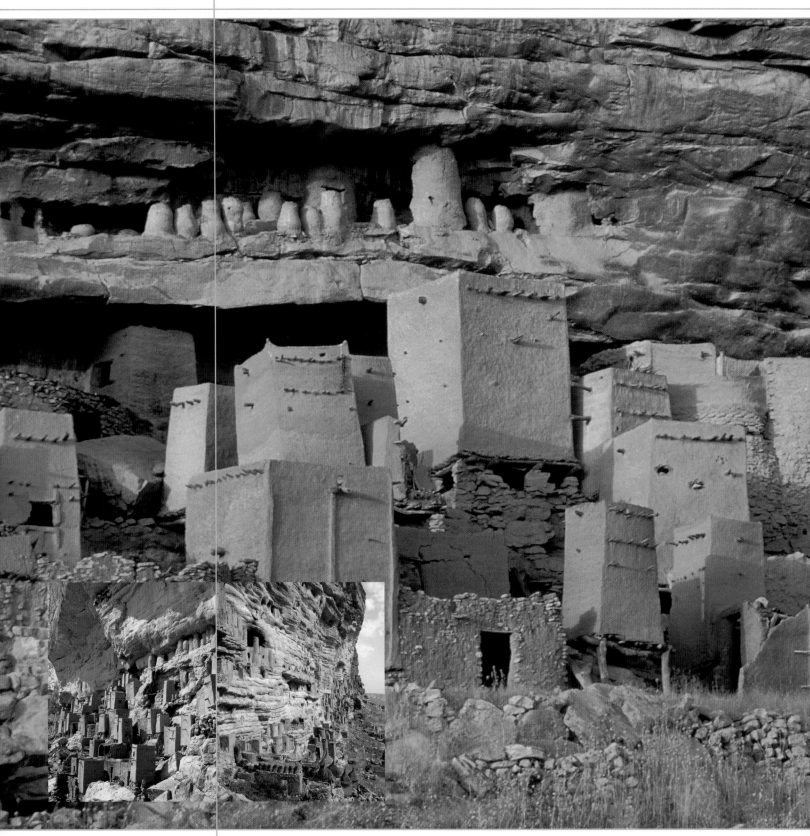

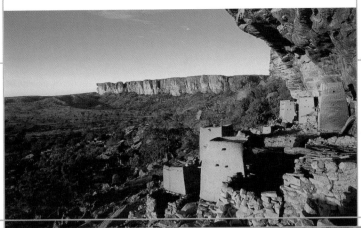

with its roof of millet stalks, the meeting place for older adult males.

Dogon mask-making, which plays a central role in their culture, is also closely connected to mythology, and there are around 100 different kinds of mask, which are donned for festivals and rituals.

The mud huts of the Dogon cling to the cliffs of the Bandiagara escarpment like bird's nests. Many can only be reached by ladder. Even graveyards are built here.

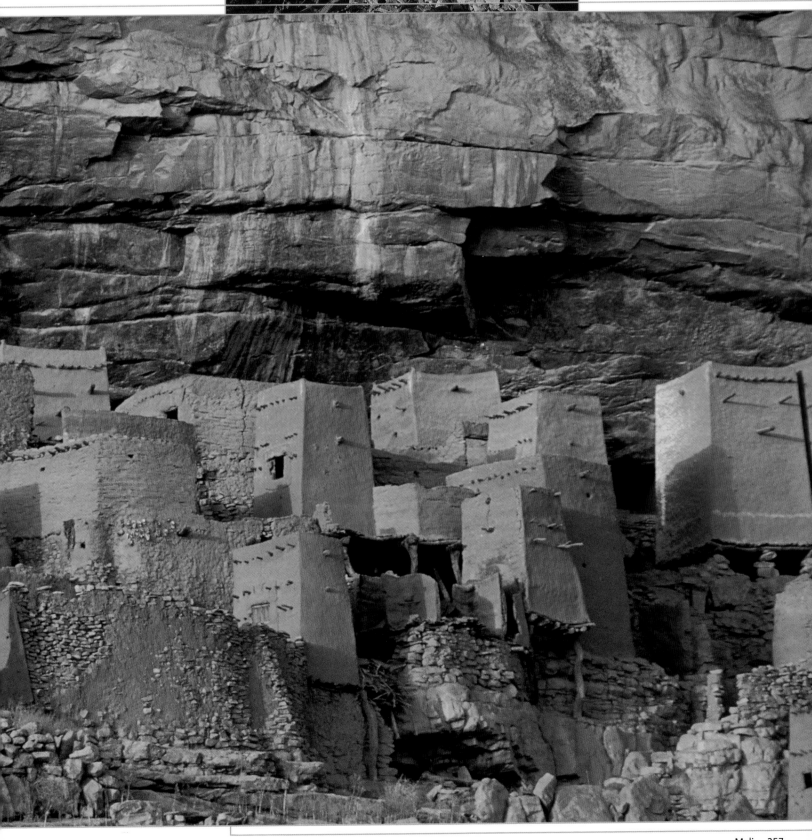

The Dogon also display their artistic talents through rock painting. These paintings are from a cave near Songo, in which the Dogon perform circumcision rites three times a year.

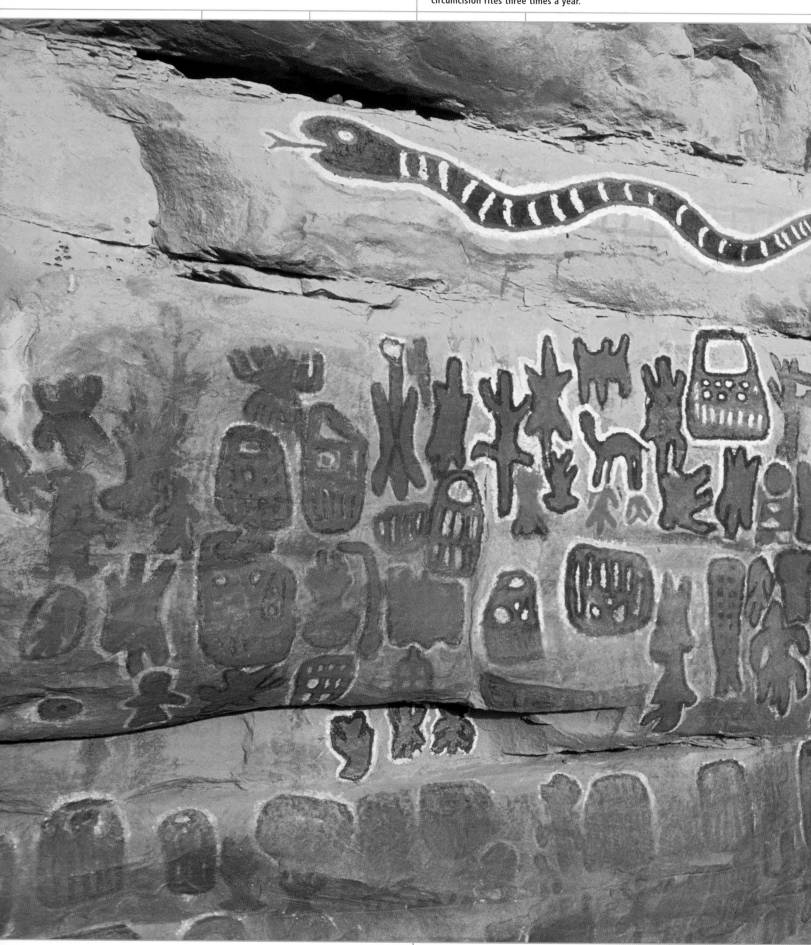

For the paintings, red, white, and black pigments are applied using the fingers. The subjects depicted represent mythical ancestral figures, masks, weapons, animals, everyday objects, and cosmological and historic events.

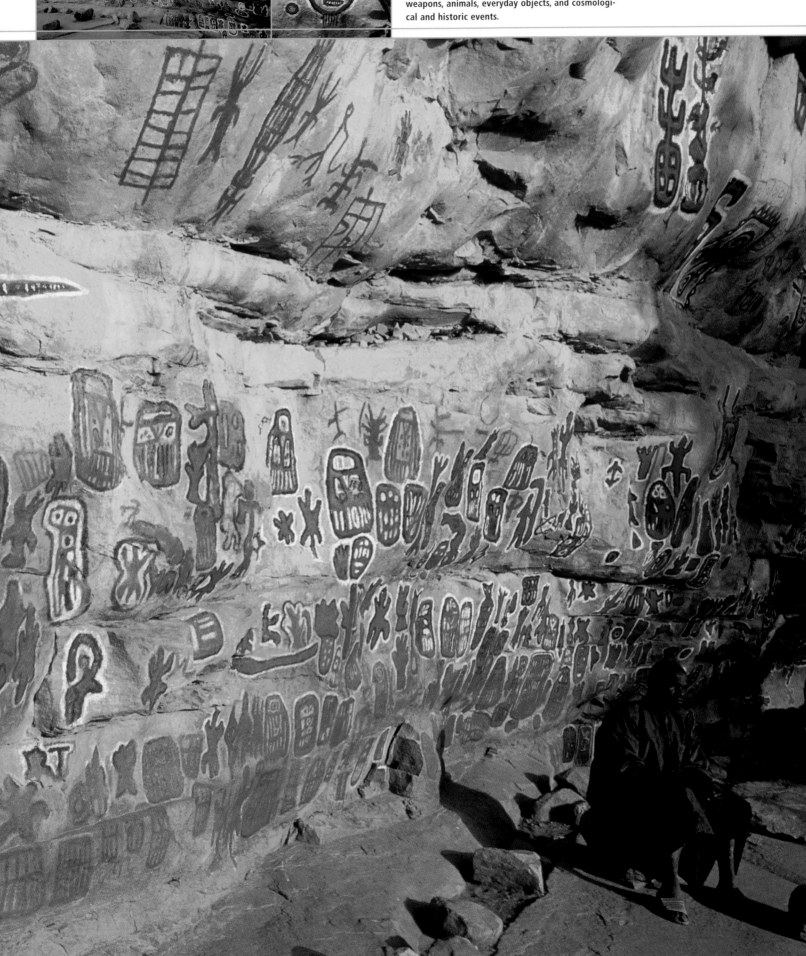

AÏR AND TÉNÉRÉ NATURE PARKS

The Aïr massif and the Ténéré desert offer fantastical scenery, typical Sahara and Sahel flora and fauna, and unique prehistoric rock art.

Date of inscription: 1991

Africa's largest nature reserve covers some 80,000 sq. km (31,000 sq. miles). The Aïr massif in north-western Niger runs for 400 km (250 miles) from north to south. It is a crystalline peneplain of volcanic origin, 700 m (2,300 feet) high in the middle, with a series of steep intrusion peaks separated by sand-filled valleys (koris), culminating in Mont Gréboun, the highest point at 2,310 m (7,580 feet). Adjacent and to the east, the Ténéré desert gradually develops from plains of gravel and sand into a sea of dunes at its center. Often, no rain falls here for years at a time and there are vast variations in temperature.

On the damper south-western slopes of the Aïr lie grass prairies. Palms and acacia shrubs flourish in the koris, which retain groundwater, and olive trees and cypresses find a hold in the mountains. Aïr mouflon, wild asses, and desert foxes also live here. Prehistoric humans created great rock art in the northern part of the mountain range. The oldest paintings and engravings, from the neolithic period of cattle domestication, suggest a period of damper savannah climate.

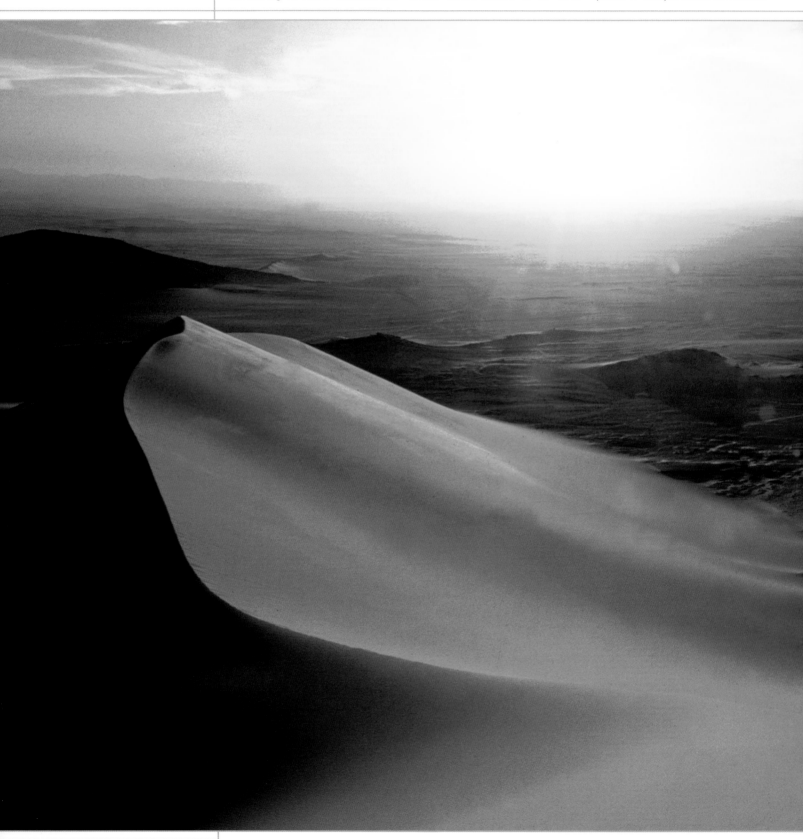

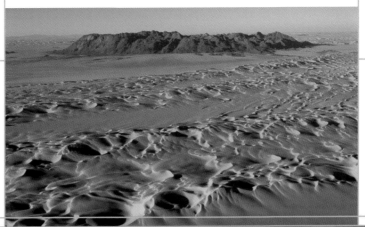

In the early Quaternary period the Ténéré desert was covered in part by the shallow Lake Chad. Many of the fossil finds are from this period (dinosaurs, turtles, crocodiles, extinct fish species).

Rock art and arrowhead finds attest to the existence of a flourishing culture of hunting and herding in the period around 7000 to 3000 BC.

Some of the most impressive scenery in the nature reserve is to be seen in the transition zone between Aïr and Ténéré, where rock formations and desert converge, providing a fascinating contrast.

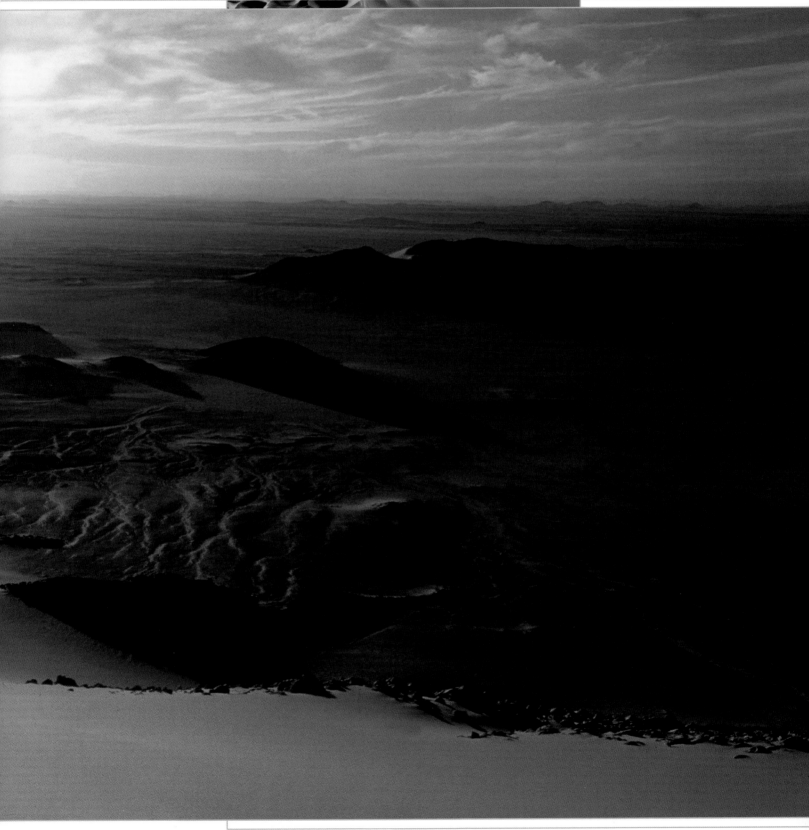

"W" NATIONAL PARK

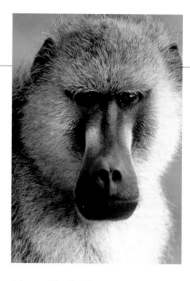

This cross-border nature reserve, the largest in west Africa, takes its name from the meandering of the Niger river at its northern edge, which forms a "W" shape.

Date of inscription: 1996

About 150 km (93 miles) south of Niamey in the border area between Niger, Burkina Faso, and Benin is the entrance to this national park, which extends to more than 10,000 sq. km (3,900 sq. miles), of which a section of approximately 2,200 sq. km (845 sq. miles) in Niger is recognized as a World Heritage Site.

The park is on the right bank of the river Niger in a transition zone consisting of both Sudanese savannah and wooded areas with gallery forest, in the Sudan-Guinea zone. At the eastern border of the park, near the Niger, the Mékrou river has cut a deep ravine into the sandstone. In the rainy season, the river is transformed into raging rapids and, in the dry season, water lilies grow in the rock pools that remain.

Green monkeys and baboons live in the luxuriant vegetation on the banks of the Mékrou and other tributaries of the Niger. Hippos, Cape buffaloes, and large herds of elephants inhabit the dry savannah and gallery forest beside the rivers and streams. Among some 70 mammal and 450 bird species in the park are lions, cheetahs, hyenas, jackals, antelopes, warthogs, ibises, storks, and herons. Several species of reptile are to be found in the river Niger, including the Nile crocodile.

Primates like the olive baboon (above) and the green monkey (below) live in the "W" National Park.

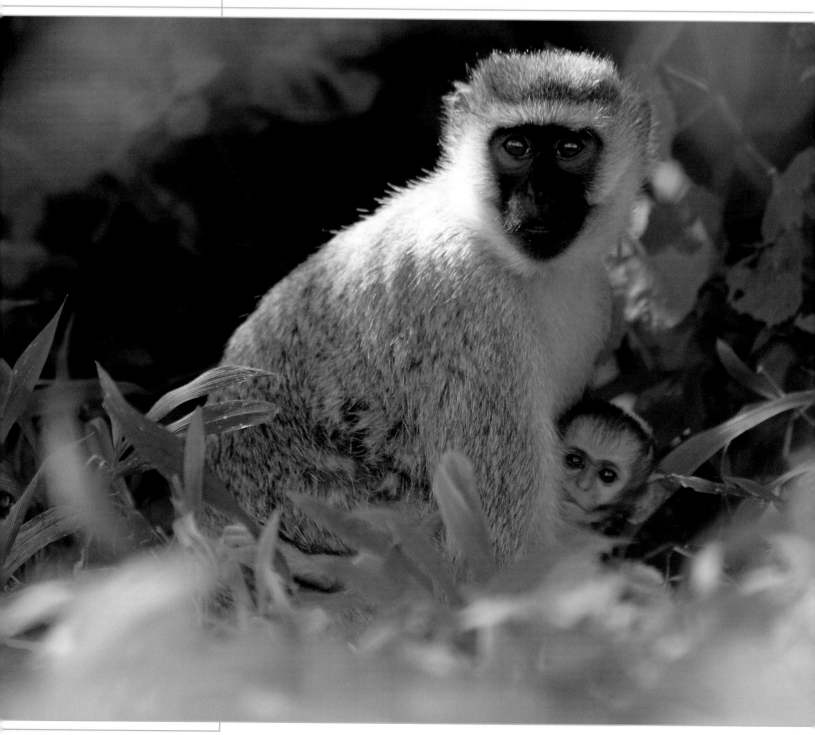

DJOUDJ BIRD SANCTUARY

In the old delta area of the river Senegal, between the Gorom tributary and the main river, can be found a bird population that is unparalleled elsewhere in West Africa.

Date of inscription: 1981

Situated about 60 km (38 miles) north-east of St Louis on the Mauritanian border, this bird sanctuary is one of the largest in the world, covering an area of 160 sq. km (60 sq. miles). It is home not only to many resident, but also to numerous migratory birds from Europe and Asia, depending on the time of year. After an exhausting transit of the Sahara, up to three million migrants take up their winter home near these richly stocked waters.

When the backwaters of the delta evaporate away in the dry season, the birds are attracted to the few remaining water source – the Gorom, which never dries out, and the bays of Lake Djoudj. Around 1.5 million waterfowl and waders populate the expanses of this unique paradise for birds, including flamingoes, cormorants, cranes, spoonbills, herons, storks, black-tailed godwits, white-faced whistling ducks, spotted redshanks, Arabian bustards, aquatic warblers, and other rare species. West Africa's largest pelican colony, with a population of over 1,000, is a particular attraction for visitors.

The conservation area not only houses feathered inhabitants, however – turtles, crocodiles, warthogs, jackals, and gazelles can also be found here.

There are birds wherever you look in Djoudj National Park: cormorants, white-faced whistling ducks (above) and pelicans (large image).

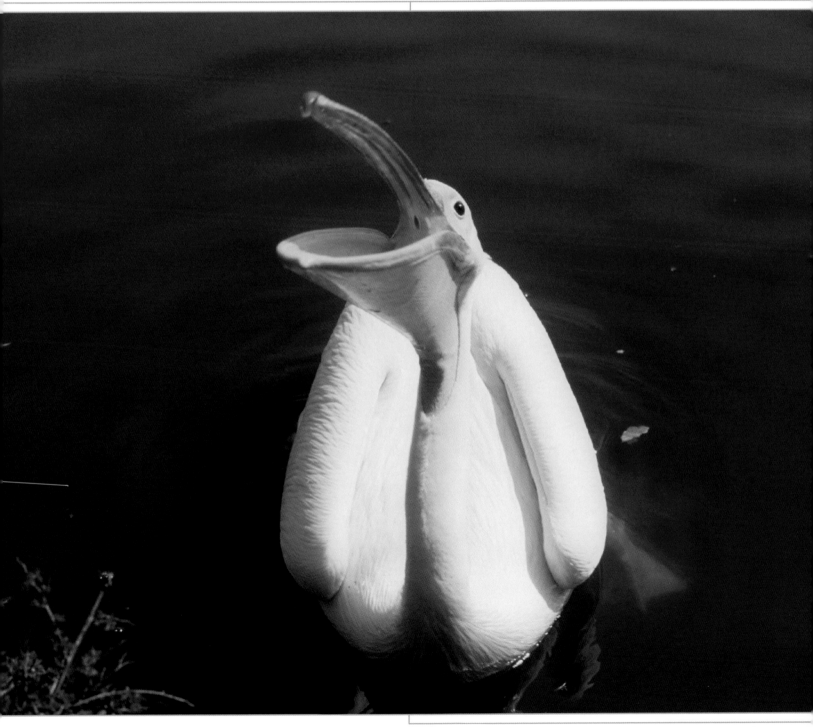

NIOKOLO–KOBA NATIONAL PARK

One of the largest nature reserves in west Africa, the region offers a last refuge for savannah animals such as lions and antelopes, whose ranges once stretched as far as the coast.

Date of inscription: 1981

The greater proportion of this national park's 10,000 sq. km (3,900 sq. miles) in south-east Senegal lies in the transition zone between dry savannah and Guinea's wetland forest. It is bordered to the south by the upper reaches of the Gambia river and territory belonging to Guinea, and to the north it runs out into dry savannah in eastern Senegal.

The three great rivers of the Gambia system, the Gambia river itself, the Koulountou to the west and the Niololo-Koba to the east, drain the area in endless meanders with a low river drop. During the rainy season, wide expanses of the park turn into marsh and mud. Along the rivers and streams, wooded savannah develops into the luxuriant vegetation of

gallery forest, with around 200 species of trees and shrubs.
This diverse biosphere affords a home to numerous animals. Around 80 mammal species live here, including the hippopotsmus, an admittedly tiny population of elephants, giraffes, Cape buffaloes, gazelles, giant elands, leopards, cheetahs, jackals, hyenas, African wild dogs, chimpanzees,

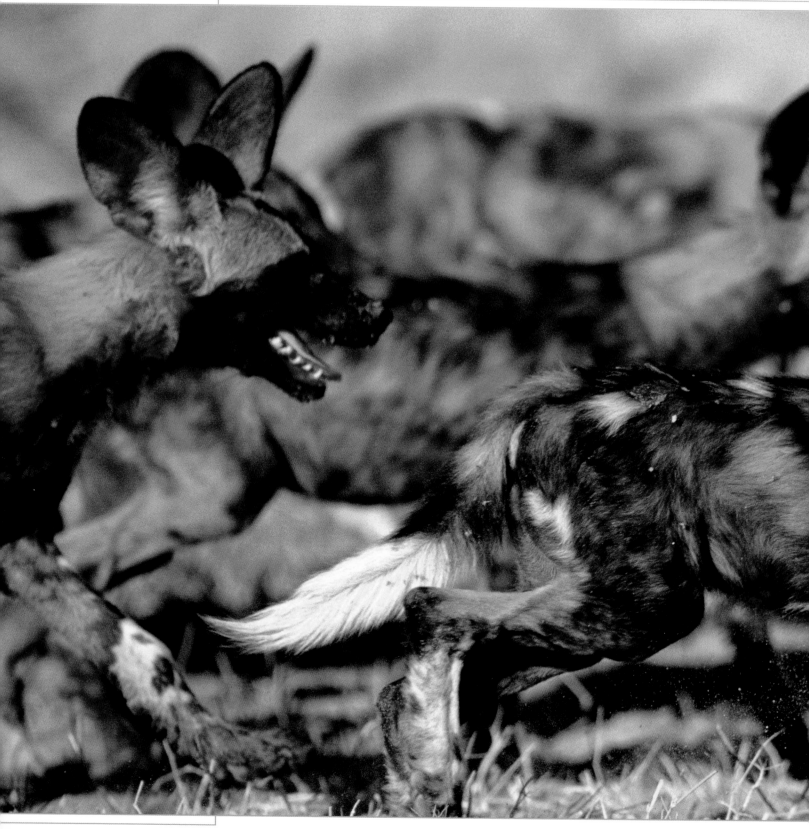

baboons, hyraxes, and mongooses. One of the largest populations of lions in Africa is a great attraction here, as are the approximately 330 bird, 35 reptile, and 60 fish species. Because of poaching and a planned hydroelectric project, the park was included on the Red List of endangered World Heritage Sites in 2007.

Typical gallery forest lines the banks of the Gambia river, which flows for about 200 km (124 miles) through the national park (left). The conservation area, consisting of a variety of different habitats, affords a home to numerous savannah animals, such as these African wild dogs, which live in packs of seven to eight adults and a few young (large image).

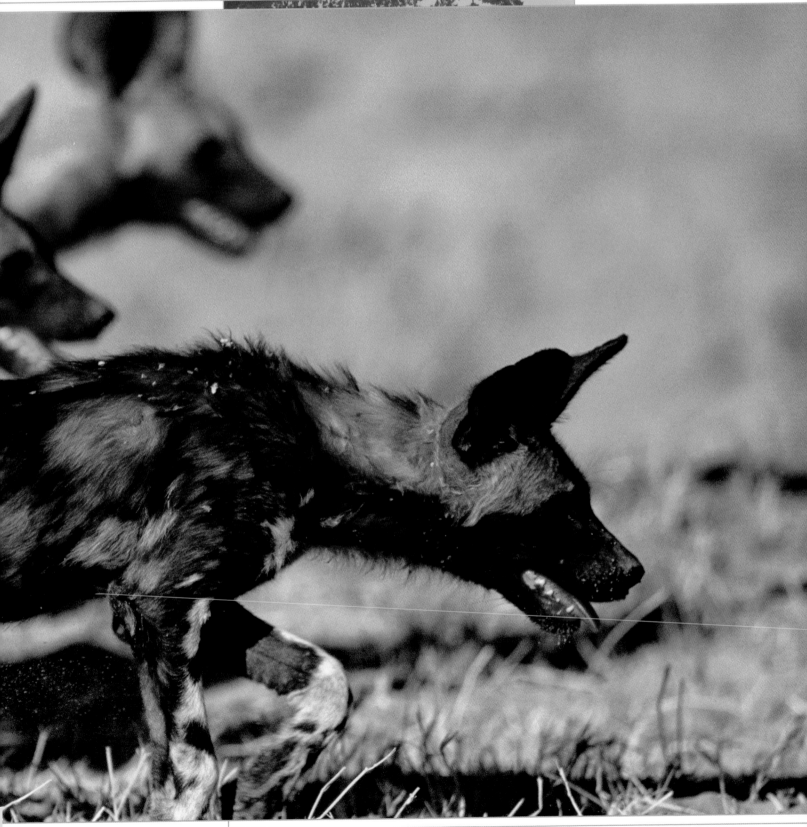

On water and on land

The hippopotamus is a real heavyweight and among the world's largest land animals. As a rule, it only visits land by night, searching for places to graze. The principal diet of these giants is grass in substantial quantities, producing an equal amount of dung, which is used to mark territory. To protect its sensitive, hairless skin from the scorching sun, *Hippopotamus amphibius* spends its days in water that is preferably sluggish and shallow, as this ungulate, despite its name, is more closely related to the pig than the horse and cannot swim well.

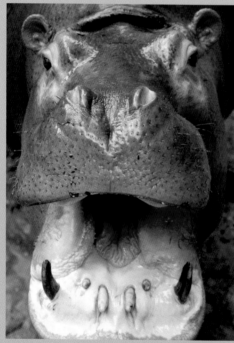

The hippopotamus grinds up some 100 kg (220 lb) of grass per day with its giant tusks.

It trots along the river bottom, surfacing to rest, showing only its ears, eyes and nostrils, which it can close. Adult hippos have no natural enemies; they are endangered only by humans. The hippo has been hunted for centuries, not least for the ivory from its giant tusks, and is now considered an endangered species. It is long since extinct along the Nile, where it was first named the "Nile Horse," and larger populations now only exist in conservation areas abounding in water, like the Niokolo–Koba National Park.

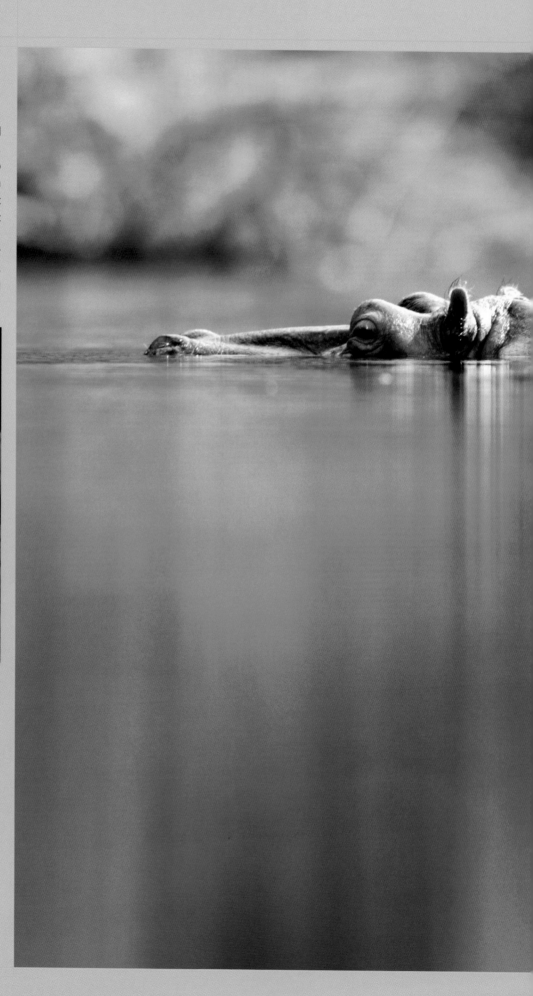

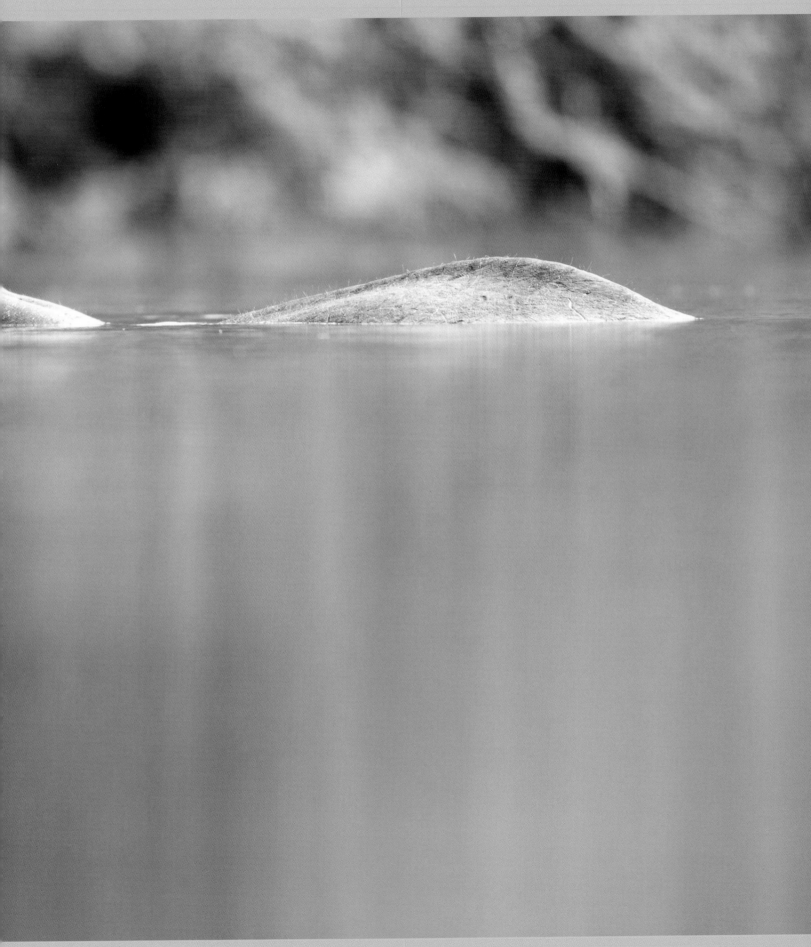

The hippopotamus shows only nostrils, eyes, ears, and a part of its back above water. Although not really a good swimmer, the animal is happiest in sluggish waters. Today, hippos are only found in sub-Saharan Africa. Evidence of earlier distribution in more northerly areas is provided by the nickname "Nile Horse," and a reference in the Book of Job.

Composed of a variety of habitats, the largest and most diverse game reserve in the Ivory Coast is located in the north-east of the country, in the transition zone between savannah and rainforest.

Date of inscription: 1983

The park owes its name to the Comoé, a river between 100 and 200 m (350 and 700 feet) wide which flows from north to south for 230 km (148 miles) through the park's 11,500 sq. km (4,500 sq. miles). The river is shrouded in dense gallery forest and continues to flow even in the dry season. Hippopotamuses, crocodiles, and numerous bird species live in close proximity to the water. The savannah is home to Cape buffaloes, warthogs, and 11 species of ape and antelopes. The forests in the southern part of the park are the preserve of elephants; while predators such as lions, leopards, and hyenas also patrol here, their numbers are few.

This World Heritage Site, too, is threatened by poaching and overgrazing.

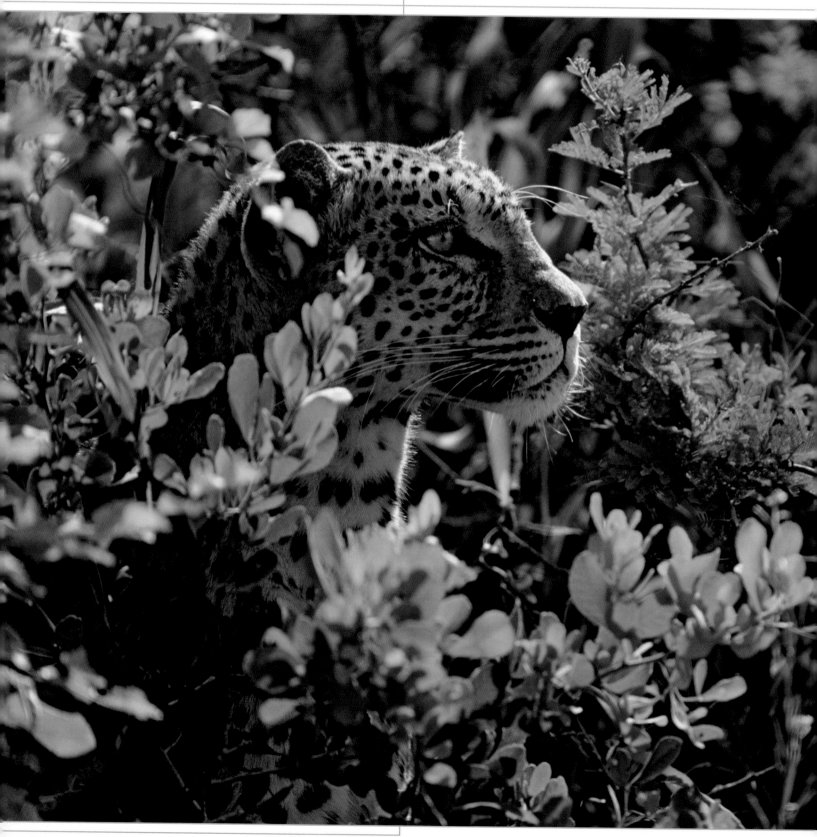

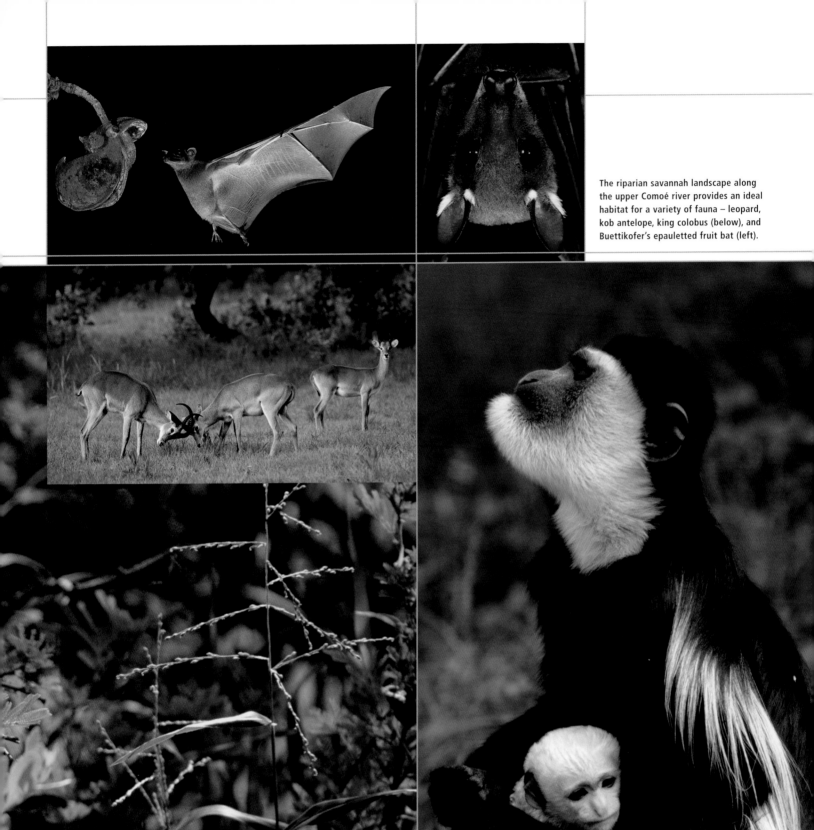

The riparian savannah landscape along the upper Comoé river provides an ideal habitat for a variety of fauna – leopard, kob antelope, king colobus (below), and Buettikofer's epauletted fruit bat (left).

The nature reserve encloses the greater part of Africa's remaining tropical rainforest, which once stretched across Ghana, the Ivory Coast, Liberia, and Sierra Leone.

Date of inscription: 1982

The dense, tropical vegetation covering the 3,300 sq. km (1,320 sq. miles) of this reserve in the south-western region of the Ivory Coast is characterized by numerous indigenous species and primeval forest, whose canopy of foliage and lianas up to 50 m (164 feet) high barely allows light to penetrate. Two kinds of forest are distinguished here, according to their undergrowth and the composition of the forest floor: to the north and south-east, poorly nourished *Diospyros manii* forest predominates, while in the south-west there is the damper soil of *Diospyros-spp.* forest. Elephants, pygmy hippopotamuses, leopards, antelopes, and buffaloes live here, along with many varieties of bird and ten species of ape, including chimpanzees.

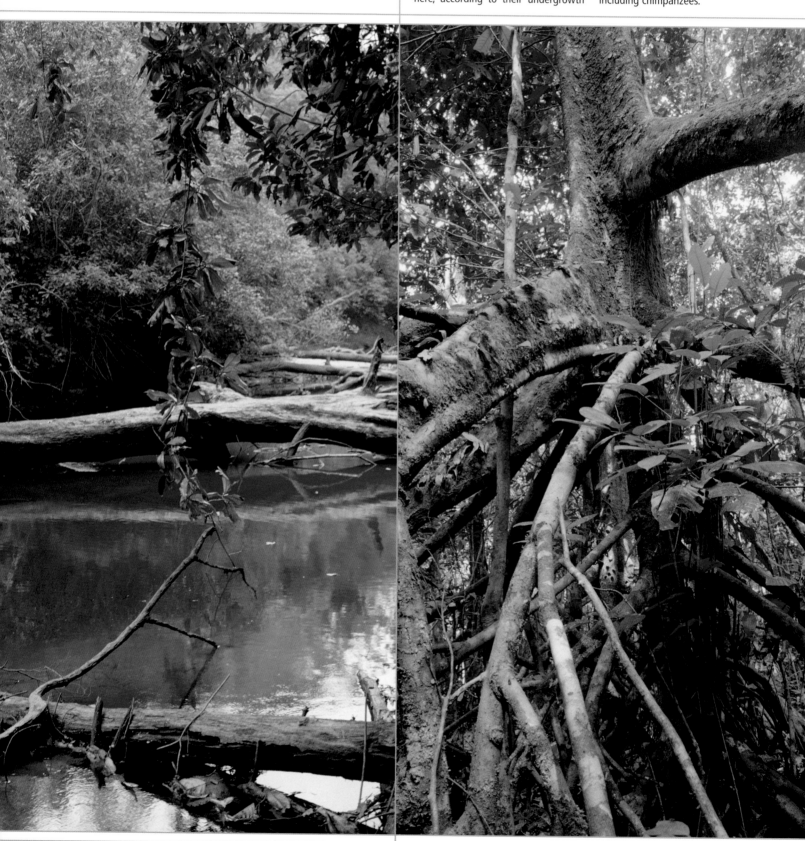

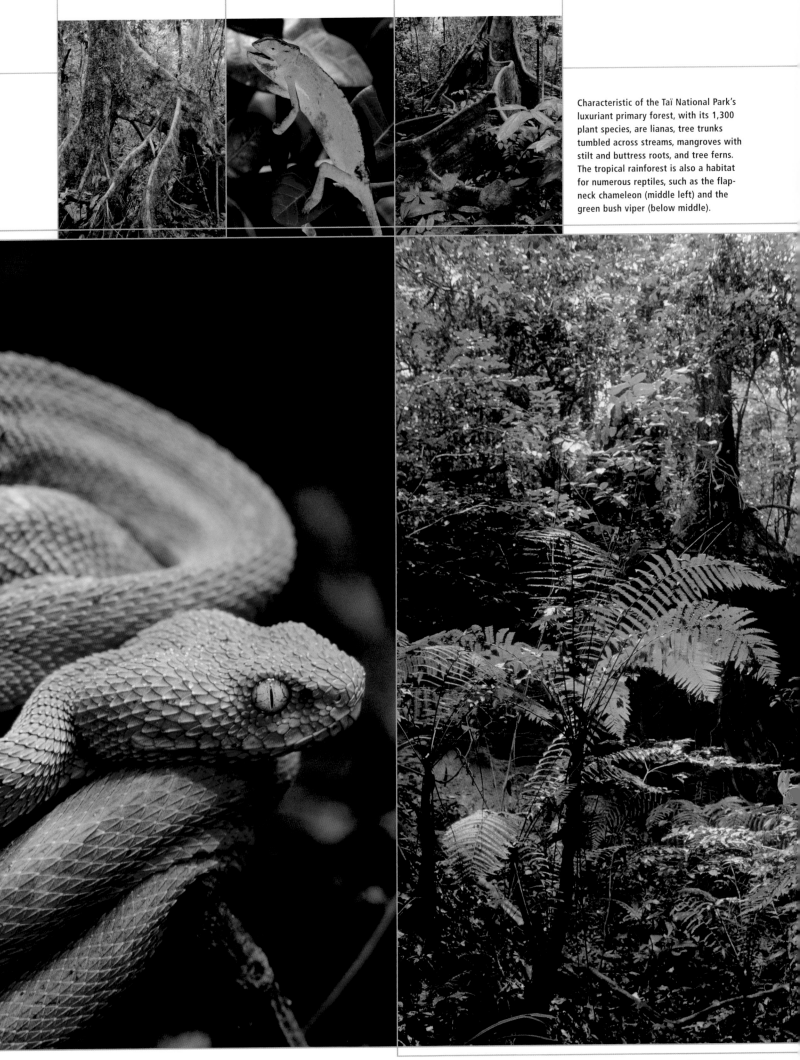

Characteristic of the Taï National Park's luxuriant primary forest, with its 1,300 plant species, are lianas, tree trunks tumbled across streams, mangroves with stilt and buttress roots, and tree ferns. The tropical rainforest is also a habitat for numerous reptiles, such as the flap-neck chameleon (middle left) and the green bush viper (below middle).

Giant of the jungle

The forest elephant is a separate species of the elephant family. Visible differences from the African elephant include its lesser size (250 cm/96 inches at the shoulder at most), the darker hue of its skin, the wider curves of its tusks, and its rounded ears. Forest elephants prefer to live in smaller herds, away from the open savannah in the primary forests of west and central Africa. Their great strength permits them to penetrate even the densest jungle. They subsist on leaves and fruit, spreading seeds in their dung.

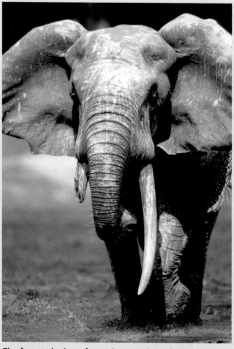

The forest elephant forces its way through the undergrowth using its inverted tusks.

The great rainforests of the Taï National Park are among the most important refuges for these, the largest animals in the jungle. The species is endangered principally due to poaching, as profit lies not just in the illegal exportation of ivory, but also in the great popularity of the meat with the local population. In extremely poor areas, such as the Congo basin, another important habitat of the species, conservation is practically impossible – the people cannot survive without the nutritious meat and become poachers through necessity.

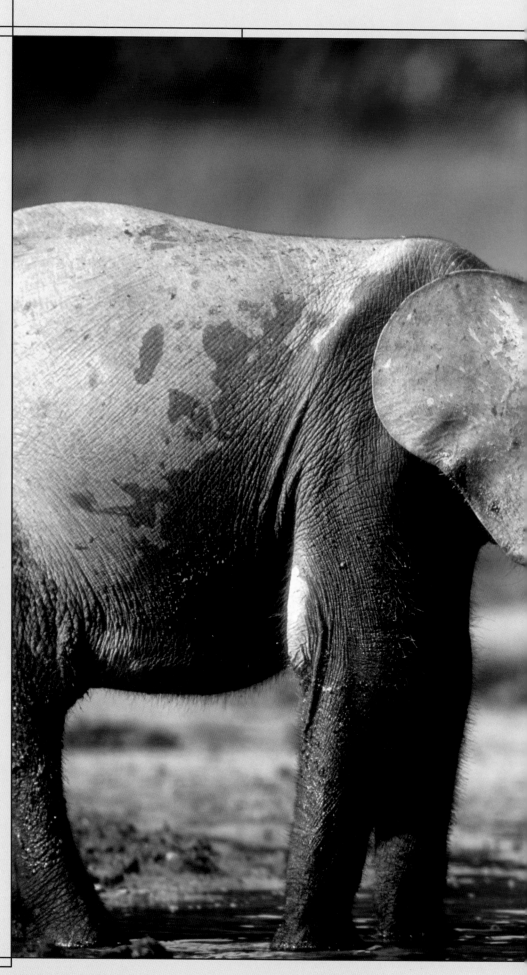

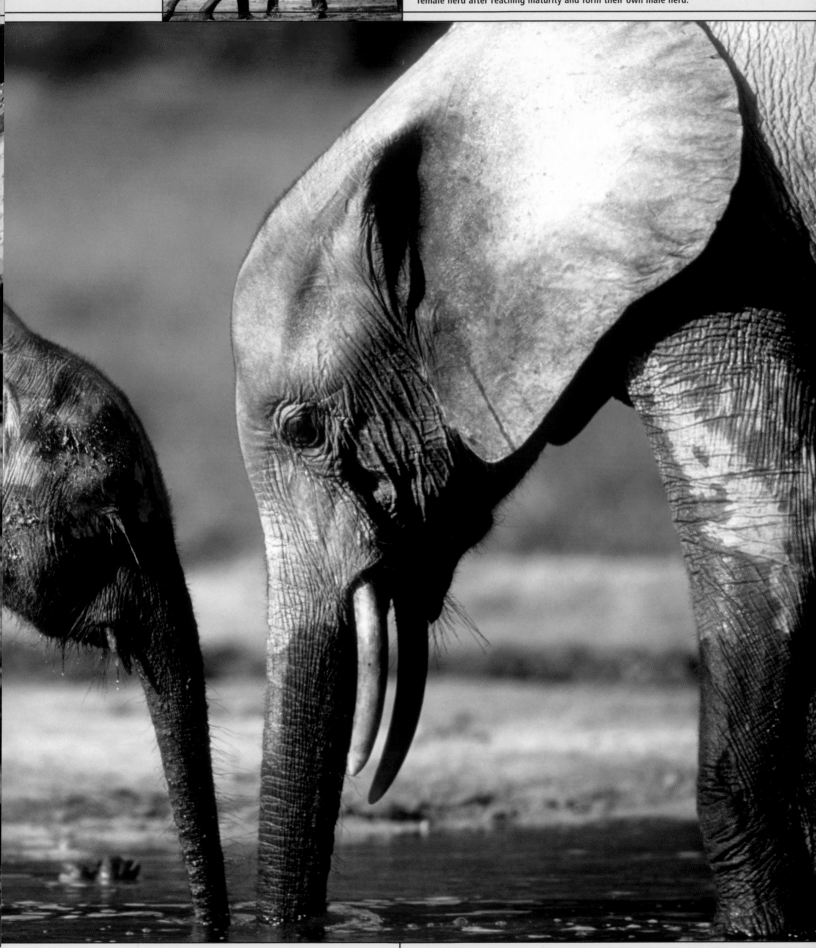

As the name suggests, the forest elephant (*Loxodonta cyclosis*) prefers the forested areas of west Africa and the Congo basin. A herd usually consists of two or three females and their young. Young bulls (left) leave the female herd after reaching maturity and form their own male herd.

MOUNT NIMBA STRICT NATURE RESERVE

The reserve, at the meeting-point of the Liberian, Guinean, and Ivory Coast borders, is a transnational World Heritage Site, shared between the two last-named countries.

Date of inscription: 1981
Extended: 1982

Straddling the borders of the Ivory Coast and Guinea, Mount Richard-Molard in the Nimba massif is, at 1,752 m (5,748 feet), the highest point of both countries and the central point of this conservation area of about 180 sq. km (70 sq. miles). It features an almost unbroken forest canopy: on the lower slopes, deciduous trees predominate, above 1,000 m (3,300 feet) there is montane forest, and the summit area is characterized by mountain savannah. Around 40 plant and 200 animal species are indigenous to the reserve, among them elephants, buffaloes, antelopes, lions, hyenas, guenons, and chimpanzees. Pygmy hippos and dwarf crocodiles are found in the wetlands. Vultures, snakes, and rare amphibians, such as the Mount Nimba viviparous toad (*Nectophrynoides occidentalis*), are also encountered here. This World Heritage Site, threatened due to iron ore mining and civil war refugees from the Ivory Coast hunting in the nature reserve, has been inscribed on the UNESCO Red List since 1992.

Numerous reptile, primate, and large game species populate the Nimba mountains, for example, the dwarf crocodile (below), the Diana monkey, and the African buffalo, a subspecies of the Cape buffalo (right).

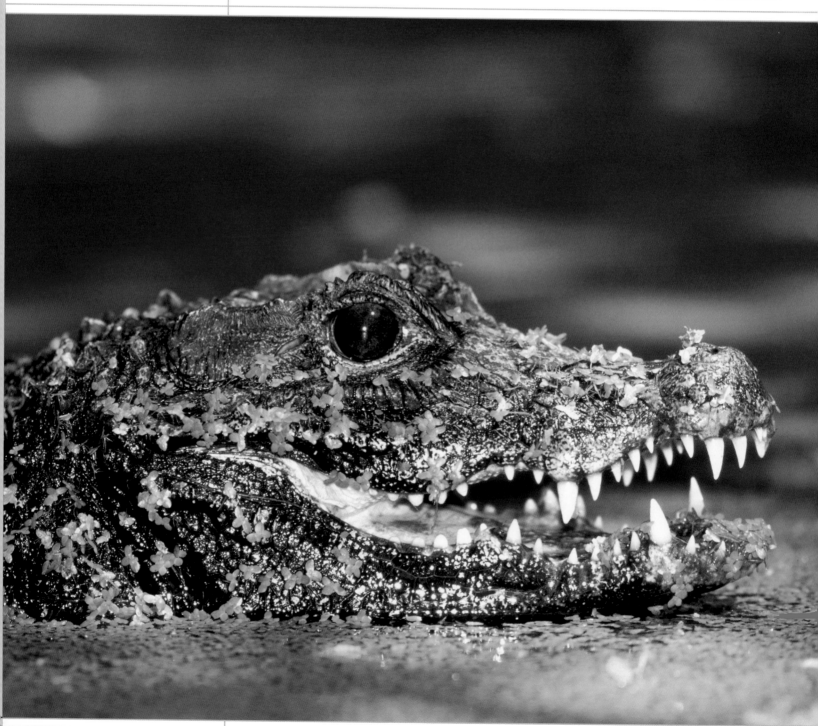

ECOSYSTEM AND RELICT CULTURAL LANDSCAPE OF LOPÉ-OKANDA

Lopé-Okanda in Gabon embodies an unusual interaction of dense tropical rainforest and drier derived savannah. Archaeological sites from the neolithic and Iron Age are evidence that the region has been a cultural area since prehistoric times.

Date of inscription: 2007

The central arm of the Ogooué river is to be found directly beneath the equator, in the north of the central African rainforests. Savannah and gallery forest alternate here across an area of about 1,000 sq. km (390 sq. miles). This open landscape is not just naturally formed; it is also the result of human intervention since the Stone Age, especially through the starting of bushfires. This permitted the ancestors of west African tribes to penetrate into the interior of the northern Congo. In the last 2,000 years, Bantu tribes from sub-Saharan areas in particular have taken this route.

The river valley and its surrounding hills form a significant archaeological site. Round blocks of stone are adorned with rock art of the greatest importance, depicting humans with iron tools such as throwing knives. The most common motifs are single or concentric circles and other geometric forms. Less than a tenth of the drawings represent small mammals or reptiles. The close community of forest and savannah ecosystems has had a positive influence on biodiversity. Around 1,550 flowering plant species, 400 birds, and 50 mammals, including primates, have been identified.

The Lopé-Okanda area, with the Lopé National Park as its focus, offers not only natural beauty in the forms of rainforest (large image) and sun-tailed monkeys (inset, below), but also neolithic rock art, revealing the presence of humans in the region 4,000 years ago (above).

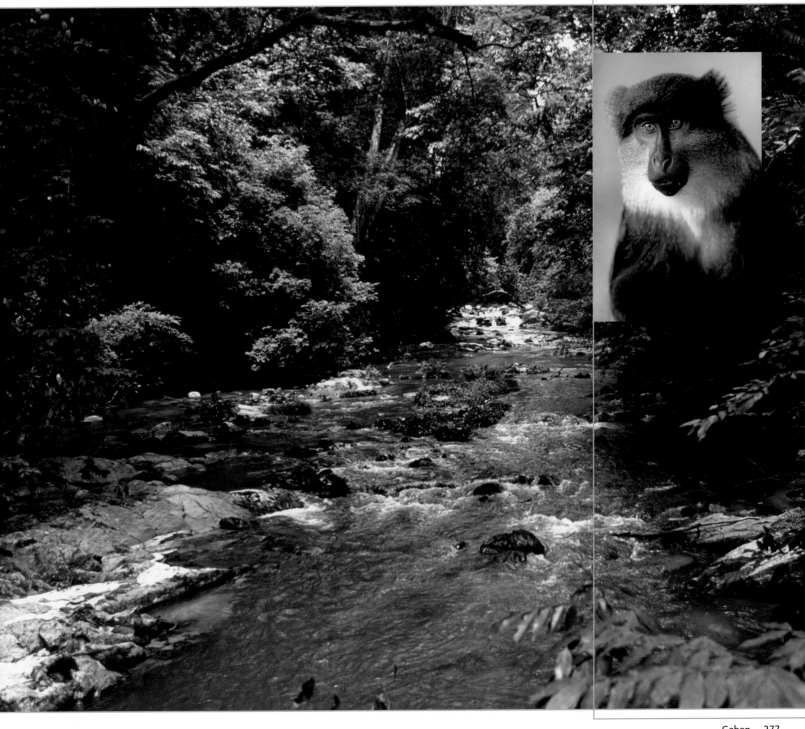

The Dja Faunal Reserve, almost entirely enclosed by the Dja river in south-east Cameroon, is distinguished by an exceptionally diverse animal population, including many primates.

Date of inscription: 1987

The Dja Faunal Reserve's 5,000 sq. km (1,900 sq. miles) lie in a natural bend in the upper reaches of the Dja river. The region is not readily accessible, and thus one of the world's largest continuous areas of rainforest has been preserved here, with its concomitant biodiversity. The forest, which is composed of about 50 different tree species, provides a habitat for an immense variety of animals, including more than 100 mammals. The reserve is especially prized for its population of great apes (gorillas and chimpanzees) and the extremely rare African forest elephant.

However, the area, inhabited only by a few pygmies, is threatened by bush fires and poachers have many of the animals in their sights.

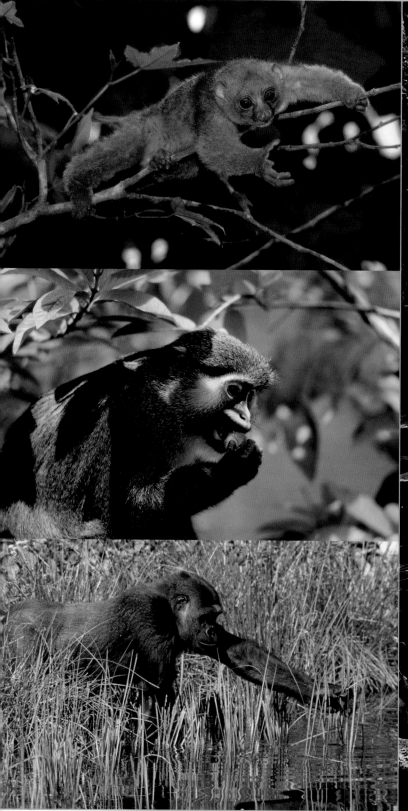

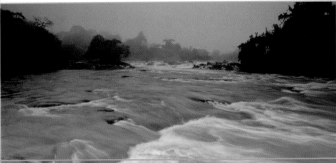

The Dja river (left), which reaches a confluence with the Sangha and then flows into the Congo river, gives its name to the Cameroonian conservation area. Here, there is largely undisturbed rainforest (below middle) and a panoply of primates, including pottos, moustached monkeys, lowland gorillas (far left, from top to bottom), and lesser white-nosed monkeys (below right).

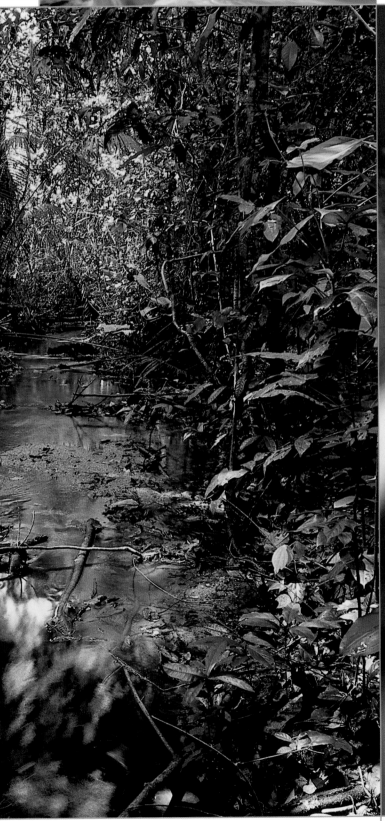

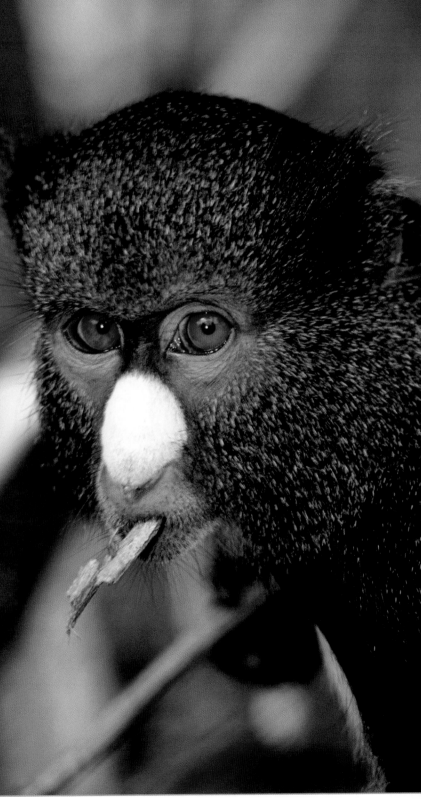

The largest primates

Gorillas belong to the order of primates, which also includes humans, and, within this order, to the family of the great apes. Common to all the apes are limbs with four fingers and an opposable thumb, as in humans, which make hands and feet excellent gripping tools. All great apes lack tails and live in groups. With a weight of up to 200 kg (440 lb) for males living in the wild – well-fed zoo specimens can be considerably heavier – gorillas are the world's largest primates. Their principal diet is leaves, their habitat the forest. The distribution of gorillas is limited to the large rainforests of central

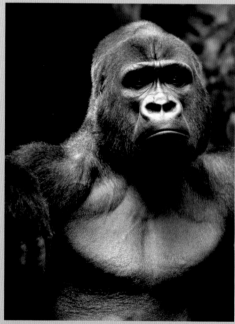

Older male lowland gorillas are called silverbacks because of their distinctive markings.

Africa. A distinction is drawn between western and eastern gorillas, and between mountain and lowland gorillas. Zoos are stocked overwhelmingly with western lowland gorillas, the commonest and most adaptable subspecies. Forest clearances represent the greatest danger to gorillas – their habitat is growing ever smaller – and this is compounded by war, diseases like Ebola, and poaching. Considerable populations live in conservation areas such as the Dja Faunal Reserve in Cameroon, but numbers are still in sharp decline.

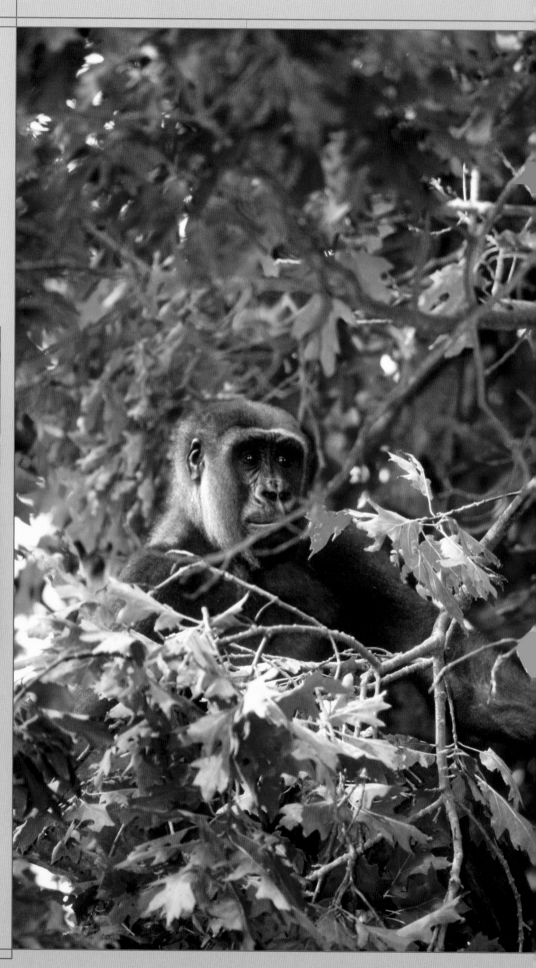

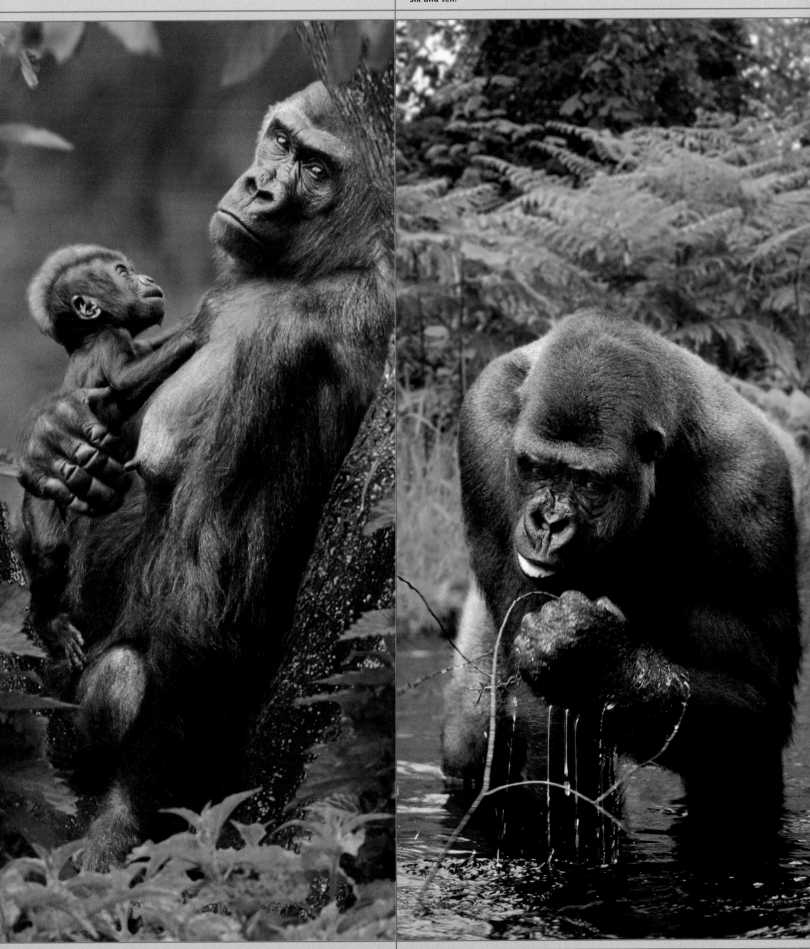

Western lowland gorillas are found in the rainforest east of the Gulf of Guinea, from southern Cameroon as far as Cabinda (Angola). The female gestation period is about nine months, as in humans. Young are carried by their mother for several years after birth, until maturity at between six and ten.

MANOVO–GOUNDA ST FLORIS NATIONAL PARK

The importance of this reserve in the Central African Republic resides in its wealth of plants and animals, especially its waterfowl and megafauna.

Date of inscription: 1988

Part of this area in the far north of the Central African Republic was declared a national park as early as 1933, and it can be divided into three zones of vegetation: the grassy plains of the north, which flood in the rainy season; the gentle hills of the savannah in the transition zone; and jagged sandstone mountains to the south.

On the northern plain, various species of waterfowl – including marabou storks and white pelicans – share about 2,000 sq. km (770 sq. miles) of the park with lions, leopards, cheetahs, wild dogs, buffalo, red-fronted gazelles, giraffe, hippos, and numerous primate species, among others. The forest elephant and the almost extinct black rhinoceros are in particular need of protection. In the past, these rare species have fallen victim to unscrupulous poachers; in the 1990s illegal hunters reduced the total wildlife population by 80 percent (as well as murdering several park rangers). A further danger is the continuing misuse of the reserve as pasture for domesticated animals.

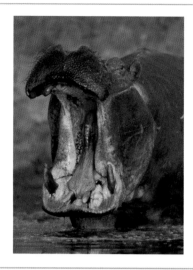

The Gounda is one of five rivers providing drainage for the park (large image). Many waterfowl and hippos live on its banks (right).

GARAMBA NATIONAL PARK

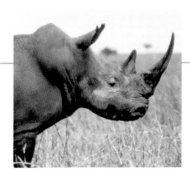

Garamba National Park, lying on the Sudanese border in the far north-east of the Democratic Republic of Congo, is home to several large mammals, including the rare northern white rhinoceros.

Date of inscription: 1980

From broad savannah and grassland to forest and marshy lowlands: the Garamba National Park, located on the river of the same name, provides an extraordinarily diverse range of habitats. This 5,000 sq. km (1,900 sq. mile) area was declared a national park as early as 1938.

More than 40 species of mammals live in the barely accessible conservation area, among them elephants and hippos. The park was in fact specifically established for the protection of giraffes and the northern subspecies of square-lipped rhinoceros, commonly known as the white rhinoceros, which, though larger than the black rhino, is harmless. The last specimens living in the wild are found only in the Garamba National Park. The already tiny population has further declined in recent years as a result of war and poaching, and it is feared that this species will die out in the wild.

One of the problems facing conservationists in the Congo is that of finance: the greater part of the necessary funds can only be raised through tourism, and this is weakened by the country's unstable political situation. The park, which is covered in grass the height of a man, can also be explored by elephant. The docile giants are trained for this task in Garamba's unique elephant school.

The white rhinoceros, also known as the square-lipped rhinoceros, owes its paradoxical name to a mistake in translation – the English "white" was derived from the Boer "wijde," meaning broad. Worldwide, there are only one or two dozen specimens of the northern species (*Ceratotherium simum cottoni*) left, all in the Garamba National Park.

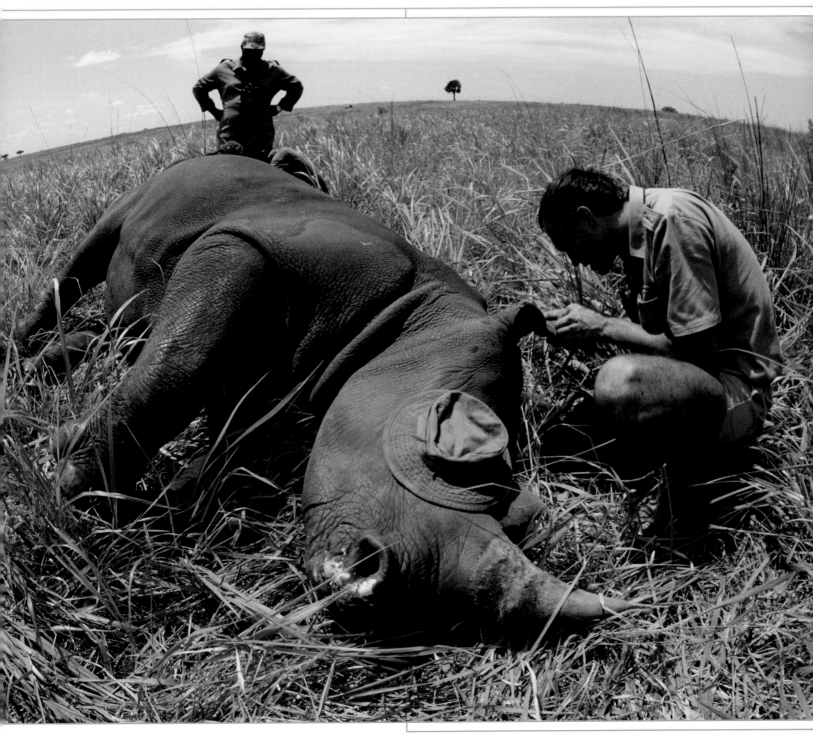

THE OKAPI WILDLIFE RESERVE

This reserve, covering 14,000 sq. km (5,400 sq. miles) in the northeast of the Democratic Republic of Congo, is famed for the okapi after which it is named. This ungulate, with its striking, zebra-striped legs, is found in the wild only in the rainforests of the Congo and has been known to science for little more than a century.

Date of inscription: 1996

The Okapi Wildlife Reserve was officially declared a conservation area in 1992. It covers about a fifth of the Ituri rainforest in the Congo basin, one of the largest drainage basins in continental Africa.

The reserve offers charming scenery, including the impressive waterfalls on the Ituri and Epulu rivers. The reserve was, however, initially established for the okapi, which was first recorded by Sir Henry Morton Stanley in 1890. He had never seen the animal and knew it only from descriptions by the local Batwa tribe, picturing it as vaguely similar to an ass. On the evidence of skeletal remains, the British Governor, Sir Harry Johnston (who was responsible for the species' scientific name, *Okapia johnstoni*), catego-

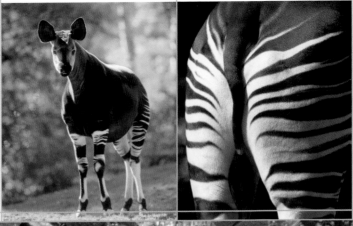

rized the animal, which had initially been considered a member of the *Equus* (horse) family, among the giraffes. Living specimens were not sighted by Europeans until the early 20th century.

It is thought that about 30,000 specimens still live in the wild, of which some 5,000 are to be found in the Okapi Wildlife Reserve.

The okapi is now also known as the short-necked or forest giraffe. In contrast to its long-necked cousin, which prefers the savannah, it lives exclusively in the rainforest, where it eats twigs, leaves, and tree shoots. The zebra stripes on its legs and rear almost give the impression that it is composed of several animals.

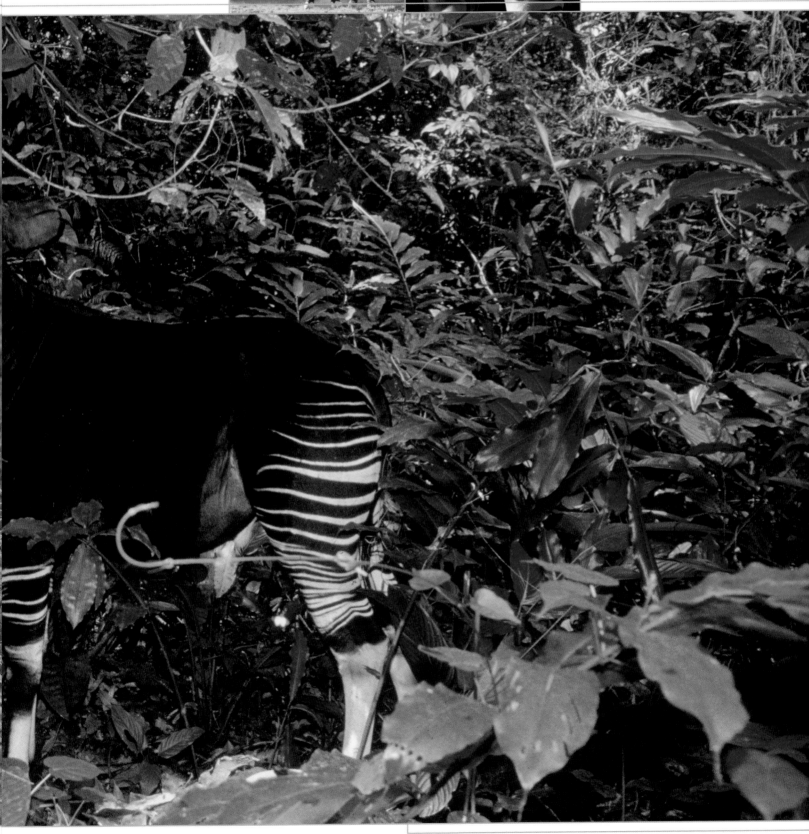

The eight volcanoes of the Virunga chain are located between Lake Kivu and Lake Edward. Nyiragongo and Nyamuragira, the two most active, with 30 eruptions recorded since 1882, lie within the borders of the park.

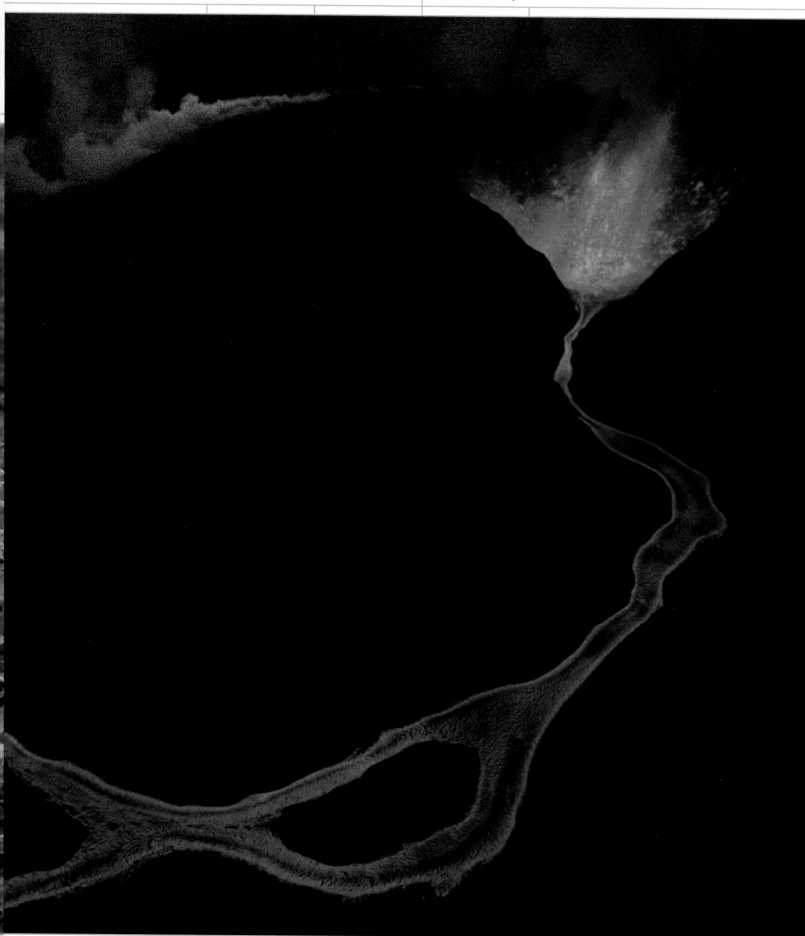

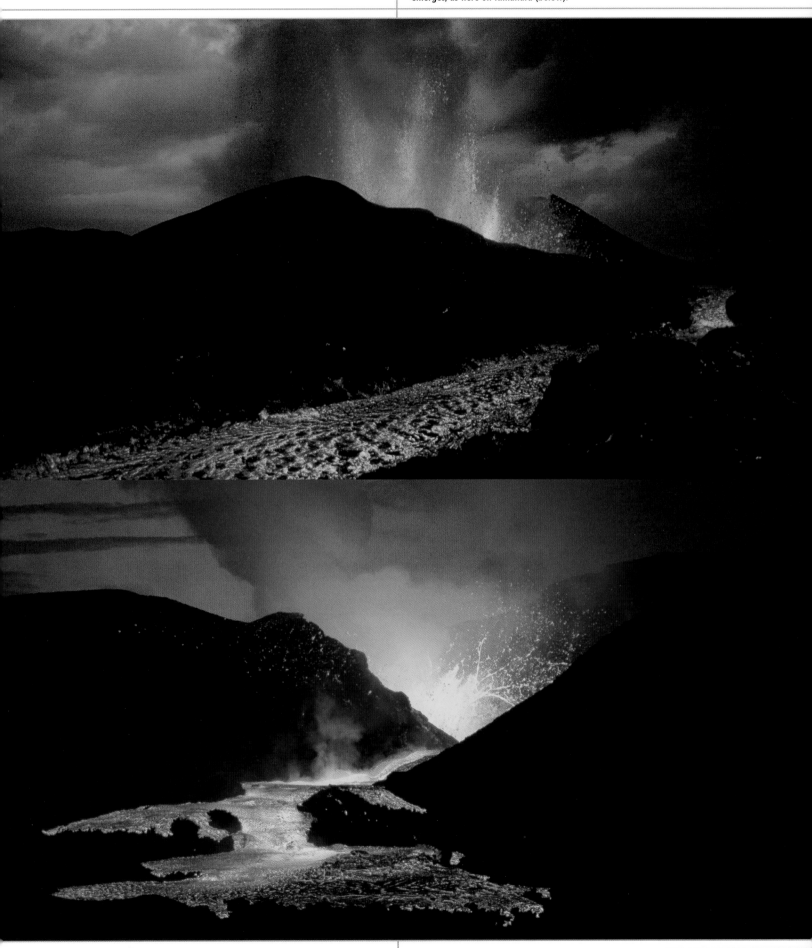

In the course of the centuries, many new cones have formed on the slopes of 3,000-m (9,800-foot) high Nyamuragira, through whose fissure vents red-hot lava emerges, as here on Kimanura (below).

The lords of the rainforest

If mountain gorillas are successfully to be preserved from extinction, this will be due to the work of the American zoologist, Dian Fossey. Before her murder in 1985, she had studied the life cycle of mountain gorillas in Virunga National Park for nearly twenty years, winning their trust and being treated almost as a member of the family.

The touching images in the 1988 film of *Gorillas in the Mist* made stars of both Fossey and her hairy companions. Public attention was drawn to the gorillas, much aiding their conservation. Recently, numbers have risen, if only slightly. The total population, now estimated at about 700 specimens, is distributed throughout the few remaining ranges: the Virunga volcanic region (Congo, Rwanda) and the Bwindi forest (Uganda).

Like all gorillas, mountain gorillas are typically forest-dwellers, but are not good climbers. They usually knuckle-walk across the forest floor, resting their forelimbs on the middle digits. Their diet consists of leaves and fruit. During the day, a troop – a

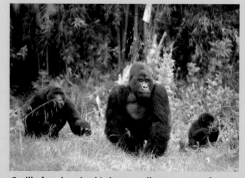

Gorilla females give birth to usually one young after about nine months of gestation.

family group usually consisting of a male, a female, and their immature young – roams its territory. At night, a comfortable nest of leaves is prepared. Territorial fights are few, as troops prefer to avoid one another. Mountain gorillas are somewhat smaller than lowland gorillas and have a longer, silkier coat. The "silverbacks," the distinctively marked older males, are especially striking and stand at the top of the hierarchy.

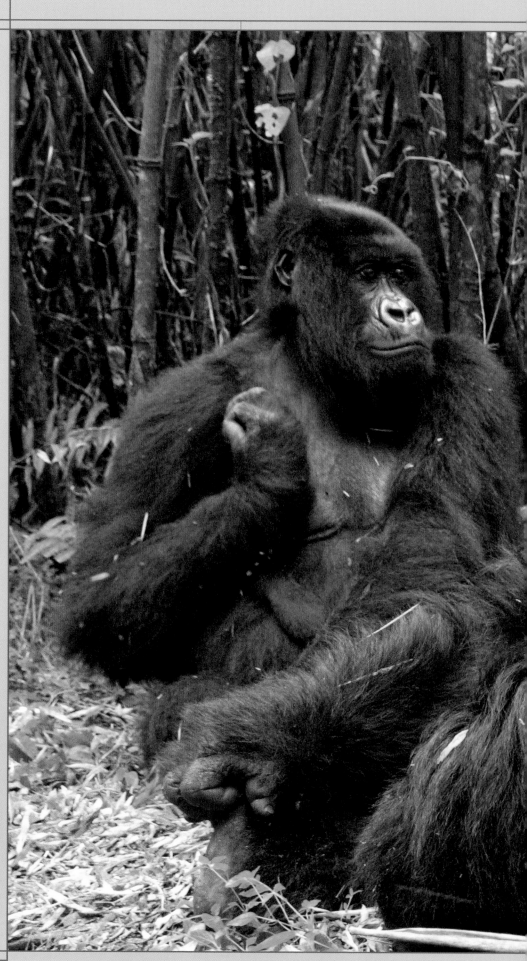

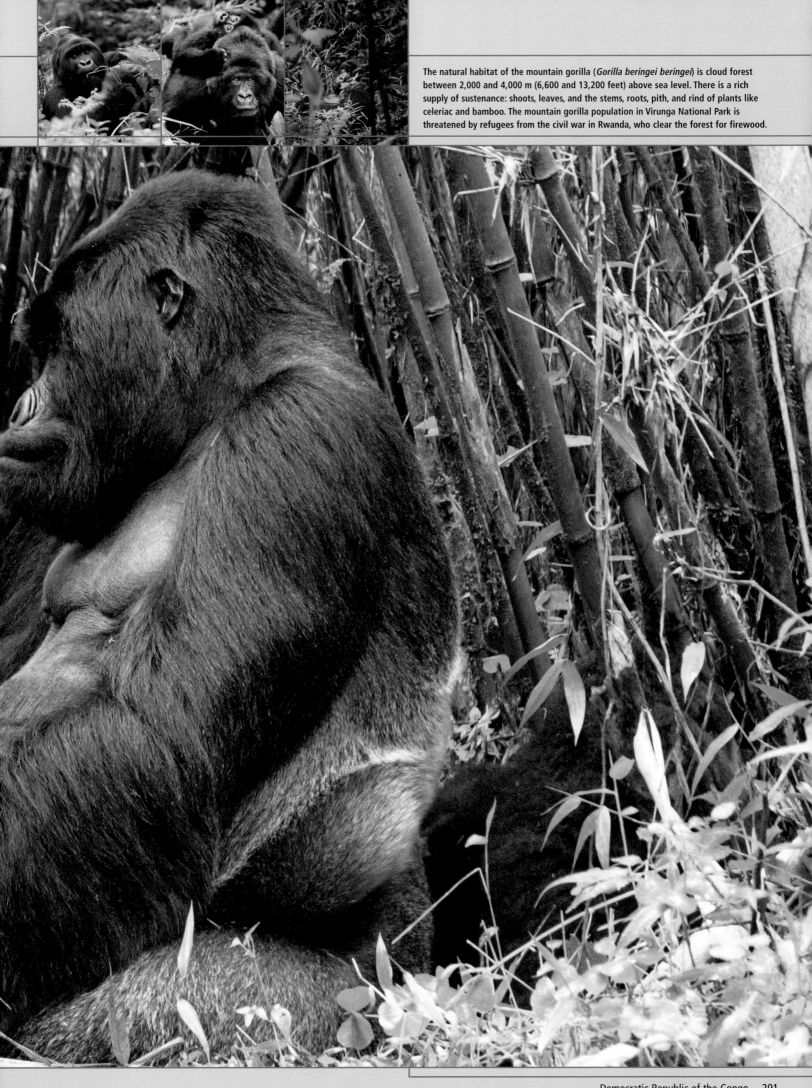

The natural habitat of the mountain gorilla (*Gorilla beringei beringei*) is cloud forest between 2,000 and 4,000 m (6,600 and 13,200 feet) above sea level. There is a rich supply of sustenance: shoots, leaves, and the stems, roots, pith, and rind of plants like celeriac and bamboo. The mountain gorilla population in Virunga National Park is threatened by refugees from the civil war in Rwanda, who clear the forest for firewood.

SALONGA NATIONAL PARK

The national park flanking the Salonga, an eastern tributary of the Congo river in the middle of the Democratic Republic of the Congo, holds one of the largest continuous areas of rainforest in central Africa.

Date of inscription: 1984

Salonga was inscribed as a national park in 1970. At 36,000 sq. km (13,900 sq. miles), it is the second-largest national rainforest park in the world. Together with Maiko National Park, the Salongo area, which consists of two equal sections separated by a corridor of human settlement 50 km (31 miles) wide, was placed under protection in order to preserve representative parts of central African rainforest. Large portions of ecologically vital rainforest in the country had already either fallen victim to forest fires or been consumed by ever-expanding agriculturalization.

The national park is accessible only by water and is thus a refuge for many species, including okapi, bongo antelopes, aquatic genets, Congo peafowl, and the African slender-snouted crocodile. The forest elephant of the central African rainforest is also to be found here.

Probably the best-known inhabitant of the Salonga, however, is the pygmy chimpanzee, also known as the bonobo (*Pan paniscus*), a great ape and a close relative of the chimpanzee, found in the wild only in conservation areas south of the Congo.

Bonobos (large image) are probably the most famous animal inhabitants of the Salonga National Park in the central Congo basin (above), the second-largest area of tropical rainforest in the world after the Amazon basin.

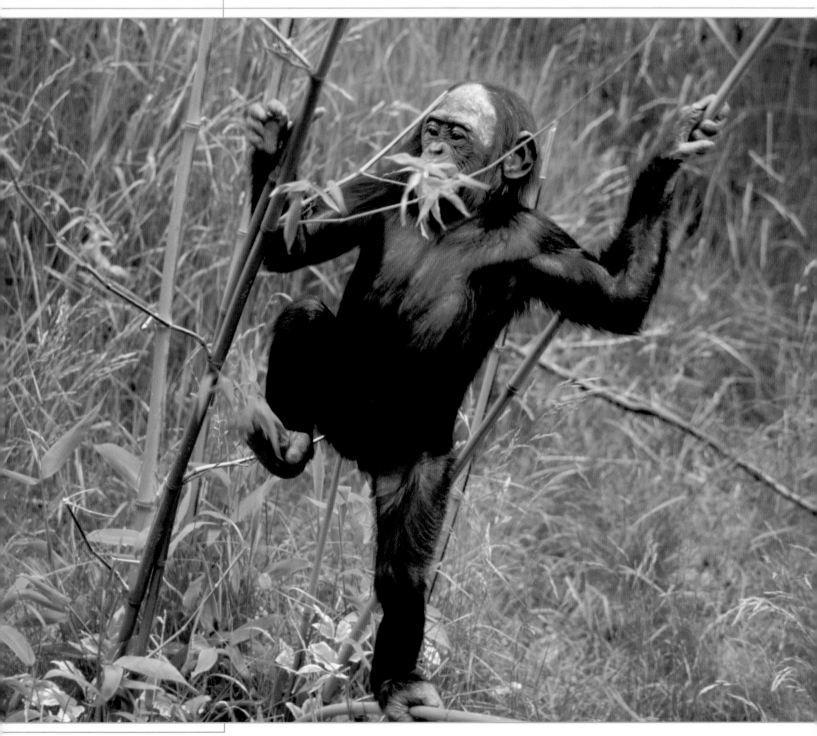

KAHUZI–BIEGA NATIONAL PARK

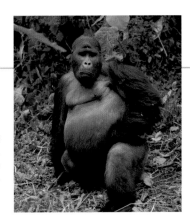

One of the last few remaining groups of eastern lowland gorillas, close relatives of the mountain gorilla, live in the forests of this conservation area in the eastern Democratic Republic of Congo.

Date of inscription: 1980

Just like Viruga, Kahuzi–Biega National Park, situated 100 km (62 miles) west of Lake Kivu, was also established for the protection of gorillas, although for eastern lowland gorillas (*Gorilla beringei graueri*) rather than mountain gorillas (*Gorilla beringei beringei*). These imposing members of the great ape family live in small troops at an altitude of between 2,100 and 4,000 m (6,900 and 13,200 feet).

The vegetarian "gentle giants" can live for up to 40 years. Older males have silver-gray markings on their backs. They intimidate rivals by rearing up with a roar and beating their chests. The gorillas, which are diurnal, forage for their diet of leaves until sundown, and then sleep at night in improvised nests made of branches and leaves.

The 6,000 sq. km (2,300 sq. miles) of the conservation area, in the shadow of the two extinct volcanoes of Kahuzi and Biega, shelter two further primate species, one of which is the common chimpanzee, our closest relative. Their natural enemy, the leopard, is also found here in the conservation area, along with elephants, buffaloes, and numerous other species.

The park has been inscribed in the UNESCO Red List of endangered World Heritage Sites since 1997.

The total world population of eastern lowland gorillas has declined to only a few thousand, of which the majority live in the Kahuzi–Biega National Park. They are typically forest-dwellers, as are the mountain gorillas.

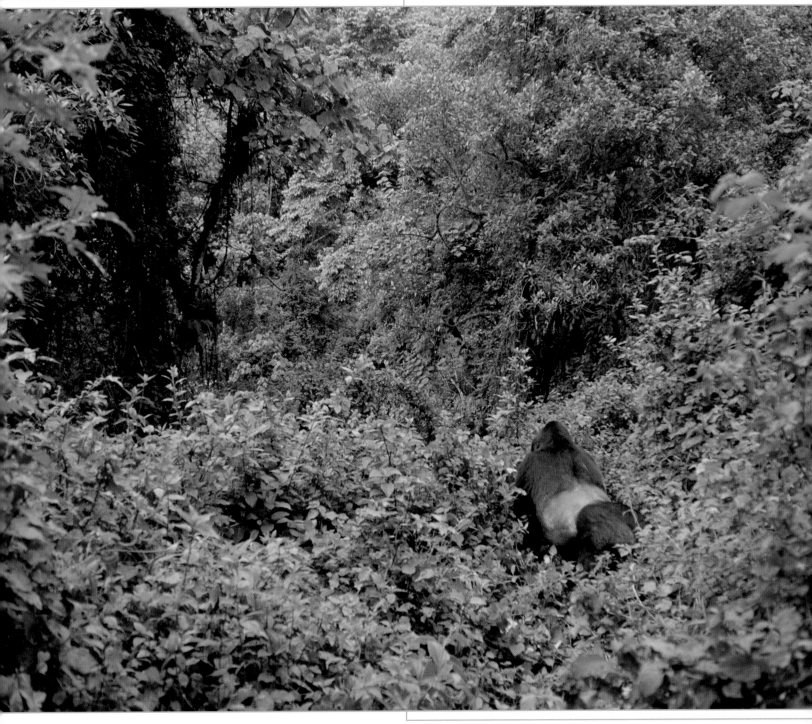

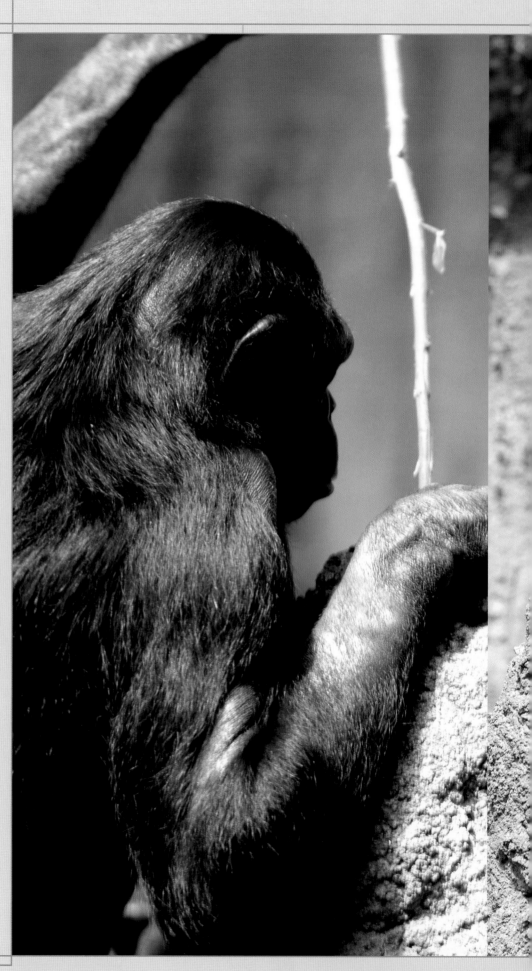

Life in the trees

The frank sexual behavior of this rare primate species ensures mass media attention. Intercourse – in the "missionary position," uniquely in the animal world – and a range of other practices, which are also engaged in with same-sex partners, form an important regulator in the communal life of the troop. It is often initiated by troop members who are low down in the hierarchy, and is connected with begging for food. Bonobos, members of the chimpanzee family, are sometimes called pygmy chimpanzees, although they are only very slightly smaller than the common chimpanzee. One clear

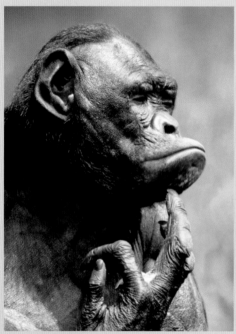

This bonobo seems to be saying: "It's a poser – let me think about it."

difference is their centrally parted head hair. The face is hairless, and in younger animals displays almost human features. Although aggression has been observed among bonobos, they live together considerably more peacefully than other chimpanzee species.

Their habitat is limited to conservation areas in the Congo basin such as the Salonga National Park. They are typically forest-dwellers and excellent climbers, finding their food principally in the trees and retiring at night to a nest of leaves high in the topmost boughs.

Tool use among primates is an area of research of recurring interest. Among bonobos, which are found in the wild exclusively in the Congo basin, this has been observed only in captivity, where they have the opportunity to use sticks to poke around in termites' nests, for example.

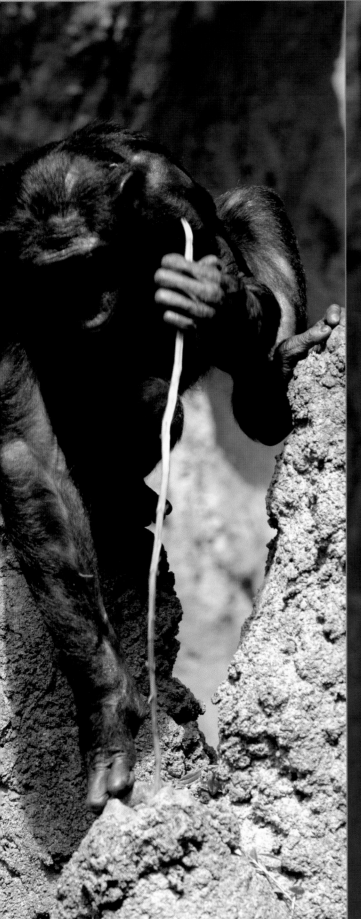
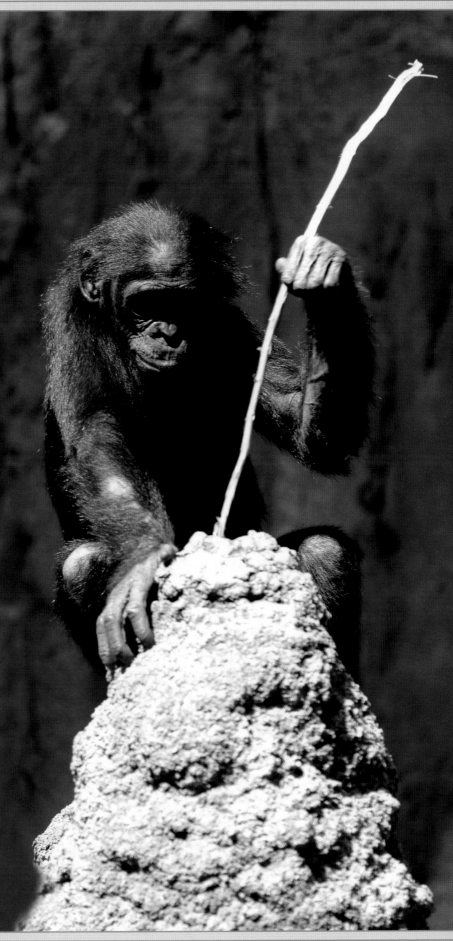

The park, located 100 km (62 miles) north of Gondar in northern Ethiopia, includes an area of mountain plateau, characterized by abrupt precipices and raging rivers.

Date of inscription: 1978

In the Simien massif, constant erosion has created some of the world's most striking scenery, with mountain peaks up to 4,500 m (14,800 feet) high, basalt valleys, roaring rivers banked by jagged rocks and cliffs, and ravines of depths of up to 1,500 m (5,000 feet). Standing over all of this is Ras Dashen, at 4,620 m (15,160 feet) the fourth-highest mountain in Africa.

The national park, named after the mountain plateau, provides a habitat for several extremely rare species, among them the gelada baboon, the Simien red fox, and the Walia ibex. When in 1996 the population of foxes and ibexes fell beneath the critical level of 20 and 250 specimens respectively, the park was inscribed in the UNESCO Red List.

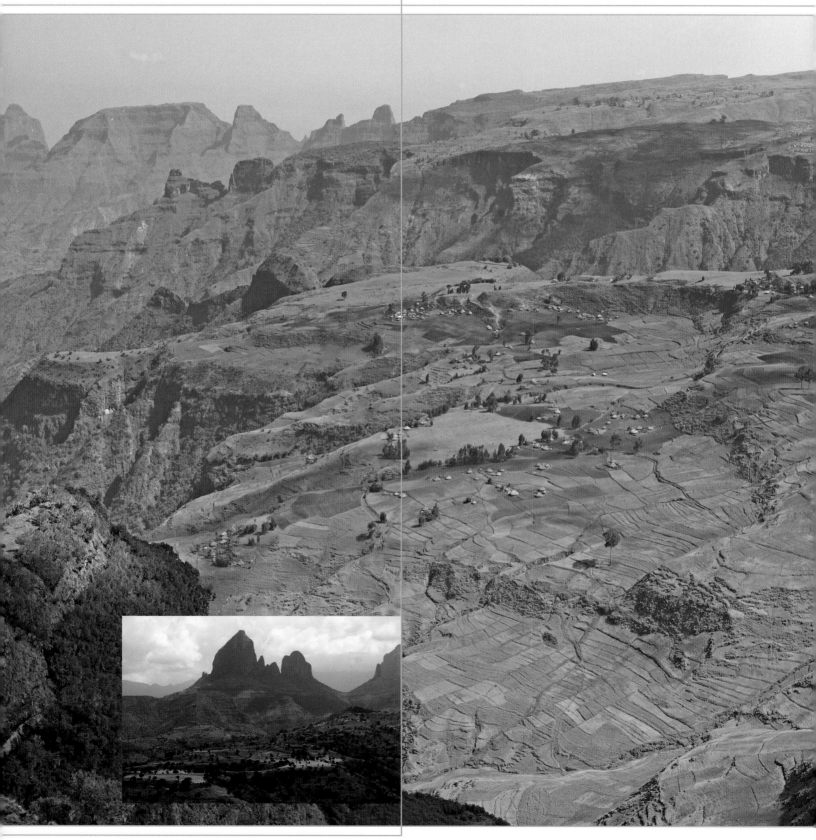

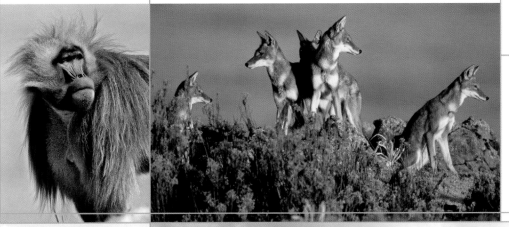

Simien National Park impresses with its high mountain plateaus and its waterfalls, streaming from the living rock (large images). Ethiopia's highest mountain, Ras Dashen (inset below), was first climbed by Europeans in 1841. The rare Ethiopian wolf and the gelada, identifiable by the red patch on its chest, also live in the park.

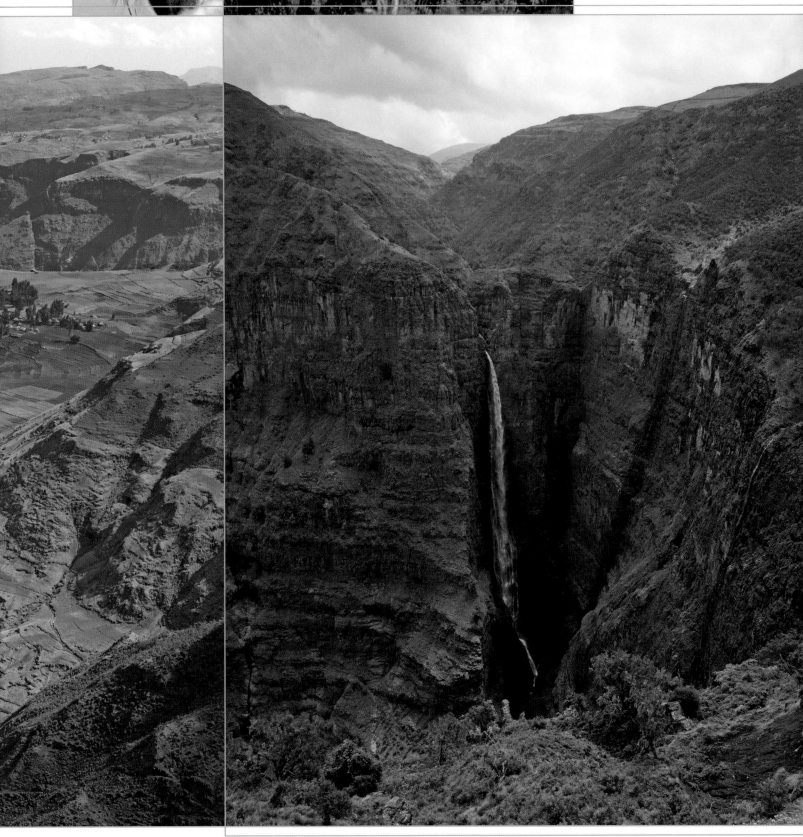

BWINDI IMPENETRABLE NATIONAL PARK

Bwindi, in the extreme south-west of Uganda, is known both for the diversity of its trees and ferns and for its rare species of butterflies and birds. The montane forest is also one of the last refuges of the rare mountain gorilla.

Date of inscription: 1994

The barely accessible Bwindi National Park (Bwindi means "impenetrable") lies in a transition zone between the steppes and the mountains, and is distinguished by a unique variety of flora and fauna. There are more than 100 indigenous varieties of fern, and the national park's montane forest is composed of no less than 160 tree species. Woodland birds make up about two-thirds of the 300 avian species so far recorded, and there are about 200 varieties of butterfly. However, the reserve is most famous for its mountain gorillas. On its upper slopes, in docile family groups led by a silverback, around 300 specimens survive, forming about half the total world population of this endangered species.

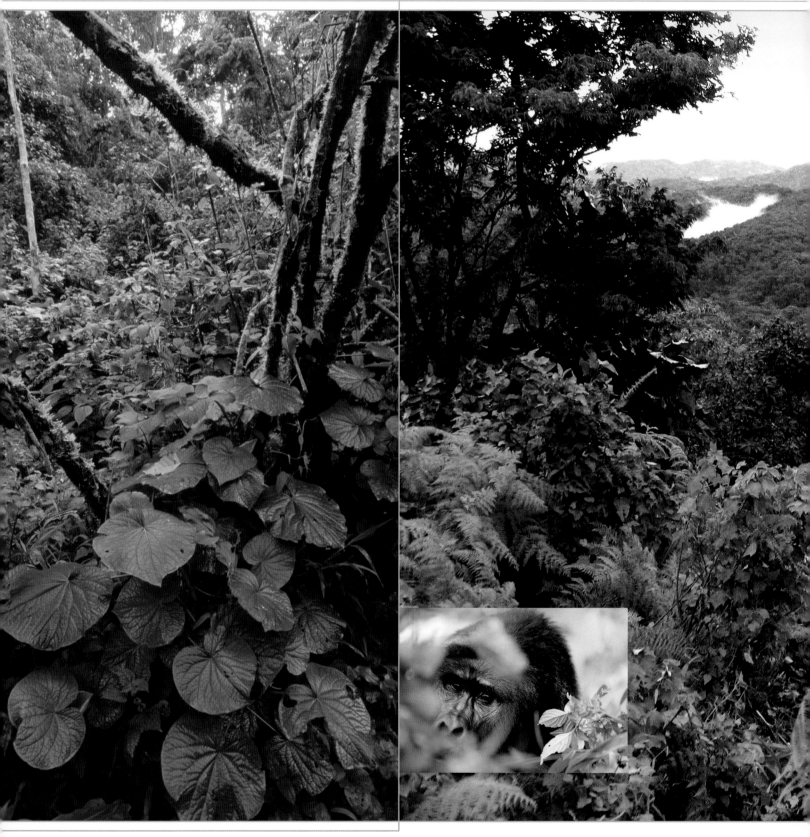

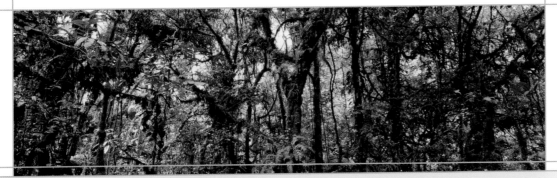

Covering 330 sq. km (130 sq. miles) and incorporating both mountain and lowland rainforest, Bwindi National Park is located on the edge of the Western Rift Valley in south-west Uganda. Many plants in the primary forest have evolved only since the last ice age (left and large images, below). A guided tour allows the close observation of mountain gorillas (inset below).

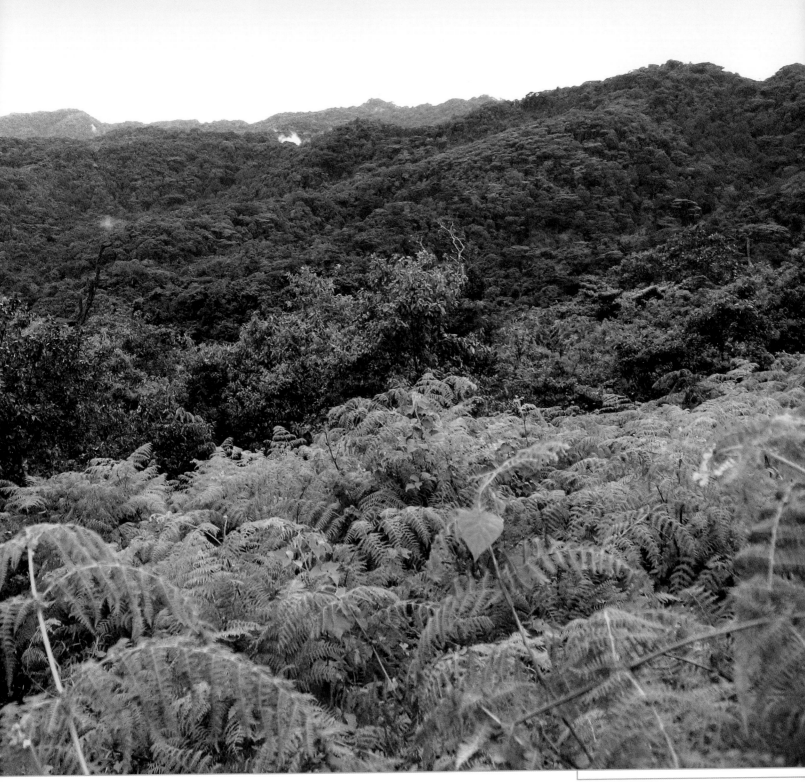

RWENZORI MOUNTAINS NATIONAL PARK

The montane forest and marshlands of the Rwenzori area are a habitat for many endangered species and for plants of extraordinary size.

Date of inscription: 1994

The Rwenzori mountains lie between Lakes Albert and Edward on the border between Uganda and the Democratic Republic of Congo. The mountain chain, formed by tectonic activity, is about 120 km (74 miles) long and 50 km (31 miles) wide, and its highest elevation, at 5,109 m (16,760 feet), is the Margherita summit of Mount Stanley. The national park encloses an area of about 1,000 sq. km (390 sq. miles) in the extreme south-west of Uganda. Along with the glaciers, lakes, and waterfalls of its higher reaches, the Rwenzori has marshland in its valleys and foothills, where tall undergrowth like papyrus provide protection for elephants. Vast numbers of gazelles, antelopes, and buffaloes find food in the wealth of grasses in the craters.

Stands of bamboo grow at altitudes of about 2,000 m (6,600 feet). This is a habitat for leopards, and also for rock hyraxes, which find shelter in the many fissures in the rocks. The tropical montane forest on the upper reaches, almost continually shrouded in mist, hides a world of plants of unusual proportions – lobelias, whose growth normally stops at 30 cm (12 inches),

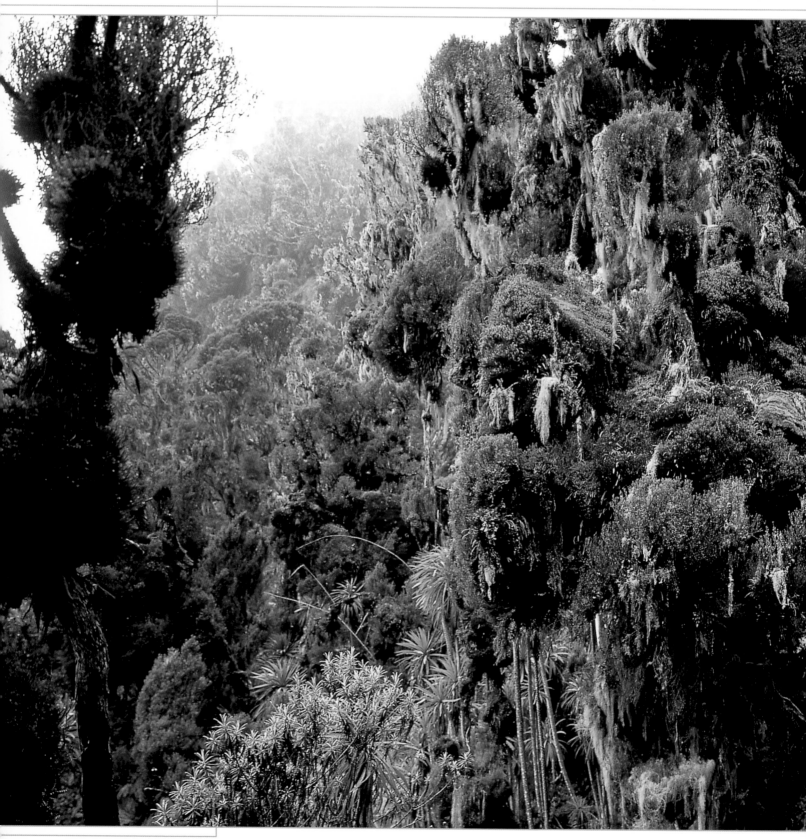

here reach a height of 6 m (20 feet). When protected from the elements, some fern species grow to a height of 10 m (33 feet), and some types of heather can grow as big as trees. This immense plant growth is attributable to a combination of mineral-rich soils, stable temperatures, high humidity, and the strong ultraviolet light on the upper slopes.

In the tropical montane forest in the Rwenzori mountains, oversized alpine plants grow at an altitude of about 4,000 m (14,000 feet, below). The Ugandan rhinoceros chameleon is a typical inhabitant of the region (right).

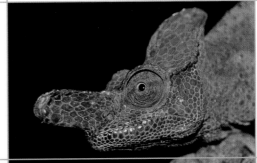

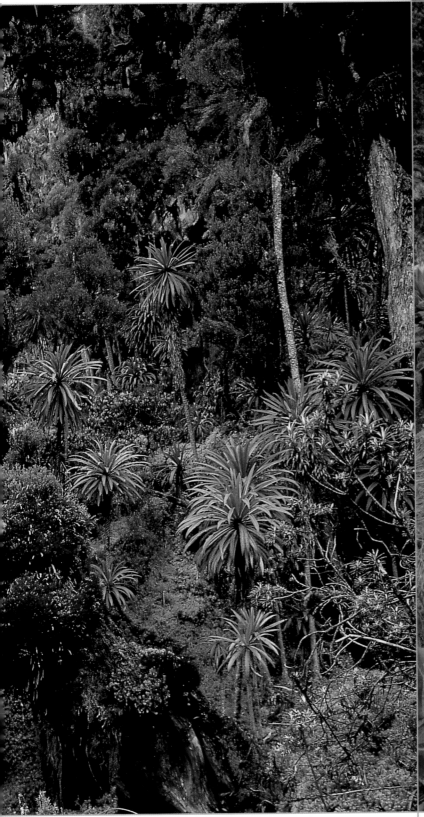

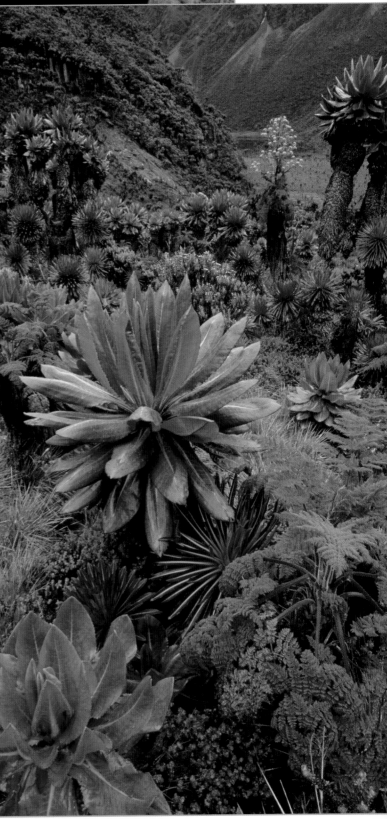

GIANT LOBELIAS
AND GROUNDSEL

A magical world in the cloud forest

The Rwenzori mountain climate is damp and warm, and 300 days of rainfall per year are not unusual. Rwenzori means "king of the clouds" or "rain-maker" in the local tribal language, Bakonjo. High humidity and warm upcurrents have ensured the development of extraordinarily rich and diverse vegetation, even in alpine areas – the treeline can be as high as nearly 3,800 m (12,600 feet).

The montane forest and upland moors of Rwenzori are considered one of the most thickly vegetated areas on earth. It is a fairy-tale world of mosses, ferns, bamboo bushes, orchids, heathers the size of trees, tussock grass, giant lobelias, and frailejones (espeletia) shrubs. Numerous plant species are found at higher altitudes in Rwenzori than is usual elsewhere. Various species of giant lobelia and groundsel are typically found at altitudes of about 3,000 m (9,800 feet). A particular variety of lobelia

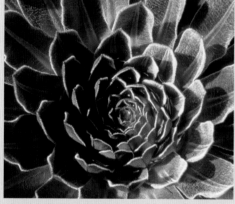

Giant lobelias grow in the alpine zone of these tropical mountain uplands.

species, of the bellflower family, grows here as rosette-trees up to 1 m (3 feet) high. *Lobelia wollastonii* can grow to a height of 7 m (23 feet), has a wide, woody stem completely covered in ciliate leaves, and produces a thick growth of bluish flowers. Groundsel, a member of the aster family, is represented by the species *Senecio ericirosenii* and *Senecio adnivalis*, and grows to a height of up to 12 m (40 feet). They produce single or minimally branched stems, at whose ends large leaves are arranged in a rosette formation.

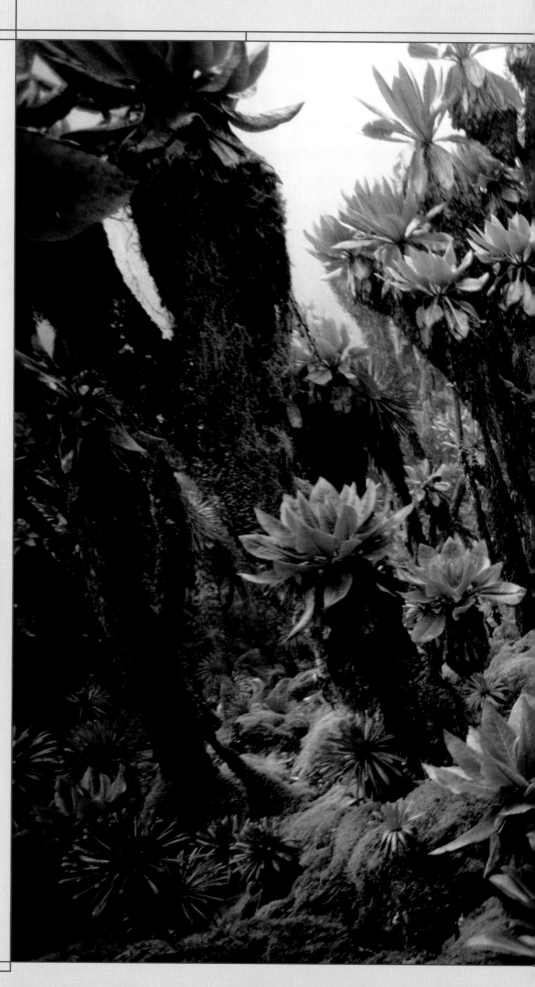

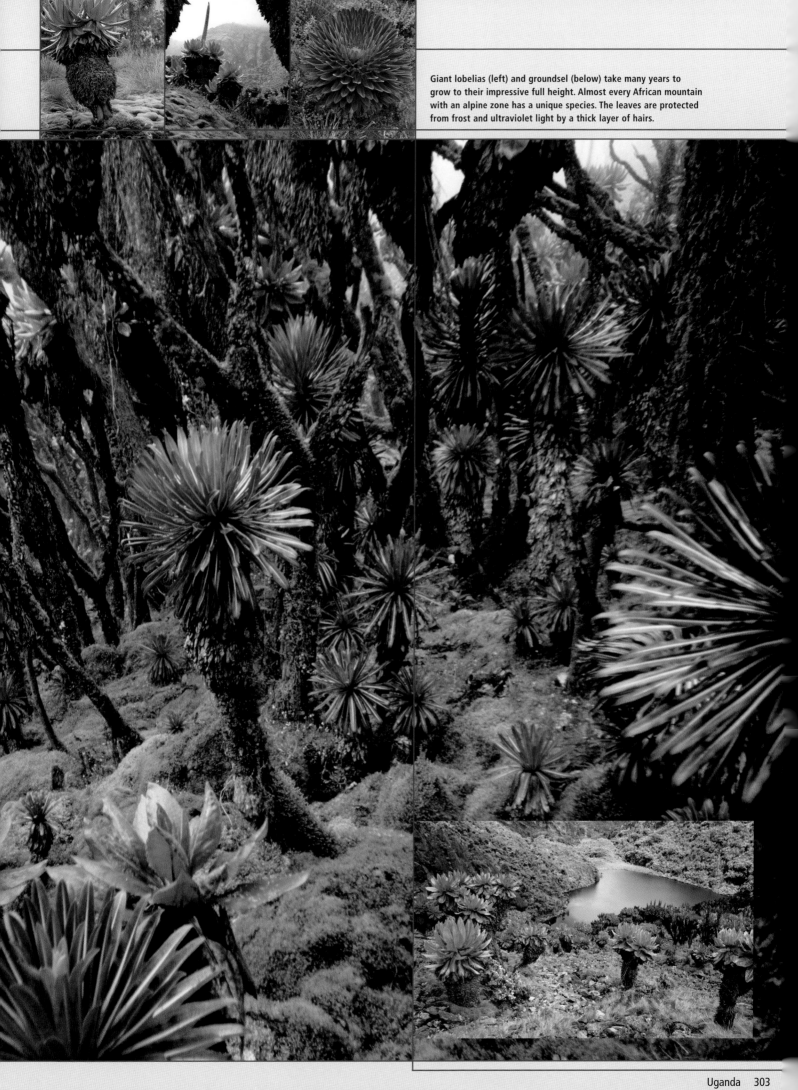

Giant lobelias (left) and groundsel (below) take many years to grow to their impressive full height. Almost every African mountain with an alpine zone has a unique species. The leaves are protected from frost and ultraviolet light by a thick layer of hairs.

LAKE TURKANA NATIONAL PARK

This World Heritage Site, internationally known for its diverse fauna, is composed of three national parks, from north to south: Sibiloi, Central Island, and South Island.

Date of inscription: 1997; Extended: 2001

In the desert-like dry steppes of the far north-west of Kenya, near the border with Sudan and Ethiopia, lies Lake Turkana, an endorheic lake with a high salt content. The Sibiloi National Park (1,500 sq. km, 580 sq. miles), lying along its eastern shore, is a habitat for lions, zebras, antelopes, and gazelles. It is, however, much better known as a breeding ground and stopover point for all kinds of birds: wading birds, flamingos, pelicans, seagulls, and other migratory birds. In the middle of the lake lie the 5 sq. km (2 sq. miles) of bare volcanic rock that make up Central Island, on which numerous species of waterfowl have made their nests, and which provides a refuge for a reasonably large colony of Nile crocodiles.

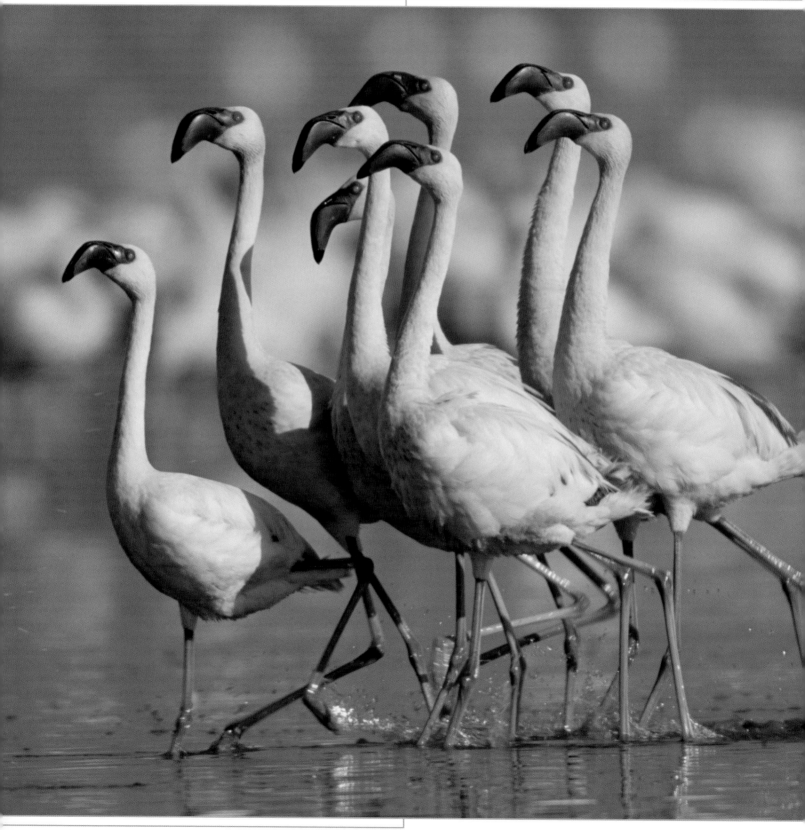

South Island, which is located 100 km (62 miles) further to the south of Central Island, has very similar fauna, and even hippos can be seen here. At Koobi Fora, a promontory of the national park jutting out into the lake, significant palaeontological finds of *Australopithecus*, *Homo habilis*, *Homo erectus*, and *Homo sapiens* have been found.

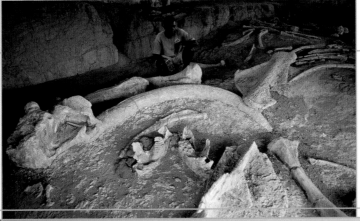

Large colonies of flamingoes (large image) live on the shores of Lake Turkana, Kenya's largest body of water. The lake is situated in a highly active volcanic area, as can be seen from Central Island (below). Koobi Fora, where many mammal fossils have been discovered, is also part of the park (left).

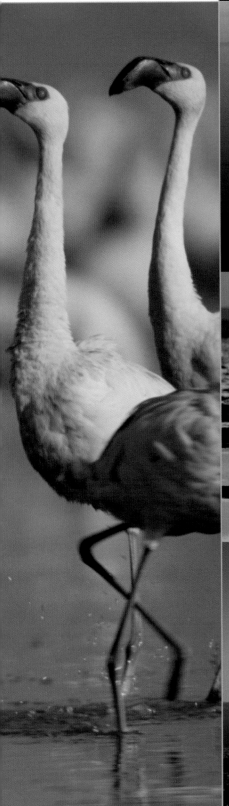

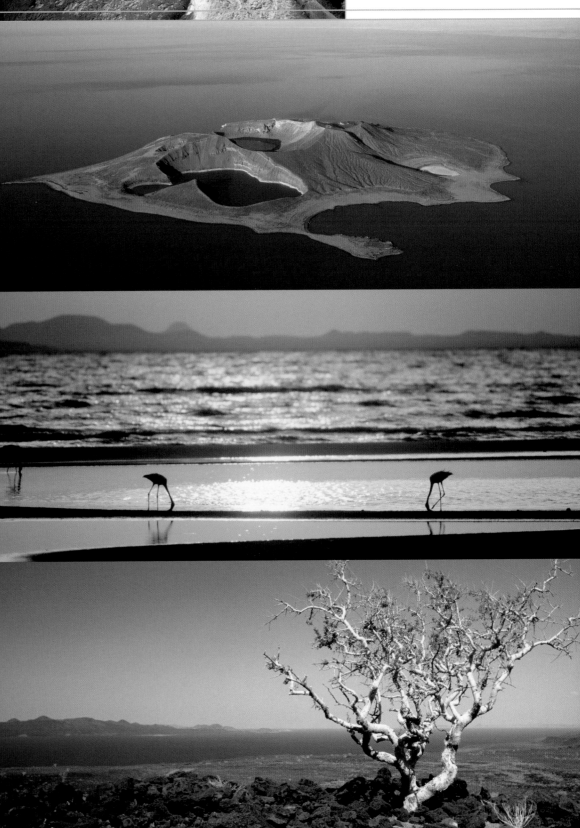

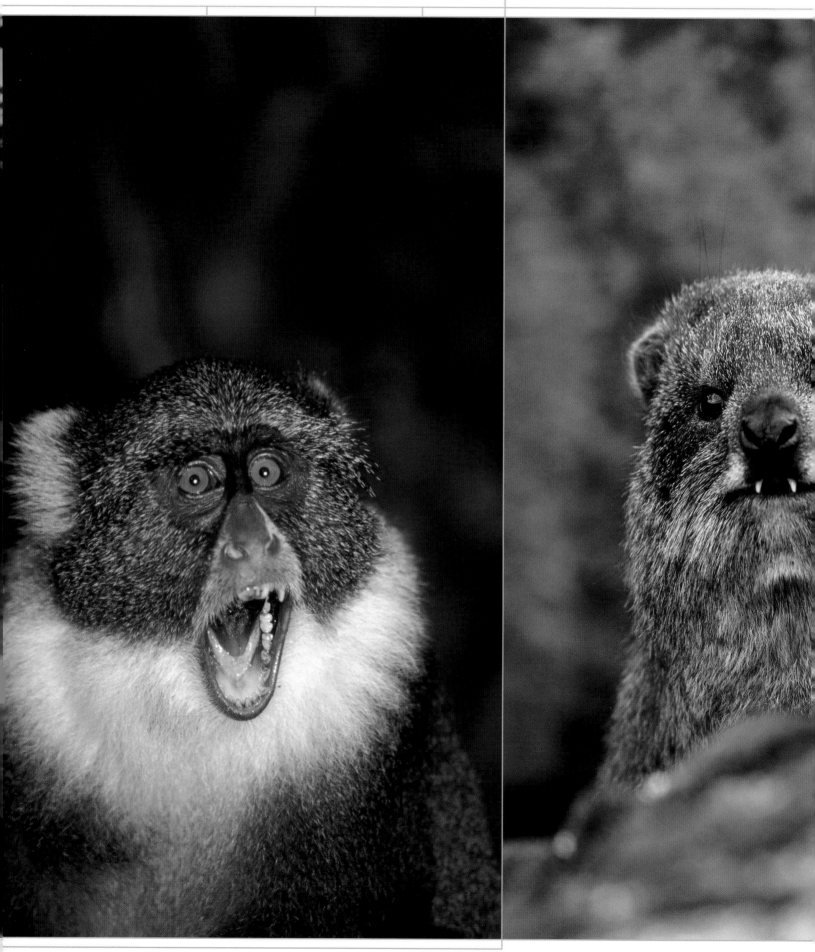

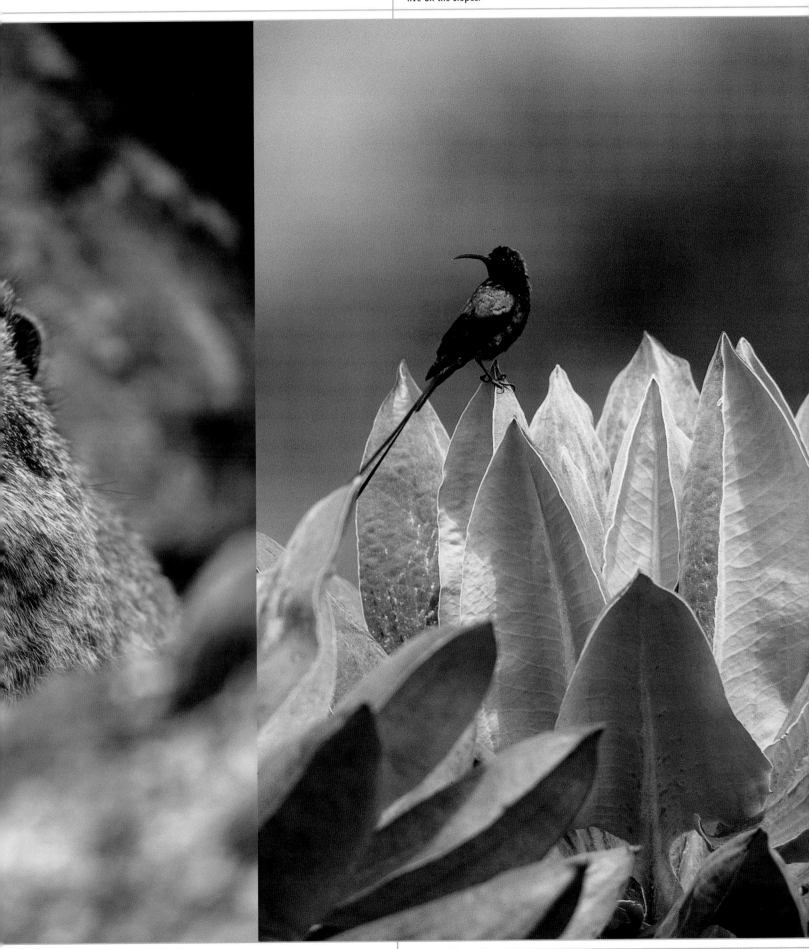

The slopes of Mount Kenya, called by the indigenous Masai the "black and white mountain," are home to numerous species of mammal, including various Old World monkeys and the hyrax, which resembles a pika or marmot. Plenty of birds, for example this red-tufted sunbird (seen here sitting on a ragwort), find a place to live on the slopes.

SERENGETI NATIONAL PARK

The Serengeti is a giant area of savannah, east of Lake Victoria, stretching from north-west Tanzania into neighbouring Kenya. Approximately 15,000 sq. km (5,800 sq. miles) of Tanzanian territory, the scene every year of extensive migration, was turned over to the national park.

Date of inscription: 1981

Throughout the year, mighty herds of more than two million Boehm's zebra, white-bearded wildebeest, and Thomson's gazelle roam the grassland and savannah of the Serengeti in search of food and water, often covering distances of up to 1,500 km (930 miles). Overcoming great hardship, these animals always follow the same routes, which are governed by the alternation of the dry and rainy seasons. Their natural enemies are hot on their trail: lions, leopards, cheetahs, and hyenas. Hardly anything else on earth portrays the struggle for life – eat or be eaten – on such an imposing scale as this mass animal migration on the Serengeti.

This area, among the world's richest in terms of animal life, is also home to

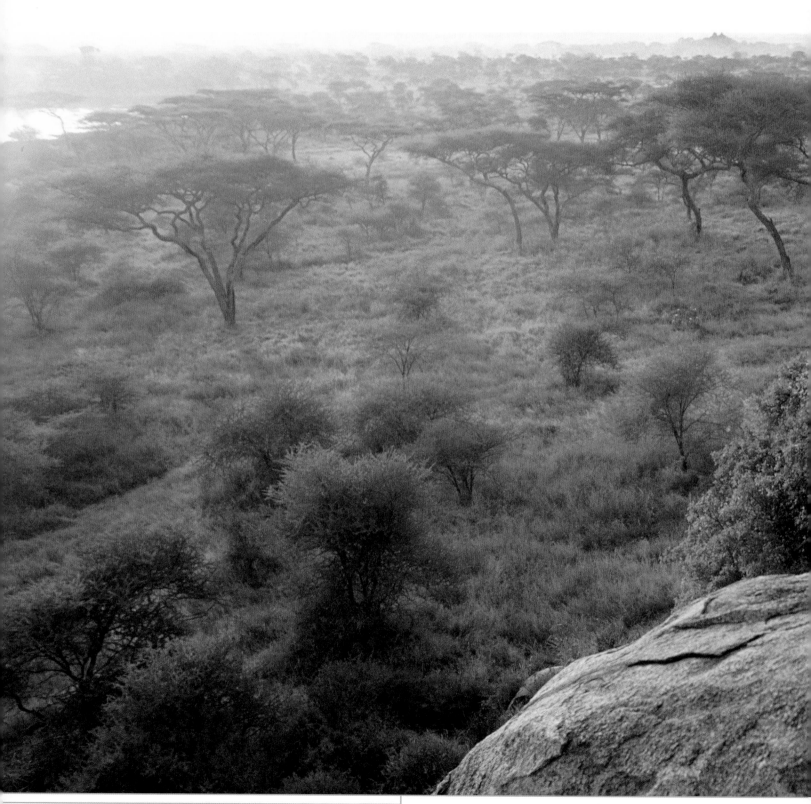

giraffes, Cape buffaloes, topi and kongoni antelopes, elands, hippos, rhinos, hyenas, African wild dogs, patas monkeys, aardwolfs, crocodiles, emus, and elephants. These last are not indigenous, but were introduced in 1957. Over the millennia, a biosphere for very diverse species has developed. All this changed with the arrival of Europeans at the end of the 19th cen-

tury. Big game hunters dealt the animal world a blow from which it may never fully recover. The Serengeti was placed under partial protection as early as 1921 and under full protection in 1929. The national park was inscribed in 1951.

"Kopjes" – Dutch for "little heads" – jut out of the grassland everywhere on the Serengeti. These rock formations of gneiss and quartzite once lay under the earth's surface and have been exposed after millennia of erosion. Both humans and animals use them as lookout points (below, and left), and they provide protection from enemy species and the scorching sun.

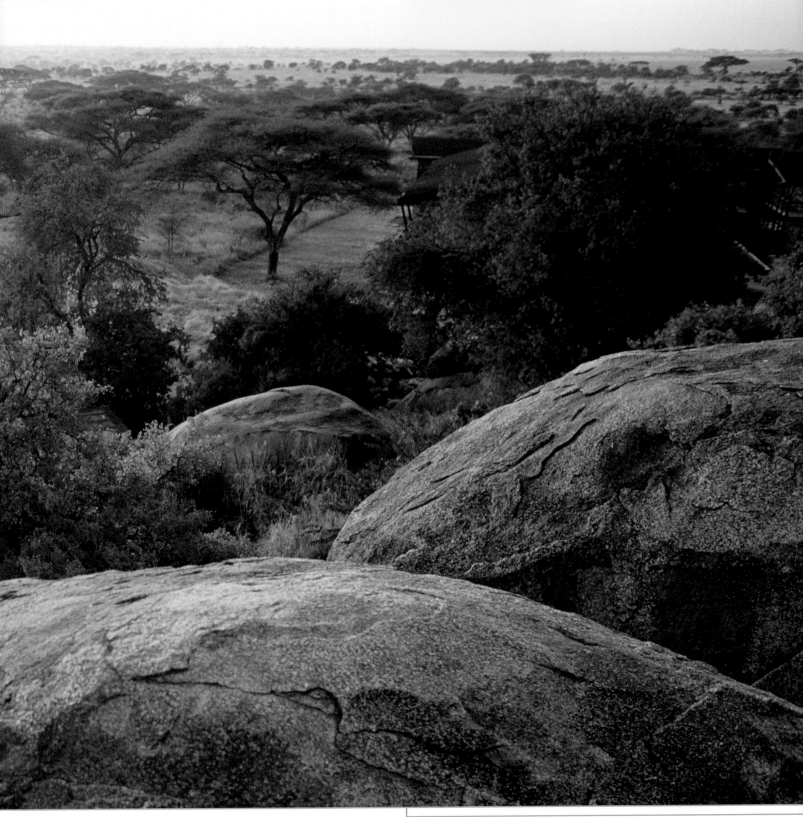

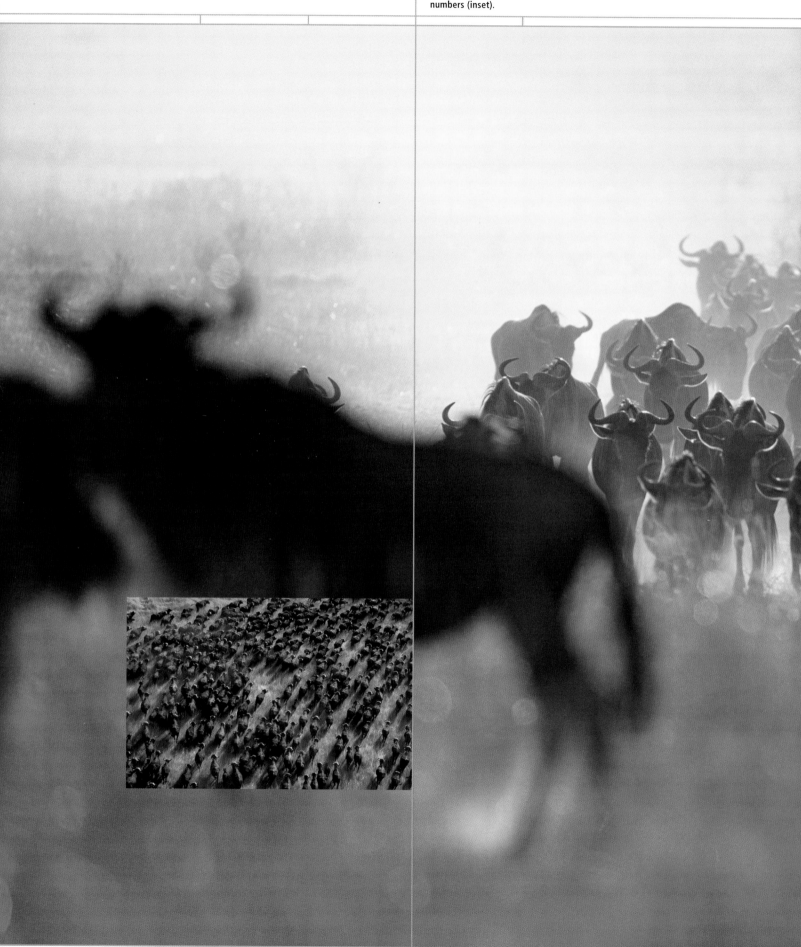

SERENGETI NATIONAL PARK

The Masai call this great savannah "Siringitu," meaning "endless plain." Twice a year, enormous herds of herbivores, particularly wildebeest, begin their great migration in search of water and fresh vegetation (below). Cape buffaloes, too, roam the Serengeti in great numbers (inset).

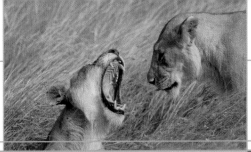

The great migration, from north-east to south-east in October and November, and back again between April and June, is joined by other herbivores, such as elephants, zebras, and giraffes (below), ensuring rich pickings for predators like lions (left).

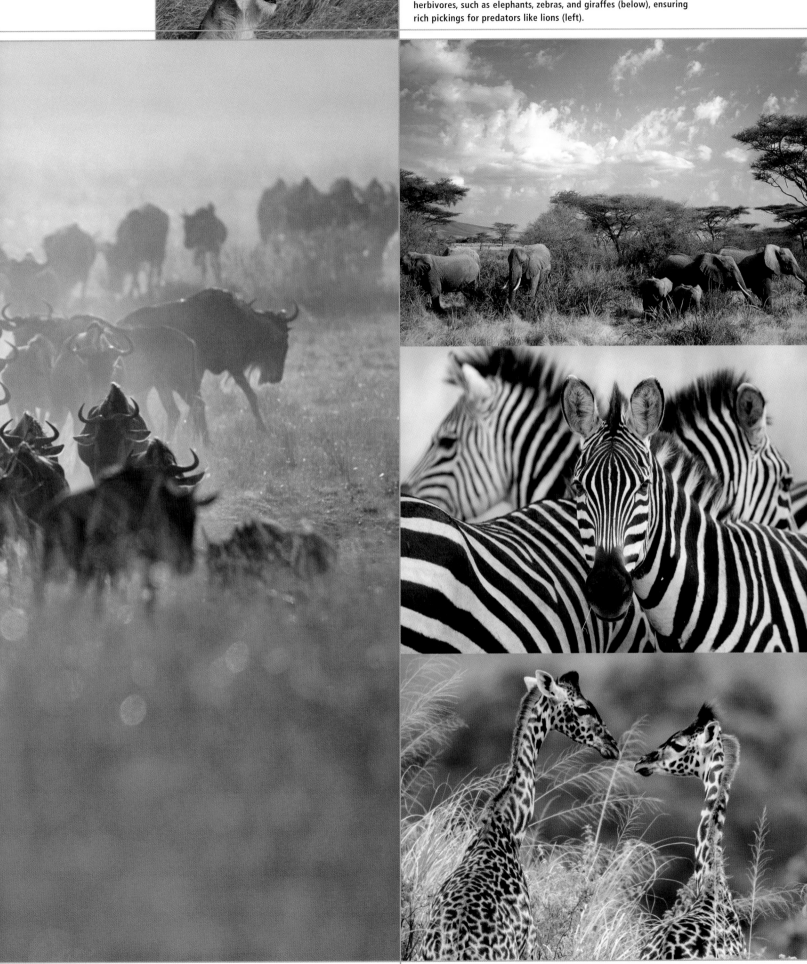

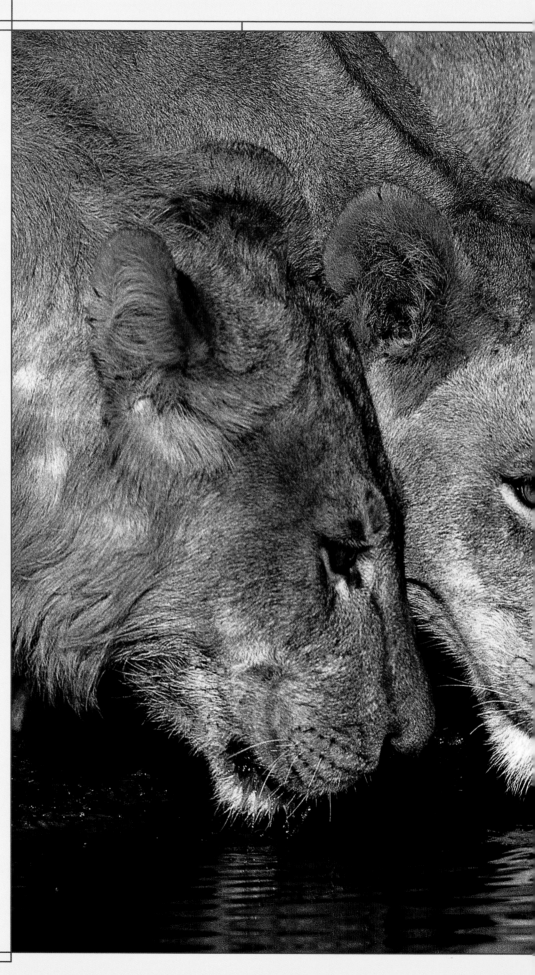

King of the animals

Africa's largest big cat is shrouded in myth. The majestic male lion with its flowing mane has fired the human imagination since time immemorial. In medieval Europe, the lion was a symbol of power and strength, worn on coats of arms long before it was ever glimpsed in the flesh. The lion has a mighty voice; when it roars, it seems to silence all other animals. On the African savannah, the last refuge of this once widespread mammal, the only danger to the king of the animals is man. The reverse is very rarely true; lions have a reputation as bloodthirsty man-eaters, but in fact hardly ever attack humans – the seemingly docile hippopotamus is considered Africa's most dangerous large animal. In contrast to other cat species, lions live in prides. These consist of females and their young and one dominant male, who commands a particular pride territory. Upon maturity, young males are obliged to leave the pride, and only the strongest

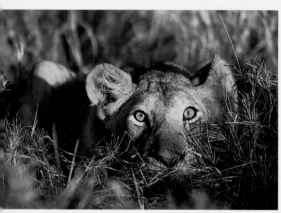

When hunting, lions usually creep up as close as possible on their prey.

succeed in wresting pride and territory from another lion. The other "bachelors" form nomadic groups in the savannah and eat carrion, as hunting is carried out by the females. Lionesses creep up in a group, encircle their prey and pounce in meter-long (3-foot) bounds, killing with a bite to the neck; the leader of the pride always has first pick of the ensuing booty.

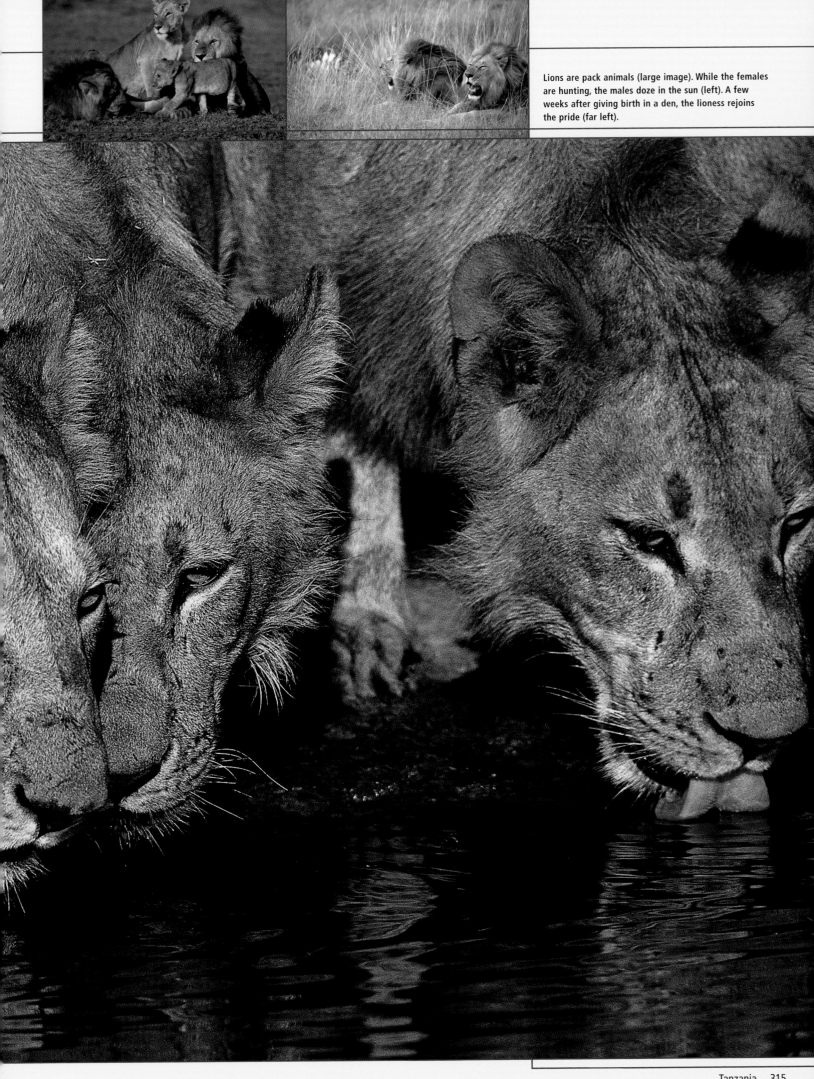

Lions are pack animals (large image). While the females are hunting, the males doze in the sun (left). A few weeks after giving birth in a den, the lioness rejoins the pride (far left).

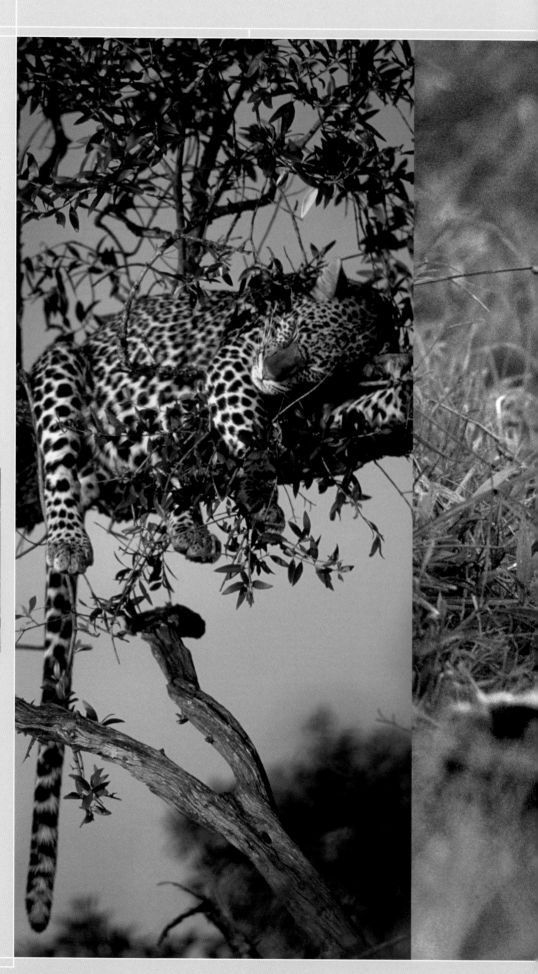

The beautiful predator

The leopard is not just distinct from the other wild animals of the Serengeti because of its spotted coat; it is also the most adaptable predator. It is not choosy about its prey, for one thing – antelopes, baboons, jackals, reptiles, and birds are all fair game – nor does it have strict hunting times by day or night. The languor with which this nimble climber lounges in a tree is unparalleled – until its unsuspecting prey strays into proximity. The perseverance it shows when stalking is also impressive; it can creep after its prey for great distances, crawling when there is no cover, trying to get as close as possible to its victim. A leopard can reach a top speed of 60 km per hour (37 mph), but only over very short distances. It will also take any prey that falls its way by chance, for example, when one of the young strays from the herd.

In contrast to the other big cats, such as the lion or tiger, the leopard is relatively widespread. It can adapt to a variety of environments and is found

The rosette-patterned spots on a leopard's coat are individual to each animal.

throughout Africa and south Asia, although the total population has been considerably reduced. Outside national parks and other conservation areas, the leopard has been virtually wiped out.

In the right light, the spots on the black panther's coat can be seen, too – this is no separate species, but a melanistic variant of the leopard.

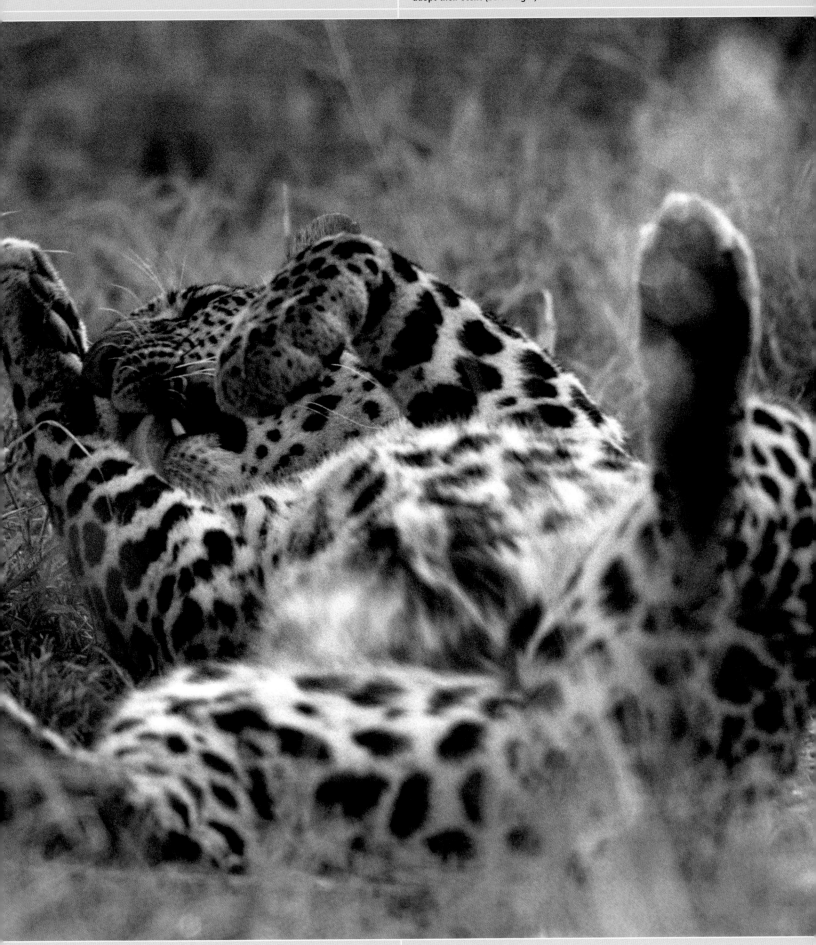

Leopards can climb trees using their claws, to lie in wait for their prey or rest after hunting (below left). Female leopards on heat roll in the territorial urine markings of the males to adopt their scent (below right).

Eat or be eaten

Annual migration between the plains of the Serengeti and the Masai Mara is fascinating, not just because of its extent, but also because of the associated complex systems of eating – and being eaten. The largest species browse first, trampling down the long grass, such that smaller species can reach the lower layers of vegetation. Zebras eat only the woody tops of the plant stems, wildebeest eat the leafy middle portion, and gazelles content themselves with the seeds and young shoots near the ground. There is a similar vertical division of dining heights among the leaf-eating elands, black rhinos, and gerenuks, obviating competition. In this

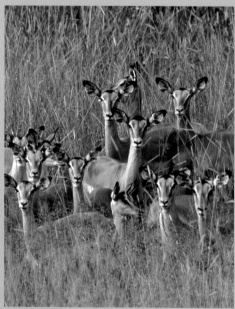

Like most antelopes, impalas live in small herds.

way, every resource the savannah has to offer is completely exploited. The predators are also part of this optimal system of nutrition, and at its pinnacle are the big cats: lions, leopards, and cheetahs. Crocodiles, too, waylay orphaned calves or the old and weak at river crossings, and anything left over is taken by the carrion-eaters: hyenas, jackals, white-headed, African, and Egyptian vultures, marabou storks, and white-necked ravens.

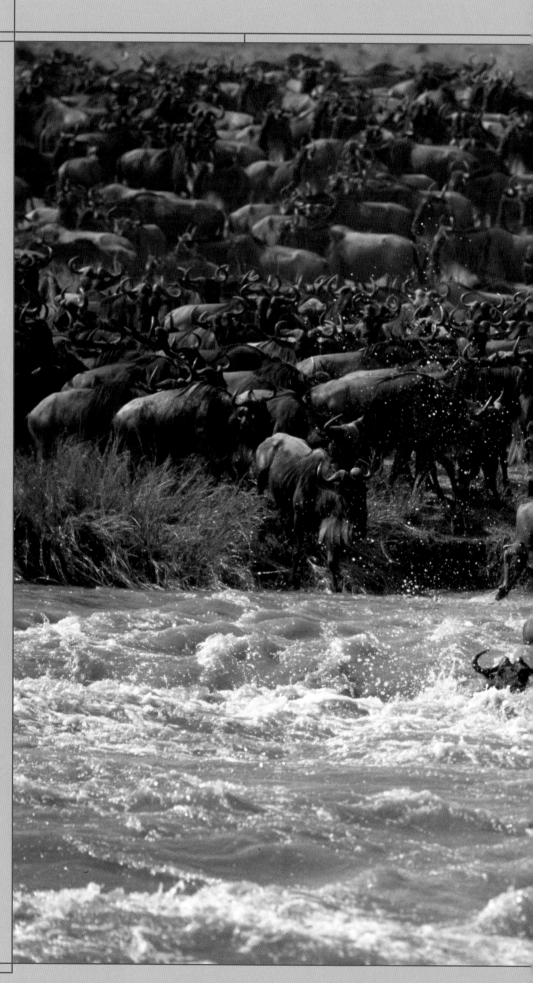

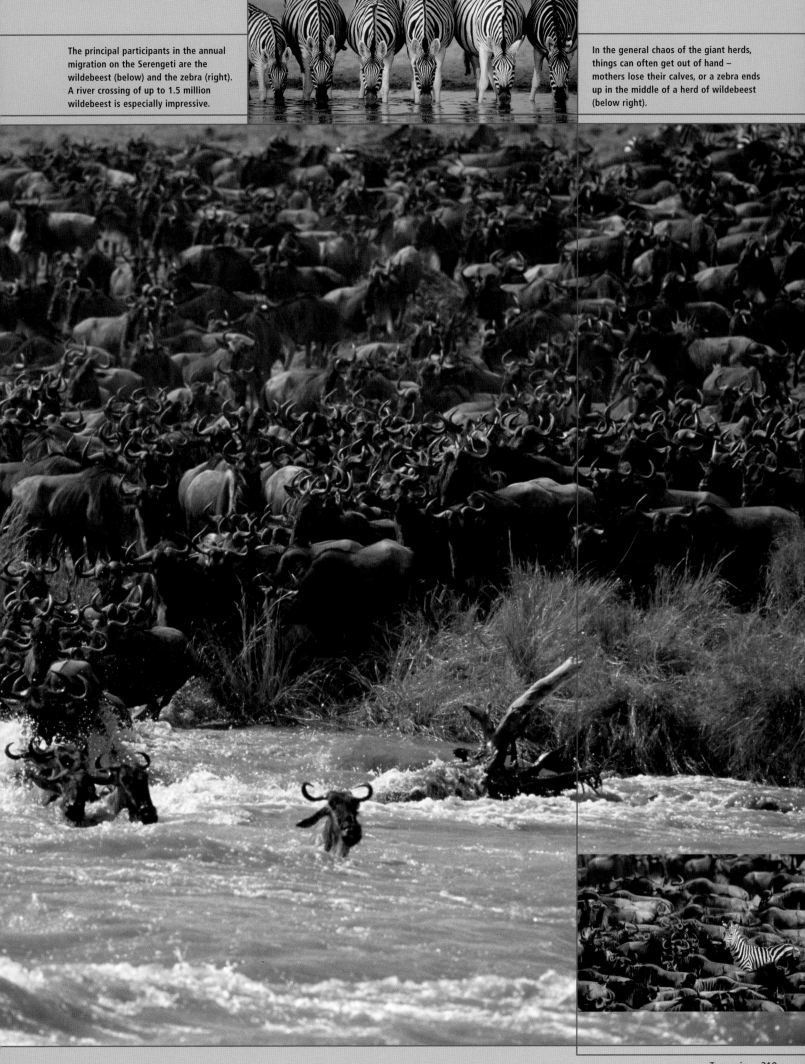

The principal participants in the annual migration on the Serengeti are the wildebeest (below) and the zebra (right). A river crossing of up to 1.5 million wildebeest is especially impressive.

In the general chaos of the giant herds, things can often get out of hand – mothers lose their calves, or a zebra ends up in the middle of a herd of wildebeest (below right).

The conservation area covers 8,000 sq. km (3,000 sq. miles) of the floor of the Ngorongoro crater in north Tanzania. Its imposing scenery is roamed by thousands of wild species.

Date of inscription: 1979

The Ngorongoro crater area was for a long time part of the Serengeti National Park, only becoming an independent conservation area in 1974. The newly established park included the Empakaai crater with its freshwater lake, as well as the active volcano, Oldonyo, Olduvai Gorge, and the Laetoli site, where fossilized remains of early ancestors of *Homo habilis* (early ancestors of *Homo sapiens sapiens*) have been found. Between the savannah and steppes of the giant Ngorongoro crater, a habitat for numerous species of wildlife, lie areas of marsh and acacia forests. The crater floor, which is largely covered in grassland, serves as pasture for the Masai's herds, and has become massively overgrazed due to

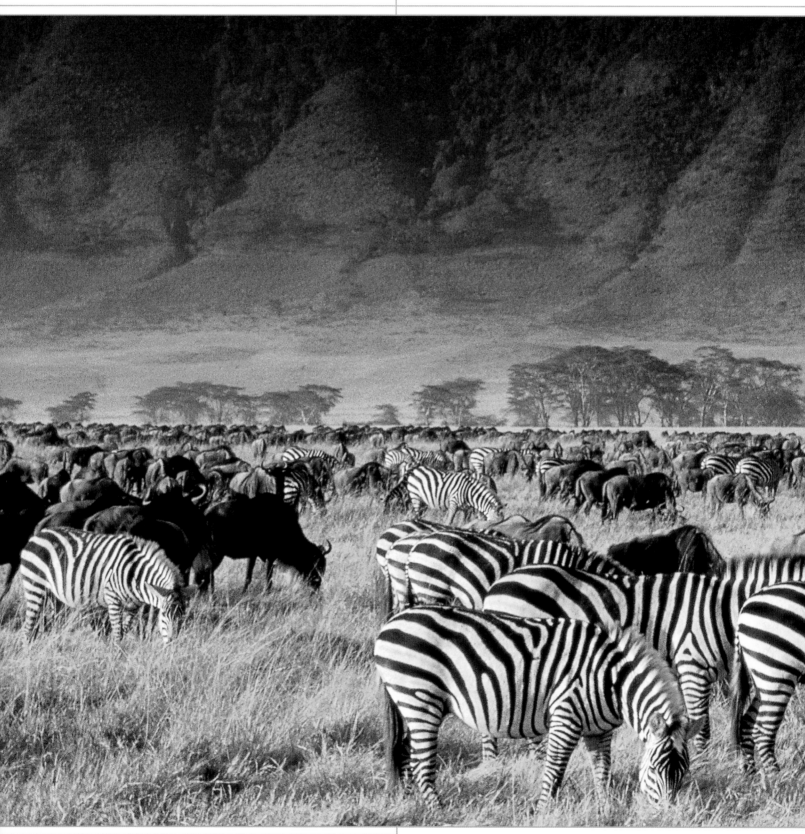

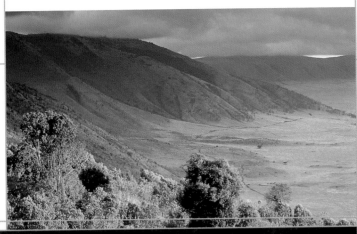

the extent of this tribe's traditional pastoralism.

The indigenous wildlife of the Ngorongoro area consists principally of wildebeest, gazelles, eland, waterbucks, and zebras. Elephants, hippos, black rhinos, lions, hyenas, and leopards complete this cross-section of Africa's wealth of fauna.

Thousands of wildebeest and zebras graze on the expansive grass plains of the Ngorongoro crater (large image). This pack of hyenas is among the 25,000 wild creatures in the crater (inset below). The crater floor, which lies at 2,380 m (7,800 feet) above sea level, is surrounded by the walls, a further 400–600 m (1,340–2,160 feet) higher (left).

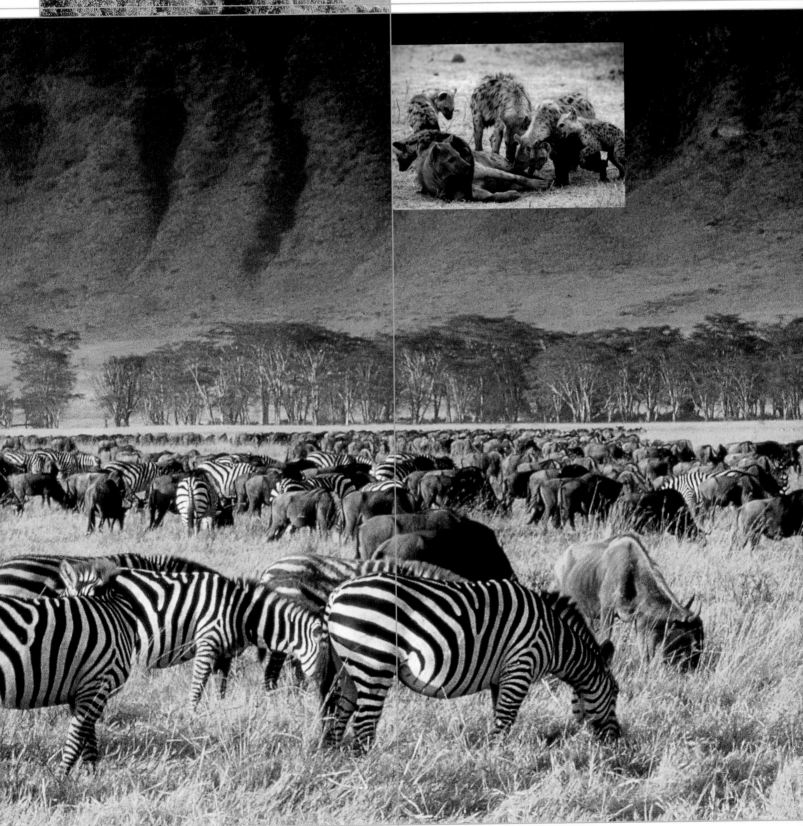

Giants of the savannah

Before the establishment of conservation areas, Africa's giants were at the mercy of big game hunters, and greed for ivory almost led to their extinction. Despite legislation and strict control of the ivory trade, the African bush elephant population is even now endangered, as its habitat of choice, the savannah, is still shrinking. Preventive measures in the Serengeti National Park include the arduous relocation of a herd, a step taken if the population expands too rapidly in one area. The African elephant is the world's largest land animal and one of its most popular, belonging to the "big five" that absolutely must be seen on safari. Its form is imposing and completely unique, not least because of its long, prehensile trunk, which in the African species ends in two finger-like projections. The trunk is an extension of its nose and is used for smelling, drinking, feeling, trumpeting, and not least for reaching food. This weighty herbivore uses its mighty tusks to dig up tubers and roots and to

For centuries elephants were hunted for their ivory tusks, Africa's "white gold."

scrape off tree bark, and in rarer cases as a weapon or in dominance displays. The African elephant's excellent adaptation to life in the savannah and steppes is shown by its giant, triangular ears. When pricked up, they substantially increase the animal's surface area and contribute to the regulation of its body temperature.

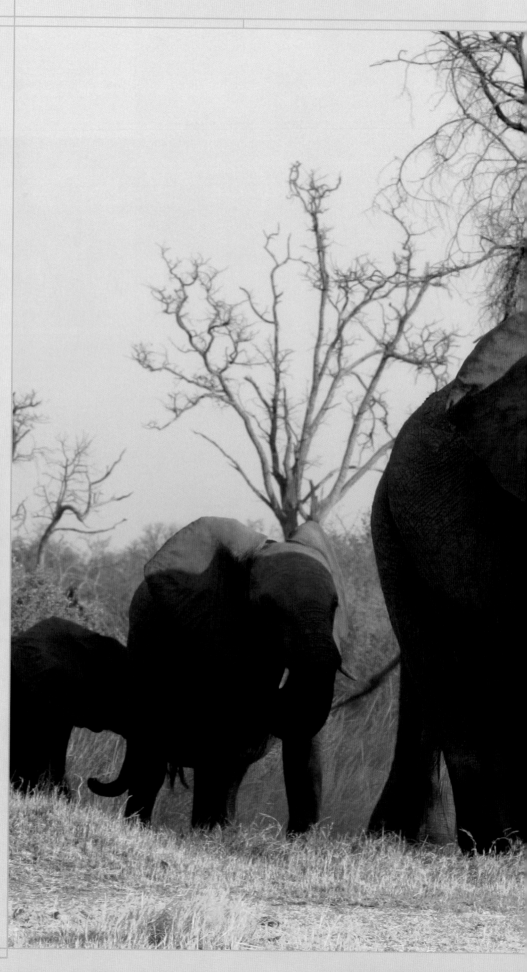

Elephant herds consist of females together with their calves. They are led on their wanderings through the savannah by a so-called matriarch, a female that is too old to breed. Baby elephants weigh about 100 kg (220 lb) at birth, and at first they are entirely dependent on their mother's milk.

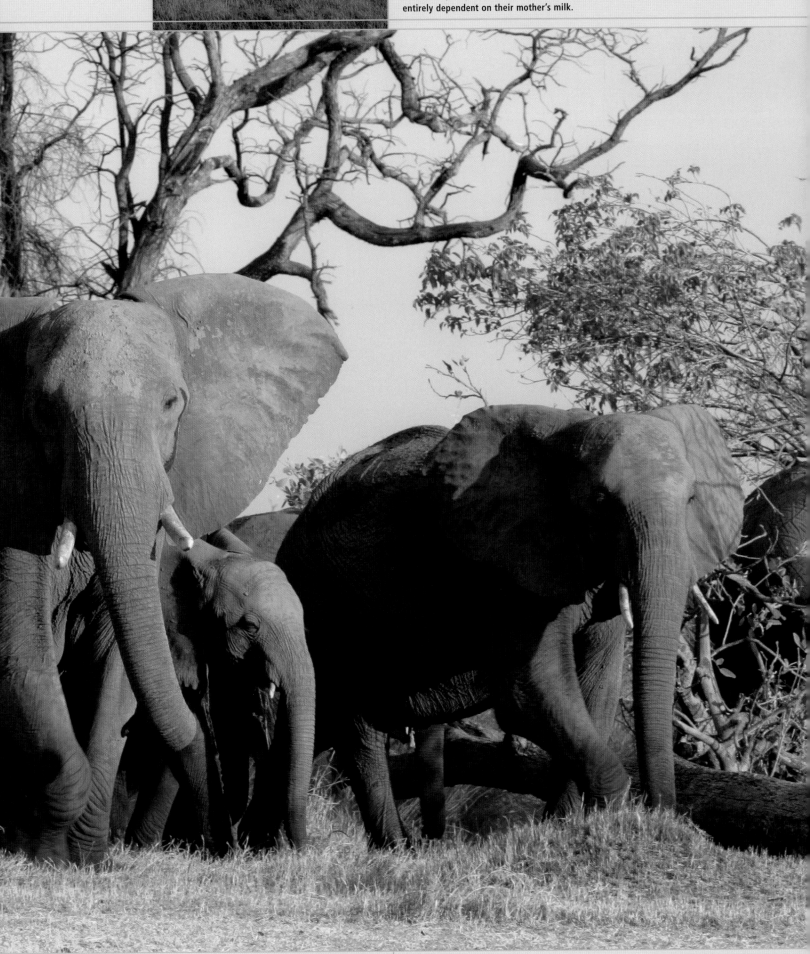

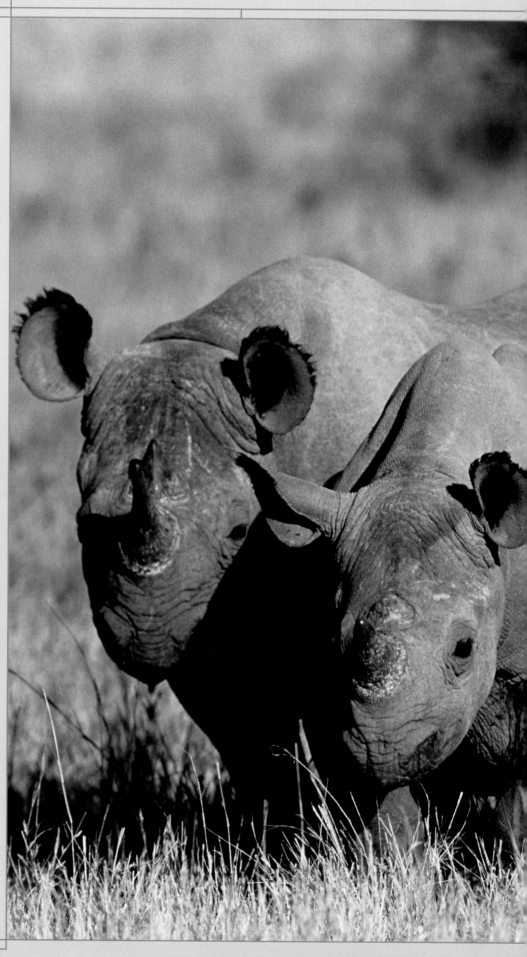

Endangered singletons

African rhinoceroses are threatened with extinction. One reason for this is the mistaken belief that their horns have aphrodisiac qualities; they command inordinate prices in the Far East, making poaching a very profitable activity. In conservation areas, protective measures have been taken that include removing the horn from tranquilized animals, rendering them unattractive to poachers. This is painless, as the horn is composed of keratin, the same substance as hair and nails. Only in territorial battles does this essentially docile herbivore use its horn as a weapon. Shyly avoiding humans where possible, the seemingly sluggish colossus can, however, become dangerous when happened upon unexpectedly.

Rhinos live singly and only seek out the company of the opposite sex during the mating season. The two species living in Africa are the square-lipped or

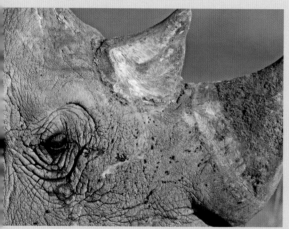

The white rhinoceros has two horns, arranged one behind the other; the rear one is noticeably smaller.

white rhinoceros, the second-largest land animal after the elephant, and the somewhat smaller black rhinoceros, so-called even though its skin shade is indistinguishable from that of its relative. The differences reside in feeding preferences and thus in habitats. The white rhino is a grazing animal, eating grasses and living on the open savannah, such as the Serengeti. The black rhino has an extended, finger-like upper lip, with which it plucks vegetation from shrubs, and so it largely prefers bush areas. The Ngorongoro Conservation Area is a refuge for this rare species.

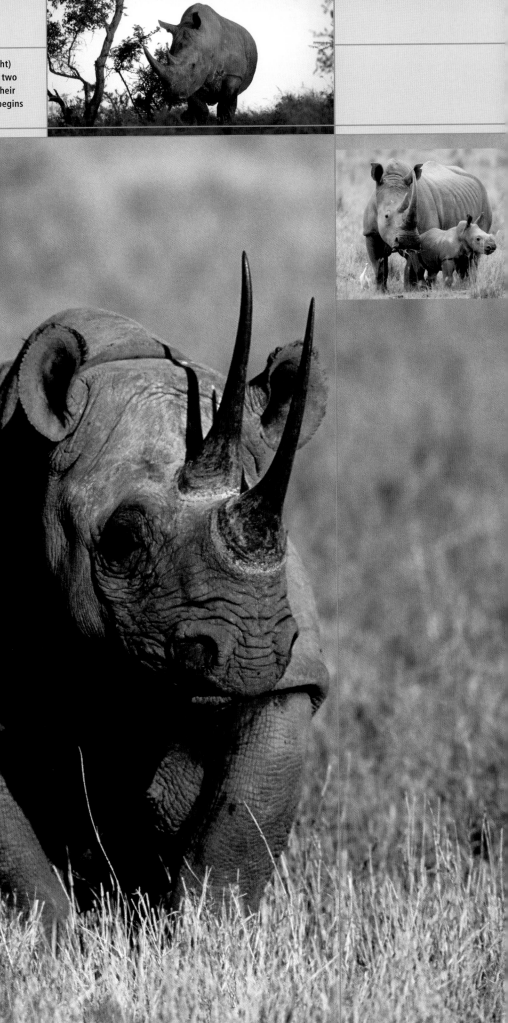

Two species of rhinoceros are found in Africa: the white rhino (right) weighs about twice as much as the black rhino (large image). The two species are also distinguished from one another by the shape of their mouths. The gestation period is 18 months and the young's horn begins to grow as early as five weeks after birth (below right).

KILIMANJARO
NATIONAL PARK

In north Tanzania, on the Kenyan border, the savannah is startlingly interrupted by the volcanic massif of Kilimanjaro. Approximately 750 sq. km (295 sq. miles) of the upper slopes of the mountain were enclosed as a national park to protect its unique montane forest.

Date of inscription: 1987

Kilimanjaro is composed of three main volcanic cones and numerous smaller summits of volcanic origin. To the west lies the 4,000-m (13,200-foot) high Shira; in the middle is Kibo, at 5,895 m (19,340 feet) the highest point in Africa; and to the east lies Mawenzi, the smallest at 5,270 m (17,290 feet). The other crests form a chain running south-east to north-west. Although not far from the equator, Kilimanjaro's peaks are always covered in snow.

This massif in the middle of the savannah enjoys extremely diverse climatic areas and zones of vegetation. Above the savannah there is a region of cultivated land, once covered in a forest savannah, which is now found only on the northern slopes. This zone merges

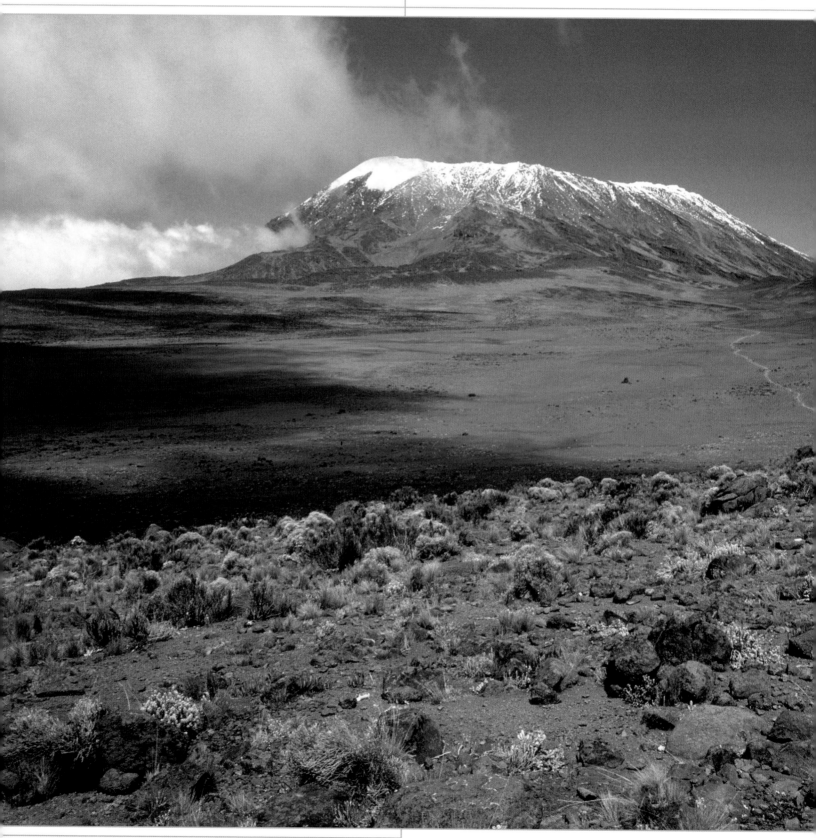

into a deciduous montane forest which rises to 3,000 m (9,900 feet). This is followed by expansive grassy uplands, and these in turn are replaced by the cold desert of the summit region. The national park is home to many animal species, including some that are endangered, including gazelles, rhinos, Cape buffaloes, elephants, and leopards.

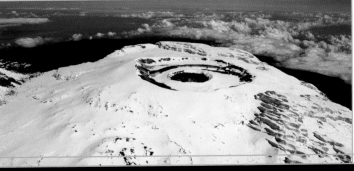

The Kilimanjaro National Park provides a refuge for rare bird varieties, such as the Cape griffon and bearded vultures (inset middle). Sulphurous fumaroles within Kibo's snow-covered crater are indicative of volcanic activity (left and below right).

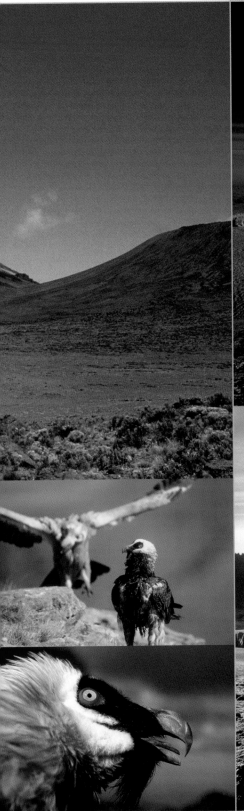

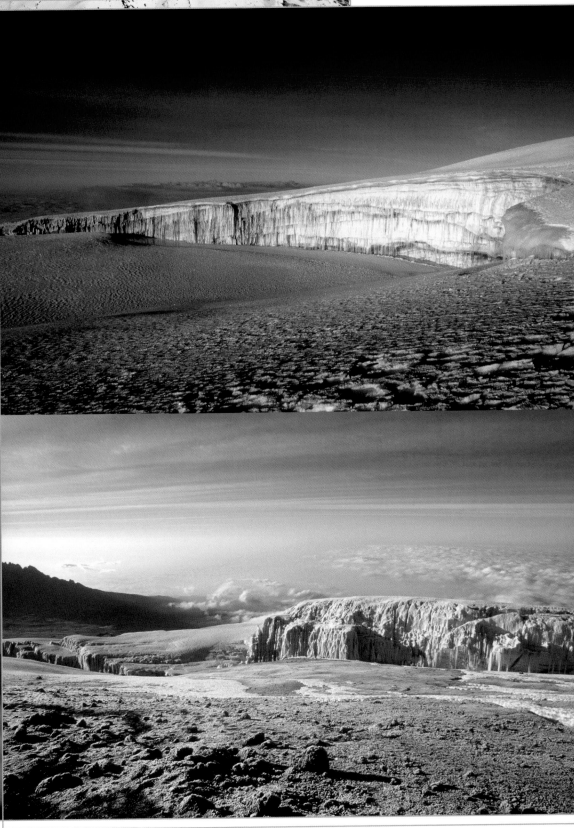

In south-east Tanzania, Africa's largest game reserve is home to about a million animals, including, among many others, representatives of the "big five" – elephant, rhino, buffalo, lion, and leopard.

Date of inscription: 1982

The Rufiji river, one of the largest in east Africa, and its many tributaries flow through the Selous Game Reserve, whose 50,000 sq. km (19,400 sq. miles) were declared a conservation area at the beginning of the 20th century. Approximately 200 km (124 miles) from Dar es Salaam, the area is largely avoided by humans because of the presence of tsetse flies, and thus provides a largely undisturbed habitat for a variety of wildlife. More than 150,000 wildebeest, 100,000 elephants, 150,000 buffaloes, 50,000 antelopes and zebras respectively, and approximately 20,000 hippos have been recorded. The world's largest crocodile population also lives here, and the various vegetation zones of the reserve are host to a considerable

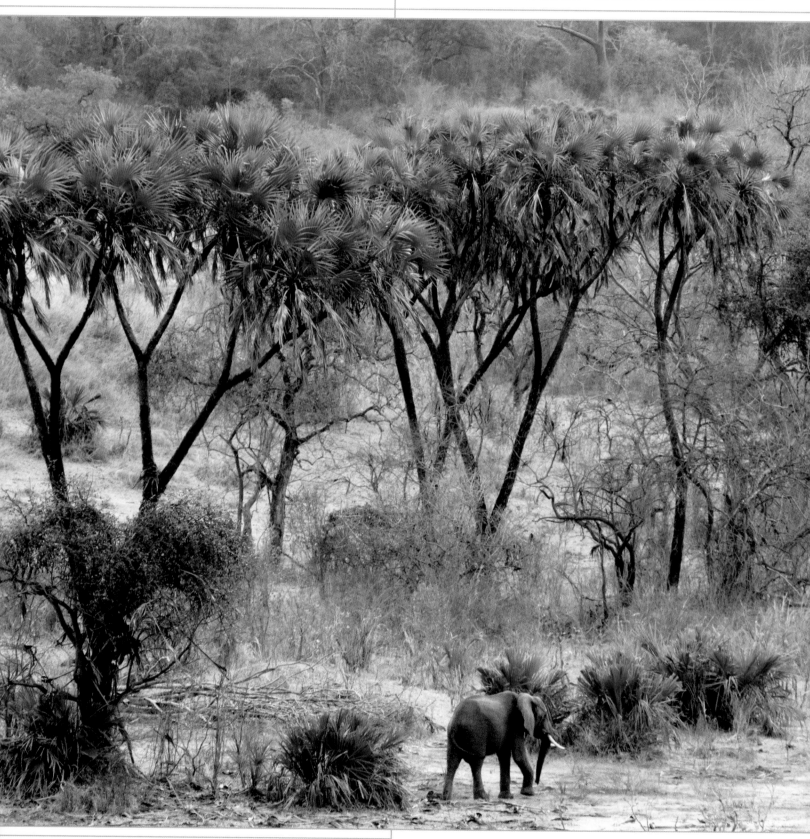

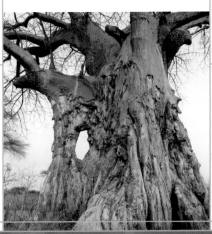

number of big cats, including cheetahs, leopards, and lions, as well as numerous giraffes.

These zones encompass steppes, savannah, lightly forested grassland, and the thick undergrowth of the gallery forest on the banks of the Rufiji and its sources, the Luwegu and the Kilombero. Miombo forest dominates the landscape.

Elephants have found a home in the Miombo forest (below left). The many watercourses flowing through the thickets and wooded grasslands are typical of the area, and flow into the Rufiji (bottom). The baobab, or "monkeybread tree," can store large amounts of water (left).

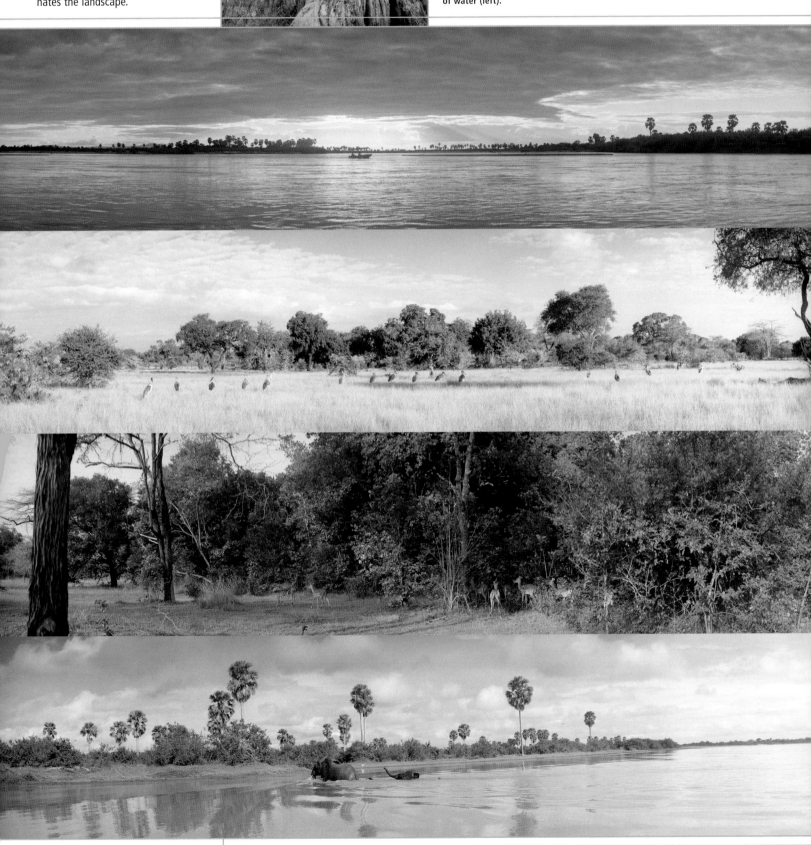

VICTORIA FALLS (MOSI-OA-TUNYA)

The Victoria Falls are among the most spectacular in the world; the waters of the Zambezi plummet from a series of basalt cliffs into a chasm over 100 m (330 feet) deep.

Date of inscription: 1989

The first intimation of the presence of the gigantic Victoria Falls is visible at a distance of about 20 km (13 miles), in the form of a cloud of spray rising 300 m (990 feet) into the air. With a deafening roar, the Zambezi, the natural border between Zambia and Zimbabwe, plunges 100 m (330 feet) into the depths, making this a truly international World Heritage Site.

This natural spectacle is echoed in the indigenous name for the five falls: Mosi-oa-tunya, meaning "the smoke that thunders." At high water in March and April the falls become a continuous curtain of water, almost 2 km (1.5 miles) wide, depositing 10,000 cu. m (353,000 cu. feet) of water per second into the gorge. During the rest of the year's dry season,

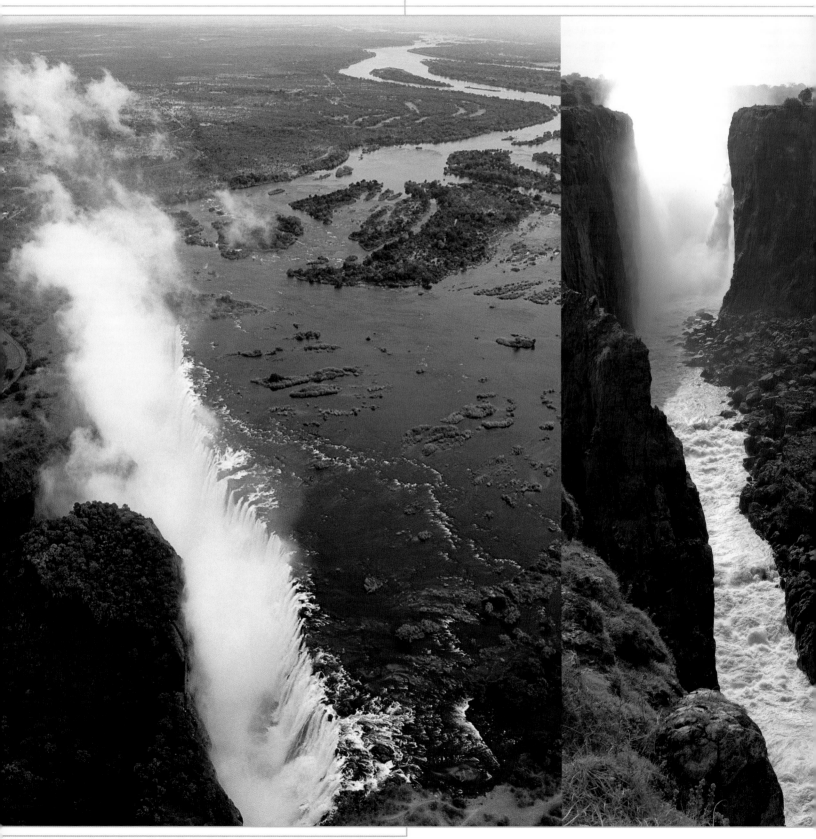

the individual falls, of which the Rainbow Falls are the highest, separate out again. The area surrounding the falls is home to some 30 mammal, 65 reptile, and 21 amphibian species.

David Livingstone, the British scientist and missionary, was the first European to discover the Victoria Falls (1855), naming them after the reigning queen of England.

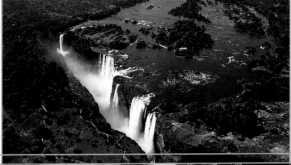

The deep gorge into which the Zambezi drops at the Victoria Falls was cut by the river itself during the course of millions of years (below and left). Even today the water continues to erode the stone and the Victoria Falls are "moving."

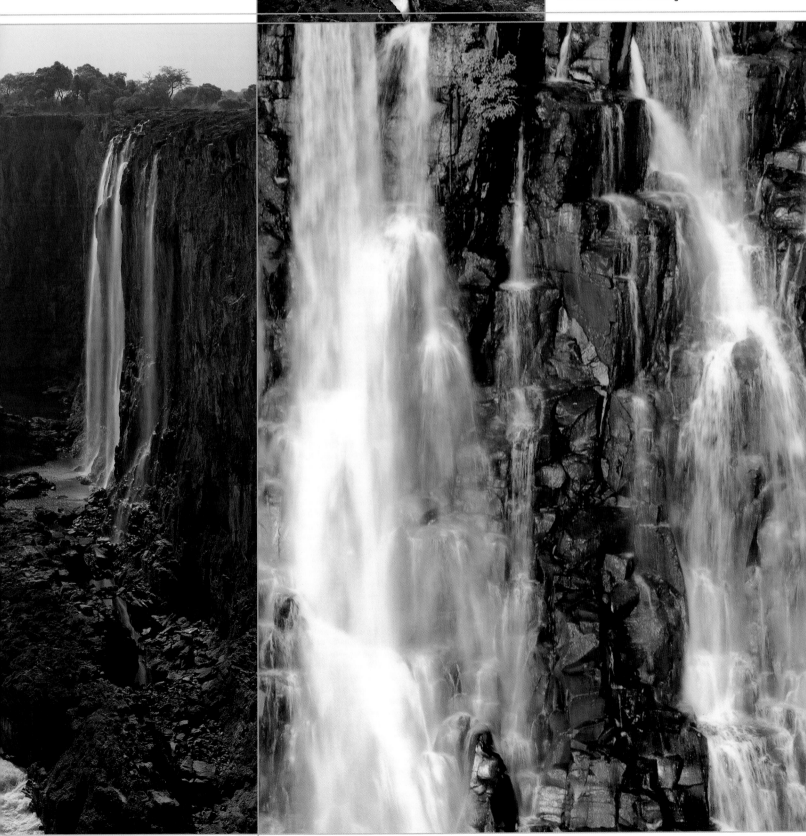

MANA POOLS
NATIONAL PARK

Situated on the southern banks of the Zambezi river, this national park, and its associated safari areas of Sapi and Chewori, is a paradise for animals.

Date of inscription: 1984

Mana Pools was inscribed as a national park in 1963, and a year later the neighboring safari ranges of Sapi and Chewore were also placed under protection. Situated at the meeting-place of the Zimbabwean, Zambian, and Mozambican borders, these three areas together cover an area of about 7,000 sq. km (2,600 sq. miles), of which Chewore makes up about half. The Zambezi river forms the park's natural border to the north. The river regularly floods the grasslands and forests of the conservation area, and "Mana Pools" refers to the four permanent pools thus created. This fertile landscape is home to a variety of animals. About 400 bird species live in the forests, thousands of elephants roam the plains, and

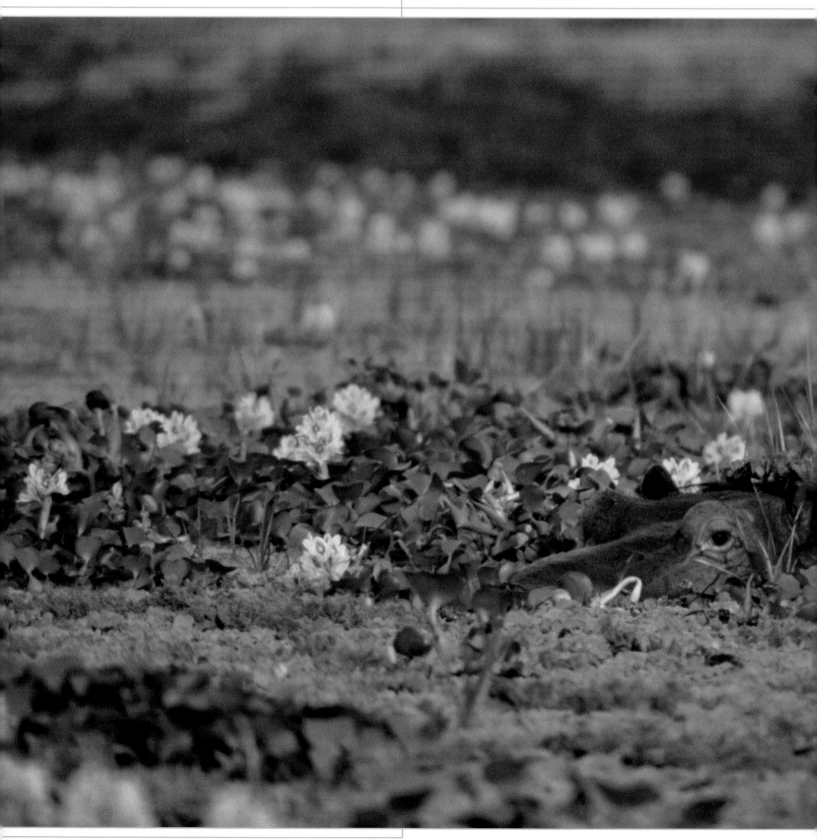

herds of buffalo and zebra offer rich prey for predators such as leopards and cheetahs.

The Chewori Safari Area has recently become home to one of the largest populations of the giant white rhinoceros. Hippos and a large number of the otherwise endangered Nile crocodile roam the peaceful waters and banks of the Zambezi.

This hippopotamus is barely visible among the water hyacinths in a pool in Mana Pools Park (main image). Elephants (left) particularly enjoy the leaves of the wild fig tree (bottom). In the rainy season a watery landscape is created as the Zambesi and its tributaries overflow their banks (column, top and middle).

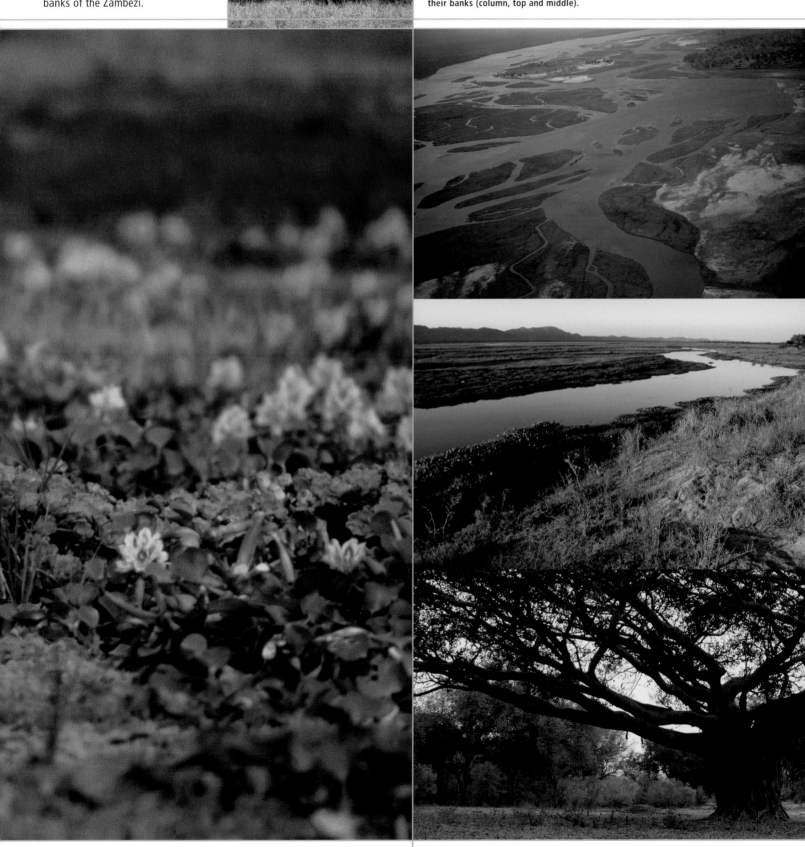

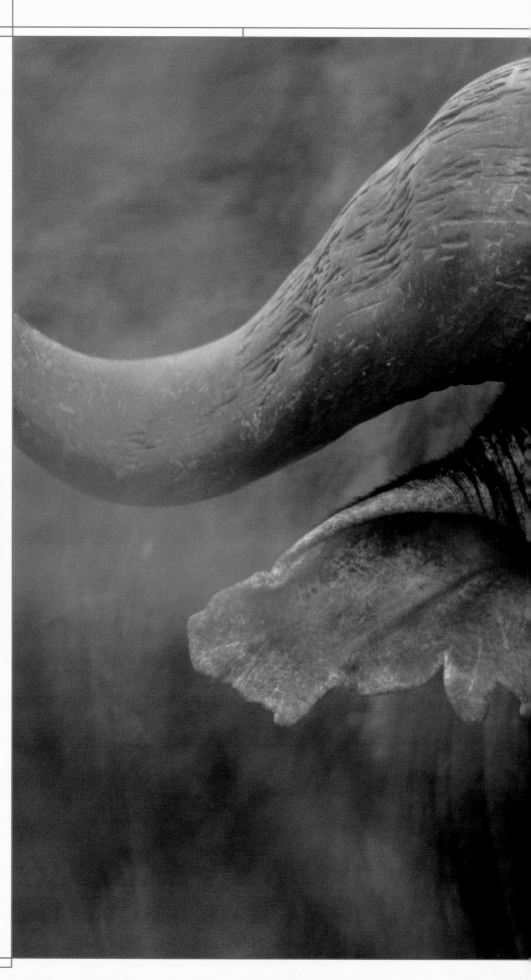

Steppe and forest cattle

An approaching herd of African buffaloes is an incomparable natural spectacle – their hooves make the earth shake. The concentrated might of these animals, flattening any obstacle, is best avoided. Stories of the bellicose nature of these mighty African cattle are, however, mostly exaggeration. As they have no natural enemies, apart from poachers and big game hunters – even lion packs will only attack stray calves or old individuals – their aggression is kept within bounds. Danger threatens when crossing rivers like the Zambezi, however, in which Nile crocodiles may lurk. These pull their victims into the water and drown them.

There are two species of buffalo: the smaller, red-brown forest buffalo lives in the rainforest and the larger, black Cape buffalo, whose horns can span up to a meter (3 feet), lives in damp savannah, such as in the Mana Pools National Park in northern Zimbabwe. Giant herds of Cape buffalo can live for

Cape buffaloes live in family groups of three to ten animals, but can also congregate in large herds of around 2,000.

years at a time in the same territory, and roam along established routes for as long as the area supplies grass and water. In the heat of the day, they cool off in the river or in swampy hollows.

The buffaloes always attract two species of bird: the cattle egret accompanies the herds and eats the small animals and insects they stir up, while the oxpecker finds a wealth of sustenance on the animals' backs.

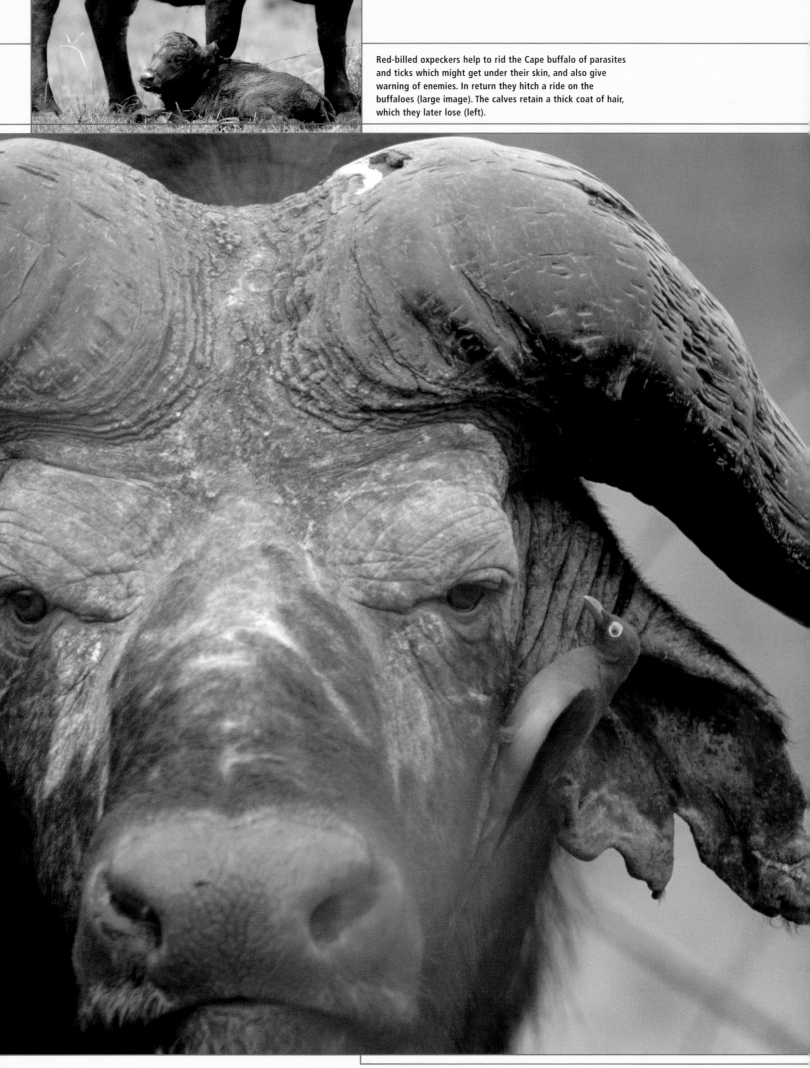

Red-billed oxpeckers help to rid the Cape buffalo of parasites and ticks which might get under their skin, and also give warning of enemies. In return they hitch a ride on the buffaloes (large image). The calves retain a thick coat of hair, which they later lose (left).

LAKE MALAWI NATIONAL PARK

Situated at the southern end of the third-largest lake in Africa, the first national park exclusively devoted to the conservation of fish is home to several hundred species of cichlid, of which the majority are indigenous.

Date of inscription: 1984

As early as 1616, the Portuguese explorer, Gaspar Boccaro, had reported the existence of a great body of water in south-east Africa, and in 1859 the British missionary, David Livingstone, reached the shores of what he called Lake Nyasa, now known as Lake Malawi. The lake is fed by 14 tributary rivers. The largest are the Ruhuhu and its only headstream, the Shire, a tributary of the Zambezi, which crosses the south of Malawi. Today, three states – Tanzania, Mozambique, and Malawi – border the lake, which is 500 km (310 miles) long and 50 km (31 miles) wide. This unique national park was established in 1980 at the southern end of the lake, on Malawian territory. Its 100 sq. km (39 sq. miles) include the Cape Maclear peninsula, three separate sections of shoreline, 12 islands, and part of the lake nearest the shore. In the clear waters of the lake, which can reach a depth of 700 m (2,240 feet), more than 200 species of fish have developed, of which 80 percent are endemic. For this reason, the lake is as important for the study of evolution as the Galapagos Islands. The reason for this concentration of unique species is the natural barrier to the species of the Zambezi formed by the Kablega Falls. Elephants and impalas live beside Lake Malawi, as well as semi-aquatic species such as hippos, crocodiles, cormorants, and fish eagles.

Mumbo Island lies off the Cape Maclear peninsula and is covered by the Miombo forest of fig and baobab trees (large image and above). A sailing boat lies at anchor in a silent bay (inset below).

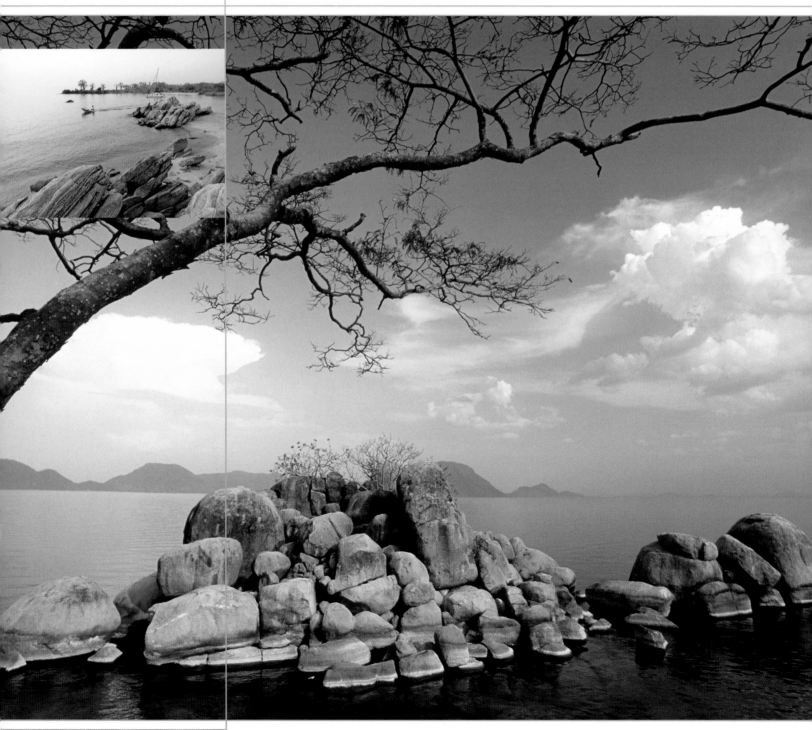

VREDEFORT DOME

The Vredefort meteorite crater, 120 km (75 miles) south-west of Johannesburg, is now considered the largest and oldest of its kind. It is thought to be a little over two billion years old and has a diameter of 190 km (118 miles). Establishing the dimensions of such craters is problematic, as they are evened out over the years by weathering, erosion, and deposition.

Date of inscription: 2005

The greatest natural catastrophes in world history have been asteroid impacts. They are now considered to have exerted an influence on evolution, and it is possible that the dinosaurs died out due to the effects of a meteorite strike. The exact make-up of the mass of rock that thundered down on South Africa is difficult to determine today, but it is possible it was an asteroid, with a diameter of about 12 km (7.5 miles) and a speed through space of about 20 km (13 miles) per second, or perhaps a smaller comet core, moving at a still higher speed. When a meteorite hits the earth, its energy is converted into heat in fractions of a second, leading to a powerful explosion and resulting in a crater. Material thrown up by the impact falls to form the crater wall. The impact energy causes changes in the minerals beneath; for example, shock pressure transforms quartz into the stishovite and coesite also found in the Vredefort Dome. So-called "shatter cones" have also been found. Stone broken into angular fragments at impact which then reform is known as "breccia." Among scientists, the Vredefort crater is known in particular for a specific kind of breccia named pseudotachylite. Horn stone, which usually only occurs in strata deep underground, can also be brought to the earth's surface by the impact.

The semi-circular structure of the Vredefort meteorite crater can be clearly seen from the air (large image). The Vredefort Dome refers to the convex hump formed in the middle of the crater by the impact.

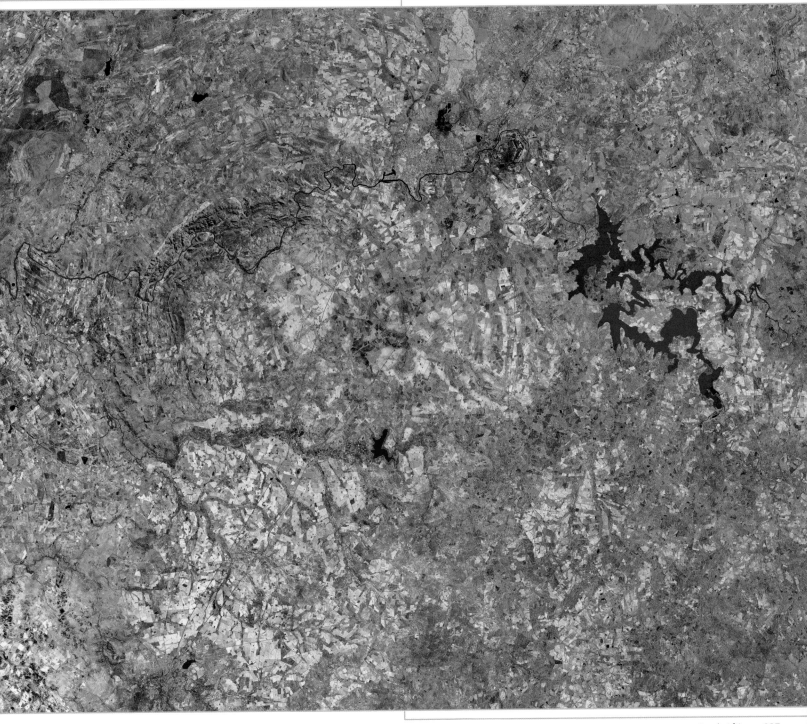

DRAKENSBERG NATIONAL PARK/UKHAHLAMBA

The rock art of the San, several thousand years old, is to be found in the spectacular natural scenery of the Drakensberg Park in eastern South Africa, immediately adjacent to the border with Lesotho.

Date of inscription: 2000

The silent majesty of the mountainous Drakensberg region is home to both the eland and to the now-rare bearded and Cape Griffon vultures. Unique cultural treasures are to be found where erosion has split the softer sandstone strata under the weight of the blocks of basalt. Unique evidence of San (Bushman) rock art has been discovered in caves and under rocky overhangs. Many of these images date back only 300 years, but are overpainted on 4,000-year-old layers of pigment.

Groups of the San lived as hunters and gatherers in this area into the first half of the 19th century. The often multi-hued paintings were situated in places that were probably used at particular times of the year for ritual purposes.

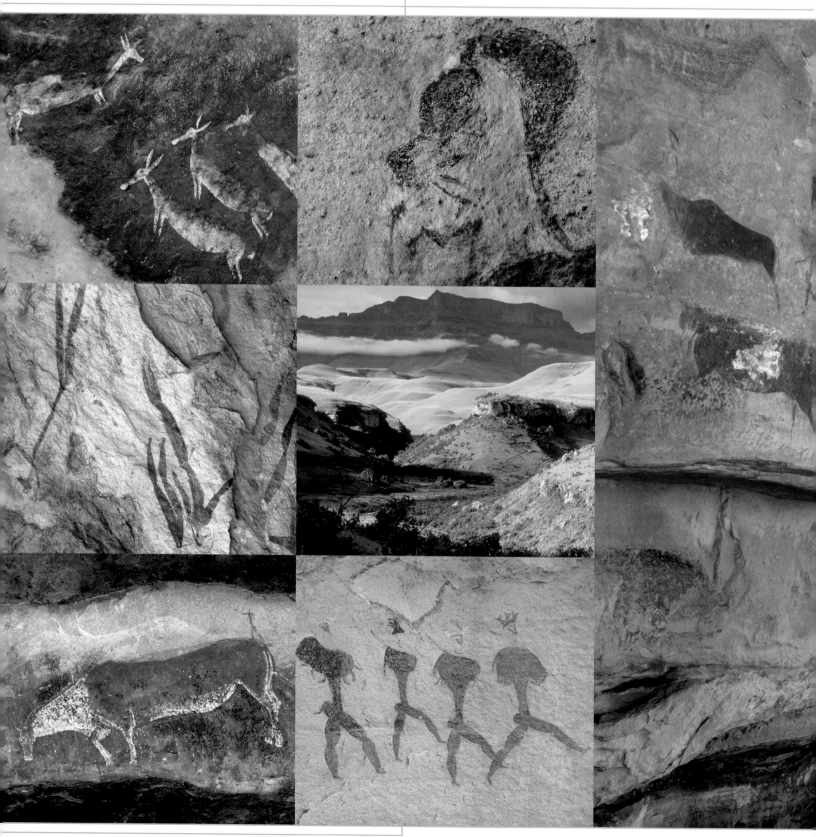

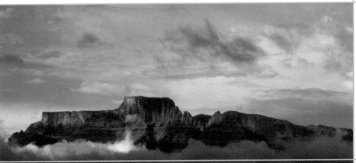

The addition to the paints of antelope blood as a fixative suggests a spiritual element to many of the depictions: it is assumed that the eland, too, held some mythological importance. Several of the paintings show dancing figures with nosebleeds, presumably representative of ritual trance states.

The Drakensberg mountains have the appearance of a rocky plateau around the Monk's Cowl (left). Around 35,000 rock paintings, of which some are prehistoric, have been created by the San. They depict hunting and everyday scenes and are to be found here, at Giant's Castle, and in Game Pass Shelter (below).

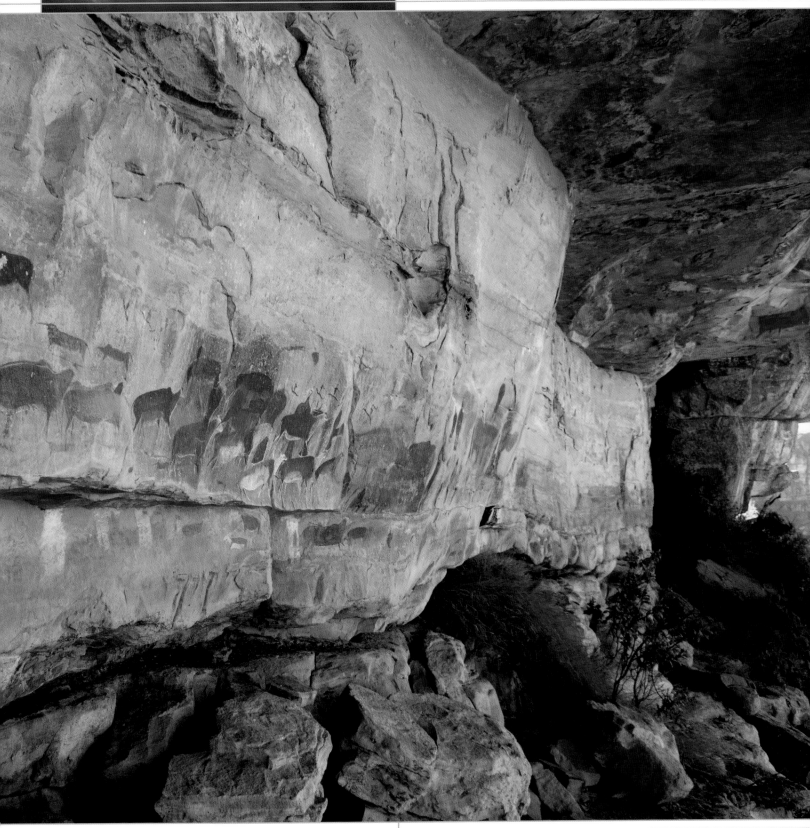

ISIMANGALISO WETLAND PARK

This reserve on the north-eastern coast of South Africa is among the largest national parks in the world and has a striking diversity of habitats.

Date of inscription: 1999

The 2,500 sq. km (950 sq. miles) of the iSimangaliso Wetland Park are distributed throughout large parts of Maputaland, in north-eastern South Africa, stretching as far as the Mozambican border.

The conservation area includes some quite differing ecosystems: the aquatic flora and fauna of the Lake St Lucia Marine Reserve; Lake St Lucia's wetlands; the Mkuze swamps, Sodwana Bay, and Eastern Shores; Cape Vidal State Forests and the coral reefs that lie just offshore there; and the grasslands of the Lebombo mountains located in the hinterland.

Lake St Lucia, at 350 sq. km (130 sq. miles) the heart of the national park, lies in a large area of marsh fed by the Hluhluwe river on its journey to the Indian Ocean. This area was placed under protection as early as 1895. The lagoon, with its islands and reed marshes, runs parallel to the Indian Ocean coast for 60 km (37 miles), never reaching a depth greater than 1.5 m (5 feet).

The tallest forested dune system in the world forms a barrier with the coast. The world's largest crocodile

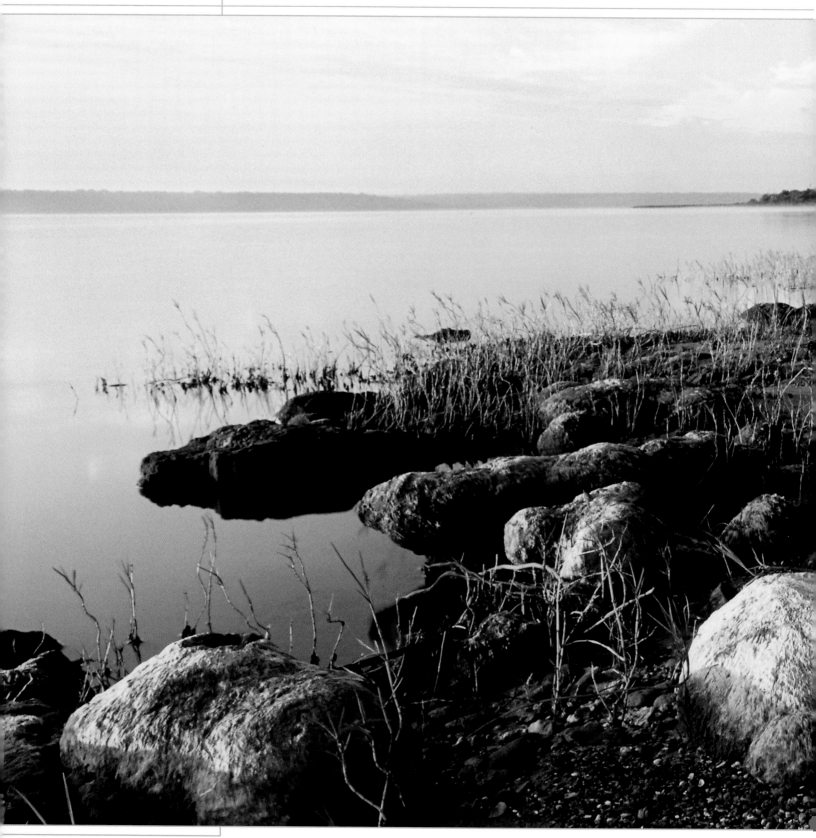

population lives in this marshy area, along with large populations of hippos and more than 400 bird varieties, such as pelicans, spoonbills, and fish eagles. Numerous wildebeest roam the lake shore. Rare somango monkeys and other tree-dwellers live among the thickly forested dunes, and the sandy beaches around Cape Vidal are the territory of several species of sea turtle. Lying off the cape are extensive coral reefs, among the southernmost on earth.

The wide grassland of the interior is a habitat for almost all of Africa's big game species, including both the white and black species of rhinoceros.

Fossils reveal the secrets of earlier ages on the shores of Lake St Lucia (large image). At the confluence of the lake and the Indian Ocean, where salt and fresh water meet, a wealth of sustenance is found by many species, including pelicans, hippos, and crocodiles, which lay their eggs in the sand (left).

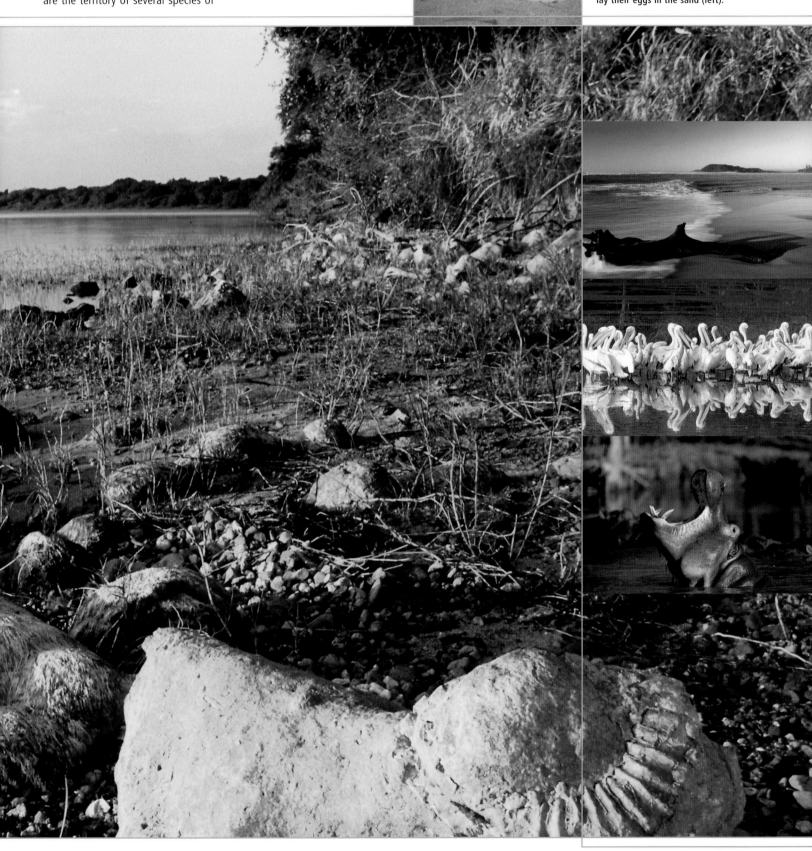

GOUGH AND INACCESSIBLE ISLANDS

The largely undisturbed volcanic Gough Island in the South Atlantic, belonging to the Tristan da Cunha island group, is the habitat of one of the world's largest seabird colonies. Nearby Inaccessible Island is also part of the World Heritage Site.

Date of inscription: 1995; Extended: 2004

The island, part of the Tristan da Cunha archipelago, was discovered in the 16th century by Portuguese sailors. Apart from a weather station, the island is uninhabited. Gough Island's especial importance resides in its undisturbed flora and fauna; the steep cliffs are a nesting place for great colonies of seabirds. Two species of birds and 12 varieties of plant are endemic here. In 2004 the World Heritage Site was expanded to include the volcanic Inaccessible Island, which lies to the south-west of Tristan da Cunha.

Gough Island in the South Atlantic is a paradise for yellow-nosed albatrosses and terns (right), macaroni and rock penguins (below left), and fur seals (below right).

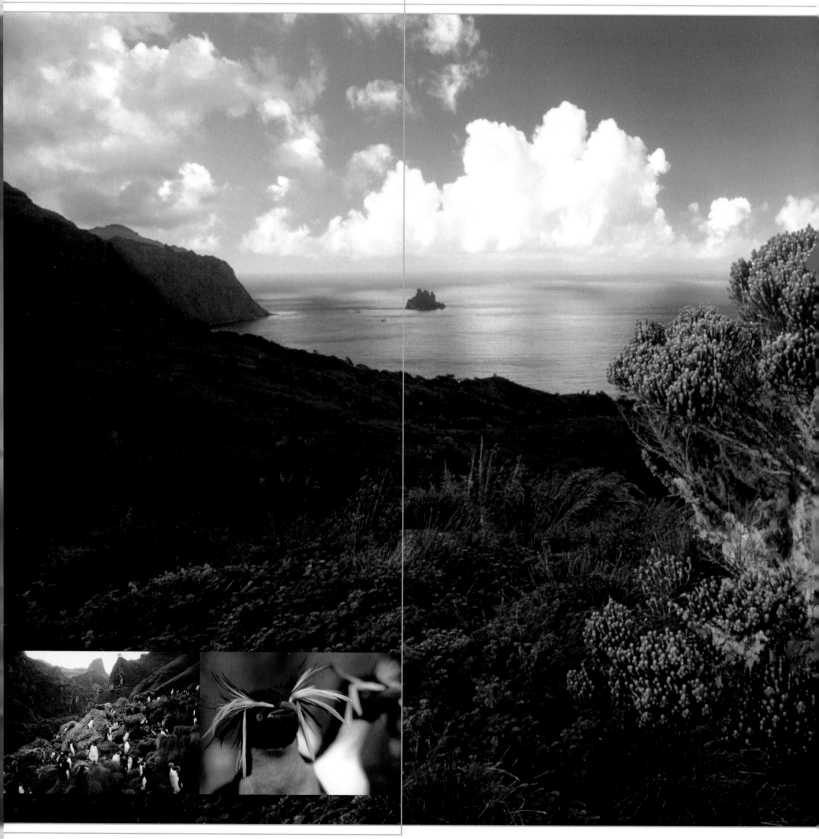

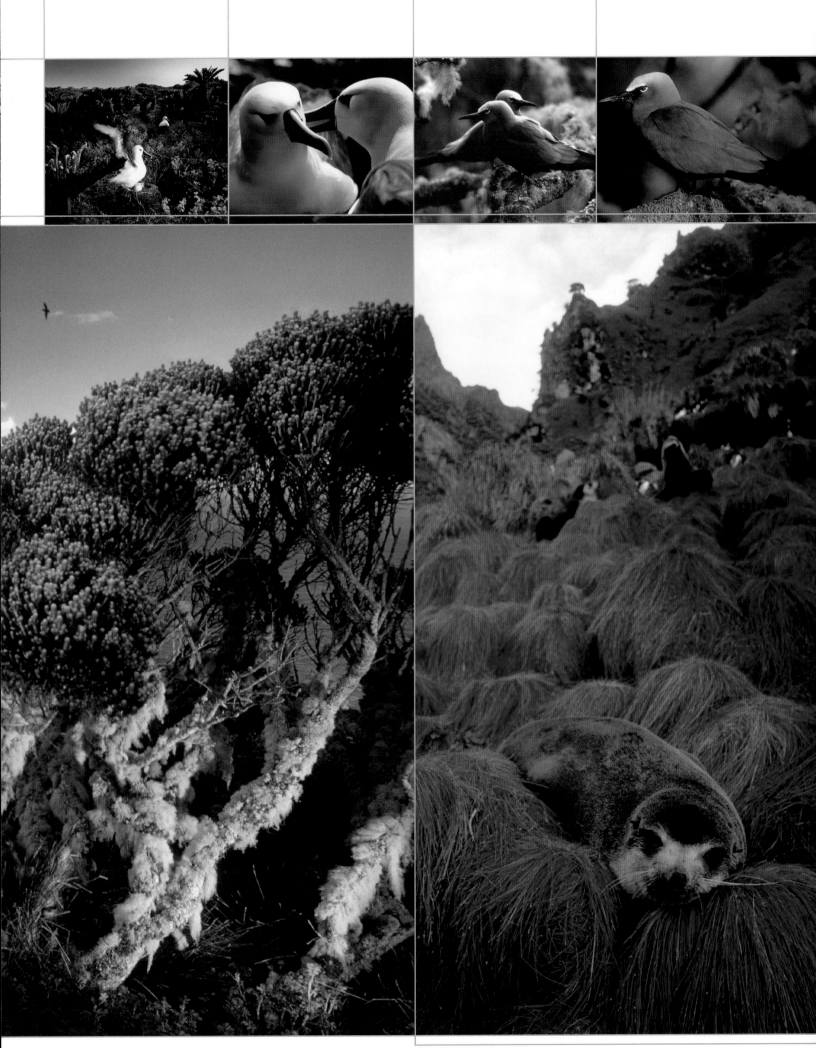

Bizarre rock faces and undisturbed forests, lakes, and mangrove swamps are all components of this unique natural paradise, which is a home for many rare varieties of animals and plants.

Date of inscription: 1990

The imposing karst landscape of the Bemaraha plateau on the west coast of Madagascar lies at roughly the same latitude as the capital, Antananarivo. Its spectacular highlights include the Manambolo river canyon and the bizarre Tsingy, a "forest" created by limestone projections. The undisturbed rainforests, lakes, and mangrove swamps of the conservation area are home to innumerable species of orchid.

The Bemaraha Strict Nature Reserve's 1,500 sq. km (580 sq. miles) are particularly important as the habitat of lemurs, which occur naturally almost exclusively on Madagascar. This prosimian species reached the island more than 40 million years ago and discovered ideal living conditions.

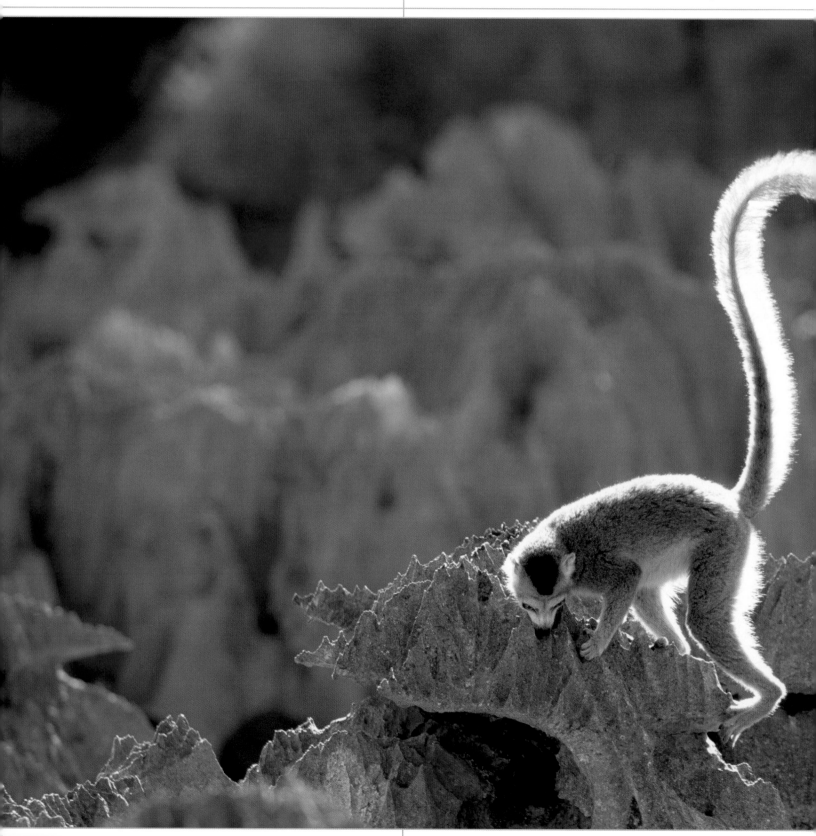

Madagascar's extremely remote location has led to the evolution of around 40 different species of lemur, and the region is also home to numerous birds, bats, amphibians, and reptiles, including geckos and chameleons.

The Tsingy limestone "forest," whose spikes can rise to 30 m (100 feet), is home to many lemurs (below left). The rivers that cross it have hollowed out underground caves, canyons, and grottos in the rock (below right). Banana, ebony, and baobab trees grow between the rocky spikes (left).

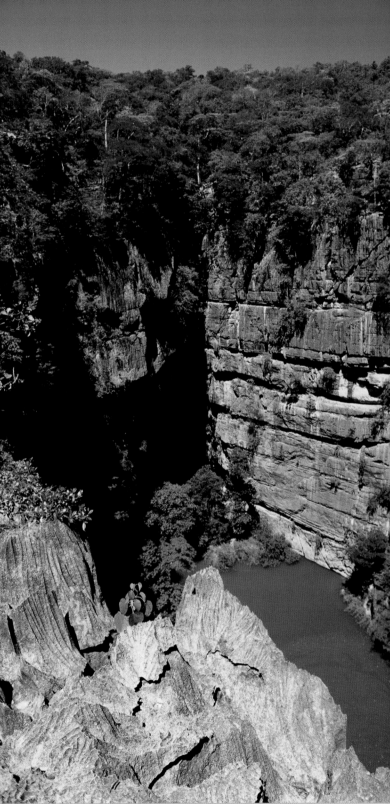

RAINFORESTS OF THE ATSINANANA

Six separate national parks in the eastern part of Madagascar have been grouped together under the heading "Rainforests of the Atsinanana," and they play an important part in the preservation of the island's biological diversity.

Date of inscription: 2007

Madagascar has been separated from continental Africa for 60 million years. This extensive period of isolation has been responsible both for the evolution of new plant and animal varieties and for the preservation of many ancient species. Madagascar and its surrounding island group is thus home to around 12,000 endemic plant species.

The best-known animal species are the lemurs, of the family once known as prosimians, now called strepsirrhines. Only Australia, thirteen times the size, has more indigenous species than Madagascar. Forests, especially rainforests, are the cradle of species diversity; unfortunately, only 8.5 percent of the formerly rainforested area of Madagascar now remains. Now

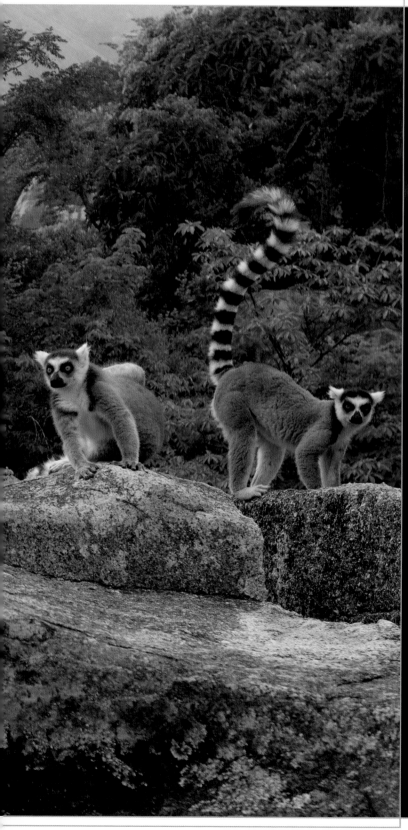

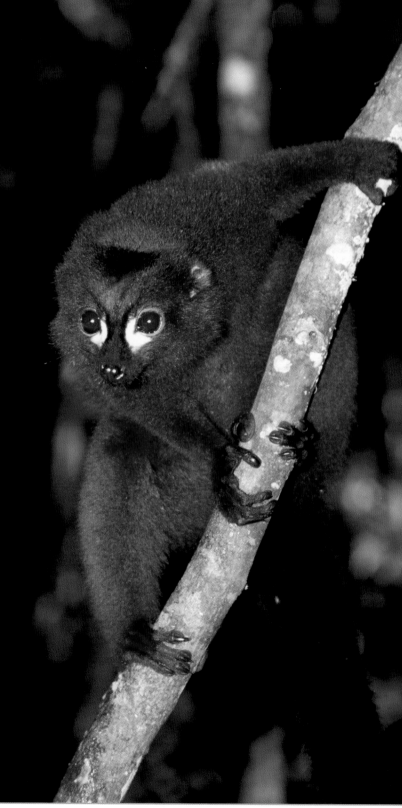

protected, the six areas of this World Heritage Site, covering a total area of about 5,000 sq. km (1,900 sq. miles), are (from north to south): Marojejy, Masoala, Zahamena, Ranomafana, Andringitra, and Andohahela National Parks. They are isolated from one another, although some of the parks are still interconnected by stretches of unprotected primary forest.

The Andringitra mountains in the national park of the same name are considered holy by the island's inhabitants (right). Among the 180 species of lizard in Madagascar are the flat-tailed gecko (*Uroplatus fimbriatus*) and the jewel chameleon. The lowland streaked tenrec is a semi-spiny hedgehog (inset image, below). The red-bellied lemur, the katta, and Verreaux's sifaka are among the species of lemur (below, left to right).

ALDABRA ATOLL

Inaccessible to the general public, these four islands form the world's largest coral atoll. Over 150,000 giant tortoises are the chief attraction of this, the westernmost island chain of the Seychelles in the Indian Ocean.

Date of inscription: 1982

The four islands of the Aldabra Atoll – Picard, Polymnia, Malabar, and Grande Terre – enclose a shallow lagoon and are surrounded in turn by a coral reef. Due to its remote location, a completely natural environment, untouched by human hand, has been allowed to develop here. The Aldabra Atoll, inscribed as a conservation area in 1976, is home to a diversity of flora and fauna astonishing for an oceanic island. It is a nesting place for numerous seabirds, but the atoll is best known for the population of Aldabra giant tortoises (*Dipsochelys dussumieri*), a species of Seychelles tortoise. These reptiles can achieve a weight of 250 kg (550 lb) and an age of 100 years. Green and hawksbill turtles are also found here.

Arab seafarers named the remote atoll of the Seychelles "al chadra," the green islands, when they discovered it many centuries ago (large image). Frigate birds, hummingbirds, herons, white-throated rails, and red-footed boobies nest on the larger islands (left). The majority of the giant tortoises live on Grande Terre, the main island of the atoll (below right). Various species of sea anemone and coral are to be found under the water (inset images).

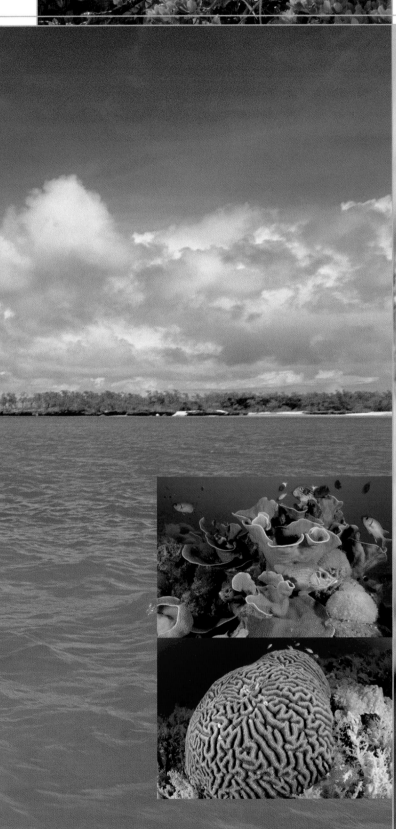

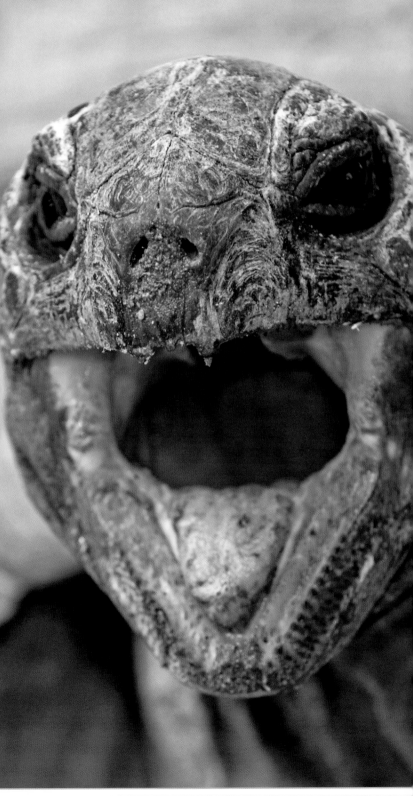

The home of the Seychelles palm is a high valley at the heart of the island of Praslin. This tree has the largest seed in the plant kingdom and lives for several hundred years.

Date of inscription: 1983

Just north of Mahé, the main island, lies Praslin, the second-largest island in the Seychelles group. In 1966 the Vallée de Mai Nature Reserve was established within the Praslin National Park at the heart of this granite island. This conservation area of only 20 hectares (49 acres) ensures the preservation of the Seychelles palm (*Lodoicea maldivica*), a living remnant of prehistoric vegetation. Due to the long evolutionary isolation of the island group, many prehistoric plant species have been retained, although for a long time all that was known of these were the seeds of a plant known as coco de mer, which could weigh up to 18 kg (40 lb) and which the Portuguese circumnavigator Ferdinand Magellan assumed to

be the fruit of a tree growing in the depths of the sea.

The Vallée de Mai is also a habitat for a wealth of animal life: various species of chameleon and gecko and many bird varieties live here, including the endemic lesser Vasa parrot, the Seychelles cave swiftlet, and the Seychelles black bulbul, as well as hummingbirds.

The prehistoric forest and idyllic waterfalls of the Vallée de Mai remained untouched until 1930, ensuring the preservation of this ancient biosphere (below). The Seychelles palm, whose seeds take six or seven years to ripen, is the symbol of this island republic. Every infloresence develops two or three fruits, each weighing 1 kg (2 lb).

The Panatal, one of the world's greatest reserves of fresh water, conceals an extraordinary abundance of animal and plant species. Among the inhabitants of this wetland is the dangerous Yacare caiman.

Glacier Bay affords a glimpse into the past of the North American subcontinent. It was completely covered with ice until a hundred years ago, but now 12 glaciers break off as icebergs into this giant bay.

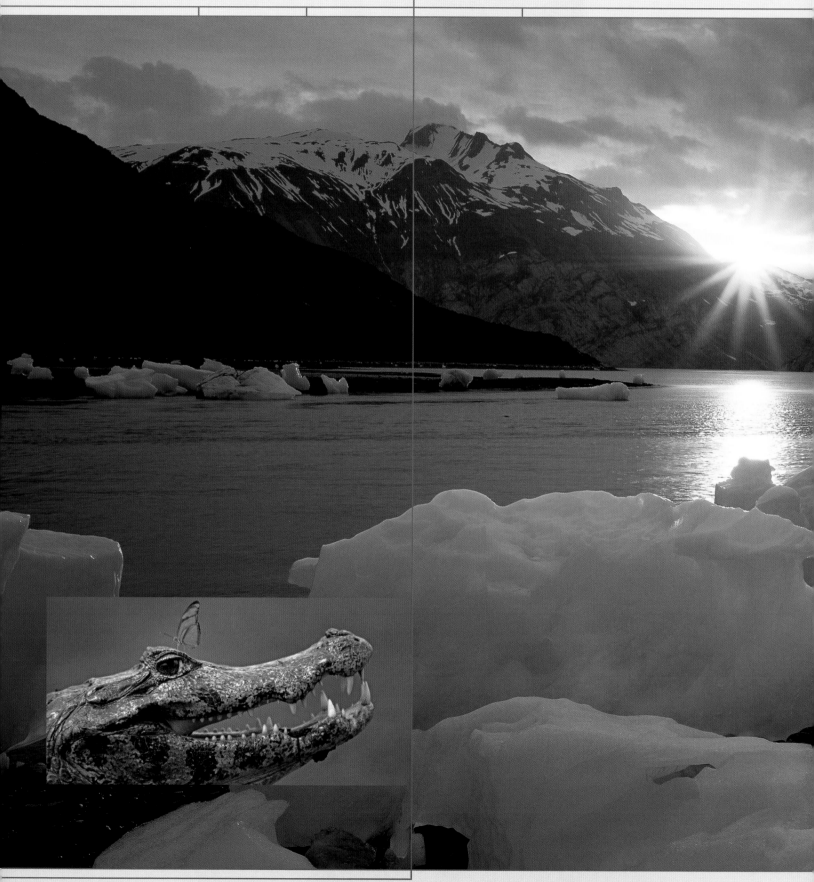

AMERICA

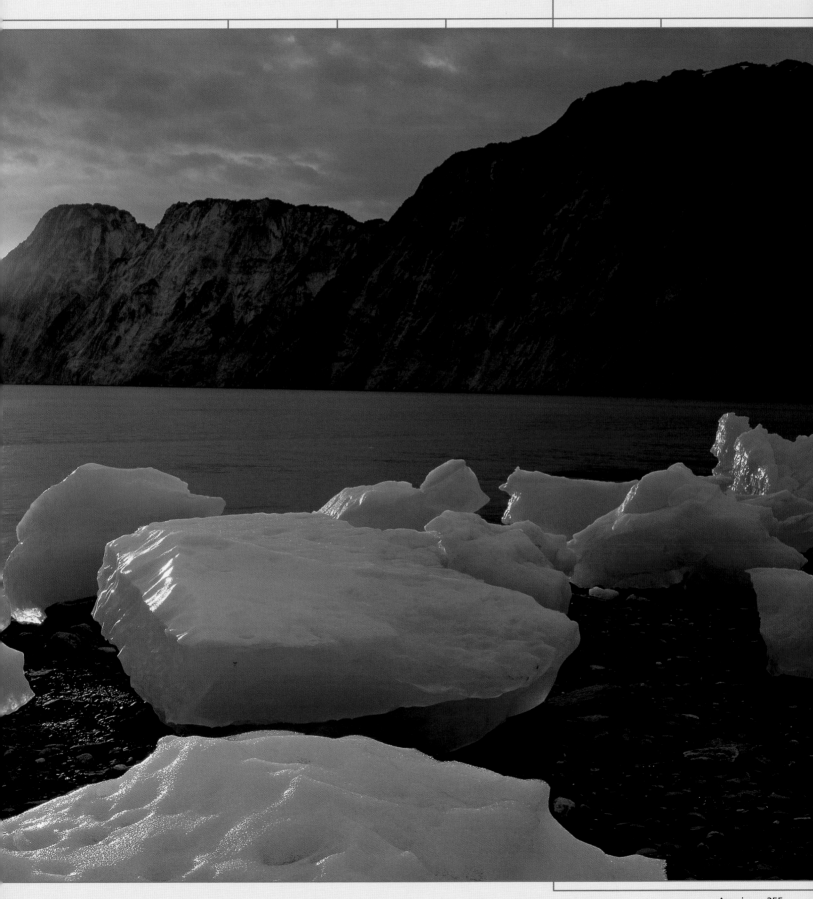

The South Nahanni river – one of the world's wildest and most beautiful – gave this barely accessible national park its name.

Date of inscription: 1978

The source of the 540-km (335-mile) long South Nahanni river is to be found 1,600 m (5,240 feet) above sea level on Mount Christie in the Mackenzie mountains of Canada's Northwest Territories. The national park area, extending along both river banks as a relatively narrow strip, 320 km (200 miles) long, begins just south of Mount Wilson. The hot mineral springs of the area, such as Rabbitkettle Hotsprings and others, ensure a mild environment and support types of vegetation unusual at such northerly latitudes. Numerous ferns, wild mint, rosebushes, parsnips, goldenrod, asters, and varieties of orchids are all to be found here.

The river meanders for 120 km (75 miles) through tundra overgrown with grasses, lichen, and dwarf shrubs, on which live caribou – gigantic North American reindeer with shovel-like antlers. In its course, the river descends through numerous rapids, representing a considerable challenge for whitewater rafters.

With a drop of 90 m (295 feet), Virginia Falls is among the most impressive of the waterfalls, and the three

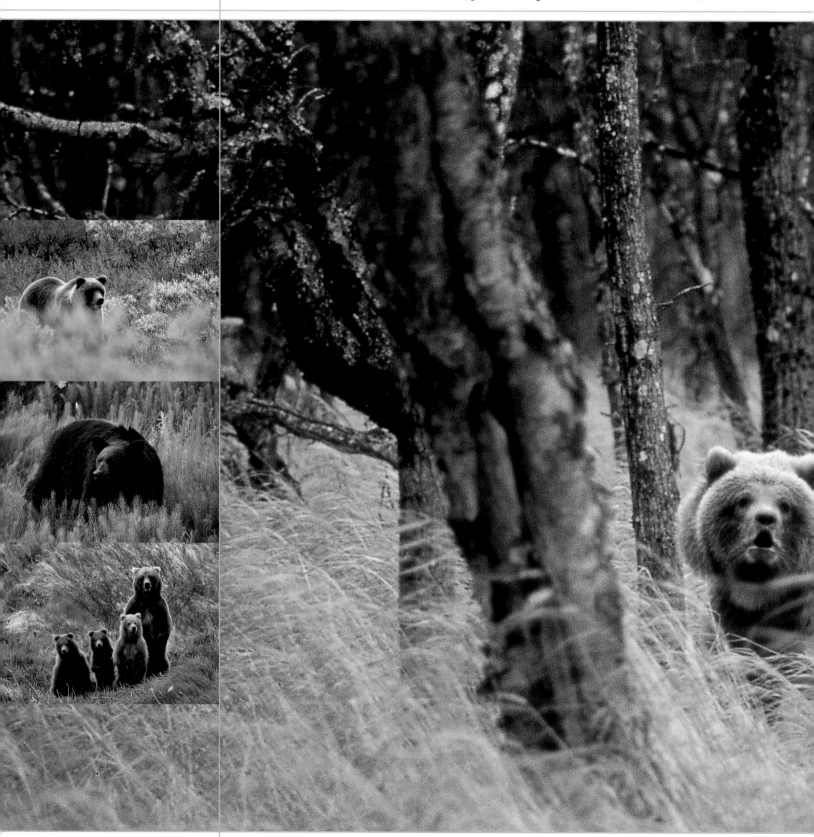

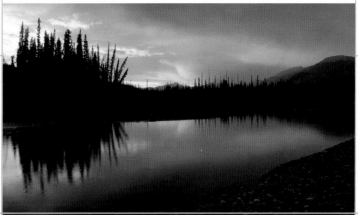

main canyons are similarly breathtaking, their sheer walls rising to a height of 1,300 m (4,250 feet). Bizarre rock formations and caves are typical for this landscape. The South Nahanni river flows past peaks reaching heights of 2,700 m (8,300 feet) before it finally disperses into many distributaries not far from the national park's southern extreme.

Over the centuries, the natural world has hardly altered in the Nahanni National Park (left: the Old Outfitters' Camp on the South Nahanni river). The park is a habitat for grizzlies, black bears, and brown bears (large image; inset images).

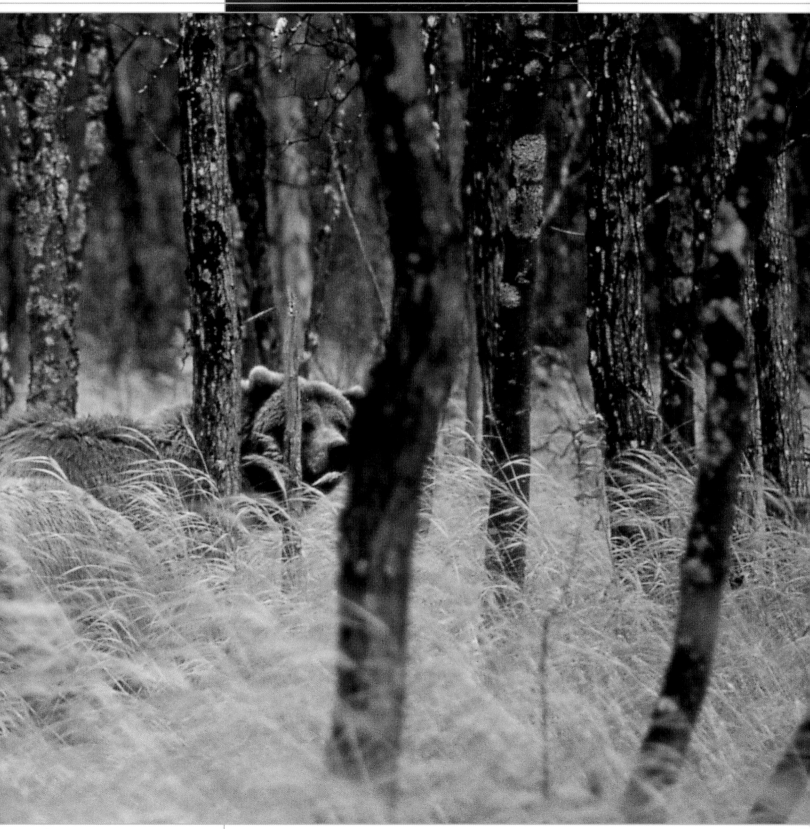

Caribou – the Native American name for the North American reindeer (*Rangifer tarandus*) – process in large herds through the park's tundra landscape. During the mating season, a male attracts a harem of females, and a hierarchy is established through heated bouts of fighting. The North American moose (*Alces alces*) is the world's largest deer (right).

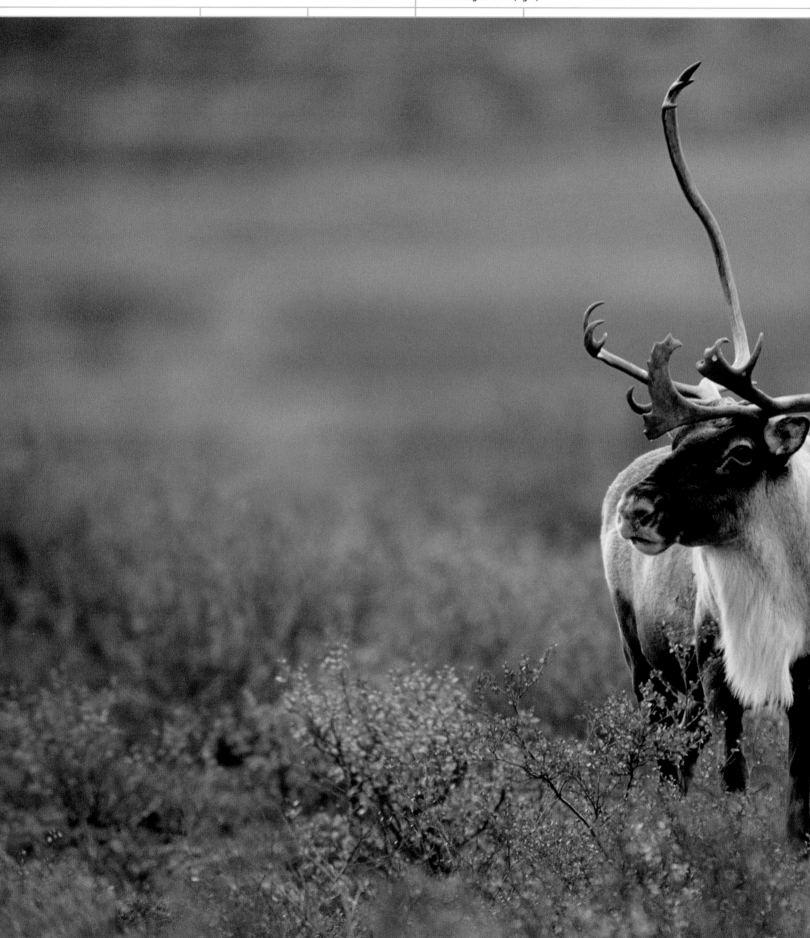

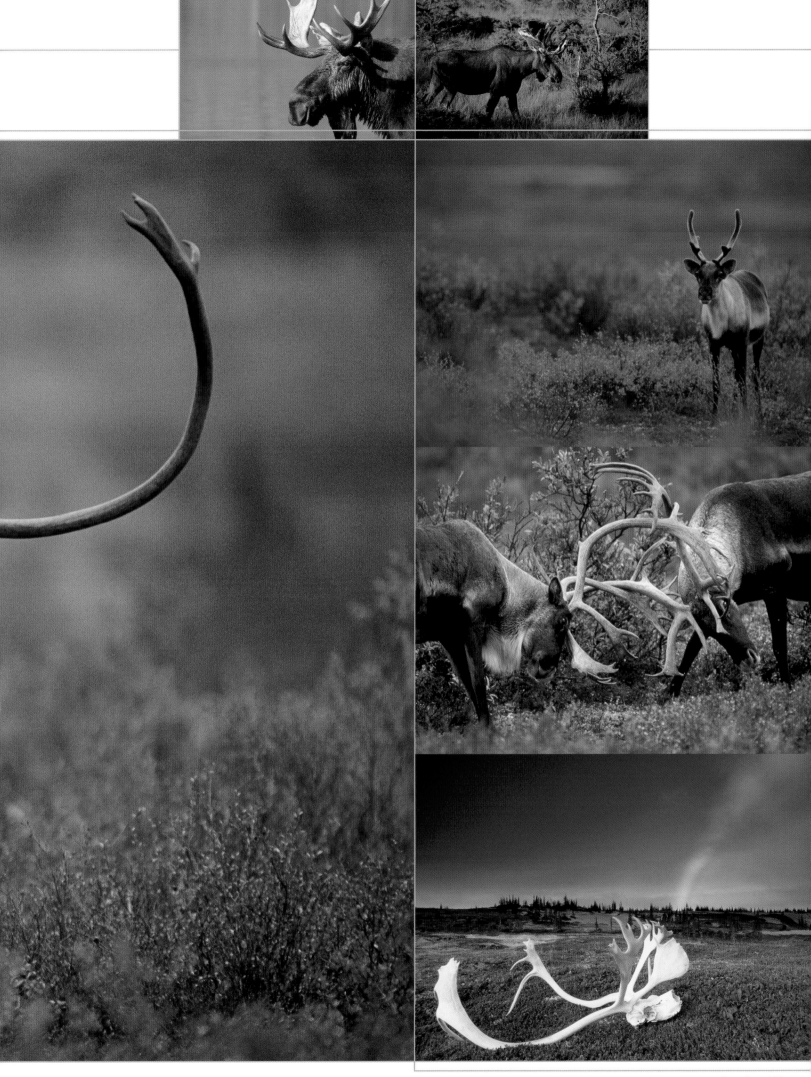

Canada's largest nature reserve was established in 1922 to protect the last herds of wood buffalo.

Date of inscription: 1983

Two-thirds of the 44,807 sq. km (17,400 sq. miles) that constitute Canada's largest national park are situated in Alberta, the remainder lying in the Northwest Territories. The park was founded in 1922, both to protect the nesting places of the endangered whooping crane and to conserve the few remaining wood bison living here. The current total bison population, including both wood bison and the equally endangered prairie bison which has in many cases joined the herds, amounts to some 6,000 specimens, the world's largest group in the wild.

The conservation area is divided into three habitats: a prairie upland cleared by forest fires; a barely drained plateau with meandering rivers, oxbow lakes, salt flats, marsh, and bog areas; and the Peace and Athabasca river delta, an enchanting world of reed meadows, marshland and shallow lakes. The park is thus a refuge for a variety of animals: moose, caribou, black bears, and gray wolves live here alongside the wood bison. In the bogland are muskrats, beavers, and American

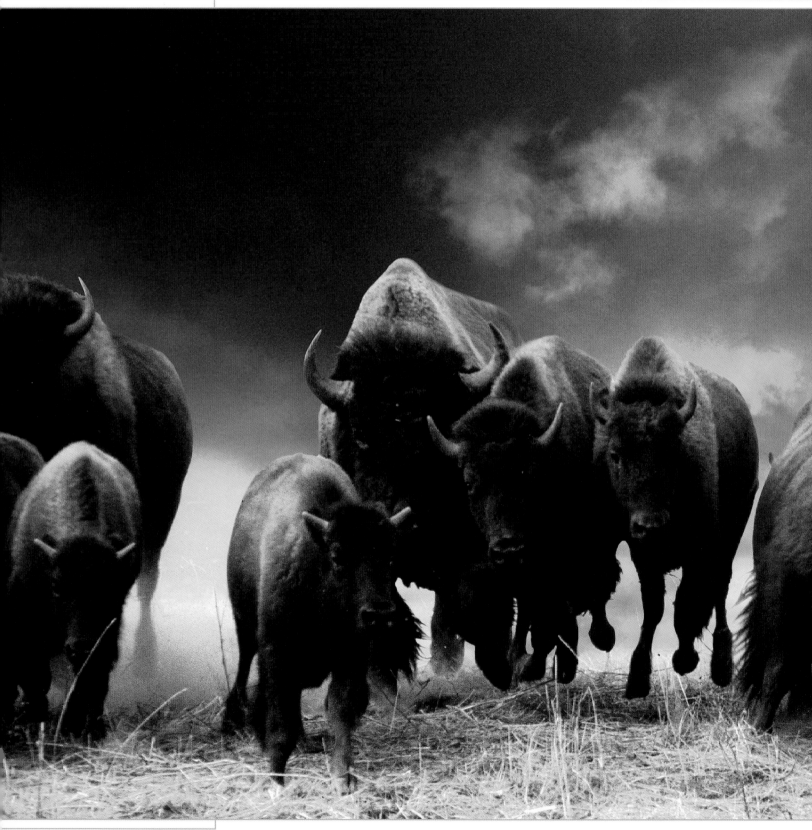

mink; in the forests, foxes, lynx, stoats, and red squirrels. The delta is an ideal habitat for 227 species of birds. Over a million wild geese, swans, and ducks inhabit the area, including the acutely endangered whooping crane. The area has been inhabited by humans since the end of the last ice age – the cultures of the indigenous Cree, Chipewyan, and

Beaver Native Americans were well-adapted to this ecosystem, and their descendants still live here today.

The mighty bison (large image), with its powerful skull, grows to a length of 3 m (10 feet) and can weigh up to 1 metric ton (2,200 lb). The Slave river also flows through the national park (left: at Fort Smith).

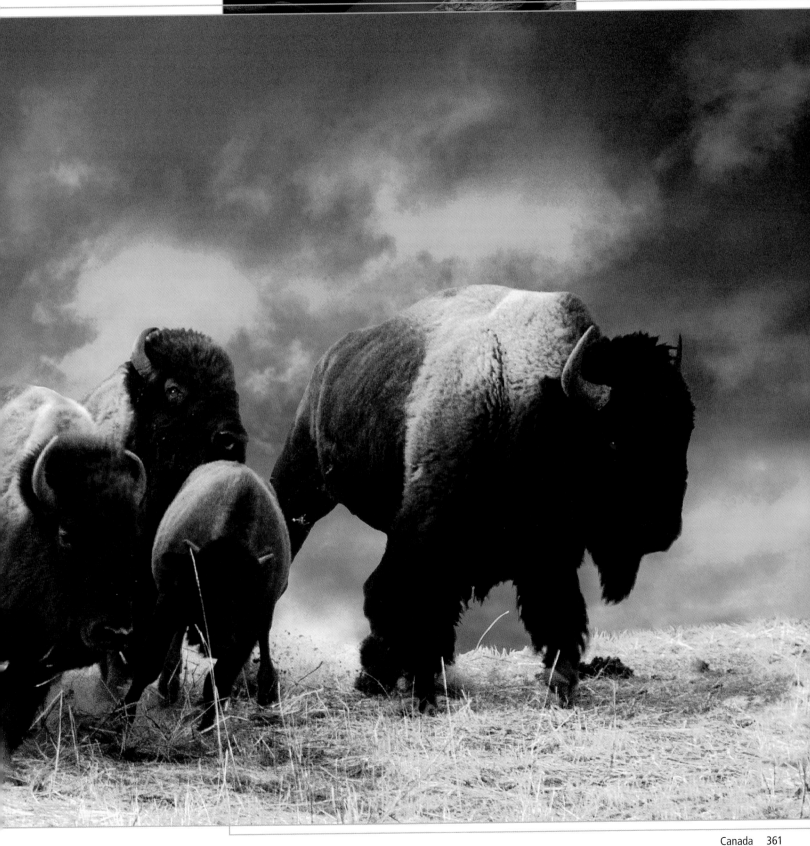

THE CANADIAN ROCKY MOUNTAINS

The four national parks of Banff, Jasper, Yoho, and Kootenay were established to conserve the unique landscape of the Canadian Rocky Mountains and to preserve its largely undisturbed biotope. This World Heritage Site has been expanded to include the provincial parks of Mount Robson, Mount Assiniboine, and Hamber.

Date of inscription: 1984; Extended: 1990

The Canadian Rockies are a 2,200-km (1,400-mile) long section of the American Cordillera, which runs down both halves of the continent from Alaska to Tierra del Fuego. The largest of the four national parks, Jasper, is also the most northerly, and boasts numerous peaks over 3,000 m (9,900 feet); Maligne Lake, which is over 20 km (13 miles) long; hot sulphur springs; and the largest continuous glacier field in the Rockies.

Banff National Park, through which the Bow river flows, adjoins the park to the south and was founded as early as 1855. Picturesque Lake Louise lies at the foot of the 3,364-m (11,040-foot) high Mount Victoria glacier, and to the west lie the Kootenay and Yoho National Parks. The falls on the Yoho

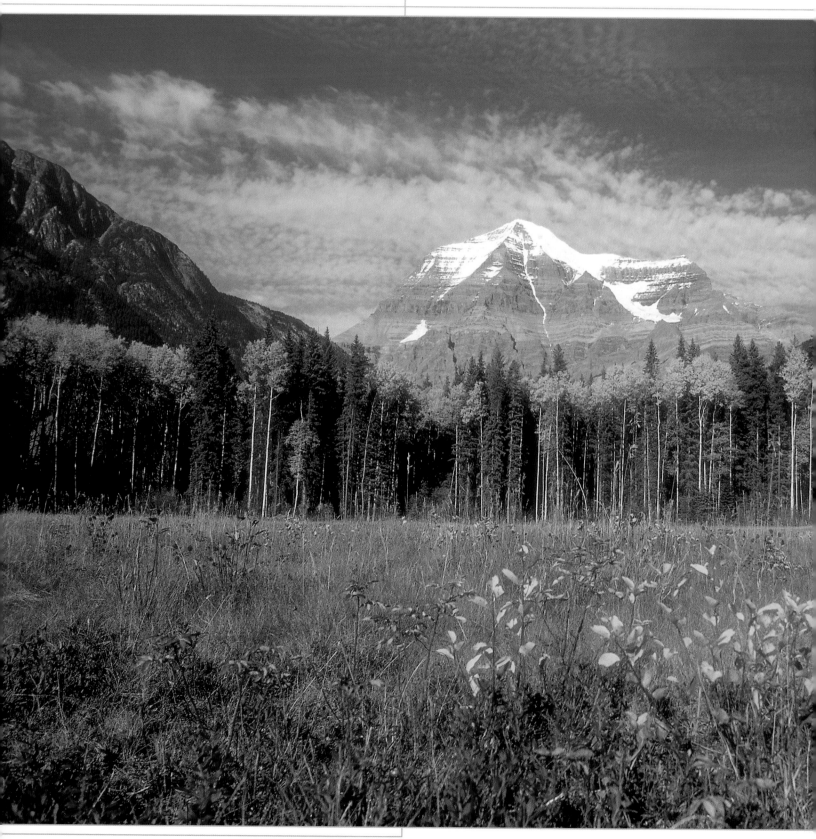

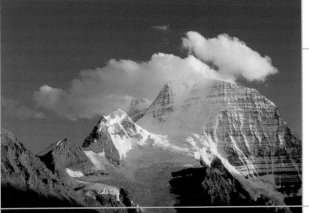

river are among the world's highest. Mount Robson and Mount Assiniboine Provincial Parks owe their names respectively to these two imposing peaks, each almost 4,000 m (13,200 feet) high. The Rocky Mountains parks, set amid glaciers, primary forest, and mountain torrents, are an undisturbed habitat for many species which have become rarer in recent times, including grizzly bears, moose, mountain goats, lynxes, wolves, beavers, and golden eagles.

Mount Robson, in its eponymous national park, is at 3,954 m (12,970 feet) the highest mountain in the Canadian Rocky Mountains. The Native Americans call it "Yuh-hai-has-hun," "the mountain of the spiral path." On the northern face of the mountain, a glacier deposits icebergs into the mountain lake (below right).

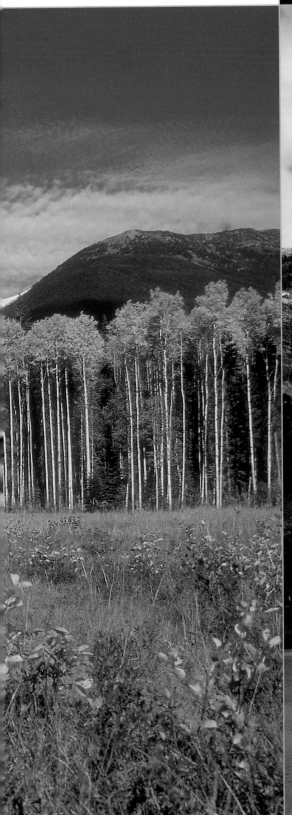

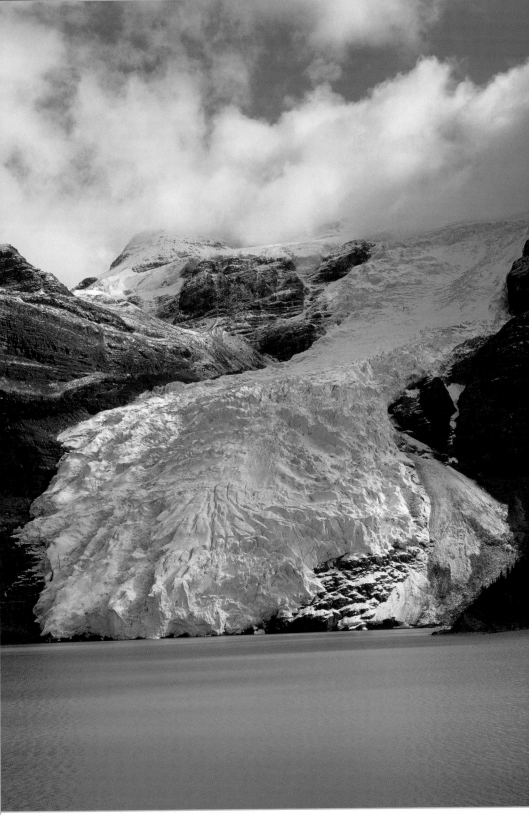

THE CANADIAN ROCKY MOUNTAINS JASPER NATIONAL PARK

Water is life: in Jasper National Park, steep cascades rush through ravines like the Maligne Canyon (far left). More than 800 lakes (below right: Lake Lorraine) are fed from the surrounding glaciers. The Sunwapta river (above left) flows close to the Winston Churchill mountains. The imposing massif of The Ramparts is also part of the World Heritage Site (below left, above right).

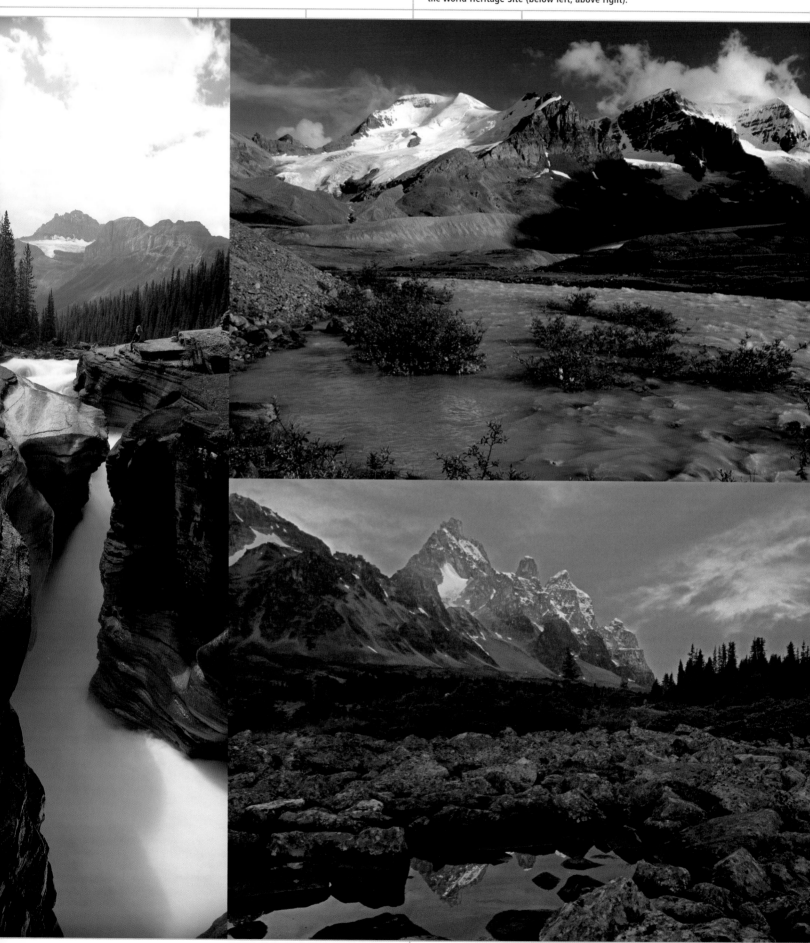

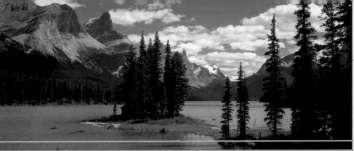

At 22 km (14 miles) in length, Maligne Lake is the largest natural lake in Jasper National Park. The ascent to the south summit passes Spirit Island (left).

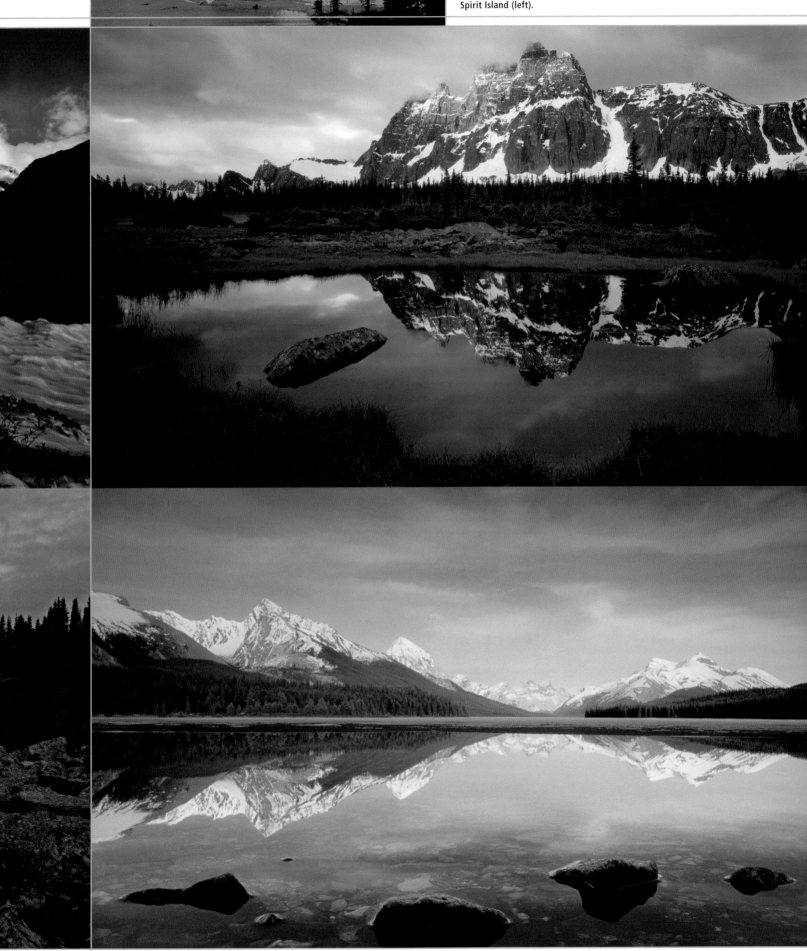

THE CANADIAN ROCKY MOUNTAINS
YOHO NATIONAL PARK

In the language of the Cree Native Americans, "yoho" means "reverence," and confronted with the magnificent scenery of this national park on the north side of the Rocky mountains, what is meant by this is easily understood. Mount Cathedral is reflected in Lake O'Hara (large image). Other scenic highlights include Kicking Horse river and the 254-m (830-foot) high Takakkaw Falls (below left).

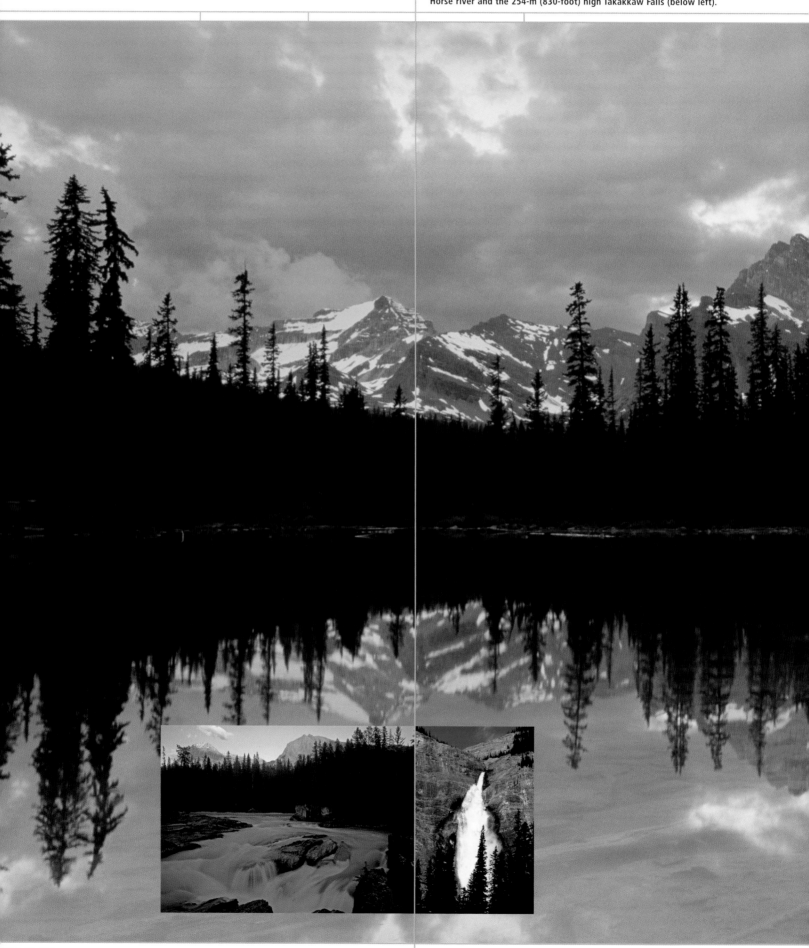

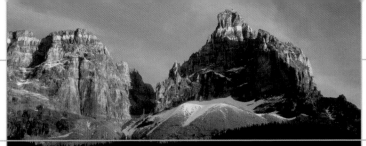

The high crown of Kicking Horse Pass, at 1,625 m (5,330 feet), embodies the so-called "Great Divide," the continental watershed between the Pacific and the Atlantic Oceans. It also marks the boundary between the Canadian provinces of British Columbia and Alberta.

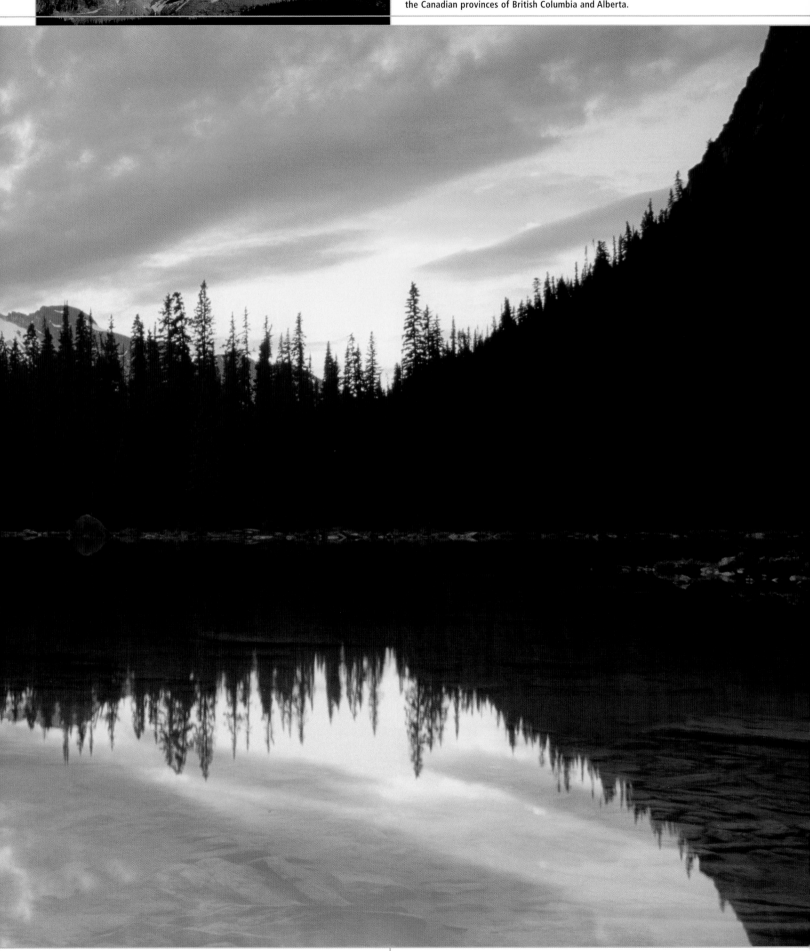

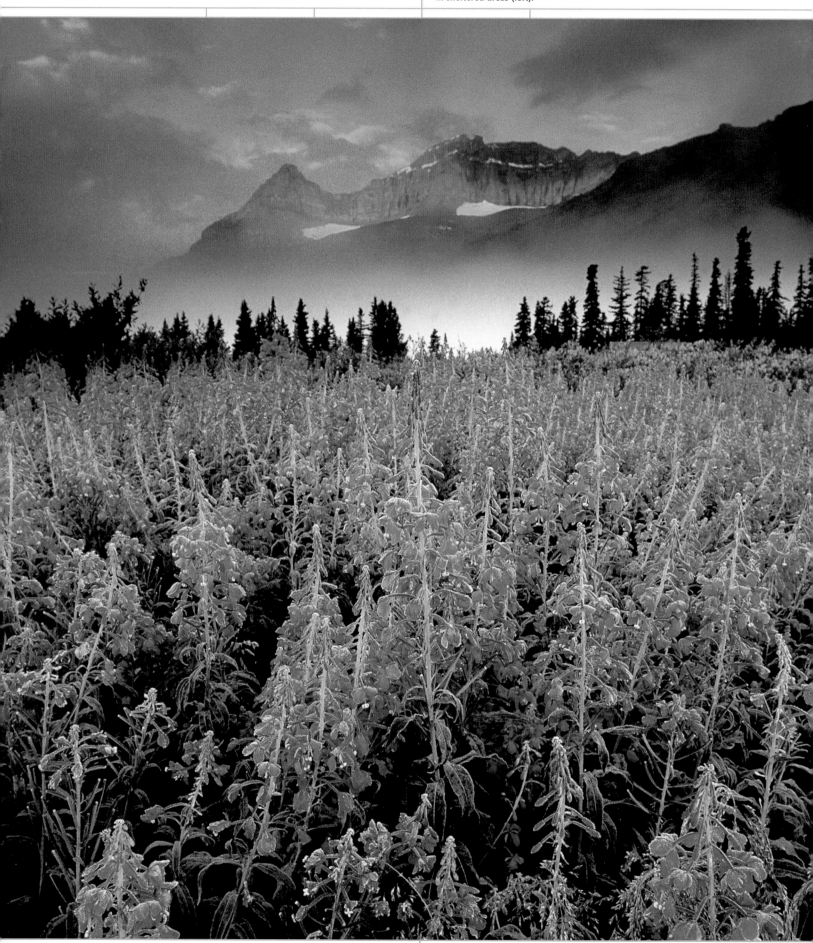

THE CANADIAN ROCKY MOUNTAINS BANFF NATIONAL PARK

Banff National Park lies on the western boundary of Alberta. Undisturbed nature is to be found in its hinterland especially, with snow-capped mountains, mighty glaciers, hidden valleys, and crystal-clear rivers (images right, from top: Lake Vermillon, Icefields Parkway, Mount Tuzo). In summer, thick vegetation springs up in sheltered areas (left).

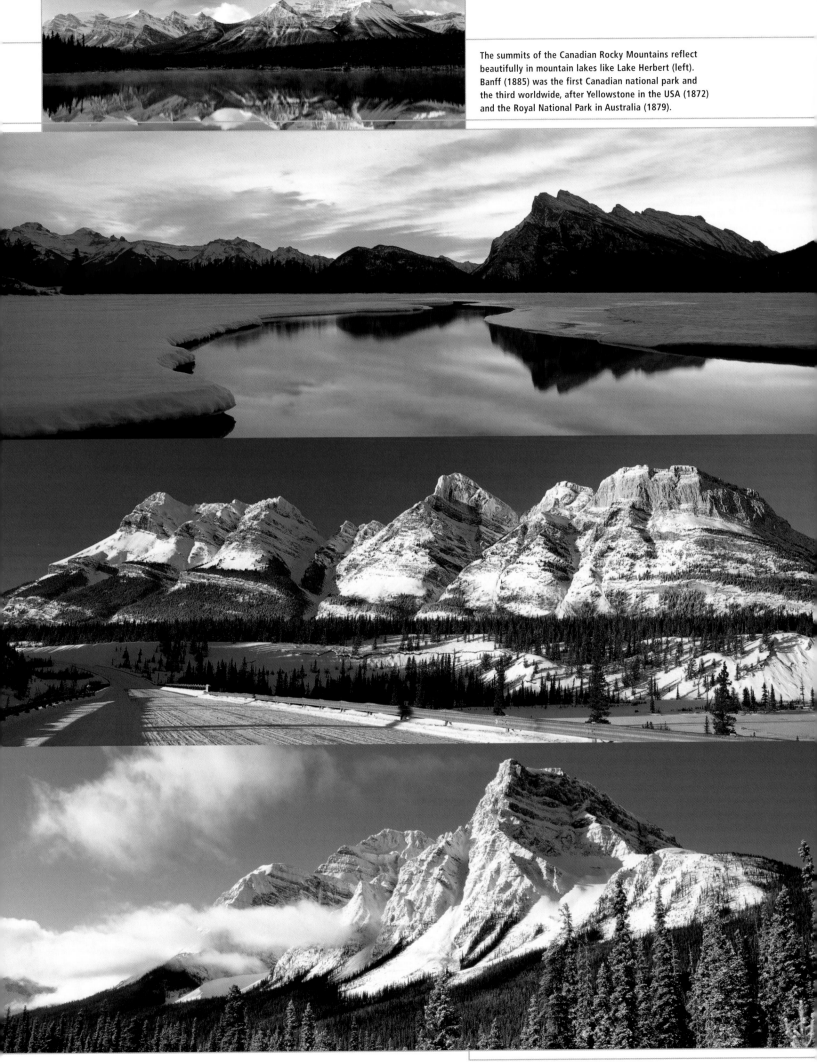

The summits of the Canadian Rocky Mountains reflect beautifully in mountain lakes like Lake Herbert (left). Banff (1885) was the first Canadian national park and the third worldwide, after Yellowstone in the USA (1872) and the Royal National Park in Australia (1879).

Kootenay National Park, lying in the south-western Canadian Rocky Mountains, includes not only an impressive mountain environment but also several lakes and rivers (above and below left). These are oligotrophic bodies of water and thus endangered ecosystems; "oligotrophic" means that the water is particularly clear, low in nutrients but high in oxygen content, which is of great benefit to the variety of species on its banks.

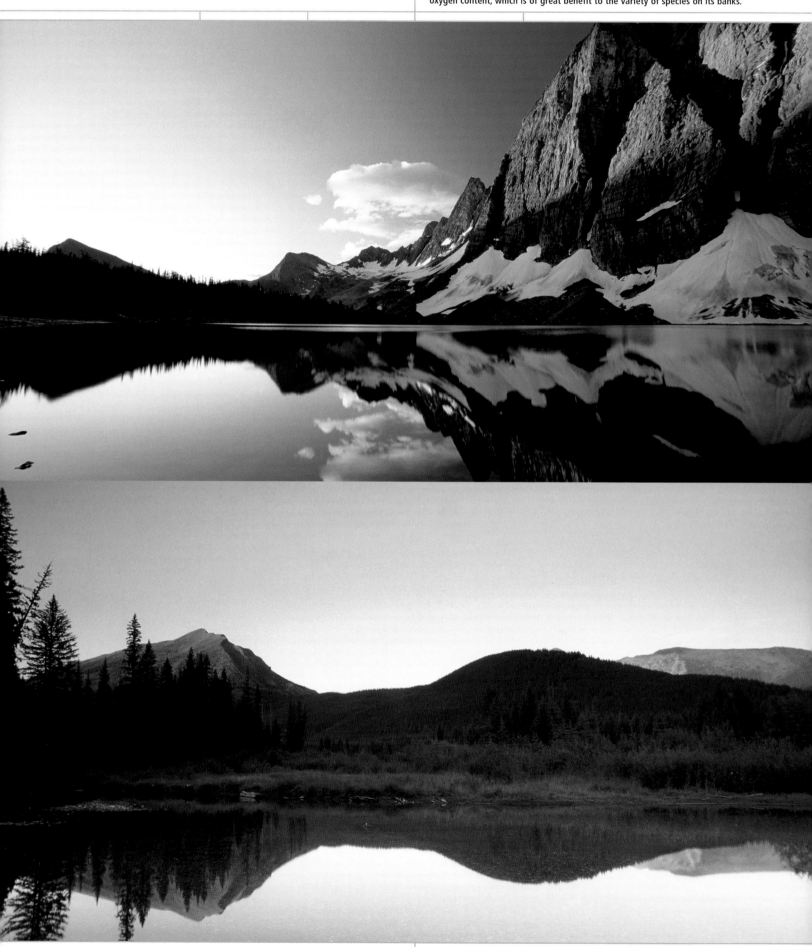

The valleys of the Kootenay and Vermillon rivers (above middle and right: Marble Canyon and a black bear) lie at the heart of this national park, whose Native American name ("Kootenay" means "place of hot waters") is indicative of the hot springs it contains.

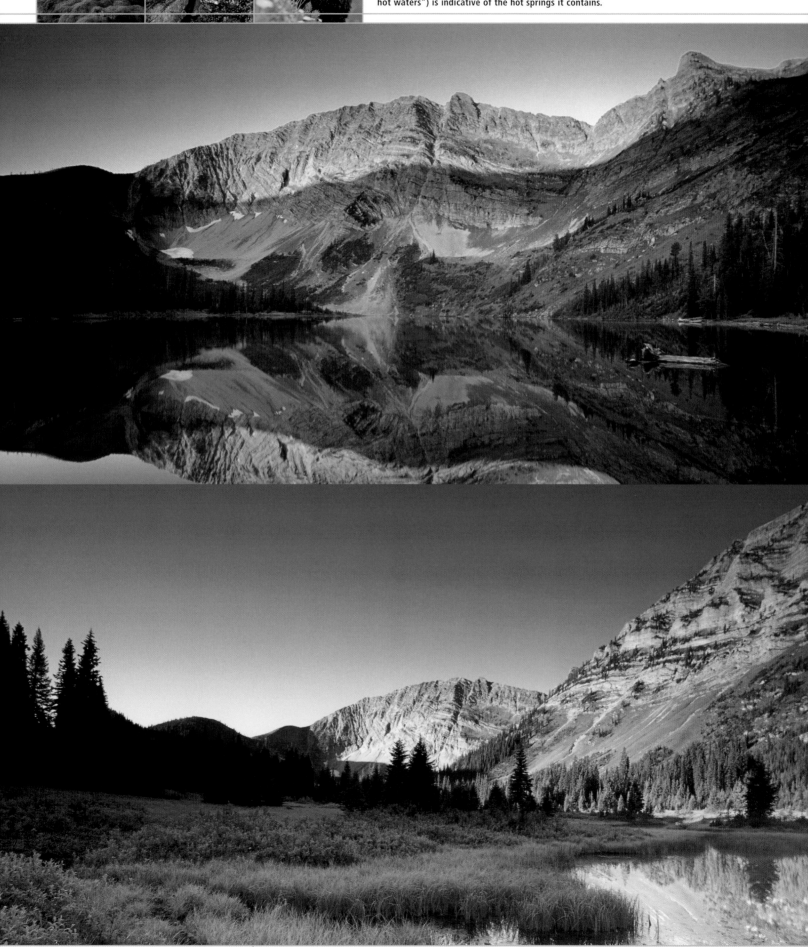

THE CANADIAN
ROCKY MOUNTAINS
MOUNT ASSINIBOINE
PROVINCIAL PARK

Native American tribes had long been settled in the Canadian Rocky Mountains when European explorers like Alexander Mackenzie first began their travels there. One tribe, the Assiniboine, hunted in the area around a massive rock peak and lent their name both to the mountain and to the modern provincial park surrounding it, whose wilderness (below) remains uncrossed by any roads to this day.

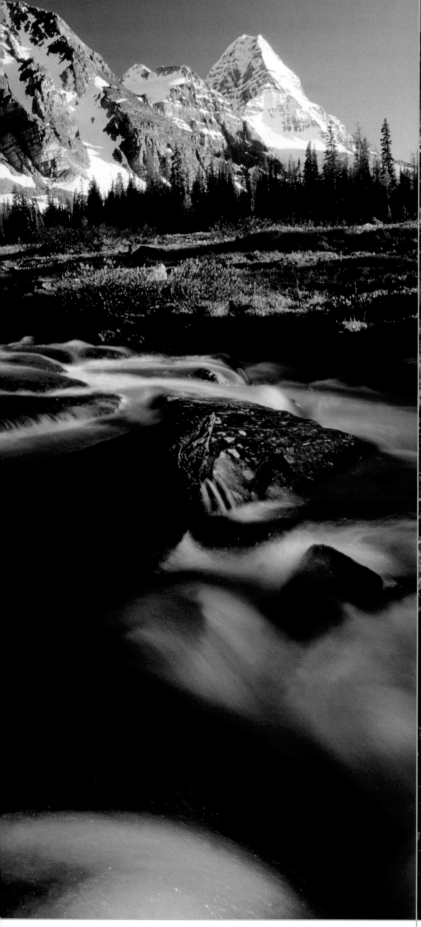

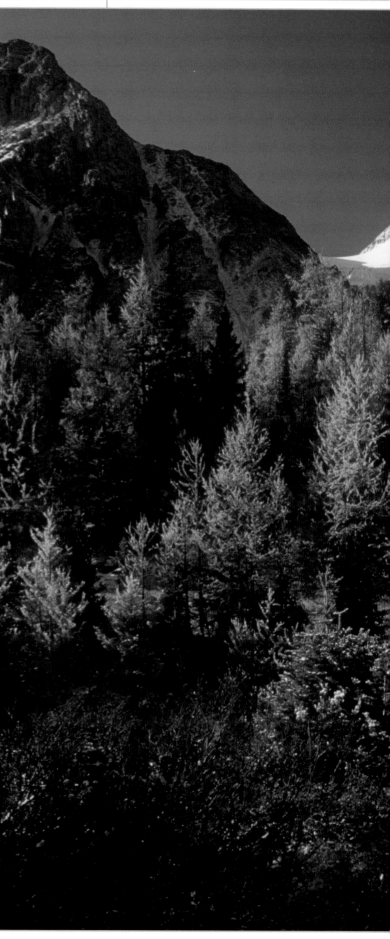

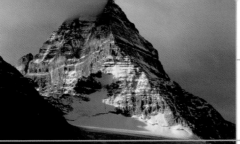

The remote rock pyramid of Mount Assiniboine (left) is the main attraction in the provincial park of the same name, often being described as the "Canadian Matterhorn."

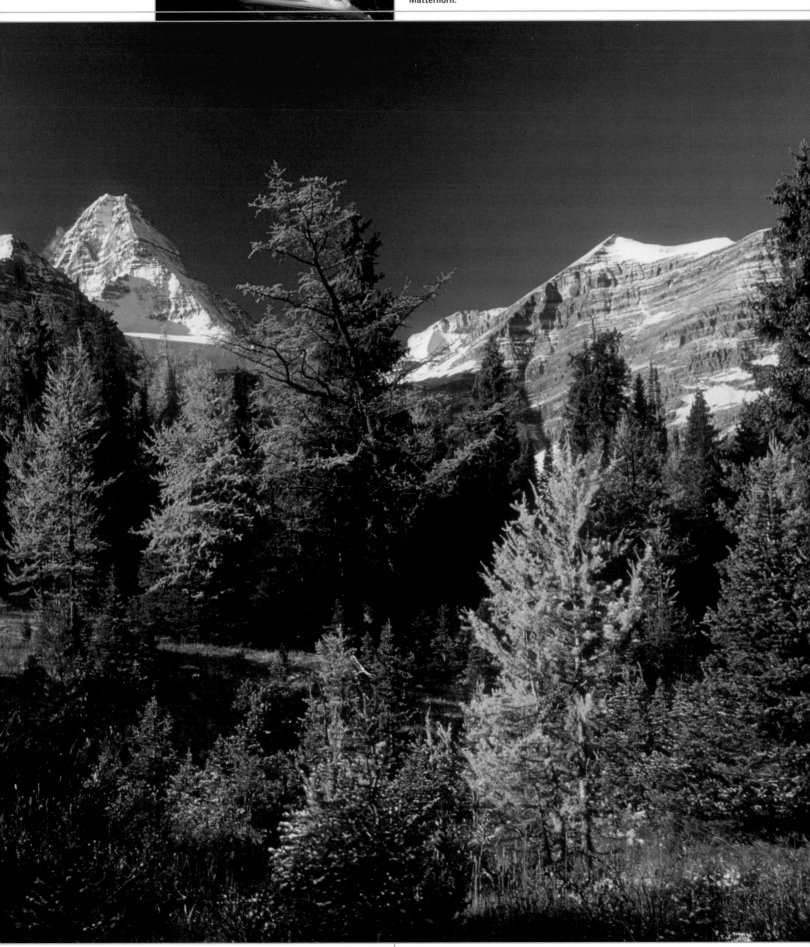

Giant dinosaurs lived 65 million years ago in the Dinosaur Provincial Park, a bizarre landscape situated on the Red Deer river in modern-day Alberta.

Date of inscription: 1979

During the Cretaceous period, approximately 65 million years ago, a variety of dinosaur species inhabited the North American continent. Some particularly well-developed Triceratops specimens could reach a height of around 15 m (50 feet), although these died out, along with the other dinosaur species, at the end of the Mesozoic period.

In no other region on earth have greater deposits of these giant lizards' remains been found. The numerous fossils, including those of turtles, fish, mammals, and amphibians, afford scientists a fascinating insight into the animal world of 200 million years ago, and these exciting finds can be viewed in a museum. This area has scenic charms as well: the Badlands are a

barren zone of erosion in which the power of wind and weather has transformed the rocks into a landscape that looks almost alien. However, the river banks are thickly vegetated, in spite of the desert-like climate, and this provides an optimal habitat, not just for a few species of red deer but also for a variety of birds including curlews, Canada geese, and nighthawks.

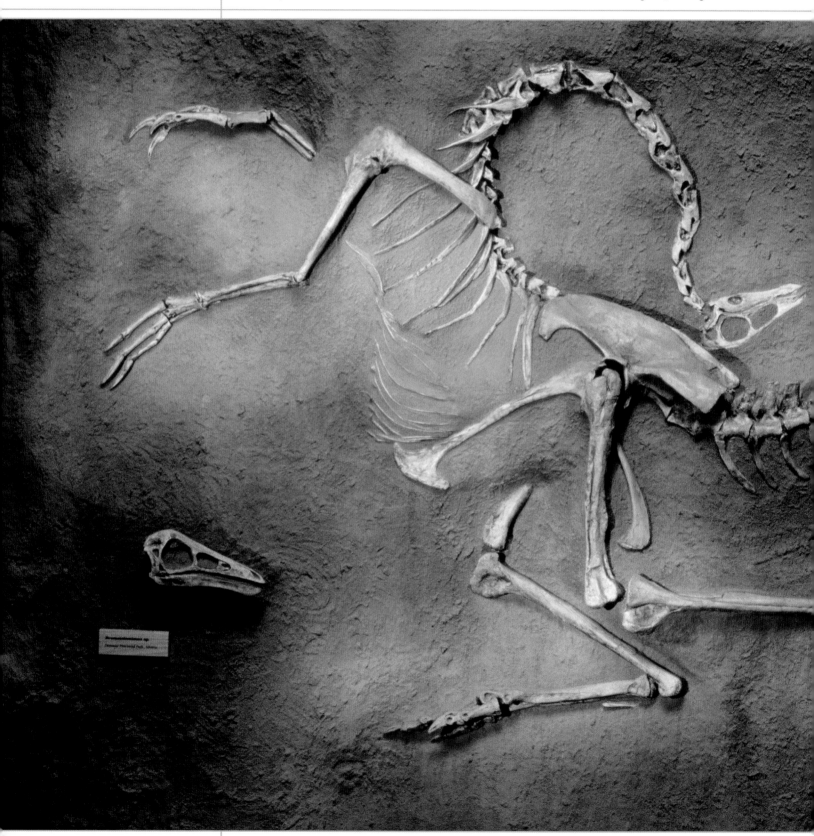

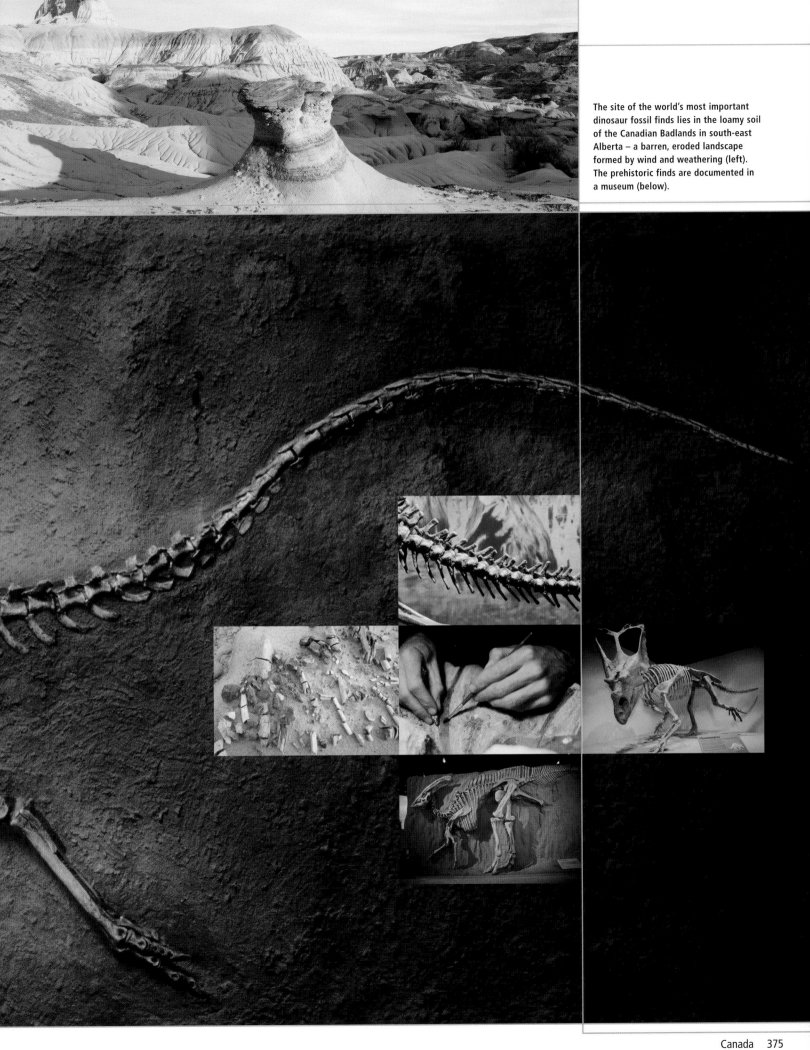

The site of the world's most important dinosaur fossil finds lies in the loamy soil of the Canadian Badlands in south-east Alberta – a barren, eroded landscape formed by wind and weathering (left). The prehistoric finds are documented in a museum (below).

The ice of the Sermeq Kujalleq glacier is transported from the Greenland interior and reaches the sea at the Ilulissat ice fjord. The glacier "calves" there and releases large numbers of icebergs into the North Atlantic.

Date of inscription: 2004

The Sermeq Kujalleq glacier flows from the Greenland ice cap, in places reaching up to 3,000 m (9,900 feet) thick, into the North Atlantic Ocean. With a daily flow rate of between 19 and 22 m (63–72 feet), the Sermeq Kujalleq is one of the fastest and most active glaciers in the world. As it reaches the sea, giant blocks of ice break off with a dramatic and deafening sound and crash into the water. These icebergs then slowly float south, where they become a danger to shipping.

The Sermeq Kujalleq "calves" 35 sq. km (14 sq. miles) of ice every year and is thus responsible for 10 percent of Greenland's total iceberg production, far more than any other glacier outside the Antarctic.

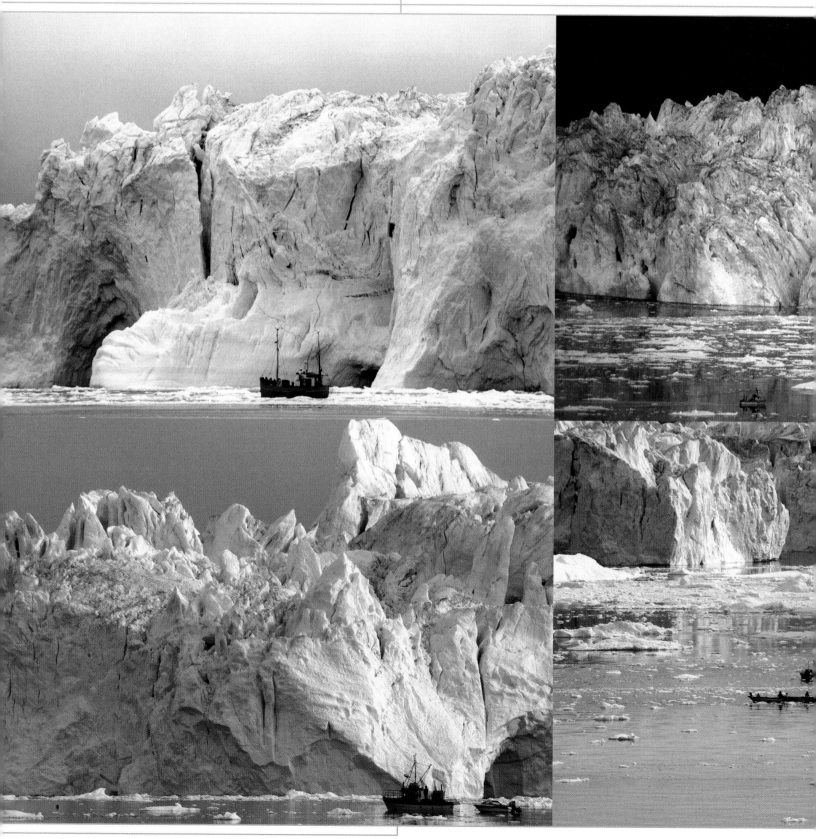

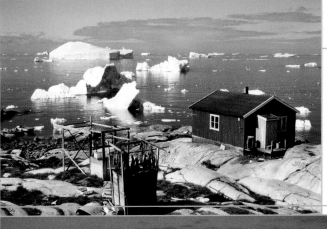

The Ilulissat and its glacier have been the subject of scientific investigation for more than 250 years and have yielded copious data regarding local geomorphology, glaciology, and general climate change. The calving glacier and the tall icebergs in the fjord are a fascinating sight. Because of the icebergs, the trip to the glacier is not without its dangers. Many of these ice giants melt only just north of New York.

Off the Greenland coast, the icebergs can reach a height of 100 m (330 feet) above the water. The cold sea is teeming with life and is a fishing ground for many Danish trawlers (below). Greenland ice was studied long before concerns about climate change (left).

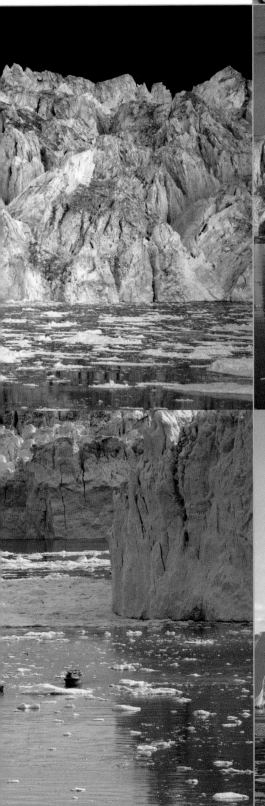

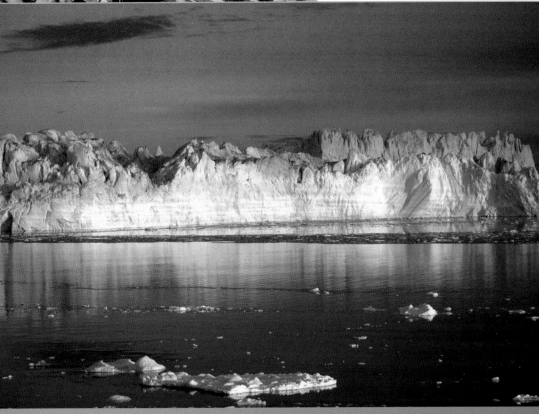

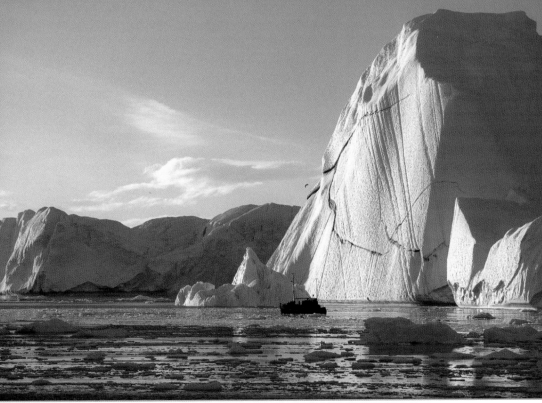

Over 4,500 years ago, the Dorset Eskimos settled in the varied landscape on the west coast of Newfoundland that was to become the site of the Gros Morne National Park – long before the Vikings became the first Europeans to land here.

Date of inscription: 1987

The national park takes its name from the 806-m (2,650-foot) high Gros Morne; adjoining this great hill there is also a 600-m (1,970-foot) high limestone plateau, setting the tone for the area with winding streams, paternoster lakes, and moraines. The subarctic climate has given rise to tundra vegetation which is found this far south nowhere else in the world.

Caribou, grouse, Arctic hares, Arctic foxes, and lynxes are all to be found here. The Long Range mountains, whose rock formations have yielded valuable geological discoveries, are of particular interest to scientists.

Gros Morne National Park's picturesque fjords were created in the last ice age. Western Brook Pond, an enclosed fjord lake with walls 600 m

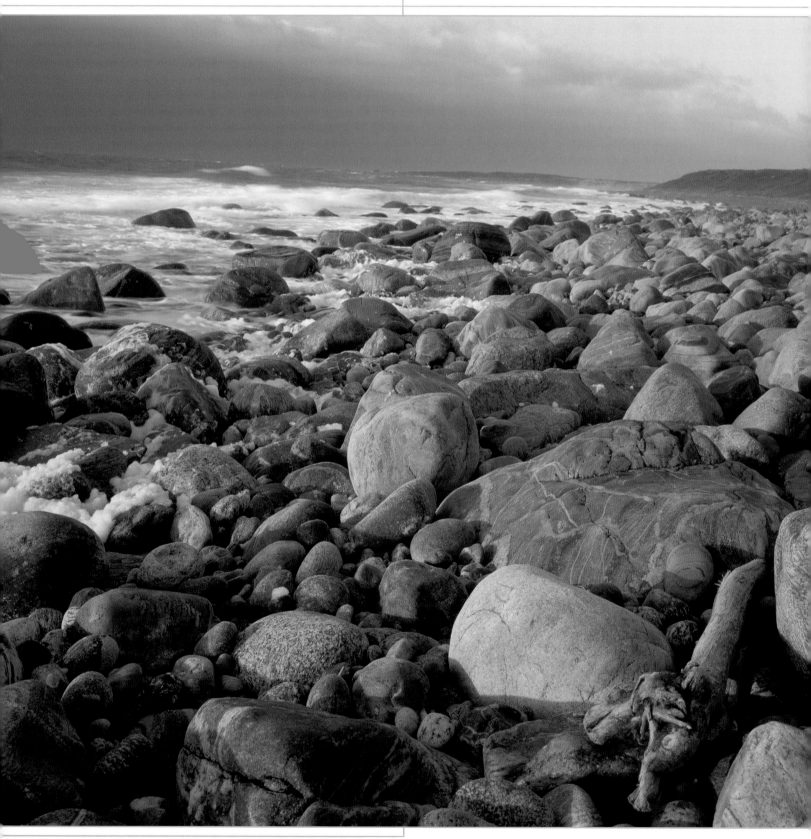

(1,970 feet) high, is an incredible natural spectacle. The coastal region is characterized by steep cliffs, moving dunes, and a great variety of wild birds, who derive as much benefit from the fish-rich waters as the seals. Archeological finds have shown that there were settlements on the site of the modern park as early as 2500 BC. The Dorset Eskimos were succeeded by the Beothuk Native Americans around AD 800, and these were given the name of "redskins " by Europeans because of their red-ochre body paint, with which they also painted their houses and possessions. There is much to suggest that this culture had contact with the Vikings, including some suspicion that so-called "blond Indians" were the result of intermarriage.

Gros Morne National Park is characterized by fjords cutting deep into the high plateau, stony coastlines, and beaches (below left and right). At Lobster Cove Head, a lone lighthouse warns shipping not to come too close to the Newfoundland coast (left).

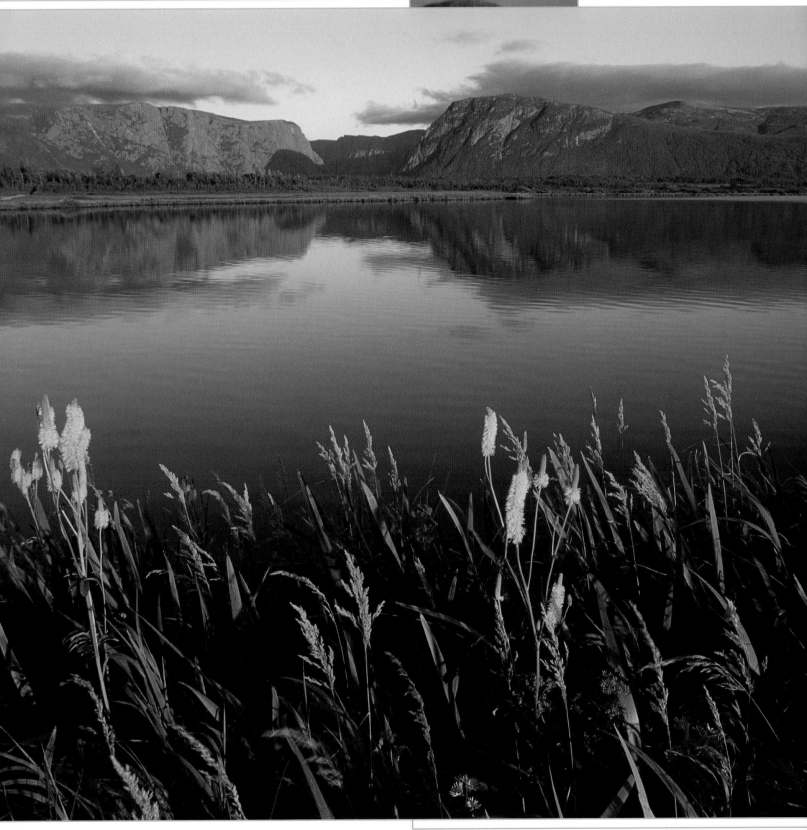

The North American moose (large image) lives on water lilies and other water plants in the park. A male can be as tall as 2.3 m (8 feet) at the shoulder and weigh up to 500 kg (1,100 lb). The multi-pointed antlers, which can reach a span of up to 1.6 m (5 feet), are shed in the winter. Gros Morne National Park is also home to Arctic hares (*Lepidus timidus*, below left).

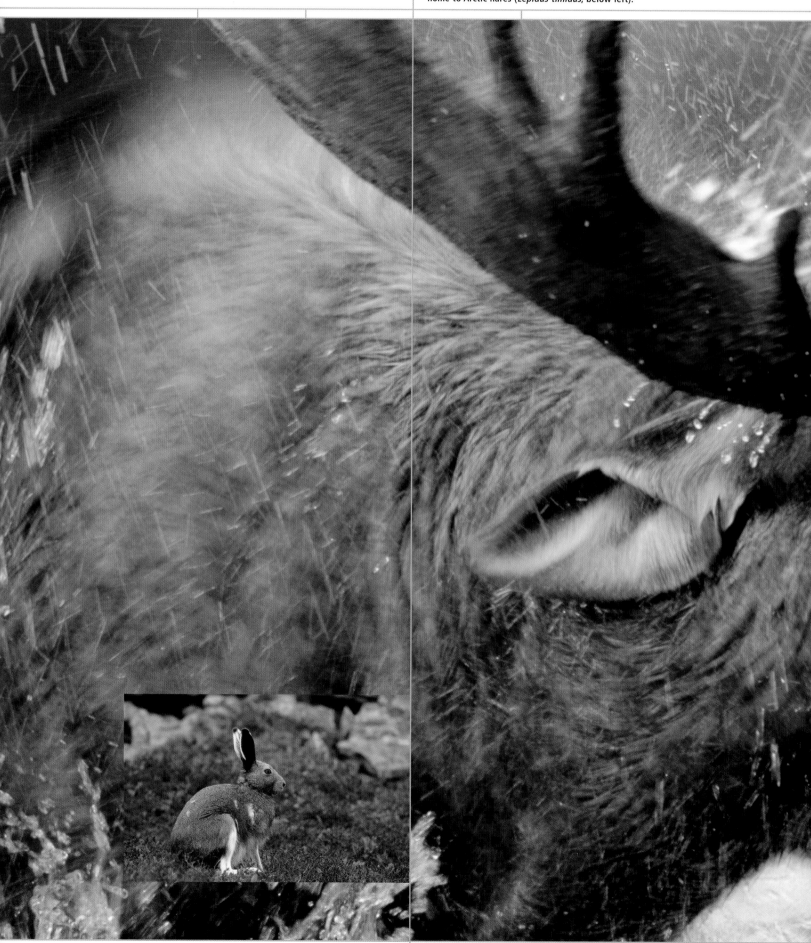

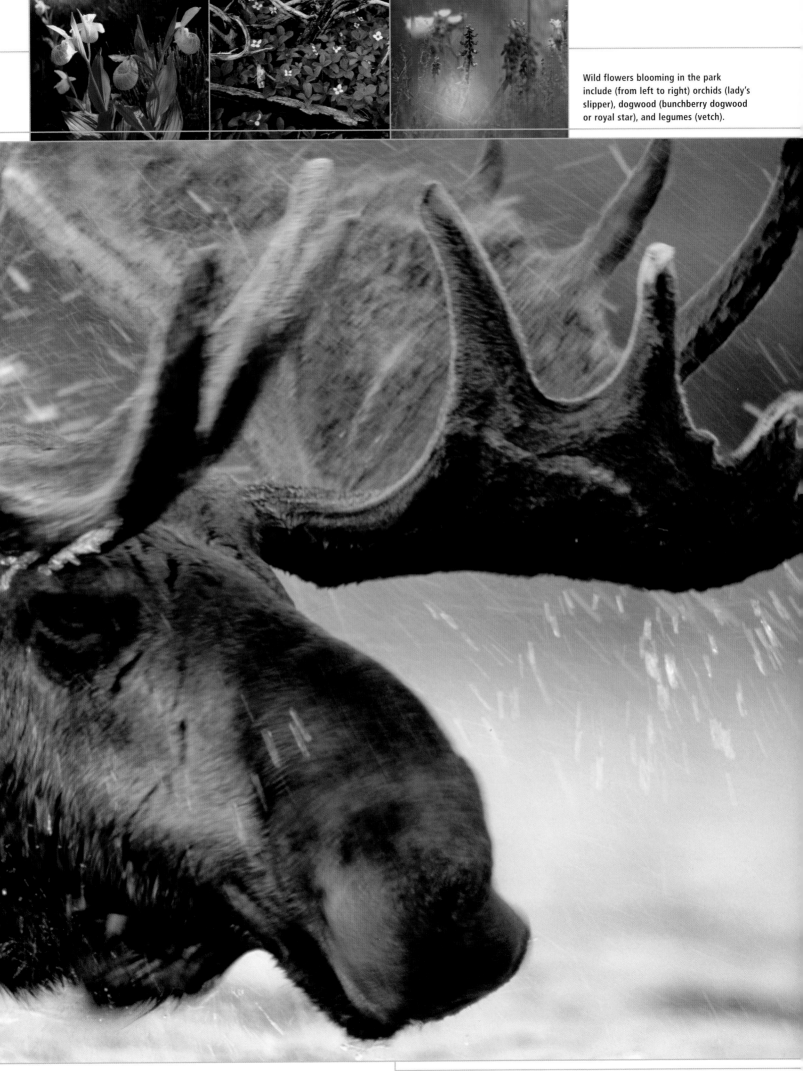

Wild flowers blooming in the park include (from left to right) orchids (lady's slipper), dogwood (bunchberry dogwood or royal star), and legumes (vetch).

MIGUASHA NATIONAL PARK

Miguasha National Park is the site of the most significant Devonian fossil finds in the world. Its most important fossils are the lobe-finned fish, precursors of the first four-legged vertebrates.

Date of inscription: 1999

Great advances in the study of the Devonian geological period are largely due to discoveries made at this World Heritage Site, located on the south coast of the Gaspésie peninsula in the south-east of Canada's Québec province. The area was first studied in 1842 by German-Canadian doctor, physicist, and geologist Abraham Gesner (1797–1864), and is named for the color of its rock formations; in the language of the indigenous Native American Mic-Mac tribe, "miguasha" means "reddish." Scientific documentation of the objects found here began in the 1880s. In the ensuing years, great collections were shipped to museums in England and Scotland, exciting much overseas interest; many museums and research centers were recipients of further collections. In 1985, Miguasha, including the steep cliffs of the 350- to 375-million-year-old Escuminac rock formation, became a conservation park, and since then some 5,000 fossils have been identified, conserved, and recorded on computer: vertebrates, invertebrates, plants, and spores from the Devonian. One of the best-known finds is the "Prince of Miguasha," a fossilized Eusthenopteron – an extinct lobe-finned fish species that lived during the Upper Devonian, about 370 million years ago, and marks the turning point between fish and land-dwelling vertebrates. This species possessed gills, rudimentary lungs and a strong endoskeleton that probably allowed it to leave the water for short periods. Forerunners to the humerus, ulna, and radius of later land vertebrates are distinguishable fore-fins.

Fossilized remains of six of the eight fish species that lived during the Upper Devonian have been found here (large image; image above).

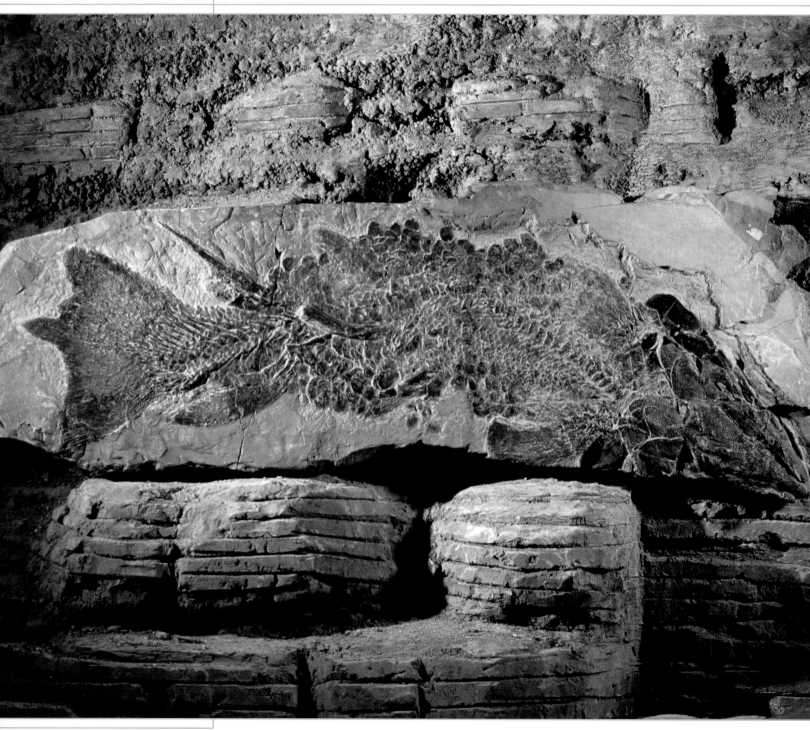

Joggins Fossil Cliffs in the Canadian province of Nova Scotia are famous for their wealth of prehistoric material. The cliffs and their roughly 300 million-year-old fossils are considered the most significant source of finds from the Carboniferous period.

Date of inscription: 2008

Known as "the Galapagos of the Carboniferous" or "the coal age Galapagos" to scientists, the cliffs have been an important source of fossil finds since the middle of the 19th century. The Canadian geologist, Sir William Dawson, discovered the first fossilized specimens of Hylonomus here in 1851. This extinct reptile species, reaching some 20 cm (8 inches) in length, was one of the first creatures to adapt fully to life on land. The British naturalist, Charles Darwin, founder of modern theory of evolution, also used finds from Joggins in the development of his revolutionary scientific principles. The area of particular paleontological interest covers about seven square kilometers (two and a half square miles) along the coast of the Bay of Fundy in Nova Scotia, where there are fossilized tree stumps from a rainforest, reptile fossils, and specimens of the earliest amniotes (egg-laying vertebrates) from the Carboniferous period, 354 to 290 million years ago. No site has yet been found anywhere in the world that yields evidence of life on land between 303 and 318 million years ago. The 15 km (9 miles) of cliffs, rocky platforms, and beaches have retained fossilized traces of three ecosystems: an estuary, a flood plain covered in rainforest, and a marshy plain with fresh water pools, which appears to have been prone to forest fires. In total, 96 genera and 148 species of fossil have been discovered.

It is thanks to the erosion caused by one of the highest tidal ranges in the world – up to 15 m (50 feet) – that the fossilized tree stumps and reptiles (large image) were discovered on the Joggins Fossil Cliffs.

WATERTON GLACIER INTERNATIONAL PEACE PARK

The United States' Glacier National Park and the Canadian Waterton Lakes National Park were united as the first "International Peace Park" in 1932.

Date of inscription: 1995

Waterton Glacier International Peace Park is a joint undertaking of the Rotary Clubs of Alberta (Canada) and Montana (USA). It was established on 30 June 1932 as a "sign of peace and goodwill between Canada, the USA, and a confederation of Blackfoot Indians." The peace park is situated on the Alberta–Montana border and comprises remote mountain valleys, windswept peaks, and fairy-tale scenery, with some 650 lakes and a wealth of flora and fauna. More than 1,200 varieties of plants and 60 mammal, 240 bird, and 20 fish species inhabit the alpine meadows, prairies, and taiga forest here.

More than 200 archeological excavation sites have yielded information about the living conditions of the park's primeval inhabitants, who were already present as far back as 8,000 years ago – long before the first European fur trappers turned up in the area at the beginning of the 18th century.

During the 19th century, prospectors, adventurers, and settlers forced the Native Americans out onto new territory on reservations.

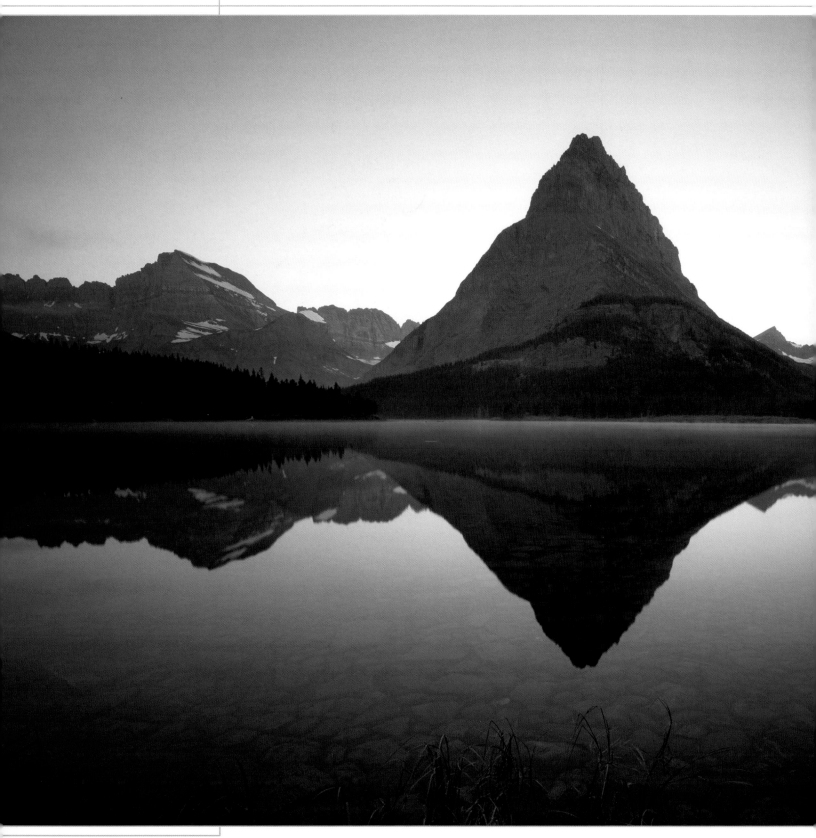

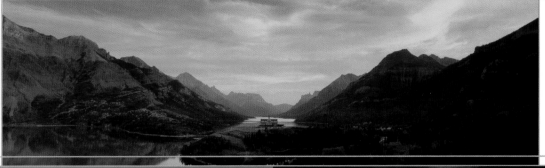

Swiftcurrent Lake (below left) and
Double Falls (below right) are just part of
the spectacular natural beauty of the
Glacier National Park in Montana. The
Prince of Wales Hotel's picture window
affords a wonderful view of the magnifi-
cent mountain panorama (left).

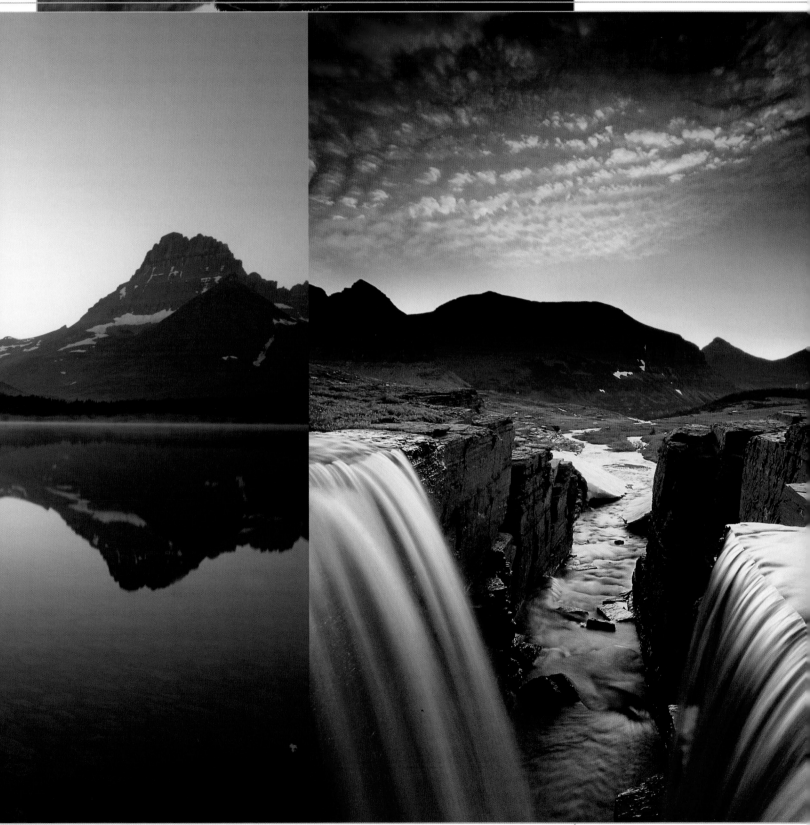

The remote valleys of the two sections of the peace park, Waterton Lakes National Park (founded 1895) and Glacier National Park (founded 1910), are home to a variety of animals, including the bighorn sheep, ubiquitous in the Rockies (large image), and wolves, gophers, cougars, and lynxes (above from left).

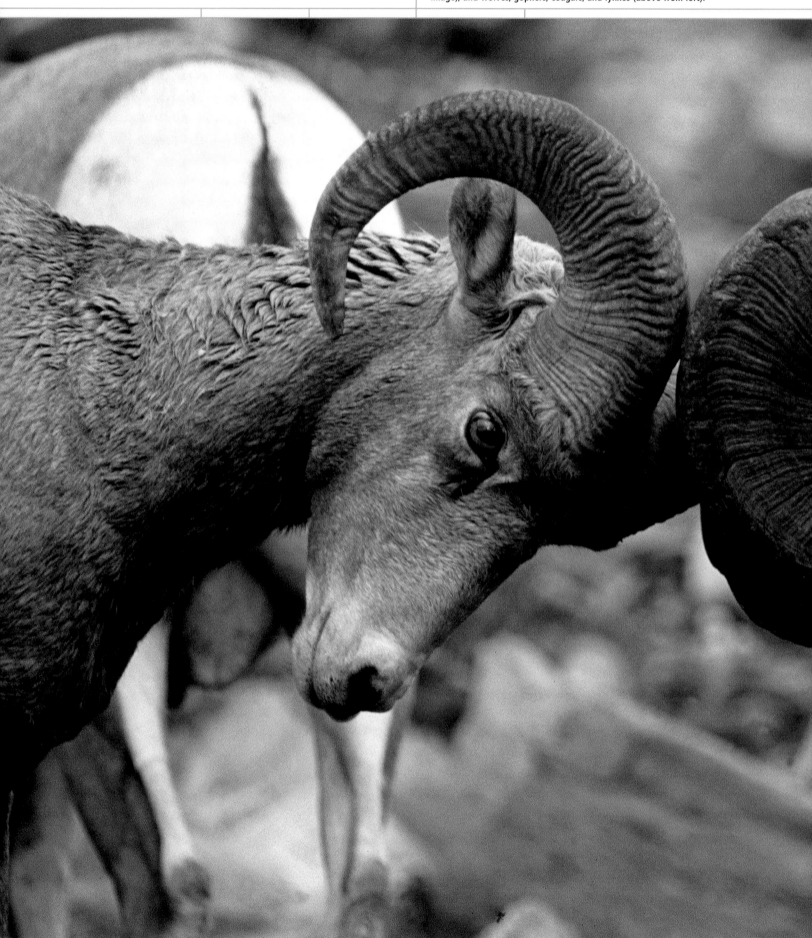

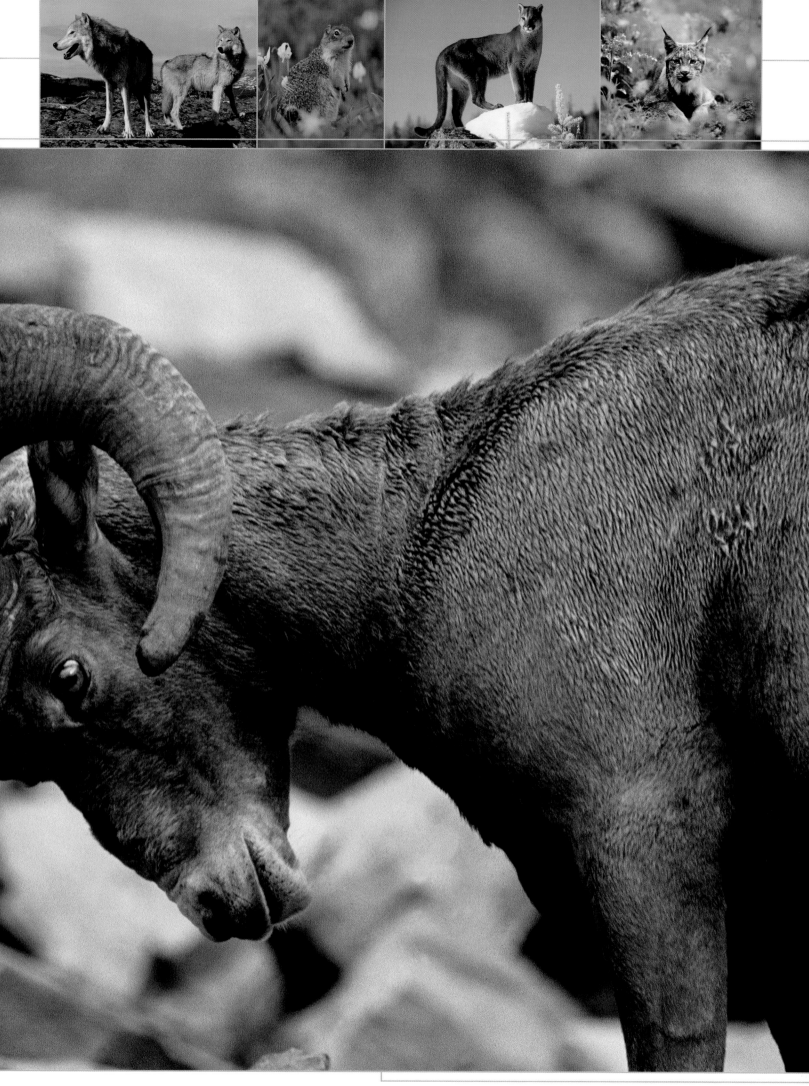

KLUANE/WRANGELL–ST ELIAS/ GLACIER BAY/TATSHENSHINI-ALSEK

The International Biosphere Reserve is home to an astonishing range of fascinating flora and fauna.

Date of inscription: 1979
Extended: 1992 (Glacier Bay), 1994 (Tatshenshini-Alsek)

Two national parks on the Canadian side, Kluane (in the Yukon Territory) and Tatshenshini-Alsek (in British Columbia), and Wrangell–St Elias and Glacier Bay National Parks (both in Alaska) together form the first binational UNESCO World Heritage Site, and also constitute the largest dry land nature reserve in the world. Its scenery is characterized by giant ice fields, mighty glaciers, high mountains, waterfalls, roaring rivers, silent lakes, and expanses of tundra and forest.

In spite of a climate typified by long winters, the local flora is astonishingly varied. Large forested areas are to be found at elevations of up to 1,100 m (3,600 feet), made up of betula, berry bushes, and deciduous and evergreen tree species, including the impressive Sitka spruce, which can reach heights of up to 90 m (300 feet). Varieties of willow and mountain meadowgrasses are found at subalpine elevations of 1,100 to 1,600 m (3,600 to 5,200 feet). Heather, wild flowers, lichen, low bushes, and cripple birch are characteristic of the alpine tundra between 1,600 and 2,000 m (5,200 and 6,600 feet).

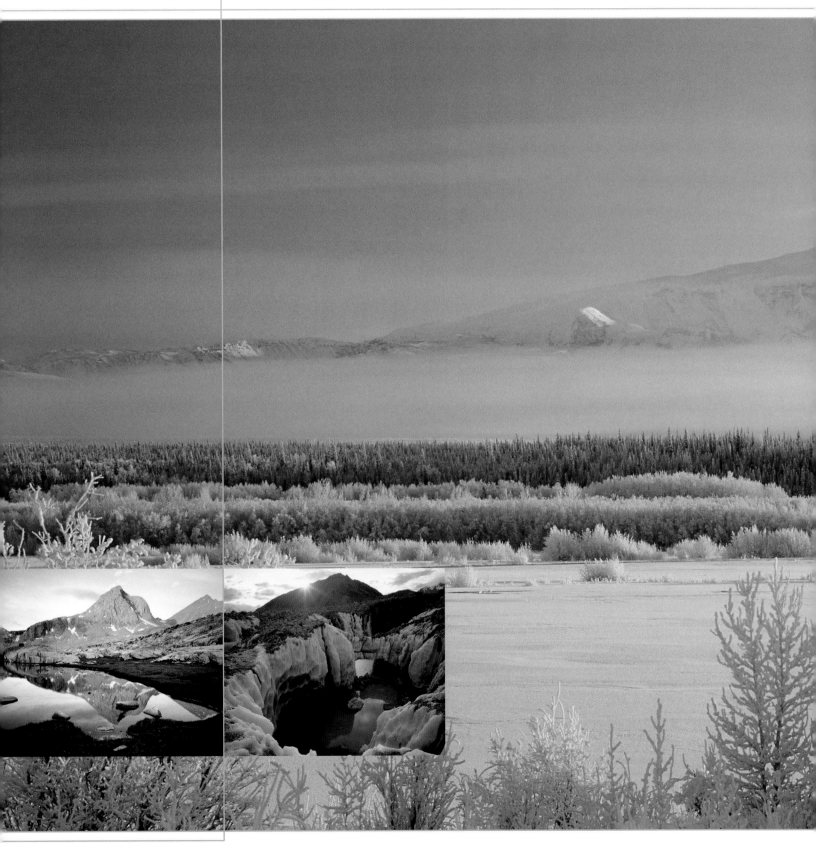

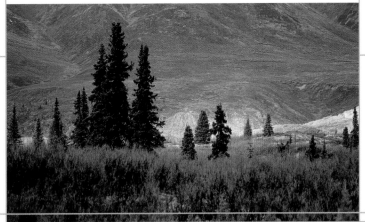

The diversity of the animal life is also impressive, with black, brown, and grizzly bears roaming the rivers, which teem with fish. The rare Dall sheep and the mountain goat share a habitat on the upper slopes. The four national parks are home to 170 species of bird, as well as red deer, wolves, red foxes, lynxes, muskrats, Arctic hares, gophers, and chipmunks.

At 4,317 m (14,160 feet), Mount Wrangell is an extinct volcano in the Wrangell–St Elias National Park, covered in a thick blanket of snow in winter (large image). At the end of summer, the soft shades of the Talkeetna mountains are a delight (left). Mount Huxley (3,828 m, 12,600 feet) is reflected in a pond, while on the Bagley ice field the forces of nature have formed a deep crater (below left).

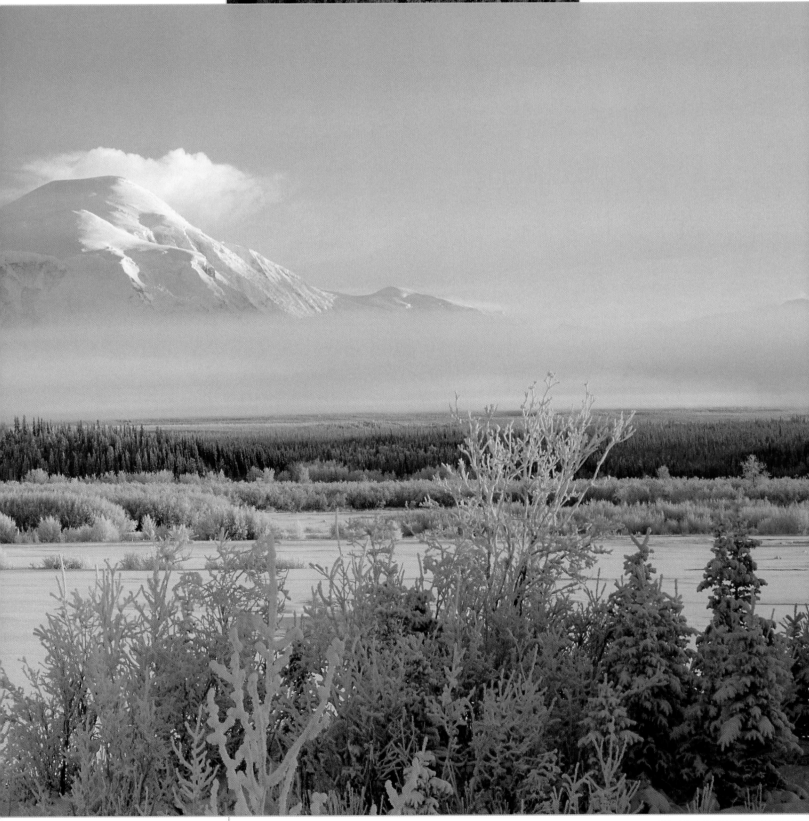

Adventurous routes by kayak and canoe lead from the camping ground on the shores of Lake Kathleen into the interior of Kluane National Park (below), whose mountains (inset image, above right) belong to the Wrangell–St Elias chain which stretches as far as Alaska. The Kaskawulsh glacier "calves" great rivers of ice (inset image, above middle; right, Kluane Lake). Haines Road skirts the mountain wilderness (below left).

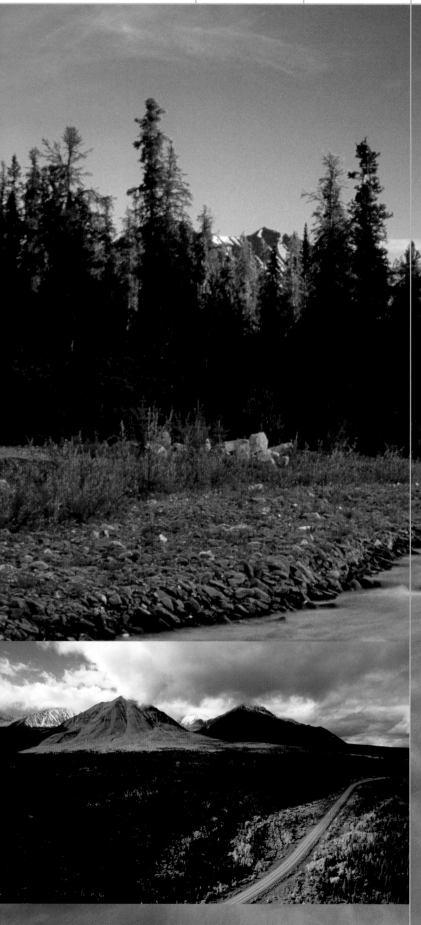

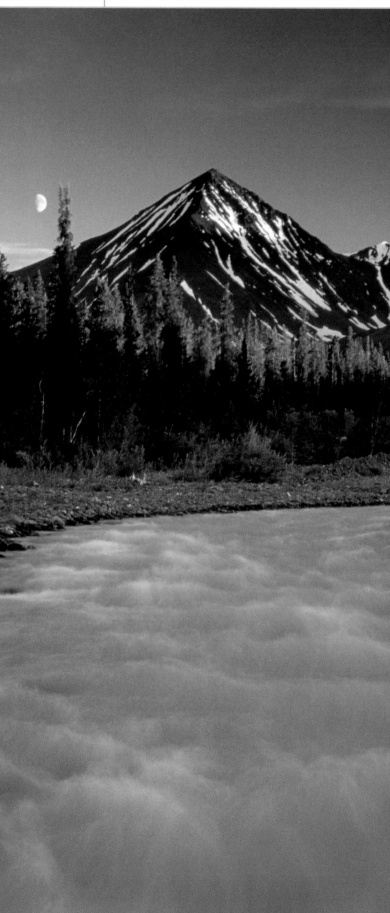

The largest eared seal, the walrus, is protected from the cold of Glacier Bay by a thick layer of blubber. These animals, which can reach 4 m (12 feet) in length and weigh up to 1 metric ton (2,200 lb), have striking tusks that can reach a length of 75 cm (30 inches). The walrus was long sought-after and hunted because of these ivory tusks, which it uses to prise crustaceans from the seabed.

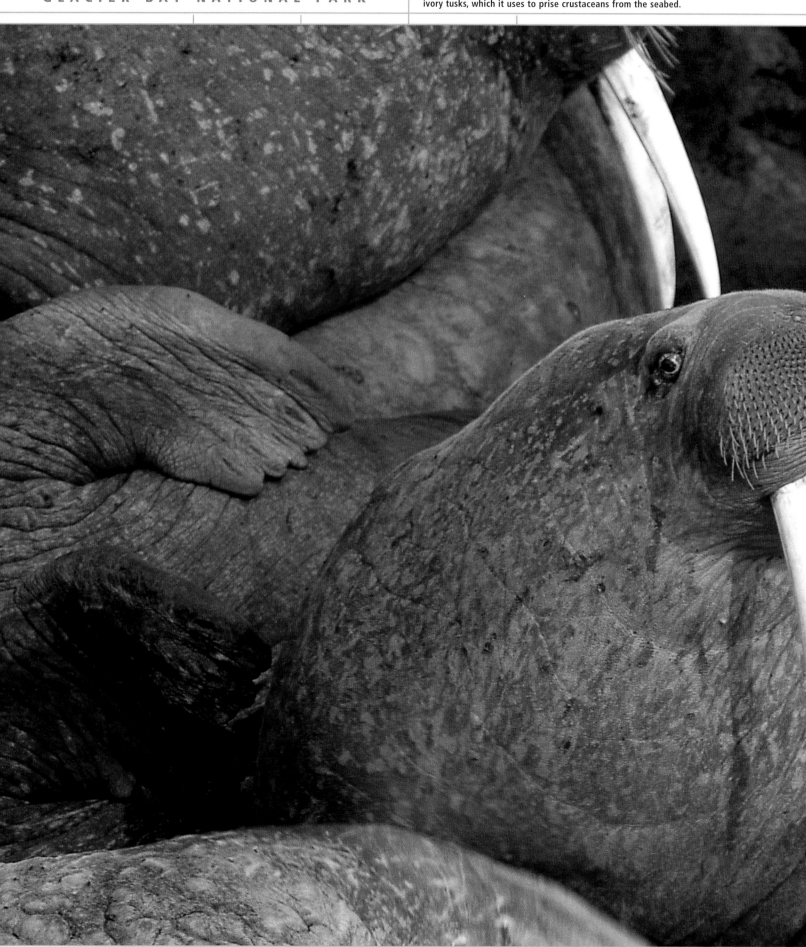

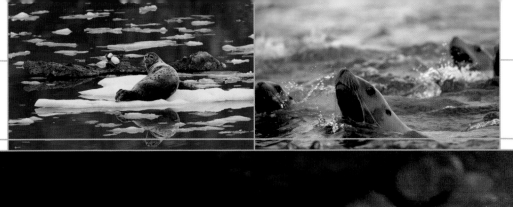

The common harbour seal (*Phoca vitulina*, left) is just as happy in the ice-cold waters of Glacier Bay. If a female bears two young, she will only suckle one of them – the other, called a "howler," is left to die.

Tatshenshini-Alsek Provincial Park (below: confluence of the two eponymous rivers) is run in cooperation with the Champagne and Aishihik First Nations and lies in the furthest north-western reaches of British Columbia; "First Nations" is the usual term for the indigenous peoples of Canada, excluding the Inuit and Métis.

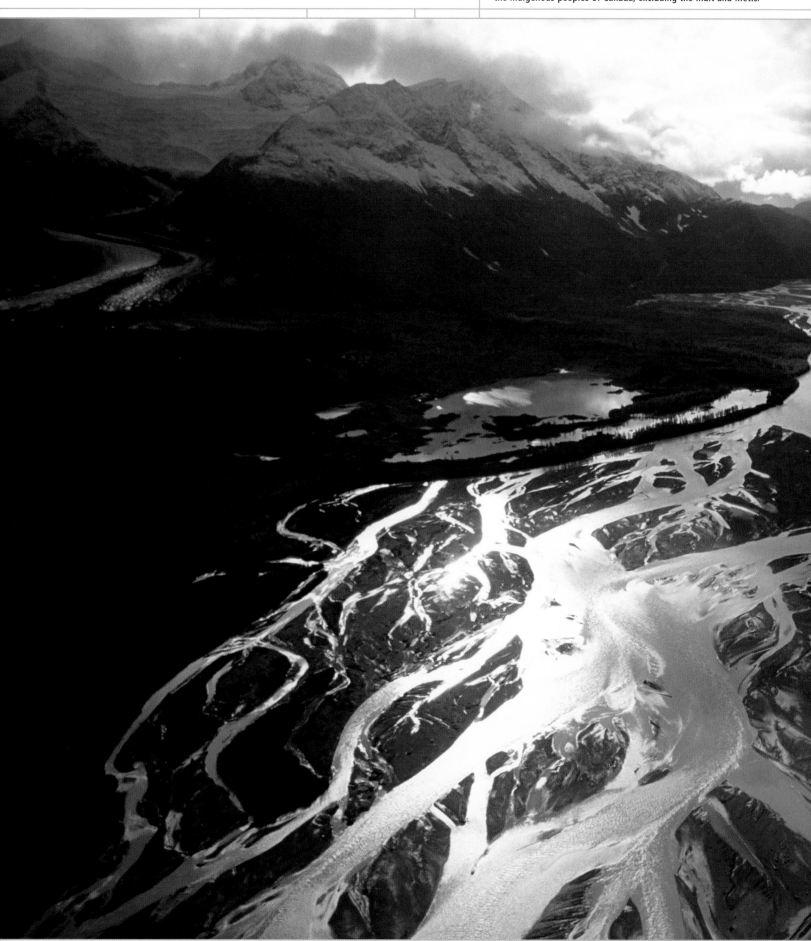

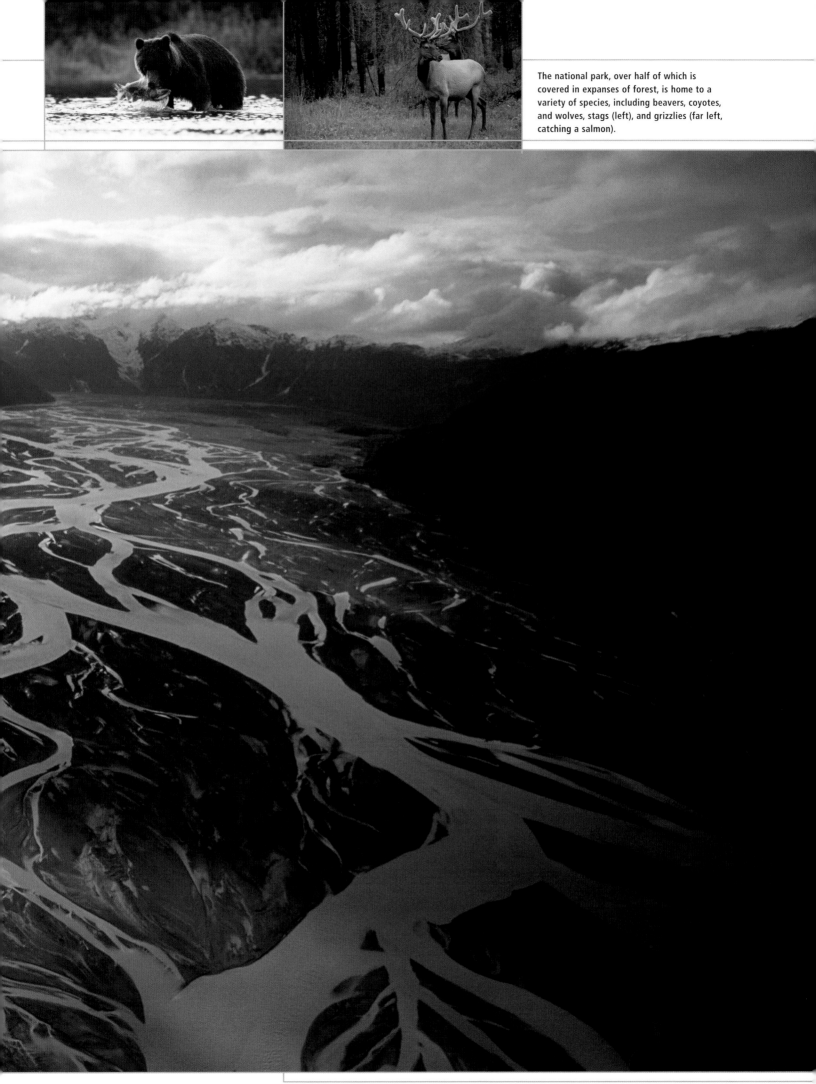

The national park, over half of which is covered in expanses of forest, is home to a variety of species, including beavers, coyotes, and wolves, stags (left), and grizzlies (far left, catching a salmon).

The most striking aspect of this national park situated in northwest Washington State is the temperate rainforest full of moss-covered trees.

Date of inscription: 1981

Olympic National Park, which covers the greater part of the Olympic peninsula to the west of Seattle, is surrounded by the Pacific Ocean to the west, the Strait of Juan de Fuca to the north, and Puget Sound to the east. Due to its geographic location, it has become a unique biosphere. Coniferous trees (firs, spruce, and cedar) the height of steeples grow in the damp primary forest. Their trunks routinely reach a circumference of 7 m (22 feet), but exceptional cases can be much larger; the record is held by "The Big Cedar Tree" which measures 20 m (66 feet) around.

Thirteen plant species, mostly wild flowers, are endemic to the region, which is divided into three ecological zones. Douglas, hemlock and giant fir, Sitka spruce, bigleaf maple, and western red cedar make up a rainforest that is home to elks, pumas, black bears, and beavers.

The almost circular cluster of the Olympic mountains in the park's interior forms a glaciated landscape of exquisite beauty. Eleven river systems have their source here, offering an ideal biotope for fish alternating

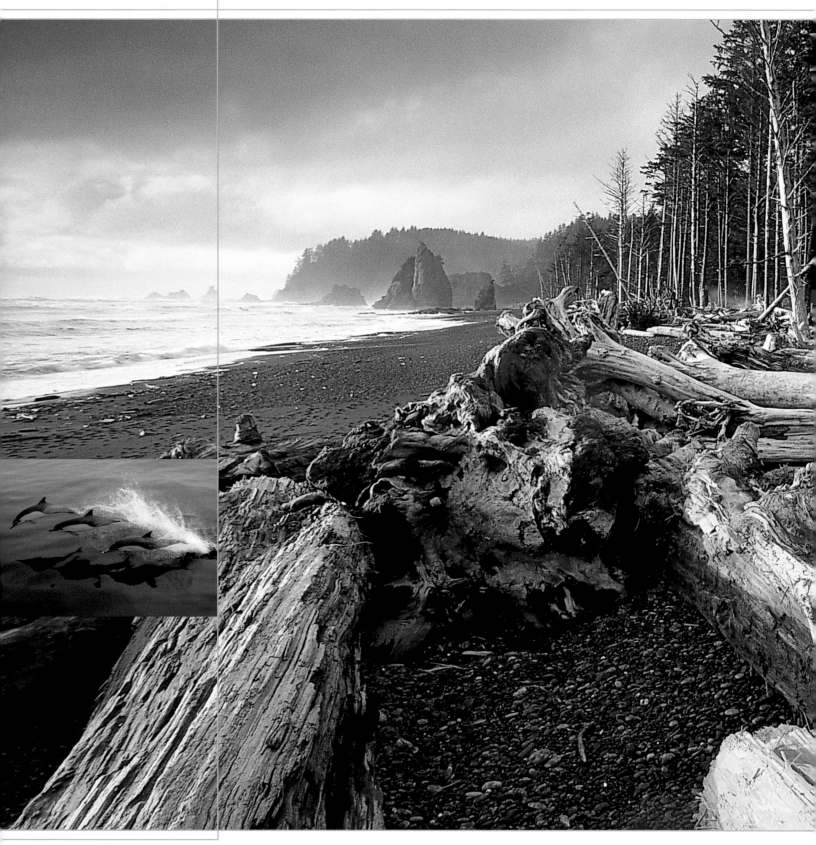

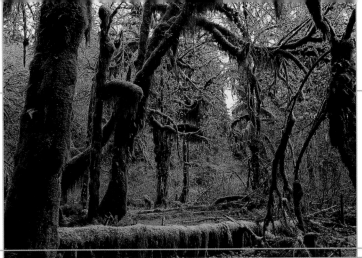

between salt and fresh water. The approximately 100-km (330-mile) long Pacific littoral is a perfect habitat for mussels, crabs, sea urchins, and starfish, as well as for the seabirds that eat them. Twice yearly, gray whales pass by on their journey to and from the warm-water lagoons of Mexico's Baja peninsula.

The Olympic peninsula was placed under protection as early as 1909, and inscribed as a national park in 1938. It boasts one of the world's few temperate rainforests (left). Driftwood accumulates on the Pacific coast (large image) and dolphins roam the seas (below left).

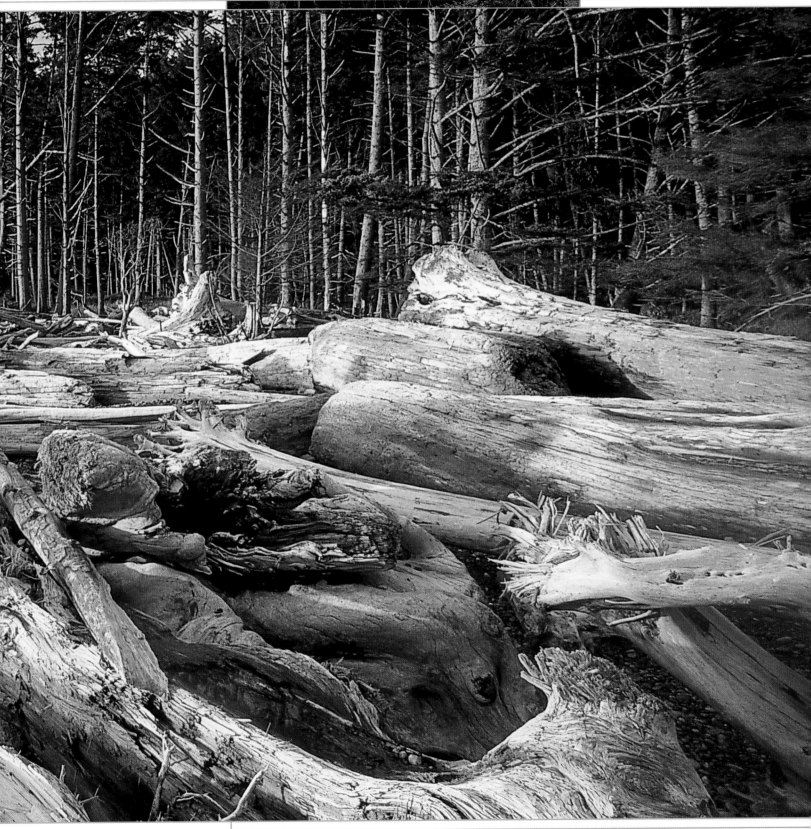

YELLOWSTONE NATIONAL PARK

The world's oldest national park is a majestic wilderness of mountains, rivers, and lakes, as well as more than 3,000 geysers. Approximately 96 percent of its total area (around 9,000 sq. km, 3,500 sq. miles) lies in Wyoming, 3 percent in Montana and 1 percent in Idaho.

Date of inscription: 1978

The heart of the national park is the 2,000-m (6,600-foot) high Yellowstone plateau, a rock feature surrounded by mountains reaching up to 4,000 m (13,200 feet) in height. The volcanic origin of this landscape is still visible today, and petrified forests bear witness to the streams of lava and ash rain which most recently flowed through this region 60,000 years ago. The earth has not yet come to rest, however, as is shown by the many hot springs, fumaroles, and geysers. Of these, Old Faithful is the most famous, shooting a fountain 60 m (200 feet) high into the air roughly every hour. Spring pools with multihued, boiling water, bursting mud bubbles, and hot steam shooting from rock fissures attest to the forces

that are still at work beneath the earth's surface.

This World Heritage Site, which was founded in 1872 and named after the yellow rock forming the banks of the Yellowstone river, is home to a variety of animals, with the grizzly bear as king, but also including wolves, bison, and elk, a North American stag with great antlers.

Yellowstone Falls are composed of the mighty Upper and Lower Falls (large image). The hot springs in the park form spectacular travertine terraces, as here at Minerva Terraces (right). The melancholy lake and river landscape (above left) was once settled by the Shoshone and Bannock tribes.

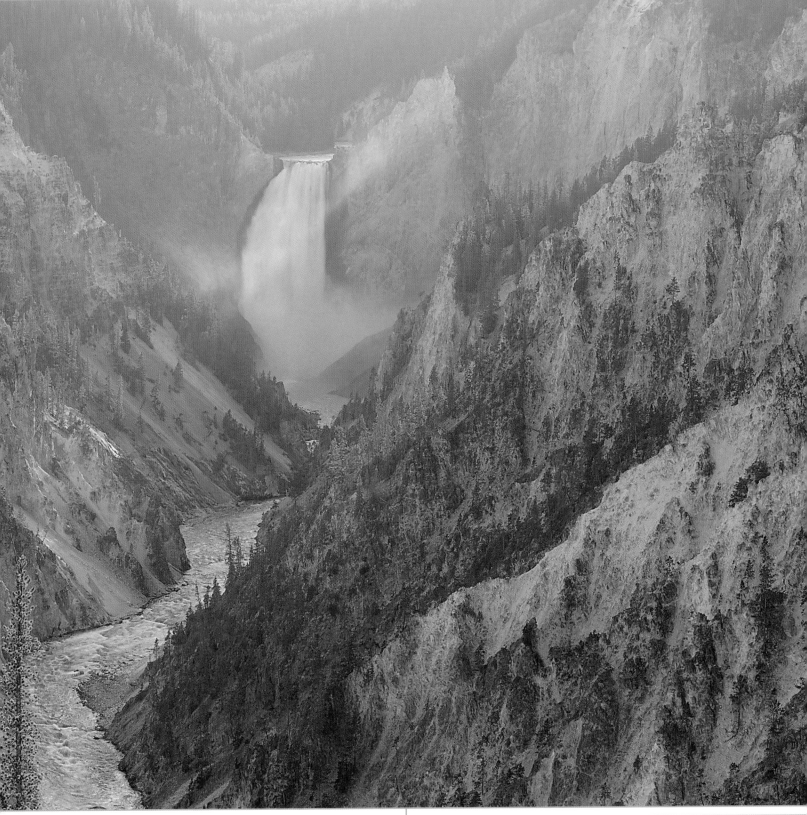

The geysers in the Yellowstone National Park are of volcanic origin. Cold water trickles through to hot chambers almost 2 km (1 mile) underground, where it heats up and is then forced back up through narrow channels. The spray from the White Dome geyser shoots high into the air (below left). The Grand Prismatic spring takes its garish coloration from microorganisms (below right).

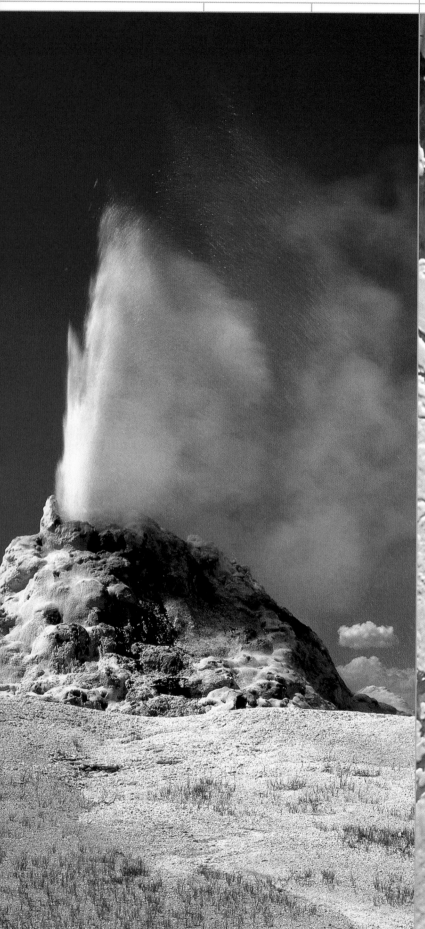

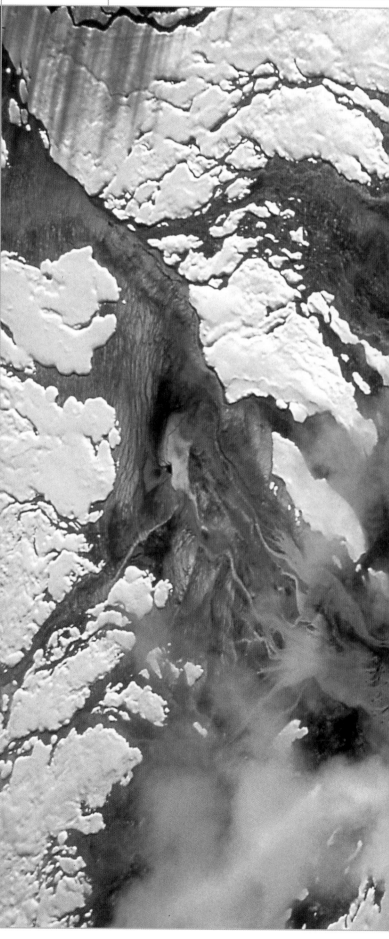

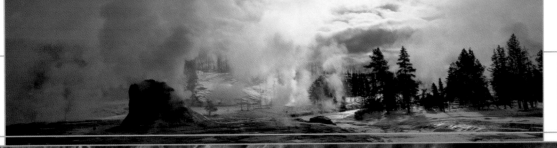

In winter, the scenery in the Yellowstone National Park has a particular charm – not least here at West Thumb geyser basin (left), one of the smallest geyser basins in the park.

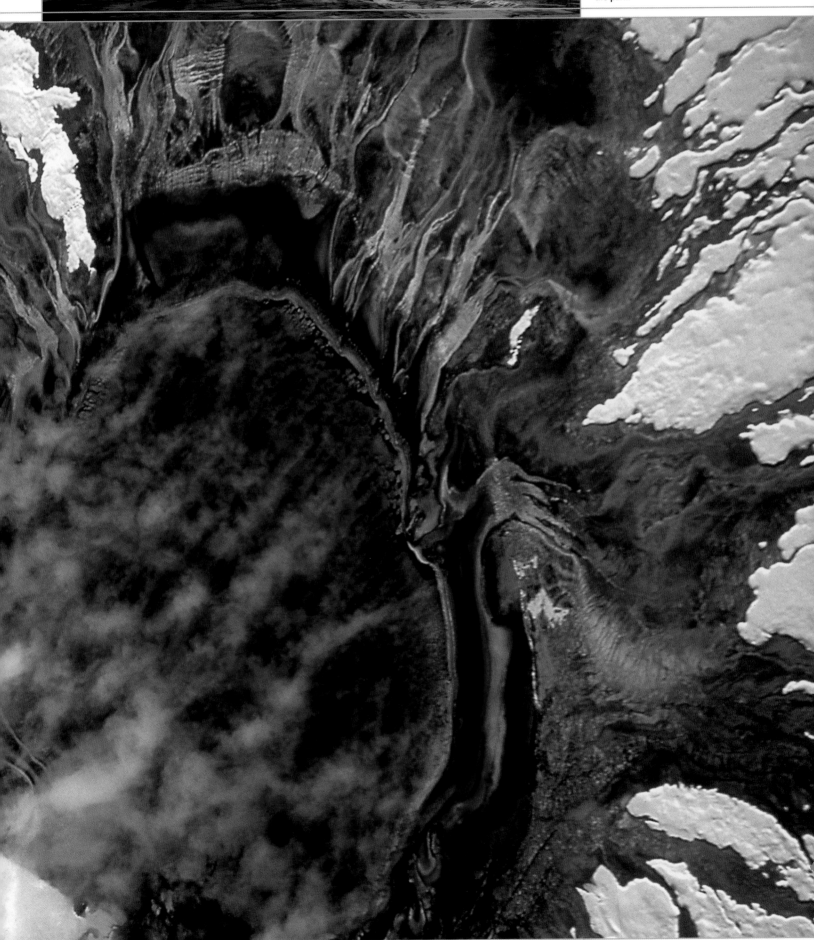

Yellowstone National Park is also well known as an important nature reserve. Of the elk, black-tailed deer, moose, bighorn sheep, pronghorns, grizzlies and black bears, pumas, coyotes, beavers, trumpeter swans, white pelicans, eagles, and sea eagles in the park, the most fascinating animal is the mighty bison (large image: two bulls compete during the mating season).

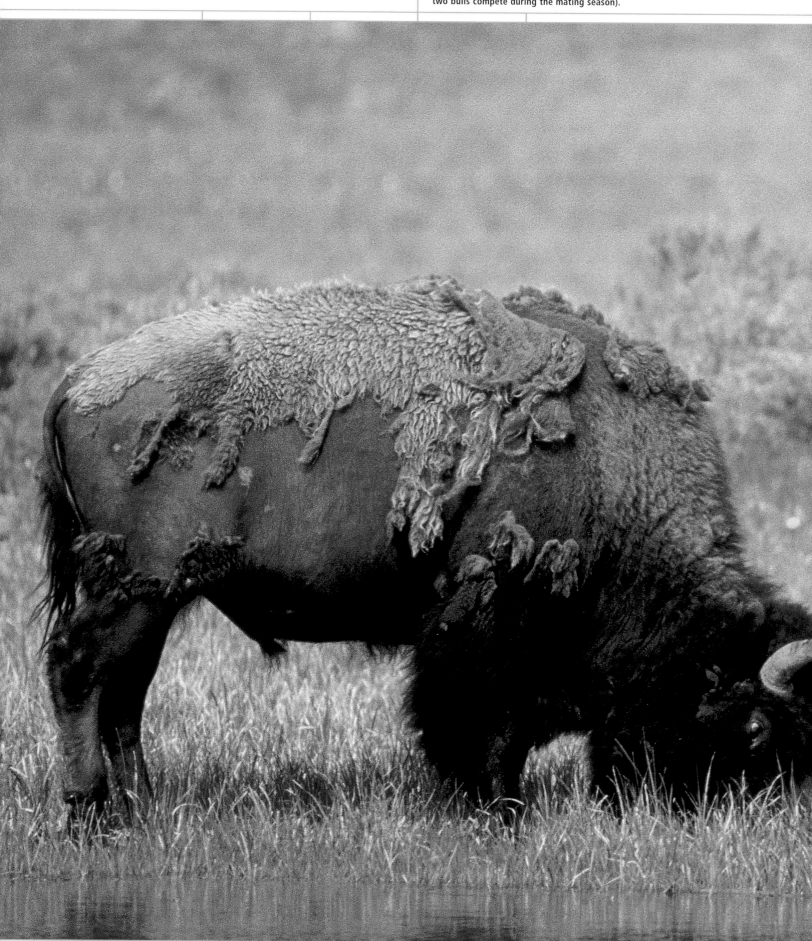

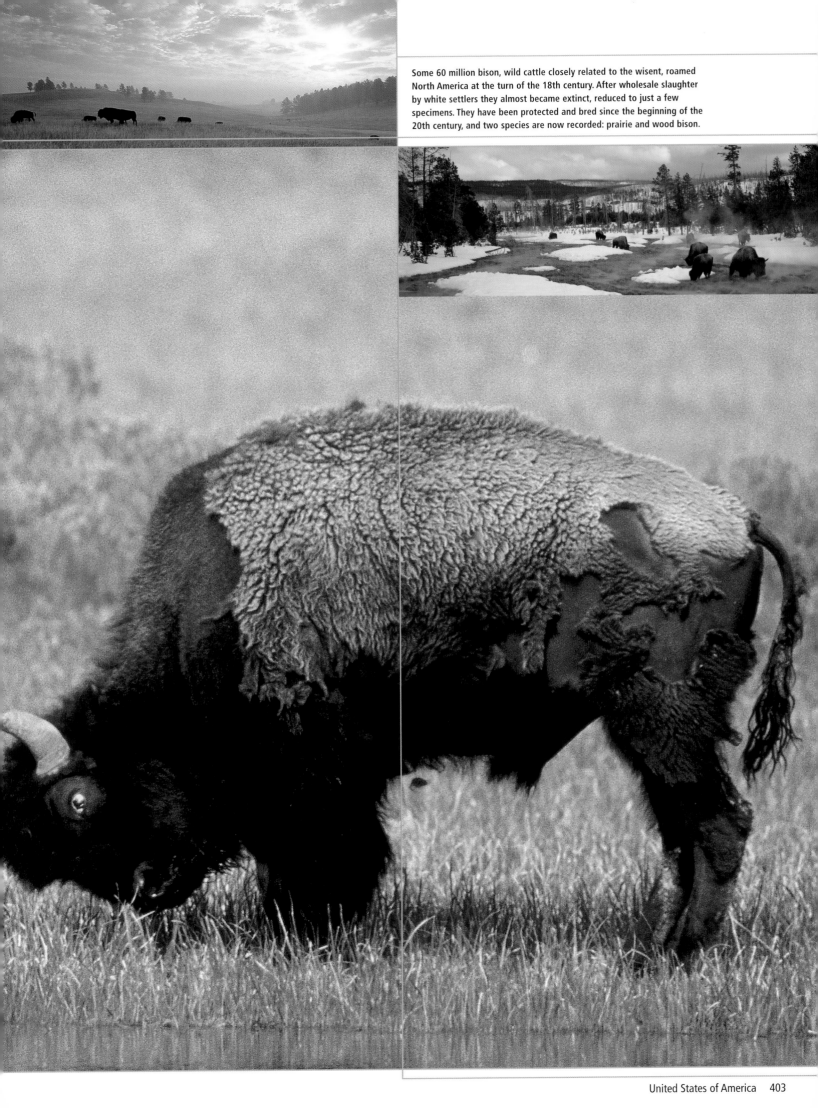

Some 60 million bison, wild cattle closely related to the wisent, roamed North America at the turn of the 18th century. After wholesale slaughter by white settlers they almost became extinct, reduced to just a few specimens. They have been protected and bred since the beginning of the 20th century, and two species are now recorded: prairie and wood bison.

REDWOOD NATIONAL PARK

The biggest plants in the world are the sequoias, called redwoods in English on account of their red bark. These giant trees give their name to this World Heritage Site lying on the Pacific coast of north California.

Date of inscription: 1980

The coast redwood (*Sequoia sempervirens*), an evergreen conifer, was once widespread throughout North America. Today, there are only a few patches of these primeval giants remaining on the American West Coast. Conservationists founded the "Save The Redwoods League" to protect these nearly 100-m (330-foot) tall trees, forcing the government to establish several state parks. Three of these parks – Jedediah Smith, Del Norte Coast Redwoods, and Prairie Creek Redwoods – were combined in 1968 to form the Redwood National Park in northern California.

About a third of the park's area (446 sq. km, 160 sq. miles) consists of sequoia forest. The biggest trees are in the Tall Trees grove near Orick, and

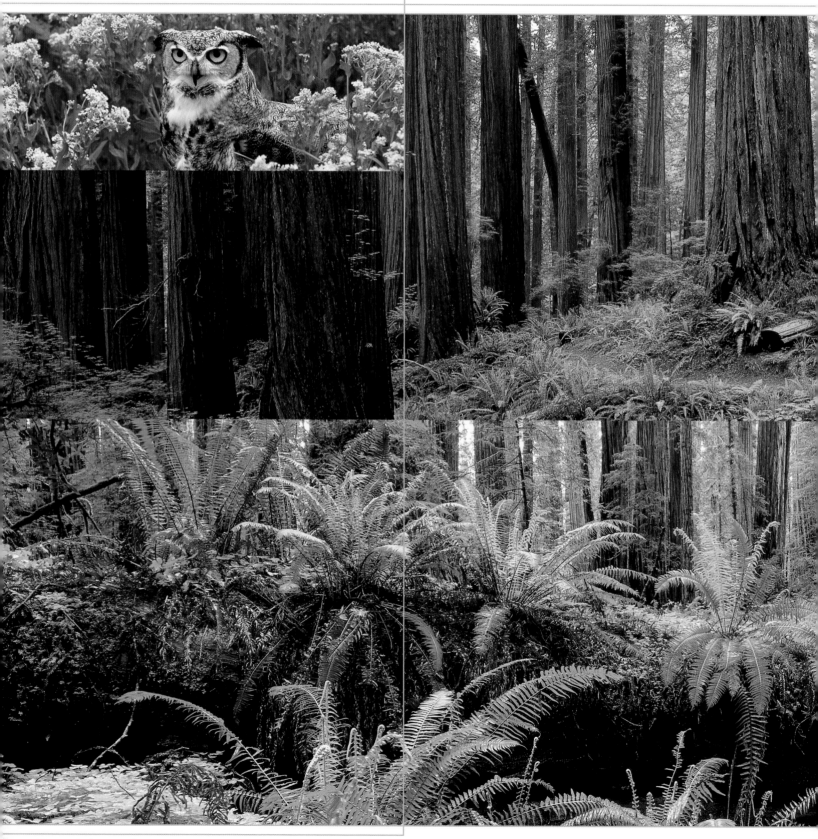

the star of these giants is the "Nugget Tree," the tallest known in the world, with a height of 111 m (365 feet). Mighty redwoods are also found in Mill Creek. The results of replanting will only be seen in the future. The imposing trees regularly reach 500 to 700 years of age; some individuals grow to an age of 2,000, only reaching maturity at 300.

These striking giant trees are not the World Heritage Site's only attraction, however. Seals, sealions, and a wide variety of seabirds, including guillemots, marbled murrelets, brown pelicans, and double-crested cormorants also live on the Pacific coast.
Although outnumbered by the coast redwoods, other giant trees also grow at higher elevations, including Sitka spruce, Douglas and hemlock fir, bigleaf maple, and Californian laurel. Pumas, skunks, Roosevelt elks, and white-tailed deer live in this mixed forest, as do gray foxes, black bears, otters, and beavers.
Numerous archeological finds also suggest that there has been human settlement of the region since prehistoric times.

The redwoods (below) were sacred to the Native Americans. They believed that these trees had a soul, and, before the establishment of the national park in 1968, they considered felling them a crime and an endangerment of native species (top left: a great horned owl).

GRAND CANYON NATIONAL PARK

This gigantic rocky panorama, cut into the stone by the Colorado river over millions of years, affords an impressive glimpse of the earth's geological history. The Grand Canyon in north-western Arizona is probably the most spectacular chasm in the world.

Date of inscription: 1979

Although Garcia López de Cárdenas, a Spaniard, was the first European to glimpse the magnificent panorama of the Grand Canyon in 1540, the area was not properly mapped until the middle of the 19th century. The Grand Canyon's geohistory is still scientifically disputed. It is conjectured that the river began seeking a way across the rocky plateau about six million years ago, and this led in the course of time to the development of this unique chasm, called by the naturalist John Muir "the greatest of God's earthly places." Wind and weathering also contributed to the bizarre formations on the rocky walls. The sequence of strata in the walls is easily discernible and clearly documents the different periods of the earth's geo-

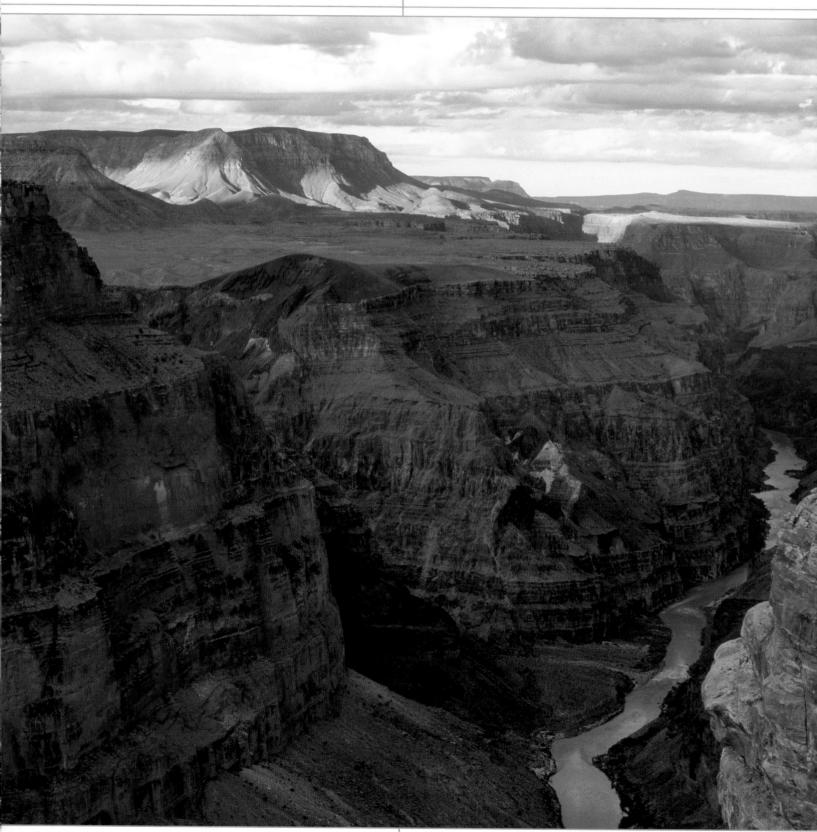

logical history; fossils found here afford an insight into life in prehistoric times. Only the hardiest of plants and animals are able to survive the temperatures of up to 50° C in the canyon, and these include various cactuses, thornbushes, rattlesnakes, black widows, and scorpions. Because of the extreme conditions, the river is a habitat for very few species of fish, but iguanas, toads, and frogs live on the banks. In some locations, even beavers and otters survive. Only the forests on the northern and southern edges offer a viable habitat for a large variety of flora and fauna.

Numerous finds attest to a history of human settlement in the Grand Canyon going back some 4,000 years. The most impressive are the thousand-year-old rock dwellings of the Anasazi. Among the Native Americans still living here are the Hulapai, who are responsible for the Grand Canyon's latest attraction: the "Grand Canyon Skywalk" offers visitors the opportunity to "hover" at a height of 1,200 m (3,900 feet) above the canyon floor, standing on a horseshoe-shaped steel bridge with a glass floor and walls.

For 450 km (280 miles) the Colorado river winds through the gorge, which can be up to 1,500 m (4,900 feet) deep and varies in width between 5.5 km (4 miles) and 30 km (19 miles).

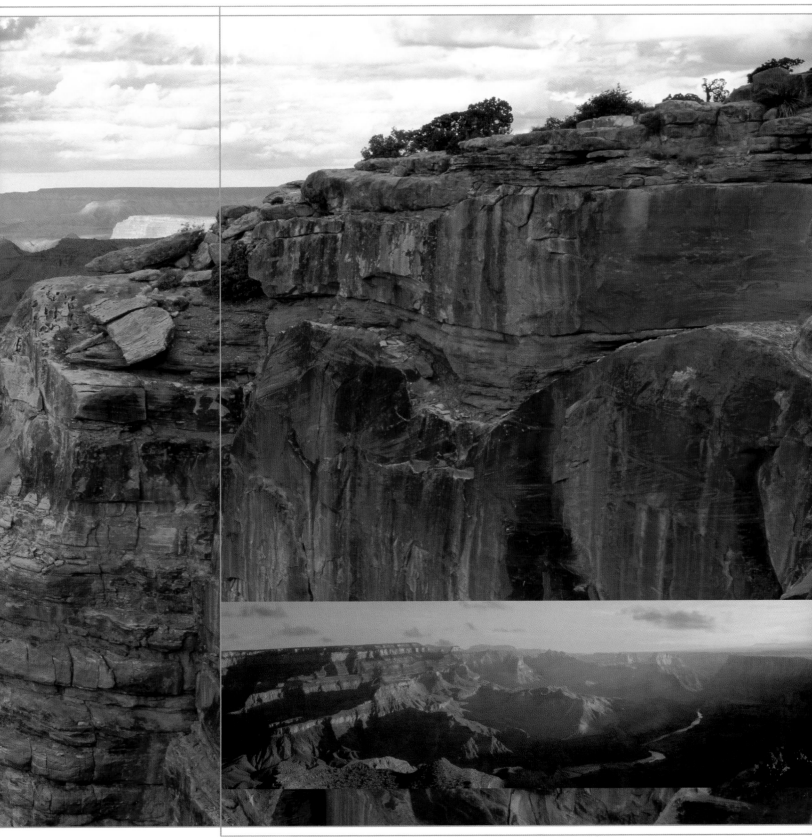

Leading down from Supai, the main town on the Havasupai Indian Reservation to the south-east of the national park, there is a path to the Colorado river which passes three impressive waterfalls: the 22-m (73-foot) high Navajo Falls, the 30-m (100-foot) high Havasu Falls (below left) and the 60-m (200-foot) high Money Falls. At Horseshoe Bend, the river curves in a shape that might be guessed at (below right).

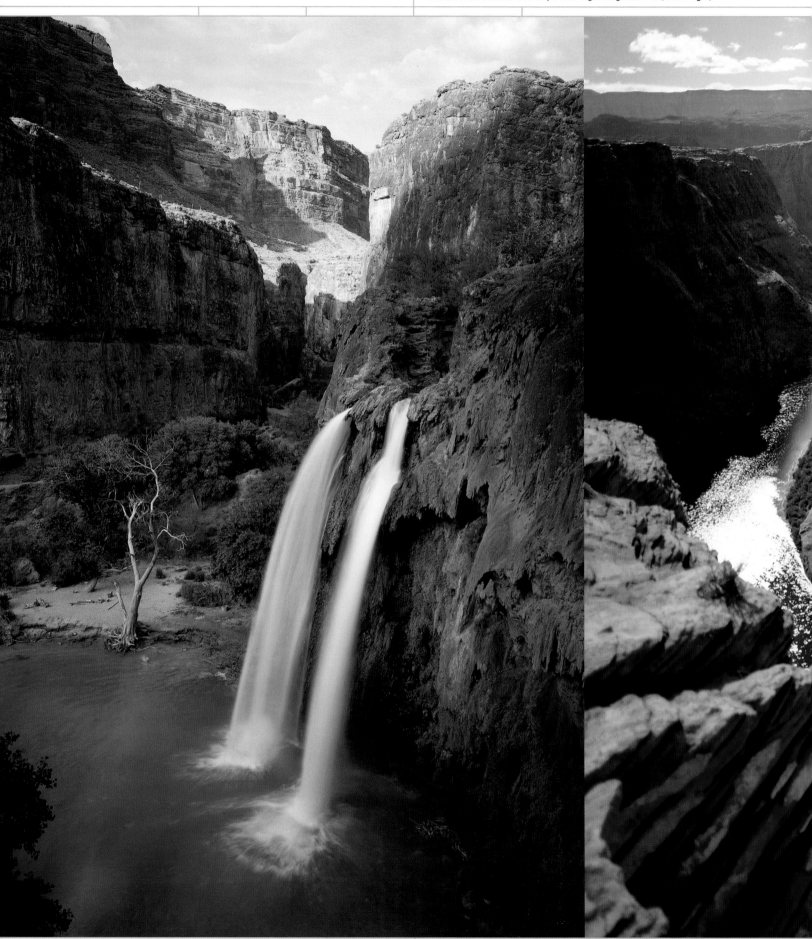

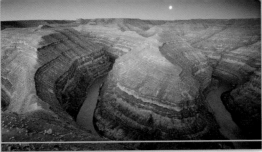

The walk down to the banks of the Colorado river is a journey through time into the prehistoric depths of the earth. The slate at the bottom of the gorge is almost two billion years old.

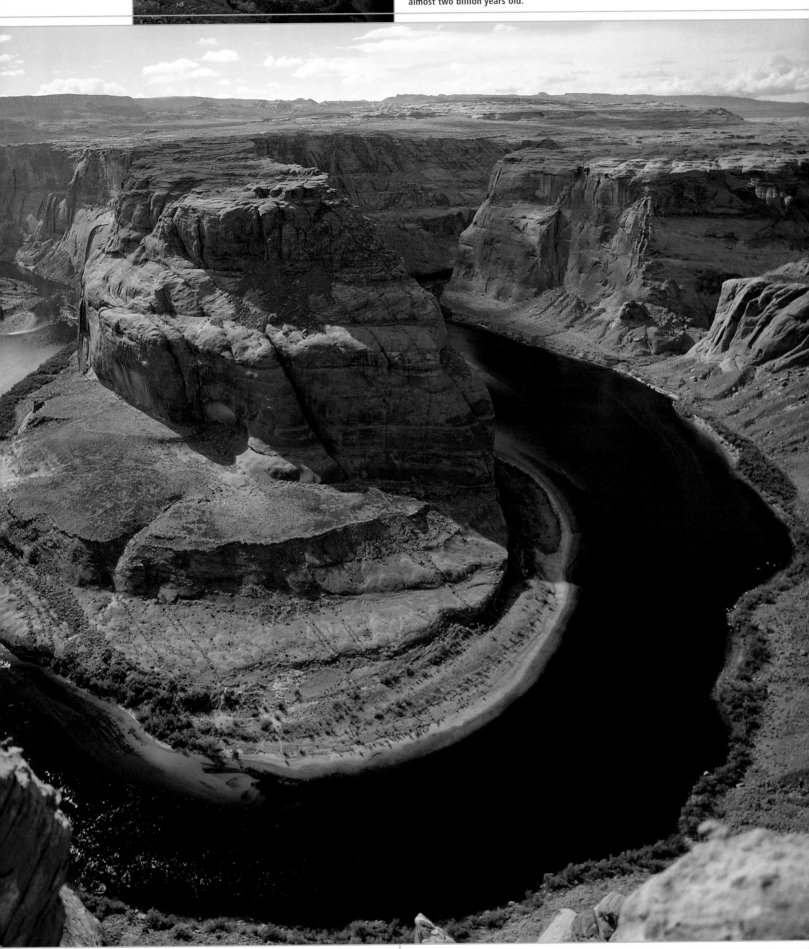

CARLSBAD CAVERNS NATIONAL PARK

Near the small town of Carlsbad, in south-east New Mexico, there is a complicated labyrinth of bizarre limestone caves, which fascinates scientists and tourists alike.

Date of inscription: 1995

At first glance, the desert and forest scenery surrounding the Guadalupe mountains might be a disappointment, but the actual charms of the Carlsbad Caverns National Park's 200 sq. km (75 sq. miles) are hidden in the mountains, in an extensive cave system. Millions of years ago, the effects of water and sulphides began hollowing out a subterranean reef dating back to the Permian era, creating giant cracks, fissures, and chambers – the modern-day Carlsbad caverns. More than 80 caves have been discovered so far, of which the Lechuguilla Cave is both the deepest (477 m, 1,600 feet) and the longest (133 km, 83 miles). Hundreds and thousands of bats sleep in the Bat Cave, and rock art dating back to before Columbus has been found. The New Cave is also a fascinating spectacle of stalagmites and stalactites. There are still many natural wonders remaining to be discovered in this fantastical, fairy-tale cave world.

The bizarre world of the Carlsbad caverns and its stalagmites and stalactites is still being created. Its development began 250 million years ago, with the depositing of layers of calcite sediment at the bottom of a sea; following a process of chemical decomposition, groundwater and rain penetrated the rock.

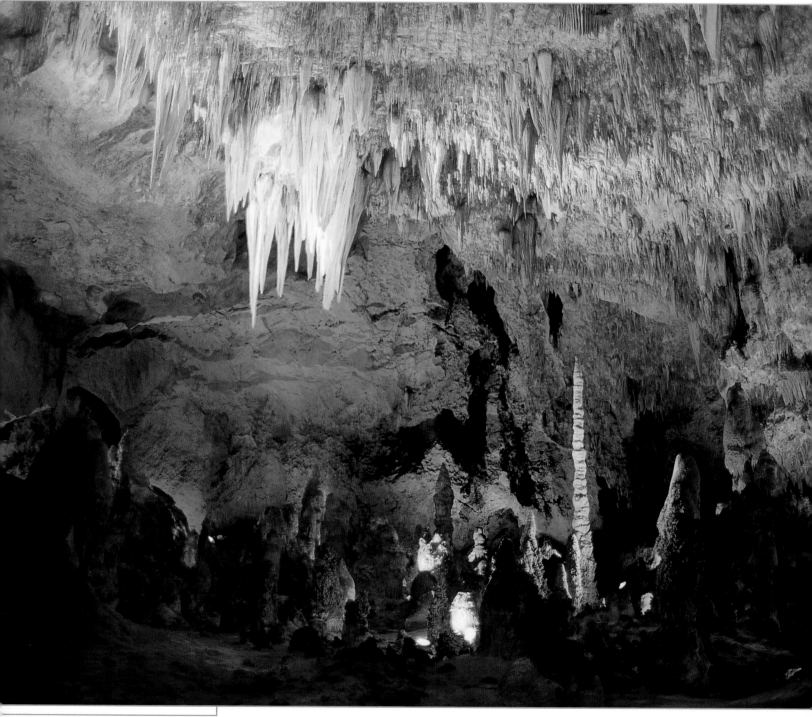

MAMMOTH CAVE NATIONAL PARK

The Mammoth Cave is the world's largest and most convoluted cave system and its tunnels are a habitat for more than 200 species.

Date of inscription: 1981

At first, the area of karst scenery on the banks of the Green river in Kentucky does not seem that spectacular; its particular charm lies beneath the ground. There, intertwining tunnels that would take days to walk through lead the visitor into a world of bizarre limestone formations, formed from the porous rock over millions of years by constantly dripping water. The giant chambers, with their impressive stalagmites and stalactites, were formed from crystallized layers of calcium carbonate over 300 million years, starting in the Carboniferous period. Water permeated through a porous stratum of sandstone into a layer of limestone lying beneath.

Chemical processes created hollow spaces, which dried out as the water table dropped. Water with a high mineral content then dripped down through the cave, forming columns of calcite deposits.

These enormous caves are a habitat for such extraordinary creatures as the blind cave fish, the Kentucky cave crab, and the cave cricket. Various salamander and frog species also live here, and the caves are an important refuge for several endangered species of bat.

A spotlight reveals the dimensions of the underground scenery (below). "Booth's Amphitheater" (above) was named after the actor, Edwin Booth, who performed a monologue from Shakespeare's *Hamlet* here.

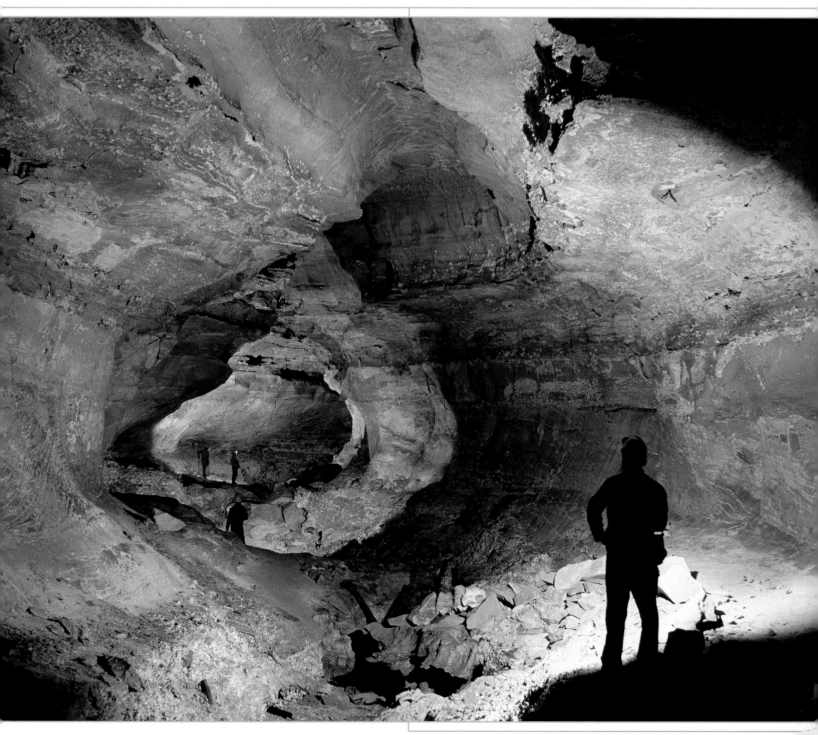

GREAT SMOKY MOUNTAINS NATIONAL PARK

Thanks to the establishment of this breathtakingly beautiful national park, a primeval forest landscape with an incomparably varied biotope has been preserved in the southern Appalachians of North Carolina and Tennessee.

Date of inscription: 1983

This national park is best known for the mist that frequently shrouds the mountains; it looks like smoke, hence the name. The high humidity is a result of luxuriant vegetation and high precipitation. The area, which was inscribed as a national park as early as 1934, has 16 peaks of a height greater than 1,800 m (5,950 feet) and mountain streams and rivers with a total length of 3,000 km (1,850 miles), as well as numerous waterfalls. Some 130 species of deciduous and coniferous trees are to be found in the primary forest that makes up a third of the total area, along with a wealth of shrubs, lichens, mosses, and fungi. The animal life is similarly diverse: black bears, white-tailed deer, and many species of birds and reptiles all live here.

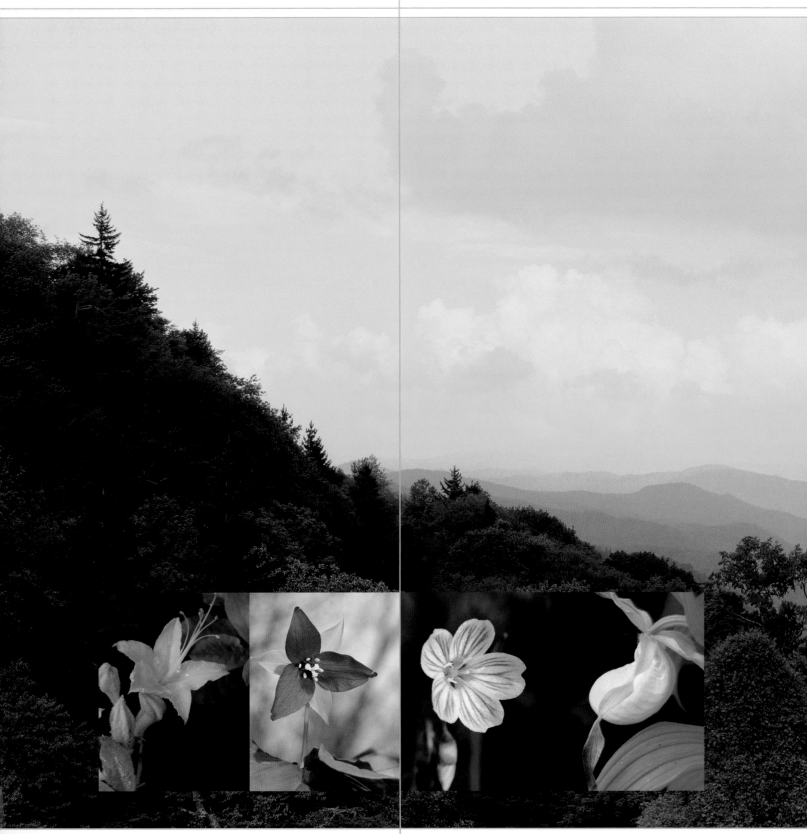

United States of America

The Great Smoky Mountains are among the world's oldest mountain ranges. The eponymous national park (below) contains some of the most beautiful deciduous forests to be found in America, more than 3,500 plant species (bottom, from left: azalea, forest lily, Carolina Spring Beauty, yellow lady's slipper), and many waterfalls (right: Grotto Falls).

EVERGLADES NATIONAL PARK

Here in the south of Florida, mangrove forests and marshland, overgrown with seagrasses, form a unique ecosystem, providing a habitat for a fascinating variety of life.

Date of inscription: 1979

Low elevation and a lack of natural drainage in this region led to the trapping of its high precipitation, and thus to the formation of areas of marshland. The Everglades' complex ecosystem is nonetheless coming under ever greater threat through increasing agriculturalization, rapacious overfishing, and the considerable drinking water requirements of neighboring cities. Despite intensive efforts, this unique habitat for animals and plants is becoming increasingly endangered. In just the last fifty years, 90 percent of the bird and 80 percent of the fish species in the Everglades have been wiped out. The endless savannah of reeds is interrupted by so-called "hammocks," stands of cypresses, pines, and mahogany on little islands.

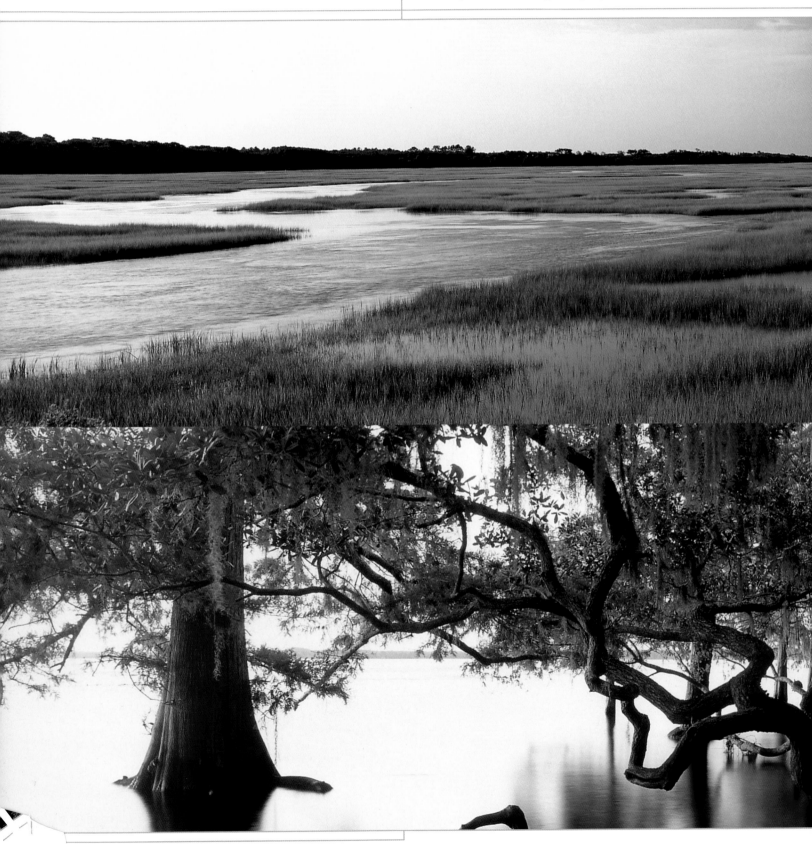

Towards the coast, mangrove forests provide an ideal habitat for microorganisms, amphibians, snails, and fish; the abundance of these is particularly appreciated by the many species of heron, which include the great blue heron and the green-backed heron. In total, the Everglades are home to around 1,000 plant species and 700 animal species.

The Native Americans called the Everglades (below) "pay-hay-okee" ("river of grass"). Swamp cypresses (bottom) grow vertically out of the water and form horizontal roots to take in oxygen. Intertwined waterways lead through the swamps (right).

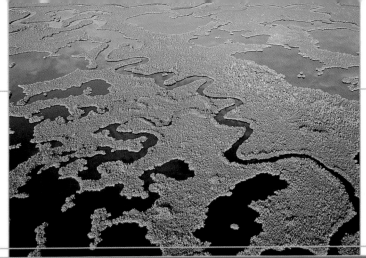

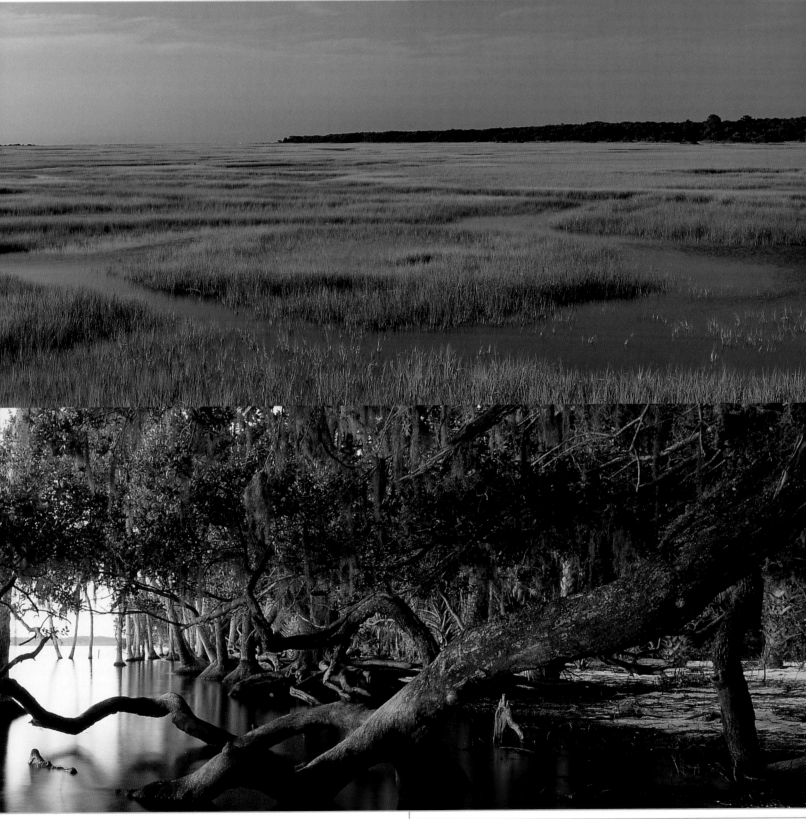

The Everglades' marshland and waters provide ideal living conditions for otherwise endangered animals, including waterfowl such as the snowy egret (below left) and marine mammals such as the West Indian manatee (below middle). The Mississippi alligator, which grows to a length of up to 6 m (20 feet), also lives here, along with raccoons, snakes, and frogs (top from left).

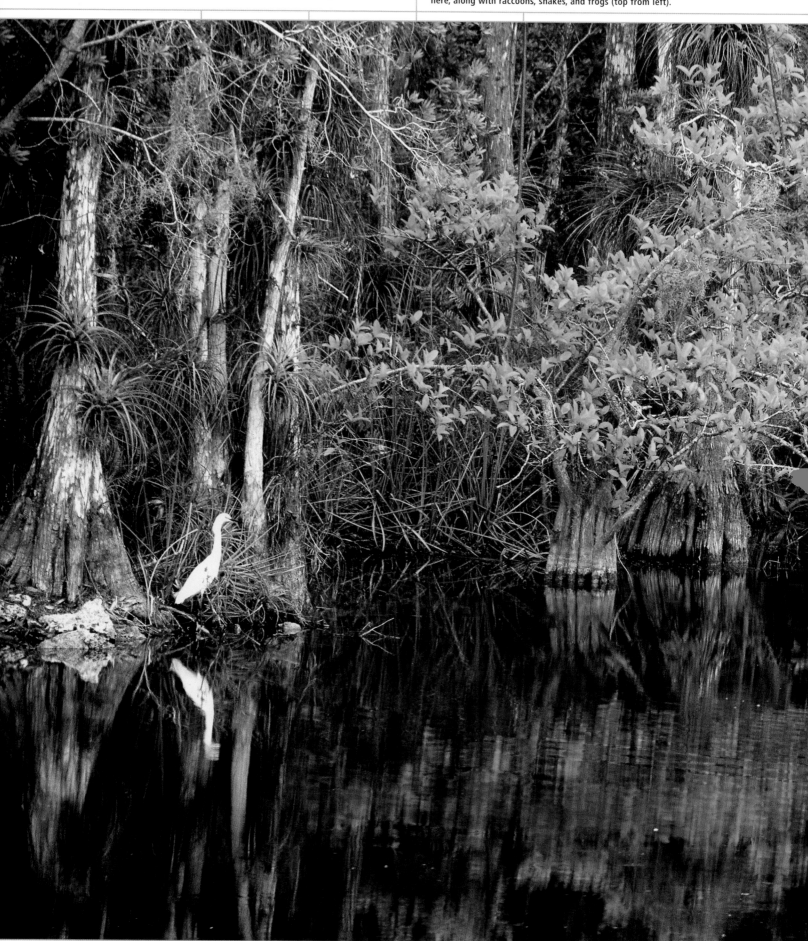

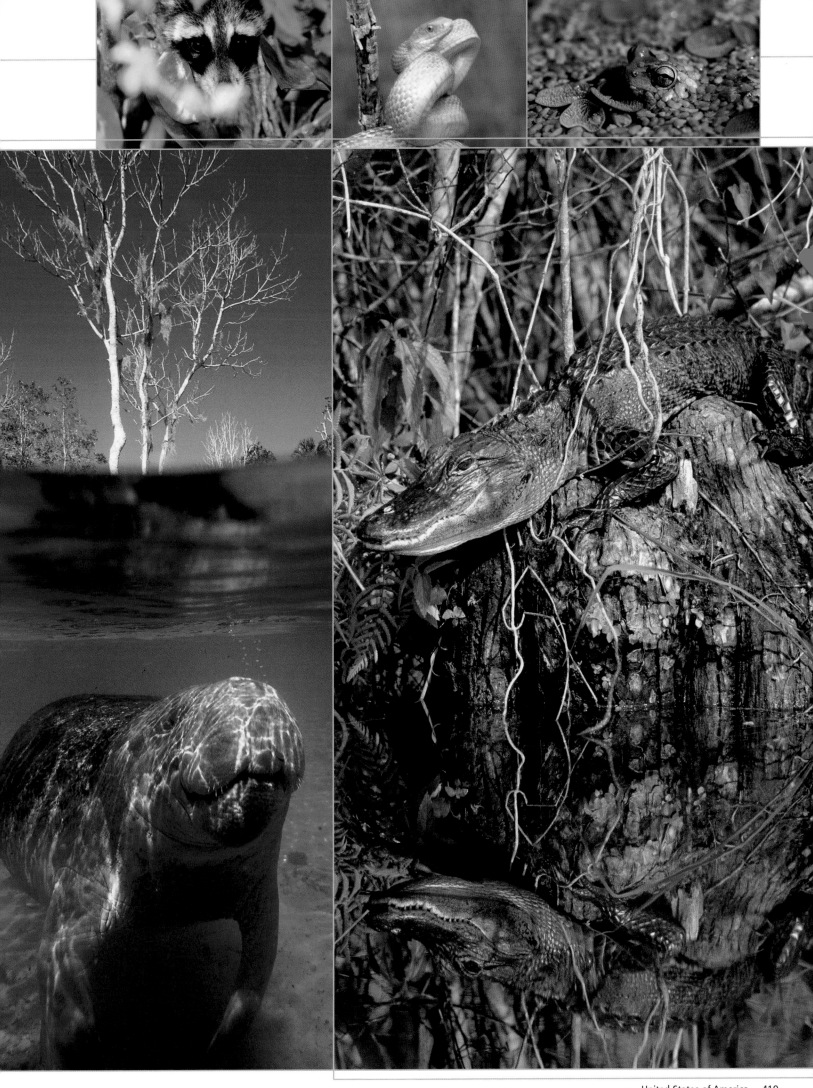

EVERGLADES NATIONAL PARK

The Everglades are a paradise for birds, especially in winter when the migratory birds arrive. Among the best-known inhabitants is the American great blue heron (*Ardea herodias*, below).

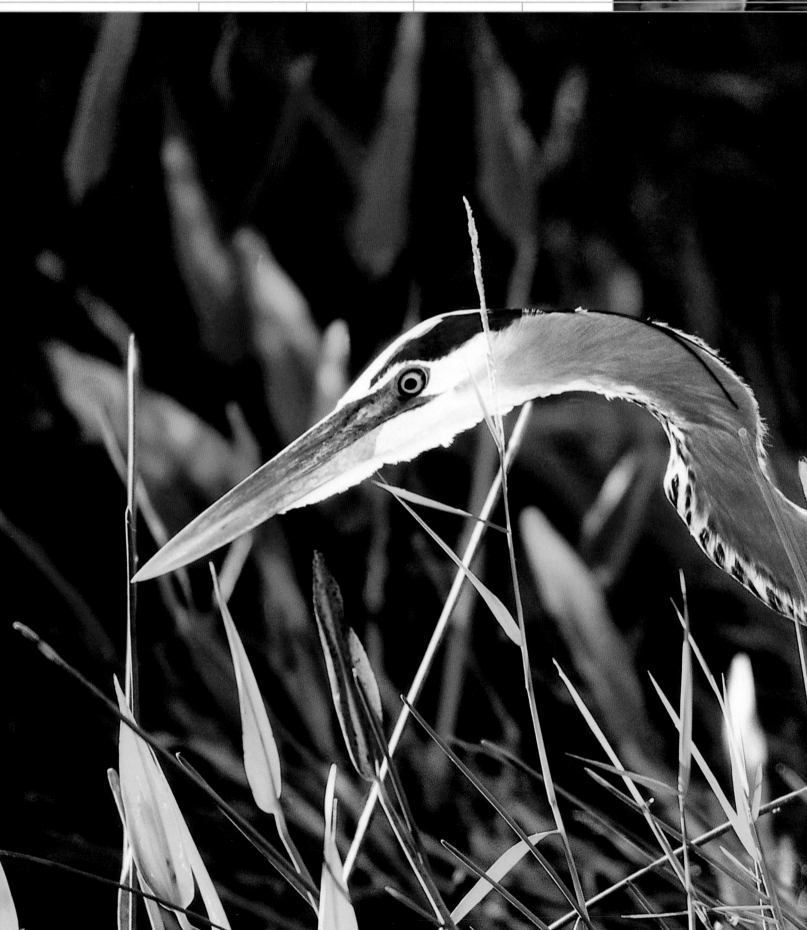

Between the "hammocks," island-like elevations in the "river of grass" overgrown with subtropical trees, the greatest variety of bird species can be observed. Above, from left: the roseate spoonbill (*Ajaja ajaja*), the snowy egret (*Egretta thule*), the tricolored heron (*Egretta tricolor*), and the American purple gallinule (*Porphyrula martinica*).

Nowhere else on earth can volcanism be better observed than on Hawaii's "Big Island." Two of the most active volcanoes on earth are part of the Hawaii Volcanoes National Park, and to this day lava is still forcing its way out of the depths of the earth to the surface.

Date of inscription: 1987

The landscape of the main island's south-eastern coast is forever being recreated by the eruptions of the volcanoes of Mauna Loa (4,170 m, 13,680 feet) and Kilauea (1,250 m, 4,100 feet). At relatively short intervals, these two active volcanoes eject quantities of red-hot lava, which flows down to the sea where it cools in clouds of steam, increasing the area of the island by 81 hectares (200 acres) in just the last thirty years.

Local religion explained the eruptions as manifestations of the moods of the fire goddess, Pele. For geologists, the eruptions are not just an impressive natural spectacle, but also the object of intensive study. Over the years, Mauna Loa has been created from layer upon layer of cooled lava. The

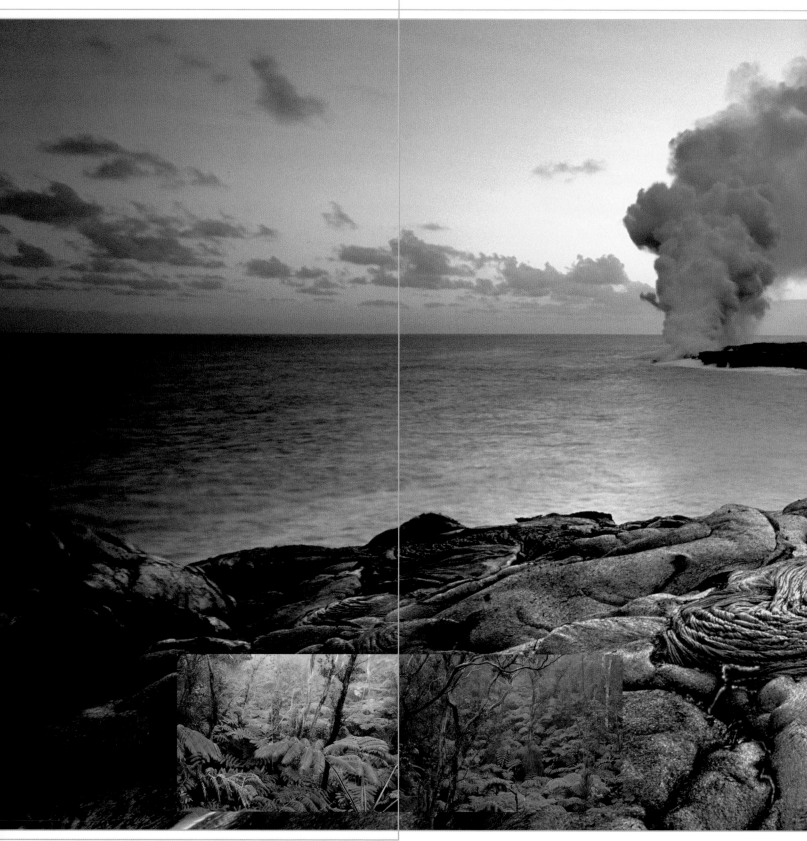

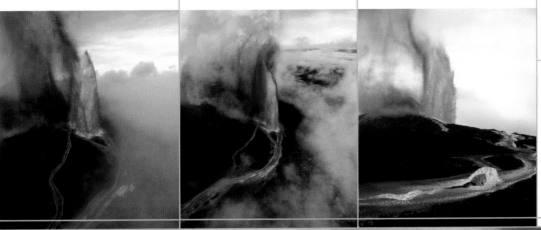

slopes of the more active Kilauea afford an insight into the various forms taken by volcanic vegetation.

Kilauea, spitting molten lava into the ocean (left). According to local lore, when the lava flows, Pele, the fire goddess, is angry. Dense thickets of ferns grow in the fertile volcanic soil (below left).

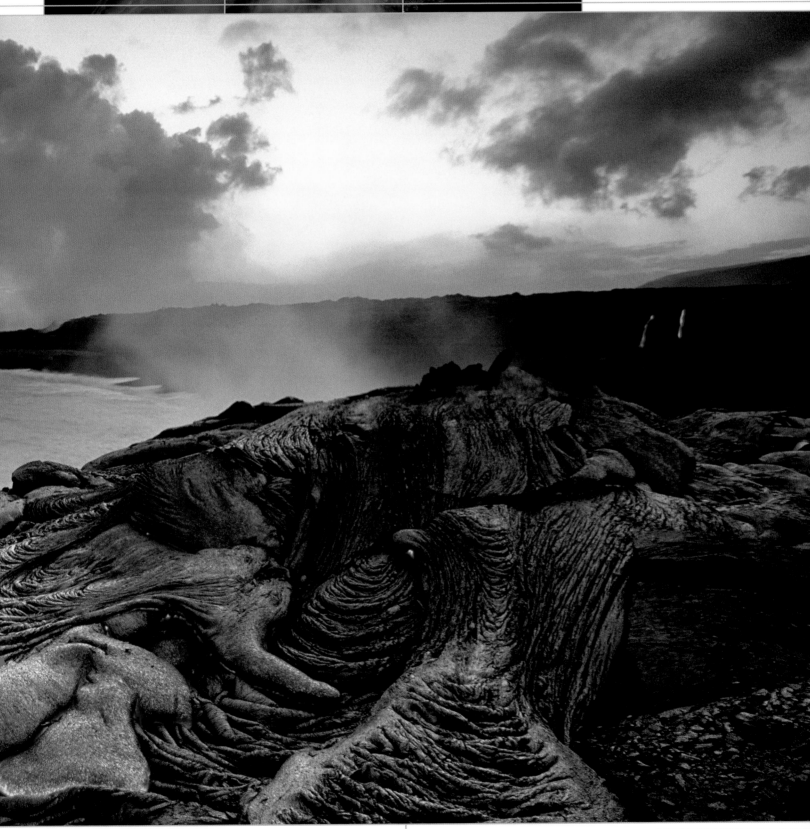

EL VIZCAÍNO
WHALE SANCTUARY

Every year, the coastal lagoons of the sanctuary play host to the mating whales and the birth of their calves. Blue whales, humpbacks, seals, sea lions, and elephant seals are also to be found here. Several species of sea turtle lay their eggs on the beaches, and some 200 bird varieties, including many which are endemic, nest or winter here.

Date of inscription: 1993

The lagoons of Ojo de Liebre and San Ignacio form, with others, a singular marine habitat that begins about halfway down the Baja peninsula in California and stretches right along the Pacific coast. Between December and March, these waters teem with gray whales. They come here to mate and raise their young, after having crossed 8,000 km (5,000 miles) of water from their summer home in the Arctic Bering Sea. Almost half of the world's population of gray whales are born in the waters of Baja California. What's more, five of the world's seven species of sea turtle are found here, and the coastal areas are an important wintering place for thousands of migrant species, such as the Pacific Brent goose.

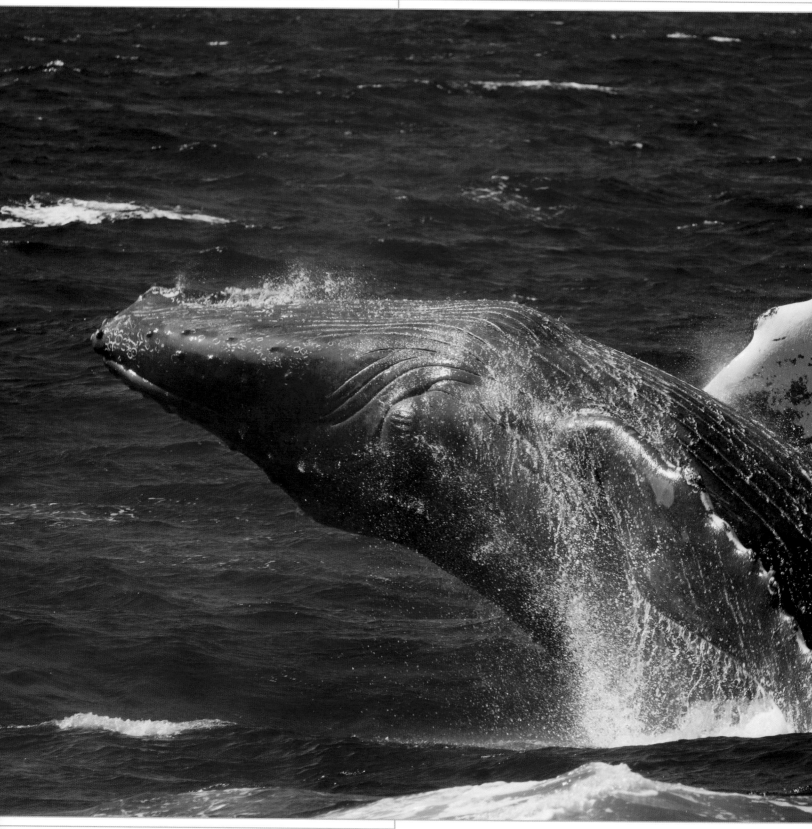

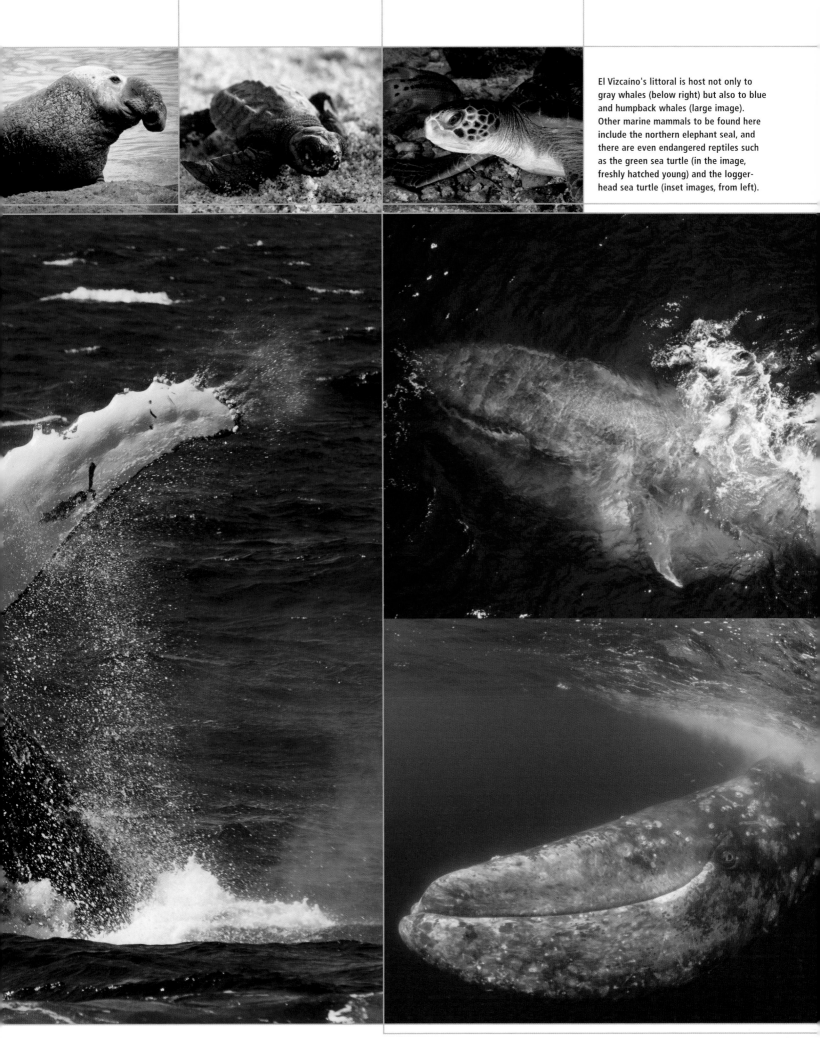

El Vizcaíno's littoral is host not only to gray whales (below right) but also to blue and humpback whales (large image). Other marine mammals to be found here include the northern elephant seal, and there are even endangered reptiles such as the green sea turtle (in the image, freshly hatched young) and the loggerhead sea turtle (inset images, from left).

THE ISLANDS AND CONSERVATION AREAS OF THE GULF OF CALIFORNIA

The World Heritage Site includes no less than 244 islands, outcrops of rock, and sections of coast, and is a habitat for an incredible variety of flora and fauna.

Date of inscription: 2005
Extended: 2007

The Gulf of California is a body of water 1,100 km (680 miles) long and 90–230 km (55–140 miles) wide, adjoining the Pacific Ocean and situated between the Mexican west coast and the Baja California peninsula.

The Gulf, together with the islands that lie in its waters, were formed by plate tectonic processes that separated the peninsula from the mainland between 17 and 25 million years ago, although seawater only flowed into the resulting depression in the earth's surface 4.5 million years ago. Nine regions have been placed under protection here, with a total surface area of approximately 18,000 sq. km (7,000 sq. miles), of which about three-quarters is marine. From north to south, these biosphere reserves, conservation areas, and national parks are: Upper Gulf of California and Colorado River Delta Biosphere Reserve; Islands and Protected Areas of the Gulf of California; the Island of San Pedro Mártir; El Vizcaíno; Bahía de Loreto; Cabo Pulmo; Cabo San Lucas; the Marías Islands and Isabel Island. The Gulf of California and its islands are considered a "natural

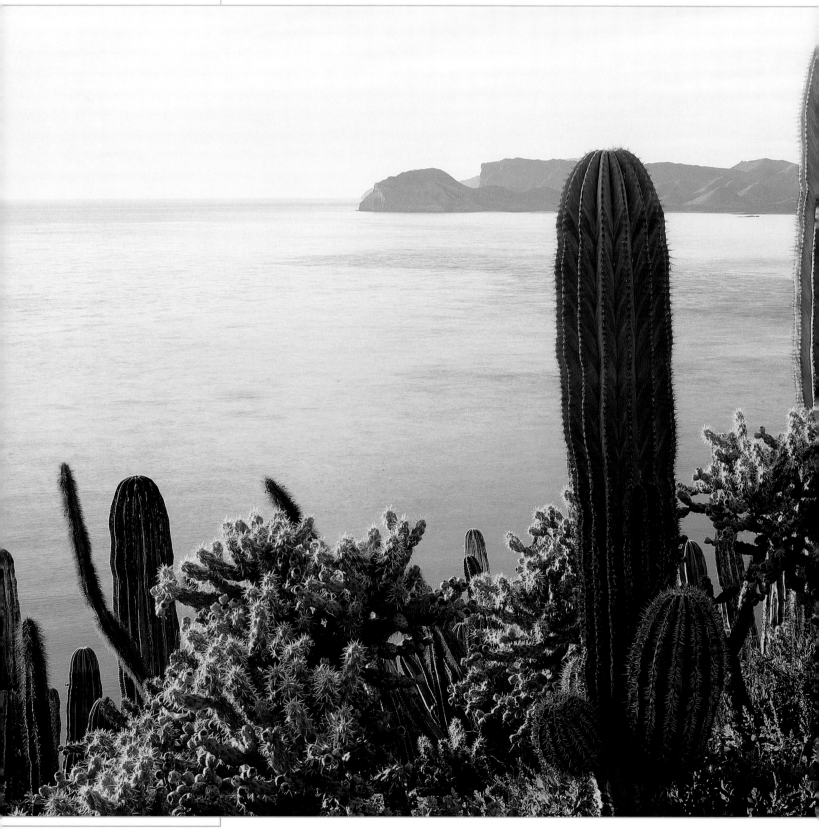

laboratory" for the study of evolution – 200 bird species from some 20 different orders are found here, in addition to 30 species of mammal and five of the world's seven species of turtle. Of the 891 species of fish in the marine conservation area, 90 are endemic. The islands are a veritable paradise for birds. The vegetation consists of many succulents and cactuses, including some of the world's largest; the Cardon cactus, *Pachycereus pringli*, for example, can reach a height of 25 m (82 feet). The diversity of an island's biotope is determined by its geographical location, its size, and its elevation; thus, Tiburón Island is home to 500 species, while the tiny island of San Pedro Mártir supports barely 30.

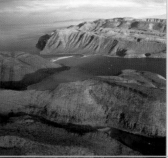

The spectacular scenery of the islands in the Gulf is composed of abrupt cliffs, sandy beaches, and lapis lazuli ocean (left: Espíritu Santo). The vegetation is characterized by succulents and cactuses, including the giant Cardon cactus (below). The islands are a paradise for birds and are home to the world's largest population of blue-footed boobies (below right).

THE MARIPOSA MONARCA BIOSPHERE RESERVE

The Mariposa Monarca Biosphere Reserve is located about 100 km (62 miles) north-west of Mexico City. Every year it becomes the home of millions of monarch butterflies which seek out the moderate climate of the Mexican uplands for their winter quarters.

Date of inscription: 2008

The biosphere reserve covers 56,259 ha (139,000 acres) of montane forest at an elevation of about 3,000 m (9,900 feet) above sea level, running along the border from the state of Michoacán to the capital, Mexico City. It is named after the migratory monarch butterfly, which in the fall travels south for some 4,000 km (2,500 miles) from the USA and Canada to Mexico. Every year, the bare rocks of the Mexican plain are the scene of a fascinating natural spectacle as several hundred million monarch butterflies arrive on the reserve and turn the whole landscape orange. The butterfly's migration is an astounding phenomenon: hatching in North America, the creatures come to Mexico, passing the winter in a kind of

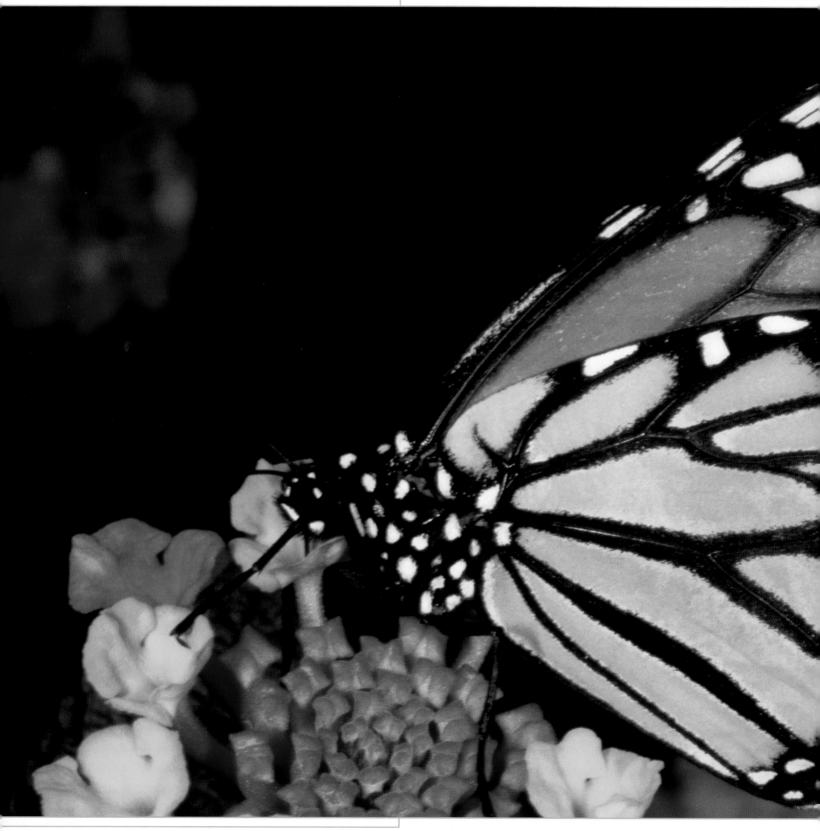

suspended animation. In the spring they return north, crossing the southern states of the USA and depositing their eggs on the leaves of the milkweed plant, a poisonous plant with silky leaves, whereupon the generation that has just spent the winter in Mexico dies. After metamorphosis, the new butterflies continue the journey north, and during the summer months three further generations will pass, some of whom may begin the journey south again. Only the fourth generation will return to Mexico. The biosphere reserve was established in the 1980s and houses several *sanctuarios*, or protected zones, intended to preserve the butterfly's habitat from increasing human settlement and unregulated logging.

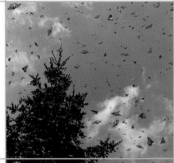

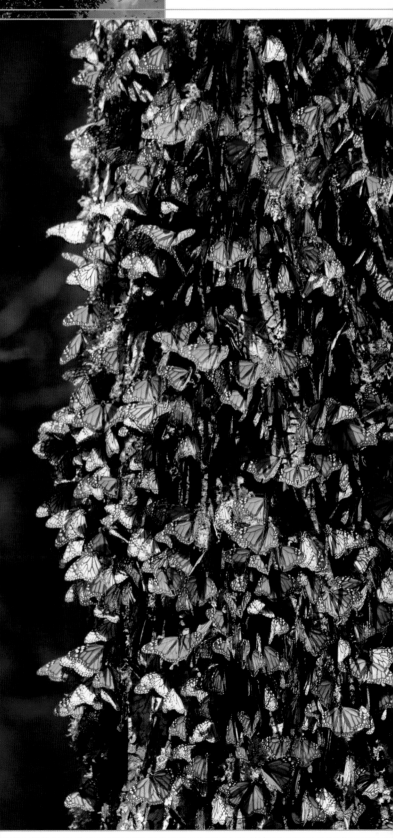

The wings of the monarch butterfly (*Danaus plexippus*) have an orange coloration with black and white markings.

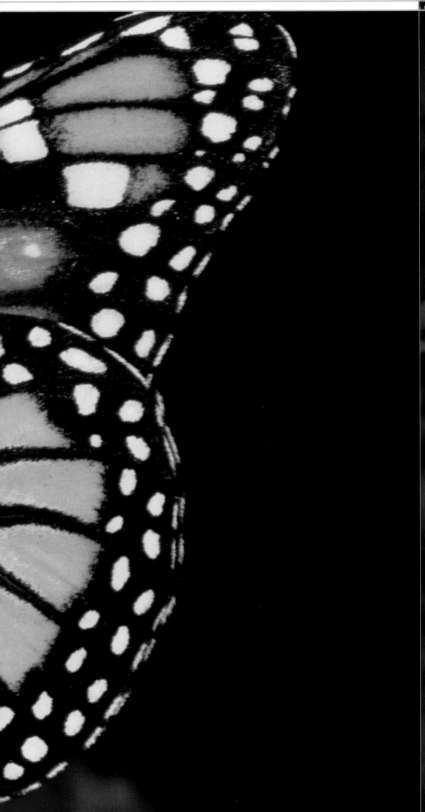

SIAN KA'AN BIOSPHERE RESERVE

This nature reserve on the Caribbean coast of Mexico has a diversity of biotopes, offering ideal living conditions for all kinds of life.

Date of inscription: 1987

Covering a total surface area of more than 5,000 sq. km (1,900 sq. miles) of the eastern Yucatán peninsula, Mexico's largest nature reserve – known in the Mayan language as Sian Ka'an, meaning "a gift from heaven" – offers sublime living conditions for a variety of unique flora and fauna. A big advantage is that only around 2,000 humans live here, mostly in the towns of Punta Allen and Boca Paila.

No less than 17 different zones of vegetation exist here, in close proximity to one another, including evergreen, deciduous, coniferous, and rain forests; mangrove swamps, savannah, and flood plains; and 100 km (62 miles) of coral reef and lagoons. These are a habitat for over 100 mammals, including rare predators such as jaguars, pumas, and ocelots, as well as other species, such as howler and spider monkeys. There are also manatees, crocodiles, and innumerable amphibians, including four rare species of sea turtle.

A quarter of the surface area of the park is taken up by ocean, principally in the Bahía de la Ascensión and the Bahía del Espiritu Santo. Some 350 species of bird populate the lagoons, trees, and sky. Sian Ka'an also has a total of 23 archeological sites, with finds from cultures dating as far back as 2,300 years ago. Its diversity is extraordinary and fascinating.

Crystal-clear streams (large image), elephant trees (above), brown pelicans (below) – all can be found at Sian Ka'an.

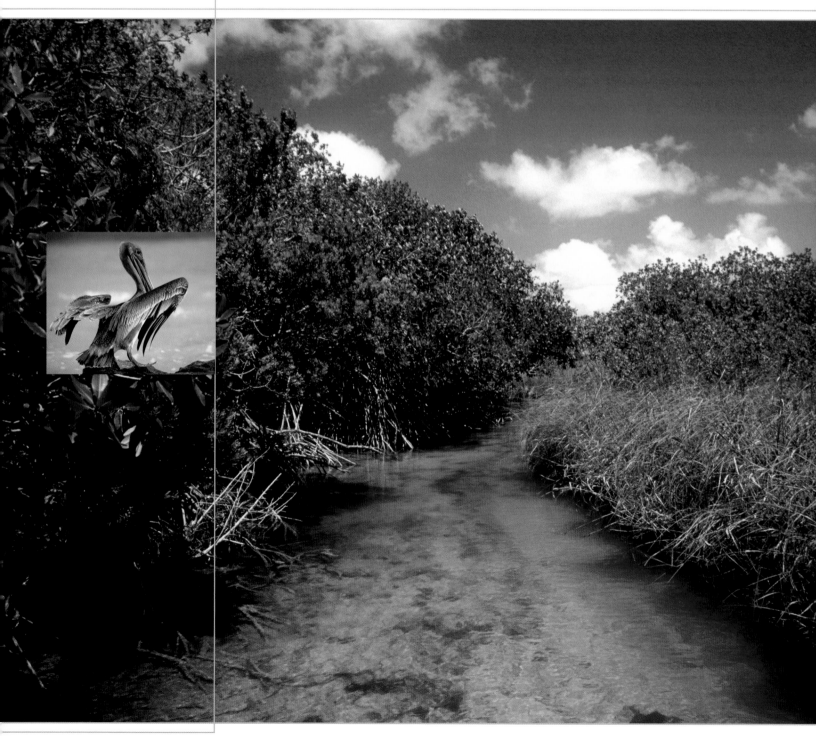

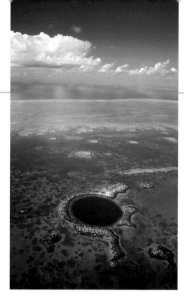

The longest barrier reef in the northern hemisphere is situated along the edge of the continental shelf off the Belize coast. This unique and vivid underwater paradise is a refuge for many endangered species.

Date of inscription: 1996

The Atlantic Ocean's largest series of coral reefs forms a highly complex ecosystem. It is composed of over 250 km (155 miles) of barrier reef, three large atolls further offshore, and hundreds of scattered islands known as "Cays," on which 170 plant species grow. Its mangroves, sandy beaches, and lagoons offer ideal living conditions for birds, including endangered species such as the red-footed booby, the magnificent frigate bird, and the lesser noddy.

The World Heritage Site amounts to 1,000 sq. km (390 sq. miles) and consists of seven conservation areas and national parks. It includes various types of reef, made from 65 different varieties of coral. These bizarrely shaped growths and columns are a habitat for innumerable species, including 250 different water plants and 350 molluscs, sponges, and crustaceans, and some 500 species of fish, ranging from eagle rays to groupers. Highly endangered marine animals such as manatees and loggerhead and hawksbill turtles also live in the conservation areas.

The Blue Hole, some 125 m (400 feet) deep, was created when an underwater cave collapsed (right). The prolific mangrove islands which lie off the coast are a habitat for all kinds of sea life (below).

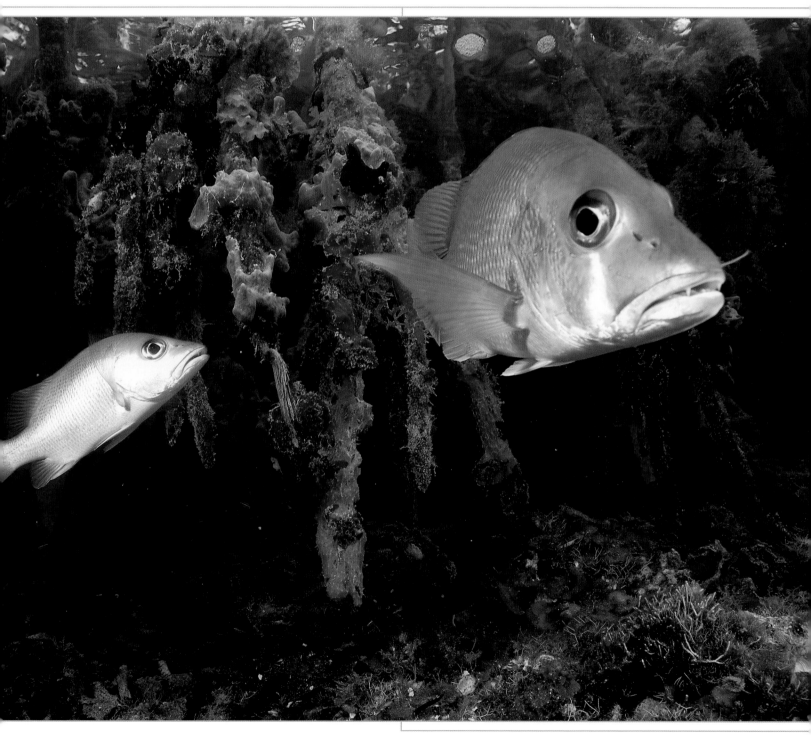

Tik'al, in north-eastern Guatemala, is among the most significant ruins left from the Mayan culture. The earliest settlement of this site in the Petén rainforest was completed by 800 BC. A gigantic complex with temples and palaces was built here in the 3rd century AD.

Date of inscription: 1979

Tik'al is distinct from other Mayan sites in that it is located in the middle of a national park. The park's 600 sq. km (230 sq. miles) of primeval forest are home to howler monkeys, birds, tree frogs, and many other animals. At the height of Tik'al's expansion (AD 550–900), up to 90,000 people lived in this temple city. More than 3,000 structures and edifices have so far been excavated in the 15 sq. km (6 sq. miles) of the heart of the city, including great palaces, simple huts, and games fields. The most spectacular are the five gigantic step pyramid temples; one of these is 65 m (215 feet) tall, and thus is the largest known Mayan structure.

Around AD 800, this cultural complex boasted 12 temples, constructed on a

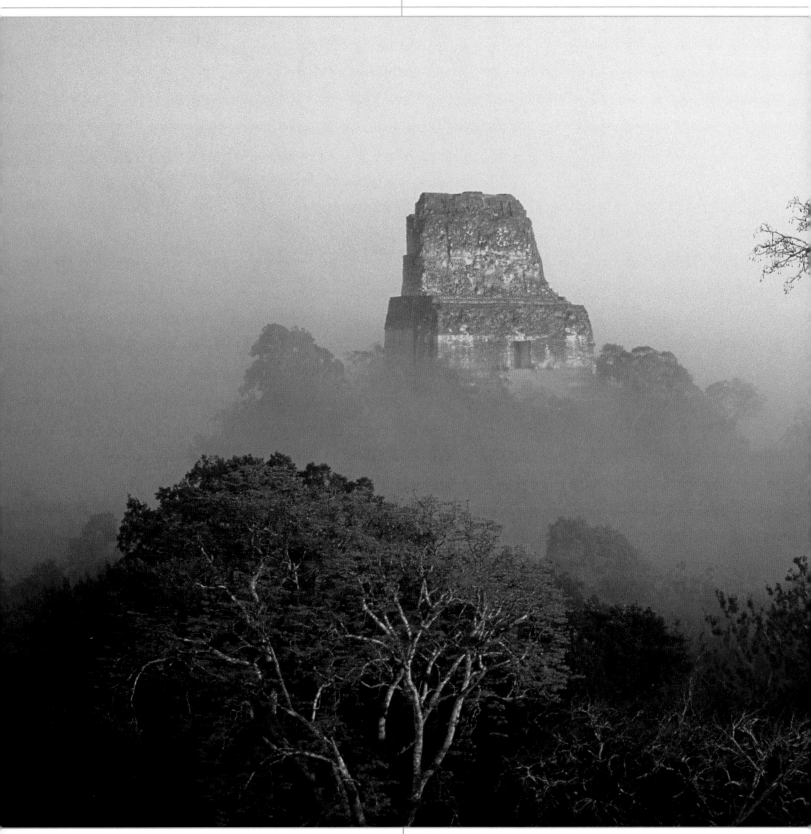

giant platform. Near these monumental buildings archeologists have uncovered numerous tools and religious objects, as well as a series of valuable grave goods.

No significant building work was attempted in Tik'al from the 9th century, and the city was finally deserted during the 10th century. It is a spectacluar site.

The contours of a monumental pyramid temple are glimpsed as an unreal silhouette through the mists of the Petén rainforest in Guatemala (large image). These vase fragments (left), excavated at Tik'al, bear witness to the sophistication of Mayan ceramic culture.

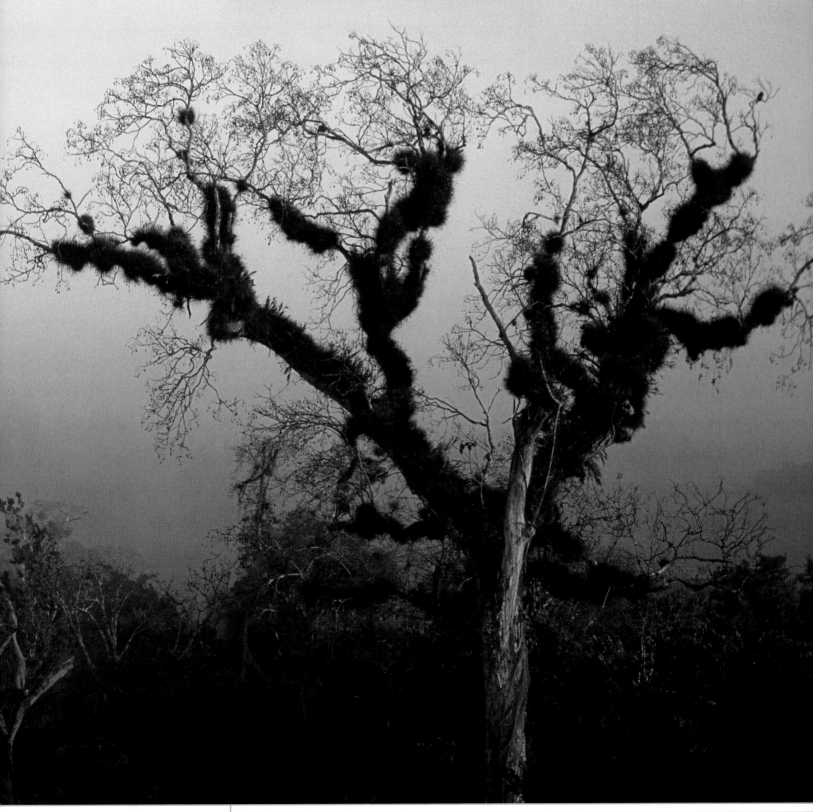

RÍO PLÁTANO
BIOSPHERE RESERVE

This biosphere reserve in the Río Plátano contains a considerable portion of the world's second-largest continuous area of rainforest. Due to its varied ecosystems, it houses a fantastic wealth of animal and plant life.

Date of inscription: 1982

The biosphere reserve covers 8,300 sq. km (3,200 sq. miles) of the Río Plátano, from the north coast to an elevation of 1,300 m (4,250 feet) in the interior of Honduras. This predominantly mountainous area takes up approximately 7 percent of the country's total surface area and includes several different biotopes. Behind untouched sandy beaches on the coast lie lagoons and mangrove forests, coastal savannah with beak-sedge and other marsh plants, and palms and umbrella pines. Further into the interior, there is tropical and subtropical rainforest, and all the diversity that these bring.

Over 2,000 vascular plant species grow here, alongside numerous trees, from the Spanish cedar to mahogany,

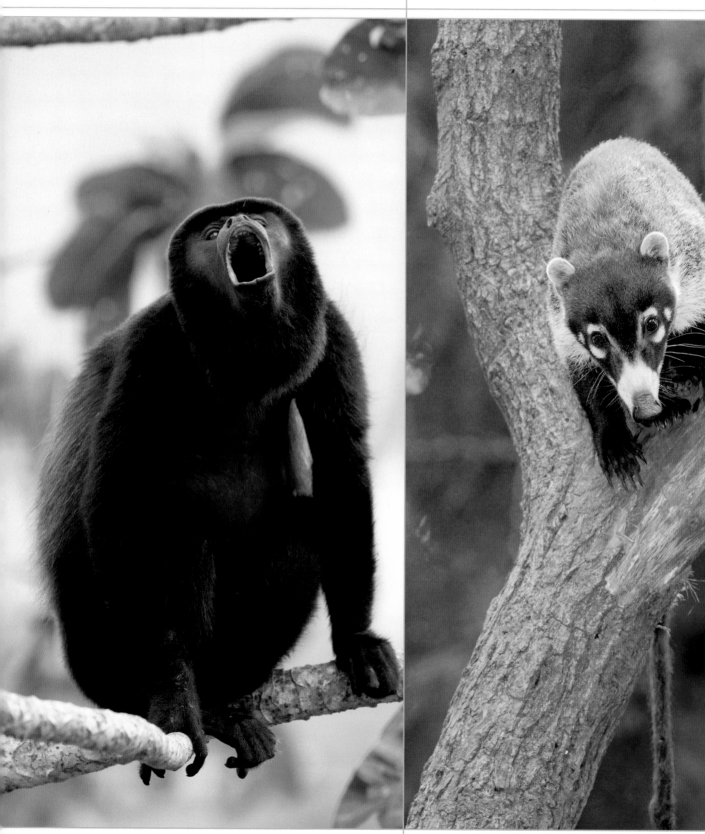

balsa, and sandalwood. Forty mammal, 380 bird, and 130 reptile and amphibian species have been recorded so far, and many others are no doubt yet to be discovered. The reserve is home to jaguars, pumas, ocelots, king vultures and harpy eagles, manatees, tapirs, and pakas; several species of monkey are to be found screaming and tumbling in the treetops. This sparsely populated region is home to only a few thousand people – the indigenous Miskito, Pech, and Tawahka, the Garifuna (an ethnic group with Caribbean and African roots), and mestizos. There are more than 200 archeological sites to be found on the reserve, bearing traces of both Mayan and another unknown pre-Columbian culture.

An unknown, pre-Columbian culture left behind artfully carved petroglyphs in the Río Plátano (above left). Among the animal inhabitants of the reserve are (below, from left to right) the mantled howler monkey, the white-nosed coati, the white-throated capuchin, and the three-toed sloth.

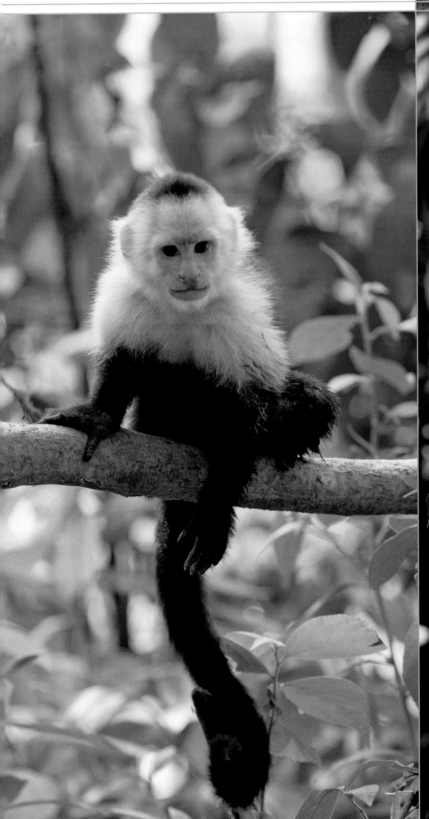

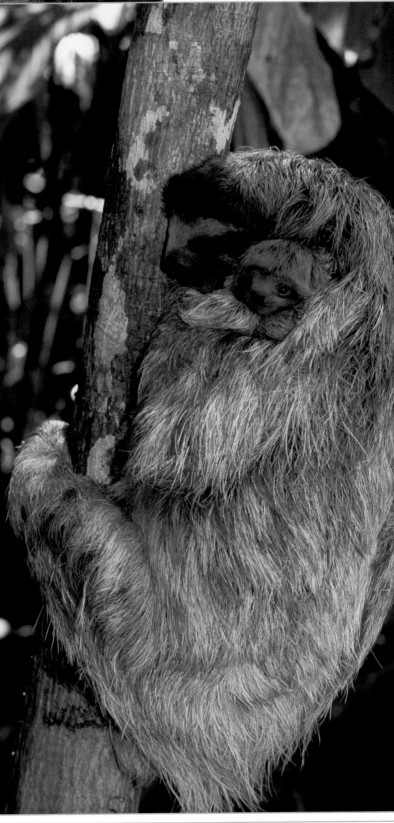

GUANACASTE CONSERVATION AREA

This extensive conservation area in north-western Costa Rica allows the observation of important ecological processes on land and in the coastal waters. The area is a habitat of many rare species.

Date of inscription: 1999; Extended: 2004

This area of 1,000 sq. km (386 sq. miles) in north-western Costa Rica consists of three national parks and several smaller conservation areas. It extends from the Pacific coast across the 2,000-m (6,600-foot) high mountains of the interior to the lowlands on the Caribbean side. Guanacaste encompasses coastal waters, islands, sandy beaches, and rocky coastland, as well as streams and rivers in the mountainous and volcanic landscape of the interior, including the still active composite volcano, Rincón de la Vieja.

No less than 37 wetlands are to be found here, along with mangroves and a tropical rainforest, whose trees shed their leaves in the hot season. This, the last great intact area of trop-

ical dry forest remaining in Central America, is one of the largest protected forest areas in the world. In total, some 230,000 species flourish in the various ecosystems. This impressive diversity is due to Guanacaste's location in a biogeographical area encompassing both neotropic and neoarctic life from South and North America.

Tropical dry forest (left) is characteristic of several sections of the Guanacaste National Park. Among its diverse fauna are Geoffroy spider monkeys (large image), scarlet macaws, Baird tapirs, margays, and giant anteaters (right, from top to bottom).

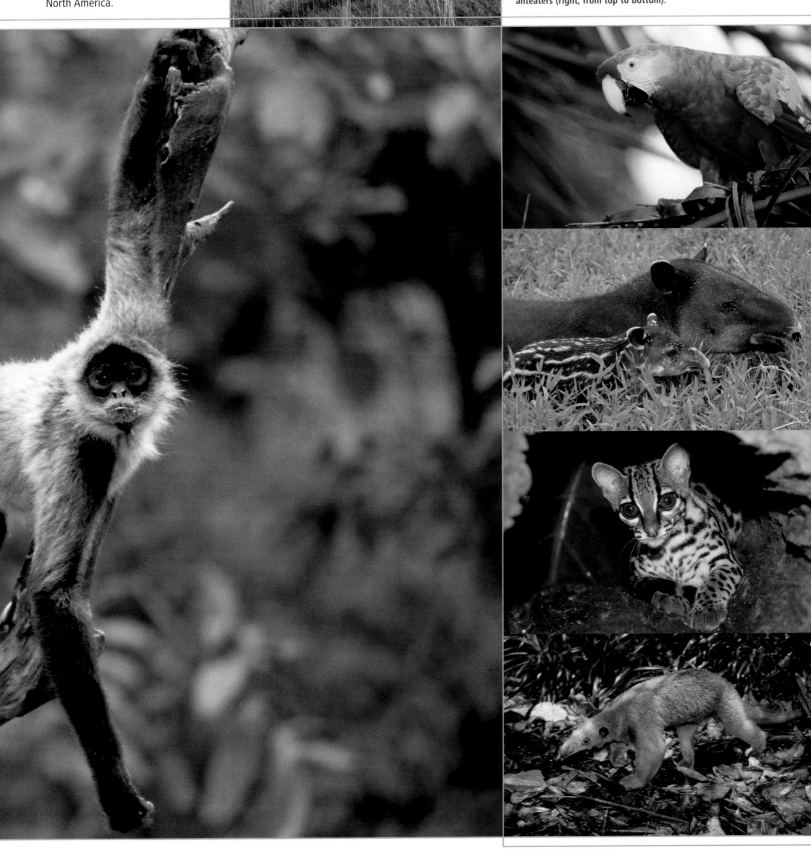

COCOS ISLAND NATIONAL PARK

Cocos is the only island in the East Pacific to be covered in tropical rainforest. Lying far from the mainland, it has evolved singular flora and fauna.

Date of inscription: 1997

Legend has it that infamous pirates buried treasure on Cocos Island in the 17th and 18th centuries – although no trace of any has yet been found. The treasure that this island, situated 550 km (340 miles) south-west of the coast of Costa Rica, definitely does have to offer lies in its tropical rain-forest. Due to its remote location, numerous endemic species have evolved here, such as the huriki tree (*Sacoglottis holdridgei*). In addition, three bird, two reptile, and more than 60 insect species are found only here. Some 100 sq. km (40 sq. miles) of coastal waters around the island also belong to the national park, and these contain large fringing reefs, with 32 species of coral and a wealth of marine life.

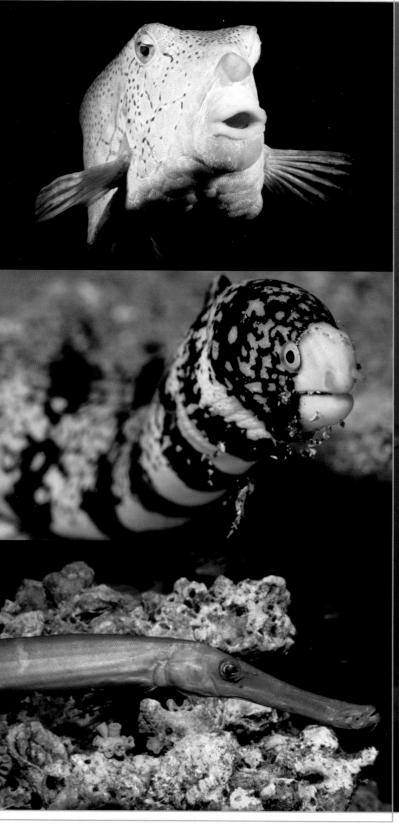

Dolphins, sharks (large image: scalloped hammerhead shark), manta rays, and 300 other species of fish live in the waters surrounding Cocos Island. The reefs teem with yellow boxfish, snowflake morays, and blue-spotted cornetfish (left, from top to bottom).

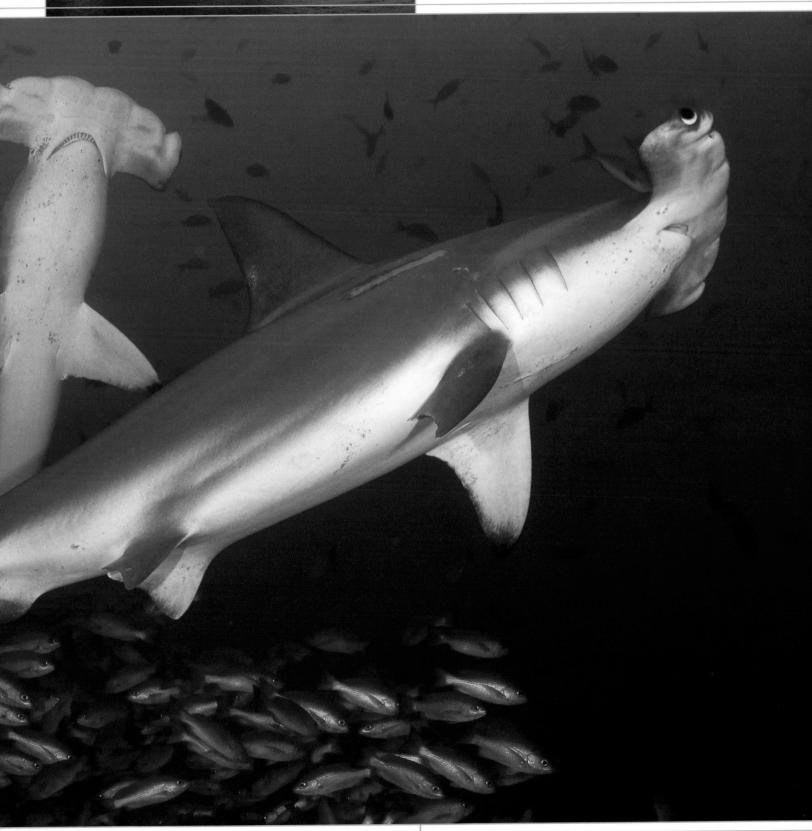

TALAMANCA RANGE AND LA AMISTAD NATIONAL PARK

This international conservation area, shared between Costa Rica and Panama, is home to a greatest diversity of life.

**Date of inscription: 1983
Extended: 1990**

This unique conservation area covers 8,000 sq. km (3,100 sq. miles) of the central Cordillera de Talamanca, stretching from the south of Costa Rica into the west of Panama. A tremendous range of scenery and habitats for wildlife is to be found at elevations that vary from sea level up to some 3,800 m (12,600 feet). The greater part of the reserve is covered in tropical rainforest, which has been growing here for 25,000 years. At elevations higher than the lowland plains there are cloud forests and areas of Páramo with bushes and grasses, as well as areas of evergreen oaks, moorland, and lakes. Due to its topographic and climatic variation, not to mention its geographical situation at the intersection of North and South America, the park boasts a diversity of animal and plant life.

Archeological finds suggest the possibility of human habitation here dating back millennia, but this research is still in its infancy. Today, around 10,000 members of the indigenous Teribe, Guaymi, Bribri, and Cabecar tribal groups live in reservations on the range.

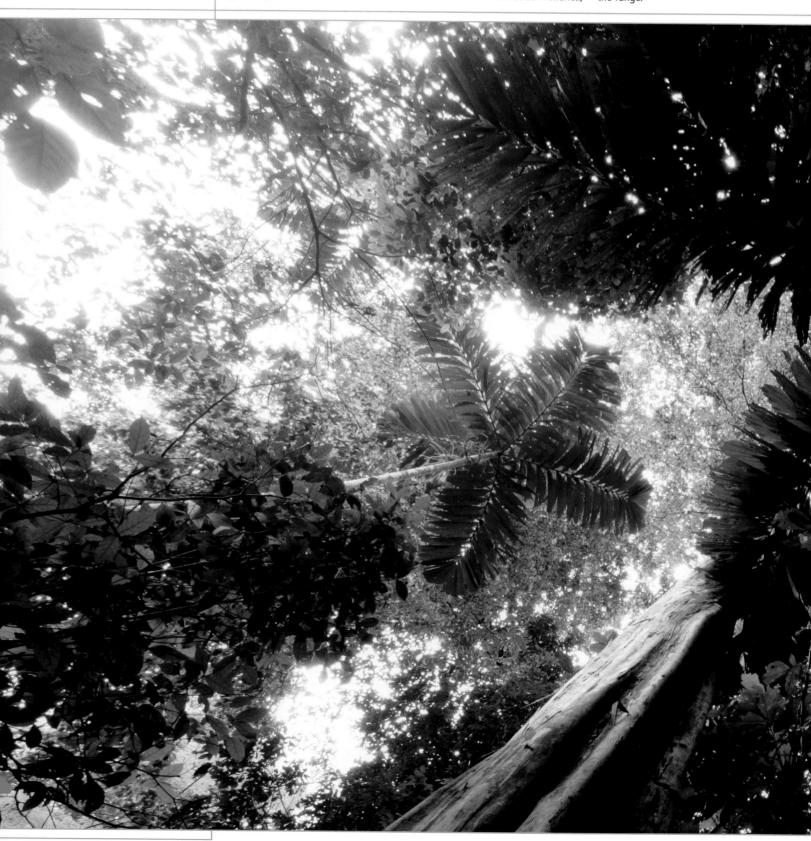

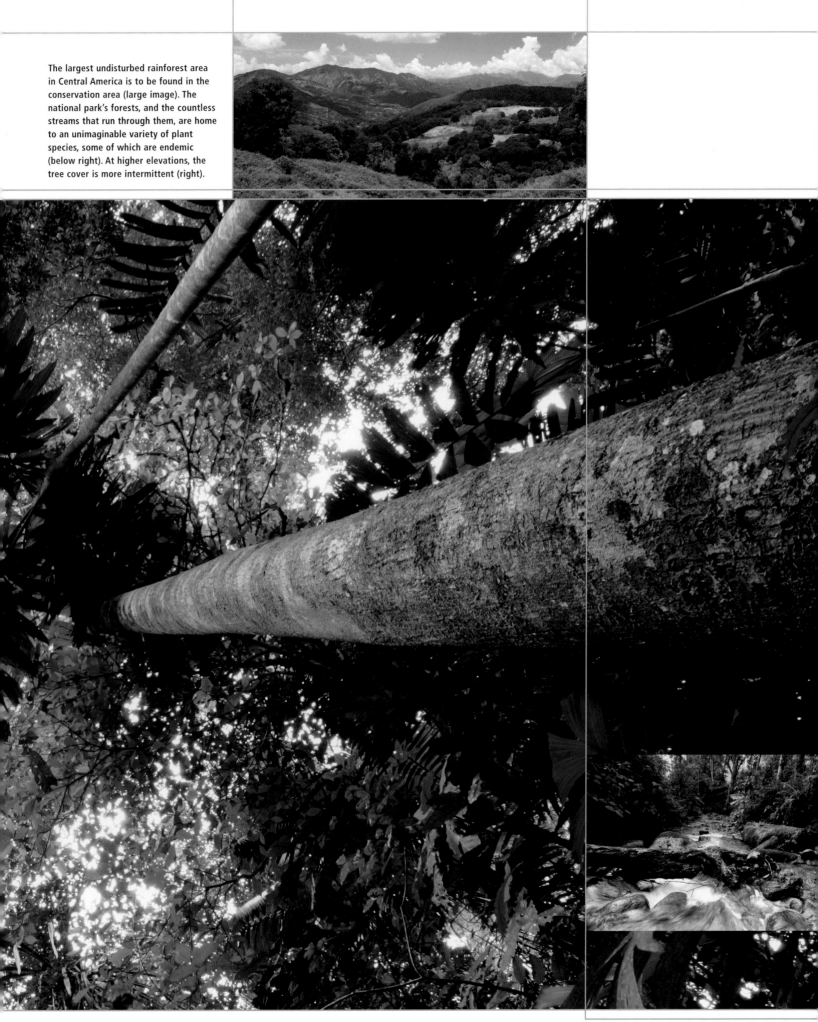

The largest undisturbed rainforest area in Central America is to be found in the conservation area (large image). The national park's forests, and the countless streams that run through them, are home to an unimaginable variety of plant species, some of which are endemic (below right). At higher elevations, the tree cover is more intermittent (right).

Some 600 bird species live in the park, and many are highly endangered. Among these feathered inhabitants are the red-tailed parrot (top right) and the quetzal (left and bottom), which had an exalted position in Aztec mythology.

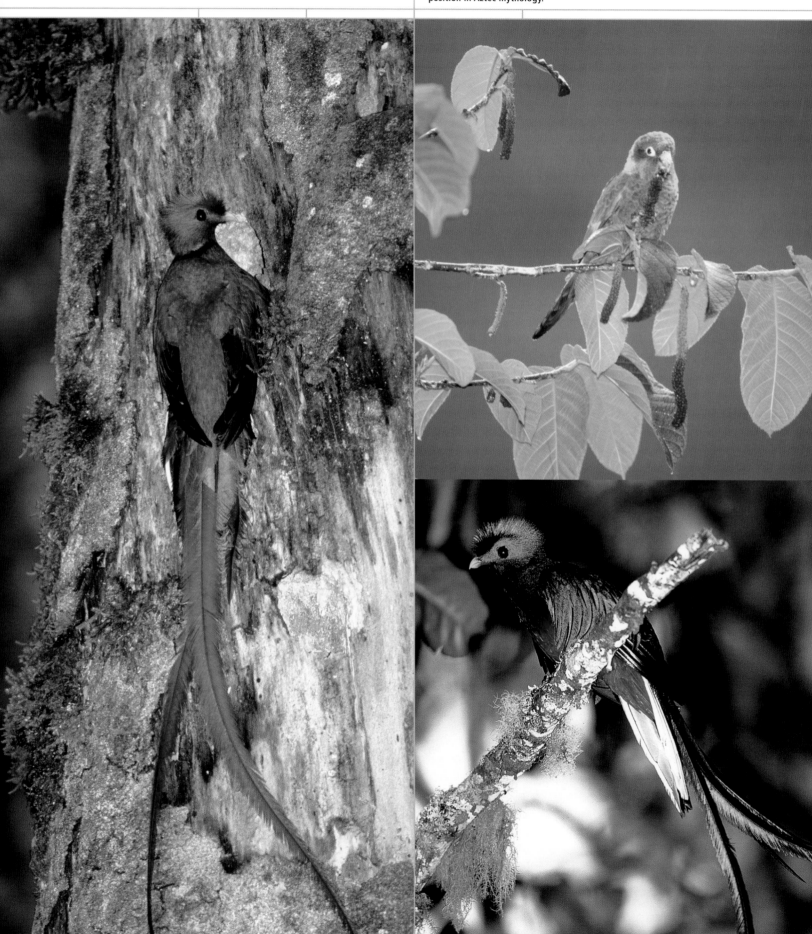

Among the variety of birds, along with various species of finch, falcon, and eagle, there are multi-hued acorn woodpeckers, attracted by the abundance of oaks in the park (left). The beautiful long-tailed silky flycatcher (right) lives in montane forest at elevations above 1,800 m (5,950 feet). The upper slopes in particular are home to around 40 endemic species.

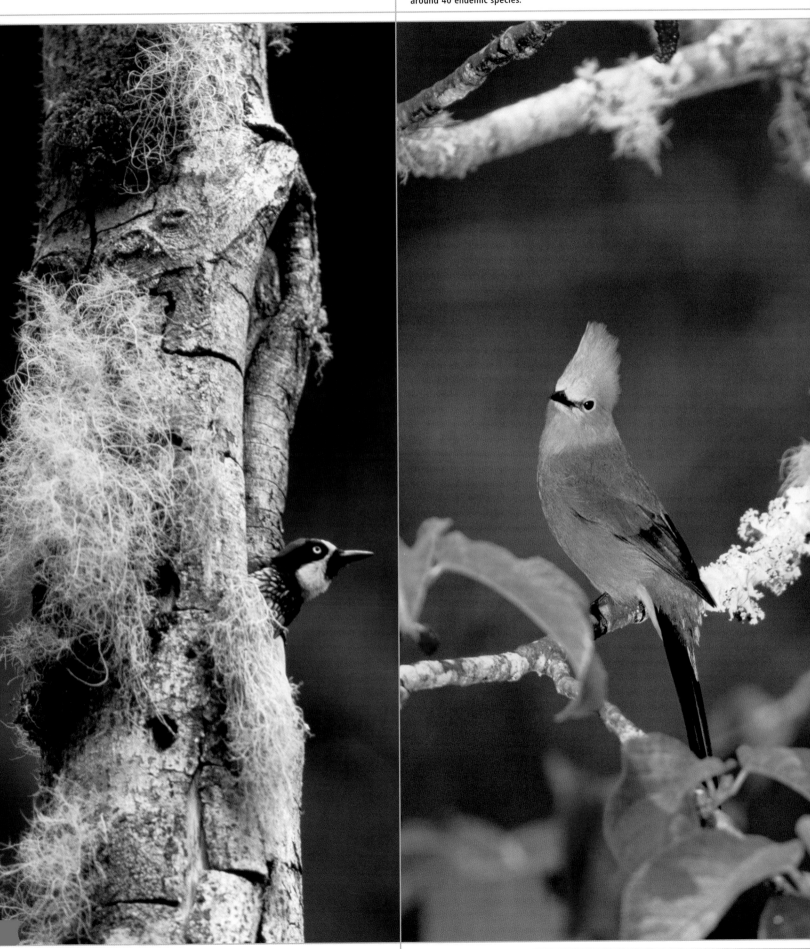

This conservation area, consisting of Pacific islands spared the storms and temperature variations associated with El Niño, has retained a great variety of species.

Date of inscription: 2005

The establishment of 4,000 sq. km (1,550 sq. miles) of the south-west coast of Panama as a national park has protected not only the rainforest of the island of Coiba, but also a further 38 smaller islands in the Gulf of Chiriquí and the immediately surrounding ocean.

The islands, which have been separated from the mainland for millennia, are of great interest to naturalists because of the evolution of various unique species and subspecies here. Among these endemic forms are rodents like the Coiban agouti, as well as several subspecies of howler monkey, opossum, and white-tailed deer. Coiba is also a last refuge for various endangered species that have died out in other areas of Panama,

such as the crested eagle and the scarlet macaw.

The marine areas of the park are especially rich in animal life, and house the Ensenada Maria Reef, which, at 160 hectares (395 acres), is the second-largest reef system in the Central East Pacific. More than 750 varieties of sea life have so far been recorded in this important refuge for

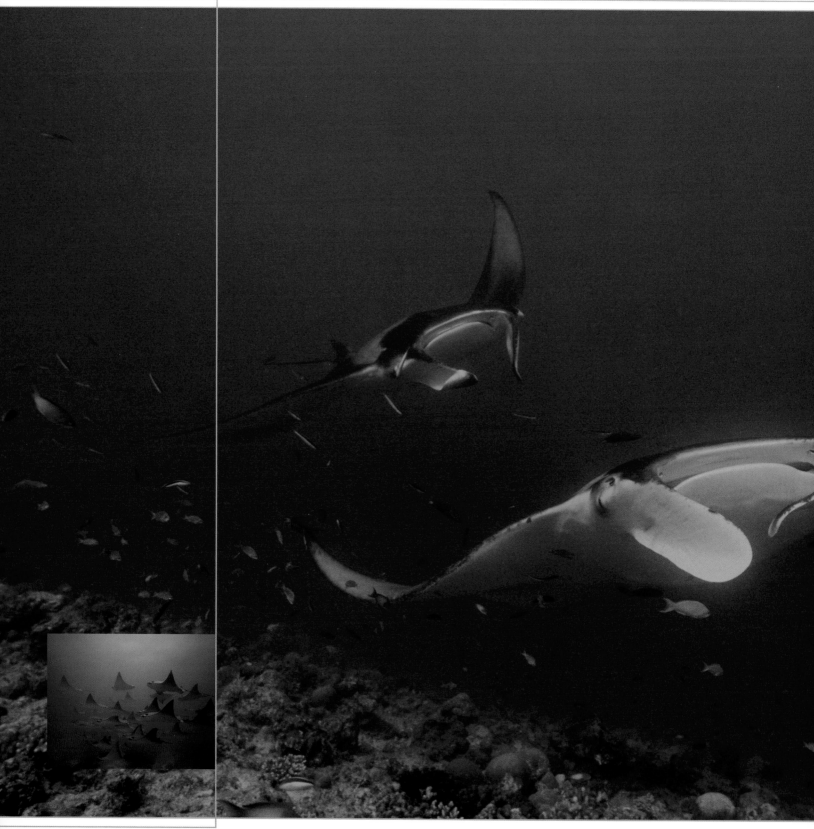

marine mammals and deep sea fish, including more than 30 varieties of shark, such as whale sharks and nurse sharks. Around 20 species of dolphins and whales add to the diversity. Giants such as orcas, humpback, and sperm whales can be observed here throughout the year.

Along with imposing manta rays, which can achieve a span of up to 7 m (23 feet, large image and inset, below left), the protected Gulf of Chiriquí's clear waters are home to a great number of shark species, including whale sharks (below) and nurse sharks (bottom).

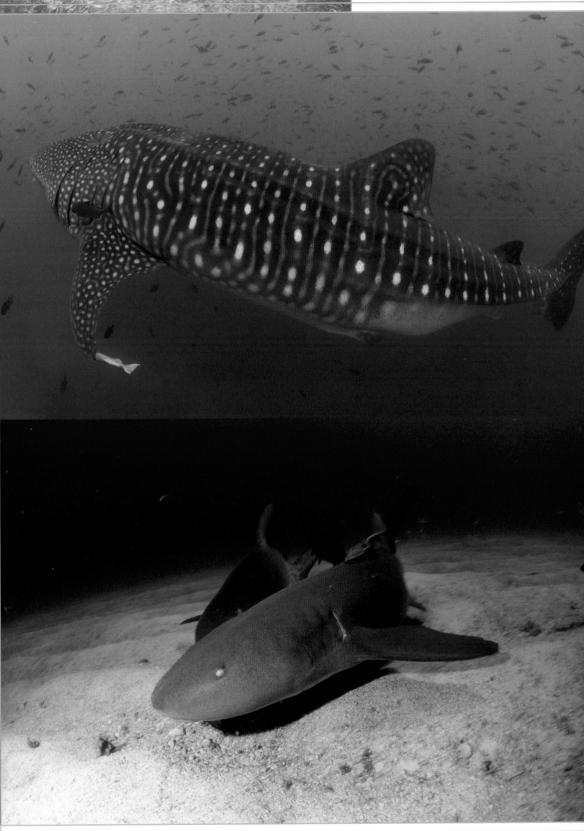

Until recently, the extent of the biodiversity of this enormous tropical wilderness could only be guessed at. Scientists have conjectured that thousands of species remain to be recorded in Darién.

Date of inscription: 1981

This biosphere reserve in eastern Panama covers 6,000 sq. km (2,300 sq. miles) and stretches from the Pacific coast to the 1,800-m (5,950-foot) high mountains of the Caribbean coast. The reserve encompasses the most diverse range of habitats, from sandy and rocky beaches, through mangrove intertidal flats, to various types of rainforest.

Its ecosystems are considered the most varied in tropical America. This wealth of habitats, and especially the park's situation at the meeting point of the furthest ranges of both South and North American species, ensure fantastic biodiversity. Some areas of the park are inhabited by members of the indigenous Kuna, Emberá, and Wounaan tribal groups.

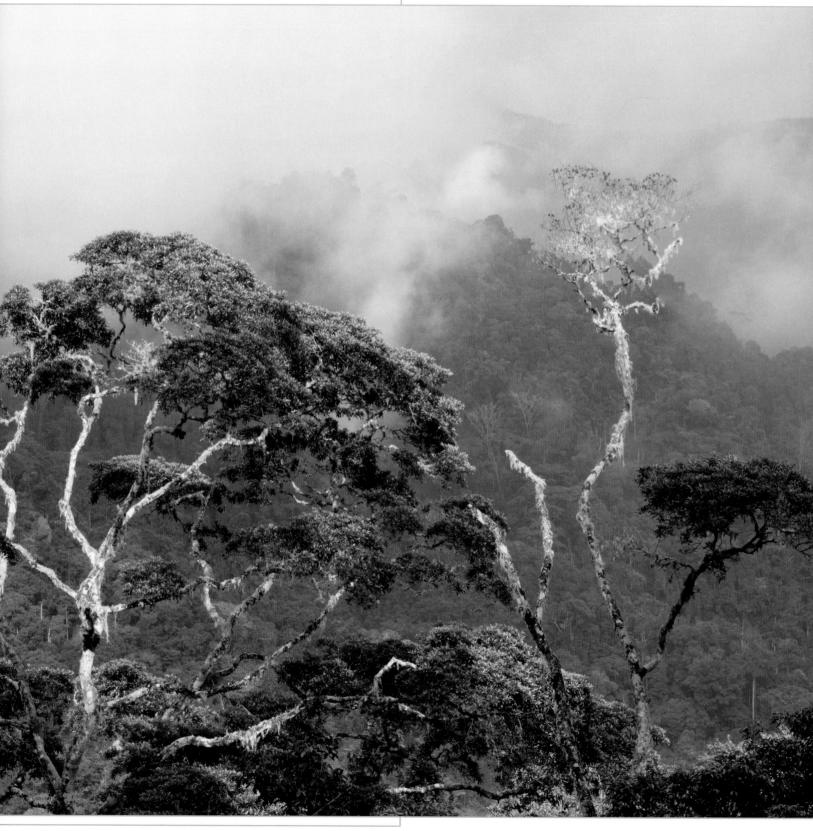

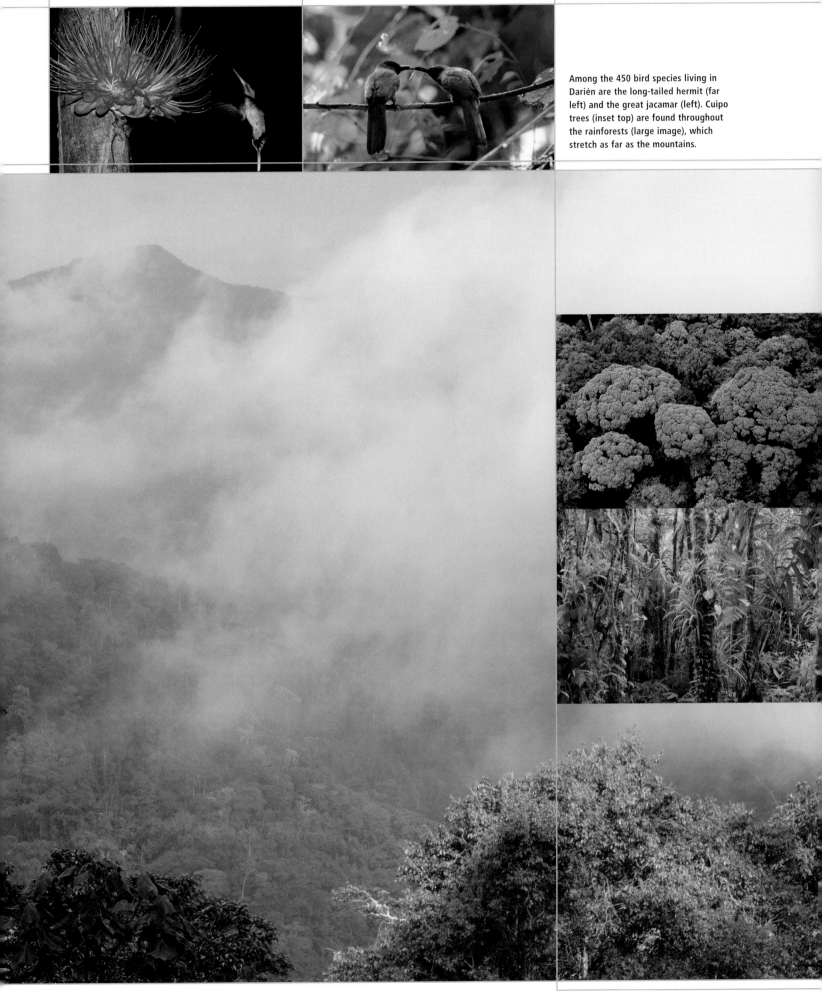

Among the 450 bird species living in Darién are the long-tailed hermit (far left) and the great jacamar (left). Cuipo trees (inset top) are found throughout the rainforests (large image), which stretch as far as the mountains.

DESEMBARCO DEL GRANMA NATIONAL PARK

These singular limestone formations, arranged like terraces at the edge of the Sierra Maestra, provide an important habitat for many rare land and marine species.

Date of inscription: 1999

The national park was named after the yacht on which Fidel Castro, Che Guevara, and 81 companions made landfall at Las Coloradas in Cuba to overthrow the Batista dictatorship in 1956 (a reconstruction of the boat can be seen at the place today). This unique coastal karst landscape of caves and canyons, surrounding Cabo Cruz, is one of the best-preserved of its kind in the world. It consists of limestone terraces, rising up to 360 m (1,180 feet) above sea level and reaching depths of 180 m (590 feet) beneath the surface.

The total protected surface area (including buffer zone) amounts to 400 sq. km (155 sq. miles) and lies at the still active convergence of the Caribbean and North American continental plates. Exactly how many varieties of plant flourish in the national park has not yet been accurately established; more than 500 species have been recorded so far, of which some 60 percent are unique. Few other places in Cuba offer such a concentration of endemic plants, and the animal world is equally diverse, with numerous species of mammals and amphibians. There are more than a hundred varieties of birds and nearly 50 reptile species, of which many are endemic. The West Indian manatee, a rare species of sea cow, is under particularly strict protection.

There are also countless insects and invertebrates, including fascinating, multi-hued butterflies, numerous snails, and many crustaceans. Several particularly rare sea turtles live in the offshore reefs. A series of caves, used by the pre-Columbian Taino people for ritual purposes, are of cultural and historical interest.

The rare West Indian manatee (*Trichechus manatus*, large image), a variety of sea cow, lives in the waters off the coast of the national park.

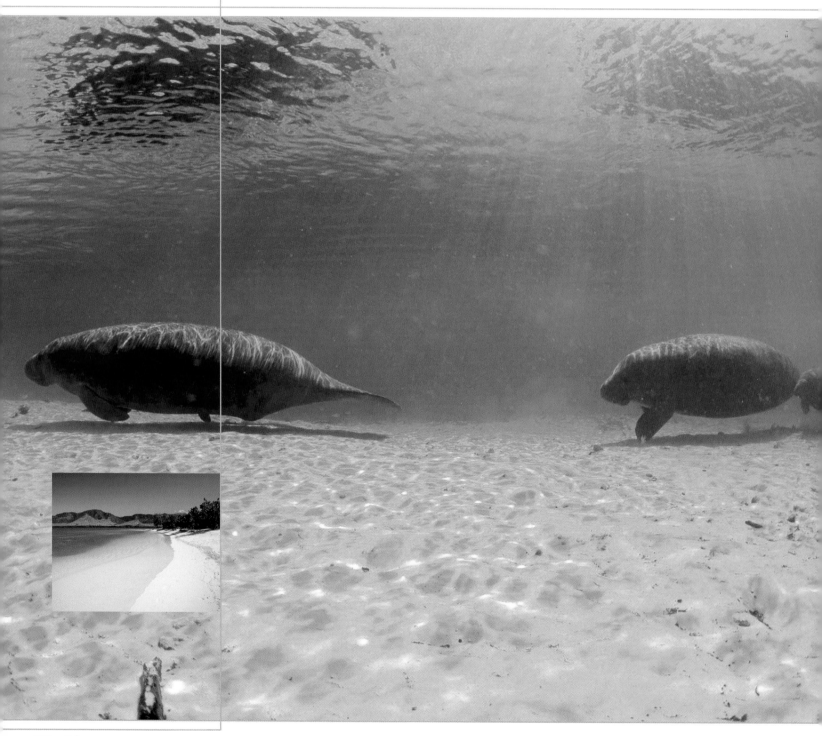

ALEJANDRO DE HUMBOLDT NATIONAL PARK

The relatively undeveloped eastern side of Cuba still retains fantastic natural landscapes. These – such as in the Alejandro de Humboldt National Park – represent probably the last refuge for many of the island's unique species.

Date of inscription: 2001

This national park, situated to the north-west of the eponymous town in the Alturas de Baracoa mountains, is largely given over for use as a biosphere reserve. Its 700 sq. km (270 sq. miles), of which 20 sq. km (8 sq. miles) are marine, boast a particularly rich diversity of ecosystems: a coastal region of coral reefs and mangroves, housing a reasonably large population of otherwise endangered manatees; wetland forests; and a mountainous region surrounding the 1,168-m (3,830-foot) high El Toldo, with its considerable stands of the endemic Cuban pine, one of more than 400 species found exclusively here, the "Noah's Ark of the Caribbean." These

statistics better those of previous "centers of endemism," such as the Galápagos Islands, by several orders of magnitude. The national park was named after the famous German explorer Alexander von Humboldt, who spent a total of four and a half months in Cuba between 1801 and 1804, principally in Havana.

There are only a few settlements in the national park (large image). Among its animal inhabitants are several species endemic to Cuba, including the Cuban amazon and the Cuban solenodon (right, above and below).

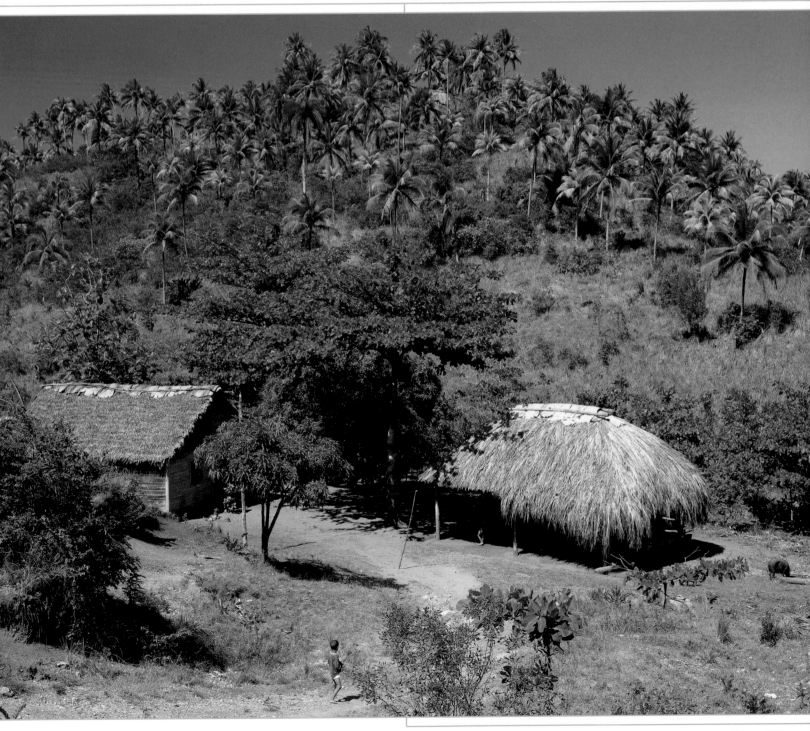

MORNE TROIS PITONS NATIONAL PARK

Morne Trois Pitons Park in Dominica, lying at the foot of the 1,342-m (4,400-foot) high mountain after which it is named, has enchantingly diverse tropical forests and all kinds of volcanic phenomena.

Date of inscription:1997

The Morne Trois Pitons National Park was established in 1975, and the rain and cloud forests, lakes and waterfalls on its 70 sq. km (27 sq. miles) provide a habitat for a variety of animal and plant life. Some 150 bird species inhabit the forests.

The various volcanic phenomena observable in the vicinity of the still-active Morne Trois Pitons volcano are of breathtaking beauty; there are hot springs, around 50 fumaroles, and five active volcanic craters. Hot mud bubbles in a boiling lake, and the aptly named "Emerald Pool" owes its extraordinary coloration to elemental processes taking place in the bowels of the earth.

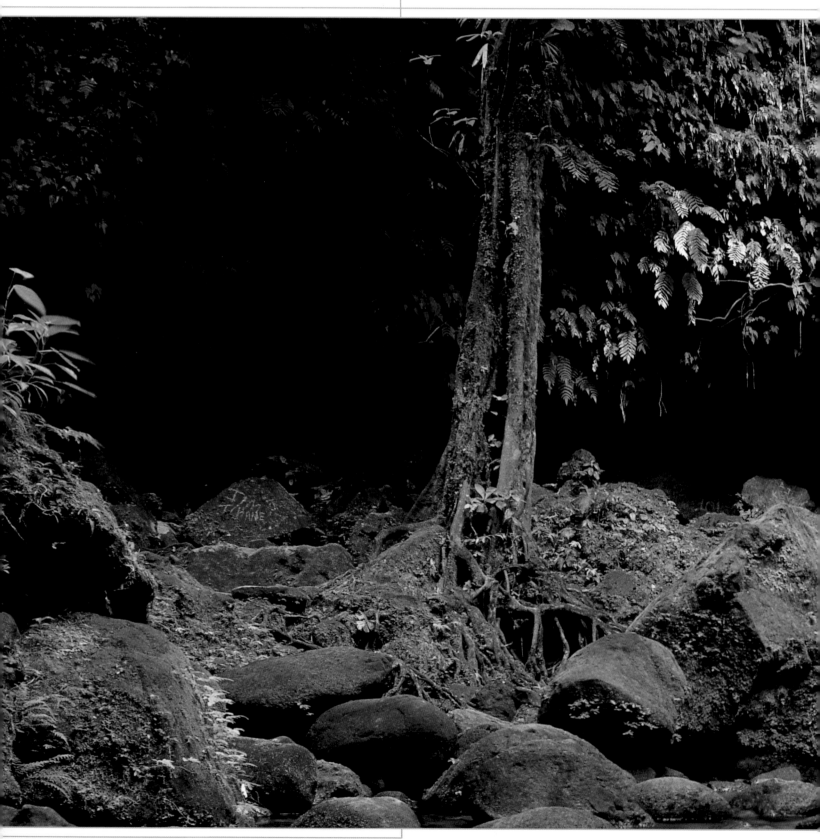

Fumaroles, such as these in the Valley of Desolation, betray the volcanic origins of the Morne Trois Pitons National Park landscape (far left). The other predominant element is water, in the form of lakes and waterfalls, as here at the Trafalgar Falls in the Roseau valley (left), or the Emerald Pool (large image).

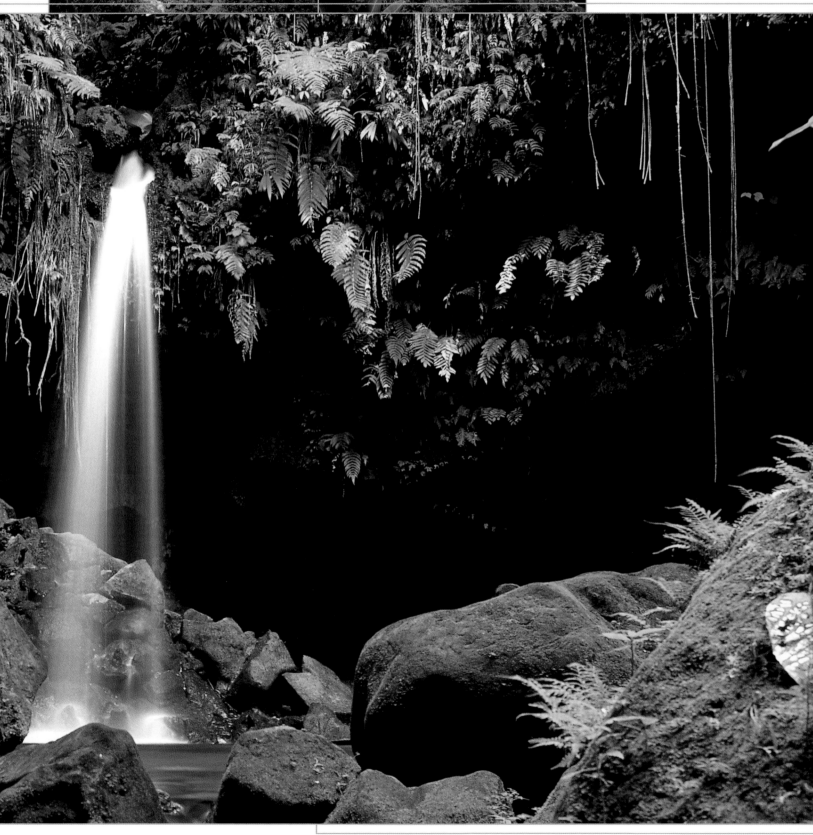

PITONS
NATURE RESERVE

Rising from the sea and connected by a ridge, these two domed volcanic peaks on the Caribbean island of St Lucia, both above 700 m (2,300 feet), are known as the Pitons.

Date of inscription: 2004

The World Heritage Site includes an area of 30 sq. km (12 sq. miles) at the south-western end of the island, near Soufrière. This is composed of the peaks of Gros Piton (770 m, 2,525 feet) and Petit Piton (743 m, 2,440 feet), the mountain ridge connecting these, a Solfatara field of fumaroles and hot springs, and the adjoining areas of ocean.

Up to 60 percent of the underwater region was once covered with coral, but in 1999 Hurricane Lenny destroyed much of this. The establishment of no-fishing zones has given the area some relief, and the waters around the Pitons are now among the most richly stocked in the Caribbean. The different species recorded include 170 fish, 60 jellyfish, 14 sponges, 11

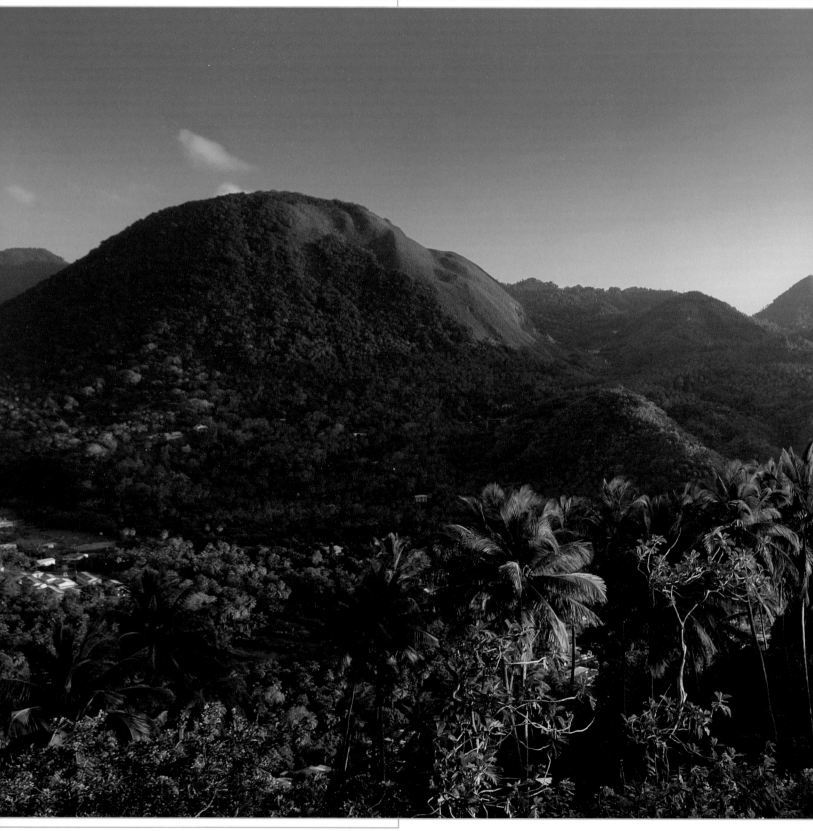

echinoderms, 15 arthropods, and eight annelids.

The predominant vegetation on the mainland is tropical rainforest, with small areas of tropical dry forest. Gros Piton is home to 150 recorded plant species, and Petit Piton about a hundred. Some 30 bird species are also to be found here, of which five are endemic.

The domed double peaks of the Gros and Petit Pitons are an easily visible landmark in the Lesser Antilles. The Nobel Prize-winning writer Derek Walcott, who comes from St Lucia, has called the two peaks, which were formed in a volcanic eruption, the "bosom of the Caribbean."

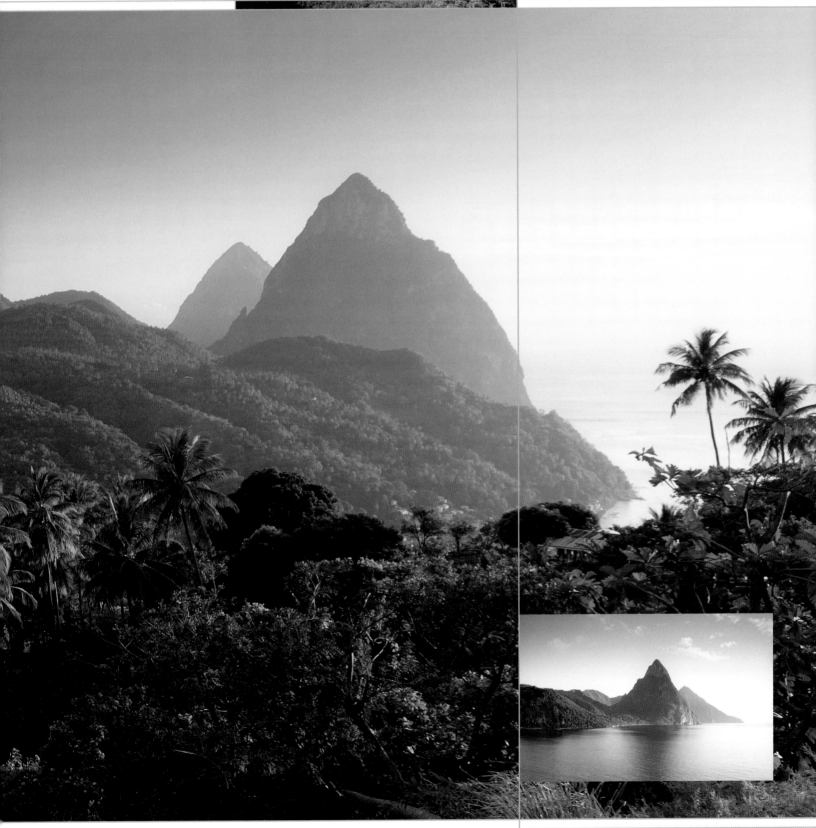

LOS KATÍOS
NATIONAL PARK

The national park in north-western Columbia, on the Panamanian border, is composed of low hills, rainforest, and swamps. This remote region provides a protected habitat for endangered species and numerous endemic plants.

Date of inscription: 1994

The national park has a total surface area of 720 sq. km (280 sq. miles), of which the eastern section encloses large parts of the swampy area surrounding the mouth of the Atrato river at the Gulf of Darién. The western section includes the jagged hill chain of the Serranía del Darién, a spur of the Western Andes Cordillera. Due to the high annual precipitation, which averages 3,000 mm (120 inches), extensive areas of swamp and rainforest have been able to evolve, and a variety of valuable timber grows here, such as balsa wood and rubber trees.

The inaccessibility of this primary forest has assured the survival of its varied plant life, much of which is endemic. It has also benefited the ani-

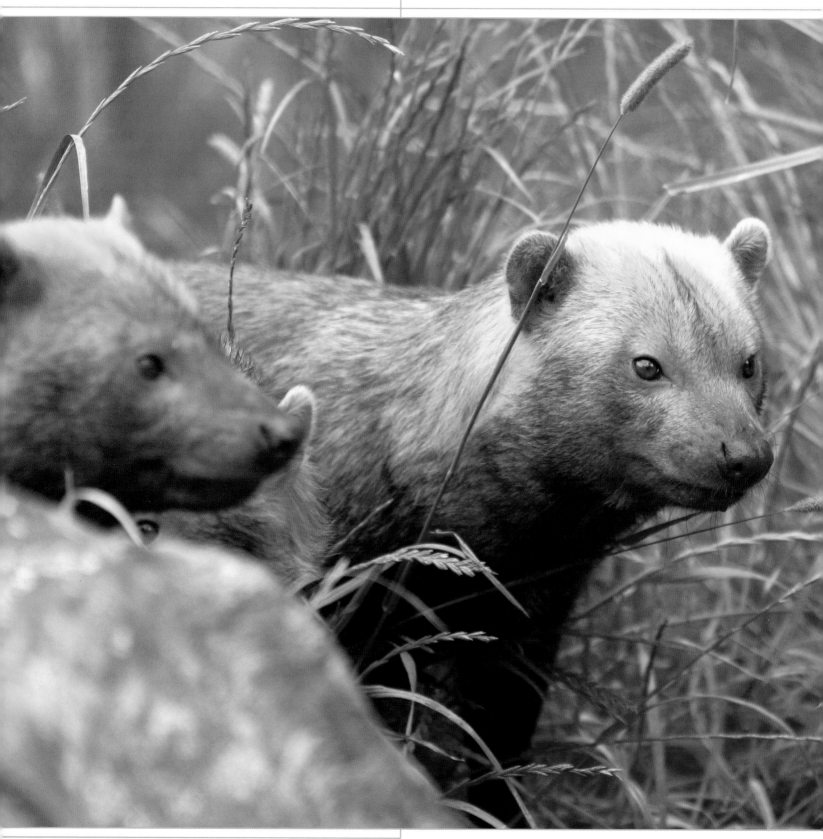

mal life; the forest is home to big cats, such as pumas and jaguars, but also to giant anteaters, tapirs, sloths, and various species of monkeys, including howlers, capuchins, and brown woolly monkeys.

There are also animals that otherwise only occur in Central America, such as the turkey-like gray-headed chachalaca.

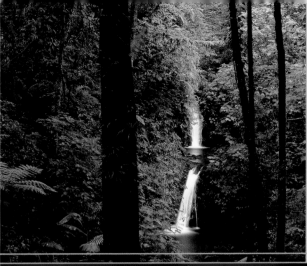

The bush dog (large image), a separate species of the dog family with a squat body, is an inhabitant of the national park, as is the ornate hawk eagle (below). There is a plentiful supply of water in the primeval forest in Los Katíos (left). The main river, the Atratos, is considered the fastest-flowing river in the world.

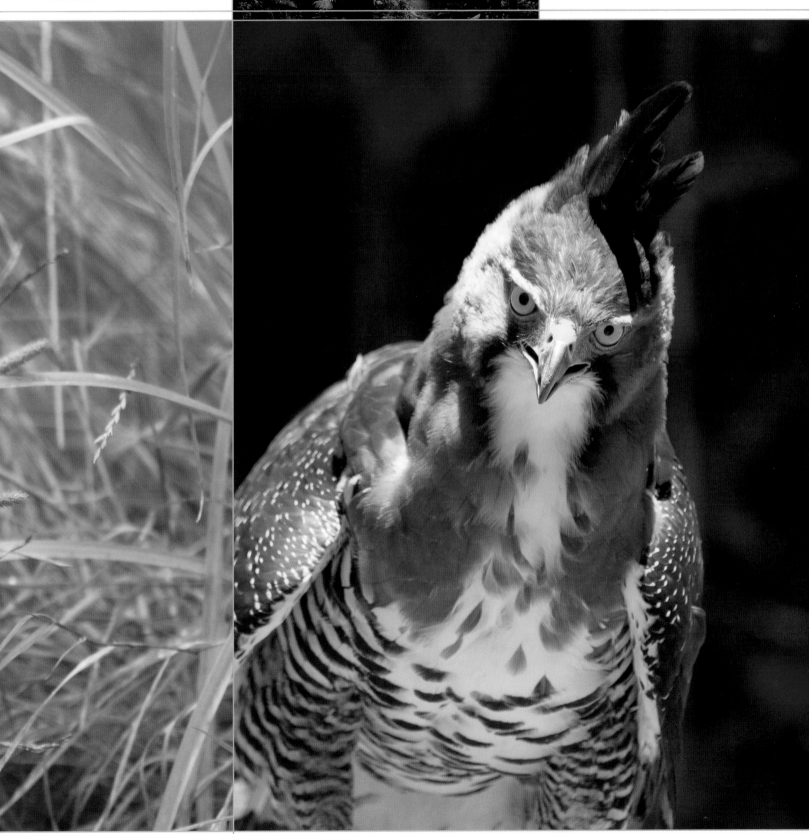

MALPELO NATURE RESERVE

This reserve in the tropical East Pacific, which includes the remote island of Malpelo and approximately 8,500 sq. km (3,200 sq. miles) of protected ocean, is home to numerous endangered marine animals.

Date of inscription: 2006

The island of Malpelo, measuring only 3.5 km (2 miles) across, lies in the Pacific, 500 km (310 miles) off the Columbian coast. Malpelo is part of a marine corridor connecting a series of World Heritage Sites, including the Galápagos Island (Ecuador), Coiba (Panama), and Cocos Island (Costa Rica). The island is the tip of the Malpelo ridge, and the seabed sur- rounding it can reach a depth of 3,400 m (11,200 feet).

Due to its varied underwater land- scape of high cliffs and vertiginous drops, deep canyons and caves, the waters around Malpelo are a popular spot for divers. The confluence of sev- eral ocean currents and the nature of the seabed here have conspired to create an exceptionally complex and rich ecosystem. The waters are a breeding ground for many marine ani- mals, including some 200 species of fish. Shark species are especially numerous and, along with the ham- merheads, whale sharks, and silky sharks, rare shortnose sawsharks roam the seas here. In addition, there are eagle and manta rays, seahorses, tuna, barracuda, bonitos, and snap-

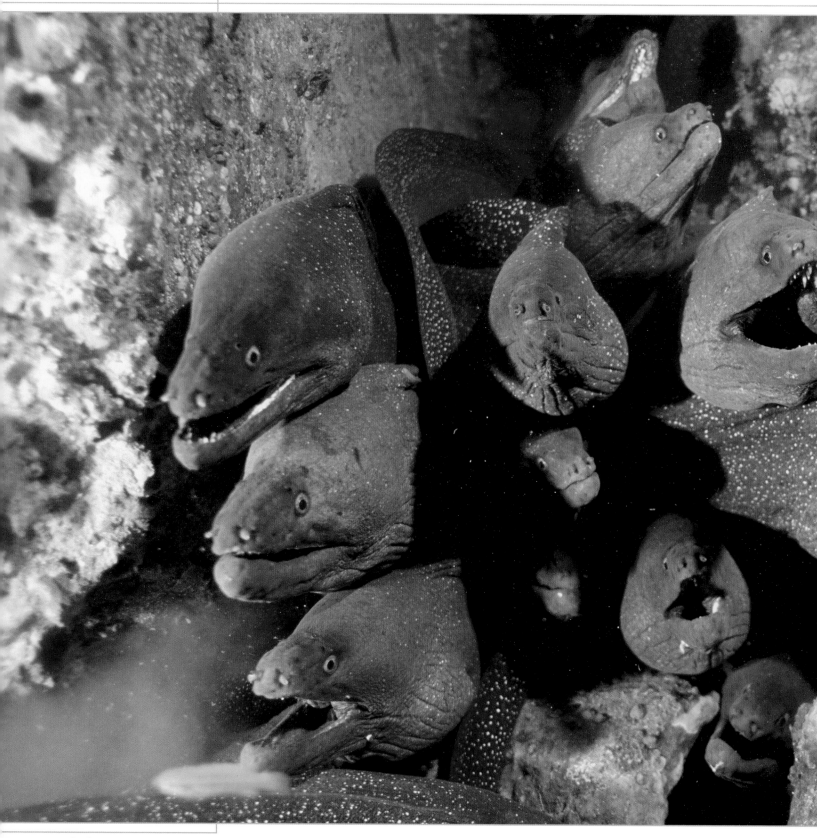

pers. The park is also a refuge for sea turtles and endemic starfish.

The island is a breeding ground for numerous seabirds, including swallow-tailed gulls and Galapagos petrels. The world's largest colony of masked booby, with over 40,000 specimens, is also notable.

The green sea turtle comes on land to lay up to a hundred white eggs (right). Morays (large image) have no scales; instead they excrete a toxic slime that covers their bodies. Many fish species roam the waters around Malpelo, including silky sharks, hammerheads, and the spotted eagle ray (inset images, right, from top).

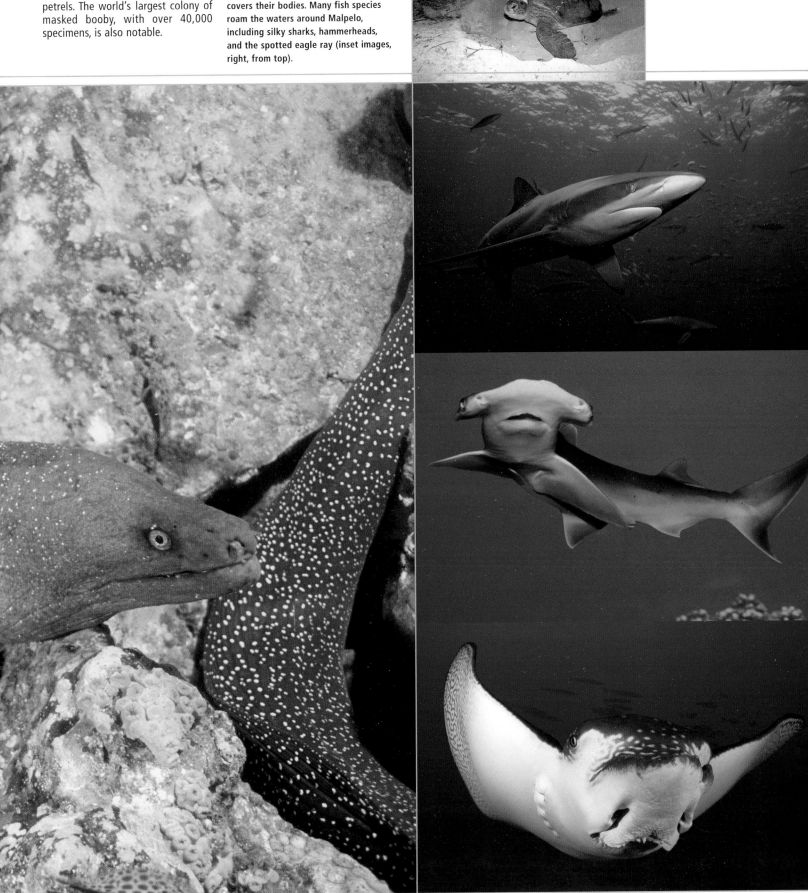

SANGAY
NATIONAL PARK

Sangay National Park is situated in the middle of the Ecuadorian Andes. Two still-active volcanoes add to the particular charm of the landscape, which is a habitat for rare plant and animal life.

Date of inscription: 1983

Barely accessible, the Sangay National Park includes three distinct zones: the volcanic High Andes, at elevations of 2,000 to 5,000 m (6,600 to 16,400 feet); the eastern foothills at between 1,000 and 2,000 m (3,300 to 6,600 feet); and the alluvial fan that lies at their foot. The central uplands are dominated by two active volcanoes – Sangay (5,230 m, 17,160 feet) and Tungurahua (5,016 m, 16,500 feet) – and the extinct El Altar (5,319 m, 17,450 feet). The successive bands of vegetation change with elevation – subtropical rainforest merges into lower montane rainforest above 2,000 m (6,600 feet), in turn being replaced by wild Páramo grasslands above 4,500 m (14,750 feet). Above 4,800 m (15,750 feet) is a zone of eternal snow.

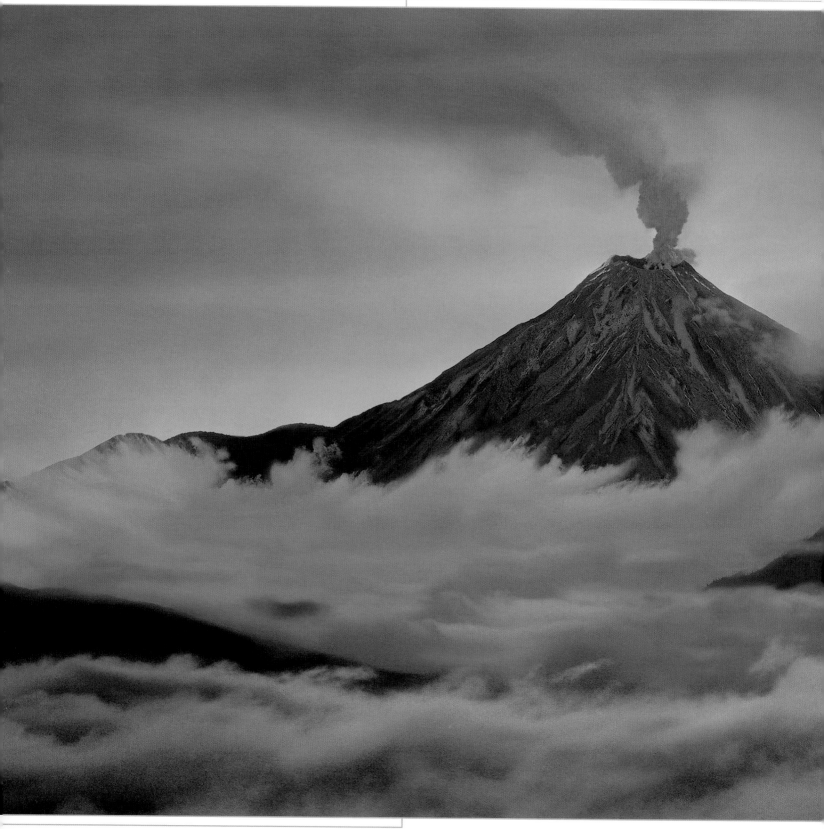

Animal and plant life gain advantage from the isolation of this primeval landscape. More than 3,000 plant species have been recorded in the national park, and the number of bird species is estimated at between four and five hundred. Many mammals roam the ancient forest, including mountain tapirs, giant otters, spectacled bears, pumas, jaguars, and ocelots.

This national park presents a dramatic landscape of impressive volcanoes. Tungurahua has undergone periods of strong volcanic activity, for example between 1916 and 1925. It has been active again since 1999 (main image). El Altar is considered to be extinct. The high Andes region is also home to rare creatures like the condor and the spectacled bear (inset).

GALÁPAGOS ISLANDS NATIONAL PARK

The volcanic islands of the Galápagos archipelago present a uniquely living picture of evolution as a result of their isolated situation.

Date of inscription: 1978
Extended: 2001

About 1,000 km (620 miles) off the west coast of Ecuador, in the middle of the Pacific, there is a hotspot where molten magma is forced out of the earth's interior to the surface, and a spectacular archipelago of twelve large and over a hundred smaller volcanic islands has arisen here. The chain's oldest islands, which are also the furthest east, arose 2.4 to 3 mil-lion years ago; the newest island, Fernandina, to the west, is only 700,000 years old.

The archipelago is affected by three great ocean currents, including the cold Humboldt Current, bringing water from the icy polar regions to the equator. These ocean currents brought life to the Galápagos from tropical and subtropical regions of Central and South America, and also from the Indo-Pacific Ocean, turning the islands into a crucible of the most diverse species. Their geographical remoteness offered plant and animal life ideal conditions for independent evolution.

Charles Darwin's visit in 1835 brought international fame to the islands. His observations of species of

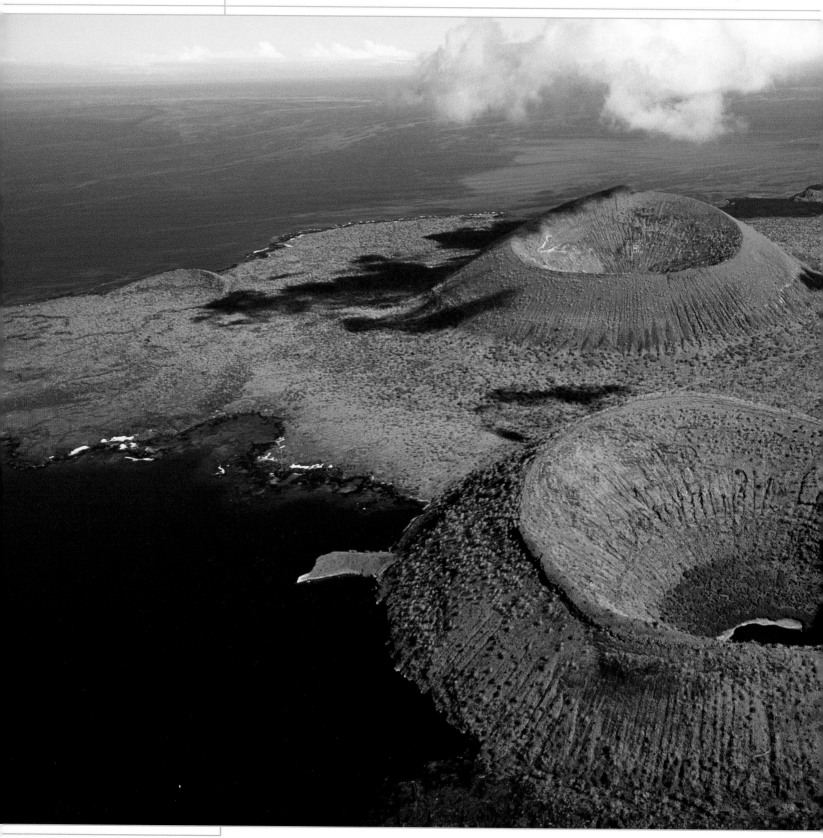

finch that were almost identical, yet had developed different shapes of beak depending on the environment of the various islands on which they lived, led Darwin to important conclusions in the development of his theory of evolution.

The Galápagos Archipelago is a paradise for reptiles and birds, although few mammals have found their way here. Most of the animal life on the islands is endemic. Among the more spectacular residents are the flightless cormorant, the Galápagos land iguana, the marine iguana, and the Galápagos giant tortoise.

The national park comprises 90 percent of the Galápagos islands' surface area; the site was extended in 2001 to include an area of protected ocean.

The Galápagos Islands and their endemic reptile species, such as the marine iguana (left), are a living archive of evolutionary history. Circular volcanic craters have been formed on San Salvador (large image), and lava flowing into the sea on Bartolomé has created new land. Only sparse vegetation grows in the soils of Santa Fé and San Salvador (below, from bottom).

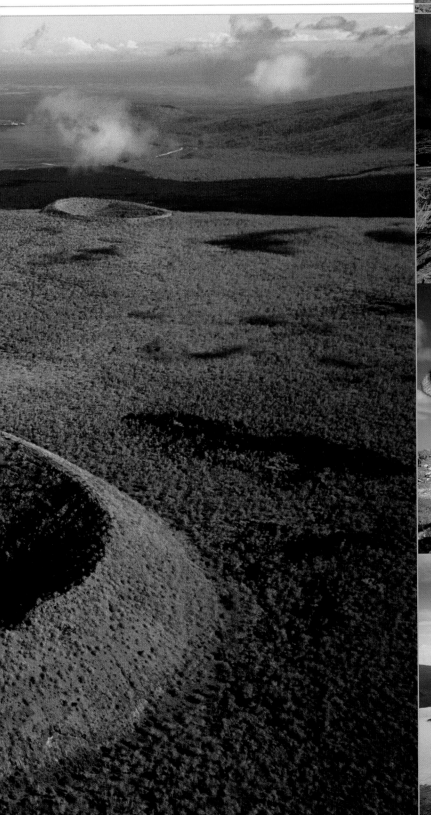

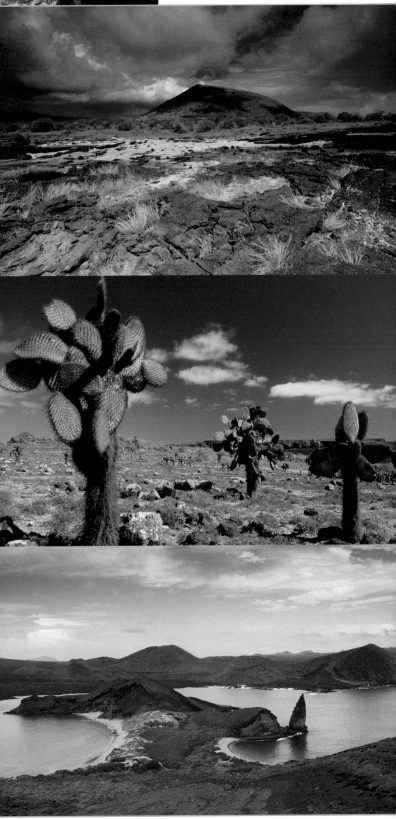

GALÁPAGOS ISLANDS NATIONAL PARK

The Galápagos Islands are an important breeding ground for the blue-footed booby. When hunting, this skilful flyer dives vertically from a great height into shoals of fish (large image and inset, below). Its near relative, the red-footed booby, is the only booby to nest in trees and has developed special toes to facilitate this (below left).

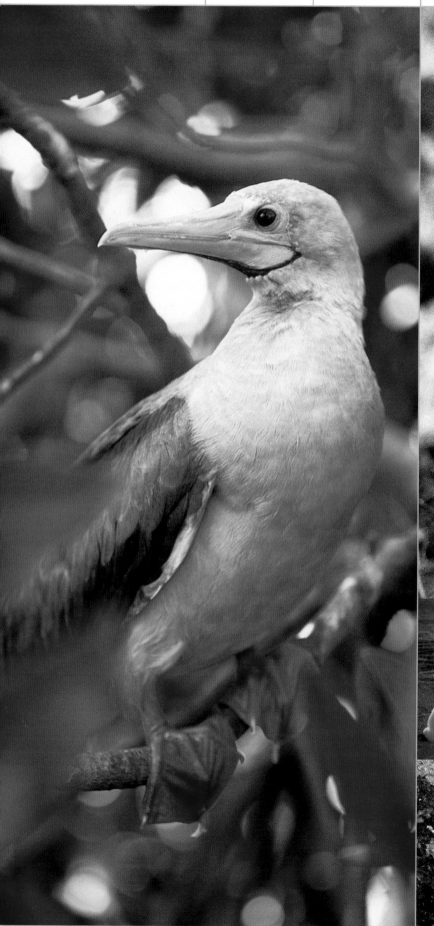

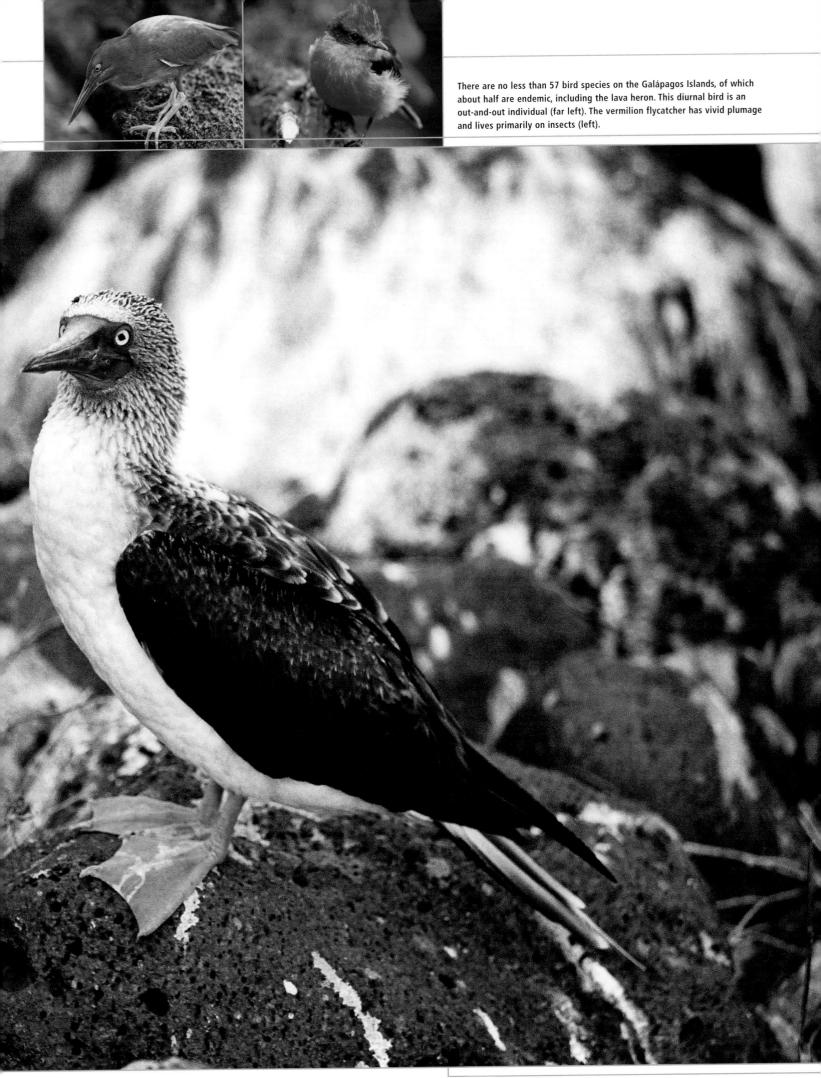

There are no less than 57 bird species on the Galápagos Islands, of which about half are endemic, including the lava heron. This diurnal bird is an out-and-out individual (far left). The vermilion flycatcher has vivid plumage and lives primarily on insects (left).

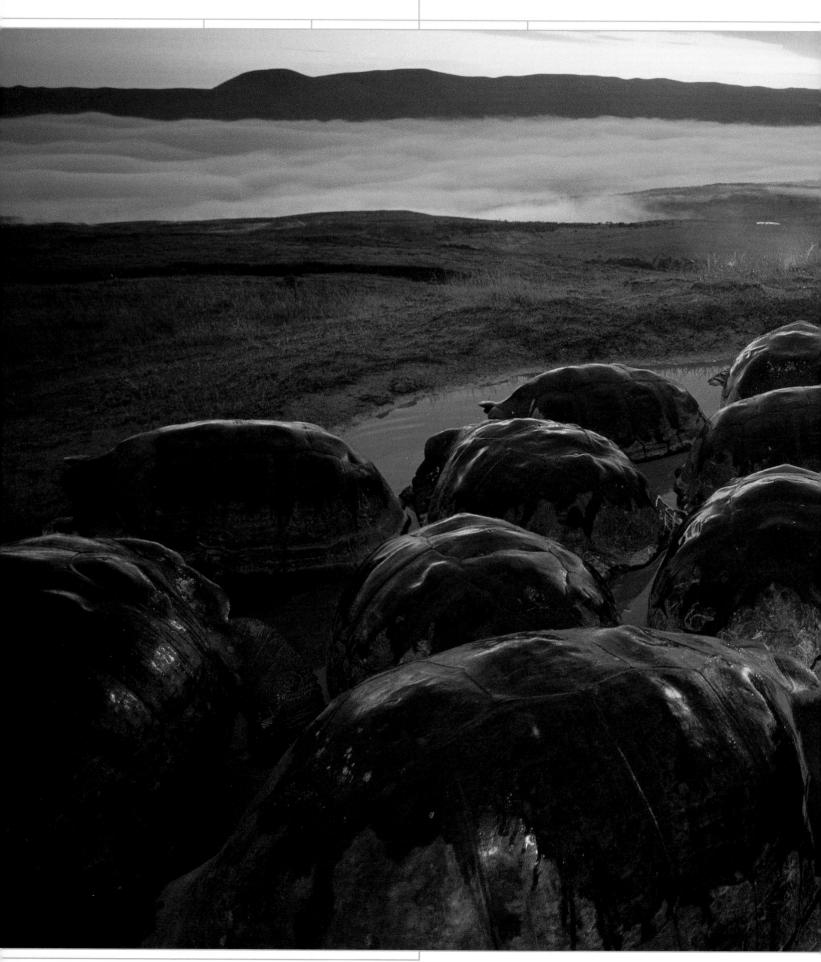

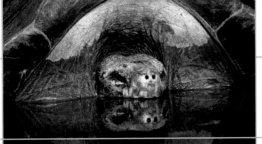

The Galápagos giant tortoise (below and left) is the world's largest living tortoise. It can reach a weight of over 200 kg (440 lb), and the oldest specimens are estimated to live for up to 150 years. The 14 subspecies are differentiated by the formation of their shell.

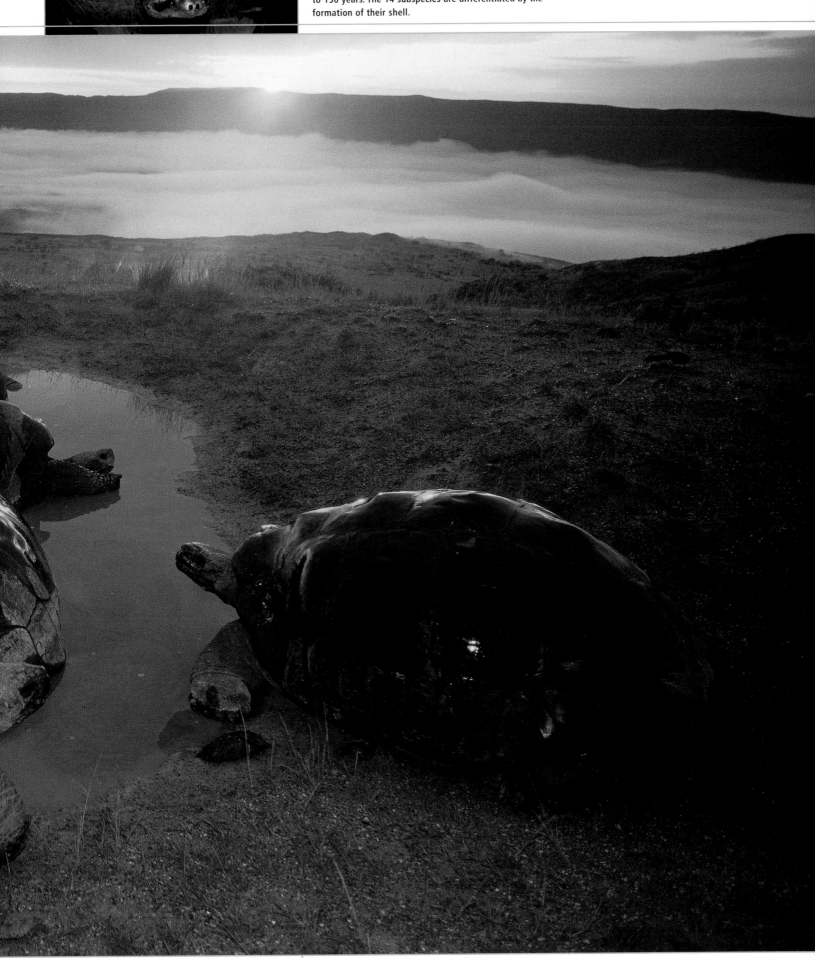

GALÁPAGOS ISLANDS
NATIONAL PARK

After a cool night, marine iguanas warm themselves in the sun (below). The marine iguana is the only species of lizard to live exclusively on food from the sea, grazing on underwater carpets of algae (above left: with a green sea turtle). They excrete excess salt from seawater taken in while diving as concentrated crystals through glands in the region of their nostrils.

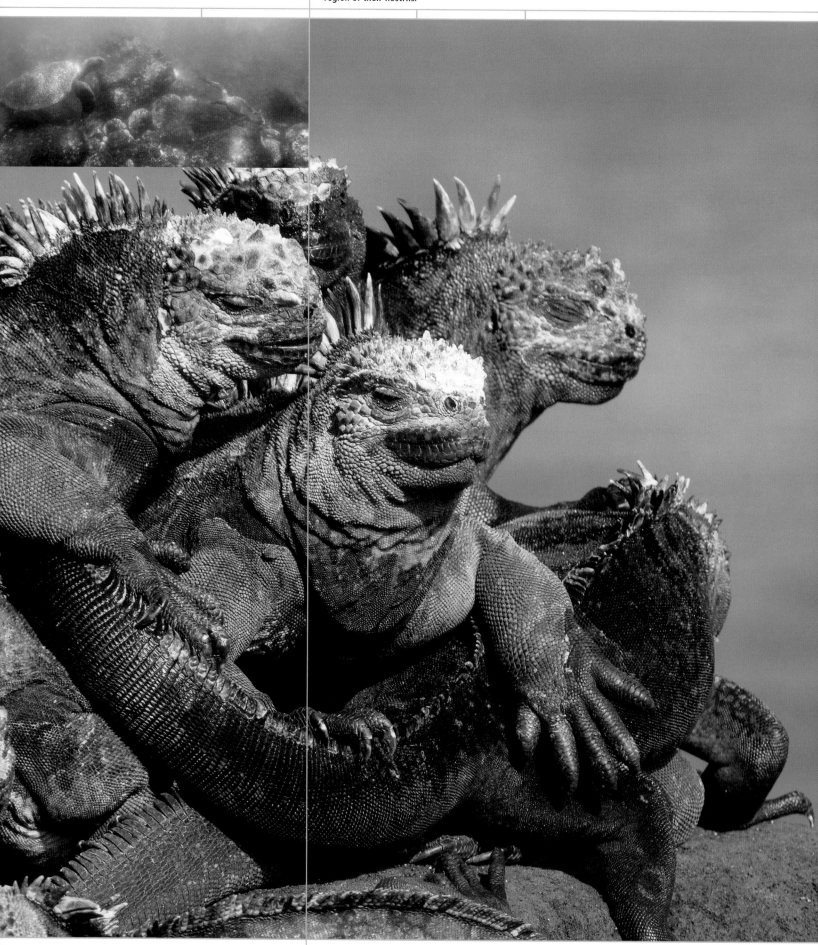

All 35 of the reptile species living on the Galápagos Islands are endemic. The Galápagos land iguana has a large crest on its neck and back (below). On these islands where fresh water is scarce, land iguanas have their own method for slaking their thirst – they eat paddle cactuses, which store water (right).

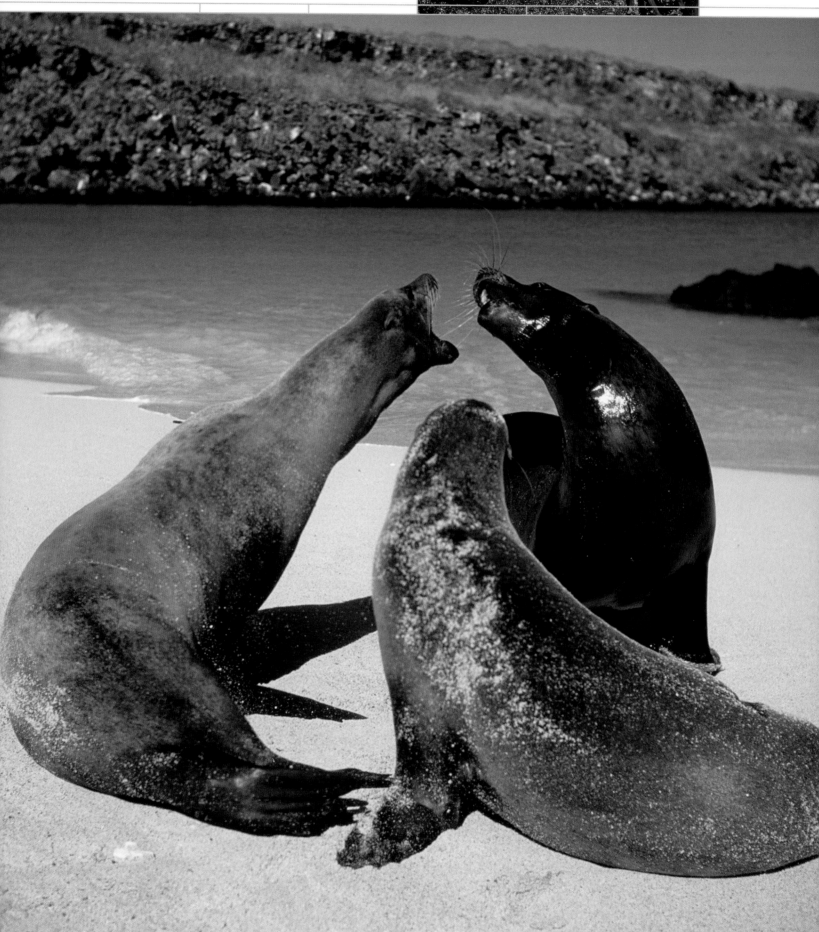

On these islands the Sally Lightfoot crab has hardly any natural enemies. It is because of this that it can afford to have such a conspicuous red carapace (left). Sealions are excellent divers. Their ancestors probably came from California, and a subspecies of sealion unique to the Galápagos Islands has developed. The fur seal (main image) originally came here from the Antarctic coast.

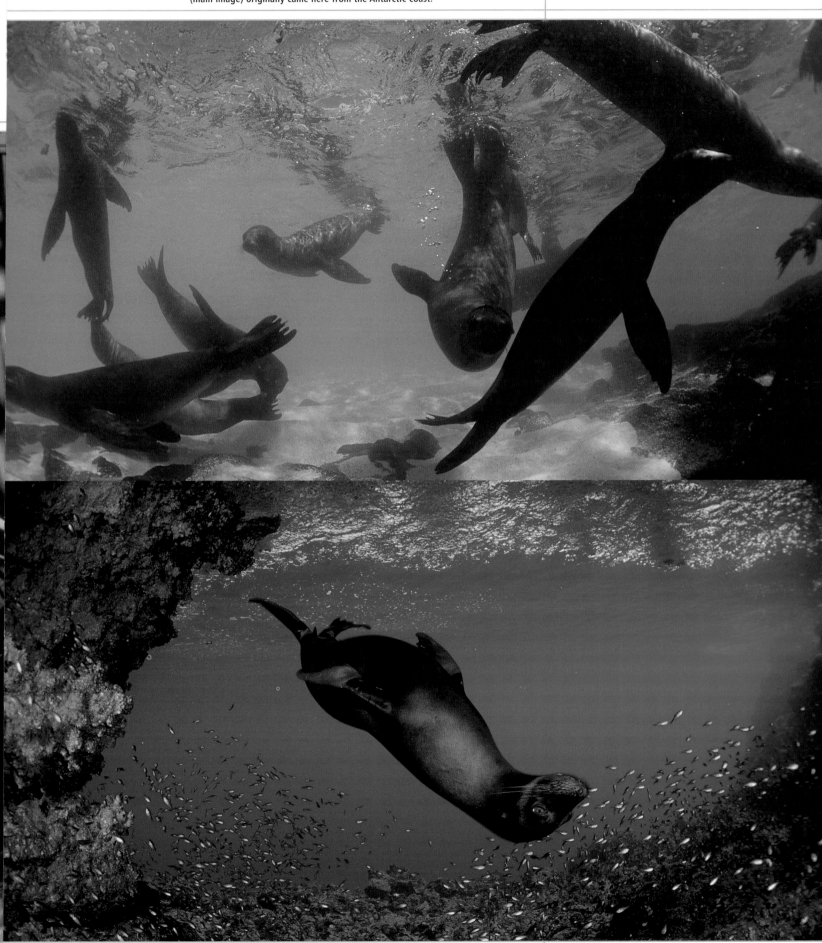

Punctuated by the snowy peaks of the Cordillera Blanca, the national park can reach elevations of 6,000 m (19,700 feet). Its gorges and glacial lakes reveal sites of extraordinary natural beauty and are home to much rare animal and plant life.

Date of inscription: 1985

The snow-capped summit of the 6,768-m (22,200-foot) high Nevado Huascarán, Peru's highest mountain, towers majestically over the national park that has taken its name. The scenery of the Cordillera Blanca, with its gigantic glaciers, silent mountain lakes, deep gorges, and roaring streams is a fascinating prospect. The Huascarán is just one of 27 peaks measured here above 6,000 m (19,700 feet), and these are flanked by 30 glaciers and 127 glacial lakes. The average temperature is 3° C, although in winter the thermometer can drop to –30° C. Nonetheless, vegetation grows here at elevations up to 4,000 m (13,200 feet), including rare cactus species and the world's largest bromelia, *Puya raimondii*.

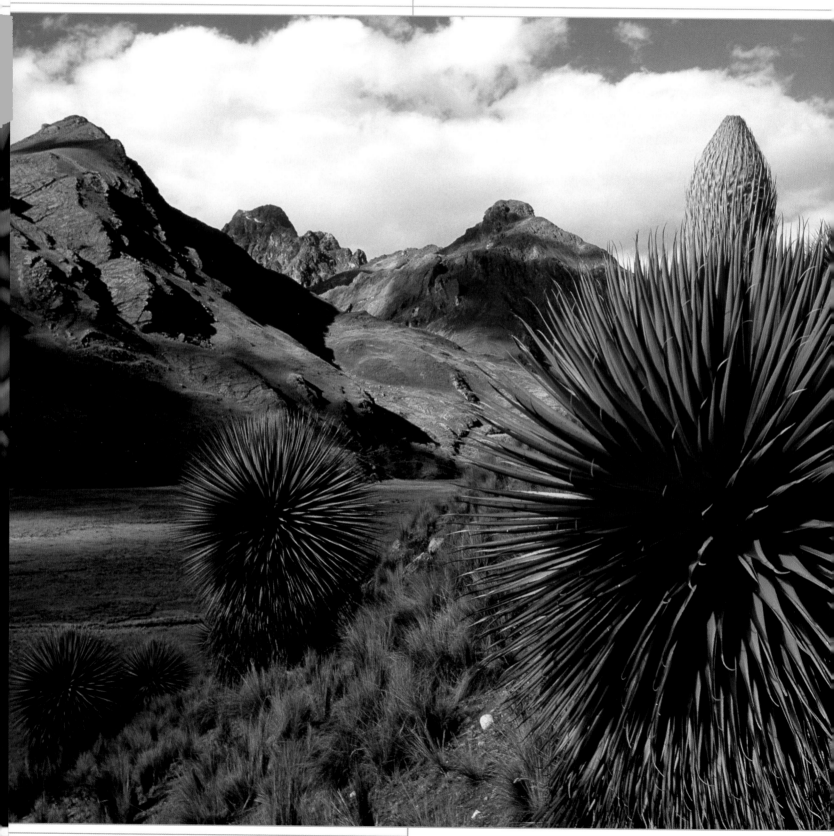

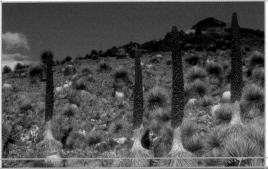

The national park is the home of *Puya raimondii*, the world's largest species of bromelia. Its spiky leaves can grow to a height of 4 m (13 feet) before developing an inflorescence that can reach a height of 8–10 m (27–33 feet, below left and right). The plant blooms only once, forming up to 20,000 brilliant white flowers on its rachis, which are then pollinated by hummingbirds (small image, below). The whole plant slowly dies off after flowering for three months (left).

The mammals living in the park, such as the spectacled bear, the puma, the vikunja, the white-tailed deer, and the Peruvian guemal, have adapted ideally to the conditions of this bare and mountainous world. Of the hundred or so species of bird living in the park, the puna hawk, the Andean condor, and the picaflor, the world's largest hummingbird, are the most spectacular.

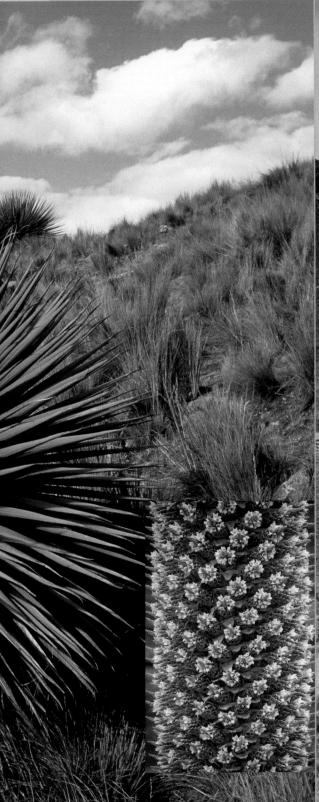

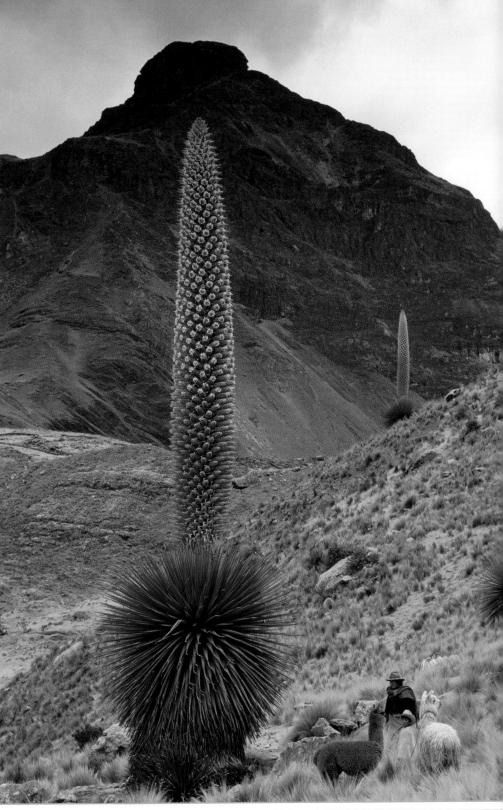

The summit of the Nevado Huascarán towers majestically against the sky (large image). In 1970, an earthquake started a rockfall from the northern summit; an avalanche of rock and ice fell into the valley and buried thousands of people in Yungay and Ranrahirca.

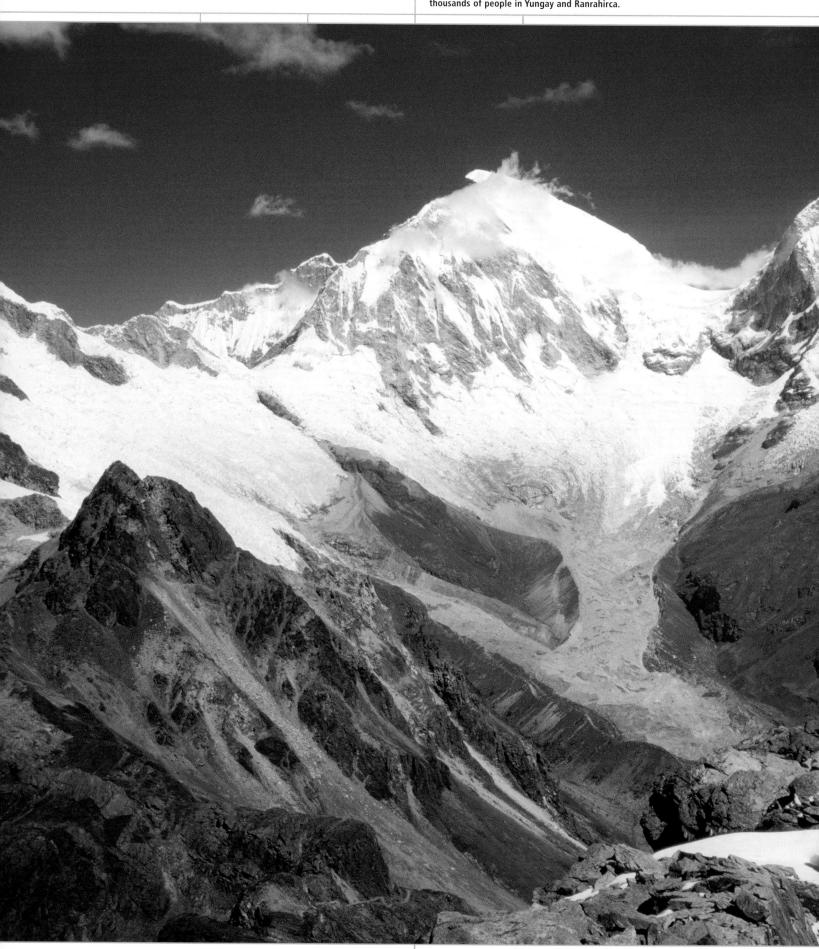

Almost 300 lakes are scattered throughout the park's mountainous landscape, including the Lagunas de Llanganuco (inset images, above and below) and many marshy areas of grass, the so-called Bofedales (inset image, middle). Many cactuses grow and flower here (left).

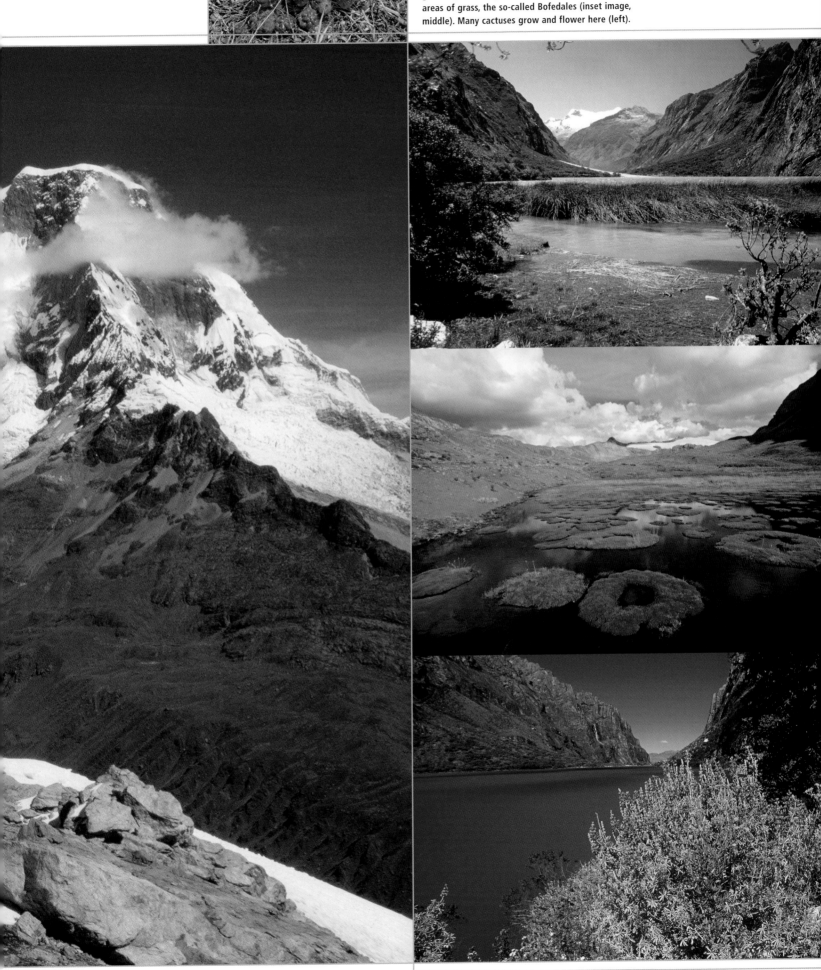

This remote park, situated on the eastern slope of the Andes towards the Amazon lowlands, is a region of superlatives, with countless species of plant and animal life, many of which are endemic. A few indigenous Indians still live here, hunting and farming using traditional methods.

Date of inscription: 1987

Established in 1973, Peru's second-largest national park has an area of 15,000 sq. km (5,800 sq. miles) and is situated at elevations that range from 150 to 4,200 m (500 to 13,900 feet). The park includes the entire catchment basin of the Río Manú, a tributary of the Amazon, in addition to sections of the Río Alto Madre de Dios basin. The conservation area consists of flood plains, hills, and mountains, and the vegetation ranges from tropical rainforest through tropical montane forest to the Puna grasslands. This area, still largely undisturbed, is a true paradise for animals, with over a thousand bird species and 200 mammals, such as the many varieties of parrot and the giant otter, which can reach up to 2 m (7 feet) in length and is threatened with

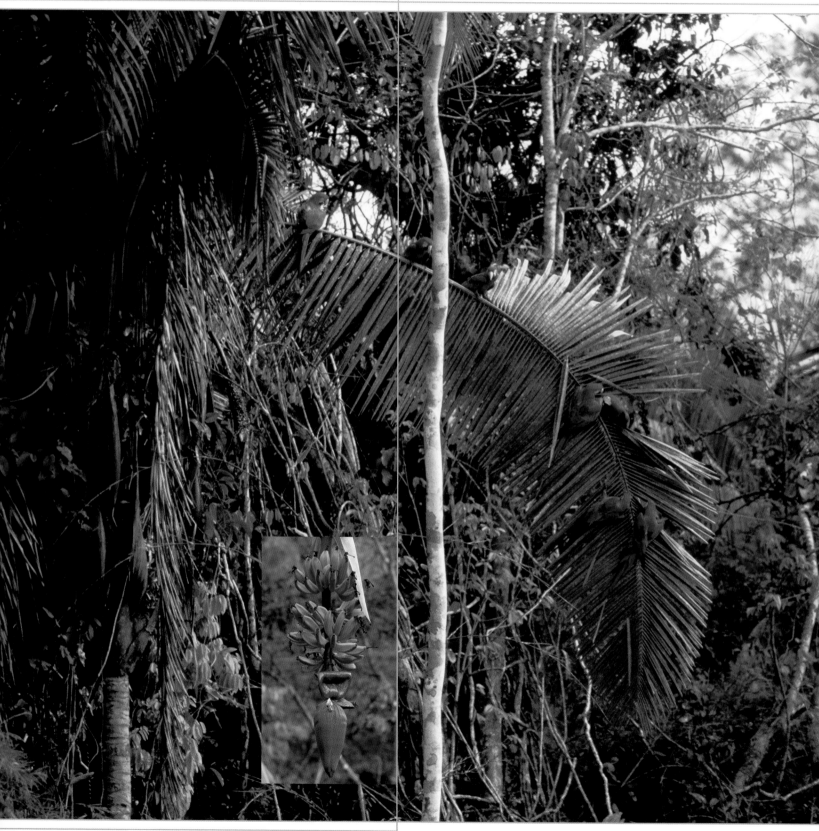

extinction. Even the river terrapin, long since extinct elsewhere, has found a home here. Hanging from trees, three-toed sloths doze upside-down. Other typical South American animals to be found here include the jaguar, the giant armadillo, and the coati. It is also hard to overlook the estimated 15,000 plant species, including 18 different varieties of fig alone.

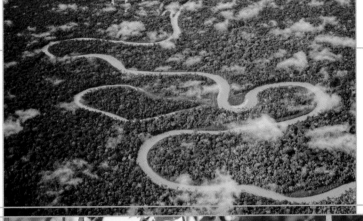

Following winding paths, the park's rivers meander through the tropical rainforest (left). Many trees, such as the Moraceae, form buttress roots (bottom). Bananas still grow in the wild here (inset). Scarlet macaws (large image) and multi-hued hoatzins (below) provide lively background noise in the forest.

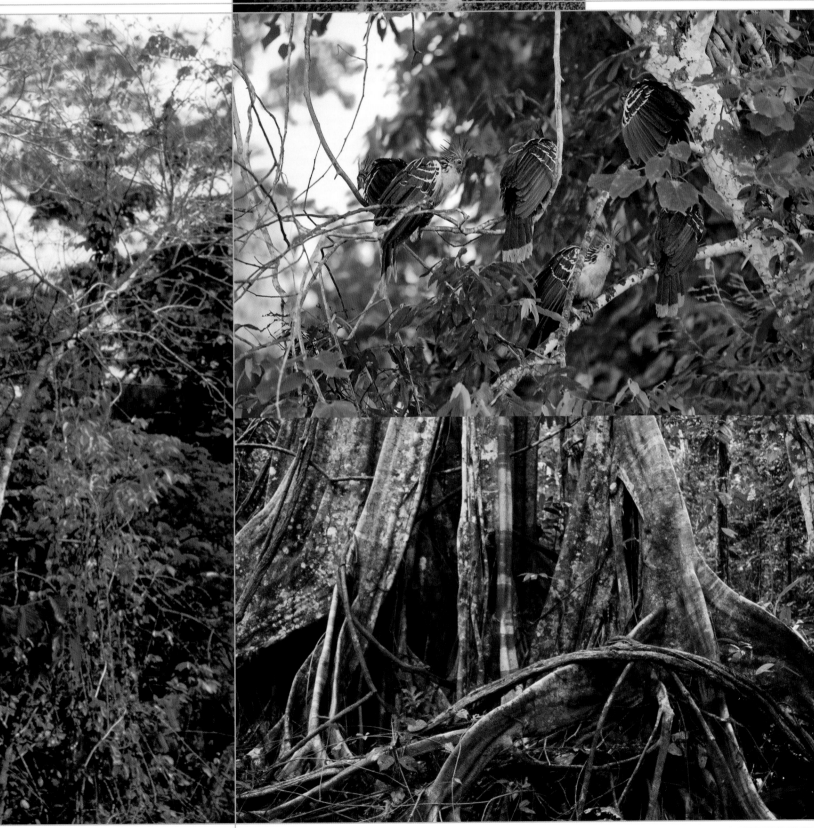

More than 800 bird species have been recorded in the Manú National Park, ranging from hummingbirds (column, top) through the wattled jacana (right) to the blue-headed parrot (large image: seen here on a river embankment, picking at loam soil for its mineral content). The black caiman, which can reach lengths of up to 6 m (20 feet), has also found a home here (column, bottom).

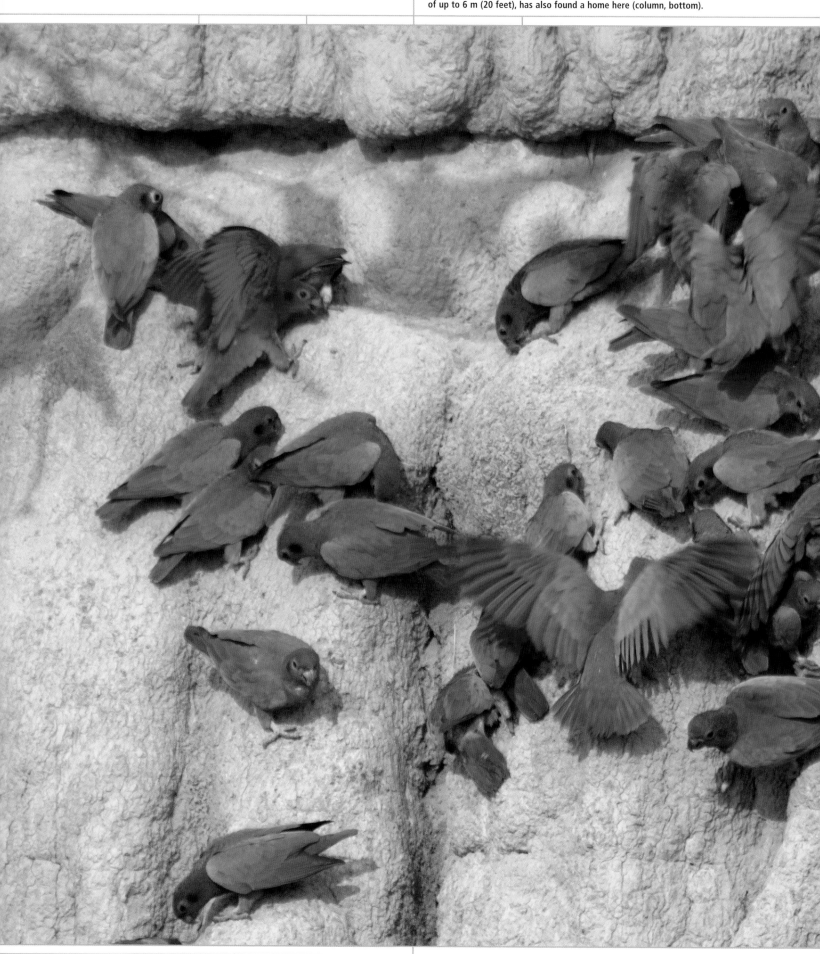

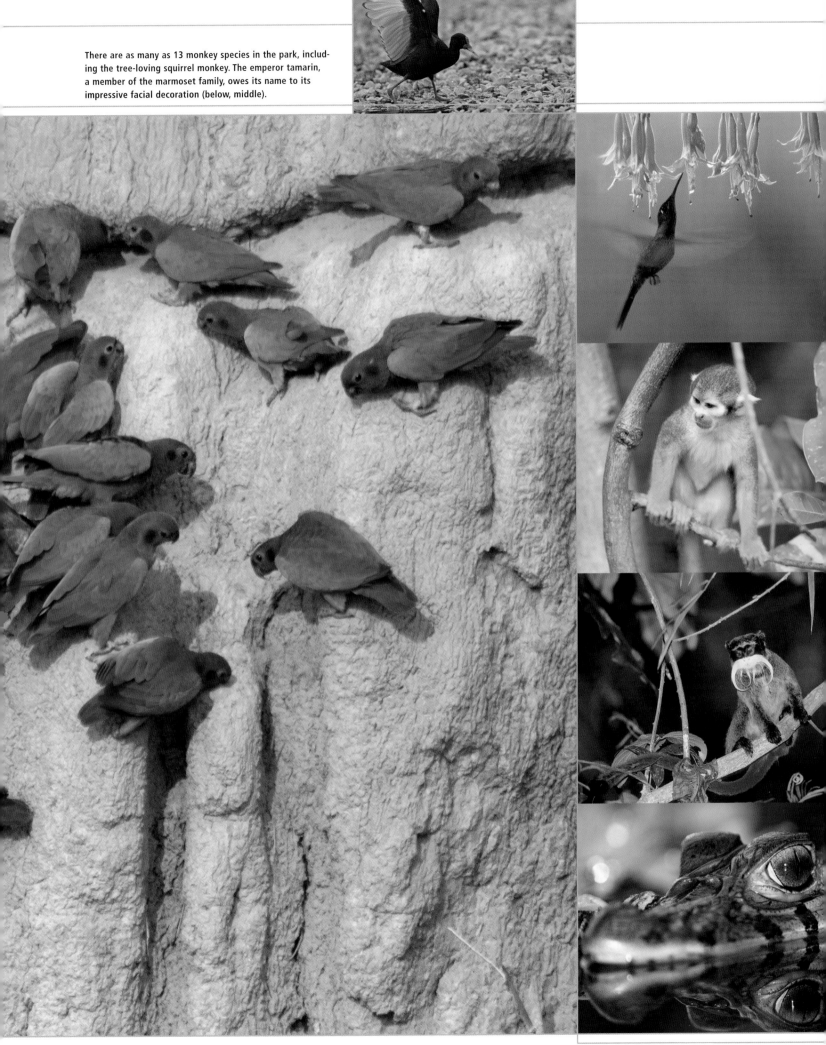

There are as many as 13 monkey species in the park, including the tree-loving squirrel monkey. The emperor tamarin, a member of the marmoset family, owes its name to its impressive facial decoration (below, middle).

Situated in the middle of a landscape of high mountains, Macchu Picchu, rediscovered at the beginning of the 20th century, is probably the most impressive and best-preserved Inca city ruin, and is also one of the most important archeological sites in South America.

Date of inscription: 1983

In 1911, an American, Hiram Bingham, became the first white man to set eyes on this spectacular Inca city. Drawing on its location beneath Huayna Picchu, the "young peak," he christened the site Macchu Picchu, the "old peak." Everything seems strange in this Inca city, hidden in the tropical mountain forest on the eastern slopes of the Andes and clinging like an eagle's eyrie to a flattened mountain-top at an elevation of 2,430 m (7,970 feet). This settlement, situated above the Río Urubamba valley, is fascinating not just because of its well-preserved buildings, but also because of the unique interplay of architecture and nature – the buildings fit perfectly into the unevenness of the terrain.

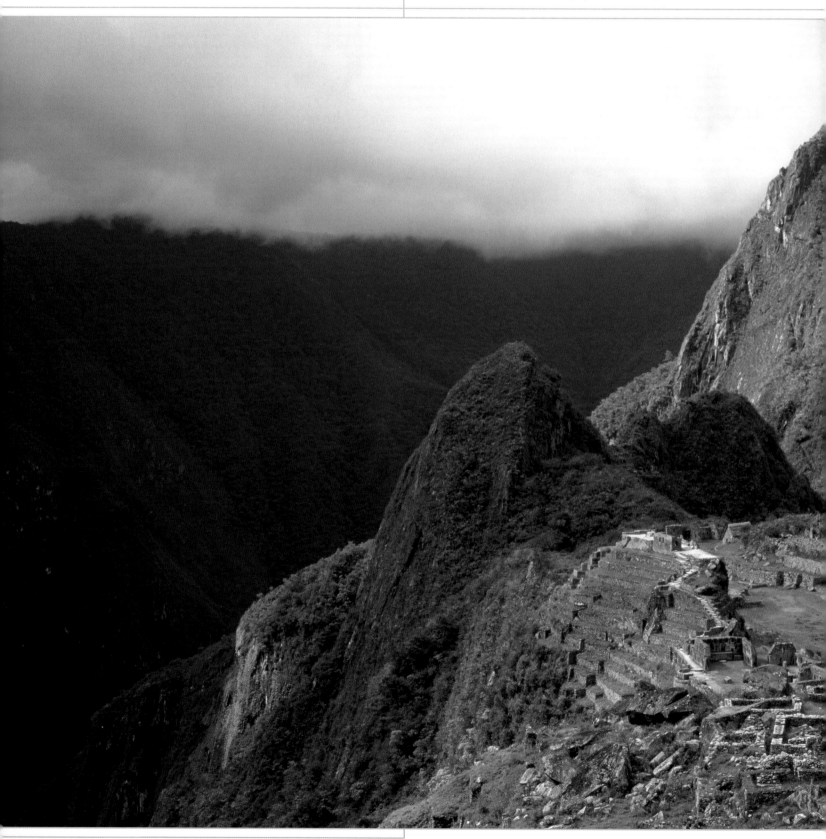

There is still speculation today about the importance of this town, which was never recorded or apparently even noticed by the Spanish conquistadors; it may perhaps represent an attempt by the Incas to colonize the eastern slopes of the Andes. All that is certain is that it was constructed around 1450, and already deserted only a century later. The site is divided into two areas: a farmed zone, with terraced agricultural land on the mountain's slopes fed by a cunning irrigation system, and an unfortified municipal area consisting of palaces, temples, and dwellings. Among the most important monuments are the Round Tower, the Temple of the Sun, and the Room of Three Windows.

Ringed by mighty mountains, the "Forgotten City," Macchu Picchu, is one of the most impressive examples of architecture incorporated into its surrounding environment. The Inca settlement was laid out on several levels on a high plateau around 1450.

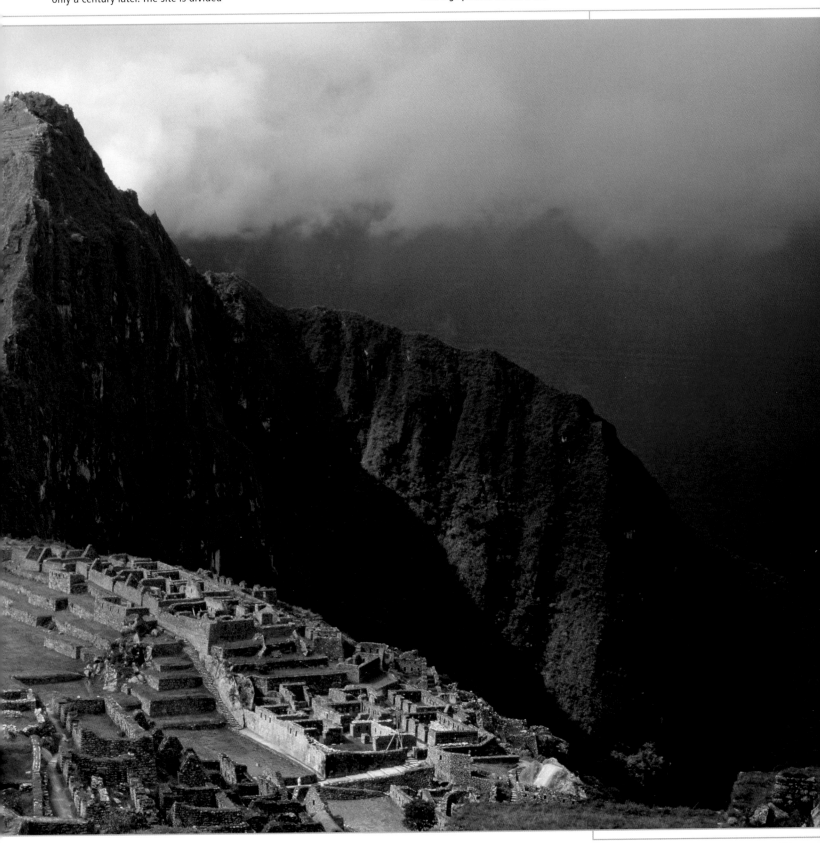

The national park, one of the largest and most continuous in Bolivia, lies on the Brazilian border in the west of the Amazon basin, and is home to an incredible variety of plant and animal life.

Date of inscription: 2000

This national park of over 15,000 sq. km (5,800 sq. miles), encompassing both the Huanchaca plateau and its surrounding lowlands, ranges in elevation between 200 and 1,000 m (650 and 3,300 feet). It includes five separate ecosystems: the tropical rainforest of Amazonia, seasonally flooding savannah, deciduous dry forest and montane forest, areas of thorny scrub forest, and extensive swamps and flood plains. This diverse vegetation houses correspondingly varied plant and animal life. The number of plant species alone in the park has been estimated at around 4,000.

Before his brutal murder at the hands of drug smugglers in 1986, the Bolivian naturalist, Noel Kempff Mercado, after whom the national park is

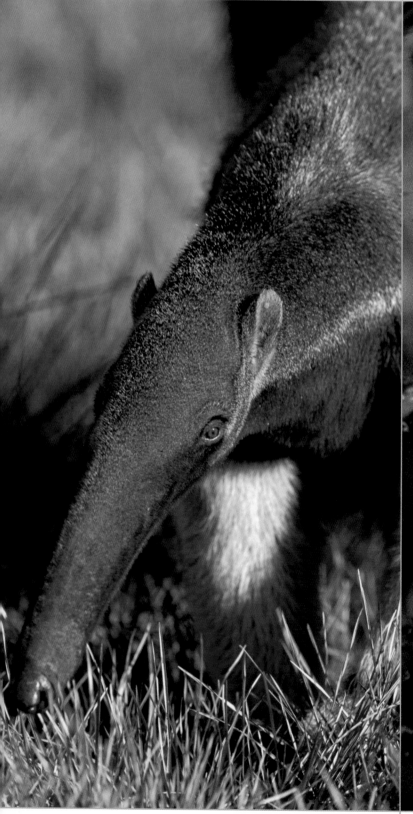

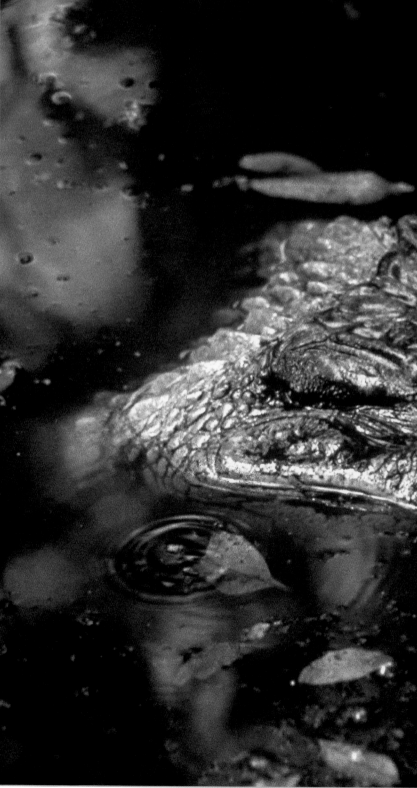

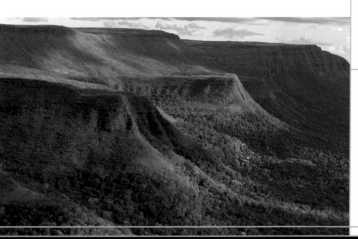

named, had begun recording the giant biosystem. More than 600 bird species and 150 mammals and reptiles have been identified, including Gould's toucanet, the hyacinthine macaw, the Amazon river dolphin, the maned wolf, and the giant anteater, in addition to jaguars, pumas, giant otters, numerous monkeys, giant river turtles, and the black caiman.

The rainforest spreads out beneath the steep edges of the Huanchaca plateau (left). The giant anteater lives in the savannah part of the park, and feeds almost exclusively on ants and termites (below left). Reaching a length of up to 6 m (20 feet), South America's largest reptile, the black caiman, has found a home in the park's rivers (large image).

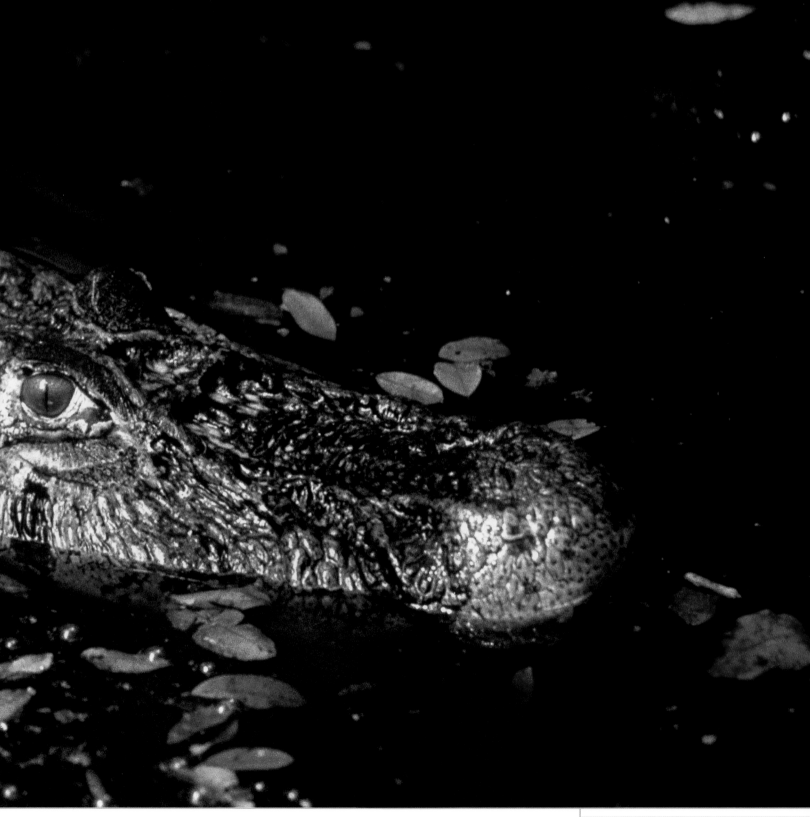

CANAIMA NATIONAL PARK

With its mighty mesas and the world's highest waterfall, the Salto Angel, the Gran Sabana is one of the world's most beautiful areas. It is also a habitat for innumerable plant species.

Date of inscription: 1994

In the language of the local Kamarokoto people, Canaima represents a dark deity, uniting all evil in itself. In contrast, Venezuela's second-largest national park (30,000 sq. km, 11,600 sq. miles) is representative of nothing but overwhelming natural beauty. Situated in the south-east of the country, near the Guyanese and Brazilian borders, the park encompasses the incomparable landscape of the Gran Sabana. Nestling in dense vegetation, a host of spectacular waterfalls, including the Salto Angel, the Salto Kukenam, and the Canaima Lagoon rapids, crash dramatically into the depths. It is thought that some 3,000 to 5,000 flowering plants and ferns grow here, of which many are endemic; besides the savannah, there

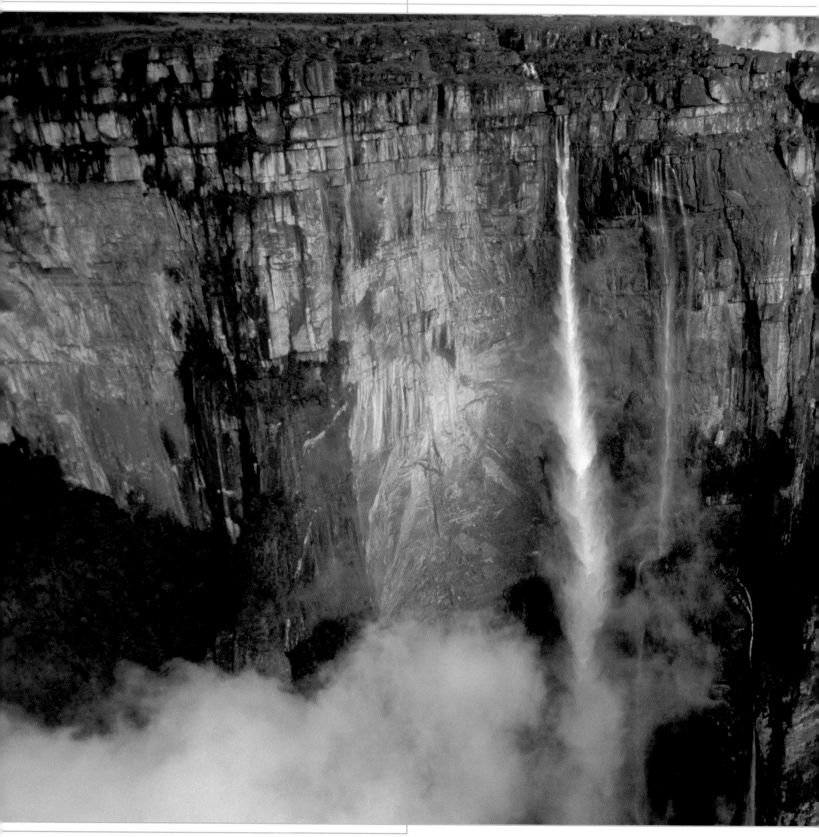

is also impenetrable montane forest and scrubland.

Unique pioneer vegetation has evolved on the many mesas, with numerous species of carnivorous plants; at least a tenth of the 900 plant species recorded on one of these mesas were found to be endemic. There is also an impressive diversity of orchid species, with the number of species estimated at around 500. Brightly hued butterflies, hummingbirds, and parrots flit between the plants.

Around 550 bird species live here, while mammals such as the giant anteater, the giant armadillo, the giant otter, the bush dog, and the oncilla roam the forest floor.

The Salto Angel falls 1,000 m (3,300 feet) from the north-eastern flank of the Auyán Tepui (large image). Around 100 Tepuis (mesas) are scattered across the green Gran Sabana, rising to a height of up to 2,000 m (6,600 feet; inset image, above). There is a variety of plant and animal life in the region, with parrots (left), orchids, and carnivorous plants such as the *Drosera roraimae* (inset image, below).

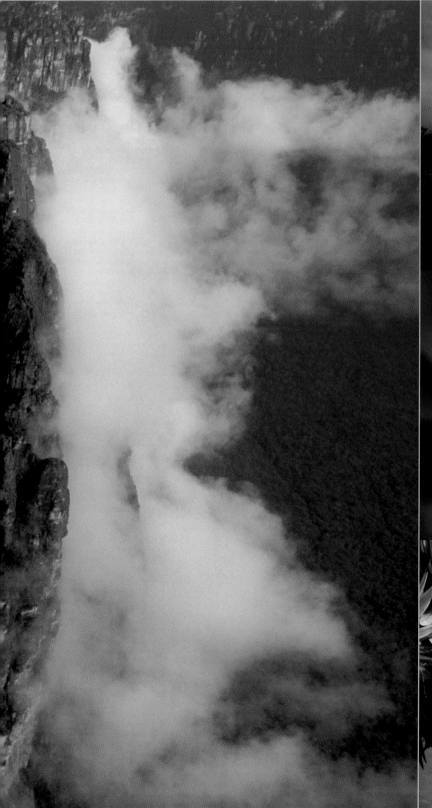

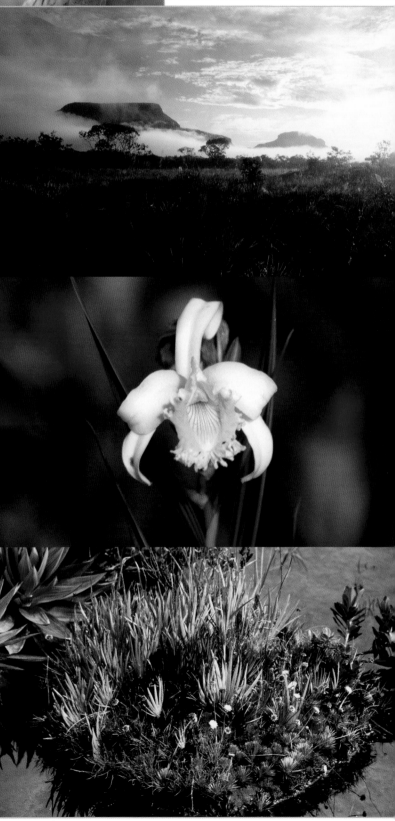

This enormous nature reserve encompasses the untouched tropical rainforest of the Guiana Shield and includes an enormous number of plant and animal species, of which many are endemic.

Date of inscription: 2000

Over two billion years old and dating back to the Precambrian, the Guiana Shield craton of the South American continental plate in north-east South America is one of the oldest formations on earth. Primeval rainforest – largely inaccessible wilderness and still unexplored – covers around 150,000 sq. km (58,000 sq. miles). In 1998, Suriname's three most impor- tant conservation areas were com- bined into a corridor of 16,000 sq. km (6,200 sq. miles), to be called the Central Nature Reserve. The area encompasses about 11 percent of Suriname's sovereign territory and includes the upper catchment basin of the Coppename river. Among its broad range of landscape formations are table-like mesas, which towers

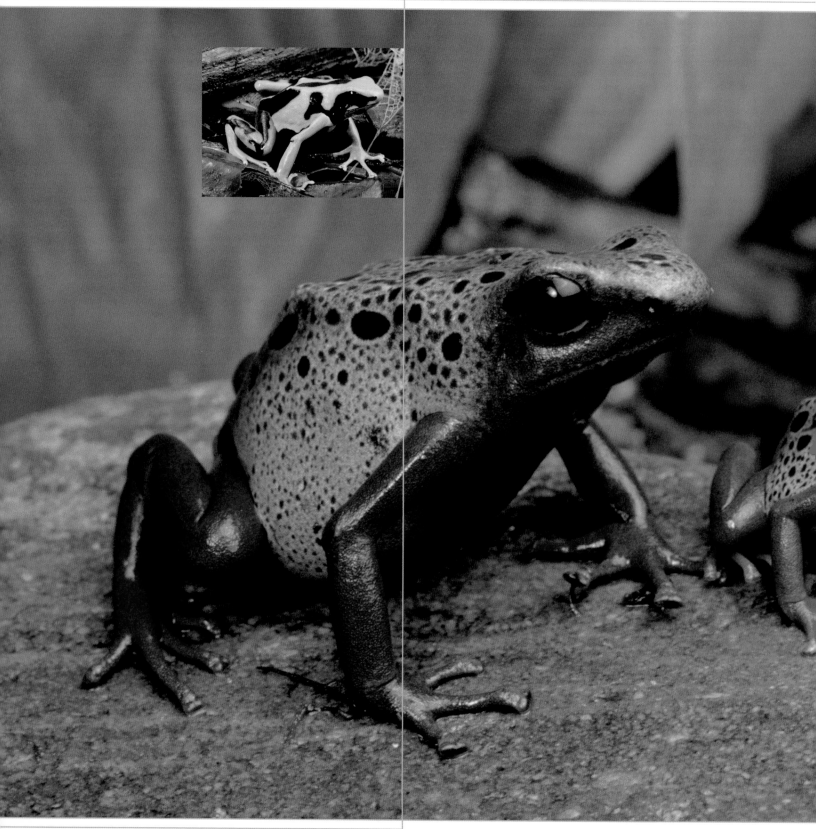

The Amazon horned frog (right) is quite a sight. Among the many poisonous dart frogs are *Dendrobates quinquevittatus* (below right), *Dendrobates azureus* (large image), and *Dendrobates tinctorius* (inset). They excrete a highly effective poison, with which the native people tip their dart-points.

350 m (1,150 feet) over the surrounding rainforest.

The conservation area has an impressive variety of plant life; 6,000 species have been recorded in the dense forests of the mountains and lowlands. Besides the rainforest, there is also wetland forest and savannah, while dry vegetation grows on granite extrusions.

The animal life on the reserve is extraordinarily diverse: 700 different birds, nearly 2,000 mammals, 150 reptiles, and 100 amphibians have been cataloged. The rivers teem with nearly 500 fish species, and, most unusually, no less than eight primate species have found a habitat in Raleigh Vallen National Park, one of the three central reservations.

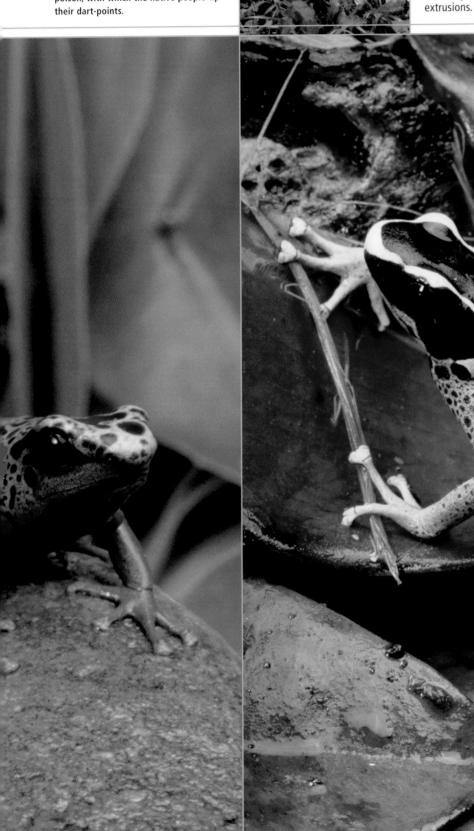

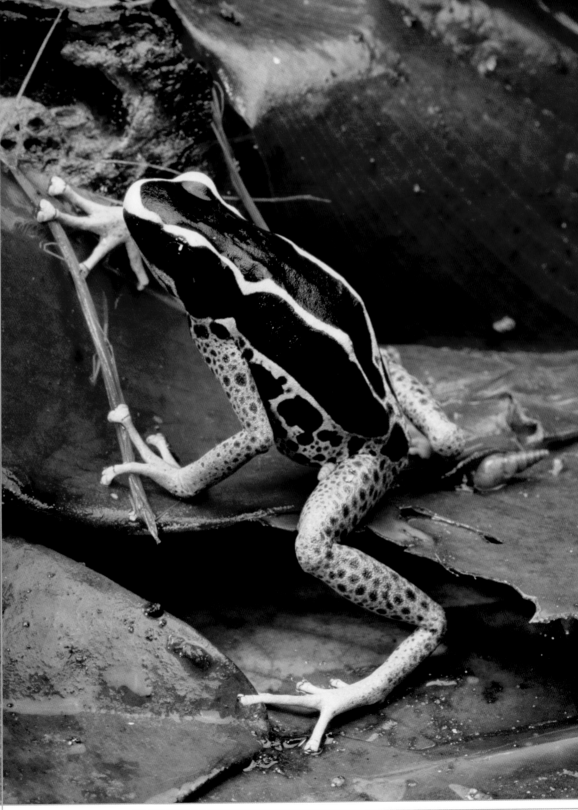

The largest conservation area in the Amazon basin includes the Jaú National Park, the Mamirauá and Amanã Nature Reserves, and the Anavilhanas Ecological Station.

Date of inscription: 2000; Extended: 2003

This gigantic rainforest park is situated about 200 km (125 miles) northwest of Manaus. The heart of the area is the Jaú National Park, covering the complete catchment basin of the Río Jaú up to its confluence with the Río Negro. In 2000, the reserve was inscribed as a World Heritage Site, and in 2003 was expanded to more than 60,000 sq. km (23,200 sq. miles) under the name Complexão de Conservação del Amazonas Central.

The Jaú and Negro rivers together form a blackwater ecosystem. The rivers' seasonal change in water level has given rise to the Igapó inundated forest area. Blackwater rivers have a dark coloration, due to dissolved tannins and organic precipitates, and contain little sediment. Inhabitants of

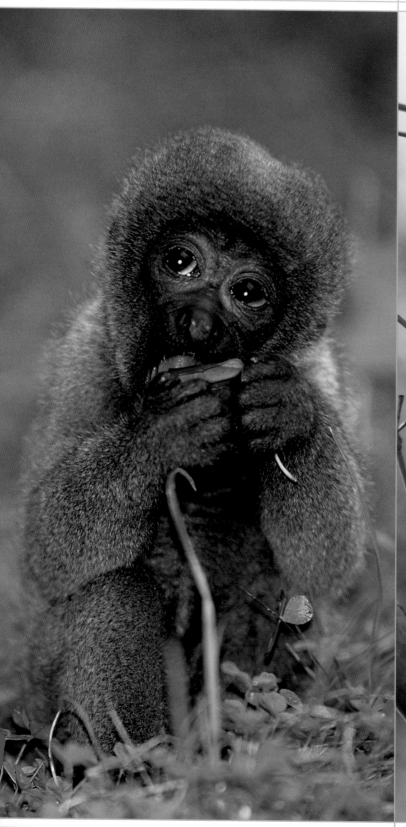

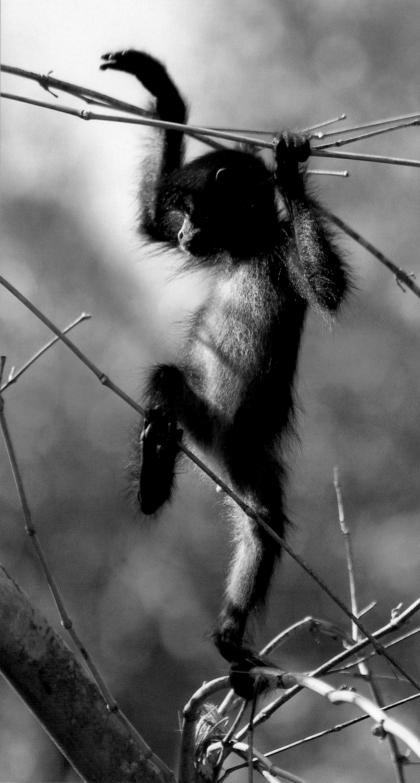

such waters include giant otters, river manatees, South American river turtles, and black caimans. In the Mamirauá reserve there are extensive whitewater flood plains ("várzea") with nutrient-rich soils – whitewater rivers have turbid waters, rich in light minerals in suspension. The conservation area is home to 120 different mammals, including the pink and gray river dolphins, more than 450 birds, and 300 fish.

The Río Jaú at sunset (left). There is a wealth of animal life in Amazonia: woolly monkeys, variegated spider monkeys, yellow-foot tortoises, giant anteaters, giant armadillos, and black-headed uakaris (below, left to right).

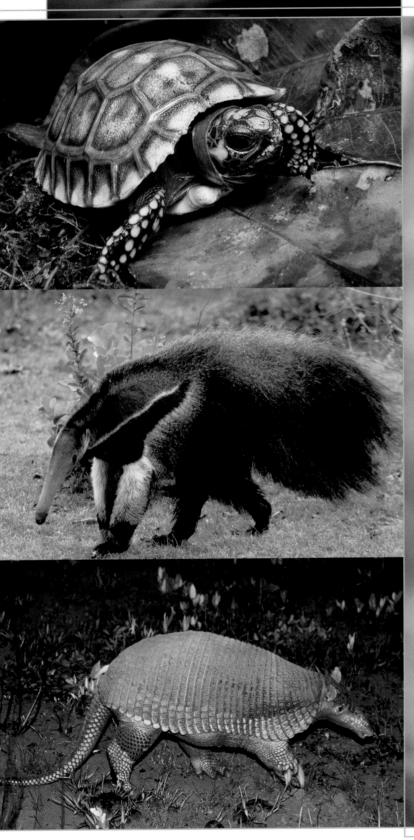

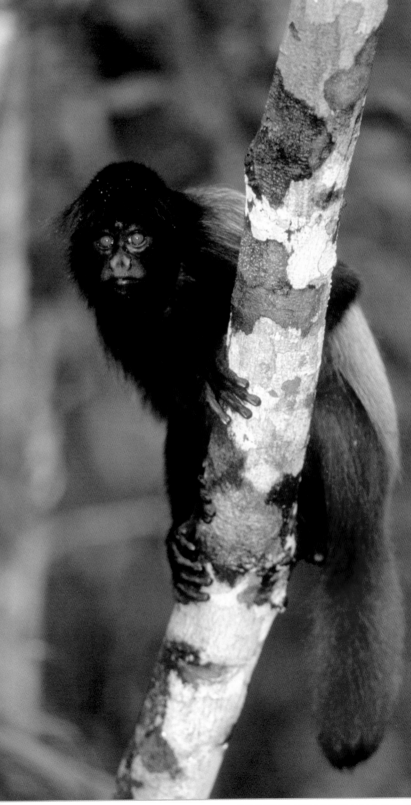

DISCOVERY COAST
ATLANTIC RAINFOREST RESERVES

The Discovery Coast Atlantic Rainforest Reserves are just part of one of the largest and best-preserved ecosystems of its kind, and home to many rare and endemic species.

Date of inscription: 1999

Brazil's Atlantic rainforest extends along the coast from the state of Bahía in the north to Río Grande do Sul in the south. Its dense vegetation is largely composed of 20- to 30-m (66- to 100-foot) high trees, on which grow orchids and bromelias. The poor light penetrating the canopy to the forest floor allows for only sparse undergrowth. The biodiversity and evolutionary history of these forests is of great scientific interest, not least as many of the plant species here are endemic. Studies have shown that in Bahía, 458 varieties of tree grow in a single hectare (2.5 acres); in Espírito Santo, it is as many as 476.

The Discovery Coast, where colonization began in the 16th century, is now shared between the states of Bahía

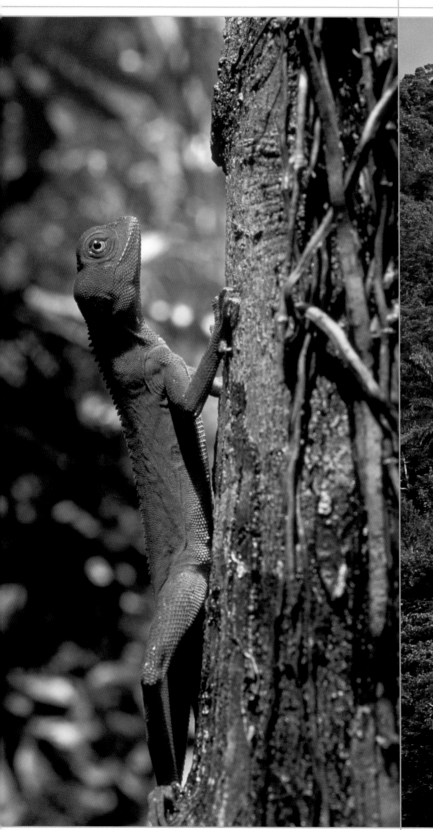

and Espírito Santo. It boasts eight protected forest and bush reserves, all part of the northern section of the Atlantic rainforest. The Reservas Biológicas of Una and Sooretama, the Reservas Particulares de Patrimônio Natural of Pau Brasil, Veracruz, and Linhares, together with the national parks of Pau Brasil, Monte Pascual (whose 536-m/1,760-foot high moun-tain of the same name is its highest point), and Descobrimento cover an area of more than 1,000 sq. km (390 sq. miles). Only a few remnants of what once were mighty growths of forest still exist – in the past, vast tracts were cleared to give way to sugar cane plantations.

Several sections of the Discovery Coast are still covered with a carpet of dense rainforest, holding the world's largest reserves of Brazil nut trees (large image). The range of its animal life stretches from the jaguar (left) through iguanas (far left), to the golden-headed lion tamarin (inset left), and Geoffroy's marmoset (inset right).

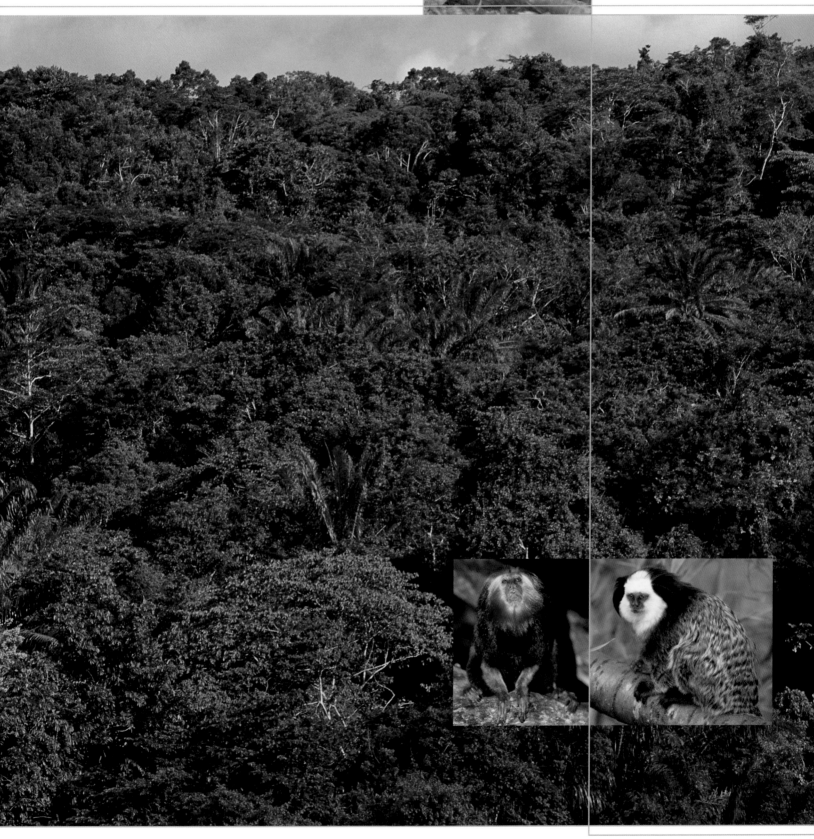

CHAPADA DOS VEADEIROS AND EMAS NATIONAL PARKS

Both Chapada dos Veadeiros and Emas National Parks in the state of Goiás are part of the Campos Cerrados, the midwestern Brazilian savannah.

Date of inscription: 2001

With an area of about two million sq. km (770,000 sq. miles), the Cerrado is Brazil's second-largest ecosystem. Despite its rather dry climate and arid soils, it has the greatest biodiversity of any of the tropical savannahs. The Cerrado is located in Brazil's uplands, and large portions of the region feature high plateaus, punctuated by abrupt ravines and river valleys.

The Chapada dos Veadeiros National Park covers a total area of 2,400 sq. km (920 sq. miles) and covers the highest points of the Cerrado, providing a home for numerous rare species, including wild deer, monkeys, and king vultures. A total of 45 different mammals and 300 birds have been recorded, as well as about 1,000 butterflies.

Emas National Park, covering a total area of 1,300 sq. km (520 sq. miles), was named after its population of rheas ("ema" in Portuguese). During the breeding season, the mating call of the male, which sounds like "nandu," can be heard far and wide. The open grassland with its termite hills is also an ideal habitat for giant anteaters.

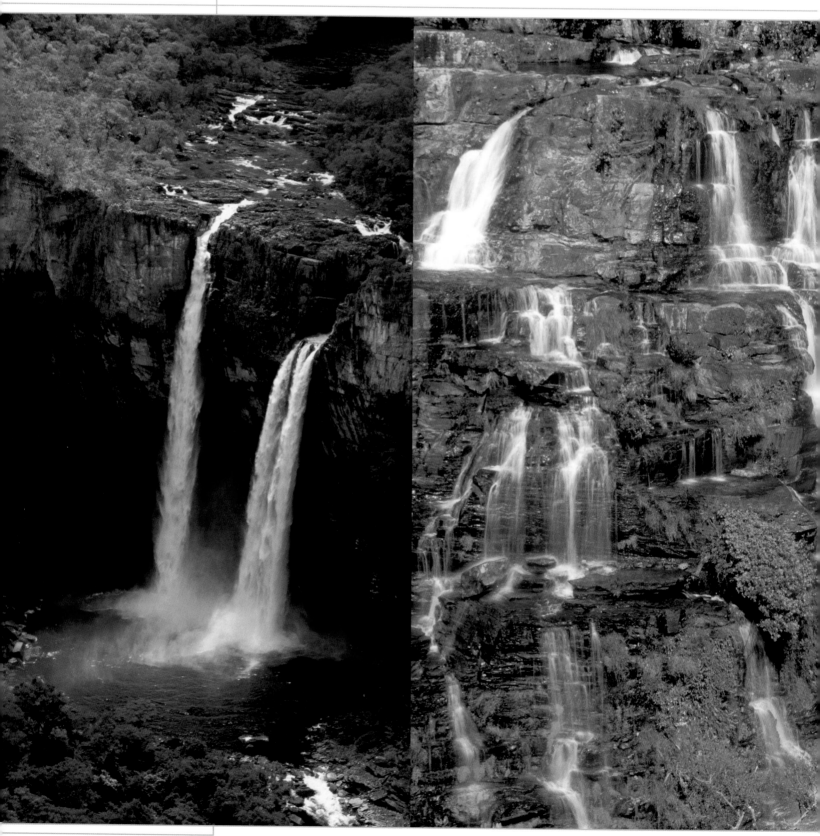

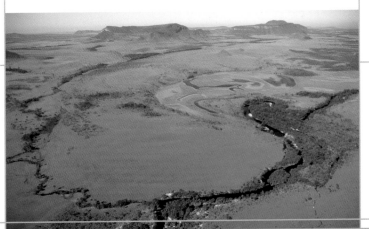

The Rio Preto, the main river of the Chapada dos Veadeiros, drops 120 m (390 feet) in this waterfall (below, far left). Waterfalls are often created where layers of rock of different hardnesses meet, as the water wears away the softer rock more quickly (below). In the Cerrado landscape the rivers form wide loops that are bordered by thick gallery forest (left).

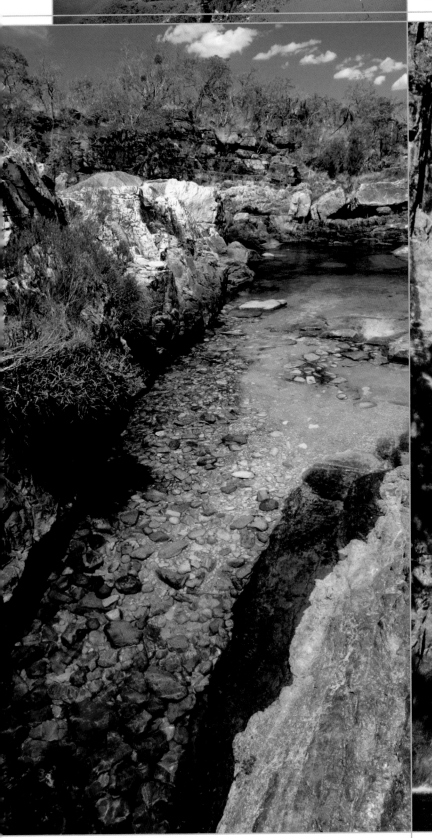

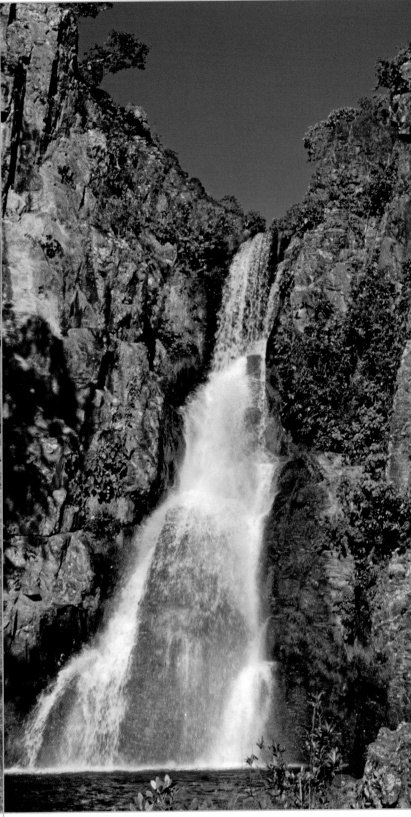

The Atlantic rainforests in this reserve are among the largest and best-preserved in south-east Brazil. The enormous range of species that lives here are testament to the evolutionary history of this part of South America.

Date of inscription: 1999

Brazil's Atlantic rainforests are considered endangered: only 7 percent of the original extent of the forests remains. A large part of these remnants grow in the south-east of the country, in the states of Paraná and São Paulo. Large parts of the rainforests of the Discovery Coast in north-east Brazil also enjoy World Heritage status.

The Atlantic forests grow in a stunning landscape that alternates between forested mountains, fast-flowing rivers, high waterfalls, and shallow swamps. Many rare and endemic plants grow in the 25 conservation areas, which together cover an area of about 5,000 sq. km (1,900 sq. miles). In some areas as many as 450 different tree species per hectare

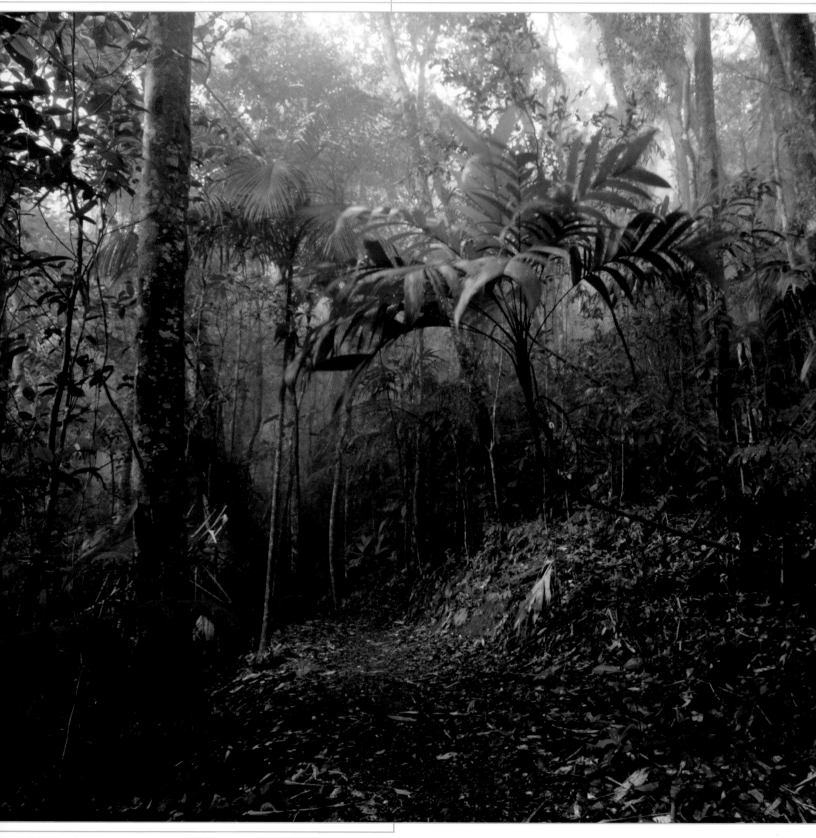

(2.5 acres) have been recorded, a botanical biodiversity greater even than that found in Amazonia. The animal life in the forest reserves is equally varied, and includes some 120 different mammals (including jaguars, otters, and anteaters) as well as about 350 bird species.

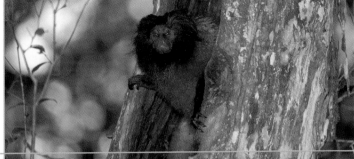

Although the upper canopy of the rainforest develops luxuriant foliage, the lack of light on the forest floor means that only sparse vegetation can grow here (large image). Streams meander beneath toppled tree trunks (below right). The black-faced lion tamarin, of the *Callithricidae* family, was only discovered in 1990 (left).

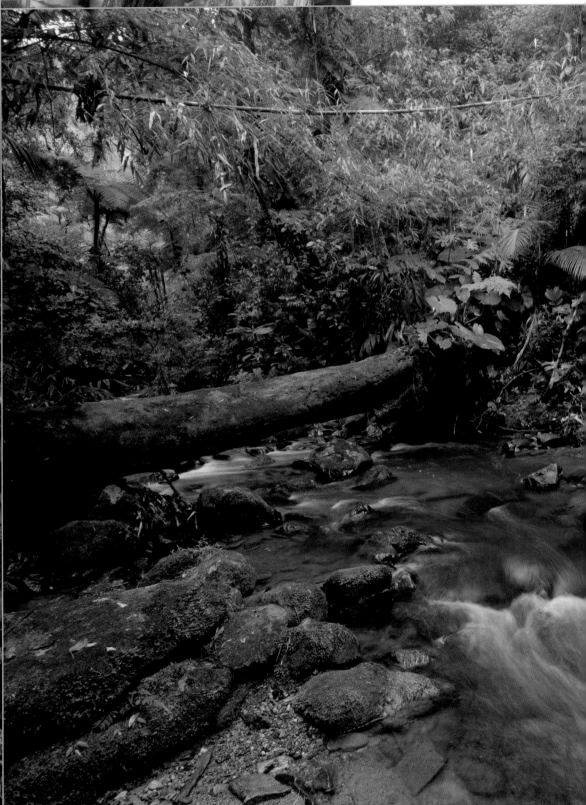

PANTANAL CONSERVATION AREA

The Pantanal is one of the world's largest freshwater wetlands and boasts spectacular biodiversity.

Date of inscription: 2000

The Pantanal wetlands extend across the far south-west of Brazil, near the Bolivian and Paraguayan borders. From November to April, torrential summer downpours flood the Río Cuiabá and Río Paraguay river systems, a low plain three times the size of Costa Rica, forming an enormous, irregular body of water with shallow lakes, swamps, and flooded morasses.

Four conservation areas here have been inscribed as World Heritage Sites, with a combined total area of around 2,000 sq. km (770 sq. miles). The annual floods function as a natural control mechanism, determining the supply, cleaning, and exchange of groundwater and rainwater. The sediment and nutrients transported by the floodwater allow healthy grassland to

grow up during the drier winter, when the waters recede between the end of April and October. During these months, Pantanal's unique scenery looks particularly spectacular, steaming in the heat beneath a usually misty sky. The conservation area remains partially inundated during the dry season, making it a refuge for fauna.

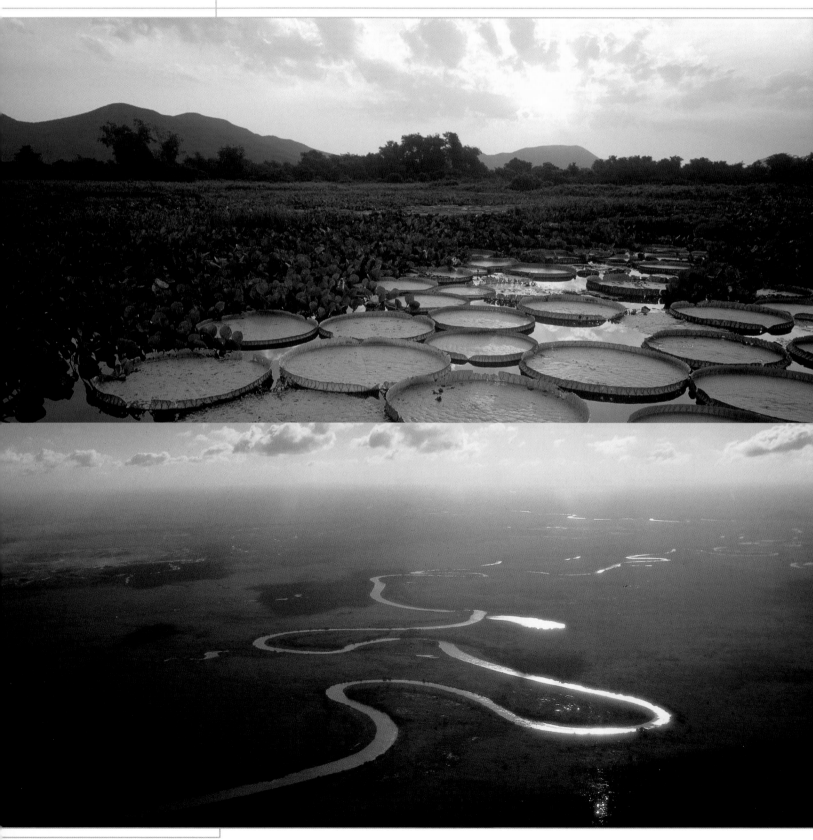

Practically nowhere else in the tropics can boast such a density of animal species, with 650 different birds, 400 fish, and 80 mammals. Large sections of the wetlands encroach upon the Cerrado savannah, which is punctuated by trees like the Jatobá, some of which can reach a great height. Acuri palms form little woods in the extensive swamplands.

Water is the characteristic element of the Pantanal in the form of shallow lakes full of water plants and rivers that flow through the landscape in wide loops. The flowers and leaves of the Santa Cruz water lily (*Victoria cruziana*) spread widely across the surface of the water (left and far left).

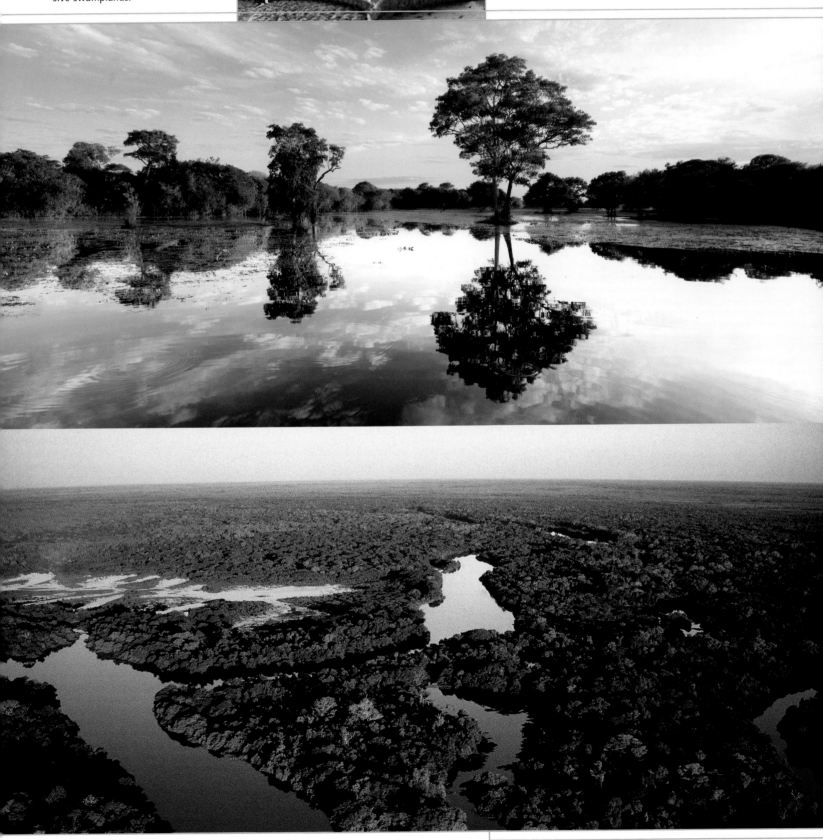

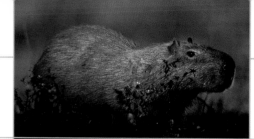

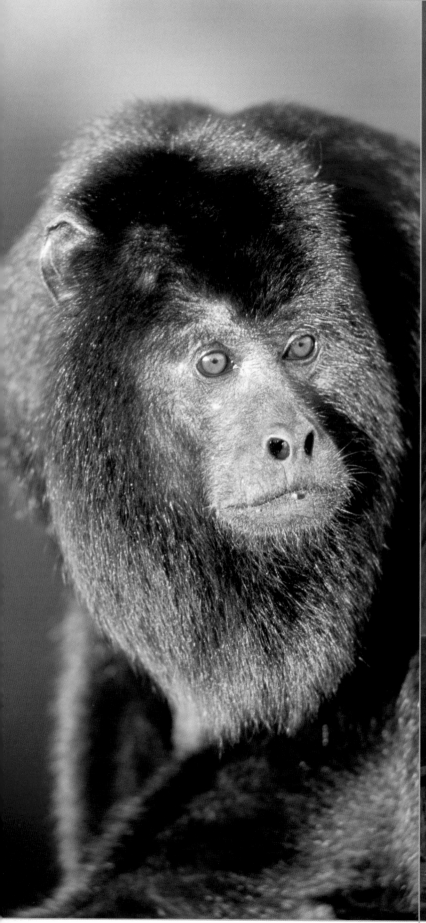

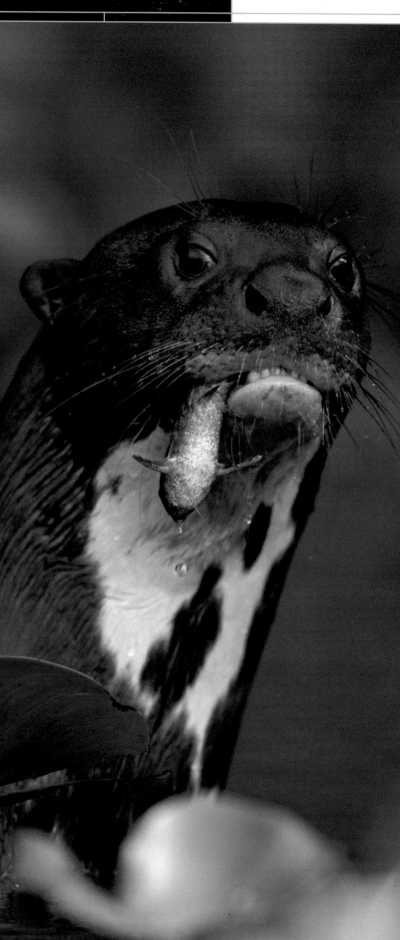

Like many other inhabitants of the Pantanal, the black howler monkey is on the list of endangered species. The streams and rivers are full of prey for the giant otter. The diurnal six-banded armadillo can rear up on its hind legs to get a better view. Even jaguars roam the area (all below, from left). The indigenous capybara is the world's largest rodent (left).

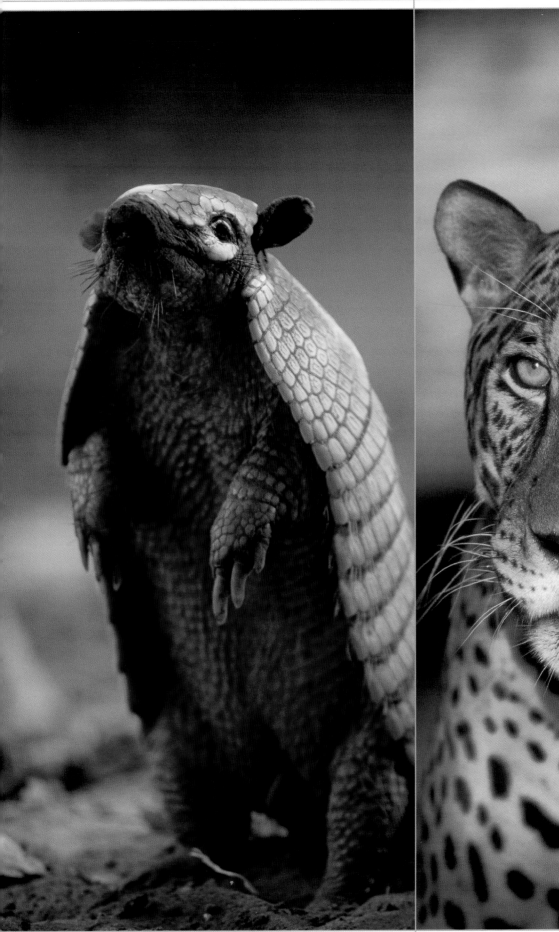

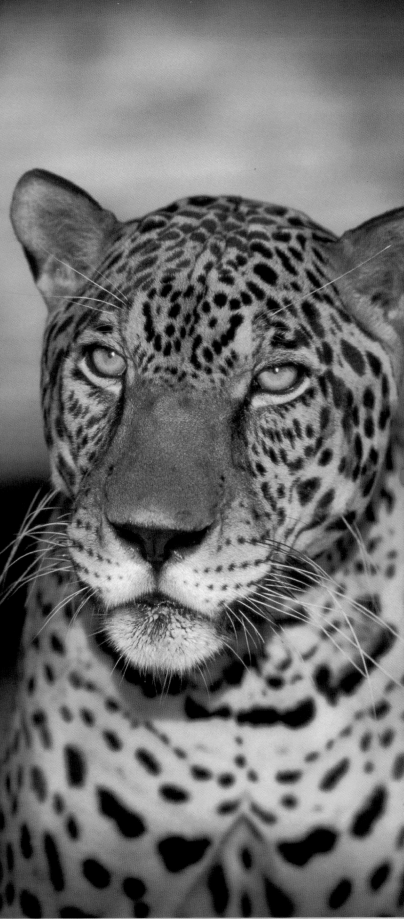

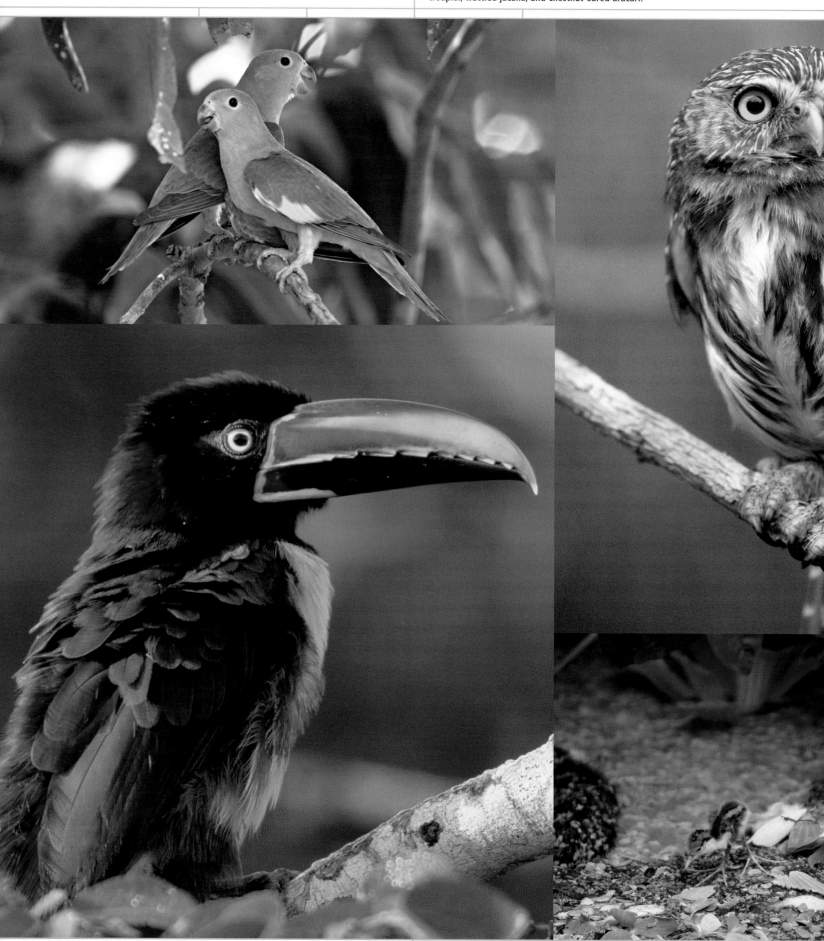

There is much singing and chirruping in the forests and swamps of the Pantanal, and a great array of bird species. Clockwise, from above left: a pair of canary-winged para- keets, least pygmy owl, a flock of red-capped cardinals, troupial, wattled jacana, and chestnut-eared aracari.

The Pantanal is home to no less than 26 species of parrot. One of the most beautiful is the hyacinthine macaw (left), with its cobalt-blue feathers and a characteristic yellow stripe across its beak and eyes. This parrot is one of the world's largest, reaching a length of up to a meter (3 feet).

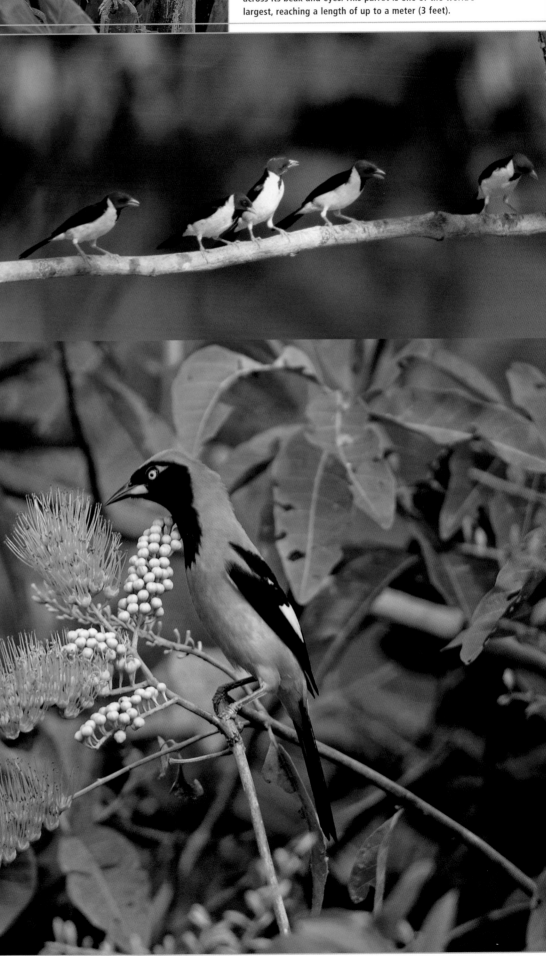

With a striking crest running right down to its tail, the green iguana looks frightening, and yet this reptile, which can reach 130 cm (4 feet) in length, is completely harmless – it eats only plants. Green iguanas are excellent swimmers. On river banks they happily climb out on to jutting tree boughs to enjoy the sun.

The extensive wetlands of the Pantanal provide almost ideal conditions for reptiles, attracting countless lizards, alligators, and snakes: (far left, from top to bottom) tri-color hognose, young Yacare caiman, parrot snake, mature Yacare caiman, and white-throated lizard. Insects such as this tick find protection by disguising themselves as thorns (left).

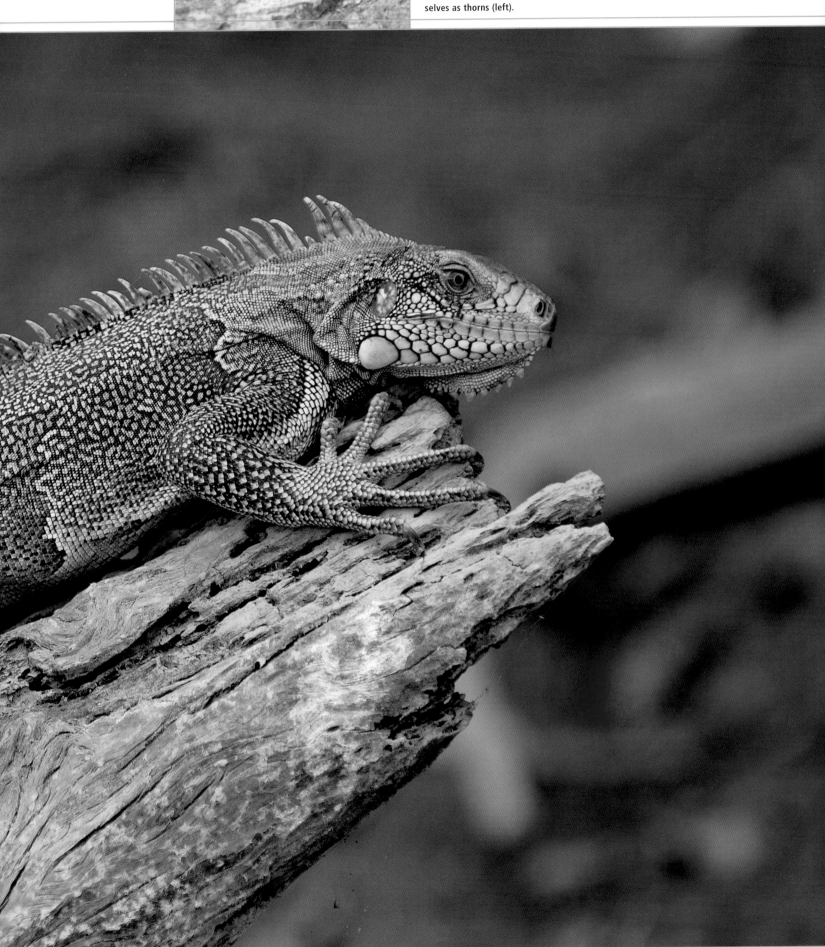

This island group, 500 km (310 miles) north-east of Recife, reveals an extraordinary wealth of animal life, with dolphins, sharks, sea turtles, and countless seabirds.

Date of inscription: 2001

The island reserves of Fernando de Noronha and Atol das Rocas are situated only a few degrees south of the equator, where the cold waters of the South Atlantic meet warm equatorial ocean currents. Fernando de Noronha, the main island, is a volcanic formation, covered in unique island forest and surrounded by a group of 21 satellite islands.

The Rocas Atoll consists of coral reefs that have formed around the summits of an underwater mountain range. The basins and shallow lagoons of this, the only atoll in the South Atlantic, offer a fascinating natural spectacle at low tide, when a natural aquarium is formed.

The island reserve also includes a marine conservation area of extraor-

dinarily rich biodiversity. The nutrient-rich coastal waters round the island group, teeming with tuna, billfish, cetaceans, sharks, and rare sea turtles such as the loggerhead, are used by many fish species as a spawning and feeding ground. The islands of this South Atlantic archipelago are also the most important staging post for many whales on their annual migra-

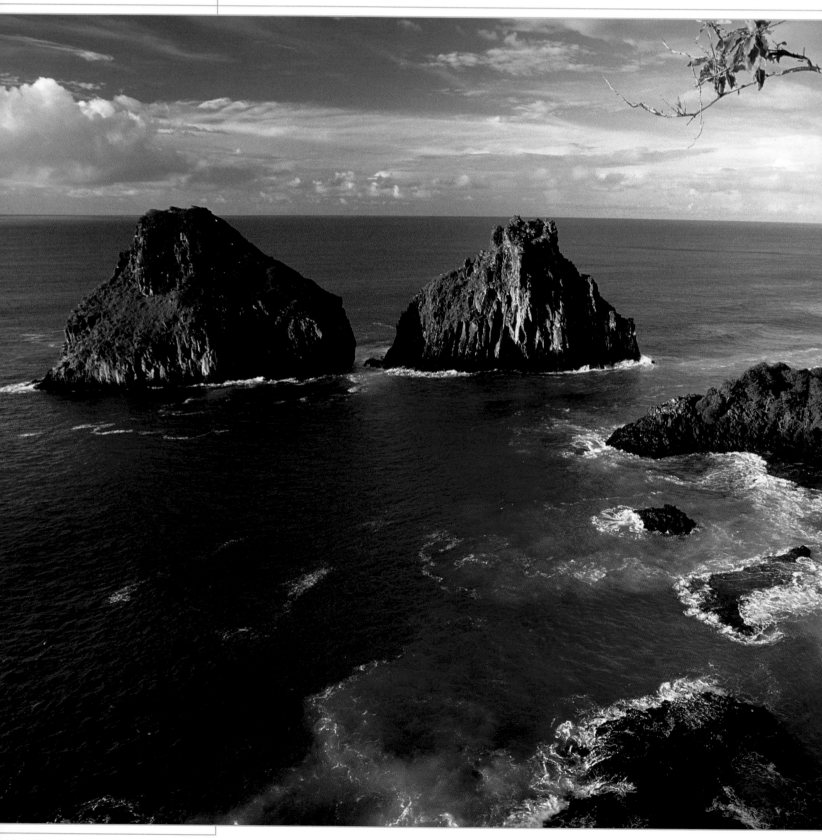

tion from north to south and back again. There are more dolphins resident in the Baía dos Golfinhos than anywhere else on earth. The islands are also a habitat for innumerable tropical seabirds, including many migratory species. The tiny Rocas Atoll alone is home to 150,000 birds.

The Baía dos Porcos, with its "Dois Irmãos" rock formations, is one of the most beautiful bays in Fernando de Noronha (large image), with numerous species of fish and marine mammals (below, from top to bottom: brown chromis, spinner dolphins, ponpon), making the waters of the archipelago a popular area for diving. Seabirds such as the brown booby (left) also find conditions ideal here.

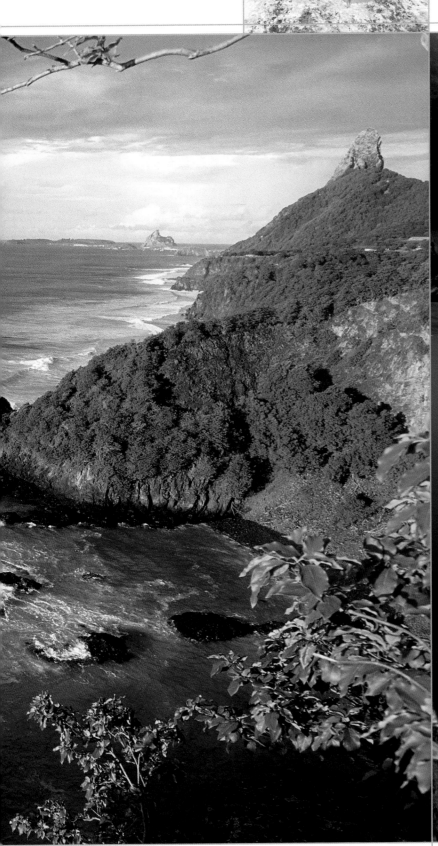

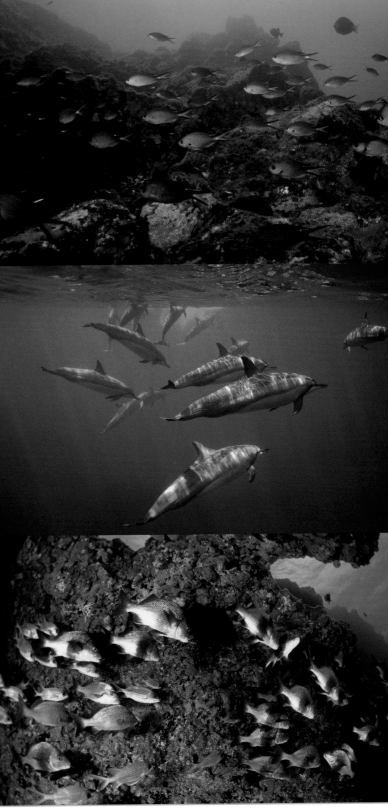

The Iguaçu Falls, situated at the border of three countries – Brazil, Argentina, and Paraguay – are among the biggest and most impressive on earth. This natural monument and its species-rich surroundings were brought under protection through the combining of two parks, one in Brazil and one in Argentina.

Date of inscription: 1986

You hear the waterfall long before you see it; first, a soft gurgling, which then quickly swells to a deafening rumbling and thundering. Flanked by dense tropical vegetation, the Iguaçu river – known in Argentina as the Iguazú – has already reached a width of almost a kilometer (half a mile) as it approaches the horseshoe-shaped falls. The foaming masses of water then cross a 2,700-m (9,000-foot) wide lip of rock, falling into the chasm with limitless force – a superlative natural spectacle. More than 270 individual waterfalls have been counted here.

The park, which covers a total area of 1,700 sq. km (660 sq. miles) on the Brazilian side, is a refuge for many endangered plant and animal species.

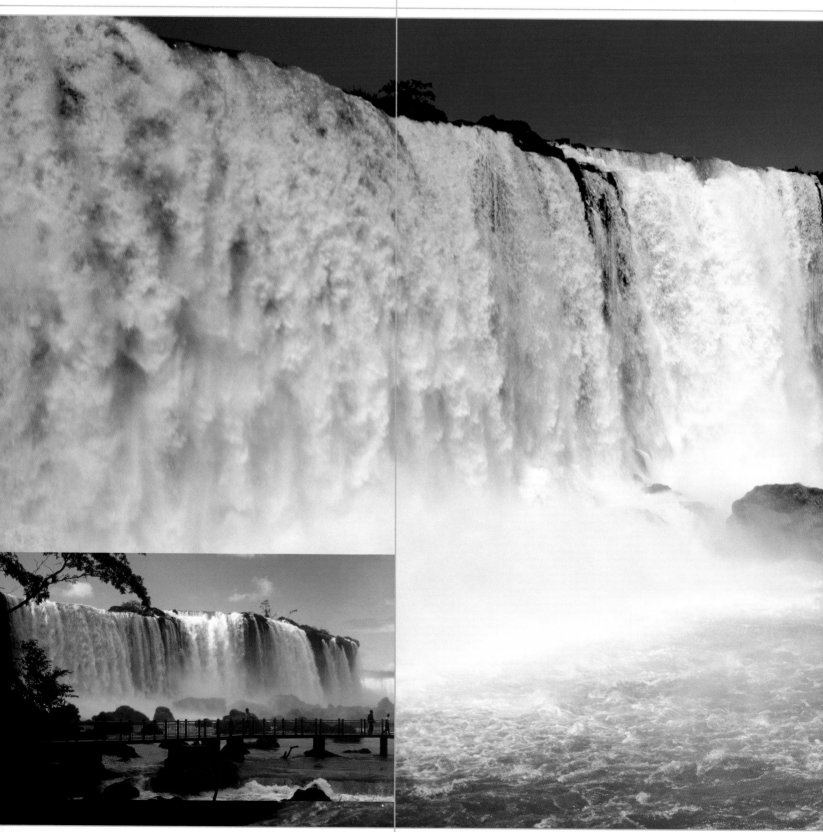

Parrots and nothuras fly in the shade of the trees, and swifts build their nests in rock fissures between the waterfalls. The luxuriant rainforests are inhabited by ocelots, jaguars, howler monkeys, tapirs, giant anteaters, and peccaries, and the now rare giant otter hunts for fish in the troubled waters of the plunge pools.

Sunlight breaks through the mist and spray and creates magical rainbows (large image). The water drops more than 80 m (265 feet) into the depths (below left). The Iguaçu approaches the lip of the falls in wide bends. Due to erosion, the falls are slowly moving backwards (right).

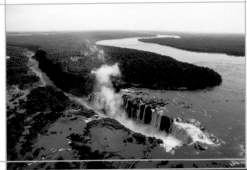

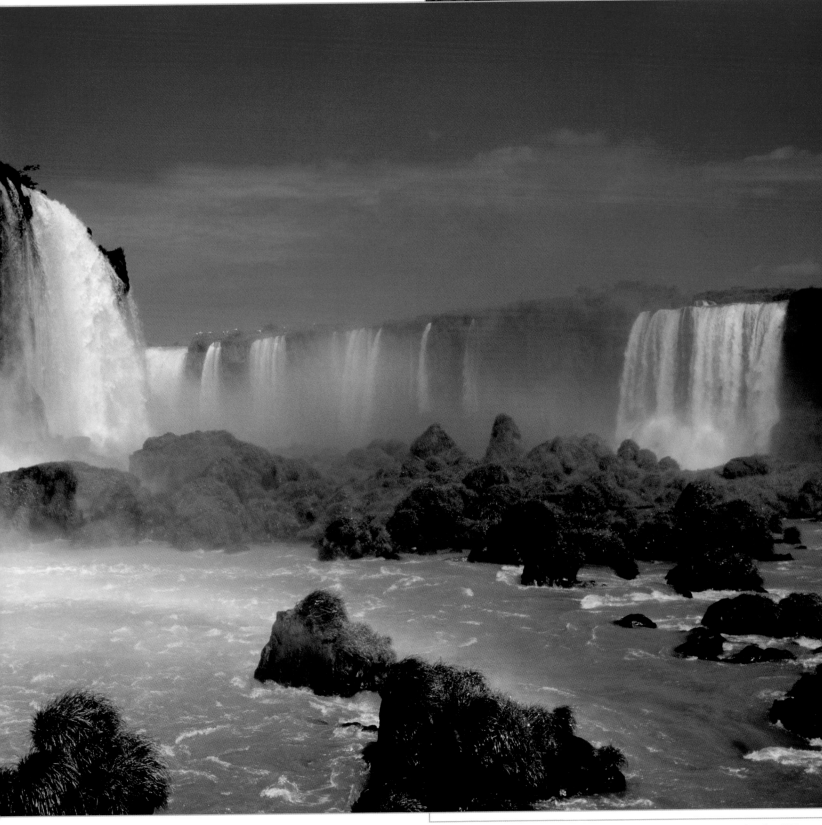

A national park has also been established on the Argentinian side of the Argentina-Brazil border, at the spectacular Iguazú Falls. Along with its main attraction, it boasts dense subtropical rainforest and is home to a variety of plant and animal life.

Date of inscription: 1984

On the Brazilian border, the Iguazú river, which has now grown to a width of 2,700 m (9,000 feet), reaches the lip of a mighty basalt plateau, where it divides into more than 270 cascades and waterfalls, and drops 80 m (265 feet) into the depths.

Dense tropical rainforest grows in the red soils of the basalt plateau. Lianas and epiphytes as well as more than 2,000 vascular plant varieties grow in the national park, which covers an area of about 550 sq. km (210 sq. miles) and is home to tapirs, giant anteaters, ocelots, howler monkeys, and even jaguars, besides more than 400 bird species and a wealth of amphibians and reptiles, including the endangered broad-snouted caiman.

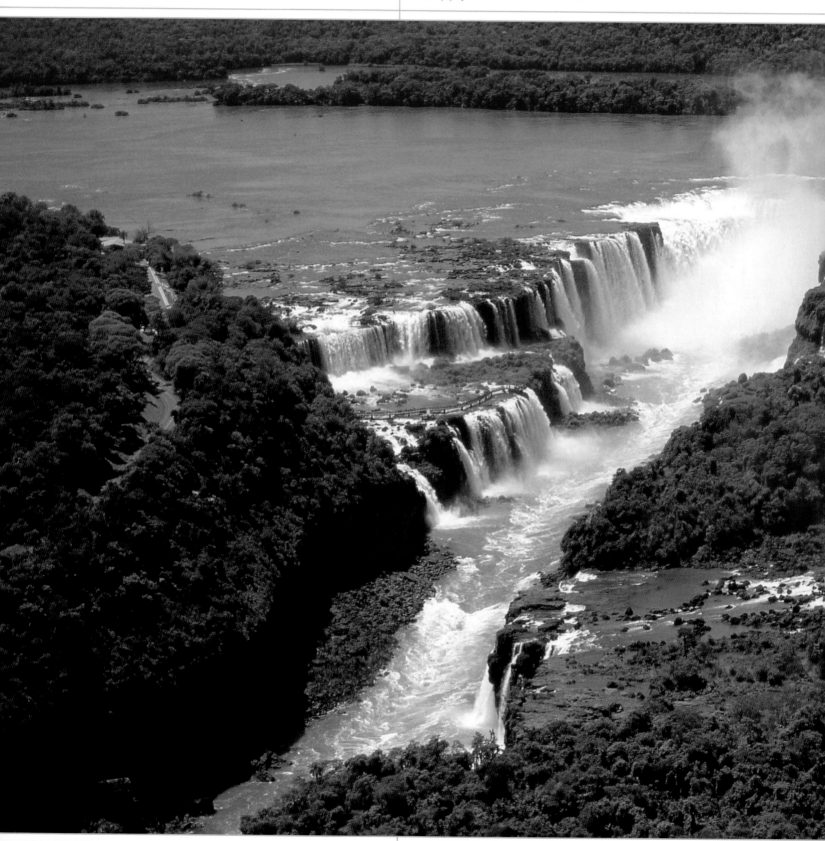

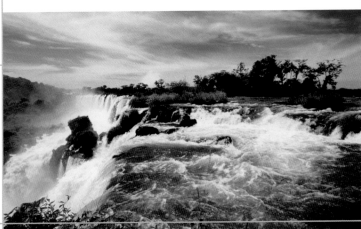

The locals call the waterfalls the "Garganta del Diablo" – the jaws of the devil. The water plunges down in dozens of cascades along a broad front (left). Even the smallest islands of the Iguazú river are thickly overgrown (large image).

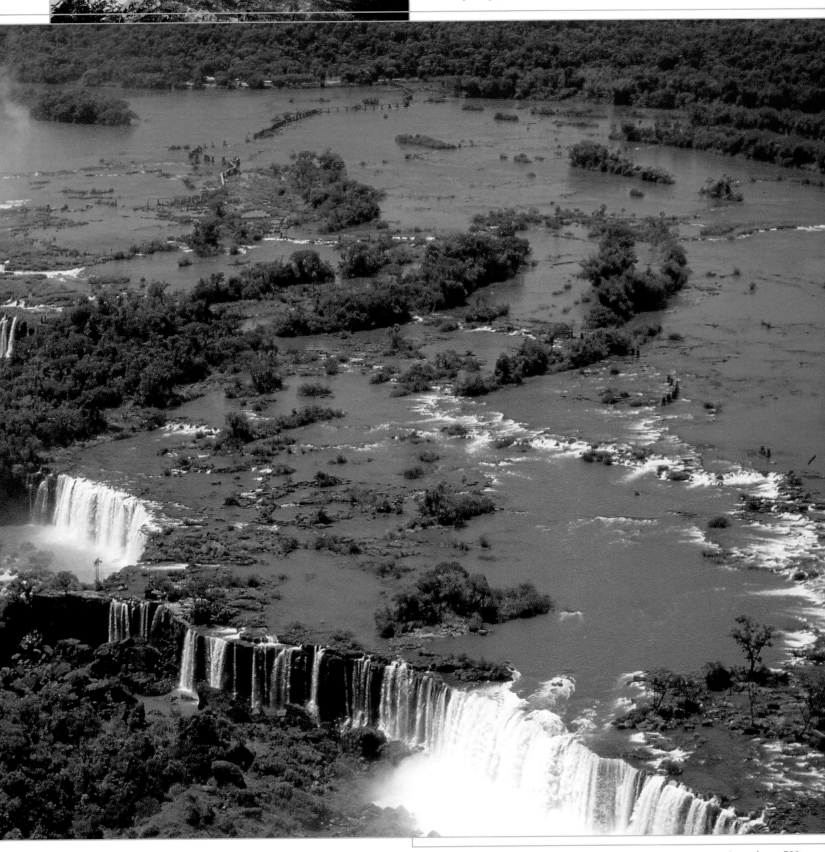

ISCHIGUALASTO AND TALAMPAYA NATURAL PARKS

The world's most complete stratified fossil record from the Triassic is to be found in these two neighboring nature parks in western Argentina.

Date of inscription: 2000

The Valle de la Luna, an extended, desert-like valley about 400 km (250 miles) north-west of Córdoba, near the Chilean border, was first noted by paleontologists in 1930, but it was not until the 1950s that systematic research was conducted here.

As far as both quality and quantity are concerned, the area is one of the most important sources of geological and paleontological finds in the world. The Ischigualasto Provincial Park was established in 1971, and Talampaya, established first as a provincial, then as a national park, was added in 1975.

The two parks combined form a continuous area of 2,750 sq. km (1,050 sq. miles). When the Andes rose from the earth's crust 60 million years ago, they radically changed environmental conditions that had persisted for 180 million years. In Talampaya, erosion, nature's sculptor, shaped dark brown and green rocks, columns, and thin obelisks, strewing them across the brick-red, sandy ground and low scrubland, as if thrown by a giant's hand. Neatly separated rock strata in steep cliffs and petrified forests in

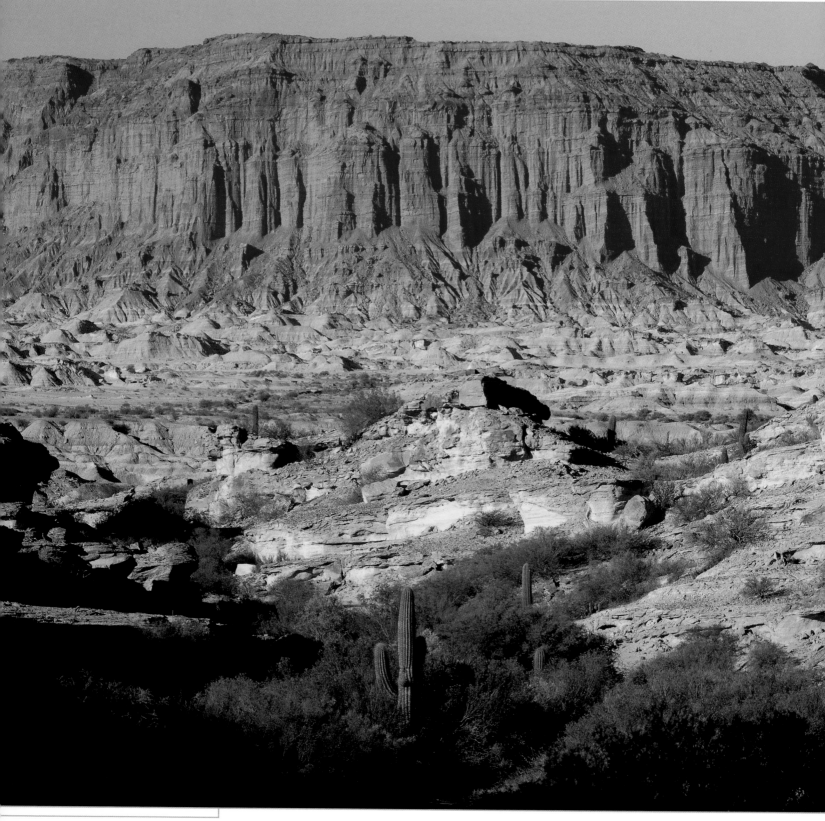

both parks are open books for geologists and paleontologists, revealing an almost complete evolutionary history of the area, stretching back to the Triassic era (245–208 millions of years ago). Along with dinosaur bones, paleontologists have excavated fossil remains of 55 other vertebrates (fish, amphibians, reptiles, and mammals) and more than 100 plant species. In the nature parks, dry shrubs and cactuses predominate in modern times, although pumas, guanacos, mountain viscachas, nandus, and condors are also seen.

Numerous pre-Columbian rock paintings in Ischigualasto and especially Talampaya are of cultural and historical interest.

In the Ischigualasto Provincial Park in the Valle de la Luna, water and wind have fashioned a fantastical landscape of petrified forests (large image) and mushroom-shaped rocks (below right). The so-called "Catedrál" (above right) is particularly imposing. Rock paintings more than 1,500 years old have been found across the parks, more than 30 in Talampaya (left).

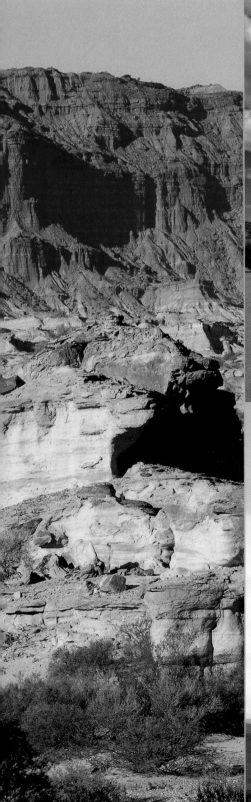

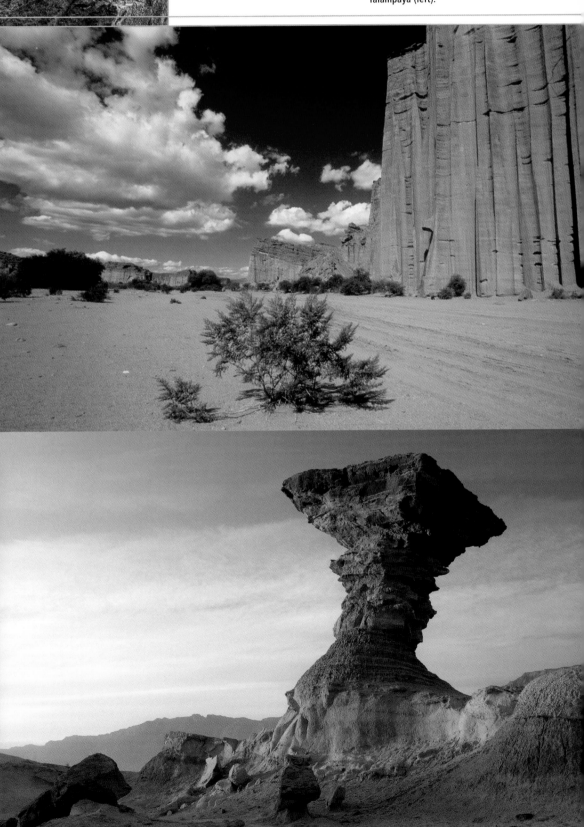

The entirety of this 3,600 sq. km (1,390 sq. mile) peninsula mid-way along the Atlantic coast of Argentina is designated as a World Heritage Site. It offers a protected living environment for sea mammals in particular.

Date of inscription: 1999

The Ameghino isthmus, 30 km (19 miles) long but only 5–10 km (3–6 miles) wide, connects the largest Argentinian peninsula to the mainland, and is surrounded by waters that are a habitat for several species of marine mammal, which breed here every year.

The southern right whale was hunted almost to extinction, with populations declining every year, but these 14-m (48-foot) long giants, which can weigh 35 metric tons, have since found a safe refuge in the Valdés peninsula, where they congregate at the beginning of every spring, remaining until December.

An enormous elephant seal colony is to be found in a protected area of the Punta Norte, the northern extremity

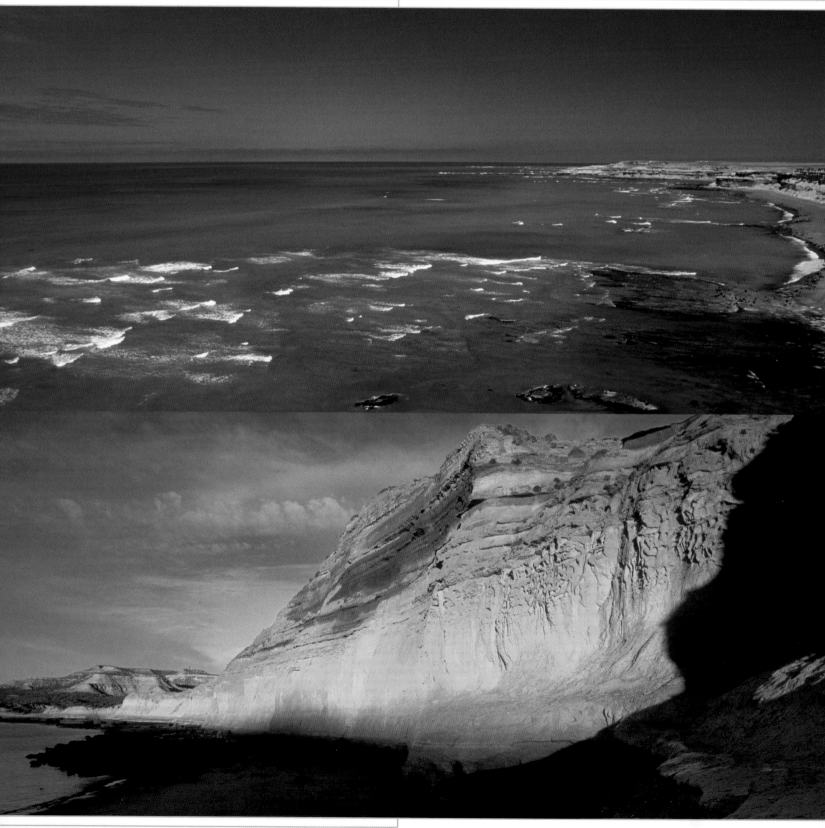

of the peninsula. These imposing animals are the largest members of the seal family and spend the greater part of their lives at sea, coming ashore only to breed.

A colony of sealions is protected on Cape Punta Delgada. These are members of the eared seal (*Otariidae*) family and live on the readily available fish in the area. A sealion colony has also been established south of Puerto Pirámides.

Orcas, the largest species of dolphin, also known as killer whales, are a natural enemy of the sealion, and their arrival in the peninsula's waters invariably coincides with the birth of the sealions' young. They have developed particular techniques to hunt these animals, even straying close to the shore to catch their prey. There are also Magellan penguins on Valdés, and 180 other bird species, of which many are seabirds. Among the land animals are guanacos, Patagonian cavies, pampas foxes, and Geoffroy's cats.

Long stretches of the Valdés peninsula's 400 km (250 miles) of coastline are composed of shallow bays and lagoons. At several points, such as around Puerto Pirámides, at Punta Norte, and at Punta Delgada, the coast rises steeply to form 100-m (330-foot) high cliffs. The seal colonies live at the foot of these, in places barely accessible to humans (below).

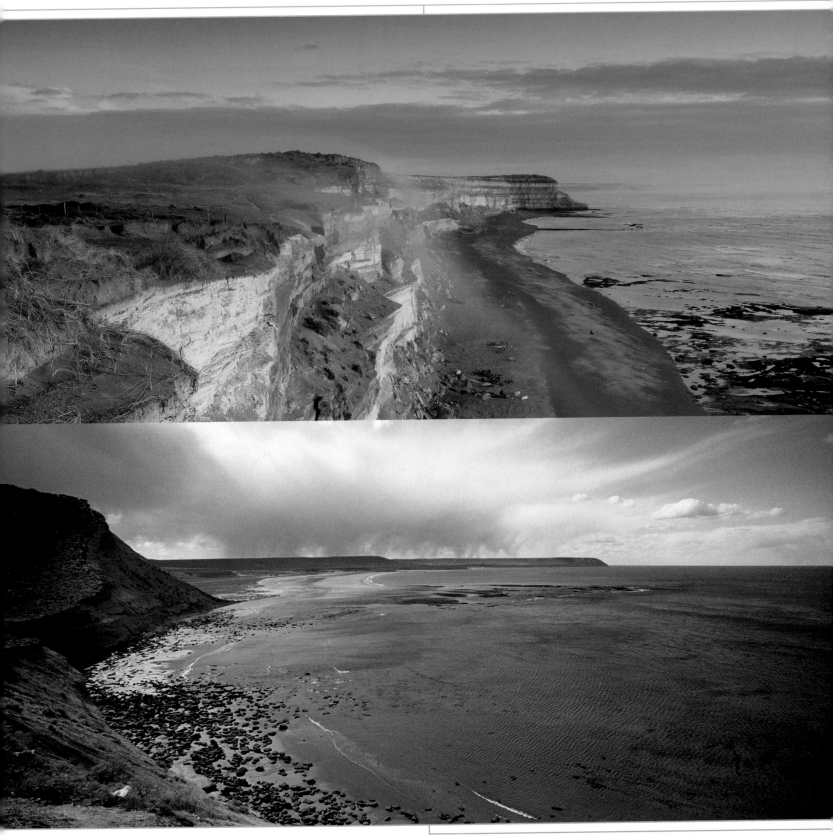

Elephant seals visit the coast of the Valdés peninsula to reproduce. The bull seal, which can weigh over 3 metric tons and reach 6.5 m (22 feet) in length, marks out his territory, and after a few weeks a harem of up to 20 females gathers round him. Each of these will give birth to just one cub (large image).

The peninsula is home to over 30 different mammals, including sealions (inset images, top: mother with young; third image from top: hunting in the water) and southern right whales, which breed and give birth in the shallow waters around the peninsula (second image from top). Over 40,000 Magellan penguins live here in five colonies (bottom).

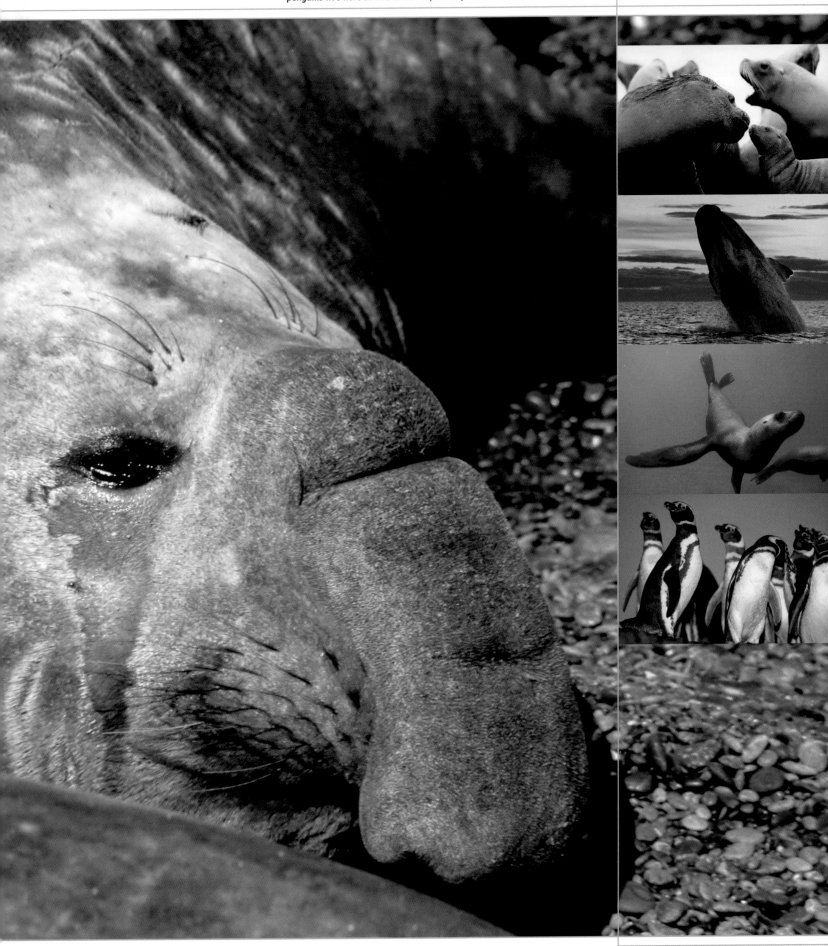

LOS GLACIARES
NATIONAL PARK

The 4,500 sq. km (1,800 sq. miles) of this national park are situated in the heart of the Patagonian Andes, next to the Chilean border, and boast extraordinary scenic beauty, with spectacular mountains, glaciers, and lakes.

Date of inscription: 1981

The national park's 13 glaciers form just a part of the extensive Patagonian ice field, which is composed of 47 large glaciers and is the largest continuous mass of ice outside the Antarctic, with a total surface area of 15,000 sq. km (5,800 sq. miles). There are a further 200 smaller glaciers which are not directly connected to the ice field.

The best-known of these is the Perito Moreno glacier, 30 km (19 miles) long and 5 km (3 miles) wide, which "calves" into Lago Argentino. As one of the few glaciers left in the world that is not retreating, it gradually pushes its terminus out as a kind of peninsula, cutting off a spur of the lake every three or four years. The water level here then rises by up to 30

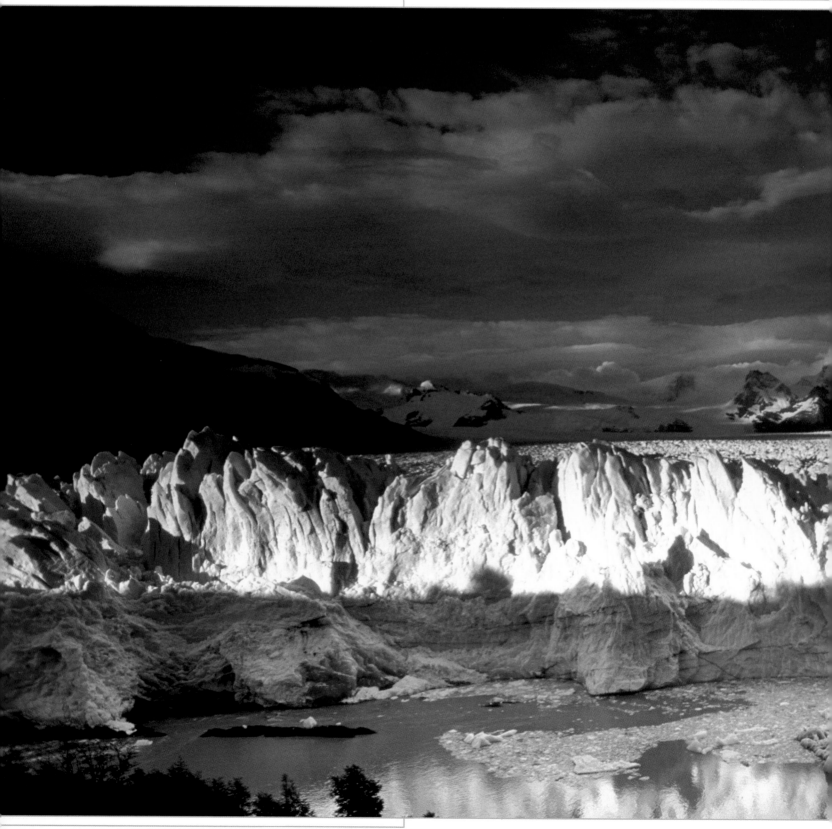

m (100 feet) and, when the wall of ice can no longer stand the intense pressure, an impressive natural spectacle occurs as the dammed-up water ruptures a section of the glacier terminus and floods into the other part of the lake. The Uppsala and Spegazzini glaciers are also a part of this primeval, glacial world. The scenic high points of the granite summits of Cerro Torre and Monte Fitz Roy, both over 3,000 m (9,900 feet) high and challenging climbs, lie in the northern part of the national park, not far from Lago Viedma. Birds predominate among the animal life in the park; there are some 100 species, including black-necked swans, condors, the Darwin nandu, and numerous varieties of ducks and geese.

The terminus of the Perito Moreno glacier towers up to 60 m (200 feet) above Lago Argentino. Large blocks of ice continually break off, crashing into the lake with a thunderous roar (large image). The cliffs beside the lake have been worn flat by the glacier (left).

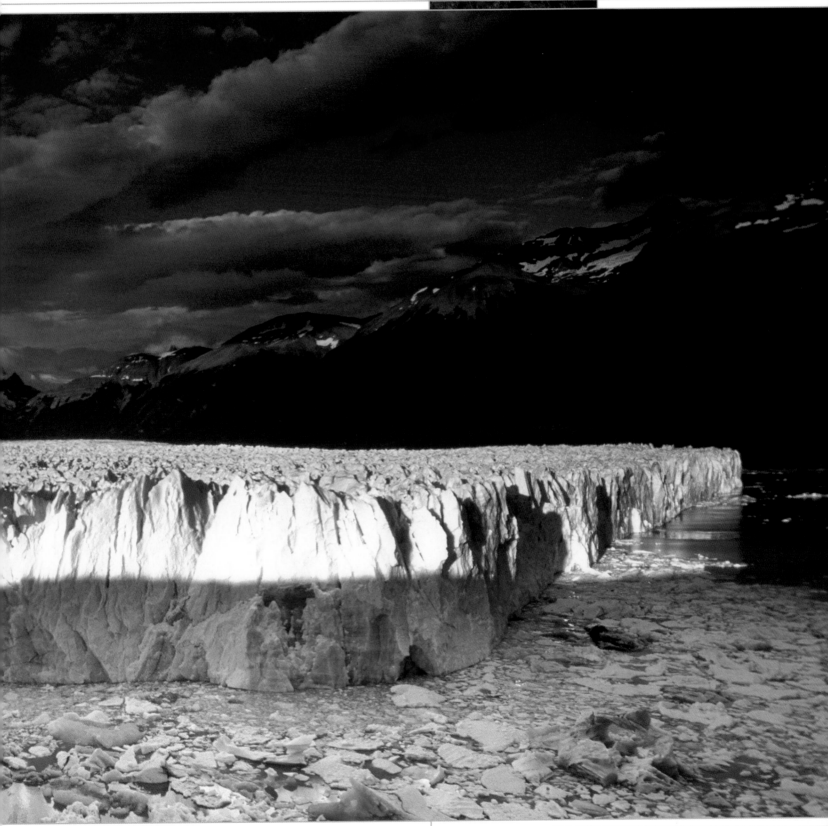

LOS GLACIARES NATIONAL PARK
MONTE FITZ ROY

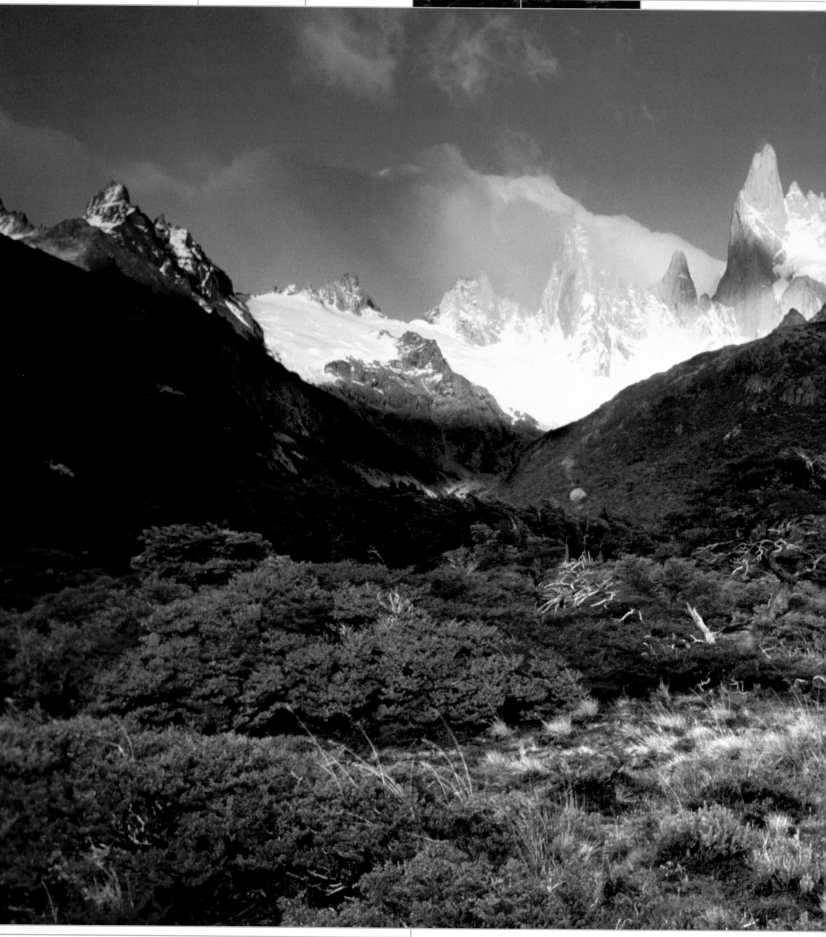

The granite tips of the tallest mountain in the Los Glaciares National Park, the 3,375-m (11,070-foot) high Monte Fitz Roy (left: seen here flanked by Aguja Poincenot), seem to pierce the sky like stone needles. The first people to settle here called this distinctive peak "Chaltén," the "smoking mountain"; it is normally shrouded in thick cloud, and an uninterrupted view such as this presents itself only rarely.

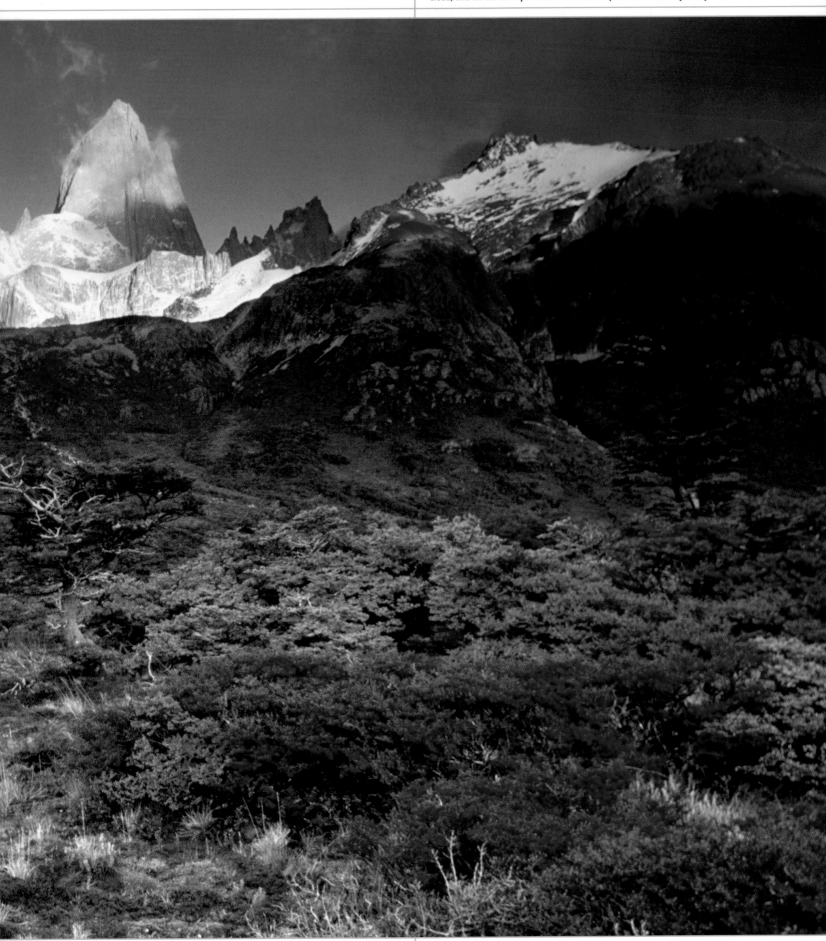

Macquarie, a subantarctic island only 34 km (21 miles) by 5 km (3 miles) in size, belongs to Australia, and for seven months of the year is home to about a million king penguins.

INDEX

This index will allow rapid location in the map section of all the World Heritage Sites described in this book. The first figure denotes the page number, and the following combination of letters and figures gives the coordinates of the map square.

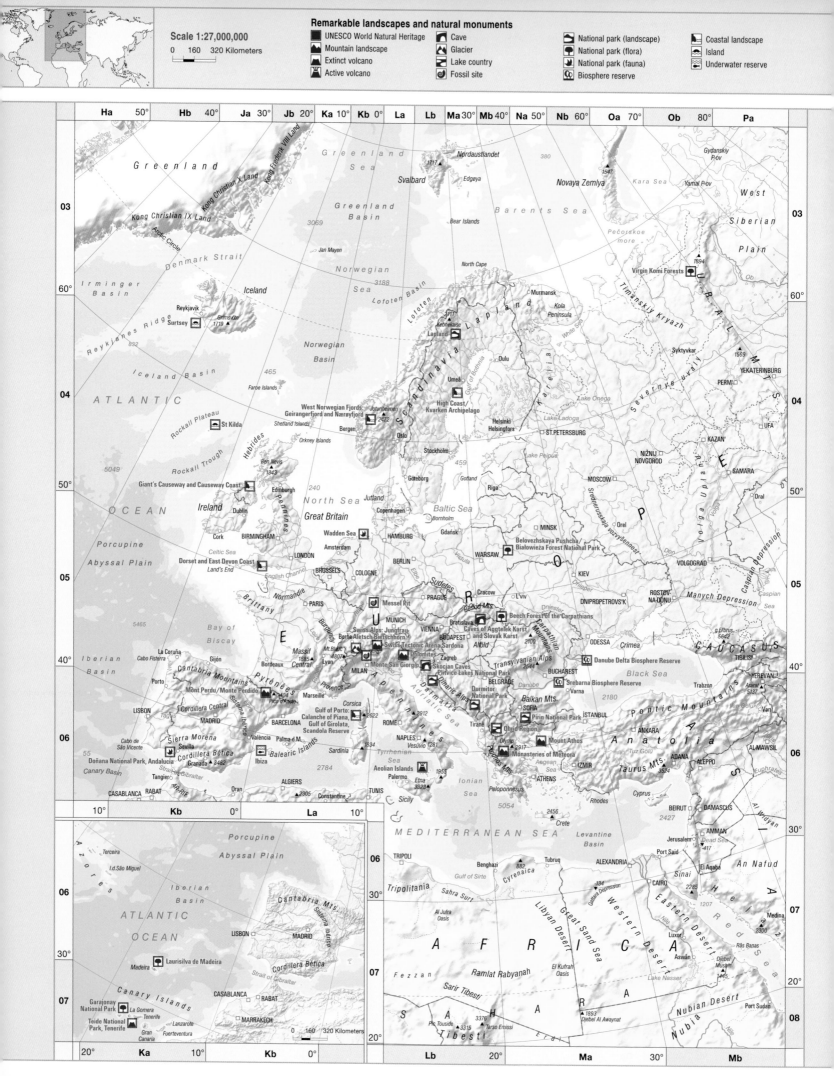

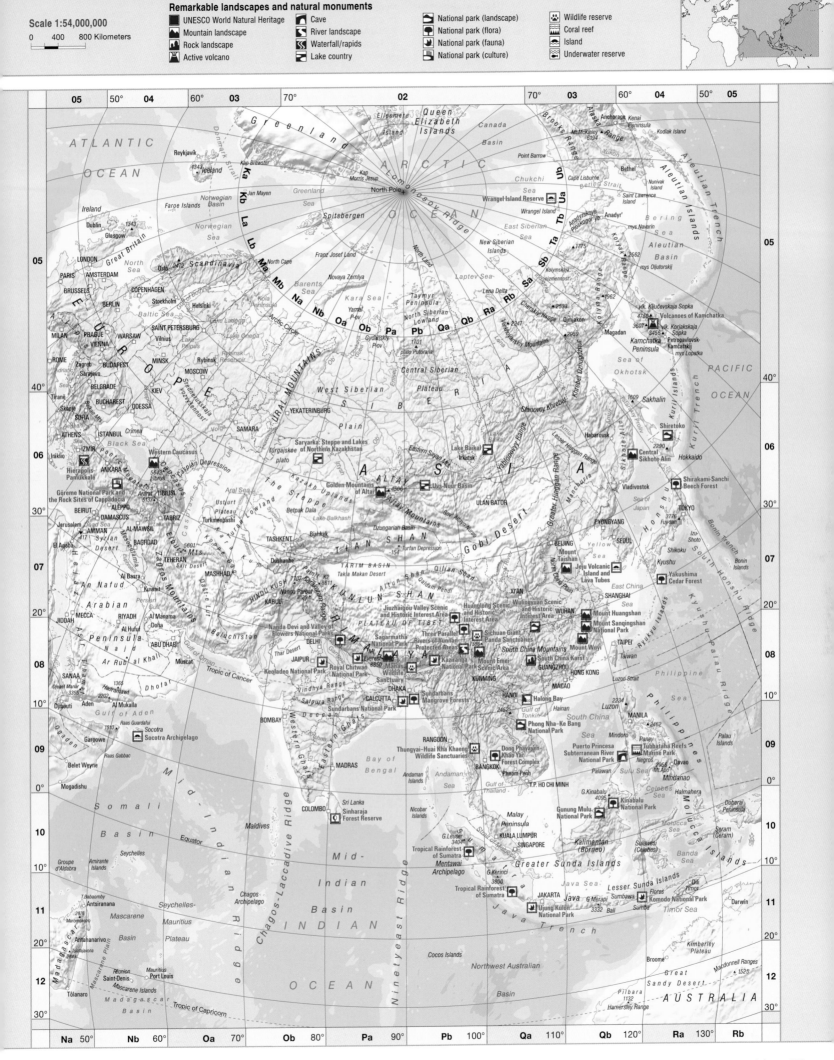

Remarkable landscapes and natural monuments

Scale 1:54,000,000

0 400 800 Kilometers

■	UNESCO World Natural Heritage	
▲	Mountain landscape	
▲	Rock landscape	
▲	Active volcano	

Cave	
River landscape	
Waterfall/rapids	
Lake country	

National park (landscape)	
National park (flora)	
National park (fauna)	
National park (culture)	

Wildlife reserve	
Coral reef	
Island	
Underwater reserve	

ATLANTIC OCEAN

Reykjavik
1343 Iceland

Ireland
Dublin
Glasgow
1343

Faroe Islands

LONDON
PARIS
AMSTERDAM
BRUSSELS
BERLIN
MILAN
PRAGUE
VIENNA
WARSAW
ROME
Zagreb
BUDAPEST
Sarajevo
BELGRADE
MINSK
MOSCOW
Tiranë
BUCHAREST
KIEV
Skopje
SOFIA
ODESSA
ATHENS
ISTANBUL
Iráklio
IZMIR
ANKARA
Hierapolis-Pamukkale
Göreme National Park and the Rock Sites of Cappadocia
BEIRUT
DAMASCUS
ALEPPO
Jerusalem
AMMAN
El Aqaba
BAGHDAD
TABRIZ
TEHERAN
Al Basra
Kuwait
MASHHAD
MECCA
RIYADH
Al Manama
Doha
ABU DHABI
Muscat
JIDDAH
Al Hufuf
SANAA
Aden
Al Mukalla
Djibouti
Garoowe
Socotra
Socotra Archipelago
Belet Weyne
Mogadishu

EUROPE

Greenland

North Pole

ARCTIC OCEAN

Spitsbergen

Queen Elizabeth Islands

Canada Basin

Brooks Range

Anchorage
Mt. McKinley 6194

Point Barrow

Chukchi Sea

Bering Strait

Aleutian Islands

Aleutian Trench

PACIFIC OCEAN

Scandinavia

Oslo 2472
Stockholm
Helsinki
North Cape

Barents Sea

Novaya Zemlya

Kara Sea

Franz Josef Land

North Land

Laptev Sea

Taymyr Peninsula

New Siberian Islands

East Siberian Sea

Wrangel Island Reserve
Wrangel Island

Kolyma Range

Volcanoes of Kamchatka

Kamchatka Peninsula

Petropavlovsk-Kamchatsky

Sea of Okhotsk

ASIA

S I B E R I A

West Siberian Plain

Central Siberian Plateau

Lake Baikal

Shiretoko

Central Sikhote-Alin

Shirakami-Sanchi Beech Forest

Vladivostok

TOKYO

SEOUL

PYONGYANG

BEIJING
Mount Taishan

Jeju Volcanic Island and Lava Tubes

Yakushima Cedar Forest

SHANGHAI

XI'AN

WUHAN
Mount Huangshan
Mount Sangqingshan National Park

Mount Wuyi

South China Karst

Mount Emei Scenic Area

GUANGZHOU
HONG KONG
MACAO

TAIPEI
Taiwan

Halong Bay

HANOI

South China Sea

MANILA

Luzon

Philippine Sea

Palau Islands

Tubbataha Reefs Marine Park

Puerto Princesa Subterranean River National Park

Phong Nha-Ke Bang National Park

Dong Phayayen-Khao Yai Forest Complex

BANGKOK

Thungyai-Huai Kha Khaeng Wildlife Sanctuaries

RANGOON

MADRAS

CALCUTTA

DHAKA

Sundarbans Mangrove Forests
Sundarbans National Park

BOMBAY

Western Ghats

Eastern Ghats

Deccan

Bay of Bengal

Andaman Islands

Nicobar Islands

COLOMBO
Sri Lanka
Sinharaja Forest Reserve

Maldives

Mid-Indian Ridge

Chagos-Laccadive Ridge

Mid-Indian Basin

INDIAN OCEAN

Seychelles

Mauritius
Port Louis
Mascarene Islands
Réunion
Saint-Denis

Madagascar
Antsiranana
Antananarivo
Tôlanaro

HIMALAYA

Everest 8850
K2 8611

PLATEAU OF TIBET

KUNLUN SHAN

TARIM BASIN

Takla Makan Desert

TIAN SHAN

Turfan Depression -154

Gobi Desert

ULAN BATOR

ALTAY

Altai Mountains

Golden Mountains of Altai 4506

Uvs-Nuur Basin

Lake Balkhash

Aral Sea

The Steppe

Kazakh Uplands

Saryarka: Steppe and Lakes of Northern Kazakhstan

YEKATERINBURG

URAL MOUNTAINS

SAMARA

KABUL

HINDU KUSH

Nanga Parbat

DELHI
JAIPUR

Nanda Devi and Valley of Flowers National Parks

Keoladeo National Park

Royal Chitwan National Park

Sagarmatha National Park

Manas Wildlife Sanctuary

Kaziranga National Park

Three Parallel Rivers of Yunnan Protected Areas

Jiuzhaigou Valley Scenic and Historic Interest Area

Huanglong Scenic and Historic Interest Area

Wulingyuan Scenic and Historic Interest Area

Sichuan Giant Panda Sanctuaries

KUNMING

KUALA LUMPUR
SINGAPORE

Malay Peninsula

Gunung Mulu National Park

Kinabalu National Park
G. Kinabalu 4095

Kalimantan (Borneo)

Sulawesi (Celebes)

Greater Sunda Islands

Tropical Rainforest of Sumatra

Tropical Rainforest of Sumatra

Mentawai Archipelago

JAKARTA
Java
Ujung Kulon National Park
Komodo National Park

Lesser Sunda Islands

Bali

Flores
Sumba
Timor

Darwin

Timor Sea

Kimberley Plateau

Great Sandy Desert

AUSTRALIA

Pilbara 1132

Macdonnell Ranges

Tropic of Capricorn

Madagascar Basin

Atlas 523

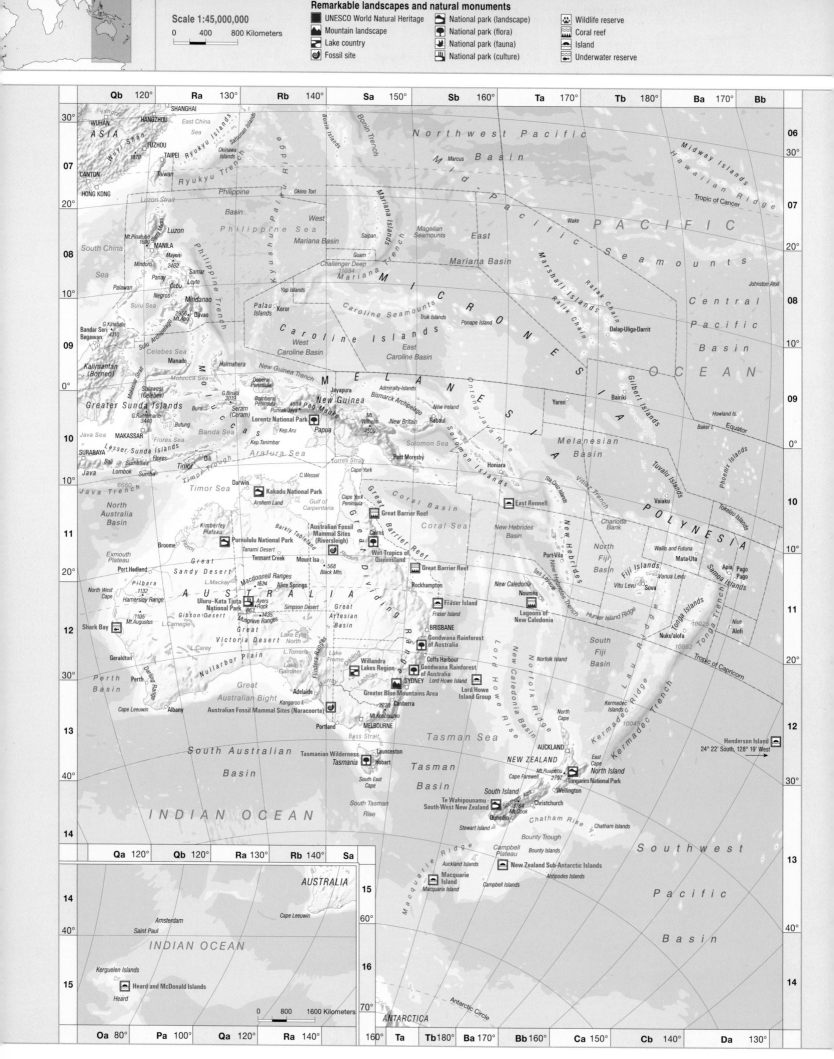

Remarkable landscapes and natural monuments

Scale 1:45,000,000

0 400 800 Kilometers

■ UNESCO World Natural Heritage
🗻 Mountain landscape
🏞 Lake country
🐚 Fossil site

⛰ National park (landscape)
🌿 National park (flora)
🌱 National park (fauna)
🏛 National park (culture)

🦌 Wildlife reserve
🪸 Coral reef
🏝 Island
〰 Underwater reserve

| Qb 120° | Ra 130° | Rb 140° | Sa 150° | Sb 160° | Ta 170° | Tb 180° | Ba 170° | Bb |

ASIA
SHANGHAI
Yangtze
WUHAN
HANGZHOU
East China Sea
Ryukyu Islands
FUZHOU
Wuyi Shan 1670
TAIPEI
CANTON
Taiwan
HONG KONG
Ryukyu Trench
Okinawa Islands
Satsuman Islands
Bonin Islands
Bonin Trench

Northwest Pacific
Basin
Marcus
Mid
Wake

Midway Islands
Hawaiian Ridge
Tropic of Cancer

Philippine
Luzon Strait
Luzon
Mt.Pinatubo 1600
MANILA
Mayon
2462
Mindoro
Panay Leyte
Samar
Cebu
Negros
Mindanao
Mt.Apo 2956
Davao
Palawan
Sulu Sea
G.Kinabalu 4110
Bandar Seri Begawan

Philippine Basin
West Basin
Mariana Basin
Mariana Islands
Saipan
Guam
Challenger Deep 11034
Yap Islands
Palau Islands
Koror

Magellan Seamounts
East
Mariana Basin

PACIFIC
Seamounts

South China Sea
Kalimantan (Borneo)

Philippine Trench
Kyushu-Palau Ridge
Mariana Trench

MICRONESIA
Caroline Seamounts
Caroline Islands
Truk Islands
Ponape Island
West Caroline Basin
East Caroline Basin

Ratak Chain
Ralik Chain
Marshall Islands
Dalap-Uliga-Darrit

Central Pacific Basin
Johnston Atoll

OCEAN

Celebes Sea
Manado
Makassar Strait
Stulawesi (Celebes)
G.Rantemario 3440
Butung
Halmahera
Molucca Sea
Moluccas
Buru
Seram (Ceram)
G.Binaia 3019
Kep.Aru
Banda Sea
Doberai Peninsula
Bomberai Peninsula
Punoak Jaya 4884
MELANESIA
Jayapura
New Guinea
Peg.Maoke
Papua
Lorentz National Park
Admiralty-Islands
Bismarck Archipelago
New Ireland
New Britain
Mt.Wilhelm 4509
Rabaul

Ontong-Java Rise
Yaren
New Guinea Trench
Bairiki
Gilbert Islands

Howland Is.
Baker I.
Equator

Greater Sunda Islands
SURABAYA
MAKASSAR
Flores Sea
Lesser Sunda Islands
Java
Bali
Lombok
Sumbawa
Sumba
Flores
Timor
Dili
Timor Trough 6660
Timor Sea
Kep.Tanimbar
Arafura Sea
Torres Strait
Cape York
Port Moresby
Solomon Sea
Solomon Islands
Honiara

Melanesian Basin
Sta.Cruz Islands
Vitiaz Trench

Tuvalu Islands
Phoenix Islands

Java Sea
Java Trench

North Australia Basin
Darwin
Arnhem Land
Kakadu National Park
Gulf of Carpentaria
C.Wessel
Cape York Peninsula
Coral Basin
Great Barrier Reef
Coral Sea
East Rennell

POLYNESIA
Vaiaku
Tokelau Islands

Kimberley Plateau
Broome
Fitzroy
Tanami Desert
Tennant Creek
Purnululu National Park
Barkly Tableland
Australian Fossil Mammal Sites (Riversleigh)
Cairns
Wet Tropics of Queensland
Mount Isa
568 Black Mtn.
Great Barrier Reef
Great Barrier Reef

New Hebrides Basin
New Hebrides
Port-Vila
Charlotte Bank
North Fiji Basin
Iles Loyaute
Wallis and Futuna
Mata-Uta
Apia
Pago Pago
Samoa Islands

Exmouth Plateau
Port Hedland
North West Cape
Great Sandy Desert
Pilbara 1132
Hamersley Range 1105
Mt.Augustus
Gibson Desert
AUSTRALIA
Alice Springs
Macdonnell Ranges
L.Mackay 1524
Uluru-Kata Tjuta National Park
Ayers Rock 867
Musgrave Ranges 1435
Simpson Desert
Great Dividing Range
Great Artesian Basin
Rockhampton
Fraser Island
Fraser Island

New Caledonia
Noumea
Lagoons of New Caledonia
New Caledonia Ridge
Hunter Island Ridge
Vitu Levu
Vanua Levu
Fiji Islands
Suva
Tonga Islands
16025
Niue
Alofi

Shark Bay
Geraldton
L.Carnegie
L.Carey
Great Victoria Desert
Lake Eyre North
Lake Eyre
L.Torrens
Lake Gairdner
Lake Frome
Flinders Ranges
Murray
Lachlan
Darling
BRISBANE
Gondwana Rainforest of Australia
Coffs Harbour
Gondwana Rainforest of Australia
Willandra Lakes Region
SYDNEY
Greater Blue Mountains Area
Lord Howe Island
Lord Howe Island Group
Lord Howe Rise
South Fiji Basin
Norfolk Island
Tropic of Capricorn
10882
Nuku'alofa

Perth Basin
Perth
Darling Range
Cape Leeuwin
Albany
Great Australian Bight
Kangaroo I.
Australian Fossil Mammal Sites (Naracoorte)
Adelaide
Canberra
2228
Mt.Kosciuszko
Portland
MELBOURNE
Bass Strait

Tasman Sea
Norfolk Basin
New Caledonia Ridge
Kermadec Islands
Kermadec Ridge
Kermadec Trench
10045

South Australian Basin
Tasmanian Wilderness
Tasmania
Launceston
Hobart
South East Cape
South Tasman Rise

AUCKLAND
NEW ZEALAND
North Island
East Cape
Cape Farewell
Mt.Ruapehu 2797
Tongariro National Park
Wellington

Henderson Island
24° 22' South, 128° 19' West

INDIAN OCEAN
South Island
Southern Alps 3764
Mt.Cook
Christchurch
Dunedin
Chatham Rise
Chatham Islands
Te Wahipounamu - South-West New Zealand
Stewart Island
Bounty Trough

Southwest

Macquarie Ridge
Campbell Plateau
Bounty Islands
Auckland Islands
Macquarie Island
Macquarie Island
New Zealand Sub-Antarctic Islands
Antipodes Islands
Campbell Islands

Pacific

Basin

| Qa 120° | Qb 120° | Ra 130° | Rb 140° | Sa |

AUSTRALIA
Cape Leeuwin

Amsterdam
Saint Paul
INDIAN OCEAN
Kerguelen Islands
Heard and McDonald Islands
Heard

ANTARCTICA

0 800 1600 Kilometers

| Oa 80° | Pa 100° | Qa 120° | Ra 140° | Sa | Ta 160° | Tb 180° | Ba 170° | Bb 160° | Ca 150° | Cb 140° | Da 130° |

Antarctic Circle

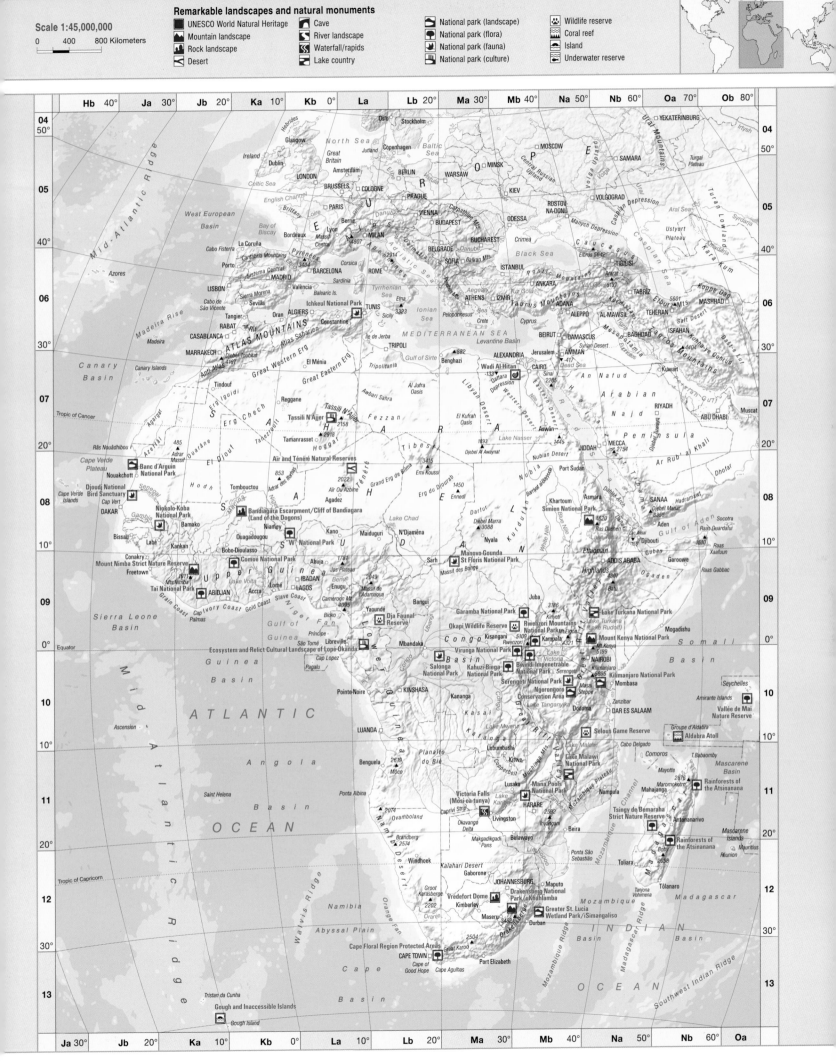

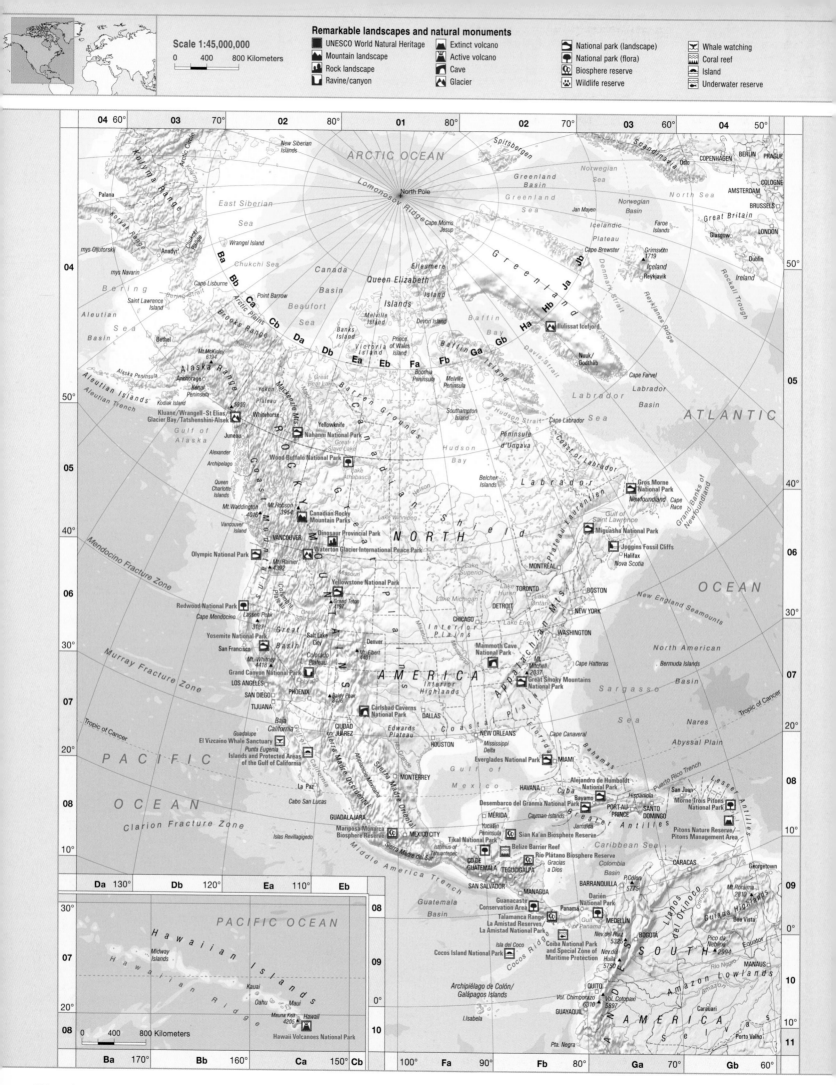

Remarkable landscapes and natural monuments

- ■ UNESCO World Natural Heritage
- ■ Mountain landscape
- ■ Rock landscape
- ■ Ravine/canyon
- ⛰ Extinct volcano
- ⛰ Active volcano
- ⛰ Cave
- ■ Glacier
- ■ National park (landscape)
- ■ National park (flora)
- ■ Biosphere reserve
- ■ Wildlife reserve
- ☒ Whale watching
- ■ Coral reef
- ■ Island
- ■ Underwater reserve

Scale 1:45,000,000

0 400 800 Kilometers

ARCTIC OCEAN

North Pole

Lomonosov Ridge

Spitsbergen

COPENHAGEN BERLIN PRAGUE
Oslo
COLOGNE
AMSTERDAM
BRUSSELS

Greenland Basin

Greenland Sea

Norwegian Sea

Norwegian Basin

North Sea

Jan Mayen

Icelandic Plateau

Faroe Islands

Great Britain

Grímsvötn 1719
Iceland
Reykjavik

Glasgow
LONDON
Dublin
Ireland

Rockall Trough

Kolyma Range
Koryak Range
Palana
mys Oljutorskij
mys Navarin
Anadyr'
Chukchi Range

Arctic Circle

New Siberian Islands

East Siberian Sea

Wrangel Island

Chukchi Sea

Cape Lisburne

Bering Strait

Point Barrow

Arctic Plains

Canada Basin

Queen Elizabeth Islands

Ellesmere Island

Cape Morris Jesup

Greenland

Denmark Strait

Cape Brewster

Ilulissat Icefjord

Nuuk/Godthåb

Cape Farvel

Labrador Basin

Bering Sea

Saint Lawrence Island

Aleutian Islands

Bethel

Aleutian Trench

Kodiak Island

Gulf of Alaska

Kenai Peninsula

Anchorage

Alaska Range

Mt.McKinley 6194

Whitehorse

5959

Kluane/Wrangell-St Elias/Glacier Bay/Tatshenshini-Alsek

Juneau

Alexander Archipelago

Queen Charlotte Islands

Mt.Waddington 4016

Vancouver Island

VANCOUVER

Brooks Range

Melville Island

Banks Island

Victoria Island

Prince of Wales Island

Boothia Peninsula

Melville Peninsula

Devon Island

Baffin Bay

Baffin Island

Davis Strait

Foxe Basin

Hudson Strait

Cape Labrador

Labrador Sea

Gros Morne National Park

Newfoundland

Cape Race

Gulf of Saint Lawrence

Miguasha National Park

Joggins Fossil Cliffs

Halifax Nova Scotia

Grand Banks of Newfoundland

Mackenzie Mts

Yellowknife

Great Slave Lake

Nahanni National Park

Wood Buffalo National Park

Lake Athabasca

Great Bear Lake

Barren Grounds

Southampton Island

Belcher Islands

Hudson Bay

Péninsule d'Ungava

Coast of Labrador

Canadian Shield

NORTH

Labrador

Plateau Laurentien

ATLANTIC

OCEAN

Mt.Robson 3954

Canadian Rocky Mountain Parks

Dinosaur Provincial Park

Waterton Glacier International Peace Park

Olympic National Park

Mt.Rainier 4392

Yellowstone National Park

Grand Teton 4197

Columbia Plateau

Missouri

Lake Winnipeg

Lake Superior

Lake Huron

Lake Michigan

MONTRÉAL

TORONTO

DETROIT

Lake Ontario

Lake Erie

CHICAGO

BOSTON

NEW YORK

WASHINGTON

New England Seamounts

Redwood National Park

Cape Mendocino

Lassen Peak 3187

Yosemite National Park

San Francisco

Mt.Whitney 4418

Great Basin

Salt Lake City

Great Salt Lake

Denver

Mt.Elbert 4401

Colorado Plateau

Mammoth Cave National Park

Mt.Mitchell 2037

Cape Hatteras

North American Basin

Bermuda Islands

AMERICA

Mendocino Fracture Zone

Murray Fracture Zone

Tropic of Cancer

Grand Canyon National Park

LOS ANGELES

SAN DIEGO

TIJUANA

Baldy Peak 3476

PHOENIX

Carlsbad Caverns National Park

DALLAS

Interior Highlands

Great Smoky Mountains National Park

Appalachian Mts

Florida

Coastal Plain

Sargasso Sea

Nares

Tropic of Cancer

Abyssal Plain

Guadalupe

El Vizcaíno Whale Sanctuary

Punta Eugenia

Islands and Protected Areas of the Gulf of California

Baja California

CIUDAD JUÁREZ

Edwards Plateau

Rio Grande

NEW ORLEANS

HOUSTON

Mississippi Delta

Everglades National Park

MIAMI

Bahamas

Puerto Rico Trench

Lesser Antilles

PACIFIC

OCEAN

Clarion Fracture Zone

La Paz

Cabo San Lucas

Gulf of California

Sierra Madre Occidental

MONTERREY

Gulf of Mexico

HAVANA

Cuba

Greater Antilles

Alejandro de Humboldt National Park

Desembarco del Granma National Park

Bayamo

MÉRIDA

Cayman Islands

Jamaica

Hispaniola

PORT-AU-PRINCE

SANTO DOMINGO

San Juan

Morne Trois Pitons National Park

Pitons Nature Reserve/Pitons Management Area

GUADALAJARA

Islas Revillagigedo

Mariposa Monarca Biosphere Reserve

MEXICO CITY

Sierra Madre del Sur

Yucatán Peninsula

Isthmus of Tehuantepec

Tikal National Park

Belize Barrier Reef

Sian Ka'an Biosphere Reserve

Río Plátano Biosphere Reserve

Caribbean Sea

Colombia Basin

CARACAS

Georgetown

Sierra Madre Oriental

CD.DE GUATEMALA

TEGUCIGALPA

SAN SALVADOR

MANAGUA

Gracias a Dios

Guatemala Basin

Middle America Trench

Guanacaste Conservation Area

Talamanca Range

La Amistad Reserves

La Amistad National Park

Darién National Park

BARRANQUILLA

P.Colón

MEDELLÍN

Darién National Park

Gulf of Panama

PANAMÁ

Nev.del Ruiz 5325

BOGOTÁ

Llanos del Orinoco

Mt.Roraima 2810

Boa Vista

Guiana Highlands

Coiba National Park and Special Zone of Maritime Protection

Cocos Island National Park

Isla del Coco

Cocos Ridge

Nevdo Huila 5750

Nev.del Ruiz

QUITO

GUAYAQUIL

Vol.Chimborazo 6310

Vol.Cotopaxi 5897

Pico da Neblina 2994

Equator

Rio Negro

MANAUS

Carauari

Amazon Lowlands

Amazon

SOUTH

AMERICA

Archipiélago de Colón/Galápagos Islands

I.Isabela

Pta.Negra

Porto Velho

Inset: Pacific Islands (Hawaiian Islands)

0 400 800 Kilometers

PACIFIC OCEAN

Hawaiian Islands

Hawaiian Ridge

Midway Islands

Kauai
Oahu Maui
Mauna Kea 4205
Hawaii

Hawaii Volcanoes National Park

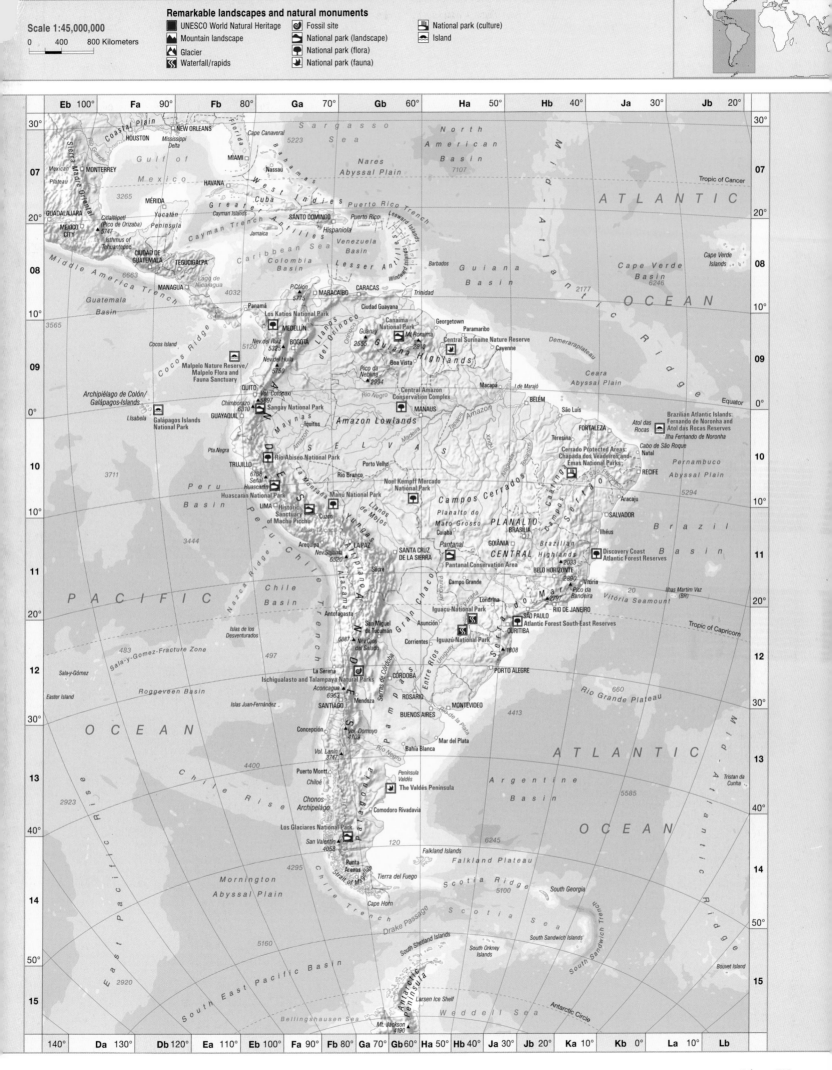

PICTURE CREDIT

A = Alamy, BB = Bilderberg, BW = Blickwinkel, C = Corbis, G = Getty Images, H = Huber, L = Laif, M = Mauritius imagesP = Premium, Sch = Schapowalow, W = Wildlife

MONACO BOOKS is an imprint of Verlag Wolfgang Kunth

© Verlag Wolfgang Kunth GmbH & Co.KG, Munich, 2009

Translation: JMS Books LLP (Malcolm Garrard & Sarah Tolley, editor Andrew Kirk, design cbdesign, proofreader Jenni Davis, consultant Kirsty Shaw)

For distribution please contact:

Monaco Books
c/o Verlag Wolfgang Kunth, Königinstr.11
80539 München, Germany
Tel: +49 / 89/45 80 20 23
Fax: +49 / 89/ 45 80 20 21
info@kunth-verlag.de
www.monacobooks.com
www.kunth-verlag.de

ISBN 978-3-89944-540-4

Printed in Slovakia

All facts have been researched with the greatest possible care to the best of our knowledge and belief. However, the editors and publishers can accept no responsibility for any inaccuracies or incompleteness of the details provided.
The publishers are pleased to receive any information or suggestions for improvement.